Memory

Luba Art
and the
Making
of History

Memory

Luba Art
and the
Making
of History

EDITED BY

Mary Nooter Roberts

and Allen F. Roberts

WITH CONTRIBUTIONS BY:

S. Terry Childs

Pierre de Maret

William J. Dewey

Guy De Plaen

V.Y. Mudimbe

Jeanette Kawende Fina Nkindi

Pierre Petit

Allen F. Roberts

Mary Nooter Roberts

Jan Vansina

The Museum for African Art, New York
Prestel, Munich

For Nancy Ingram Nooter and Robert H. Nooter,

and in memory of Ruth F. Roberts and Sidney H. Roberts.

MEMORY: *Luba Art and the Making of History* is published in conjunction with an exhibition of the same title organized and presented by The Museum for African Art, New York (2 February-8 September 1996) The exhibition will travel to the National Museum of African Art, Smithsonian Institution, Washington, D.C. (30 October 1996-26 January 1997) and other museums.

The exhibition is supported by grants from the National Endowment for the Humanities, the National Endowment for the Arts, the New York Council for the Humanities, and for educational programs, with public funds from the New York State Council on the Arts.

Design: Linda Florio Design
Design Assistant: Nadia Coën
Assistant Curator: Elizabeth Bigham

Prestel books are available worldwide. Please contact your nearest bookseller or write to either of the following addresses for information concerning your local distributor:
 Prestel-Verlag
 Mandlstrasse 26, 80802 Munich, Germany
 Phone 49 (89) 381 7090, Fax 49 (89) 381 70935
 and 16 West 22nd Street
 New York, NY 10010, USA
 Phone (212) 627 8199, Fax (212) 627 9866

Library of Congress catalogue card no. 93-80699
Clothbound ISBN 3-7913-1677-X
Paperbound ISBN 0-945802-14-5

Front cover: Stool. Luba, Zaire. Wood, beads. H. 16.5 in. The University Museum of Archaeology and Anthropology, University of Pennsylvania, Inv. no. AF5121.
Back cover: Memory board, or *lukasa*. Luba, Zaire. Wood, beads, metal. H. 13.4 in. Susanne K. Bennet.

Printed and bound in Belgium by Snoeck-Ducaju & Zoon.

Photo Credits: Roger Asselberghs, Brussels, Cat. nos. 43, 105, 108. S. Atrum-Mulzer, Staatliches Museum für Völkerkunde, Munich, Cat. nos. 25, 28, 83, 86, 104. Dick Beaulieux, Brussels, Cat. nos. 3, 4, 6, 7, 9, 10, 11, 14, 33, 56, 60, 64, 66, 71, 72, 81, 91, 107, 109. Trustees of the British Museum, Cat. nos. 8, 31, 75. The Brooklyn Museum, Cat. nos. 17, 18. Mario Carrieri, Cat. no. 99. Joel Cooner Gallery, Cat. no. 13. Dallas Museum of Art, Cat. no. 93. Hughes Dubois, Brussels, Cat. nos. 39, 44a-j, 53, 73, 74, 79, 82. Hughes Dubois, Brussels, and Musée Dapper, Paris, Cat. nos. 22, 47, 90, 95, 102, 110. Fotostudio Herrebrugh, Cat. no. 63. D. Graf, Cat. nos. 29, 30. Franko Khoury, Cat. nos. 40, 92, 97. Linden-Museum, Cat. no. 52. Paul Macapia, Cat. nos. 32, 68, 89, 98. Metropolitan Museum of Art, Cat. no. 21. Donald Morris Gallery, Cat. no. 20. Museu Nacional de Etnologia, Cat. no. 1. Museu Carlos Machado, Ponta Delgada, Cat. no. 80. M-V Photoatelier, Cat. nos. 85, 87. National Museum of Natural History, Cat. nos. 48, 54, 57, 58, 70. Denis J. Nervig, UCLA Fowler Museum of Cultural History, Cat. no. 94. Schütz, Staatliche Museen zu Berlin, Cat. no. 103. Steve Tatum, Cat. nos. 16, 37, 55, 84. Jerry L. Thompson, Cat. nos. 12, 15, 19, 23, 24, 27, 34, 35, 36, 38, 42, 45, 46, 62, 67, 69, 76, 77, 78, 100, 101, 106, 107. Jerry L. Thompson and the Walt Disney-Tishman African Art Collection, Cat. no. 88. C. Randall Tosh, Cat. nos. 50, 59. University Museum of Archaeology and Anthropology, University of Pennsylvania Museum, Negative no. T4-628, Cat. no. 96. University of the Witwatersrand, Cat. nos. 5, 41, 51. Katherine Wetzel, Virginia Museum of Fine Arts, Cat. no. 61. Diane Alexander White, The Field Museum, Negative no. A109443c, Cat. no. 26.

Contents

Preface and Acknowledgments

WHEREAS printed media, books, television, CD-ROMS, and videos are the primary means for mnemonic preservation and the transmission of cultural information in the West, the Luba peoples of southeastern Zaire have used oral narratives, origin myths, and visual and performative culture to share important cultural and historical information. For the Luba, stools, bow stands, and *lukasa* memory boards are transmitters and generational bridges that sustain certain cultural beliefs and transform others. The exhibition "MEMORY: Luba Art and the Making of History" and the essays in this accompanying book affirm that among Luba, as in the West, history as well as personal and collective memory are constructed, often manipulated and changed in oral recollection and repetition, and not always rooted in indisputable historical fact. This project demonstrates that memory and history can often be evoked in the service of cultural and political agendas and used to construct specific historical perspectives, to codify beliefs, to sustain myths, to exalt or demystify heroes, and to slant events in favor of one person or group over another. In effect, they are as subjective as the experiences that triggered them. By examining the broad themes of memory and the construction of history manifest in Luba social, religious, and artistic practices, the essays in this book provide intellectually engaging and seminal scholarship on the Luba peoples and their neighbors. They also provide a basis for understanding how, as social constructs, memory and history transcend cultural boundaries.

The realization of an exhibition and publication of this scope requires years of planning and dedicated effort. For Mary (Polly) Nooter Roberts, former Senior Curator of the Museum and curator and primary author of "MEMORY," this project marks the culmination of over a decade of research and fieldwork among the Luba peoples. The exhibition is groundbreaking in that it provides a fresh and interesting thematic context for appreciating the artworks, which were selected as examples of the superb quality and stylistic range of Luba culture. The exhibition and publication are hallmarks of Polly's scholarship, engaged intellect, and stimulating curatorial vision. We thank her for the patience, graciousness, and diligence with which she worked with us during the various phases in the exhibition's life—from the intense period of grant preparation and submission, through the identification of consultants and lenders, to securing loans, writing the book, developing education programs, and installing the exhibition.

On the staff of the Museum, we acknowledge the special effort of Frank Herreman, who recently joined the staff as Director of Exhibitions, and who came onto the project at a critical juncture. Frank has done an exceptional job of overseeing the organization of every aspect of the production of the exhibition and publication. Special thanks to Elizabeth Bigham, Assistant Curator and in-house coordinator of the project, for her hard work and highly commendable effort in organizing the many logistical details of exhibition planning and implementation. Thanks also to Carol Braide, Executive Assistant and Publications Coordinator, who managed the editing of the book with her usual efficiency. For their work in coordinating the loans, transportation, and installation, we thank Linda Karsteter, Registrar, and Erica Blumenfeld and Eliot Hoyt, the Museum's former Registrar and Assistant Registrar. We also thank Sarah Bennet, Patricia Blanchet, Danielle Milligan, and Sally Yerkovich for their extraordinary efforts to secure funding for the exhibition, and Clifford Armogan and Patrice Cochran for their

managementof exhibition finances. In the Museum's Education Department, we thank C. Daniel Dawson, Lubangi Muniania, Marjorie Ransom, and the Volunteer Museum Educators for their development and implementation of the education programs accompanying the exhibition. We are grateful to Linda Florio, graphic designer; Jerry L. Thompson, photographer; Chris Müller, exhibition designer; and Paula Webster, public relations consultant.

The Museum is grateful for the outstanding support provided for the "MEMORY" exhibition, publication, and education programs by the National Endowment for the Arts and the National Endowment for the Humanities, both federal agencies, and the New York Council for the Humanities. Their support, especially during a period of internal crisis at the agencies, has been essential to the project and a particular vote of confidence in the Museum.

The Museum is as always especially indebted to the many individuals and institutions whose loans of objects from their collections have enabled us to present an exhibition comprised of Luba works of the highest aesthetic, historic, and intellectual merit. We also thank the scholars who have contributed essays to this catalogue and have acted as consultants to the exhibition for their expertise in providing a critical frame for understanding these objects, particularly Allen F. Roberts, co-editor of this volume, for his thorough knowledge and commitment to the project.

Thanks to the Board of Trustees for their support of "MEMORY," and their continuing dedication to the Museum.

Finally, we acknowledge and thank the Luba people, not only those who have been directly involved in this project, but also the artists whose impressive works are presented in this exhibition.

Grace C. Stanislaus
EXECUTIVE DIRECTOR

Acknowledgments

THIS BOOK and the exhibition it accompanies would not have been possible without the effort, support, and generosity of many individuals and agencies. Implementation of the book and exhibition were made possible by awards from the National Endowment for the Humanities, the National Endowment of the Arts, and the New York Council for the Humanities. We are grateful to each of these institutions for their confidence in this project, as expressed by their sustaining support.

At the Museum for African Art in New York City, we wish to thank Grace C. Stanislaus and Frank Herreman for their cooperation and assistance throughout the implementation stages of this project. Elizabeth Bigham, in-house coordinator of the exhibition, adroitly handled all the logistical aspects of the book and exhibition, with the steadfast assistance of Carol Braide. Patricia Blanchet and Sally Yerkovich are to be thanked for their dedicated work on the grant proposals, Linda Florio and Nadia Cöen for their creative and thoughtful design of the book, Jerry Thompson and Hughes Dubois for their elegant photography, Chris Müller for innovative exhibition-design ideas, and Paula Webster for her intellectual approach to public relations. Daniel Dawson, Lubangi Muniania, Marjorie Ransom, and volunteers and docents have initiated and implemented a creative education program to complement the exhibition. We also wish to thank Jane Katcher and Irwin Smiley, Co-Chairs of the Museum's Board during the course of this project, for their encouragement and commitment to this exhibition and to the Museum more generally, and Robert Rubin, Treasurer, for his personal investment of time and energy in this exhibition's planning and preparation.

It has been a special honor and great pleasure to work with our consultants and contributors to this volume: S. Terry Childs, Guy De Plaen, William Dewey, Johannes Fabian, Clementine Faïk-Nzuji, Jeanette Kawende Fina Nkindi, Pierre de Maret, V. Y. Mudimbe, Pierre Petit, and Jan Vansina.

A great many friends at museums around the world have helped to obtain and facilitate loans and photographs, and have helped with our other requests. Of these, very special thanks are extended to Mary Jo Arnoldi, Ramona Austin, Rayda Becker, Christraud Geary, Julie Jones, Maria Kecskesi, Hans-Joachim Koloss, Alisa LaGamma, John Mack, Pamela McCluskey, Doran Ross, Victoria Rovine, Christopher Roy, Enid Schildkrout, William Siegmann, Kevin Smith, Sylvia Williams, and Richard Woodward.

In Belgium, we have many good friends to thank for inviting us to view their collections and for making our visits so pleasant while so productive. Marc Félix and Louis de Strycker, in particular, have played significant roles in this project from the very start. Jos Christiaens, Pierre Dartevelle, Bernard de Grunne, Baudouin de Grunne, Marcel de Toledo, and Lucien Van de Velde have also been most helpful. At the Royal Museum of Central Africa (Tervuren), we wish to thank Gustaaf Verswijver, Viviane Baeke, and other curatorial and support staff for warmly collegial interactions. We deeply regret that the recent decision to require rental fees for objects from the permanent collection proved prohibitive, and borrowing from Tervuren for this exhibition therefore proved impossible. We also wish to thank Huguette Van Geluwe for her assistance over the years, and we are especially indebted to the late Albert Maesen for his

generous contributions to our knowledge of Luba art. He was a brilliant scholar, and a true connoisseur of central African art.

Mary Nooter Roberts's predoctoral field and archival research among and about Luba people of Zaire was supported by an American Association of University Women Dissertation Fellowship (1986–87); a Wenner-Gren Foundation for Anthropological Research Grant-in-Aid (1987); a Belgian-American Educational Foundation Fellowship (1987–88); a Columbia University Wittkower Fellowship (1987–88); and a Smithsonian Institution Pre-Doctoral Fellowship (1989–90). She is most grateful to her mentors at Columbia University—Suzanne Blier, Esther Pasztory, and Marcia Wright—for their intellectual guidance, and also wishes to thank Susan Vogel for inviting a Luba exhibition, and for demonstrating and teaching her brilliant approach to exhibition creation. Allen Roberts's field and archival research among and about Tabwa people of Zaire was guided by the late Victor Turner and by the stimulating work of Luc de Heusch, and was sponsored by the U.S. National Institute for Mental Health; the Committee on African Studies and the Edson-Keith Fund of the University of Chicago; Sigma Xi, the Scientific Research Society; a National Endowment for the Humanities Summer Stipend; and Mellon Foundation Faculty Development Grants via Albion College.

In Zaire, we wish to thank the Institute of National Museums for sponsoring Mary Nooter Roberts's two years of field research (special appreciation to Lema Gwete), and the University of Lubumbashi for Allen F. Roberts's forty-five months of research affiliation in the mid 1970s. Most important, we are grateful to the many Luba people who contributed to the fieldwork on which the present book is based. First and foremost, Mary Nooter Roberts is indebted to Mutonkole Milumbu Kennedy, who served as her principal research assistant in the Kinkondja region. Kabulo B. Kiyaya was a brilliant research assistant in Kabongo Zone. Pierre Banyko, Kabange Ilunga, Les Soeurs de Notre Dame de Kinkondja, Mukanya Seba, Marie and Ngoy Kaodi of Mwanza, Father Hubert and the late Father Martin of Malemba Nkulu, and Dorothy McDonald of Mulongo figured importantly as guides, mediators, mentors, and friends.

But it was the intellectual brilliance of so many Luba elders, titleholders, ritual specialists, chiefs, and artists that brought Mary Nooter Roberts's project to fruition. They include Chief Dilenge Kumwimba Kabongo ka Nshimbu Edouard, Chief Mwana Ngoy Ntambo Lulu Munza Nzaji and his late father, Ngoy Kasenga Kitolo Mwine Munza, the late Chief Mutonkole Myulu Diluba, Chief Mulongo, and each of their respective coteries of titleholders: Bwana Kudie Mitonga Banze, Bwana Banze, Mwema Kapanda wa Mwenze, Ngoi Zaina, Lolo Angilanyi, Nday Kasongo, Ngeleka, Kioni Kumwimba, Nkulu Mulombi, Ngoy Kyungu, Muswele Kabamba Faustin, Kasongo Ngole Kimilenda Lwaba, Ilunga Mpyana-Nandu Kamanji Ntambwa Bilolo, Ngoi wa Numbi Kisanga, Ngoi wa Numbi Tusulo, Omba Banza Miketo, Ndal Kintu, and Mulea Kalenga Kabamba. We have maintained the anonymity of these and other individuals in the text to protect their identities, and have omitted the names of their towns and villages. The erudition and wisdom of these and many other individuals have been invaluable: Mwafwakoi!

Mary Nooter Roberts and Allen F. Roberts

Lenders List

American Museum of Natural History

Armand P. Arman

Susanne K. Bennet

The British Museum

The Brooklyn Museum

Buffalo Museum of Science

Joseph Christiaens

Olivier Cohen

Al and Margaret Coudron

Dallas Museum of Art

Margaret H. Demant

Drs. Nicole and John Dintenfass

Ethnografisch Museum, Antwerp

Dr. Vaughana Feary

Felix Collection

The Field Museum

Marc and Denyse Ginzberg

Philippe Guimiot, Brussels

Lawrence Gussman

Henau Collection

Horstmann Collection

Mr. and Mrs. John Lee, Dallas

Linden-Museum, Stuttgart

Drs. Daniel and Marian Malcolm

Metropolitan Museum of Art

Carlo Monzino

Museu Carlos Machado, Ponta Delgada (Açores)

Museu Nacional de Etnologia, Lisbon

National Museum of Natural History, Smithsonian Institution

National Museum of African Art, Smithsonian Institution

Mr. and Mrs. J. P. De Pannemaeker - Simpelaere

Rolin Collection

Saul and Marsha Stanoff

Seattle Art Museum

Staatliche Museen zu Berlin, Preussischer Kulturbesitz, Museum für Völkerkunde

Staatliches Museum für Völkerkunde, Munich

The University Museum of Archaeology and Anthropology, University of Pennsylvania

The University of Iowa Museum of Art

Lucien Van de Velde, Antwerp

The Walt Disney-Tishman African Art Collection

University of the Witwatersrand Art Galleries, Johannesburg

Virginia Museum of Fine Arts

and other anonymous lenders.

Contributors

S. Terry Childs, Research Collaborator of the Conservation Analytical Laboratory at the Smithsonian Institution is an archaeologist specializing in ancient African metallurgy, especially iron production and use. Her laboratory analyses of iron artifacts from the Luba area are discussed in many important journal articles.

Guy de Plaen is an anthropologist who worked for many years at the Zairian National Museum at Lubumbashi. His fieldwork among Yansi and related peoples of west-central Zaire is well known, and he has also conducted extensive research among Luba, Yeke, and others of southeastern Zaire.

William J. Dewey, who teaches at The University of Iowa, bridges between archaeology and art history, as he studies ancient and contemporary iron arts in central, southern, and eastern Africa. He and S. Terry Childs conducted a comparative study of iron arts among Luba peoples of Zaire and Shona peoples of Zimbabwe.

Jeannette Kawende Fina Nkindi is a doctoral candidate in anthropology at the Université Libre de Bruxelles and a former curator at the Zairian National Museum at Lubumbashi. Her field research concerns Luba royal arts, with an emphasis on mnemonics.

Pierre de Maret, of the Université Libre de Bruxelles, is an archaeologist and ethnographer of central Africa whose many years of research in the Luba area stand out as a profound study in African archaeology.

V. Y. Mudimbe, William R. Kenan Professor of French and Italian, Comparative Literature and Classics at Stanford University, is a preeminent scholar of the comparative literature, philosophy, religion, and anthropology of central Africa, and a poet-novelist as well. His landmark books include *The Invention of Africa* (1988) and *The Idea of Africa* (1994).

Pierre Petit is an anthropologist at the Université Libre de Bruxelles. His dissertation concerns Luba social organization and his most recent fieldwork is among Bwile and related groups of northeastern Zambia.

Allen F. Roberts teaches anthropology and African-American world studies at the University of Iowa. His predoctoral fieldwork among Tabwa and related peoples of southeastern Zaire led to a major traveling exhibition, "The Rising of a New Moon: A Century of Tabwa Art" (1986). More recently he was author and co-curator for "Animals in African Art: From the Familiar to the Marvelous" (1995) at The Museum for African Art.

Mary Nooter Roberts, who was Senior Curator at The Museum for African Art for ten years and a visiting professor of art history at Columbia University and Swarthmore College, is now a scholar affiliate at the University of Iowa. She organized "SECRECY: African Art That Conceals and Reveals" (1993), a major traveling exhibition. Her extensive predoctoral fieldwork among Luba people of Zaire is the basis for the present book and exhibition.

Jan Vansina, Professor Emeritus of History at the University of Wisconsin, Madison, is the foremost historian of central Africa. His *Kingdoms of the Savanna* (1966) is a classic study of Luba and related peoples of southern Zaire.

Foreword

From Memory to History: Processes of Luba Historical Consciousness

No person can live without a sense of self, a sense of uniqueness defined in part by the concrete evidence of one's own body and in part by the selective memories that continually forge a unique personal history. These tell a person what her or his self is. Similarly, no enduring community of people, whether a family, an association, a polity, or a nation, can exist without assuming an identity that, while it has no concrete body of its own, is still expressed by criteria for membership and mutual behavior based on and justified by a shared "historical consciousness." Thus a child is part of a family because of its birth, a historical event that it accepts and shares with its parents. And so it goes for any other group. Part of the American identity, for instance, is the acceptance of the common relevance of the Declaration of Independence of 1776, and the narratives associated with this event.

Readers of this book and visitors to its exhibition are entering the minds and lives of central African people, some of whom lived around the turn of the century, others who live in Zaire today. They will see how Luba peoples of southeastern Zaire have called upon common memories to create varieties of historical consciousness. Luba culture will be unfamiliar to most non-Luba readers and visitors; walking around inside the minds of people may be even more unfamiliar to them. Hence it may be helpful to keep in mind the way historical consciousness is created in the society of most Western readers and exhibition viewers. This occurs in part through a remembrance of written texts, in part through memories of stories told within families and communities and made authentic by reference to objects such as photographs, monuments, or documents such as the original Declaration of Independence. Such *objects*, as clearly defined and concrete as one's own body, prove that memories are "true" by showing them to be unchanging, since they are embodied in unchanging material things.

In reality, of course, historical consciousness continuously re-creates its contents with the changing of times, despite the objects to which it is linked. The words of an original document do not change, but their interpretation certainly does. And so it goes even with monuments, photographs, and other works of art and expression. Indeed, "restoration" often amounts to the reinvention of an original.

Historical consciousness among Luba is like this too. The historical narratives of Luba peoples were and are oral, not written, but they too have been bolstered by objects as concrete "proofs"— even more so than in the West, precisely because they *were* and *are* unwritten. Among these objects, some, such as the *lukasa*, are specific aids to memory; as the Luba say, they are "signs of remembrance" (*kivùlukilo*). They are mnemonics. "Written" on them is a series of symbolic signs referring to narratives about the past. These signs are not writing, because they are not univocal: a sign does not correspond to either a single sound or a single meaning. Symbolic signs are multivocal, referring to many subjects at once, only one or a few of which may relate to such historical narratives as the coming of kingship to the main Luba kingdom. As a consequence, the scope for various interpretations of such a set of signs is far greater than in the case of writing — but still, that scope is not infinite: it can tell a common historical narrative. As the present authors demonstrate, so do other Luba symbolic assemblages like those constructed from beads or even body scarifications.

Perhaps the most striking impact of this book and its exhibition may be a sense of the overwhelming range of Luba mnemonic expression. The exuberant variety of the objects shown is astonishing, ranging from the humble lump of stuff to large figures and abstract designs. The

sheer number of mnemonics relating to high political authority, and the loving care and exquisite beauty with which many of these objects have been fashioned, are especially remarkable. The history of a kingdom is remembered first through baskets and through the *makumbo* or "great dwellings" in which remains of previous rulers are kept, then by *kitentà* or commemorative sites at each of which a medium is dedicated to the spirit of a particular dead king. Strewn across Luba lands are other memory-laden sites, sometimes hedged by ritual prohibitions that recall the past. There are *mbòko* containers with sacred chalk brought from the mythical source of kingship — chalk that proves the legitimacy of a ruler, as he is anointed with it during the initiation rituals through which he becomes king, in a sort of "apostolic succession." There are chapters of the Mbudye Association, which maintain mnemonic tools to commemorate the epic beginnings that legitimize a kingdom, just as a constitution does in Western-style nations. A rich array of regalia, from thrones to bow stands, makes mnemonic reference to ancestral founders, episodes of the epic, sacred places, and the origin of honors and rights. In addition, there is the oral side, presented in this book through tales of "men of memory" who recount the successions and wars of various kings, of historical songs with mnemonic melodies, historical proverbs whose special tonal patterns provided mnemonics also, and the praise names of kingship and of individual kings. Moreover, there are reenactments of episodes of the royal past, especially on certain occasions at court and during Mbudye rituals.

When academic historians first set out to reconstruct a history of the main Luba kingdom, they relied on written records of Luba historical oral narratives and on the tales of oral historians whom they interviewed. Because historical consciousness changes over time to provide guidance on the burning issues of the day, it is important to realize that the narrative sources of academic historians, like many of the objects shown here, may date from the dawn of colonial occupation in the area and reflect the turbulent times that preceded this subjection. Only a handful of written

Why has such an exuberant array of memories been so carefully preserved, and bolstered by such powerful and beautiful objects? Because historical consciousness defines a kingdom and provides it with its ideology. Even the main Luba kingdom could not maintain a standing army in precolonial times, and though it could raise a temporary one that, for the span of a few weeks at least, could raid at great distances from the capital, it could only coerce a tiny number of its subordinate communities at any given time. A Luba kingdom had to rely on the consent of its constituents and basically autonomous regional communities, whose chiefs replicated its instruments of memory to establish their own local legitimacies. Even the main Luba kingdom was first and foremost a construction of the mind. Regional communities belonged to it because they *proclaimed* that they belonged to it. They shared in its historical consciousness and believed in its contents. Sometimes they were whole-hearted believers, and played a part in the affairs of the main kingdom's capitals, participating, for instance, in wars of succession. Sometimes they were believers "in principle," who merely bolstered their local authority by the possession of some emblem received from the central court. Farther away — indeed, even hundreds of miles farther away — there were imitators who had similar emblems crafted locally, and who derived power by reference to the prestige of the main Luba court. Thus the objects discussed in this book and on view in the accompanying exhibition were the very foundation of the main Luba kingdom, and the gist of a Luba-inspired concept of "civilized life" for much of southeastern Zaire and nearby Zambia.

When academic historians first set out to reconstruct a history of the main Luba kingdom, they relied on written records of Luba historical oral narratives and on the tales of oral historians whom they interviewed. Because historical consciousness changes over time to provide guidance on the burning issues of the day, it is important to realize that the narrative sources of academic historians, like many of the objects shown here, may date from the dawn of colonial occupation in the area and reflect the turbulent times that preceded this subjection. Only a handful of written

references from the nineteenth century mention the kingdom and some of its rulers. Nevertheless, with these data it has been possible to provide a reasonable outline of the main political events affecting the kingdom from about 1700 onward, and to do this more thoroughly than any single oral historian could, because writing allows the academic historian to compare oral accounts from different parts of the region. By studying the traditions and objects relating to the myriad regional and local political communities, it should be possible in the future to achieve considerably more detail and even more plausible historical reconstructions.

Before 1700, the oral record consists only in the founding Epic, which reflects conceptions of cosmology and civilization more than a record of specific events in the past. To go farther back than 1700, therefore, one must rely on archaeological data from the numerous cemeteries that dot the Upemba Depression. Such data add a thousand years of time depth, and furnish a chronology to boot. They convincingly show that Luba civilization in the main kingdom after 1700 is but the latest expression of a millennium-long cultural continuity.

In the future, yet another class of data will have to be used. The systematic comparative study of Luba vocabulary promises to provide further historical information. Such a study can distinguish among words that are ancestral in the language, words that were borrowed, and words that are innovations. Thus "mfùmù," "chief, notable," is ancestral and older even than the Luba language itself; but "mulopwè," "king," is a later borrowing, and "lutéè" (*lutô*), "memory," is an innovation of unknown date, from "kitéè," "a heap containing charms — including Mbudyè thrones." Cognates for this last term occur (recorded already by the 1620s) in the kingdoms of western central Africa to designate an "idol" or "bundle of charms." Thus the ultimate mnemonic guarantee for memory in the Luba world is supernatural.

The signs of remembrance discussed and shown here impress on us how much the Luba cared about the memory of their identities, but these signs cannot by themselves go beyond the visual. Hence this book is needed as a complement to the exhibition. It allows us fuller access to the subtleties of historical consciousness in Luba minds a century ago, and in present-day Zaire. Experts with an intimate experience of the Luba world offer us a wealth of further information, including ancient antecedents of these signs of memory, their social contexts, and the endless shuffling and reshuffling of familiar symbolic "words" in strings of novel symbolic "sentences," to permit readers to savor a fuller range of the harmonics of thought and emotion that surround the objects shown. Thus, together, book and exhibition give us the privilege of participating in the wisdom and the beauty of what was and is Luba civilization.

J. Vansina

A Note on Spelling and Grammar

Luba speak a Bantu language, as do African peoples from southeastern Nigeria across the continent to Kenya and southward to the Cape of Good Hope. Bantu languages are characterized by seven or more noun classes, each with its singular and plural prefixes demanding different accords with adjectives and verbs. For nonspeakers of such languages, differentiating between singular and plural forms may be daunting. While we have included a number of key Luba terms because no precise equivalents exist in English, we have chosen to simplify the words by treating most of them as though they were collective nouns (like "fish") that remain the same in singular and plural. Furthermore, in several instances when a word is used frequently throughout our text, such as "lukasa," we have Anglicized the word: one lukasa, two lukasas. We have also used italics sparingly, so as to help readers identify terms new to them without keeping Luba words "foreign," as sustained use of italics may imply.

The names of groups of people speaking Bantu languages are preceded by prefixes from the noun class that signifies animate beings. One should say "one Muluba, two Baluba." Following a longstanding convention of academic writing, however, we have dropped the prefix to facilitate comprehension, again as though "Luba" were a collective noun or adjective. Readers should be aware that in some older literature, "Baluba" or "Warua" (the same word as spoken by a speaker of Swahili) refer to the people we call "Luba."

Finally, Luba is a tonal language, with subtle spoken differences denoted by the use of accents when the language is written. Recording tonality is exceedingly difficult, often depending upon the "ear" of particular researchers; a good deal of confusion will remain until Luba and related languages can be studied more systematically than they have been to date. Some writers have recorded Luba tonality, others have not; some suggest tonality that others contest. Luba have no trouble speaking their own language, of course—it is only we outsiders who do! In this book Luba words are written as we have found them in the literature, recognizing that these discrepancies add yet another source of ambiguity to any ethnographic text.

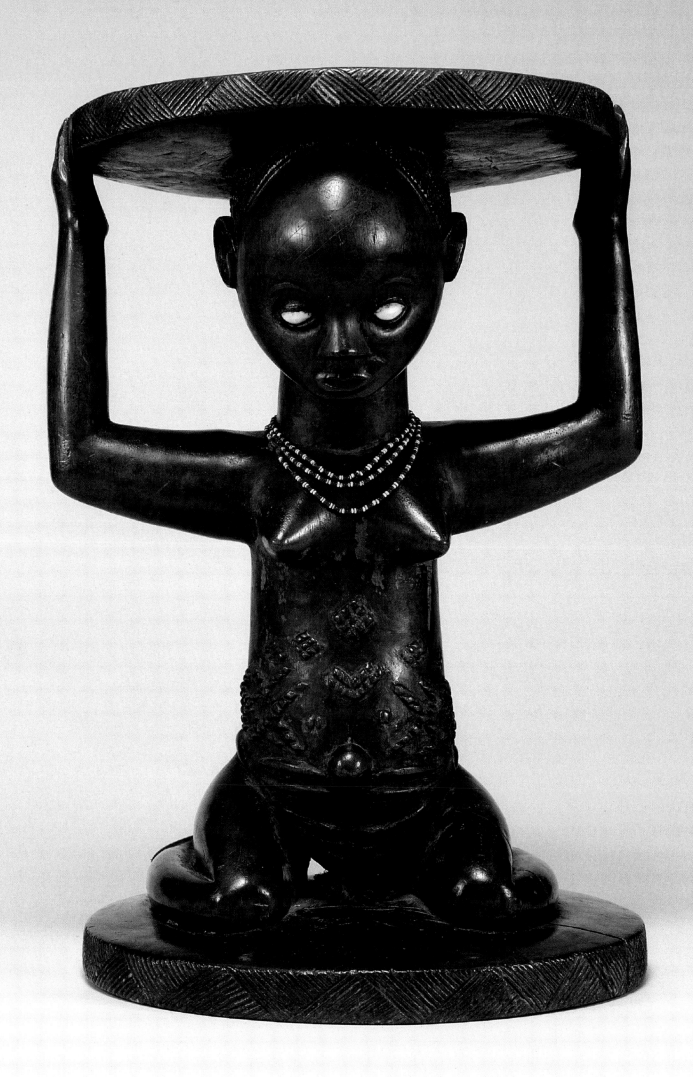

In order to force the past, when forgetfulness is
hemming us in, poets engage us in reimagining. . . .
They teach us "the audacities of memory." One poet
tells us the past must be invented: "Invent. There is
no feast/At the bottom of memory."

—Gaston Bachelard, 1971

INTRODUCTION

Audacities of Memory

Mary Nooter Roberts and Allen F. Roberts

Memory is a subject of timely and far-reaching import. As postmodernists question the nature of
truth, memory, and history; as history books are rewritten to reflect multiculturalism, polyvocality,
and the decentering of knowledge; as the humanities become increasingly reflexive; and as issues
of memory loss and retrieval are researched, debated, and litigated, it is appropriate to consider
how other cultures conceive and use memory.

This book explores relationships among memory, history, and art made and used by Luba, a
central African people of southeastern Zaire. Memory boards, ancestor figures, royal staffs, divina-
tion instruments, and other Luba mnemonic devices dating from the eighteenth to the twentieth
century demonstrate the importance of visual arts and related expressive culture to the formation,
development, and remembrance of Luba kingship and political relations. Our essays demonstrate
that since precolonial times, the recounting of history has been a specific and highly valued form
of intellectual activity among Luba; and that visual representation has been and is a primary
vehicle for the making of Luba histories of kingship and center/periphery political relations.

Memory is not passive, and the mind is not simply a repository from which memories can be
retrieved. Rather, memory is a dynamic social process of recuperation, reconfiguration, and out-
right invention that is often engendered, provoked, and promoted by visual images (Küchler and
Melion 1991, Casey 1987). Such an approach to memory is useful for understanding many African
contexts in which history is both evoked and produced through oral narratives and performances.
Despite ideologies that suggest that history (like truth) is immutable, expressive forms change over
time. Paradoxically, their flexible semantic structures allow for the creative re/construction of
memory, while at the same time providing "proof" of past truths because they render concepts,
emotions, and interactions concrete (Vansina 1985). A sense of security results, as expectations of
how things "always" have been and should be are confirmed, even as new solutions are sought to
meet evolving needs.

It is one of the goals of this volume to correct any misperception that while African cultures
without writing may have collective memory, they possess no history:

> The history of black Africa, even until recently, existed for the outside world only through
> the written word of its European conquerors. Today. . . [African history] has come into
> being as an autonomous discipline. No one would dare to propose now, as did some

CAT. 1: STOOL. LUBA, ZAIRE. The soul of
each Luba kingship is literally enshrined in
a throne. When a Luba king died, his royal
residence was preserved for posterity as a
"spirit capital," *a lieu de mémoire* where his
memory was perpetuated through a spirit
medium called a "Mwadi" who incarnated
his spirit. This site became known as a
"*kitenta*," or "seat"—a symbolic seat of
remembrance and power, which would
continue the king's reign. The king's stool,
a concrete symbol of this larger and more
metaphysical "seat," expresses the most
fundamental precepts of Luba power and
dynastic succession. *Wood, shells, glass,
beads. H. 17 in. Museu Nacional de
Etnologia, Lisbon.*

scholars in the middle of this century, that there might be an African past, but that for lack
of writing its history does not exist. . . . Africans tell, sing, produce (through dance, recita-
tion, marionette puppets), sculpt, and paint their history. Just like other peoples, they have
always sought to master their past, [and] have had their historical discourses which render
and interpret the facts of the past, placing them in an explicative and aesthetic frame pro-
ducing the sense of their past (Jewsiewicki and Mudimbe 1993:1, 4).[1]

For Luba peoples, objects and performances generate memory for historical documentation,
political negotiation, and everyday problem-solving. Here we shall present the nuanced relation-
ships of memory and visual representation in the production of Luba historical thought, to suggest
how the work of memory is a work of art, and vice-versa.

Myth and the Written Word

Luba peoples inhabit the vast savanna, rolling hills, and scrubby forests of Shaba, a province
of present-day southeastern Zaire (figs. 1–3).[2] Their location along the tributaries and lakes of
the great Zaire/Congo River (figs. 4–6), their participation in long-distance trade, and their
exploitation of rich natural resources including salt, iron, palm oil, and fish, all contributed to the
establishment of an influential central African kingdom in the latter half of the present millennium
(Reefe 1981, Vansina 1966, Wilson 1972)(figs. 7 and 8). As our first chapter will demonstrate,
evidence of such political consolidation is revealed in an astounding archaeological record from
what is now deemed the Luba "Heartland." Advanced metal-working and ceramic technologies
over a 1,500-year continuum, as well as linguistic factors, identify Luba as a preeminent Proto-
Bantu population—that is, as the nucleus for expansion by peoples now inhabiting much of
central Africa.[3] In addition, Luba are recognized for an extensive and brilliant body of oral his-
tory, court poetry, and visual arts.[4] These include a wide range of royal sculptures and emblems
from the seventeenth to the nineteenth centuries, when the Luba kingdom was at its height
(cat. nos. 1–4). The wealth of these materials makes the Luba past a rich field for investigating
African notions of memory and history, and how they may be related to state formation and
processes of political economy.

A caveat is in order. The written discourses and on-the-ground policies of colonialism and the
early postcolonial period have contributed to the creation of a Luba ethnicity or "supertribalism,"
based on growing urbanism and other factors (Young 1965:240–41, 264), and reflecting the sup-
posed precolonial existence of a Luba "empire."[5] This rigid model of centralized rule, the result of
a literal reading of the founding myth of sacred kingship, reflects a fundamental misunderstanding

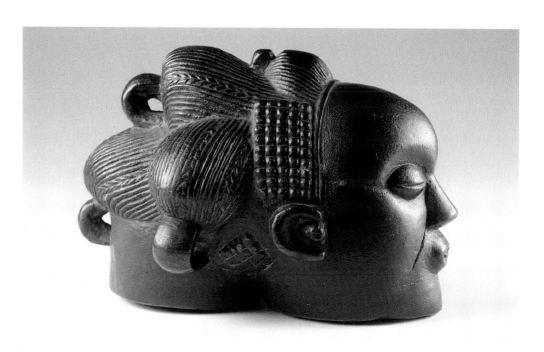

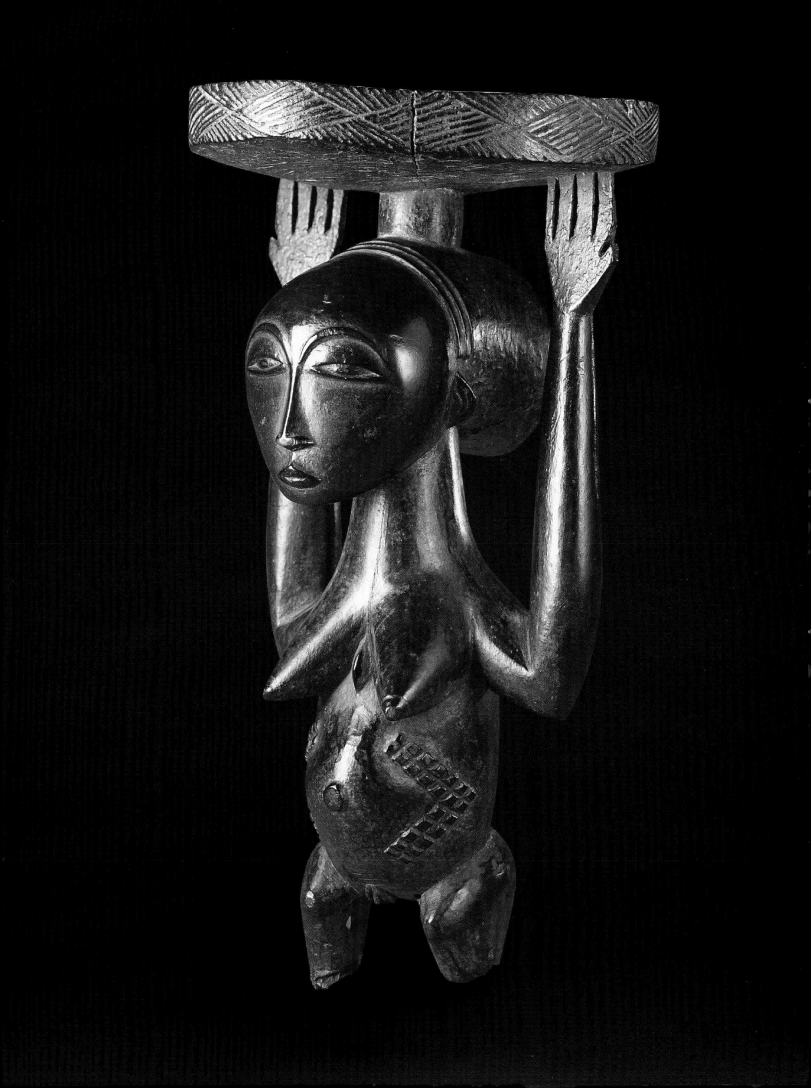

Bow stands were among the most sacred regalia in the treasuries of Luba kings and chiefs. These beautifully formed objects, with their three projecting wooden branches and iron shafts, functioned as resting stands for bows and arrows, but were primarily symbols of royal authority. Never displayed in public, bow stands were fastidiously guarded in the king's residence by a female dignitary called the Kyabuta, who, at public ceremonies, followed the chief holding a simple bow between her breasts. Within a shrine house at the king's residence, bow stands were regularly provided with prayers and sacrifices, and were subject to elaborate ritual and taboo. The same shrine house contained the relics of past rulers, considered the most potent of all royal property. *Wood. H. 23.4 in. Ethnografisch Museum, Antwerp, Inv. no. AE. 722.*

of African political economy on the parts of Belgian colonial authorities, based upon a prevailing sense that kingdoms *must* have existed, even when evidence of stateless societies suggested the contrary. As authorities in the Belgian Congo imposed their version of "Indirect Rule" in the 1920s and early 1930s, they sought to reverse the "disaggregation of indigenous authority" that they attributed to havoc from the east African slave trade and other turmoil of the late precolonial period. Through the "guided evolution" of "royal-blooded chiefs," paramouncies would be recognized where they "still existed" or when it was "possible to revive them."[6]

Ironically, even as colonial authorities, following their sense of a feudal African past, sought to create "vassals" and "fiefdoms" for such "suzerains," they were preoccupied with their subversion of existing centralized African societies, so that these, like the "revived" paramouncies, would submit to colonial rule.[7] And the ironies are sustained, for many of the political structures invented during the colonial period have been lived realities ever since. Yet memories remain of what was or might have been. The tragedy is that contention over local-level political legitimacy still sometimes leads to intense suffering and pitched battles between rival factions (Roberts 1979, 1989).

This is by no means to say that a Luba state did not exist, nor would we diminish its accomplishments in political economy, erudition, art and expressive culture, and other domains. Indeed, these are the principal subjects celebrated in our book. Instead, we suggest that the Luba state involved a far more flexible set of relationships that extended in a wide circle of influence rather than authority (cf. Mair 1977:11), for "Luba" is a social identity available to a much vaster complex of cultures than that of the Heartland itself. As Pierre Petit (1993:30) notes, "Luba" is a most ambiguous category that may refer to five thousand or five million people, depending upon its particular, situationally defined application. While the question of Luba ethnicity will be given detailed consideration in our last chapter, it is nonetheless essential to establish some basic points from the outset.

One must first consider the manner in which Luba enshrine the origins of sacred kingship in an epic. Referred to in the literature as a "genesis myth" and sometimes here as a "royal charter," this long oral narrative has been transcribed in numerous versions.[8] The Epic has a basic structure (Heusch 1982), in which Mbidi Kiluwe, a handsome hunter and "prince" from the east, introduces royal bearing and a new political order to the indigenous population, governed until then by a cruel, drunken despot named Nkongolo Mwamba. The union of Mbidi Kiluwe with one of Nkongolo's sisters produces a son named Kalala Ilunga, who grows to become a heroic warrior. After great antagonism and a protracted battle with Nkongolo, Kalala defeats his maternal uncle with the help of a visionary named Mijibu wa Kalenga, and accedes to the throne to institute sacred kingship as embodied and introduced by Mbidi Kiluwe. All subsequent Luba kings, thirteen of whom appear in most recited pedigrees, are said to descend from Mbidi Kiluwe and his son Kalala Ilunga.

This political charter gained particular importance through the eighteenth and nineteenth centuries. Luba histories written by turn-of-the-century colonial administrators and other expatriate observers were based on literal interpretation of the myth as narrated at the royal court, thereby promoting the notion of a single dynastic line ruling a Luba "empire." The term "empire" first appeared in several histories formulated by Belgian territorial administrators (e.g. Van der Noot 1936). Edmond Verhulpen, who based his influential history *Baluba et Balubaïsés du Katanga* (1936) on unpublished and often uncited early-colonial documents (Reefe 1981:15), asserted that there were two Luba "empires," the first that of Nkongolo, through the seventeenth century, and the second that of Kalala Ilunga, established thereafter. This second empire allegedly extended far to the west and eastward to Lake Tanganyika, drawing numerous ethnic groups into the sphere of Luba sovereignty, including Kalundwe, Kaniok, Kunda, Sanga, Hemba, Tumbwe, Zela, Lomotwa, and some others, thus giving rise to the term *"balubaïsés,"* or "Luba-ized" peoples (fig. 9). As we shall see, this term is useful, in that it suggests a dynamic process through which attributes of one culture are emulated, adopted, and adapted by people of another; but there is no credible evidence that Luba-ized peoples ever constituted an "empire" ruled by a supreme authority. Instead,

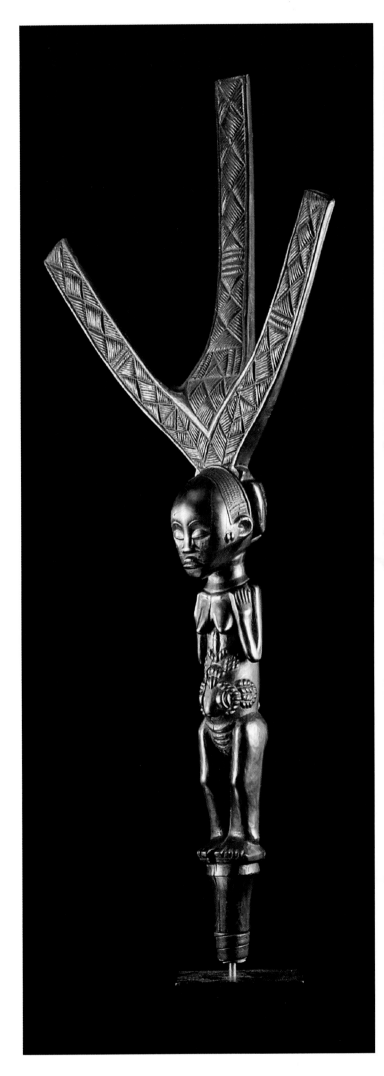
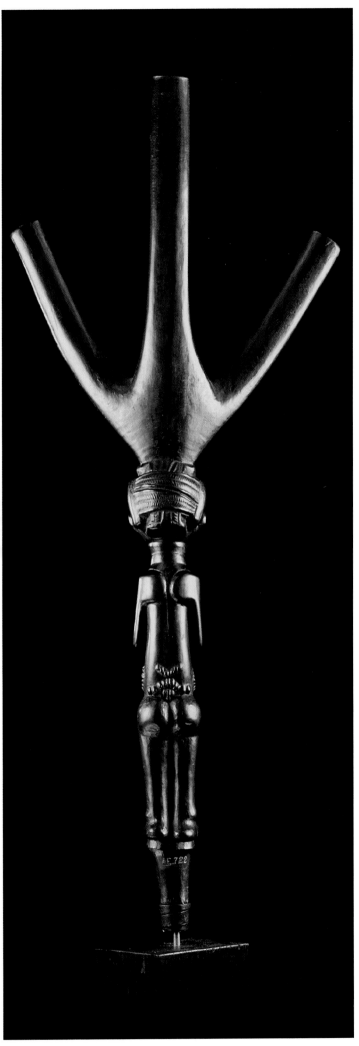

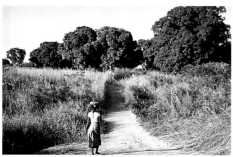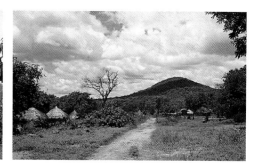

Figs. 1–3: Shaba landscapes, including savanna, rolling hills, and village scenes. *Photos: Mary Nooter Roberts, 1987–89.*

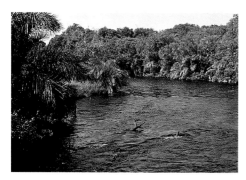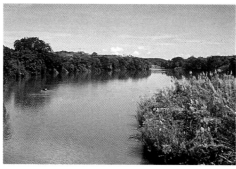

Fig. 4: Lomami River between Kabongo and Kamina. *Photo: Mary Nooter Roberts, 1989.*

Fig. 5: Lualaba River near Bukama. *Photo: Thomas Q. Reefe, 1970s.*

Fig. 6 : Lualaba River near Kinkondja. *Photo: Thomas Q. Reefe, 1970s.*

Fig. 7(opposite): Map of Zaire showing Shaba region (formerly Katanga), where Luba reside. Luba is not a discrete, closed identity contained in a distinct region; instead, it is fluid, open-ended, and histori- cally situational. *Map by Chris Di Maggio.*

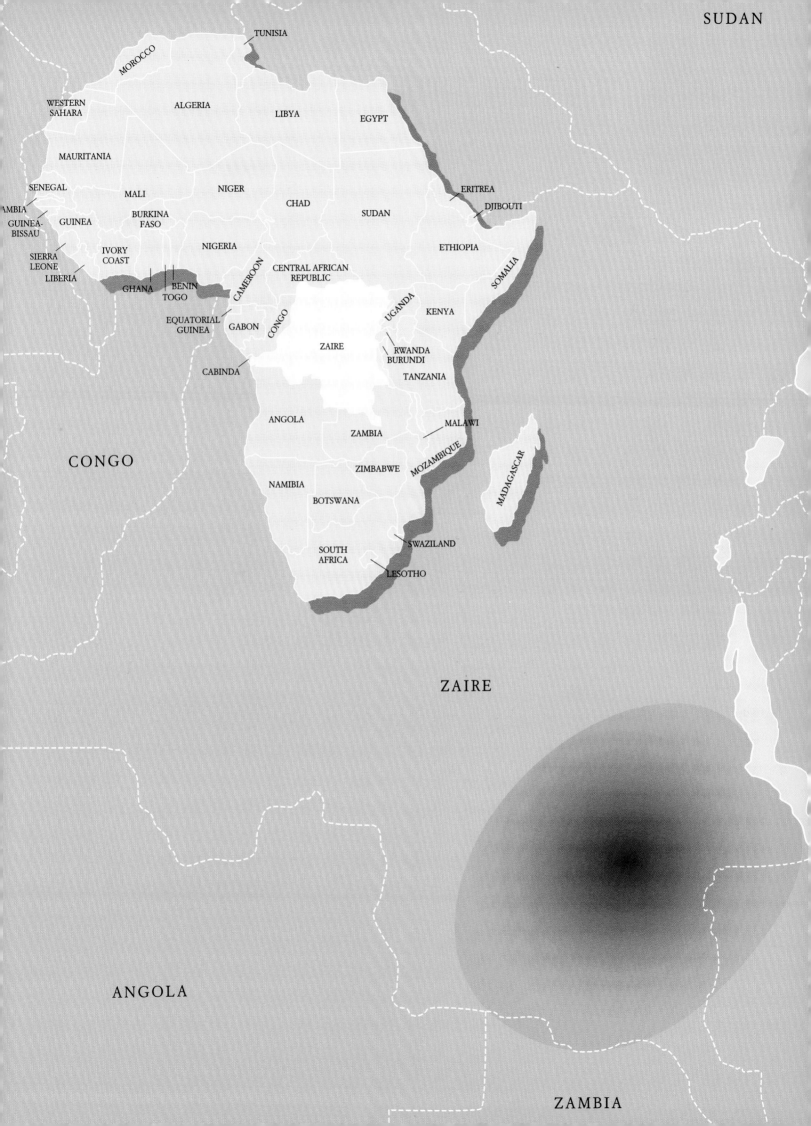

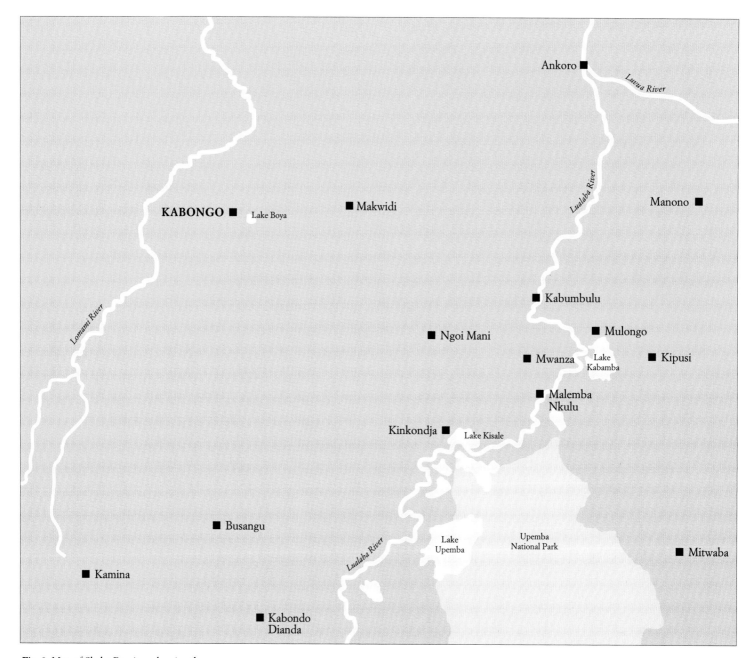

Fig. 8: Map of Shaba Province showing the principal towns and village collectives of major Luba Heartland chieftaincies. *Map by Chris Di Maggio.*

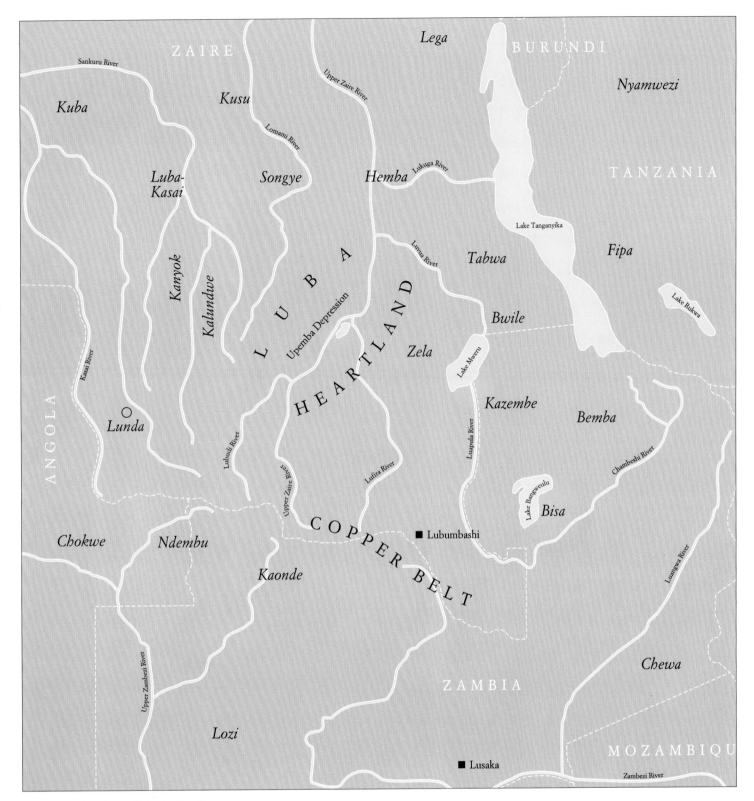

Fig. 9: Map of the larger "Luba-ized" region, showing the Heartland at the center, with indications of the surrounding ethnic groups that have been influenced in various ways by the kingdom. *Map by Chris Di Maggio.*

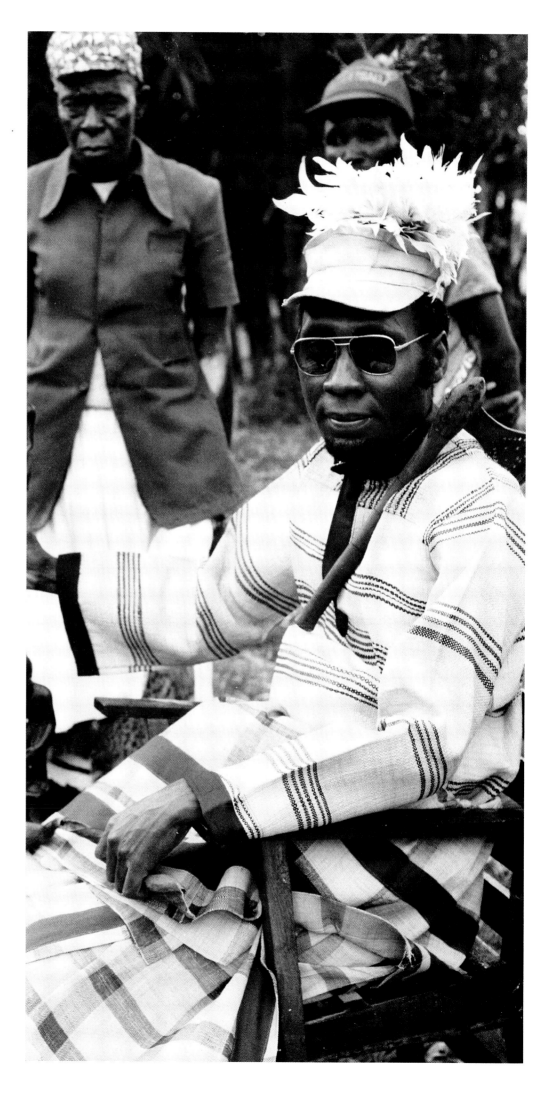

Fig. 10: Chief Kumwimba Kabongo ka Nshimbu Edouard seated in state, with two titleholders in attendance, and bearing the emblems of his office, which include a sculpted staff of office, an ax worn over his left shoulder, and a ceremonial fly whisk. *Photo: Mary Nooter Roberts, 1989.*

Fig. 11: Chief of Makwidi, sacred former residence of the first mythical Luba king, Kalala Ilunga. Surrounding the chief are his son; Kabulo Kiyaya (Mary Nooter Roberts's interpreter/field assistant in the Kabongo zone); royal dignitaries; and court historians. *Photo: Mary Nooter Roberts, 1989.*

Fig. 12: Chief of Mulongo surrounded by members of his family. Mulongo was and is an important chiefdom on the eastern side of the Lualaba River. Closely aligned with the royal center, it was critical to Luba expansion, for its chiefs guarded the strategic river crossing where the Lualaba River (also called the Zaire River) flows out of the Upemba Depression. The Heartland kings depended upon Mulongo paddlers to transport titleholders, royal messengers, and warriors across the river in dugout canoes. *Photo: Mary Nooter Roberts, 1988.*

Fig. 13: Chief of Kinkondja, who ruled until his death in the early 1990s. Kinkondja was an independent Luba substate located along the edge of Lake Kisale, an enlargement of the Lualaba River. *Photo: Mary Nooter Roberts, 1987.*

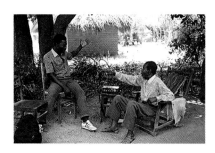

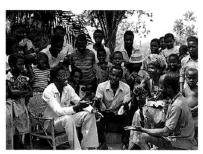

Figs. 14 (top) and 15 (bottom): Luba intellectuals, historians, and titled officials engaging in debates on history. The young man in fig. 14 is Mutonkole Milumbu Kennedy, Mary Nooter Roberts's interpreter/field assistant in the Kinkondja zone. *Photos: Mary Nooter Roberts, 1987.*

a Luba polity based around the Upemba Depression constituted a Heartland of active commerce and political influence. Armed raiding outward from this center served both defensive and offensive purposes, but again, there is no substantive proof that "imperial authority" was imposed or even sought by Heartland Luba kings, at least in most cases.

Peripheral leaders affirmed trade networks and political alliances through occasional gifts of deference (*milambo*) to Heartland kings, to acknowledge the utility of such relationships (fig. 10). In most cases, it is doubtful that these gifts constituted the "tribute" that Belgian administrators (and some more recent authors) have taken them to be, a misreading arising from the feudal model of African society that the colonizers "recognized," sought to "re-create," or simply imposed in accordance with their notions of what "primitive" society must be like. Instead, these irregular gifts signified recognition of seniority, as though through kinship and political expediency—that is, in the way that a junior member of a lineage or clan may honor elders with gifts of goods and services. Such a kinship idiom is important for understanding precolonial cultural dynamics in this part of central Africa, for, as we shall see in the essays to follow, it explains not only everyday social relations, but creative uses of memory to establish and affirm social identity and status. "A royal center," then, was more an ideological construct than an empirical reality.[9]

Approaching Luba political organization through oral accounts stimulated by visual mnemonics, as well as through the available archaeological record, provides a more useful perspective on Luba polity than that of "empire." Although court chronicles accentuate the preeminence of a single royal patriline originated by Mbidi, the mysterious hunter-hero from the east, archaeological records show that Luba have had a continuous and progressive history of sociopolitical and technological development for more than 1500 years, with no radical changes in kind or degree, and with no clear evidence of the introduction of a new or foreign political order (see chapter 1). Likewise, visual arts and contemporaneous oral testimonies generated about them indicate that Luba power rested not with a single dynastic line of kings or with a single "center," but with a constellation of chieftaincies, officeholders, societies, and sodalities that validated claims to power in relation to what we suggest to be a largely mythical center. The paradox is explicit: there was no real center, yet belief in one allowed cultural integration of an entire region. Identification with a "center" was in effect a means of legitimizing the "periphery" (Nooter 1991)(figs. 11–13).

A further point may be made. The inability to align or accord late-20th-century Luba accounts of the past with the monolithic descriptions of Luba empire presented in colonial histories suggests a more fractured picture of Luba hegemony and a more local-level political phenomenon than presumed. The translation of the Luba genesis myth into a written history taught to Luba schoolchildren, and into a text analyzed by structuralists and historians, has diminished the Epic's multidimensionality, and its ability to be retold and remade anew with every narrative performance.[10] As James Clifford states, in our endeavour to "write" culture we transform the disjunctions of lived experience into the integrated portraits of our cultural representations (1988:39). The impact of the Epic, continually reconfigured according to contemporary sociopolitical realities, is weakened in the process. Yet as we shall see, just such refabulation of the past is the *work*, as well as the *art*, of memory.

Memory in the Present

It is no longer fully possible to retrieve or reconstruct a positivist's "true" picture of the Luba past. What can be pieced together are the resonances and reprises of later generations. Academic historians possess other tools, of course (Vansina 1985); yet "history is always a problematic and incomplete reconstruction of what is no longer . . . a representation of the past" (Nora 1984:xix).

The recognition of oral tradition as a valid form of historical production was a methodological breakthrough in African historiography, achieved during the last third of the twentieth century. Africanist scholars such as Jan Vansina, David Henige, Harold Scheub, and Robert Cancel have demonstrated how oral tradition can be a legitimate and penetrating tool of historical reconstruction in societies by whom writing was not used for record-keeping until the colonial period. Of

even more recent interest is the way verbal discourses inhere in the material world—that is, the way texts are attached to, or secreted in, two- and three-dimensional forms of visual representation. Although text/object relationships have received less attention than oral traditions, they constitute one of the important ways that certain African peoples construct and perpetuate their pasts.[11] They are the primary focus of the present book.

While some archaeologists and materialist historians contest the accuracy of oral and related expressive traditions when compared to the tangibility and supposed "scientific" precision of archaeological and written records, S. Terry Childs and Pierre de Maret discuss in this volume their recent research suggesting the integrity of such sources for understanding the past, and, even more to the point, the potential of such expressive forms as registers of present significance. Not only are Luba concerned with their past, they—like people everywhere—continually reinvent the past for purposes of the present, especially as nationalist and local histories are reconfigured to meet emerging needs of political economy (figs. 14 and 15). Often, the primary means for doing so are through text/object relations (cf. Diouf 1992a, 1992b; Roberts 1996c).

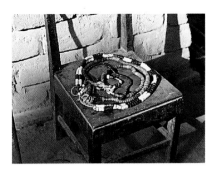

Fig. 16: Strings of beads owned by a royal titleholder in Kinkondja. Beaded accouterments constitute a language of memory, facilitating remembrance—as well as negotiation—of historical facts. One Luba word for memory shares the same root as the word for a string of beads, "*mulanga*." *Photo: Mary Nooter Roberts, 1987.*

The conventional breakdown of African history into broad precolonial and postcolonial periods, with "the colonization period constituting a major border" between the two (Jewsiewicki and Mudimbe 1993:3), is an artificial representation of Africa's past. Its result is that "precolonial history was then presented as the melting-pot of truly African experiences; colonial history was neglected because it was perceived as a parenthesis, a time of acculturation and of domination" (ibid.:3). It is truer to lived experience to consider the past as represented and assigned value according to its purposes for group identity and political legitimacy in the present. "History is a legend, an invention of the present" (Mudimbe 1988:195), and memory is always now.[12]

The politics of history-making in the present and the intentions of political legitimacy underlying historical pursuits require that even oral narratives and related expressive media used for history-making, such as the visual mnemonics to be explored in this book, must be deconstructed to be understood. Bogumil Jewsiewicki and V. Y. Mudimbe propose that memory represents a rich, as yet untapped resource for African history. And even though memory and its corollaries of recollection and collective memory remain abstract, ambiguous concepts, they offer a more incisive approach to understanding indigenous notions of history than any one specific medium of historical production. "Memory in all its various forms can thus be used much more effectively than 'oral tradition' to conceptualize the post-scripted word" (Jewsiewicki and Mudimbe 1993:4), for "memory is the raw material of history" (Le Goff 1992:xi). Yet despite how obvious the answer may seem, we still must ask, what *is* memory?

The Cultural Construction of Memory

Memory has had its own histories in Western and non-Western societies (Casey 1987, Yates 1966, Terdiman 1993). While definitions are perpetually modified, recent research suggests an important premise: memory is a cultural construction rather than a discrete, biologically grounded, universally shared mental property or activity. Not only do forms of memory vary from one society to the next, but even notions of time and space are culture-bound.[13] Memory exists in what Kirsten Hastrup (1991:113) calls "uchronia." Just as a utopia is ideal because, as reflected in the word's ancient Greek roots, it is a "nonplace," so a uchronia is "a structured world, nowhere in time." Such positions contradict previous theories of memory, beginning with Platonic and Aristotelian discourses which assert that memory is a universal function of the mind, a storage bank, so to speak, wherein data and knowledge may be deposited and retrieved at will (Küchler and Melion 1991:3).

Cross-cultural examination demonstrates the extent to which memory is a particular invention of every society and every era, reflecting local cosmologies and inexorably changing cultural values (Küchler and Melion 1991; Bateson 1958). While collective memory has often been regarded as monolithic, static, and undifferentiated, in the view of Jewsiewicki and Mudimbe (both eminent scholars of Zairian realities), collective memory "is a means of producing meanings which belong to a political field" (1993:10). In other words, memory is active, always in the present, and a construction, transaction, and negotiation, as opposed to a reproduction.

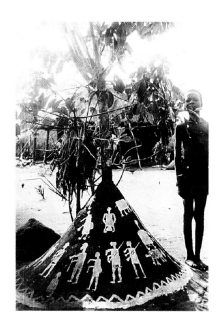

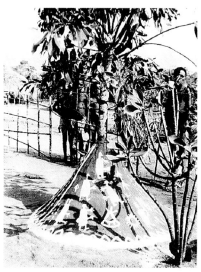

Figs. 17a and 17b: Front and back views of a *kitê* earthen shrine. The name is linked etymologically to a word for memory. W. F. P. Burton, who photographed the shrine, described it as follows: "At Kabwila there is an interesting kite of earth, which contains all the ingredients for a number of *nkishi* charms, etc—but instead of these being carved they are painted in white clay and palm-oil on the kite. One can see the 'kikuvunika' (for overturning spirits) painted upside down, Ilunga with two heads, the sun for shining curses onto an enemy, and indeed all the best known nkishi painted on the kite. When the rain washes the pictures off it is said to intensify the 'bwanga' inside, and new images are painted each year." *Photo: W. F. P. Burton, 1927–35. Courtesy of the University of the Witwatersrand Art Galleries, BPC 4.33.*

History, too, is particular to and located in a social and moral universe, from a Luba or any point of view that does not subscribe to positivist absolutism (Cunnison 1959:35, Gellner 1973:180). If memory is uchronic, history is linked to time; but time may not be linear, and probably was not for Luba, at least until the introduction of literacy, capitalism, and other Western cultural paradigms (cf. MacGaffey 1983:128–29). As it is understood here, history is a formalization of collective memory that implies "involved remembrance" (Connerton 1991:4)—that is, contingent purpose and the seizing upon "the explosive pertinence of a remembered detail" (Davis and Starn 1989:5).

Pierre Nora differentiates memory from history in ways important to this book:

> Memory is life, borne by living societies founded in its name. It remains in permanent evolution, open to the dialectic of remembering and forgetting, unconscious of its successive deformations, vulnerable to manipulation and appropriation, susceptible to being long dormant and periodically revived. History, on the other hand, is the reconstruction, always problematic and incomplete, of what is no longer. Memory is a perpetually actual phenomenon, a bond tying us to the eternal present; history is a representation of the past. Memory, insofar as it is affective and magical, only accommodates those facts that suit it; it nourishes recollections that may be out of focus or telescopic, global or detached, particular or symbolic. . . . History, because it is an intellectual and secular production, calls for analysis and criticism. Memory installs remembrance within the sacred; history, always prosaic, releases it again. . . . Memory is by nature multiple and yet specific; collective, plural, and yet individual. History, on the other hand, belongs to everyone and no one, whence its claim to universal authority. Memory takes root in the concrete, in spaces, gestures, images, and objects; history binds itself strictly to temporal continuities, to progressions and to relations between things. Memory is absolute, while history can only conceive the relative. . . . History is perpetually suspicious of memory, and its true mission is to suppress and destroy it (1989:7–8).[14]

Through the centuries, Luba have made history as they have consolidated their political economy into a kingdom. Peoples peripheral to Luba have made their histories in reaction as well. Memory remains, however, sometimes as *milieux de mémoire*, or social environments in which memory is lived and the sacred is not rigidly differentiated from the profane; and sometimes, with accelerating frequency just prior to and during the colonial and postcolonial periods, as *lieux de mémoire*—places or concrete things bounded by secular history, through which one can still find release into the affect and ecstacy of memory's uchronia.

We shall consider the dynamic processes of "making history," then; yet, as Anton Blok notes, that phrase "is not without its problems. First, it carries voluntarist overtones. As Marx wrote in his *Eighteenth Brumaire*, 'men make their own history, but they do not make it just as they please'" (1991:121). History takes form in the structures of mythical thought, as Luc de Heusch tells us (1982), and we must recognize the ironies and accidents through which history is composed; but we must not overlook the intentionalities *because* of which history calls upon and contends with memory. A dominant faction's history may require subservient people's "forced forgetting" (Connerton 1991:12), yet "counter-memory" persists as a subversive source of ontological alternatives.[15] Memory and history are closely interdependent, then, and many would equate culture itself with collective memory (Blok 1991:125), as opposed to the agendas of history. Indeed, "memory seems to be the main place where culture exists" (Teski and Climo 1995:2–3).

The value accorded memory and history in different cultures is exemplified in Vansina's acclaimed book *The Children of Woot* (1978), which discusses the etymology and hermeneutics of Kuba historical concepts.[16] In order to reconstruct any culture's history, one must begin with an understanding of what that culture means by history and memory in the first place, for "without understanding their conception of history and their attitudes toward it, we cannot hope . . . to interpret these critical sources. For this reason we must first examine what that attitude entails, what the relevant modes are that help shape their collective thought, and what the different genres

of oral traditions are" (ibid.:15). Or, as Michel de Certeau puts it, "before we can understand what history *says* about a society, we have to analyze how history functions within it" (1988:68). To discern the ways history functions in Luba society, we turn to an analysis of Luba concepts and constructions of memory, with an understanding of the indeterminacy that may exist in the translation of such a philosophically significant concept.

Luba Memory and Mind

Like all humans, Luba possess memories, remember, and forget; yet there is no reason to believe that they necessarily do so (or at least understand their doing so) in the same ways that one does in the West. To begin to grasp what Luba mean by "memory," one can consult dictionaries that have been compiled for Luba and neighboring peoples.[17] Looking up "*mémoire*" in A. Gillis's *Dictionnaire Français-Kiluba*, one finds the words "*kalandu*," "*mulandu*," "*nangunangu*," "*lutesima*," and "*lute*" (1981:324). Checking these terms in E. Van Avermaet and Benoît Mbuya's wonderfully encyclopedic *Dictionnaire Kiluba-Français* (1954), one finds a fan of meaning and usage suggesting the transactional notion that Luba and their neighbors ascribe to what we in the West call "memory."

"*Kalandù*" and "*mulandù*" are both simply defined as "mémoire," while the related "*milandù*" is "a dispute to which one returns"—that is, one that is unresolved and still a source of contention (Van Avermaet and Mbuya 1954:338).[18] "*Kilàndà*" is an outstanding debt, while "*bulanda*" is "poverty, indigence, misery, sadness, affliction, chagrin, regret, abandonment, isolation, or solitude" (ibid.:337). Something is clearly missing, and sorely so; but the unfulfilled nature of exchange (debt) and of expectation or desire (poverty) nonetheless expresses relationships and transaction.[19] At issue are *connections*, sometimes salubrious, sometimes not, and the relationships that are accordingly presumed or posited.

The same terms find roughly similar development in neighboring dialects. Among Bemba, "*kulanda*" is "to talk, chat, or discuss," with derivatives referring to all manner of discursive activity (White Fathers 1954:310). For Tabwa, the verb "kulanda" is also "to speak," "*kulandula*" "to contradict or protest," and "mulandu" "words, speech, an affair, litigation." Such communication implies negotiation among narrators and audiences, often in contexts of local-level politics; but again, "*mulando*" is "a tree thrown across a stream as a bridge," in a more literal connection between one bank and another (Van Acker 1907:42). The lexicographer of Tabwa, Auguste Van Acker, did not assert that "mulandu" means "memory," as it may for Luba, although Tabwa usage of "-landa" clearly follows the same logic. Instead, he attributes that sense to the verb "*kulanga*," "to show," the derivatives of which may mean "to demonstrate, prove, teach, remind, remember, think, or reflect" (ibid.:43).

Among "eastern Luba" and neighboring Lamba, "*malango*" (or "*malangu*") is "memory" (Vandermeiren 1913:776; Doke 1933:76). As a Tabwa noun, "*mulanga*" is "a string of beads," however, suggesting that the contingencies of beads in a necklace can be lent symbolic significance, and foreshadowing our later discussion of beaded necklaces as important mnemonic devices for Luba (fig. 16). The attribution of meaning to such contingencies (or the opposite, that contingency *is* meaning) is reflected in other early missionary translations of "malango" as "spirit, intelligence, or thought." A common praise name for God is Leza Malango, "Almighty Intelligence" (Van Acker 1907:43; Kaoze n.d.; Theuws 1954:80). God may possess such omnipotent thought and knowledge, but It (for no gender is asserted) does so through Its demonstration (kulanga) of what we in the West would call memory.[20]

Another term adds its sense to Luba memory. "*Nàngunàngu*," which Van Avermaet and Mbuya define as "memory" (1954:424–25), is from the verb "*kunànga*," "to wander, stroll, or lounge about," with derivatives referring to visiting friends and neighbors. Here again there is a sense of the active relationship between visitor and visited, and nouns from the verb can refer to "the depression between two summits of a mountain" (that is, what connects the two points), or to the sap of plants, viscosity, or glue (what sticks things together). Still other derivatives can be "reflection, deliberation, judgment, or circumspection" (*tunàngù*), "to recall something after having

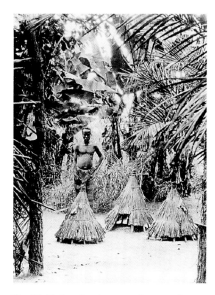

Fig. 18: Shrines for the remembrance of spirits. *Photo: W. F. P. Burton, 1927–35. Courtesy of the University of the Witwatersrand Art Galleries, BPC 21.25.*

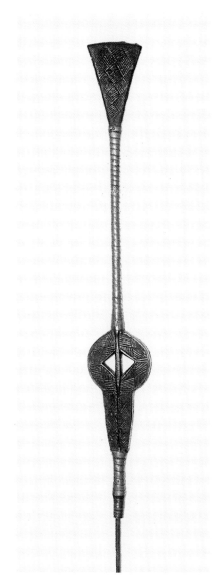

Fig. 19: Nonfigurative staff. Luba made both figurative and nonfigurative emblems of royal office, yet few nonfigurative Luba emblems were collected during the colonial era— a result of prevailing Western notions of what constituted "art." *Collection: the Royal Museum of Central Africa, Tervuren, Belgium. Photo: Mary Nooter Roberts, 1988.*

made an effort of memory, or to finally recognize something" (*kunànguna*). These, one must conclude, draw their meaning from the "wandering" of the mind until some "landmark" is recognized that orients thought and "makes a connection" by the "stickiness" of association, analogy, metaphor, or some other rhetorical device.

A final Luba term allows one to speculate about the location of memory in human anatomy, and the nature of the mind itself. "*Lutê*" (or "*lutéè*") is defined as "mémoire," and someone possessing lutê "has a good memory—he retains or remembers well." "*Lutê*" may be derived from the verb "*kutà*," "to set, spread out, or extend" (*tendre* in French), as one does a hunting net, or when building pit traps (*mbào*) for larger game.[21] "*Kutà*" can also be "to hunt" more generally, and can refer to competitive games such as *masòko* and *bulundu* (Van Avermaet and Mbuya 1954:656–67, 681–82). In both hunting and game-playing, a sense of random motion and outcome is introduced that is essential to a Luba sense of memory.

Two nouns from the same radical as "lutê" are also of interest. *Mitê* are "sun rays" allowing one to perceive place and moment; while a *kitê* is "a little mound of packed earth (in a house or courtyard) in which charms (*manga*) are hidden" that protect and keep peace in the household and hamlet. A kitê may also be a magical bundle placed in fields to keep thieves away, or at a crossroads to honor the birth of twins or to mark a death (Van Avermaet and Mbuya 1954:681–82). Such a kitê, photographed by William Burton (see Becker 1992:17)(figs. 17a and b) between 1927 and 1935 at Kabwila village, "contains all the ingredients for a number of 'nkishi' charms, etc.— but instead of these being carved they are painted on the 'Kitê.' One can see the 'kikuvunika' (for overturning spirits) painted upside down, Ilunga with two heads, the sun for shining curses onto an enemy, and indeed all the best known 'nkishi.' . . . When the rain washes the pictures off it is said to intensify the 'bwanga' inside, and new images are painted each year."[22] The visual perception of such ideograms informs memory and the making of history for Luba in many other circumstances to be discussed in this book.

Van Avermaet and Mbuya (1954:682) extend the discussion of "lutê" by noting that "*kutà ku mushima*" is "to fix in the spirit," to remember (fig. 18). *Mushima*, "the seat of sentiments" for Luba and surrounding peoples, may be the liver, where thought (malango, as discussed above), knowledge, ideas, intelligence, will, taste, inclination, desire, love, envy, hate, suffering, and spirit are believed to originate and reside.[23] For Luba, then, "heart," in the figurative sense given in the West, may be the anatomical liver, while no particularly spiritual qualities are attributed to the anatomical heart, *mukunka* or *mûngu*. But if this is so, then as the seat of thought, ideas, and intelligence, the mushima is also the mind.[24]

If, for Luba, memory is an active process of connecting and creating relationships, what is "forgetting"? The principal verbs translated as "to forget" (*oublier* in French) are "*kwilwa*" and

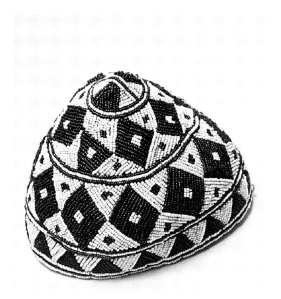

CAT 5: ROYAL CAP. LUBA, ZAIRE. Westerners have paid little attention to nonfigurative, nonsculptural Luba emblems, and few examples were collected in the early part of this century, when definitions of "art" favored sculpture with anthropomorphic elements. Yet the nonfigurative aspects of Luba art are most important from a semantic point of view. The patterns and designs found on all Luba regalia are the language of power. This cap once belonged to Chief Kajingu of Mwanza, in the Luba Heartland, who is shown wearing it in fig. 81. It bears the pattern of continuous triangular motifs that appears on virtually every Luba royal emblem and memory device. The patterns refer both to the prohibitions of kingship and to the sacred spirit sites and memory capitals of past kings. *Beads, textile, fiber. H. 5.75 in. Burton Collection, Social Anthropology Department, University of the Witwatersrand Art Galleries, Johannesburg, Inv. no. WME/035.*

"*kuvùlama*," both of which have interesting etymologies. The Bantu suffix "-*wa*" indicates passive action: something is being done to the subject of the verb. If the verb "*kwìla*" is "to become or to make black or obscure," then "*kwilwa*" may be "to be made black or obscure."[25] The noun "*kîlwa*" is "frequent forgetfulness," and "*mwilangalanga*" (again from the verb "*kwìla*") is "in the dead of night" (Van Avermaet and Mbuya 1954:187–88). "Black" is always a highly charged symbol for Luba and related peoples, referring not only to obscurity but to concealment, often of arcane knowledge (Roberts 1993). If "*kwilwa*" is "to forget" by being made "black" and obscure, there must be a lurking suspicion that the protagonist may not have forgotten at all, but is purposefully withholding information as a secret—perhaps as a demonstration of benign authority, perhaps with malicious intent.

"*Kuvùlama*" is "to forget," and "*buvùlaminyi*" and its synonym, "*kîlwa*," obliviscense ("*oubli*" in French). The opposite sense is obtained in "*kuvùluka*," "remember" ("*se rappeler*"). Both verbs are derived from "*kuvula*," "to be abundant or numerous, or to repeat an action frequently" (Van Avermaet and Mbuya 1954:797–99, Vandermeiren 1913:984). "To remember," then, is to make abundant (-ly clear), for "repetition automatically implies continuity with the past" (Connerton 1991:45); while "to forget" is to neglect, disrupt, or entangle. The one establishes and ensures the relationships of memory, the other breaks or obscures them.

Luba concepts of remembrance, and their counterpart, obliviscence, are so rich, nuanced, and associative that it is surely an oversimplification to call them "memory" and "forgetting." Yet the very point of an etymological exercise such as that above is to permit other cultures' epistemological frameworks to challenge and broaden one's own understanding of concepts previously deemed familiar. Similarly, Luba visual representations derived from or relating to such concepts widen and deepen our definitions of what "art" is and is not, and suggest alternative understandings of truth, history, and discourse.

Memory and Visual Representation

In addition to the culturally specific nature of memory, a second key premise of this book is that memory operates through re/presentation (with an emphasis upon the prefix "*re-*"). Memory is "a process precipitated and shaped by the relaying of visual information" (Küchler and Melion 1991:3). In other words, images engender modes of recollection as much as they are determined by them. We shall demonstrate ways that Luba constructions of memory, conceptually based upon contingency, transaction, negotiability, and bricolage, are engendered visually; and how visual and related forms of expressive culture are used to re-create memory in the present through a politics of re/presentation and image/ination.

If Luba have a rich vocabulary to express concepts of memory, they also possess a proliferation of visual forms to encode and stimulate mnemonic processes. These include beaded necklaces and headdresses (cat. no. 5); wooden memory boards, thrones, figures, and staffs; and scepters, axes, adzes, spears, and other objects incorporating iron and/or copper. These things constituted the treasuries of precolonial Luba kings and certain chiefs, and some are still in use today. Instruments of divination and healing, and the initiatory emblems of secret associations, are also mnemonic. Yet despite the stunning breadth and conceptual achievement of these materials, it is only recently that their mnemonic dimensions have been recognized and explored by scholars.[26]

Previously, Luba art has been viewed only in terms of its aesthetic appeal and for its sculptural strength (Neyt 1994), as well as for its reflection of a complex indigenous African state. The collecting conventions of the late nineteenth and early-to-mid twentieth centuries emphasized and therefore valorized certain kinds of objects to the neglect of others, in response to prevailing Western definitions of "art" (cat. no. 6). Many early colonial collectors only valued representational and figurative works, ignoring those that lacked anthropomorphic elements (cf. Schildkrout and Keim 1990; Mack 1991:17, 81)(figs. 19 and 20). The result was that nonfigurative works and most of those produced from beadwork, textiles, basketry, fiber, feathers, animal pelts, pottery and unfired clay, metal, gourds, and perishable materials were left behind.[27] Yet those very objects, as well as in situ graphic arts such as painted wall murals (fig. 21), pictorial earthen thrones,

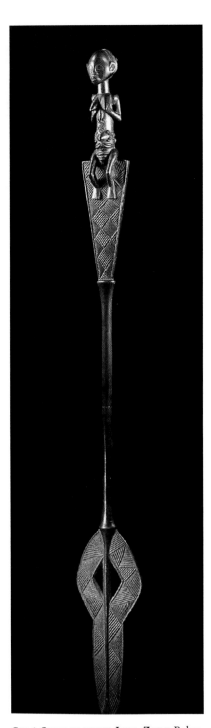

CAT 6: **STAFF OF OFFICE. LUBA, ZAIRE.** Rulers and certain dignitaries possess elegant staffs that affirm their power and position. Hereditary objects passed down the royal line, staffs played a critical part in precolonial investiture processes, during which the chief's sister and/or first wife preceded him with the staff and placed it next to the royal throne. The ruler held this emblem as he swore his oath of office. The custom of planting the staff in the ground appeared in all important public ceremonies, as well as in war, when the upright staff on the battlefield signified victory. When not in use, the staff was held by the guard of one of the ruler's wives or dignitaries. *Wood. H. 53.4 in. Ethnografisch Museum, Antwerp, Inv. no. AE. 61.62.2.*

Fig. 20: Pyroengraved gourds decorated with mnemonic graphics, and used in Mbudye initiation rites. *Photo: Mary Nooter Roberts, 1988.*

Fig. 21: Mnemonic wall mural from an Mbudye initiation house used to teach novices about the origins of Luba royal culture and about the location of spirit sites across the Luba landscape. *Photo: Mary Nooter Roberts, 1988.*

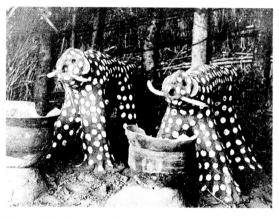

Fig. 22: Clay shrine with leopard figures. *Photo: Burton 1961: fig 13.*

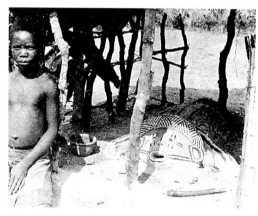

Fig. 23: Shrine with molded *buyubwanga* figurine. *Photo: Burton 1961: fig. 14.*

Fig. 24 (right): Leader (Kikungulu) of the Mbudye Association and his assistants in the early twentieth century. Kazaza village, Bukama zone. *Photo: courtesy of the Section of Ethnography, Royal Museum of Central Africa, Tervuren, Belgium.*

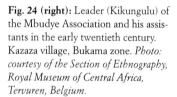

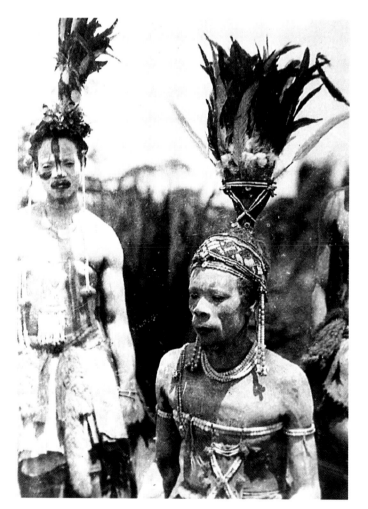

Fig. 25 (opposite): Mbudye officials displaying emblems of office, including two *lukasa* memory boards and a staff of office. Luba kingship was counterbalanced by a number of institutions with specialized functions. Most important was Mbudye, an association responsible for the maintenance and transmission of historical knowledge. *Photo: Mary Nooter Roberts, 1989.*

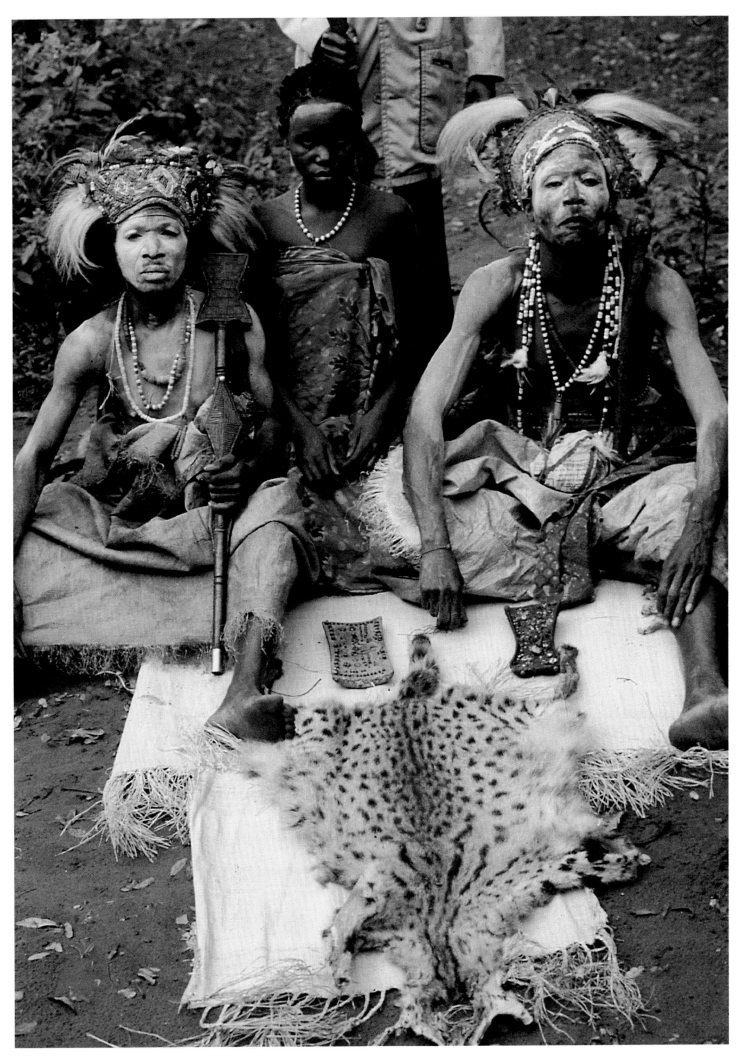

Figs. 26 (above) and 27 and (right): Mbudye dancers performing at night. Many Mbudye dances are intended to be mnemonic—to recall episodes of the Luba Epic. *Photos: Mary Nooter Roberts, 1989.*

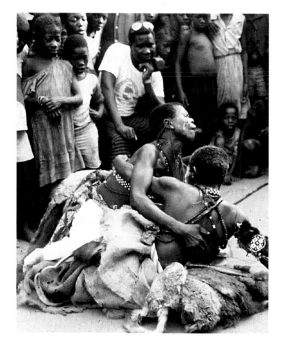

Figs. 28 (above) and 29 (left): Mbudye dancers performing daytime skits. Some are mnemonic, others are contemporary adaptations and intended only for entertainment. *Photos: Mary Nooter Roberts, 1988.*

ideogrammatic magical mounds, or unfired clay shrine sculptures (Burton 1961:plates 13, 14) (figs. 22 and 23), not only frequently constitute important Luba mnemonic forms, they also shed light on the symbolism and purpose of the works that *have* been collected as the West's arbitrarily selected signifiers of Luba culture and history.

Mnemonics take diverse forms and serve a range of functions in different cultures. Some are indices of oral lore and literature. Others transmit esoteric information to members of secret associations. Mnemonics also serve the political and economic interests of complex states. Indeed, invention of a mnemonic system suggests a conscious effort to systemize collective memory as history and to preserve and catalogue information pertaining to a large community or polity, indicating a certain level of centralization and social organization (Goody 1987:14–19).

Luba mnemonics have fulfilled all of these functions and more. Among Luba, oral traditions most closely associated with royal history were dependent upon visual memory devices. These oral charters were sacred, to be guarded and disseminated by a politico-religious association called Mbudye (fig. 24). In the eighteenth and nineteenth centuries, Mbudye adepts created rituals for memory transmission. Mbudye historians were rigorously trained "men of memory" (*bana balutê*) who could recite genealogies, king lists, and all of the episodes in the founding charter of kingship (Reefe 1977, 1981).[28] They traveled with kings, danced in celebration of their deeds, and spread propaganda to outlying areas about the prestige and sanctity of Luba kingship. The power of Mbudye was so great that all kings and all holders of royal office underwent initiation, and the association could dethrone a king or chief.

Though literacy was introduced during the colonial period, the history produced through oral and visual representation remains an integral activity of rural Luba chieftaincies. Luba officials still stage oral recitations of local history (fig. 25), and Mbudye continues as a judicial branch of political authority and performs public dances reenacting history (figs. 26–29). Mbudye inducts new members into its ranks, and still uses visual memory aids that date to the association's beginnings.

Luba Memory Devices

Principal among Luba memory devices is the *lukasa*, a flat, hand-sized wooden object studded with beads and pins, or covered with incised or bas-relief ideograms (figs. 30 and 31)(cat. nos. 7 and 8). During Mbudye rituals, a lukasa is used to teach neophytes sacred lore about culture heroes, clan migrations, and the introduction of sacred rule; to suggest the spatial positioning of activities and offices within the kingdom or inside a royal compound; and to order different office-holders' sacred prerogatives concerning contact with earth spirits and the exploitation of natural resources.

A lukasa is a most important device of Luba royal history. The colors and configurations of beads and ideograms on a lukasa indicate the codes of kingship through a fan of connotations triggering remembrance of deeds and exploits, qualities and physical appearance (figs. 32 and 33). For example, Nkongolo Mwamba, the tyrannical antihero of the Luba charter, is always represented by a red bead, for he is the red-skinned rainbow-serpent associated with bloody violence. Blue beads (considered "black") stand for Mbidi Kiluwe, the protagonist and culture-bearer of kingship, whose skin is shiningly black like that of a bull buffalo, symbol of ambivalent power and secret potential (Roberts 1995). Significant events, relationships, and the paths of Luba migration are indicated by lines and clusters of beads. Chiefs and their counselors, sacred enclosures, and defined places are shown by circles of beads.

The building blocks of this mnemonic system are to be found in the myriad—and until now neglected—beaded and shell emblems of Luba royalty, ranging from necklaces and badges to hats and headdresses. Beads constitute a kind of alphabet that articulates a vocabulary for Luba royalty. Their plurality of forms, colors, and sizes provides a perfect vehicle for the "cognitive cuing structures" of mnemonics (Bellezza 1981)(fig. 37). The same associations underlie the geometric designs and pictorial ideographs on both mnemonic devices like the lukasa and royal emblems in nonbeaded media, such as wood, metal, painting, pottery, and weaving.

While the lukasa of each Mbudye chapter conveys the history of the Luba state, other

CAT. 7 (OPPOSITE): MEMORY BOARD OR LUKASA. LUBA, ZAIRE. Principal among Luba memory devices is the lukasa, a flat, hand-held wooden board studded with beads and pins, or covered with incised or carved ideograms. During Mbudye rituals to induct rulers into office, a lukasa is used to teach sacred lore about culture heroes, clan migrations, and the introduction of sacred rule, and to recite genealogies, king lists, and the episodes in the founding charter. Each lukasa elicits some or all of this information, but the narration varies with the knowledge and oratory skill of the reader. This memory board is one of the oldest known examples, with complex patterns of beads that show signs of extensive use. *Wood, beads, metal. H. 10.75 in. Felix Collection.*

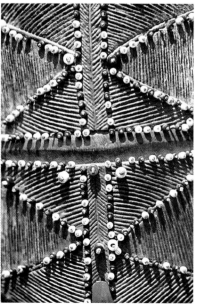

Figs. 30 (top) and 31 (bottom): Front and back details of lukasa, showing vocabulary of memory. Bennet Collection, Washington, D.C. *Photos: Mary Nooter Roberts, 1989.*

memory devices such as sculpted thrones, staffs, bow stands, and spears are used by individual officeholders to elicit local, family, and personal political histories, as well as histories of physical, psychological, or spiritual catharsis (fig. 35). A staff may be used to remember clan history and migrations, for instance. Its owner will exhibit and "read" its iconography when the legitimacy of his authority is at issue (fig. 36). Luba thrones and bow stands often depict female figures, in memory of historically or spiritually significant women. As often, though, these female figures, as spirit mediums, convey the wisdom of men who once ruled. Yet other mnemonic devices are kinetic. Divination baskets contain symbolic items, similar to the beads or figures of a lukasa, that are cast so that their changing juxtapositions can be interpreted. Through such divination, meaning is cut loose from matrix, so that the past may be reconstructed to identify and remedy present misfortune.

Questions remain. How do these mnemonics embody and enact the active principles of Luba memory process while providing a cultural framework for truth? And what is the nature of a system of representation that can produce convention and invention, remembrance and obliviscence, at one and the same time?

Les lieux de mémoire

Place memory provides a model for understanding how Luba mnemonics generate the semantic dynamism and social construction of Luba historical thought. Recollection, as practiced by Luba, is neither an account nor a pedigree, such as a genealogy or a king list, but a meaningful configuration of selected, negotiated events around "loci of memory" (Jewsiewicki and Mudimbe 1993:10). A locus of memory or lieu de mémoire is a landmark around which past events structure present memory. As both actual and imagined places, lieux de mémoire can be topoi—that is, "both places and topics, where memories converge" (Blok 1991:125). The term originated in classical texts expounding two fundamental principles of memory: places and images (*loci* and *imagines* in Latin). Memory arts (*ars memoria*) were based upon memory places (*loci memoriae*) that could be "seen" and "visited" in the mind (ibid., citing Nora). To remember their speeches, ancient orators imagined buildings and assigned topics and subtopics to the "rooms" through which they would mentally "walk" as they delivered their talks (Yates 1966).[29]

In a discussion of the powerful effects that architectural spaces can have on vivid recall, Gaston Bachelard (1969) describes how people "house" their memories, and how rooms become abodes for an unforgettable past. The more nooks, garrets, attics, cellars, closets, and secret alcoves a building has, the more places there are for the storage of sentiment, knowledge, and memory. Significantly, Bachelard discusses the way memory is localized and enacted through space, not time. The actual duration of the past can never be relived, only the thought of it. "Memories are motionless, and the more securely they are fixed in space, the sounder they are" (ibid.:9). Memory exists in uchronia, then, independent of linear time and driving purpose, and "implying permanence and antiquity" (Hastrup 1991:115).

The association of memories with spaces of intimacy is what Bachelard refers to as "topoanalysis." The house where we spent our earliest years is inscribed in us. It is outside time in the sense that it preceded our being in the world, and we return to it constantly as the singular, preeminent experience of habitation. The house and its rooms can be "read," for they are the psychological diagrams of the subconscious. Camillo's famous "Memory Theater" of the Renaissance (Yates 1966:129–59) was similarly based on the proposition that spatial programming can shape collective memory and consciousness. This was an imaginary space designed to store and preserve the collective knowledge of humanity. Yet there was nothing performative about Camillo's theater. It was used as an architectonic model of and for human history, to exist in and occupy the mind.

In both cases, the spatial paradigm serves as a map of the mind, an architecture of memory, and a metonymic model for consciousness within which particular historical facts are selectively preserved and positioned to enable remembrance. These examples are directly applicable to the Luba case, for powerful connections exist between spatial consciousness and memory, as expressed visually. Luba mnemonic devices, whether memory boards, staffs, necklaces, or divination gourds, are

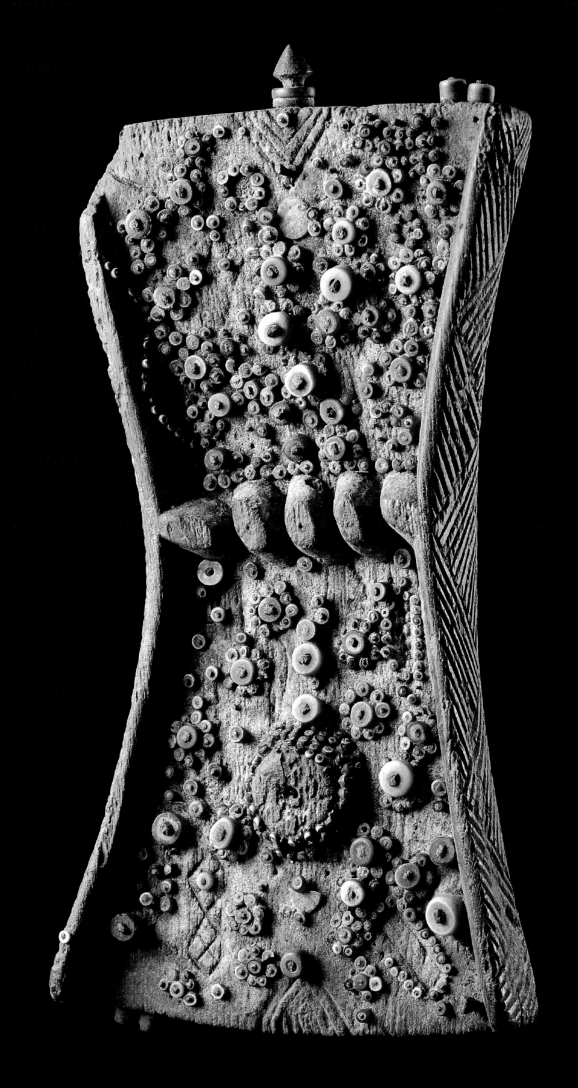

Figs. 32 (right) and 33 (far right): Mbudye officials displaying lukasas. The beaded type of lukasa (fig. 32) is from the Kabongo zone; the inscribed type (fig. 33) is from the zone of Malemba Nkulu. All lukasas convey the same general kinds of information, though their forms vary, as do their particular interpretations. *Photos: Mary Nooter Roberts, 1988 and 1989.*

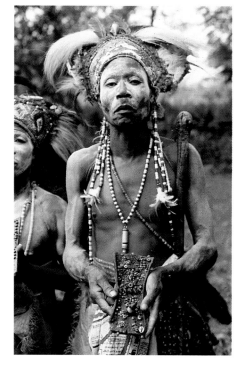 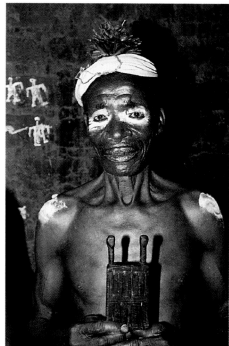

Fig. 34 (below): Mbudye official "reading" a lukasa. The recitation of history facilitated by the lukasa memory board is a performance, and will vary according to the identity of the reader and his or her audience. *Photo: Mary Nooter Roberts, 1989.*

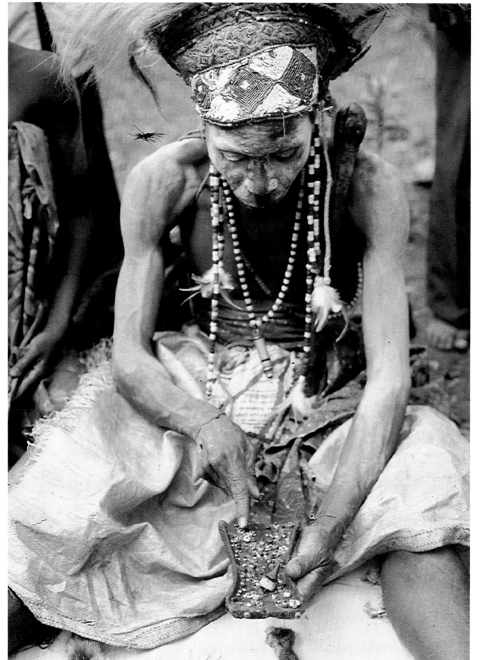

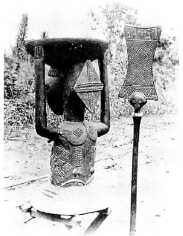

Fig. 35: Staffs and stools are also mnemonic devices, sharing the same vocabulary as the lukasa. *Photo: W. F. P. Burton, 1927–35. Courtesy of the University of the Witwatersrand Art Galleries, BPC 14.1.*

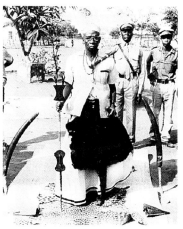

Fig. 36: Chief of Malemba Nkulu displaying a staff of office used for affirmation of title, and also for remembering details of chiefdom's history. *Photo: Jeanette De Plaen and Guy De Plaen.*

devised as lieux de mémoire to organize personages, places, objects, and relationships. They encode ideology, enlist politics, and refer simultaneously to anatomy, architecture, landscape, and cosmos. These objects-as-landmarks are multilayered and multireferential, lending themselves to endless possibilities for combination.

The lukasa memory board, for example, is based on the spatial paradigm of the Luba royal court, analogous to the Renaissance memory theater. The royal court presents a mental geography that maps and orders the universe, the kingdom, human relations, and the mind. The physical and conceptual layout of the court encompasses the structure and order of Luba cosmology, while—a bit like a conceptual pinball machine—the beaded studs positioned upon it allow for the passages, detours, random excursions, exits, entrances, rebounds, ricochets, and thresholds that characterize the active social processes of memory. Since beads have no actual connection with the content to be remembered, meaning is assigned to them by contingent positioning. But although the lukasa is learned, particular meanings are assigned on a significant occasion in a specified locale for a given audience. Reading the lukasa, therefore, is dependent upon the relationships of the signifiers to one another, as well as the relationships of the reader to the audience, and the reader to the constituency that s/he represents (fig. 34). Memory, then, is an art of negotiation and rhetoric, not an "abstract presentation of truth" (Fabian 1983:112).

It is through the activities of negotiation and association that spaces and sites are transformed into places of meaning and memory. For both Edward Casey (1987) and Yi-Fu Tuan (1977), space and site are undifferentiated and anonymous. They possess "no points of attachment onto which to hang our memories, much less to retrieve them. . . . Place, in contrast, characteristically presents us with a plethora of such cues. Thanks to its 'distinct potencies,' a place is at once internally diversified . . . and distinct externally from other places." Place aids in remembering by being "well suited to contain memories—to hold and preserve them" (Casey 1987:186). The ultimate container for holding memories is the body itself, the vehicle through which the intimate relationship between memory and place is realized.

Memory Embodied

Through the lived body, place and memory are actively joined. Casey (1987) discusses the conventional yet misplaced emphasis on memory as a procedure contained within the mind. Yet, as he points out, memory always lies on the border between self and other. The body constitutes the frontier of difference and sameness, and is a sieve through which historical facts are negotiated in remembrance, obliviscence, and the signifying games of representation.

Luba works of art, which emphasize place and body simultaneously, offer a signal opportunity to explore a Luba concept of "body memory." Luba mnemonics are almost always anthropomorphized and gendered to serve as spirit containers (cat. no. 9). Scarification and coiffure in particular are marks of civilization that encode memory about a person's place in society and history (see Rubin 1988). These and other body arts are developed through an individual's life, with information added as memory grows. Luba explain that only women, as childbearers, are strong enough to hold powerful spirits and the secret knowledge associated with them (cat. no. 10). Most important, every Luba king is incarnated by a female spirit medium after death. Called "Mwadi," these mediums inherit the deceased king's emblems, titles, and residence, which becomes a "spirit capital." Memory lives at and through these sacred sites, in the women who embody the kings of yore, and in visual representations of such women (fig. 38).[30] Through spirit possession and its representation in adjacent arts, Luba transform the body into a site of memory and a microcosm of the Luba world. The body's surface becomes a text, to be both "written" and "read." In this way, the past is perpetually reified through the embodiment of memory, to be enacted in the present (cat. 11).

Memory as Performance

As in any political context, "official" wisdom, even as conveyed through use of a lukasa, was and is contested by others' interpretations of the same instruments. Recent research questions

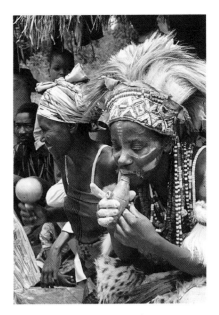

Fig. 37: Diviner in possession state wearing beaded regalia containing mnemonic codes. *Photo: Mary Nooter Roberts, 1989.*

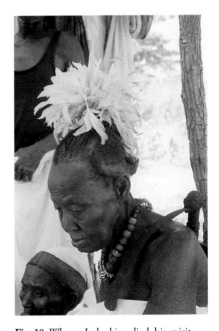

Fig. 38: When a Luba king died, his spirit was incarnated by a female spirit medium, whose title was "Mwadi." This Mwadi was the incarnation of King Kasongo Niembo, who died in 1931. She resided in his former royal village, acquired all of his titleholders and his emblems of office, and received gifts on a regular basis from the new king. In the past, each Mwadi was succeeded at death by another woman in her lineage, thus ensuring the perpetuation of the title. This particular Mwadi, however, was the last in the Luba region, and was not succeeded at death, marking the end of that tradition. *Photo: Thomas Q. Reefe, 1970s.*

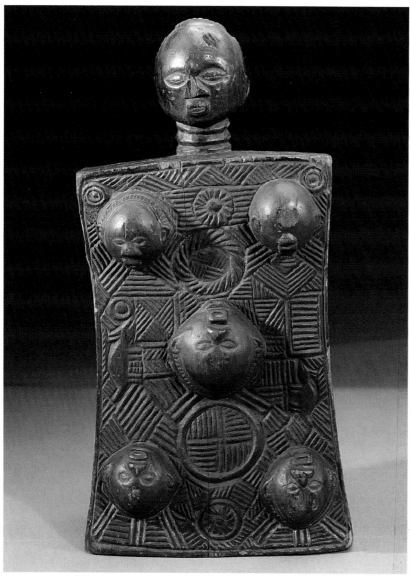

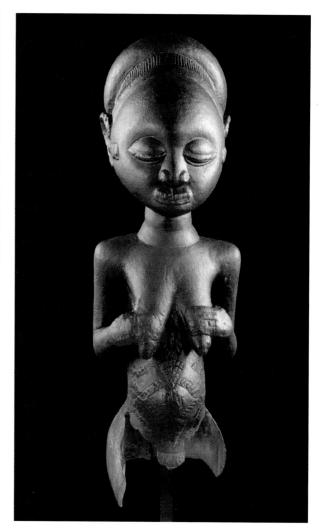

CAT. 10 (OPPOSITE AND ABOVE): FEMALE FIGURE. LUBA, ZAIRE. Luba people say that only a woman's body is strong enough to contain a powerful spirit like a king's, so sculpture dedicated to kingship is almost always female in gender. Through her gesture, expression, and adornment, this figure expresses fundamental principles of power and spirit embodiment. Her coiffure encircles her head like a halo, her face is ethereal and timeless, and her simple gesture of hands to breasts signifies her devotion to the spirit world. *Wood. H. 18 in. Joseph Christiaens.*

CAT. 8 (ABOVE): MEMORY BOARD OR LUKASA. LUBA, ZAIRE. While most lukasas are beaded, some are sculpted, combining incised motifs and figures in relief. This exceptional example shows five sculpted heads in relief against a background of patterns and ideographs. The sculpted heads probably serve the same purpose as the most prominent beads on the beaded type of lukasa: the designation of lieux de mémoire, landmarks that structure present memory of past events. Lukasas do not symbolize thought so much as stimulate it. Their multireferential iconography affords a multiplicity of meanings. Yet the reading of these visual texts varies from one occasion to the next, depending on the contingencies of local-level politics, and demonstrates that there is no absolute or collective memory of Luba kingship, but many memories and many histories. *Wood. H. 17.9 in. Trustees of the British Museum, London, Inv. no. 1954.Af.23.2981.*

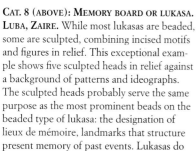

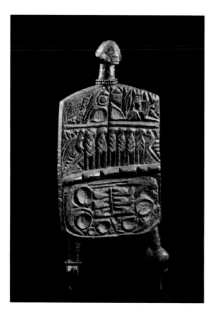

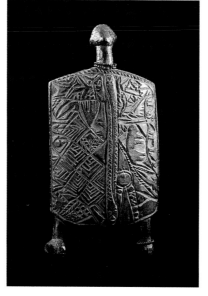

CAT. 9 (LEFT): MEMORY BOARD OR LUKASA (FRONT AND BACK). LUBA, ZAIRE. All lukasas are anthropomorphic and zoomorphic at the same time, for they represent Lolo Inang'ombe, the Mbudye Association's founding ancestress—a woman in the form of a tortoise. This lukasa includes both a head and feet, and it is covered on both sides with complex ideographs that stimulate memory about royal history and sacred geographies. For the tortoise is the Luba landscape itself, where the tutelary spirits of kingship reside in the form of mountains, grottoes, forests, and lakes. The serpent that slithers along the lukasa's "spine" may refer to Nkongolo Mwamba, the cruel tyrant of the Luba Epic, who is often manifested by a double-headed serpent. *Wood. H. 16 in. Joseph Christiaens.*

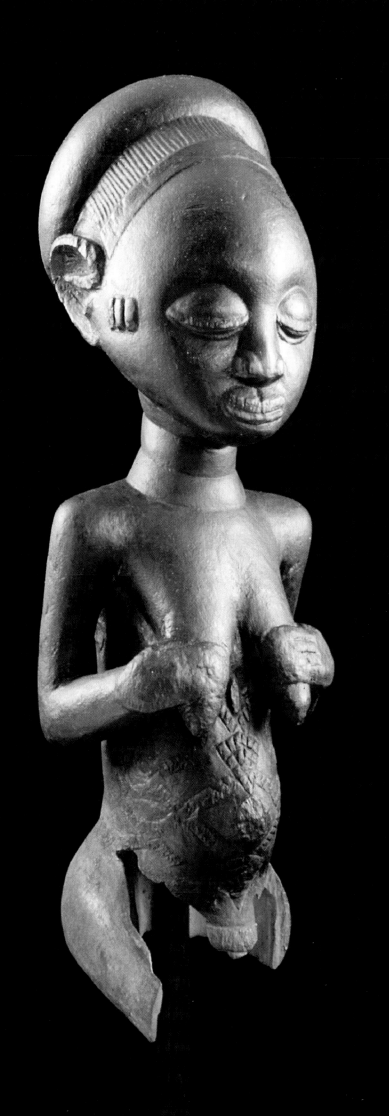

nineteenth-century notions of memory as a fixed and accurate record of past experience (e.g. Gyatso 1992), suggesting that memory "is not a fossil of the past but rather a system of categorization in which the past is recreated in ways appropriate for the present" (Lopez 1992:36). Current emphasis is less on mental storage of past events than on the performative function of memory in the present. Mnemonic devices elicit visual, verbal, and performative arts, and Luba objects were and are read, spoken, sung, danced, and manipulated.

That the mnemonic process is performative also means that historical recitation never occurs in precisely the same way twice. Political interests inexorably change, and memory is defective. The need to fill in forgotten details, to adapt history to new circumstances, and to follow fads by borrowing glitzy ideas from prestigious neighbors all mean that memory is generative. Indeed, if we are to grasp how and why history is made, we must understand *forgetting*. The negotiation of historical facts necessarily involves a process of discard and re-creation. "Forgetting and recollecting are allied mnemonic functions. Forgetting can be the selective process through which memory achieves social and cultural definition" (Küchler and Melion 1991:7). The erasure and selective elimination of certain historical facts are as critical to the collage that is memory as the retention and careful preservation of others. Early Greeks recognized that forgetting and remembering were an indissociable pair, and were both instrinsic to memory process. Only later in the history of Western thought was forgetting forgotten.[31]

Luba memory devices do not symbolize thought as much as they stimulate and provoke it. Their multireferential iconography affords a multiplicity of meanings. The reading of these visual "texts" varies from one occasion to the next, depending on the contingencies of local-level politics, and makes manifest the objects' abilities to instigate processes of politics, economy, and religion.

Whether through the reading of a beaded memory board, the narration of a sculpted wooden staff, or the deciphering of a diviner's object-filled gourd, Luba mnemonics operate according to principles of contingency and association, relationship and refabulation. Some historical facts can be selectively preserved and recombined, others omitted in an editing of the past. As a result, identity and history are always in the making, as new circumstances urge reconsideration of one's relationship to a "center" and to a past. Social identity is a matter of social process and local politics, to be reckoned differently according to the circumstances. There is nothing absolute about the history and identity, then, of individuals or of the groups in which they find themselves. One can "be" any number of things, depending upon whom one is speaking to, and when (cf. Rosen 1984).

With these concepts in mind, we turn to Luba art, culture, and history to explore the vital ways that art forms of the past continue to inform historical consciousness in the present. In so doing, we seek to overcome the static divisions separating a "precolonial" or "traditional" African history from a "postcolonial" or "contemporary" one.

CAT. 11 (OPPOSITE): DOUBLE BOWL FIGURE. LUBA, ZAIRE. Paired female figures occur often in Luba art. Luba spirits of kingship called *"vidye"* are always twins, and are represented in actual life by female spirit mediums who live in pairs at special sites, such as hot springs, or at the foot of certain mountains. The figures in this sculpture show the finest Luba accouterments, including beaded waist bands, iron hairpins, cowrie hair adornments, and scarifications. These are not strictly for physical beauty; their radiance and elegance are intended to activate the spirits' attention. In Luba thought, beauty is created, not innate: the female body must be perfected before it can serve as a receptacle for a spirit. Both the iron hairpins and the scarification patterns are to hold the spirit within. *Wood, cowrie shells, metal hairpins, glass beads. H. 13.2 in. Collected by J. Van Den Boogaerde, 1916–18. Collection Mr. and Mrs. J. P. De Pannemaeker-Simpelaere.*

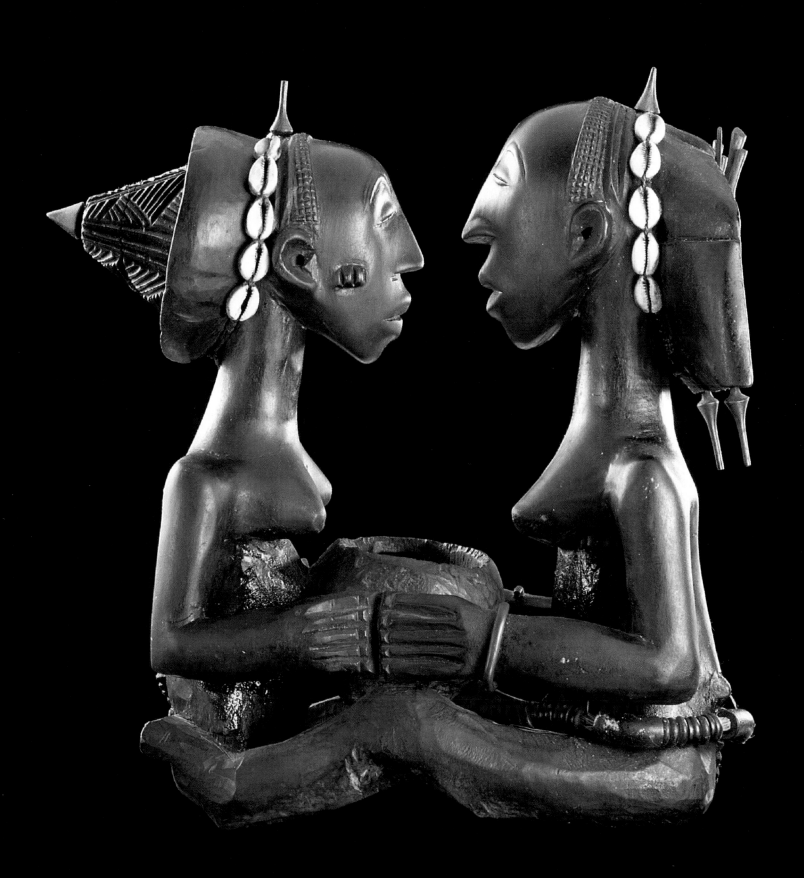

Endnotes

1. The study of how and why nonliterate non-Western peoples have been portrayed as "lacking history" has been an important anthropological pursuit, led by Eric Wolf's seminal *Europe and the People without History* (1982) and his students' "articulation of hidden histories" (Schneider and Rapp 1995). See also John Davis's "History and the People without Europe" (1992).

2. Zaire has been known as the Congo Free State (1885–1908), the Belgian Congo (1908–1960), and the Democratic Republic of the Congo (1960–67). Its current name, "The Republic of Zaire," is contested by those who would replace or overthrow the oppressive dictatorship of Mobutu Sese Seko, president since 1967. They would see "Zaire" revert to its earlier colonial and postcolonial name, "Congo," and the provincial name "Shaba" to "Katanga."

3. "Bantu" is the name given to a vast complex of languages extending from southwestern Nigeria all the way across Africa to central Kenya, and southward to the tip of the continent. Bantu-speaking peoples share a common grammar and logic (Heusch 1982), like people of European ancestry who speak Romance languages (e.g., French, Spanish, Portuguese, Italian, and Romanian). "Proto-Bantu" is the early language and culture shared by Africans living in this enormous area, as Latin is for the aforementioned European peoples.

4. To name a few of the more readily available sources, Luba oral and related performative arts are collected and discussed in Faïk-Nzuji 1974, Mufuta 1969, and Stappers 1964; music in Gansemann 1978, 1980; and visual arts in Neyt 1994.

5. Luba ethnicity is discussed in greater detail in our last chapter. In *The Invention of Africa* (1988) and *The Idea of Africa* (1994), V. Y. Mudimbe discusses the process whereby African "identity," as perceived, experienced, and interpreted by both Westerners and Africans, has been constructed in disciplines and discourses about Africa through categories and conceptual systems that depend on a Western epistemological order. Cross-cultural examples of colonial invention of "tribes" and "ethnicities" like "Luba" are presented in Vail 1989.

6. Citations are from ACB 1958. A small number of Belgian colonial officers (never more than several hundred) were faced with 6,095 recognized chiefdoms in 1917. Individual territorial commissioners were charged with the documentation of local histories and with the responsibility of consolidating as many of these as possible into larger, more manageable paramouncies that would then be granted substantial rights to local government. By downgrading precolonial kingdoms to paramouncies (called "*grands chefferies*" in the Belgian Congo) and upgrading some dependent or independent chiefdoms to the same rank, the colonizers caused havoc in local-level and colonial politics. Zairians are still rancorous about what they consider the resulting "illegitimacy" of certain chiefs and paramounts. See Roberts 1987, 1989.

7. An analogous situation is signaled in Schildkrout and Keim (1990:30) among Mangbetu-related peoples of northeastern Zaire, where distorted observations by early Western visitors led to the creation of myths about a highly centralized Mangbetu kingdom. Yoder (1977) discusses the overemphasis on states of the central African savanna to the exclusion of "peripheral polities."

8. Published and unpublished accounts of the Luba genesis myth include Colle 1913; Donohugh and Berry 1932; Van der Noot 1936; Verhulpen 1936; Van Malderen 1940; Makonga 1948; D'Orjo de Marchovelette 1950; Sendwe 1954; Theuws 1954, 1962, 1964; and Womersley 1975. More recent accounts and analyses include Heusch 1982, 1991; Mudimbe 1991; Nooter field notes 1987–89, 1991; Reefe 1981; and Roberts 1980, 1985, 1991, 1993.

9. No choice of political terminology is "innocent" of bias and baggage. One way to speak of the Luba Heartland and its peripheries might be as a "nation," in the sense of the word as "a people who share common customs, origins, history, and frequently language" used by some Native American groups (Soukhanov 1993:1203); but the same term often implies more centralized authority than Luba evidence suggests, and as we shall see, origins, histories, and even languages of the "Luba" sphere are as often in contention as they are shared.

10. One of the most brilliantly original and sadly overlooked treatises on the dynamic nature of history for central African peoples is Ian Cunnison's long essay "History on the Luapula" (1959). "Luapula peoples" is a term chosen to suggest a multiplicity of origins and potential ethnic identities similar to that of Luba peoples. For such groups, "histories . . . are particular" and "known well only to the groups which partook in the events enumerated. More accurately, a history is always and only the history of a group. . . . There is no coherent wider history" (ibid.:1–6). The effects of establishing a universal Tabwa history through writing, despite such a dynamic, are discussed in Roberts 1989.

11. Studies of material culture, both in situ and as collected and exhibited in other circumstances, are gaining broad cross-disciplinary interest. In 1994, for example, coincidentally with our project begun two years earlier, the Institute for Advanced Study and Research in the African Humanities at Northwestern University held a pertinent workshop, "Texts in Objects," with published proceedings in the Institute newsletter, *Passages* (1994, vol. # 7).

12. Johannes Fabian's recent manuscript *Remembering the Present* (in press) explores the politics of memory in the narratives associated with Zairian popular painting, in which artists rewrite colonial and postcolonial history through pictorial and oral relationships.

13. Although we are asserting the relativism of cultural accounts of what memory is and does, we are aware of neurological research investigating brain structure and the physiological nature of memory. While all humans are biologically equal, cognitive processes such as the devices by which people remember vary cross-culturally; see Colby and Cole 1973. Churchland 1995 offers a "journey into the brain" and a useful review of the neurological literature.

14. It is possible that Nora's distinction between memory and history is drawn more tightly than is appropriate to Luba circumstances: for Luba, memory and history may overlap to a degree that they do not in the French experience that Nora and his collaborators seek to elucidate. Still, the Luba state did create its histories for particular reasons of political economy, and as we shall see at the end of this book, the kind of anomic disjunction between memory and history that Nora finds in France has certainly occurred for Luba over the course of their colonial and postcolonial pasts.

15. The term "counter-memory" is from Foucault 1977; see Davis and Starn 1989:2. A burgeoning literature concerning "resistance through memory," "state-managed forgetting," "the memory of this forgetting," and history as "the forcible illumination of darkened memories" in the radical sociopolitical change of eastern Europe is exemplified by Richard Esbenshade's "Remembering to Forget: Memory, History, National Identity in Postwar East-Central Europe" (1995). Memories of the Holocaust are also the subject of many texts, such as James Young's *The Texture of Memory: Holocaust Memorials and Meaning* (1993) and Carolyn Forché's poetry collection *Against Forgetting* (1993).

16. Kuba are a congeries of peoples living in west-central Zaire, northwest of the Luba Heartland but adjacent to Luba-related groups.

17. These have not been composed by Luba for Luba, though. They were written during the colonial period *by* French-speaking Europeans and principally *for* French-speaking Europeans (especially missionaries) who wished to learn Luba language (see Fabian 1986). At issue is what Walter Benjamin called "translatability," in reference to the way "a special significance inherent in the original manifests itself" (1988:71). The key word is "special": the translator chooses the referent for a reason, and the translation becomes separated from the original. The reader must be aware that a dictionary's equivalence of meaning may be rough, at best, between expressions from cultures that are fundamentally different; and that the lexicographer's implicit intentions may have given shape to the "special significance" translated for eventual readers. Furthermore, notions of memory and the mind are exceedingly abstract in any language, requiring the interpretive inquiry of hermeneutics. Invaluable insight can result from such an exercise. Hermeneutical studies of Luba and related peoples are reviewed in Mudimbe 1991. Useful references to similar studies elsewhere in Africa are Abiodun 1990 and Hallen and Sodipo 1986.

18. Van Avermaet and Mbuya give diacritical marks, indicating the tonality of the Luba language, that are omitted in the Gillis dictionary (1981) and in key ethnographies (e.g. Burton 1961). Because of this discrepancy, it is not possible to judge whether "*-làndà*" and "*-landa*" (Van Avermaet and Mbuya 1954:337–38) are truly distinct, especially when, as in "*kilàndà*" and "*bulanda*," the meanings and usages seem so closely related. Our thanks to Jan Vansina for his cogent suggestions regarding this section of our introduction. Professor Vansina's linguistic analysis is acute, and his caution well taken when he asserts that tonal differences lead one back to different proto-Bantu roots. When he states that "there clearly is something wrong with the tones in Van Avermaet/ Mbuya," however, he reveals the degree to which close study of Bantu languages is in its infancy. Speculation must result, and we readily admit that our discussion may occasionally be broader than Professor Vansina would find comfortable.

19. In the Luba royal charter myth, Bulanda is the wife of one culture hero and mother to the other. It is they who fulfill the expectations of human potential.

20. Luba add their own twists to the verb "*kulanga*," which may mean "to think, reflect upon, consider in spirit, meditate, offer an opinion about, suppose, claim, intend, or affirm." The derivative noun "*dilango*" is "a thought, idea, concept, supposition, hypothesis, or opinion," while "*malàngà*" are "preoccupations, apprehensions, perplexities, incertitude, or a feeling that one misses or needs something." Clearly, there is significant conceptual overlap between "-landa" and "-langa" for Luba-speakers. Van Avermaet and Mbuya add that "kulanga" also has a special usage as "to explain all there is to know about a *bwanga* [magical medicine], or to stipulate the observances, rites, and taboos related to it" (1954:339).

21. Jan Vansina suggests that "*lutê*" may be derived not from "*kuta*" but from "*kutiga*" (or "*kutia*"—the *g* is sometimes dropped), "to leave" or, as in Swahili, "to put, place, or include." "However, because of the abnormality of the tones, this could be a skewed item, i.e. a loan from somewhere else . . . so one cannot conclude!" Our thanks for this personal communication of June 1995.

22. Burton does not add a circumflex to "kitê," and the term may have been mistaken for the English word "kite" by readers of his account. An *nkishi* is any power object, as discussed in later chapters. *Kikuvunika* is a magical bundle, usually buried at a crossroads, that contains herbs and a human bone. "This bwanga forces the dead to look at the ground, and when the magic is fresh, the [spirit of a] dead [person] cannot stop looking at the bundle, and so is rendered powerless to harm" the living (Van Avermaet and Mbuya 1954:325).

23. The reference of "*mushima*" is rather vague: although it can be the liver, it may also refer to the stomach, or suggest a more general sense of the gut.

24. The brain, *bubongo* (Van Avermaet and Mbuya 1954:81), is perceived as having little ostensible function, and is not the location for the "mind," as in the West. Yet cleverness is located in the head (although perhaps not in the brain per se), as are perception, dreams, and prophesy. See Davis-Roberts 1980 for a discussion of ethno-anatomy among neighboring Tabwa.

25. Two verb roots with different tonalities may be at play here, as Professor Vansina suggests; and it may be best, as he would have it, to "suspect that the active meaning simply got lost."

26. See Faïk-Nzuji 1992; Nooter 1990, 1991, 1992, 1993; Reefe 1977, 1981; Roberts 1980, 1988, 1992, 1993.

27. By making subjective choices as to which objects were worth "saving," "salvaging," and carrying away for "preservation" in the West, colonial collectors sometimes unknowingly distorted the artistic repertoires they meant their collections to represent (Clifford 1988:231, Clifford, Dominguez, and Minh-ha 1987, Kirshenblatt-Gimblett 1991:386). Such decisions rarely if ever reflected the judgments of the objects' original makers and users.

28. "*Bana*" (*mwana*, singular) means "children" or "child," so the expression "*bana balutê*" suggests descent from, identification with, or dependence upon memory, rather than simple mastery of it, as one might infer from Reefe's translation. Although "bana" is a term without gender, bana balutê are always men. Important chiefs among Luba and surrounding peoples still have bana balutê, who assist in litigation and other local-level political contexts.

29. Pierre Nora and his colleagues have considered a broad range of lieux de mémoire in their three-volume opus. They associate place memory with larger issues of ideology, demonstrating how national monuments bespeak ongoing memory-making, and the like (Nora 1984, 1986, 1993).

30. The last Mwadi has died, thus marking the termination of that institution.

31. Remembering and forgetting as the interdependent, coexistent sides of memory were acknowledged in archaic Greek history with two gods deified as Remembrance and Forgetting, Mnemosyne and Lemosyne.

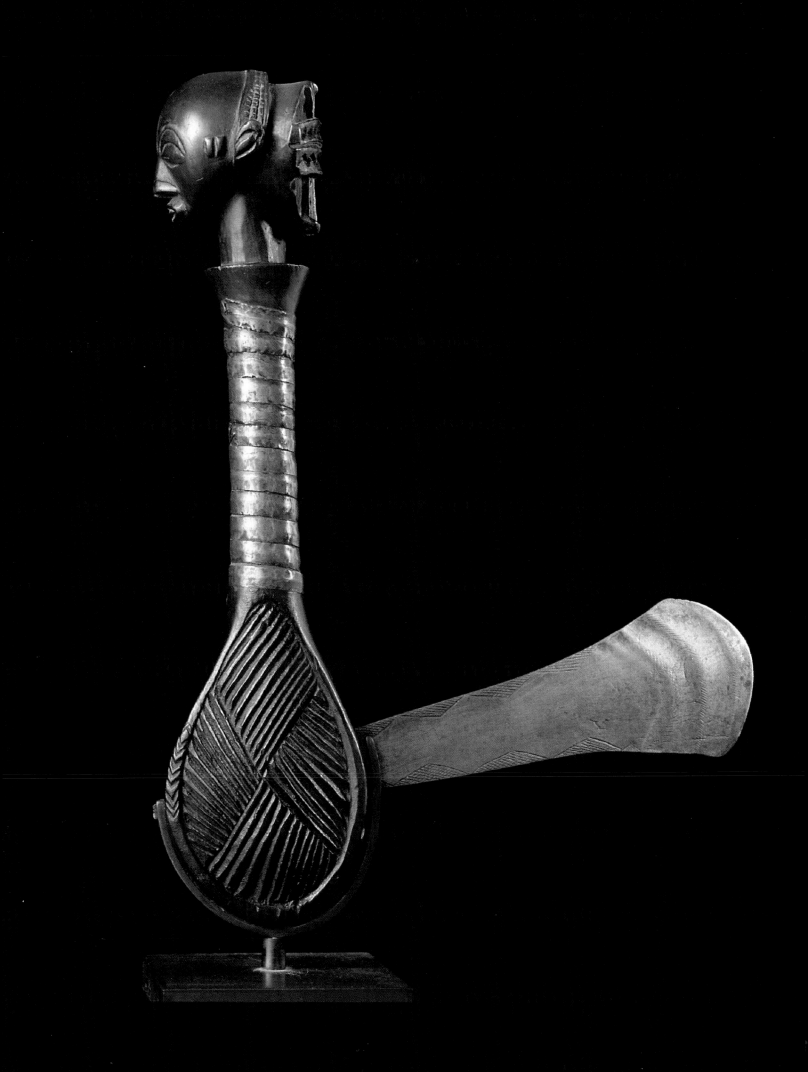

CHAPTER 1

Re/Constructing Luba Pasts

S. Terry Childs and Pierre de Maret

Ancient objects and stories link peoples to their pasts, and archaeology and oral tradition are two ways of knowing about and understanding such associations. Archaeology is a Western, science-based construct that focuses on material remains and stresses objectivity and replicability. In non-Western contexts, however, archaeology is generally seen as a strange pastime of foreigners who use unusual tools and dig very square pits to uncover bits and pieces of objects made by people long ago (figs. 39 and 40). Surely, local people are known to say, archaeologists must be looking for something valuable in those pits, like gold or diamonds, rather than the useless broken pots and bits of bone they keep turning up. Oral traditions, on the other hand, rely on memories passed down through many generations. There may be rigorous training of memory specialists in some societies (Vansina 1985, Muriuki 1990), as among Luba, as well as precise definition of rules for access to and acquisition of certain knowledge (Williams and Mununggurr 1989). As they attempt to attain a "true" understanding of past cultures, archaeologists and historians often question the reliability of memory and point out the subjectivity of oral traditions (Vansina 1985, Mudimbe 1991).

Certainly there are real differences in the methods and theory behind these two ways of knowing the past, just as there are clear prejudices about their relative merits. Archaeology and oral traditions *do* have several things in common, however: both provide highly valued knowledge to the groups of people who use them. Both are used by social groups to identify their ancestry in time and space, so as to place themselves in the present and situate themselves for the future (Layton 1989). Both use objects and information from the landscape, either as replicable data points or as mnemonic devices, to provide details about the past. As a result of their reliance on concrete objects, places, and things to elicit credible reconstructions of the past, however, both practices generate "stories" that invariably have missing, ignored, or altered elements. Archaeological reconstructions of past life-ways are never complete, since even the best or most scientific methodologies cannot bring back the most perishable remnants—baskets, nets, charms, cloth, foodstuffs—of important past activities. Oral traditions, on the other hand, may use the landscape to provide precise locations of events in the recent past, but, for earlier times, such locations become blurred through iconotropic processes—that is, elision of structurally or cognitively similar places. Furthermore, the locations of accidental finds of skeletons, ancient pottery, or rock art are often integrated into oral traditions and may become "facts" over time in fields of ideas having nothing to do with original contexts and purposes (Roberts 1984, Vansina 1985, Maret 1990).

Fig. 39: Luba children pretending to be archaeologists during excavations. *Photo: Pierre de Maret, Sanga, 1974.*

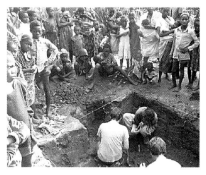

Fig. 40: Luba villagers observing archaeologists at work. *Photo: Pierre de Maret, Sanga, 1974.*

Both archaeology and oral tradition are dynamic, and involve reinterpretation and manipulation of "facts" about the past to suit ideological and practical needs in the present. Although academic archaeologists and historians have long questioned the reliability of oral traditions because they are manipulated and changed by narrators, often unconsciously (Vansina 1985), it is clear that archaeological data can be similarly maneuvered. Important African cases include the use of archaeology in colonial Southern Rhodesia (now Zimbabwe), where the magnificent stone buildings of Great Zimbabwe were claimed to have been built by Phoenicians in order to justify what was said to be culturally similar but more recent colonial expansion (Hall 1990). Similarly, in apartheid South Africa, archaeology was used to provide "politically correct" information on the origins and identities of ethnic groups in order to justify white colonial domination of the land (Hall 1984).

Oral tradition and archaeological data are also subject to different interpretations and applications depending on the interests of the users. The archaeologist Louis B. Leakey, for example, known for his discovery of early man in Africa, read the chippage pattern on various stones found in California as evidence of early man in the New World (Leakey et al. 1972), an interpretation still debated (Dragoo 1975). Oral traditions, in turn, can be variously interpreted and given different emphases by distinct groups, such as royals, clans, or secret societies, within the same society (Vansina 1985, Nooter 1991). One version of a tradition may be manipulated to accomplish the political goals of a powerful group (Henige 1974, Molyneaux 1994). Finally, souvenirs of the past, whether oral or material, may be used to legitimize an institution. Following Independence, Southern Rhodesia was renamed Zimbabwe after the famous archaeological ruins, to suggest continuity with the glories of the *African* (rather than a "Phoenician") past. In contrast, Mobutu Sese Seko of Zaire wears an "authentic" cap of modern design, made from leopard skin—a material associated with sacred chiefs and ultimate authority in many Zairian societies (Roberts 1995a:97–102). In Mobutu's case, however, such reinvention of symbols for baldly self-serving political purposes has been rightly described as "Afrokitsch" (Cosentino 1991).

Luba peoples who live in the Upemba Depression, along the shores of Lakes Kisale, Kabamba, and local rivers, present an interesting case study, because both archaeological and oral information on their past is available (fig. 41). In fact, the largest cemetery yet studied in sub-Saharan Africa is in the Upemba, and the depth and breadth of archaeological information the area has yielded is virtually unique. Are these sources complementary? Do they reveal similar information? Or do they challenge and test each other?

These are questions we shall address here as we examine the archaeological evidence from the Upemba Depression and compare it with aspects of Luba oral history. Of particular interest are the length of occupation by metal-using fishers and farmers in the Upemba, the evidence for changing levels of sociopolitical complexity over time, and the technological sophistication achieved. We end with some discussion of the need for archaeologists and indigenous peoples to recognize the benefits of each other's approaches to the past and to integrate their methodologies for a fuller, more collaborative understanding of the past in the future.

Archaeology in the Upemba Depression

The Upemba Depression is a naturally delimited zone now a part of the Luba Heartland. Archaeological investigations have been intermittently conducted there for almost four decades by several different scholars (Nenquin 1963; Hiernaux et al. 1971; Maret 1978, 1985a, 1992; Childs et al. 1990). The results of these sustained efforts are highly unusual and valuable for studies concerning the last 2,000 years of occupation of central Africa and even much of sub-Saharan Africa, where archaeology has not been widely developed to date (see Robertshaw 1990).

Archaeological work in the Upemba Depression has primarily focused on excavations of burials frequently found along the lake shores; relatively little evidence of occupation sites and other activity areas of ancient peoples has been preserved (Maret 1985a:191–92, 1992:177–87). The excellent state of preservation and spectacular nature of some of the burials have also encouraged this sort of work in the area. Archaeology in the Upemba, then, has become biased toward an under-

standing of the past based on data retrieved from burials. It concerns continuities and changes in ancient burial practices and rituals, subsistence and technological activities, and the symbolic uses of objects found in burials, as well as some information about trade and sociopolitical structure. How people were distributed over the landscape, the size and configuration of villages, ethnic identity, details of political and religious organization, and other aspects of social group activities in the Upemba over time may never be known with any certitude. The kinds of interdisciplinary, corroborative research that are necessary to pursue such issues require considerable coordination and financial support to overcome logistical, political, and other constraints that arise in a country like Zaire, which is suffering such dire and extended political crisis. Training of Zairian archaeologists to pursue and coordinate projects will continue to be instrumental to developing such complex research (fig. 42).

Perhaps the most important result of the excavation and analysis of nearly 300 burials from five cemeteries in the Upemba is that farmers, fishers, hunters, artisans, and traders continuously occupied the lake shores from about the seventh century A.D. to the present day. Furthermore, not only did people arrive and stay in the area, but both the population and the level of sociopolitical complexity increased over time. The distribution of people on the landscape was not uniform, however, since burials in each cemetery located along a specific area of the lakeshore span somewhat different periods of time. Changes in burial ritual, accompanying grave goods, and burial frequencies suggest the following synopsis of the periods of occupation (also see table 1, and Maret 1977, 1979, 1985a, 1992).

In the Kamilambian period, between the seventh and eighth centuries A.D., people occupying the Upemba Depression made pottery vessels and iron tools, probably farmed, and hunted with iron arrows rather than the stone arrowheads that their very distant predecessors had used. Little else is known about these people, except that they arrived in the area sufficiently knowledgeable in several important skills and technologies (notably iron-working and pottery) to be able to exploit available resources and make a viable living.

The relatively small number of burials found to date suggests that a fairly small population lived in the Upemba during the Ancient Kisalian period, between the eighth and tenth centuries. The presence of Ancient Kisalian burials at four of the five cemeteries excavated in the Depression, however, indicates that people had become well dispersed during this period. Burial contents reveal a variety of activities practiced at the time, and suggest some local beliefs. Potters made a wide range of vessels, presumably for many different functions, and decorated them in a different manner from that of the potters of the earlier, Kamilambian period. In particular, the vessels had sinuous and elaborate shapes, and distinctive decorations on the rims. Iron workers skillfully made a number of objects, the diversity of which can probably be related to the economic and social prosperity of a growing population. These include jewelry (bracelets, necklaces), arms (spears, knives), agricultural tools (hoes, axes), and items for ceremony and displays of power (distinctive axes and knives) (Childs 1991a).

Copper, valued for its relative scarcity, malleability, and distinct and perhaps symbolically significant red color, began to be traded into the Upemba during the ninth century. It was probably brought up from the Katangan Copper Belt to the south of the Luba Heartland, where the earliest evidence of its production dates from the fourth century A.D. (Anciaux de Faveaux and Maret 1984, Bisson 1976). Craftsmen used this copper to produce ornamental goods, such as necklaces and bracelets. The presence of these and other goods in Ancient Kisalian graves indicates their intrinsic value to the living and perhaps to the dead as well, suggesting that the deceased may have required such goods in the afterlife (Maret 1992).

Not everyone had equal access to this range of objects and materials during the Ancient Kisalian period, however. There was a considerable disparity in the quantity and types of objects buried in the excavated graves; only a few individuals were buried with a large number and variety of pottery, iron, copper, and other prestige items. Copper objects in particular were found only in the most elaborate graves at two of the five cemeteries excavated. Very rare objects were found in these graves, such as an elaborately decorated ceremonial ax and an anvil (fig.43). These are

Fig. 41: Village of Kamilamba. *Photo: S. Terry Childs, 1988.*

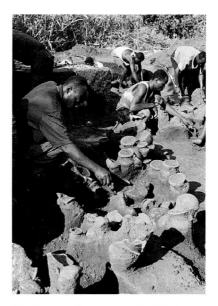

Fig. 42: Luba villagers excavating Kisalian graves. *Photo: Pierre de Maret, Sanga, 1974.*

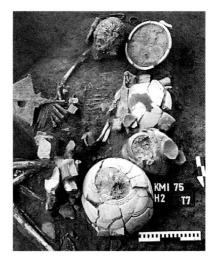

Fig. 43: Rich Ancient Kisalian grave containing a ceremonial ax, with the nails that once decorated the wooden shaft and a cylindrical iron anvil against the skull. *Photo: Pierre de Maret, Kamilamba, 1975.*

Fig. 44: Rich Classic Kisalian man's grave.
Photo: Pierre de Maret, Sanga, 1974.

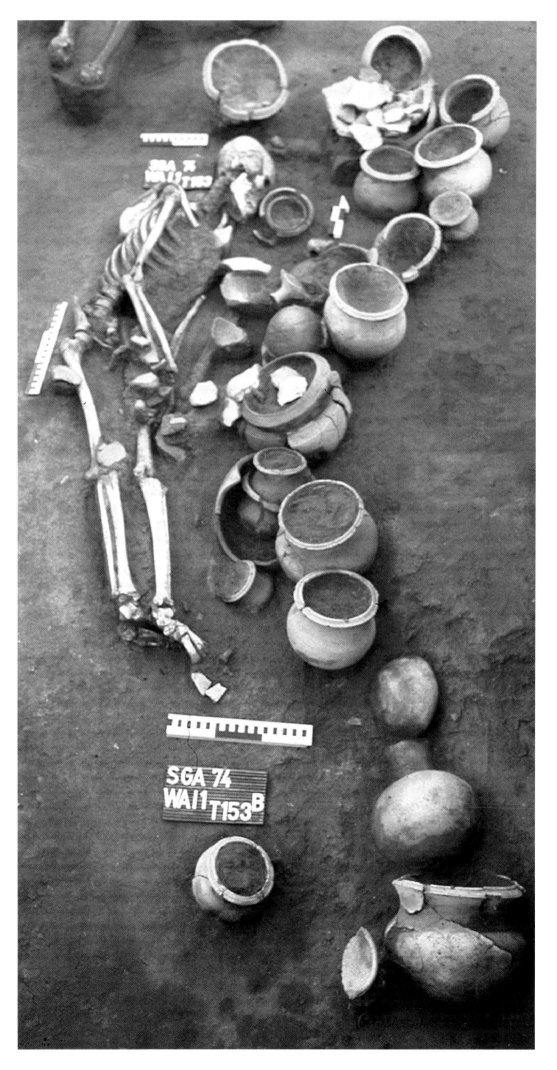

known to have been and still are important symbols of political and religious power among Luba and other central African peoples (Womersley 1975; Maret 1985a, 1985b; Childs 1991a; Childs and Dewey 1995), as is discussed in chapter 2. All of this evidence indicates that some degree of sociopolitical differentiation and ranking was instituted during the Ancient Kisalian (Maret 1979, 1985a, 1992; Bisson 1976). These associations also strongly indicate that the buried individuals were local, autonomous leaders of individual villages or a group of neighboring villages (Maret 1985a:265). To help them to legitimize their authority, such leaders might have adopted and elaborated various highly valued objects used in other domains, such as agriculture, as symbolic statements of sociopolitical status (see Roberts 1985).

The largest number of excavated graves date from the Classic Kisalian period, between the late tenth and the mid thirteenth centuries (fig. 44). This suggests significant population growth, probably due to improved ability to exploit the rich variety of food and other natural resources of the Upemba. The frequency of child burials, however, also indicates high infant mortality. Food and other products of fishing, farming, hunting, and trading are common in the graves, as are the equipment for those activities, such as harpoons, hoes, pots, and spears.

Increasingly specialized and skilled artisans made the objects buried in Classic Kisalian graves. There was a sharp increase in the copper available in the Upemba. Correspondingly, metalworkers now made utilitarian items out of copper, such as fishhooks, harpoons, needles, nails, and knives, in addition to decorative and ritual objects. Skilled potters made new types of vessels; they also changed the decoration on the pots from the motifs popular in earlier times. Pots were important funerary items. Their extreme uniformity of design, shape, and firing characteristics suggests that some were even produced in series for interment. Many were miniaturized, for burial with infants and children. Accomplished ironsmiths made numerous objects for agriculture, hunting, fishing and harpooning, warfare, ritual, and jewelry. Other artisans made ornaments of shell, ivory, and bone, including human and animal teeth and complete human jawbones. The use of materials foreign to the Upemba Depression, such as copper from the Katangan Copper Belt to the south and cowrie shells from the Indian Ocean, suggests that local people benefited from both short- and long-distance trade at this time.

Although some aspects of burial ritual during the Classic Kisalian period were relatively consistent, such as how the cadaver was oriented and configured in the grave, and the importance given to grave goods, there were also differences based on gender, wealth, and social status. Women, and especially children, were sometimes buried with one or more leg bones of an antelope or goat carefully placed parallel to the corpse or in its hands (fig. 45). The knobby joint of the bone was oriented as though it were a top or "head," and the bones were sometimes decorated, suggesting they might be figures associated with fertility, similar to ones used by twentieth-century Luba children and adults (Maret 1985a:167–68, Centner 1963:81–83). Anthropomorphic pottery bottles, at least one engraved with a scene of copulation, reinforce the sense that these objects may have had something to do with fertility (Maret 1994:190).

Differences in social status and wealth were clearly indicated by the unequal quantity and types of objects placed in the graves. Some of the richest burials, particularly those containing a lot of copper, were of children, suggesting that rank and status were inherited by this time, and that the sociopolitical system was becoming increasingly complex—possibly an early state (Bisson 1976, Maret 1985a). As in the Ancient Kisalian, a few adults of this period were buried with a ceremonial ax, an anvil, or both, as markers of their distinctive social status (fig. 46). The recent discovery of a miniaturized ceremonial ax buried in the grave of a small child further suggests inherited status.

While Kisalian culture was blossoming in the northern half of the Depression, Katotian culture was developing in the southern part. As far as the more limited archaeological research carried out in this area allows us to reconstruct, Katotian culture resembled Kisalian in many ways, except for a distinct pottery tradition and some unusual iron tools (Hiernaux et al. 1972). Judging from the presence of only a few pots of Katotian origin in Kisalian graves and vice versa, contacts between the cultures appear to have been limited.

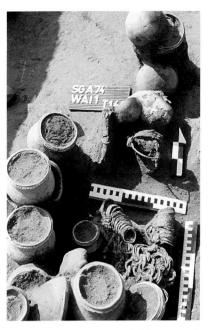

Fig. 45: A very rich Kisalian child's grave with 2.5 kg of copper and iron bracelets, belt, necklace, and anklets. An antelope horn in the grave has been anthropomorphized as a human figure and ornamented with a copper belt. *Photo: Pierre de Maret, Sanga, 1974.*

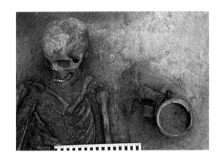

Fig. 46: Detail of what is probably a Kisalian grave containing a ceremonial ax. *Photo: Pierre de Maret, Kikulu, 1975.*

Fig. 47: A Kabambian grave containing a copper cross placed on the thorax of the deceased. *Photo: Pierre de Maret, Kikulu, 1975.*

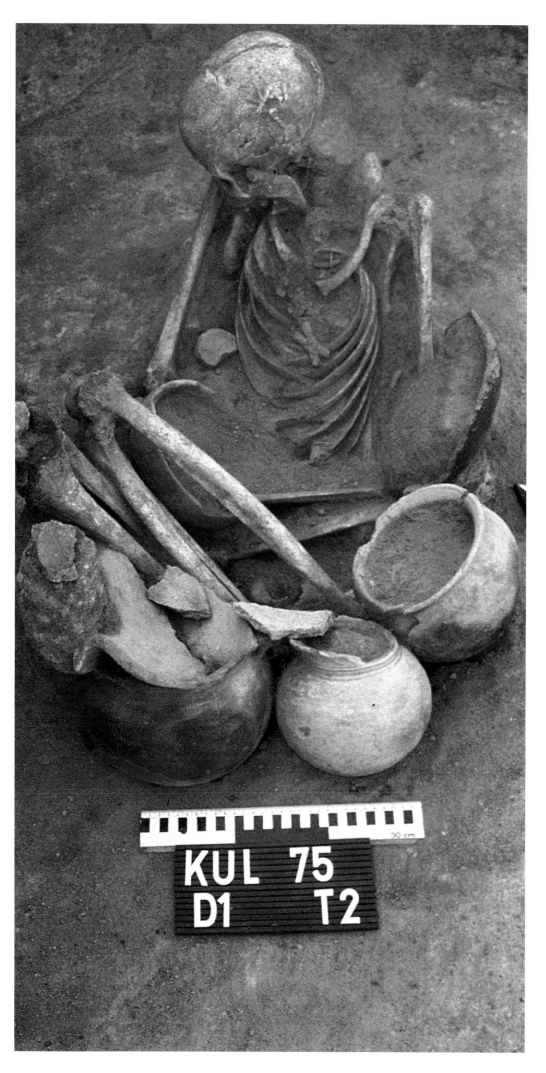

There seems to have been a short transition phase between the Classic Kisalian and the Kabambian period of the thirteenth century, as indicated by several graves that contain a mixture of objects typical of each period, such as distinctive Kisalian pottery and a Kabambian cast-copper cross. Characteristic of the Kabambian period were changes in details of burial ritual, such as body orientation and the quantity and types of objects placed in the graves. There also seems to have been less consistency in rituals, possibly because people had differing opinions on their performance. Individuals were buried with fewer items on average, particularly the pottery, copper, and iron objects that had been popular grave goods in the Kisalian periods. Copper appears in very limited and specialized forms, and only occasionally were graves rich in goods such as iron jewelry, tools, and weapons. Interestingly, the richest Kabambian burials lack the distinct markers of sociopolitical status, such as ceremonial axes or anvils, that were used during earlier periods, as well as more recently by Luba. It is likely that the most important leaders who possessed such regalia were buried in special locations, away from the rest of the population, as has been practiced far more recently by Luba.

Trade over long and short distances was important in the Upemba between the fourteenth and seventeenth centuries. This is most evident in the presence in the graves of cross-shaped copper ingots. The earliest and largest of these were cast in molds in the Katanga region to the south (Bisson 1976). They were used as prestige goods and specialized currency, such as for bridewealth transactions, and were traded in a wide area that included parts of present-day Zaire, Zambia, and Zimbabwe (Maret 1981, 1995; Bisson 1975). In Kabambian graves, these crosses were usually placed on the deceased's upper chest, and may have been used to facilitate a smooth transition to ancestorhood and for exchange in the other world (fig. 47).

Copper crosses were made smaller and more standardized until the eighteenth century, when they disappeared from the graves and were replaced by glass beads. Their decreased size and standardization were probably related to the expansion of a market economy in the area. Interestingly, neighboring cultures also used copper currencies, but of very different sizes and shapes, which, aside from aesthetic differences, may suggest that they circulated in different economic spheres (Herbert 1984:186–91). Kabambian people tended to be buried with tiny copper currencies at their hip or in their hands, sometimes in bound packets or strings. Cowrie shells sometimes placed in the graves with small copper crosses were most likely also used as currency at this time. Dried fish, salt, and iron products were probably the principal items exported from the region, in ever-widening networks of trade. These goods, along with ivory, would be essential to Luba people's profitable commerce after the eighteenth century (Reefe 1981).

There is comparatively little archaeological evidence of the Luba period, because villagers are aware of where ancient as opposed to Luba burials are located, and they have assisted archaeologists to avoid these latter. Rich information on Luba culture has come largely from oral traditions, history, and ethnohistory rather than from archaeology (Burton 1961, Theuws 1962, Reefe 1981, Womersley 1984, Nooter 1991). Luba graves that have been inadvertently excavated or otherwise examined reveal well-preserved skeletons placed in a contracted position with their hands to their faces, a position that contrasts with the more extended position of the body in Kabambian burials (fig. 48). Rarely is any pottery found, and what has been recovered is decorated differently from earlier pottery, although the change in design is gradual. The most frequent Luba grave goods are glass beads made into bracelets, belts, and anklets. One grave also had several thick copper rings. In 1988, a well-preserved individual, possibly 300–400 years old and lying in a contracted position, was found with no grave goods other than an elaborate hair ornament made up of conical iron and copper nails or hair pins.

Archaeology and Oral Tradition

The most significant difference between the archaeological record of the Upemba Depression and Luba oral history revolves around cultural continuity and the sequencing of culturally important events. This difference relates to other disconformities between the two ways of knowing the past. Luba oral tradition narrates a specific past with a major break in the sociopolitical structure at

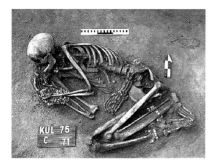

Fig. 48: A nineteenth-century Luba grave. *Photo: Pierre de Maret, Kikulu, 1975.*

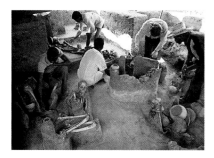

Fig. 49: Villagers and archaeologists at work together. *Photo: Pierre de Maret, Kikulu, 1975.*

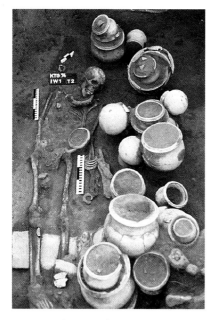

Fig. 50: A Classic Kisalian grave. *Photo: Pierre de Maret, Katongo, 1974.*

the time of Nkongolo, the "red-skinned," self-made tyrant—a break instigated by Mbidi Kiluwe, the mysterious "black" hunter from the east (see Heusch 1982, 1991; Roberts 1991, 1993). Mbidi Kiluwe's son, Kalala Ilunga, is said to have defeated Nkongolo and to have instituted refined behavior at the Luba court, thus marking the beginning of a second period of history. To make the political disjunction as obvious as possible, Nkongolo was beheaded, an act through which "the present is to be separated from what preceded it by an act of unequivocal demarcation" (Connerton 1991:7).

The use of cultural discontinuity in oral traditions glorifies incumbent Luba culture at the expense of the primitive society of Nkongolo. As V. Y. Mudimbe explains the creation of a cogent history,

> The opposition between Nkongolo and Mbidi, or the primitive and the civilized, recites a historical succession and a major paradigm: the origin of history is linked to the foundation of the state. Both witness to the same binary opposition that the myth emphasizes: the possibility of a history means the invention of a refused space and its figures—those of a primitive, which are whisked away in the name of civilization. The meaning of this invention of a prehistory makes itself explicit in the rejection of an original sin. In this confrontation with its own past, a civilized society establishes itself as a cultured space opposed to untamed nature and its aberrations (1991:83).

Despite the usefulness of such fissive history to legitimize political economy contemporary to the narration, archaeology in the Upemba Depression shows that there was actually considerable cultural *continuity* over 1,500 years or more, the details of which are highly unusual in sub-Saharan Africa. Although archaeology reveals changes over the centuries in burial rituals, pottery-making, and in the use of materials such as copper and of particular objects such as ceremonial axes, these changes were not abrupt, nor do they reflect the dramatic conquest of one society by another. A general conclusion from archaeological analysis, then, is that the people who lived during the Kisalian and Kabambian periods in the Upemba Depression were the ancestors of modern Luba (Maret 1979, 1985a, 1992).

Luba villagers who watched and discussed our archaeological excavations were adamant about a significant cultural break between their ancestors and the earlier people whose remains they often unearth in the course of daily life (Maret 1992). Indeed, they used the differences between ancient and Luba pottery to underscore this temporal break. Oral histories they provided contain some elements of the Luba genesis tradition, as well as other information to explain the early skeletons (fig. 49). The story also varies by region within the Upemba Depression. Villagers along Lake Kisale, for instance, said the remains were those of tall, red-skinned people called Ziba, or "people of the lake," to whom present-day Luba are in no way related. When the area became too populated, these Ziba dug their own graves, collected their valuables in the pits with them, and voluntarily died. Alternatively, the Ziba were said to have been killed by ancestors of present-day Luba villagers. It should be noted that the height and skin color attributed to these ancient people resemble the features of Nkongolo, but the details of the death of the Ziba people are not related to the downfall of Nkongolo in the Luba genesis myth. Similar stories of the demise of autochthonous people abound in the region (e.g. Cunnison 1959:35), and their purpose can be considered ideological as much as "factual."

Villagers from around Lake Kabamba, in the north, described the skeletons they sometimes found as those of tall people called Bumbawewe, or "old potters." This name could be related to the large number of pots commonly uncovered with ancient skeletons, but it may also refer to the mother of Nkongolo in the Luba charter myth, called Kibumba-bumba, or "she who makes many pots" (fig. 50). In the same area, oral traditions collected in Mulongo in 1909, but going back to at least the early nineteenth century, also attributed chance discoveries of human bones, pots, and copper crosses to the Kabulutuba, a red-skinned and tall people (Boterdal 1909). The translation of "*mu-kulùtubà*" in the area is "ancestor," or a predecessor of the Luba (Van Avermaet and Mbuya 1954:306).

The numerous skeletons found in the course of contemporary village life and through archaeology needed local explanation, for which people often turn to the Luba genesis myth. It was and continues to be critical to local villagers to differentiate these ancient people clearly from Luba ancestors, so that accidental disinterment (a not infrequent occurrence), or purposeful discovery by archaeologists, does not anger the spirits of dead ancestors whose graves have been defiled. Some Luba did admit that these ancient people were buried with objects similar to theirs, such as clapperless bells and knives, but they insisted that these were coincidences and that no ancestry was implied. They treated the objects they found as curiosities, and even used some for practical purposes: ancient pots are sometimes used to catch and store rainwater, to redirect rain around houses, or as children's toys (fig. 51). Diviners occasionally use old pots, in obvious reference to the ancestors, and contemporary healers sometimes use scrapings from copper crosses to disinfect wounds.

Fig. 51: Luba child using a Kisalian pot as a toy. *Photo: S. Terry Childs, Sanga, 1988.*

The cultural break in Luba oral traditions supports and justifies the political hegemony of the Luba sacral king, or *mulopwe*, by recounting the introduction of royal manners and rituals, and of the customs and technologies of a much more civilized culture than that of Nkongolo. Many of the material attributes credited to Luba civilization, such as the introduction of iron metallurgy, the use of ceremonial regalia to signify divinely approved leadership, the relationship between political leadership and iron-working, and culturally sophisticated practices like filing teeth to points, however, are challenged by the archaeological record.

Kalala Ilunga, the first Luba mulopwe, is said to have introduced the Luba to iron-smelting. Indeed he is said to have built his capital in a place where iron ore was plentiful, probably to capitalize on this resource for purposes of the trade and commerce that have been documented historically (Reefe 1981). As Harold Womersley suggests, "Kalala Mwine Munza saw that with the secret of iron-smelting his, he would have supreme power as incontestable ruler, with an unrivaled store of arms. On the other hand, he could develop agriculture and encourage his people to progress and enjoy the settled life of a more or less civilized community" (1984:20). The archaeological record strongly indicates that almost 1,500 years ago, the first settlers in the Upemba Depression used tools of iron, not stone. Although in other parts of sub-Saharan Africa the earliest use of iron and copper seems to have been for personal adornment (Childs 1991b), the earliest grave goods found in the Depression to date are iron tools and arms: a knife, an ax, arrowheads, and what may be a hoe (Maret 1992:42–43). It is possible that these were imported into the area, and further archaeological investigations are needed to find early local smelting sites. The frequency and variety of iron objects in the graves during the entire occupation of the Upemba, however, indicates that they were valued, and were made by expert artisans. Confirming that religious ideas and practices change over time, Luba villagers now insist that it is very dangerous to bury a relative with iron, especially knives, since the spirit might use it to harm the living.

The oral presentation of the relationship between iron metallurgy and political leadership as a strictly recent, Luba phenomenon is also questioned by archaeology. Several objects made of iron, or related to iron-working, are mentioned in that tradition as Luba royal regalia or symbols of royal authority, including the ceremonial ax, the hammer/anvil, and the bellows used at a forge.[1] Excavations of several graves dating to the Ancient Kisalian and Classic Kisalian periods revealed that they were unusually rich in objects, including, in a few instances, elaborately decorated axes. This evidence suggests that inhabitants of the Upemba had developed some degree of social stratification well before the seventeenth to eighteenth centuries, and that a few individuals used such ceremonial objects to symbolize their authority. It is possible that these were nonhereditary leaders (in the way that Nkongolo is portrayed) who used regalia to announce, legitimize, and glorify their claim (see Roberts 1985). The presence of a miniature ceremonial ax in the grave of a child buried during the Classic Kisalian period, however, strongly indicates that at least by the eleventh century, political leadership was inherited.

Furthermore, several of these axes, along with a knife, had a series of iron nails hammered into their now-disintegrated wooden handles. This unusual decorative and probably symbolic feature (discussed in the next chapter) is present on many Luba ceremonial objects found today in

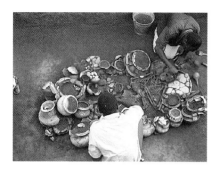

Fig. 52: Excavating a rich Classic Kisalian woman's grave. One of the excavators is the son of the paramount Luba chief of Malemba Nkulu. *Photo: Pierre de Maret, Sanga, 1974.*

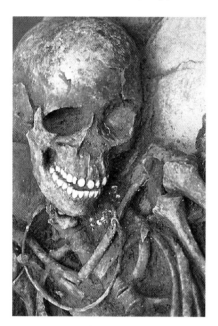

Fig. 53: Detail of fig. 52, showing woman's upper incisors filed to a point, a mark of Luba social identity and beauty. Also visible are a copper necklace and *Achatinae* perforated disk shells, which differ from *mpande* cone-shell disks. *Photo: Pierre de Maret, Sanga, 1974.*

museums. The continuous use of this feature for over a thousand years is remarkable, and again challenges the alleged cultural discontinuity represented by Nkongolo and Mbidi Kiluwe/Kalala Ilunga in Luba oral tradition.

The hammer/anvil is another important symbol of royal authority for Luba and neighboring societies (Maret 1985b). Two hammer/anvils, for example, were excavated in the grave of a Rwandese king buried several centuries ago (van Noten 1972). Among Luba, not only are anvils kept as royal regalia (Petit 1989), but an important ritual during the investiture of a new sacred king was called "beating the anvils." The *Twite*, a royal title-holder, struck the knees of the new mulopwe with his fists, as though he were transforming iron on an anvil at the forge. As he changed the mortal into a sacred king, the Twite reminded the new ruler of the importance of iron to the kingdom, and of how "the anvil is the secret of power and progress" (Womersley 1985:71).

The hammer/anvil, however, evidently had special significance long before the development of the relatively recent Luba polity, since an anvil was found beside the head of an individual of the early Classic Kisalian period. Some archaeologists might interpret this grave as that of a blacksmith, but the wealth and rarity of the accompanying grave goods, including a ceremonial ax with nails, and the lack of any other iron-working tools in the grave strongly suggest that the individual had a special social role during life (Maret 1985b). Also, among the numerous graves excavated at the contemporaneous site of Katoto, at the southern end of the Upemba, two richly interred individuals were buried with both an anvil and a ceremonial ax. These similar yet distinct culture groups, then, both bestowed sociopolitical importance on the anvil long before Luba began to do so.

Finally, Luba oral traditions are explicit about the royal etiquette and customs that Mbidi Kiluwe demonstrated to Nkongolo upon their first meeting. Mbidi Kiluwe required a special house in which he privately ate foods that were prepared by a specially designated cook. He also would not drink in public, but only behind a curtain. Another feature of his royal personality was his carefully filed teeth. The archaeological record rarely provides evidence of individual customs involving perishable materials such as thatched houses, food, and drink. The custom of filing the incisors *can* be investigated by archaeology, however, and there is clear evidence that this practice had begun by the Classic Kisalian period (Maret 1992)(figs. 52 and 53). Again, the archaeological record contests the oral tradition's claim that this custom was Luba in origin.

Conclusions

Some see archaeology as a liberator—a way of knowing the past that provides a historical voice to those who have lost theirs through the oppression of a dominant, often politically motivated group (Molyneaux 1994). The archaeology of the Upemba Depression and Luba oral traditions clearly provide very different details of the past. The dominant royal traditions particularly glorify specific social, political, economic, and technological accomplishments and values attributed to royal ancestors, because these are important to the continued vitality of Luba royalty in the present and future. Upemba archaeology, on the other hand, presents a broader view of the past, in which rich and poor, old and young, and male and female farmers, fishers, traders, and hunters lived and died over the course of more than 1,500 years. A striking result of comparing these two methods of understanding the past is that many of the elements presented in oral traditions are also found in the archaeological record (Reefe 1981, Heusch 1982, Maret 1992). Only the proposed timing or chronology of events differs dramatically.

It is crucial that future historical research among Luba and other societies closely integrate the methods of archaeology and learning from oral traditions, and the knowledge derived from them. Indigenous peoples and archaeologists tend to view material and natural worlds in very different ways, and may be able to benefit from each other's insights (Layton 1989). Local people use a variety of devices to elicit memories about the past that can be useful to archaeologists. For Luba, these include objects like lukasa memory boards, built and rebuilt shrines, and locations of graves, as well as trees, waterfalls, boulders, caves, and other lieux de mémoire deemed of religious or economic importance. Luba oral traditions are full of these mnemonics, and several researchers who have collected them have also visited the sites involved. Furthermore, oral traditions provide

a wide variety of clues about past events, and about the habits that leave material remains for archaeologists to study, such as directions of migrations, networks of trade, and other significant cultural practices. The present authors' agenda for future archaeological research in the Luba area, in collaboration with Zairian and other colleagues, will be heavily influenced by the places in the Luba Heartland that are remembered in oral traditions and other performances. We shall also seek to learn more about the trade and use of both copper and iron in the area, details of which are virtually ignored in oral traditions.

As archaeologists begin to understand the benefits of working with memory specialists, it is critical that they respect the rules and values that may be associated with places mentioned in oral traditions. Many are sacred and should not be disturbed by archaeological excavation. Archaeologists must be prepared to develop other discovery techniques that honor local proscriptions concerning important lieux de mémoire.

If oral traditions can be of such great help to archaeology, how may the results of archaeology affect future oral traditions? Archaeology can be a boon, but it can also be a nuisance to those who do not choose to challenge their ways of knowing the past (Molyneaux 1994). After initial skepticism, Betsileo elders in Madagascar have worked closely with archaeologists to locate significant excavation sites through oral traditions, and are now using the resulting information to clarify details of their history (Raharijaona 1989). In 1988, Pierre de Maret gave his book on the 1970s Upemba excavations to the people in whose village he had worked. Many Luba have been literate for several generations now, and some are superb scholars. As James Clifford has noted, our once-upon-a-time "informants" are now reading over our shoulders, and "indigenous readers will decode differently the textualized interpretations and lore" of Western ethnography and archaeology (1988:52–54). De Maret's book and others concerning Luba life may influence future oral traditions. In turn, these new readings may have impact upon the local practice of archaeology and may provide new insights into how Luba pasts are reformulated and transformed through memory.

TABLE I:
Chronology of Luba Archaeology

Periods and Centuries

KAMILAMBIAN:
 seventh century A.D.
ANCIENT KISALIAN:
 eight–tenth centuries A.D.
CLASSIC KISALIAN:
 tenth–thirteenth centuries A.D.
KABAMBIAN:
 thirteenth–seventeenth centuries A.D.
LUBA:
 seventeenth century until present.

Endnotes

The authors are indebted to a number of people and institutions. First and foremost are the people of Sanga, Kinkondja, and nearby villages for their cooperation and aid, and the Institute of the National Museums of Zaire, especially Muya wa Bitanko, Kanimba Misago, Nkulu Ngoy, Kisimba Mwaba, and Mukaz Waranakong, who provided critical assistance and expertise in the field. William Dewey and Geneviève Thiry also deserve our thanks for their help in the field. Funding and other support was most graciously provided by the J. P. Getty Trust, the National Scientific Research Foundation of Belgium, the Center for Materials Research in Archaeology and Ethnography at the Massachusetts Institute of Technology, the Royal Museum of Central Africa in Tervuren, Belgium, and the Government of Zaire.

1. The hammer/anvil, a dual-purpose object with two sections, can be used as a hammer when the tapered section is held in the hand, and as an anvil when the tapered section is driven into the ground.

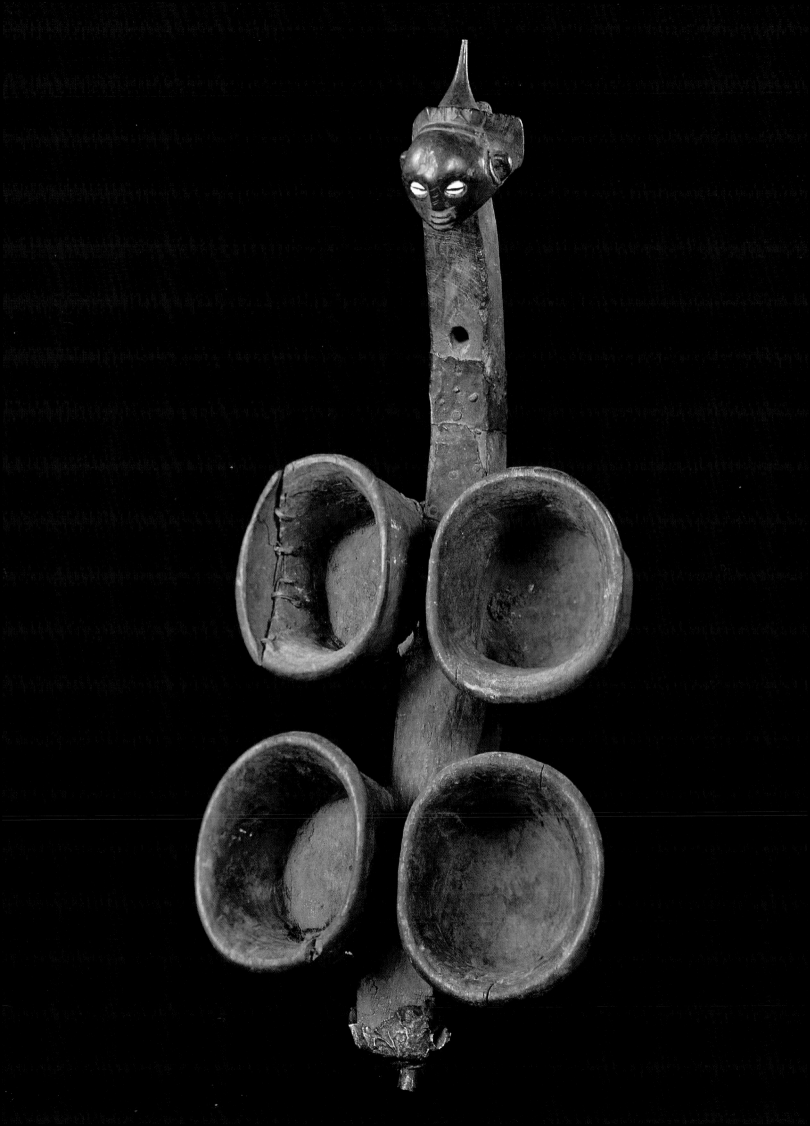

CHAPTER 2

Forging Memory

William J. Dewey and S. Terry Childs

Iron has long been critically important to Luba social life.[1] Over the centuries, iron has been the substance and agent of transformation that has allowed people to forage, hunt, fish, till the soil, and assure their own protection and prosperity. Iron creates and saves lives, but takes them too. In precolonial times, iron-smelting and smithing technologies were greedily sought and jealously guarded, for their control could promote a king's ambition and a soldier's fortune. An element of such significance must have divine inspiration, and Luba hold that it was their culture heroes who introduced these essential skills and the social organization they imply.[2] Iron-smelting has not been practiced for decades now, but Luba blacksmiths still make a range of iron objects from scrap (fig. 54). In the essay to follow, we will show that in forging iron, Luba forge memory—and kings, too.

What is remembered of royal iron art? Even asking Luba such a direct question may introduce a bias, for as Pascal Boyer has noted, there is a "systematic discrepancy between what anthropologists are seeking, namely some semantic memory data, and what conversations with informants provide in abundance: memories of singular situations" (1990:43). As a growing number of researchers are discovering, memory is dynamic, "a system of categorization in which the past is recreated in ways appropriate for the present" (Lopez 1992:32). In analyzing ritual performance among nearby Lunda, Filip De Boeck (forthcoming) aptly notes that complementary modes of remembrance operate at the same time: "inscriptive" ones such as oral and textual recollections interact with "performative" and "embodied" modes. The oral, textual (that is, in our case, art objects as "texts"), and performative activities of Luba blacksmiths seem similarly interconnected.

Objects are useful vehicles for memory. As Susanne Küchler and Walter Melion have noted, "Memory operates through representation. Images do not simply encode prior mnemonic functions . . . [they] posit a dynamic of mnemonic processing" (1991:7). In the course of field research, we regularly showed people photos of Luba objects from museum collections, asking them to explain their use and meaning. We had some success, but it was frustrating to discover that most people did not remember such objects directly, and often had no sense of how they fit into Luba collective memory either. The performative aspects of manufacturing such objects were what we sought most, but such details proved hardest to track down. Such research into the styles, organization, and dynamics of technology posits that as much can be learned about objects by examining the culturally constructed ways in which they are made as by examining the end products (Lechtman 1977, Childs 1991c). Anthropologists and art historians study performative

CAT 13: BELLOWS. LUBA, ZAIRE. Figurative bellows, such as this four-chambered bellows surmounted by a finely sculpted head, were the prerogative of kings and chiefs only, and were kept secretly. Bellows are not only a critical component of blacksmithing, they are powerful symbols of the important connections between metalworking arts and sacred kingship. The head on this bellows is punctuated by an elegant iron pin, the miniature symbol of the hammer/anvil. Its presence on the sculpture ensures the containment of the spiritual energy necessary to the volatile processes of smelting and smithing. *Wood, cowrie shells, metal. H. 12.4 in. Mr. and Mrs. John Lee.*

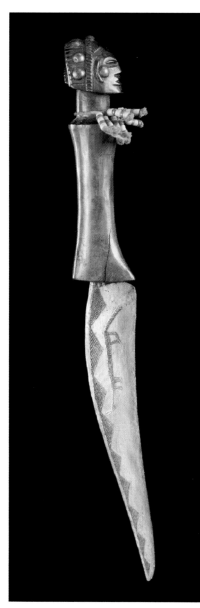

CAT 14: CEREMONIAL KNIFE. LUBA, ZAIRE.
Knives are among the most sacred items
in a Luba king's treasury, and also constitute
part of the regalia of secret-association
members and spirit mediums. These other-
wise utilitarian tools become objects of
ceremony and exclusivity when shaped with
sculpted human figures and engraved with
geometric patterns. *Metal, wood. H. 13.75 in.
Ethnografisch Museum, Antwerp, Inv. no.
AE.1187.*

**CAT. 15 (OPPOSITE): CEREMONIAL KNIFE AND
SHEATH. LUBA, ZAIRE.** Once or twice a year,
to honor the chief's predecessors, a sacrifice
was made to the royal knife. The knife was
removed from its sheath and placed on the
bare earth. Meanwhile, women nearby
prepared millet beer, which was then
sprinkled around the knife in a circle. The
participants observed the sacrifice and then
danced in celebration. The ritual was called
"*lupopo,*" from "*kupupa,*" in a general term
for "offering," and was made by the chief,
who recited the entire list of his predecessors'
names from memory. *Metal, wood, brass pins,
leather, fiber. H. 19.5 in. (knife); 24 in.
(sheath). Private collection.*

aspects of African ritual routinely; now performative aspects of technology, and the lives of those
engaged in it, deserve more examination.[3]

Origins and Investiture

Blacksmiths and iron objects figure prominently in Luba myth and ritual.[4] Versions of the Luba
Epic vary. In some, the primordial tyrant Nkongolo uses metal tools and weapons; in another,
Mijibu wa Kalenga, the first spirit medium, is also a blacksmith (Womersley 1984:4). More com-
monly it is the culture heroes Mbidi Kiluwe and his son, Kalala Ilunga, aided by their blacksmith,
Kahasa Kansengo, who are credited with introducing iron technologies and subsequent adoption
of iron objects among Luba. It is not so important to determine who was the first to introduce
iron-working, however, as it is to note how iron-working makes manifest the interconnections
among religion, politics, and technology. The Luba heroes Mijibu wa Kalenga, Mbidi Kiluwe,
and Kalala Ilunga (with Kahasa Kansengo) respectively represent these three domains.

Stories are told of how Kalala Ilunga defeated his uncle, Nkongolo, in a Luba game of marbles
(masòko). Masòko (singular: disòko) are the round seeds with which the game is played; the
same term can mean "testicles" (Van Avermaet and Mbuya 1954:623). Kalala had a magically
empowered disòko made from iron, left for him by his father, with which he easily defeated his
maternal uncle. Nkongolo's political demise was foreshadowed and the symbolic importance of
iron asserted.[5] After beheading Nkongolo and taking power, Kalala established his royal court
at Munza, in precolonial times one of the most important iron-producing districts. Then he
summoned Kahasa Kansengo to teach people how to smelt iron. Subordinate lineages were
subsequently sent a forge or bellows with instructions in their use, and many still claim that this
event signaled the origin of their subchieftancies.[6]

In the investiture ritual for Luba kings and certain important chiefs of the sacred blood
(*bulopwe*), the tools and products of blacksmiths have played significant roles.[7] When a king or
important chief passes away, society dies a symbolic death as well. An interregnum follows that is
of critical importance, for many of the key elements of the Luba charter for sacred royalty are
symbolically reenacted in the ensuing rituals. In other words, interregnum is a rite of passage
through which society is moved from loss to "rebirth" with the investiture of a legitimate succes-
sor. Such memory theater is the stuff of this book.

In the past, succession was often anything but an easy affair. Fratricidal battles might rage as
heirs sought to ascend to the king's throne (cat. nos. 14 and 15).[8] Oracles and ritual tests were
performed to verify an heir's claim to the throne, such as a "lake-wading" ritual at Lake Kalui, led
by the most senior spirit medium. *Pemba* chalk was applied to the candidates' bodies, and after
wading in the lake, the man who emerged with chalk still adhering to him was judged the true
successor. White chalk is a sign of harmonious contact with the other world, and when pemba was
not washed off, as must ordinarily happen, this remarkable reversal of expectation could only
mean the approval of the spirits (fig. 55).

Of particular interest to memories of iron and kingship is another test involving an iron "sky
hook" called "*mulebweulu.*"[9] This instrument was said to have been brought by Kalala Ilunga
from his father's home when he was returning to battle Nkongolo to the death. The iron hook is
thrown up high, where it mysteriously hangs in midair. "The prince who is being tested jumps
up and grabs it. If the tribal spirits favor his claim, he is able to swing on it, but if he hasn't their
support he falls to the ground and the hook falls with him" (Womersley 1984:66–67). Pierre Petit
reports a related story of the king throwing a staff and an adze (*nseso*) up in the air; when they
become suspended, this proves that there is none like the king, and that the lands are rightly his
(1993:433). Such miraculous events in conjunction with leadership assertions are quite commonly
reported in central Africa (see Herbert 1993). The Kuba legend of royal contenders throwing
hammer/anvils into a lake to see whose would float and thereby prove their legitimacy (Vansina
1978) is but one of many such stories. As Petit notes, the objects are said to hang between heaven
and earth, demonstrating the king's mediation, betwixt and between and so beyond any limita-
tions of ordinary existence (1993:434).

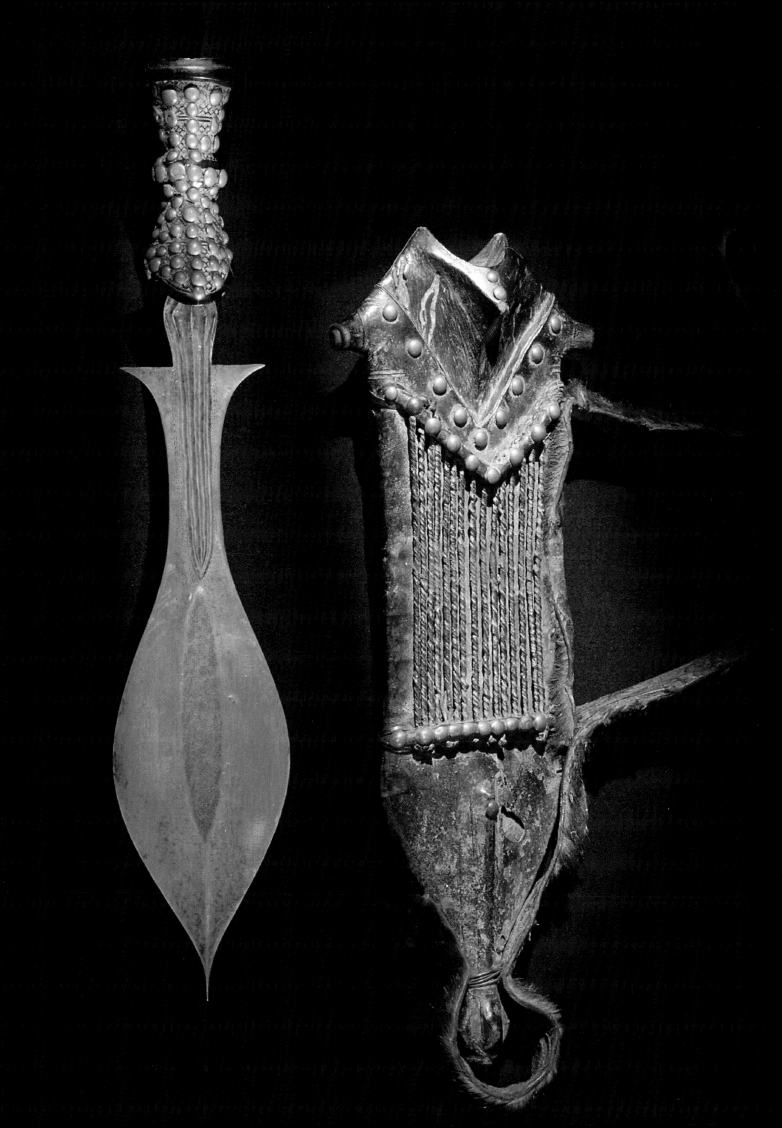

Fig. 54: Luba blacksmiths at work. Blacksmithing is a technology of transformative power, said to have been introduced to Luba by the first sacred Luba king, Kalala Ilunga. *Photo: S. Terry Childs, 1988.*

Fig. 55: During investiture rites, a king or chief is transformed from an ordinary mortal into a sacred ruler. Here, two elder titleholders anoint a candidate to the office of territorial chief with white pemba chalk and attach white feathers to his head. The color white is indicative of ritual transition and accord with the spirit world. *Photo: Mary Nooter Roberts, 1988.*

Fig. 56: Titleholder Kioni with the sacred *dikumbo* basket said by Luba to contain the relics of previous rulers. Kioni occupies the throne during the transition between the death of one king or chief and the installation of a new one. *Photo: Mary Nooter Roberts, 1987.*

When the successor is chosen, he is stripped of his old clothes and social identity. He has a final communal meal, after which all the pots used in cooking and eating it are smashed to symbolize the end of his old life, for once he is king he will never eat in public again. He is then secluded in a specially constructed house with no doors or windows, the *kobo ka malwa* (house of suffering or unhappiness). Secluded with him is a close female relative, and the *dikumbo* basket containing the skull and other relics of his predecessor. During the several days that follow, the heir and his kinswoman commit incest. If a male child is conceived of this union, this son will eventually become a royal dignitary (Kioni) who can have no claim to the throne, and so can help maintain order during the interregnum after his own father's death (fig. 56).

Eventually, "the chief burst[s] forth [out of the house], dancing, and prophesying, supposedly under the inspiration of the spirits of his forefathers" (Burton 1961:22). He is ritually purified in a stream, freshly dressed, and given the regalia of the office. Although these accouterments vary from region to region, they may include "an enormous red [parrot] feather headdress, a shell necklace, a bead necklace, a leopard skin, a belt made of twisted hippopotamus or elephant hide, a bone or ivory bracelet, a spear, a staff, a stool, a bowl for *pemba* [chalk], a receptacle for the cranium and genitalia of the last ruler, an ax, a knife, iron bells, and a drum" (Weydert 1938:5).

The king's new name is then proclaimed and the *kutomboka* dance performed (Verbeke 1937). During this dance the king is lifted on a litter of weapons by his most heroic warriors, and carried in a triumphant procession as the cheering crowds rejoice. Stephen Lucas notes that the kutomboka dance may be performed in the context of other rites of passage, such as male initiation and funerals (1967:102). The king and his kingdom thus undergo a typical rite of passage, with stages of symbolic death, liminality, and rebirth. From this point on, the king is sacred and possessed of incredible power, but he is also expected to follow the rules of etiquette introduced by Mbidi Kiluwe, such as always eating and drinking alone, in strictest privacy.

Harold Womersley describes an additional ceremony enacted at the end of the enthronement of Luba kings early this century. Upon completion of the other rituals, kings went to Makwidi Munza, the important iron-producing region and site of Kalala Ilunga's first capital. There the

> Twite [an important titled official] and the king, together with some of the tribal elders, retired to a prepared house where two carved stools had been placed facing each other. The young king was placed on the larger one and the old Twite on the smaller one. An old man brought from its hiding place a large roll of raffia cloth and handed it to the Twite, who opened it and revealed the special emblems of the kingdom, a royal *fundanshi* or double-ended spear (cat. no. 16) and a ceremonial copper headed *mutobolo*, or war ax of beautiful beaten work. These, it is said, had belonged to Kalala Ilunga and were left by him with instructions that each succeeding king should hold them in his hands while the "beating the anvils" ceremony took place, after which they were returned to their hiding place until the next enthronement.
>
> The new king now held the spear in one hand and the copper ax in the other. The Twite then cried out, *Ke tu komena manyundo* ("Let us strike the anvils") and, raising his two fists in the air, proceeded to beat the bared knees of the king. "May you be firmly fixed in the kingdom," he added, beating again, "and live and reign as long and as well as your illustrious ancestor Kalala Ilunga Mwine Munza," then, adding the long list of praise names always associated with Kalala Ilunga: "I do this to remind you that your forefather Kalala Ilunga introduced iron-working into this land. He was a wise man. Whether weapons of war or tools of peace, whether for arrows and spears or for axes and hoes, the anvil is the secret of power and progress. Remember your people, do not be satisfied merely to take their tribute, give them of your wisdom and of your protection and the success of your kingdom will be assured" (1984:71).

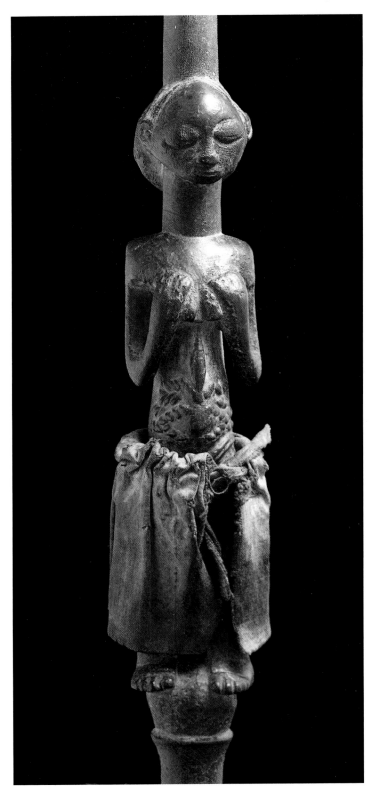

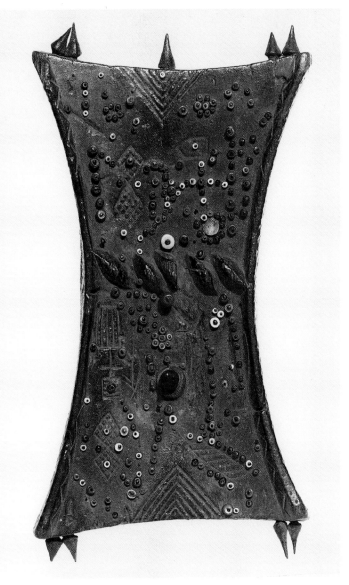

CAT. 17: MEMORY BOARD OR LUKASA. LUBA, ZAIRE. This elegant lukasa has iron hairpins added to its edges and surface. Usually the presence of an iron hairpin signifies a kitenta, or spirit capital. Spirit capitals are the ultimate lieux de mémoire, for they symbolize the place where the memory of a Luba king is perpetuated for posterity. The pin in the board's lower center designates the king in whose honor the board was made. The pins around the perimeter may refer to other, related spirit capitals, for example those of royal diviners and Mbudye Society chapters connected to the kingship in question. *Wood, beads. H. 10 in. The Brooklyn Museum, gift of Mr. and Mrs. John A. Friede, Inv. no. 76.20.4.*

CAT. 16: ROYAL SPEAR (DETAIL). LUBA, ZAIRE. Few Luba spears have arrived in museum and private collections, which may indicate that these objects were the rare prerogative of sacred kings only. In addition to their usually refined execution, they often incorporate elegant female figures in their shaft, which is also often wrapped with copper. The sanctity of spears is suggested by the practice of their concealment: in its earlier context, the female image in this spear was always covered with the cloth that it now wears on its waist. This cloth was intended to guard it from the public eye, and was removed only on special occasions. *Wood, iron, cloth. H. 61 in. The University of Iowa Museum of Art, The Stanley Collection, Inv. no. CMS 546.*

Fig. 57: Anvil (*nyundo*) inherited by Mwepu Muleka, Kinkondja. The anvil is the symbol and secret of royal authority. Length: c. 8 in. *Photo: William J. Dewey, 1988.*

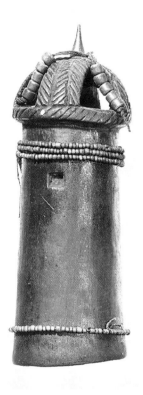

CAT. 18: TWIN FIGURE. LUBA, ZAIRE. Twins are sacred for Luba and Luba-related peoples; they are called "children of the moon," and can be the harbingers of both good and evil. Twins must be honored and appeased through devotional songs, prayers, blessings, and gifts made every month on the night of a new moon. Figures like this served to commemorate the spirit of a twin, and the insertion of an iron pin in the top of the head is intended to contain and channel the spirit within. *Wood, beads, metal. H. 7.8 in. The Brooklyn Museum, Museum Expedition 1922, Robert B. Woodward Memorial Fund, Inv. no. 22.815.*

CAT. 19 (OPPOSITE): STANDING FEMALE FIGURE. LUBA-SHANKADI, ZAIRE. The angular forms of this figure are unusual, the mark of an unconventional and innovative artist. Emphasis is placed upon the points of articulation—the joints, for example, and the hairline. The presence of a row of iron tacks along the curve of the forehead creates a kind of crown for the head—seat of power and intention, dreams and memory. *Wood, beads, metal. H. 13.8 in. Private collection.*

Like a blacksmith's transformation of unformed iron into an object of art or utility, so the once-common man is forged into a king. The *komena manyundo* ritual marks the ultimate transformation, but Womersley's translation of the phrase as "to strike the anvils" is inadequate. The verb "*kukomena*" is from "*kukoma,*" "to be strong and energetic, and to reach one's full growth"; but while "kukomena" can mean "to harden, fortify, or establish," it also bears a sense of a burden so heavy that it may overcome a person (Van Avermaet and Mbuya 1954:276–77). As Petit was told, reference to the iron hammer/anvils (manyundo) assures that the king's soul (*mutima*) will be hardened (1993:460). Thereafter, he can never feel fear or flee, for to do so would be to lose the sacred power of kingship. In another version of the investiture ritual practiced at Malemba Nkulu, the titleholder installing the new king wears small double anvils on his left shoulder, which he strikes together to "render force to the chief at his enthronement" (Nooter 1991:152). Manyundo anvils might also be touched to the king's "articulations" (presumably his knees and elbows) and forehead, and might be struck together during certain festivals when he ate and drank, to remind him of the event of his transformative "forging" (Petit 1993:467, 482–83).

Luba are not alone in linking blacksmiths, kings, and powers of transformation. As a number of scholars have shown (e.g. Devisch 1988; Herbert 1993; Heusch 1975; Maret 1980, 1985b, 1994), variations on the theme are found across central Africa, from Kongo to Kuba to the interlacustrine kingdoms of Rwanda. It is apparently an ancient relationship as well, for as Terry Childs and Pierre de Maret have discussed in the previous chapter, anvils have been found in the Upemba Depression interred in graves of high-status individuals that may be over a thousand years old.

Miniature Anvils

Conical hairpins or nails of copper or iron are perhaps the most important category of object made by Luba blacksmiths to forge and recall royal memory.[10] Previous authors have virtually ignored these objects as "mere decoration," but Luba intended them to be much more. As Childs and Maret have explained in chapter 1, such pins appear quite often in the graves of periods such as the Ancient Kisalian, as embellishment for axes or elaborate coiffures. That similar conical nails are found on the lukasa memory boards of the Mbudye society is also significant (cat. no. 17). As will be explained in detail in chapter 4, Mbudye members recount the origins of sacred kingship and ensure the glorification of the political status quo. The individual beads and nails on a lukasa are mnemonic devices that recall important places, positions, events, and people. "When placed on a lukasa, the metal pin signifies the extraordinary power of the king . . . [and] embodied the structure and spiritual potency of kingship itself" (Nooter 1991:259). A conical nail representing the king or culture hero for whom the board is made is also considered the most potent "spirit capital" or *kitenta*. These particular nails figure prominently in iconography, then, especially as iconography actively reinforces Luba kingship and state. It is important to note that this kind of nail is called *kinyundo*— "hammer/anvil."[11]

The close relationship between the religious and political sectors of Luba society is also seen in Mbudye initiation rites. Upon reception of his or her tutelary spirit, a novice mounts an earthen throne. This conelike structure has images of the royal hierarchy painted around its perimeter, and is called a *kikalanyundo* (Nooter 1991:156). The prefix "*kikala –*" refers to a threshold, step, or bench of packed earth (Van Avermaet and Mbuya 1954:220), while the other root, "*nyundo,*" is the smith's hammer/anvil again. In other words, the Mbudye initiate sits upon an earthen anvil, where final ritual transformation is effected.

The similarities in the forms and symbolic meanings of these objects are extremely important. Conical nails, like hammer/anvils (fig. 57), are multilayered symbols of political power. A glance through this book shows how extensive the use of anvil-shaped pins has been in royal regalia. Every category of art form, from knives, axes, and staffs to lukasa memory boards and figurative sculpture, is studded with them (see also Childs and Dewey forthcoming 1996)(cat. nos. 18, 19, and 21). The location of the pins is often symbolically important, as when they center power in the forehead, or at the four corners of the elaborate plaited royal coiffures (cat. nos. 20 and 23).[12]

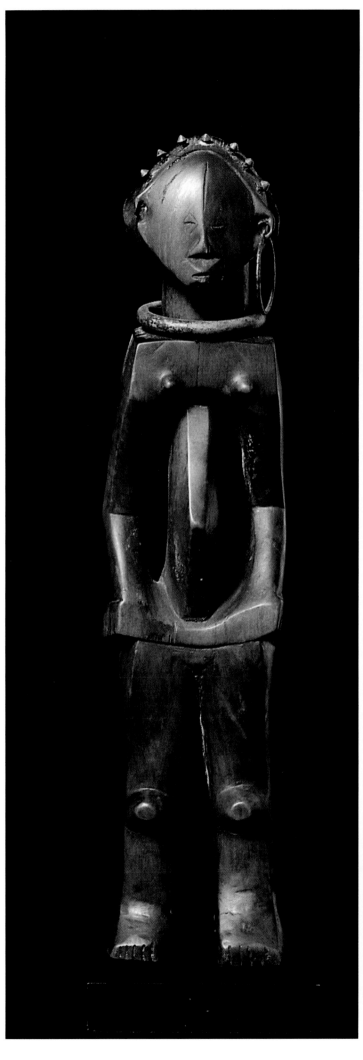
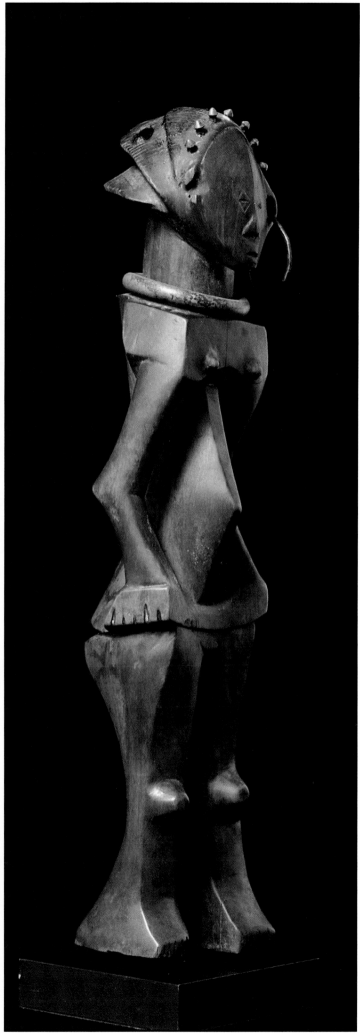

Fig. 58: Smelting iron at Kayeye, before 1929. From *The Geographical Journal* 70 no. 4, p. 325.

They may also mark the body's articulations, including the places on a king's body touched during the *kukomala manyundo* ritual. These vulnerable points of juncture and opening must be protected from the evil magic of adversaries. Enhanced and empowered by anvil-shaped pins, these same points mark the figure's—hence the spirit's—transformative capacities. Royal use of anvil-shaped hairpins has largely stopped among Luba, but these pins may still be found on some divination figures (cat. no. 22). The nails "close" such objects, keeping out what is dangerous and keeping in what is precious—in this case, the spirit embodied by and inhering within the figure (Nooter 1990a, Roberts 1990a).

A final word may be said about Luba pins as anvils in miniature. "The miniature has the capacity to make its context remarkable," Susan Stewart tells us (1993:46), for its scale refers to the familiar but is other than the familiar, in what is paradoxically both a reduction and an opening to possibility. "The miniature achieves a delirium of description" (ibid.: 46–47), for, as Gaston Bachelard would have it, the "metaphysical freshness" of tiniest things derives from their being "automatically verbose" (1969:160–61). They tell us a great deal, more than we can or perhaps need to know. But this is the "essential *theatricality* of all miniatures. . . . First, the object in its perfect stasis nevertheless suggests use, implementation, and contextualization. And second, the representative quality of the miniature makes that contextualization an illusive one; the miniature becomes a stage on which we project, by means of association or intertextuality, a deliberately framed series of *actions*" (Stewart 1993:54). We can presume, then, that when Luba adorned themselves with anvil-shaped hairpins, the "automatically verbose" tiny objects spoke worlds, both of what an anvil is and does at a blacksmith's forge and of what all this represents to the transformative capacities of royalty. Every wearing is remarkable, because of its deliberate theatricality—the act of representation made tangible, however elusively.

Smelting

The last iron-smelting among Luba probably occurred in the 1920s or early 1930s (fig. 58). Thereafter, Belgian colonial agents subtly or overtly discouraged further local production, and the economy became flooded with cheap European iron.[13] Compared to iron-smithing, the skills of iron-smelting are and were relatively secretive in most of Africa, and it is rare for smelting to be associated with leadership in the way that smithing is (Maret 1985b, Herbert 1993). Perhaps this is because of associations between smelting and the sacred earth rather than royal authority, and because of the particular prohibitions and pollutions of smelting. In the Luba case, smelting is not reenacted through ritual and regalia, but it is a subject of magic and myth. Significantly, it is remembered through embodiment, and is specifically linked to the female form and human procreation.

Among Luba, the smelting furnace was known as *dilungu*, from a verb meaning "to join," which has obvious sexual connotations and which also appears in the name of the culture hero Kalala Ilunga. The missionary W. F. P. Burton (1927:fig. 1, 1961:119) apparently observed Luba iron-smelting in the 1920s, and noted that "the furnace itself is shaped roughly like a woman, and often even clay breasts are added, while the actual extraction of the molten metal takes place in such a manner as to represent a birth." The conjunction of sexual and reproduction metaphors with iron-smelting is common in many areas of Africa (Childs and Killick 1993), and "gynecomorphic furnaces" were found among groups near Luba, such as Bena of Tanzania, Shona of Zimbabwe, and Chokwe of Angola and Zaire (Herbert 1993:32–36). Smelting furnaces were usually located away from villages; and women, except those past menopause, were prohibited from coming near. The men performing the smelting observed strict sexual prohibitions, to "frame" the event. Instead, they engaged in symbolic coitus with the furnace itself. Like neighboring Tabwa (Roberts 1996a), they probably placed in the furnace some of the same fertility magic ordinarily used to assist women to conceive or overcome sterility; and songs and other performance activities accompanying smelting may have included songs celebrating sexual exuberance.

By the time of our Luba fieldwork in 1988, we were unable to find any Luba who still knew how to smelt iron, and only a handful of older men remembered the processes at all. An elderly

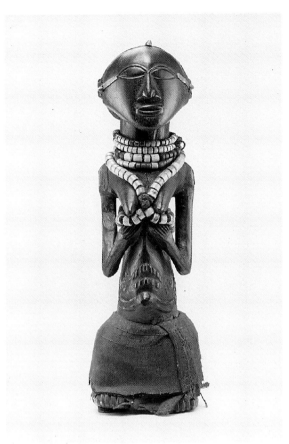

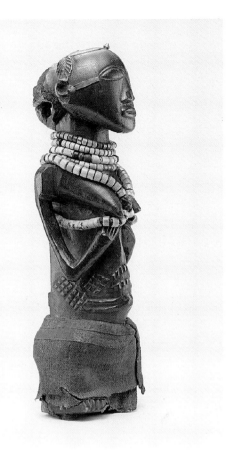

CAT. 20: FEMALE FIGURE. LUBA, ZAIRE. Laden with beadwork apparel having mnemonic references, this figure has been "locked" with iron pins inserted into the critical points of articulation around the head. The top of the head, the temples, and the quadrants of the coiffure are all "closed" by the pins, to discourage the spirit inhabiting the sculpture from abandoning this home for another, and to protect against the evil of one's adversaries. *Wood, beads, cloth. H. 17 in. Margaret H. Demant.*

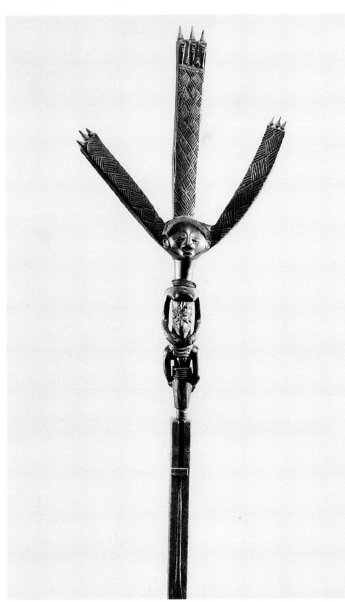

CAT. 21. BOW STAND. LUBA, ZAIRE. Bow stands testify to the relationship of hunting to kingship among Luba; their mythic culture bearer of kingship, Mbidi Kiluwe, was a renowned hunter whose treasured emblem was his bow. Iron pins have been added to the tips of this bow stand's branches to recall the secret of Luba power and sacred royalty: the blacksmith's anvil, symbol of transformative power and metamorphosis. *Wood, metal. H. 38.5 in. Michael C. Rockefeller Memorial Collection of Primitive Art, Gift of Nelson A. Rockefeller, Wunderman Foundation Gift, Metropolitan Museum of Art, Inv. no. 1978.412.486.*

Fig. 59: Knives and tools resting against a rail used as an anvil in the workshop of Muleka wa Ilunga. *Photo: William J. Dewey, Kinkondja, 1988.*

CAT. 22 (OPPOSITE): BOWL FIGURE. LUBA, ZAIRE. Bowl figures are owned by both chiefs and diviners to honor and remember the critical role played by the first mythical diviner, Mijibu wa Kalenga, in the founding of kingship. Rulers keep them at their doors, filled with a sacred white chalk associated with purity, renewal, and the spirit world. Usually, however, these figures are the prerogative of royal diviners called "Bilumbu," who use them as oracles, and as receptacles for their possessing spirit's wife. The female figure holding this bowl bears the marks of civilization in her scarifications, elegant coiffure, filed teeth, beaded accouterments, and the iron pin that protrudes from her head. Luba people say that the purpose of such pins is to guard and hold the spirit safely inside the receptacle. *Wood, beads, metal. H. 17.9 in. Lucien Van de Velde, Antwerp.*

man named Nkulu Mulogo, who knew quite a few of the details of smelting although he had never been a participant, kept a small piece of bloomery iron in his home as an heirloom.[14] He and his brother had done some smithing in the old days, and more recently had become pastors of an Evangelical Methodist church. They offered no information about symbolic uses of bloomery iron, but it is likely that, as among Tabwa (Roberts 1996a), iron bloom may be used in magic to help with women's reproductive problems, given the "gynecomorphic" symbolism of at least some of the furnaces. The brothers did remember that iron formed into variously sized round shapes was a form of currency that had been traded from Kilulwe, where they originally lived. In this, they echoed Womersley's report that "in the main iron-bearing districts of Munza, Kibanza, Kalulu, and Kilulwe, hoes became current coinage or means of exchange, just as further south the large copper crosses called *miabo* were similarly used" (1984:21).

Blacksmiths and other people we interviewed were shown photographs of figurative bellows carved with figures or heads (cat. no. 13). They often identified these as belonging to kings or chiefs, adding that they were kept secretly. One young fifth-generation blacksmith in the town of Kinkondja remembered that his father, who had been a blacksmith and also the chief of a nearby village, had had special bellows like these. He was the only blacksmith we interviewed who still owned a conical-shaped hammer/anvil (nyundo), made by his grandfather. He kept it as an heirloom and no longer used it, preferring a piece of rail for his smithing.

Smithing

Luba blacksmiths we interviewed in 1988 were of different ages and backgrounds. Most were part-time smiths primarily engaged in subsistence farming or fishing. Some told us they had learned their trade from their parents and grandparents, while others claimed to be self-taught. Some were aware of the strict prohibitions once associated with iron-working, and some still observed them. Others claimed they followed no such rules, and it is clear that Christian missions and especially the popular indigenous Evangelical churches have had an impact on the old beliefs and practices (or at least what they were willing to tell us of them). Despite the emphasis on blacksmiths in royal myths and ritual, we heard almost no mention of these contexts from blacksmiths themselves. They were doers, not philosophizers or "men of memory." Instead, their memories were couched in their own personal histories and "singular situations" of the sort described in Boyer (1990:43).

What contemporary blacksmiths remember of early practices—which some still follow, at least in part—is that there was a hierarchy among smiths as in other spheres of Luba life. Young men underwent long apprenticeships and sometimes paid fees before they became independent smiths. They learned both technical and esoteric knowledge, including the rites to initiate and cleanse a forge, and various rules and prohibitions to maintain it. These processes involved some secrecy, although it probably was not as strict as for iron-smelting (Childs and Killick 1993, Herbert 1993). As a strategy to regulate access to information for use as an object of negotiation (Nooter 1993), this secrecy would have provided a form of power that was also used by other Luba specialists.

Only some village-level smiths achieved the highest status of Sendwe, or expert. It was these master smiths who were commissioned by the royal court, spirit mediums, or elite Mbudye Society members to make regalia such as spears, axes, adzes, anvils, hairpins, bow stands, and bracelets. The Sendwe, like other Luba politico-religious specialists, could interact with the spirit world. Our sources explicitly described prescriptions and prohibitions of the spirits, including the sacrifice of a chicken or the offering of beer at every new moon; prohibition of menstruating women at the forge; abstinence from sexual activity before forging; prohibition of nonsmiths from touching anything in the forge area; and prohibition of whistling at the forge by anyone except the smith. Whistling by nonsmiths may have been thought to arouse malevolent forces, or to undermine a general conception that the forge is sometimes a ritual space (Herbert 1984:95).

Several smiths called themselves *mulopwe wa luanzo*, or "sacred ruler of the forge." No one is allowed to sit higher than the smith in this space.[15] The true mulopwe, or sacred king, is either excluded altogether from the spatial confines of the forge or, if permitted entry, must pay homage

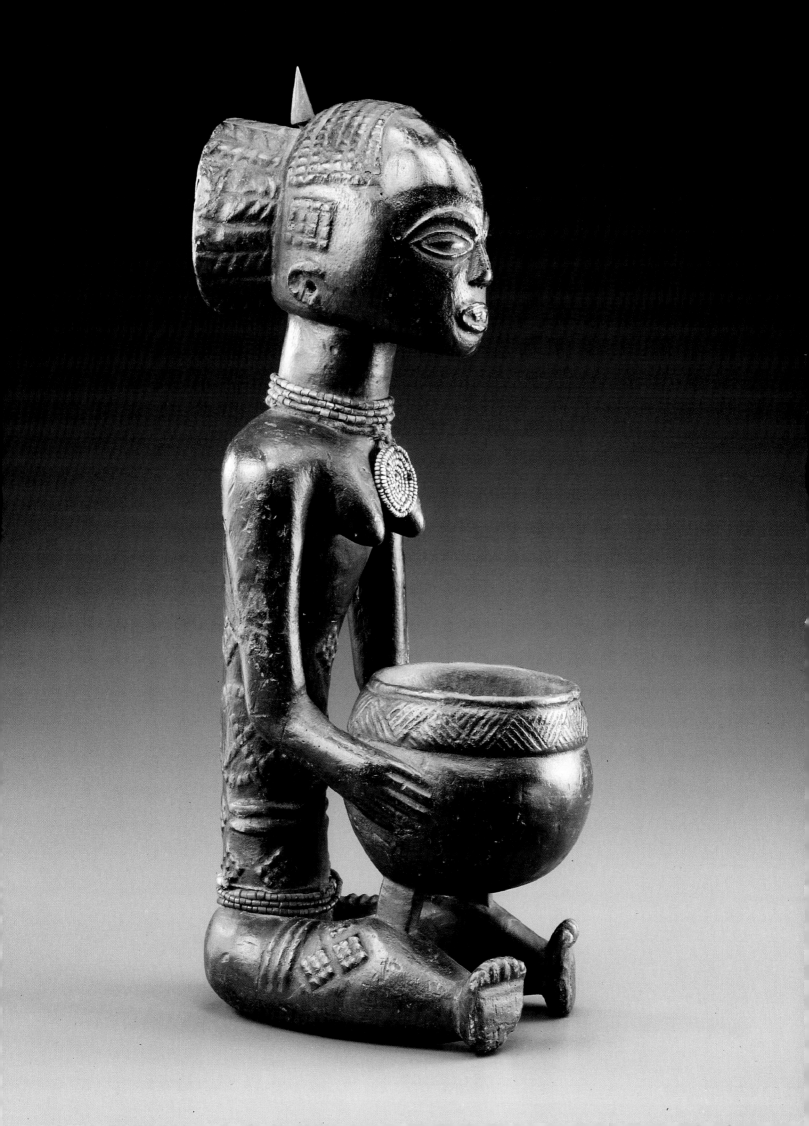

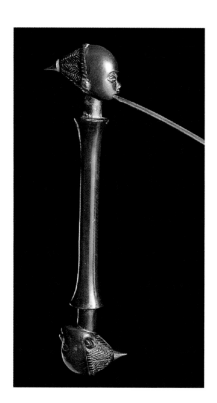

to the fact that the smith is master at the forge. Thus vestiges of the complementary relationships between kings and blacksmiths survive, and perhaps these were once manifested as overt competition.

Blacksmiths as Technology Brokers

All contemporary Luba blacksmiths use scrap iron, as is standard practice across Africa. Many express a preference for automobile springs as one of the most accessible and usable materials, recycled from disabled vehicles. Blacksmiths use a wide variety of tools, some of local origin, some imported, such as pliers, files, and hammers (fig. 59). Contemporary bellows are a good case of how adaptable smiths are: they range from carved two- or four-chambered wooden ones, made after ancient models, to some in which tin cans replace the wooden chambers; and from accordion bellows to imported, industrially manufactured units often powered with attached pulley systems incorporating bicycle wheels (figs. 60 and 61).

The blacksmiths we interviewed had a general idea about the purpose and meaning of royal insignia, but smiths of the last generation may have been the last to produce such regalia. A man named Ngoi Kisula had made ritual items, such as small bells that a spirit medium might wear on a belt to call the spirits. He had also made two items of regalia for a chief: a *kibiki* ax and a spear. Several blacksmiths said that kings and chiefs no longer have sufficient money to commission anything of this kind. There may even be an adversarial relationship between smiths and chiefs these days: one blacksmith said he sold his products by the road rather than take them to the main market and be required to pay the 20 percent tax that the chief demanded.

That so many blacksmiths make utilitarian items from recycled materials is a reflection of the desperate state of the Zairian economy (see Roberts 1996b). People have been forced to return to basic subsistence farming, and the roles of blacksmiths reflect the same humiliating difficulties. While some smiths are continuing in family traditions, many other Luba men are taking up smithing as an outlet to informal-sector markets. In this, blacksmiths negotiate new relationships of power, even if they do not re-create the fame of ancient smiths.

As an example of the cruel ironies of "the dialectics of oppression in Zaire" (Schatzberg 1988), one smith showed us his membership card to the "Union of Free Zairian Blacksmiths," which claims to be a "nonprofit association." The blacksmith turned out to be the one who was without profit, for the organization's recruiter "ate" his money, as the local expression has it, in what was just another scam in a country whose "economy" is based upon little else (J. MacGaffey 1983, 1986). The fact that he kept the card indicates his perception that blacksmiths *should* be important and associated with political power, even in Zaire.

Luba blacksmiths are clever "technology brokers" (Roberts 1996b), better equipped than many to adapt to these changing circumstances. Many are reworking old muskets and making new ones from scratch, for instance, or fixing stolen military rifles. Muskets have been traded into the area for well over a hundred years (Womersley 1984). Only the most skilled blacksmiths are able to make flintlock shotguns of the sort we saw being produced, and only two or three of the dozen smiths we interviewed do this kind of work (fig. 62). In theory, the Zairian penal code prohibits people from owning—let alone making—guns of any sort; yet there seems to be little enforcement. One successful smith even had the symbol of a gun on his shop sign. The guns are often studded with brass furniture tacks, which seem to be the latest variation of the nyundo nails ornamenting the newest objects of power and status (fig. 63).

A new angle on the symbolism of smithing technologies has also developed. One smith declared that the ceremonial axes of chiefs need to be quenched—that is, plunged red hot into water—to give them strength, reflecting the powers of the chief himself. Another made twisted iron bracelets (*mazenze*) similar to ones collected among turn-of-the-century Luba by Emil Torday.[16] He explained that these are magical charms to give men strength, and that these, too, are quenched to make them strong. Luba have made iron objects for ritual and ceremony for centuries, but quenching seems a new technology. One of us has found no signs of the practice in her metallurgic analysis of ancient Luba artifacts, and based on the analysis of other ancient African

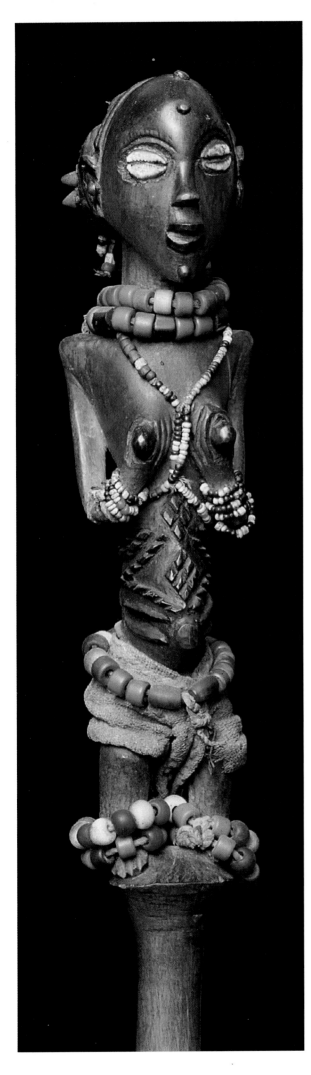
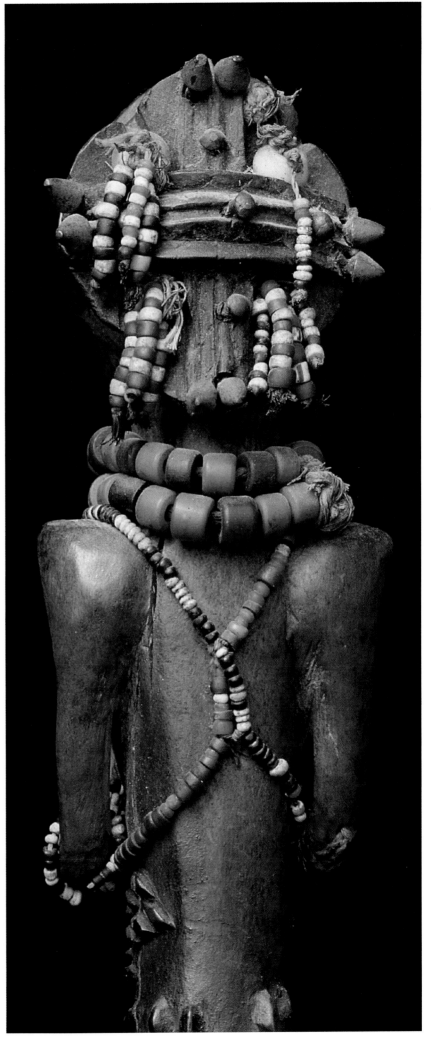

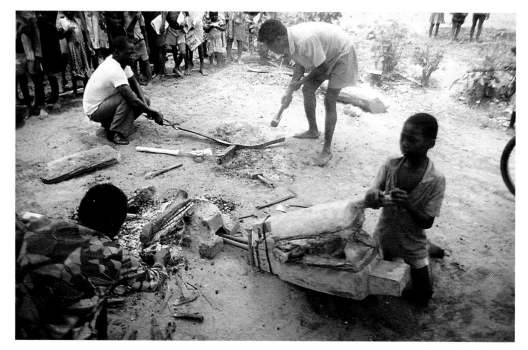

Fig. 60: Kisula-family workshop. Note constructed accordion-type (foreign) bellows. *Photo: William J. Dewey, Kamakanga, 1988.*

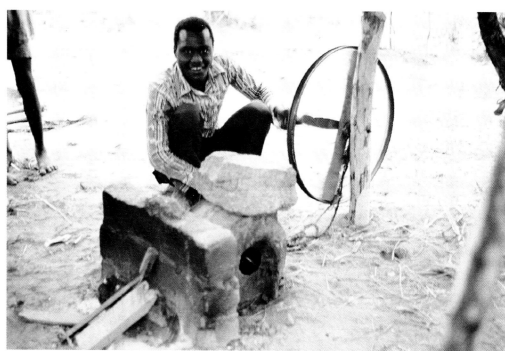

Fig. 61: Luba smith using imported bellows powered with a bicycle wheel. *Photo: William J. Dewey, 1988.*

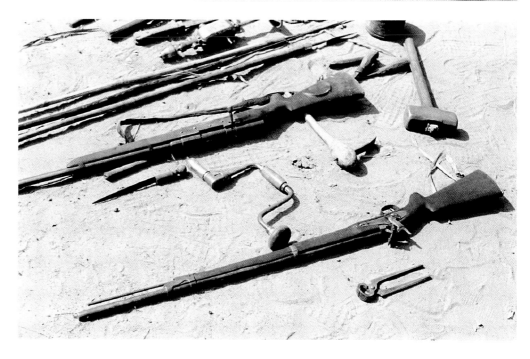

Fig. 62: Flintlock gun and rifle in the workshop of Ilunga Bwele. *Photo: William J. Dewey, Bunda, 1988.*

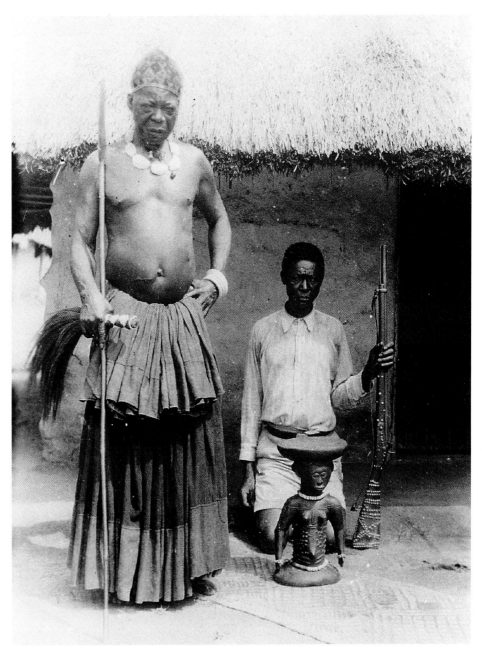

Fig. 63 (right): Chief Kajingu with his stool, staff, and a gun studded with brass furniture-tacks. The tacks are a modern variation of the anvil-shaped pins used to adorn objects of status and power. *Photo: W. F. P. Burton, 1927–35. Courtesy of the University of the Witwatersrand Art Galleries, BPC 13.5.*

Fig. 64 (below): Titleholder Inabanza displaying *mazele* iron rattles, an insignia of Kinkondja royal office. The rattles are sounded to convoke titleholders for a drinking ceremony. *Photo: Mary Nooter Roberts, 1987.*

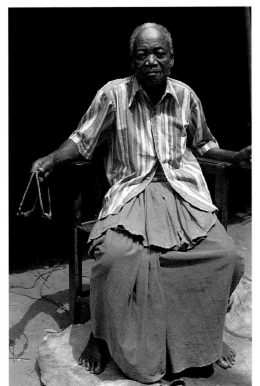

Fig. 65: Detail of *mazele* iron rattles. *Photo: Mary Nooter Roberts, 1987.*

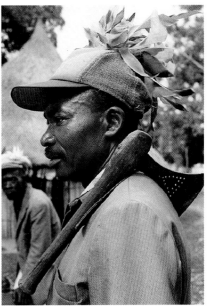

Fig. 66: Titleholder Twite wearing ceremonial ax over left shoulder to indicate status. *Photo: Mary Nooter Roberts, 1989.*

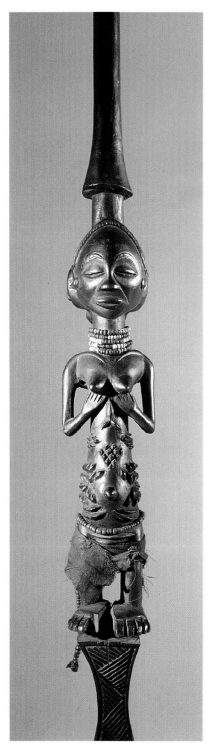

CAT. 26: ROYAL SPEAR (DETAIL). LUBA, ZAIRE. The spear figured in rituals as a symbol of legitimation: it was planted in the ground next to the royal stool, and opposite the staff of office. The spear was also among the weapons that supported the king's palanquin in the *kutomboka* dance. This dance was a reenactment of a mythical event in which Nkongolo, the cruel despot of Luba myth, invited his nephew Kalala Ilunga to perform a dance over a concealed pit planted with upright spears. But Kalala Ilunga, forewarned by a diviner, detected the pit with his own spear as he was dancing and thus foiled Nkongolo's plan for his destruction. *Wood, metal. H. 53.5 in. The Field Museum, Chicago, Inv. no. 210462, Neg. no. A109443c.*

metal, she believes that the process is of relatively new introduction to sub-Saharan Africa. One wonders if quenching might refer to a praise name for God, Kafùla Môba, "The One Who Forges Suns." In Luba cosmogony, God forges a new sun each day of red-hot iron, which He throws into the sky; each evening, the disk falls into a "great lake" to the west, extinguishing—"quenching"—it (Theuws 1954:80). At any rate, Luba smiths have recently added this performative "technological style" to their repertoire of symbolic associations between iron and transformative power (figs. 64 and 65).

Objects of Power

Luba performance of iron-smelting and -smithing provides some understanding of their "forging of memory"; other clues come from the items produced by blacksmiths. As accouterments and emblems of position and power, iron objects are among the most important Luba memory devices. Even if not routinely carried and displayed—and some were and are so secret they are only ever seen by a select few—they were tangible reminders of the Luba charter myth and of the glories of royal history. Coupled with colonial policies, the "underdevelopment" of Zaire (Gran 1979) over the past thirty years has brought about a radical decline in the political importance and wealth of Luba kings and chiefs. Blacksmiths are making utilitarian tools almost entirely; given the virtual nonexistence of a national economy, there is no longer call to make much else but utilitarian tools. The regalia illustrated in this book are still remembered, however, and some similar items are still preserved and occasionally used by political and religious leaders.

Axes are in constant use all over Africa, for subsistence activities such as chopping wood and clearing brush, and sometimes for self-defense or aggression. It is not surprising, therefore, that ceremonial axes are prevalent as well (Fischer and Zirngibl 1978, Widstrand 1958) (cat. nos. 24 and 25). They often feature highly ornamented handles, with figurative sculptures enhanced by prestige metals. Through allusion to the constructive and destructive cutting force of axes, these embellished axes signify the potential and status of their owners (fig. 66).

Luba ceremonial axes appear infrequently in myth. As previously noted, the "ceremonial copper headed *mutobolo*, or war ax of beautiful beaten work" (Womersley 1984:71) said to have been left by Kalala Ilunga, is held in the king's hands during the striking-of-the-anvils investiture ceremony. Kalala Ilunga is also said to have bestowed a copper ax and a decorated paddle upon a local chief as a way to safeguard a river crossing or ferry location, and thus to establish a political alliance (ibid.:15). Luba-style axes and other emblems also appear throughout southeastern Zaire. As will be explained in the last chapter of this book, even areas with little political connection, let alone allegiance, to Luba kings often emulated their art styles. The most ornate and figurative Luba axes were probably reserved for kings, chiefs, and court officials, but ceremonial axes were also emblems of spirit mediums and Mbudye members. Except in a very few cases when reliable field documentation is available, it is impossible to say to whom or even to what category of person specific museum examples belonged.

Ceremonial axes were one of the most important products of Luba blacksmiths. Luba smiths forged various grades of steel by extensive hammering and welding (Childs 1991a, 1991b). They also formed axes into distinctive types, based on blade shape and ornamentation. The blades of axes for utilitarian tasks have simple elongated-triangle shapes; the ritual and symbolic axes called "*kibiki*" and "*kasolwa*" have blades with flared ends, often in shapes comparable to those found in ancient burials. In addition to the axes' elaborately carved handles, then, the decorative qualities of their blades make these art forms quite distinctive. Both the undulations in thickness seen at the ends of blades and their incising are called "*ntapo*," the same word used to refer to women's scarification patterns (Van Avermaet and Mbuya 1954:678).[17] In the archaeological examples found to date, only a few surface decorations are still evident, due to severe corrosion. Few blacksmiths are still able to do this intricate work, although there are some old axes in the field, such as the one possessed by the Bwana Vidye spirit medium shown in figs. 67 and 68.

Production and decoration of Luba axes further emphasize symbolic linkages between the

CAT. 25: CEREMONIAL AX (RIGHT AND DETAIL BELOW). LUBA, ZAIRE. Beyond their roles as prestige emblems, axes carry more profound messages in Luba royal ritual, playing a central role in the initiation rites of Mbudye, the association responsible for inducting persons into royal office: the ax is the instrument used to clear the path leading to civilization. The notion of cutting the path and making traces upon the land is also expressed by the delicately engraved patterns that adorn the ax blades themselves. Called *"ntapo,"* these marks represent the scarification patterns worn by women—for erotic pleasure and for beauty, but also as a form of writing to communicate identity and social status, and to convey concepts of order, cosmos, and physical as well as moral perfection. *Wood, metal. H. 15.3 in. Staatliches Museum für Völkerkunde Munich, Inv. no. 13-57-127.*

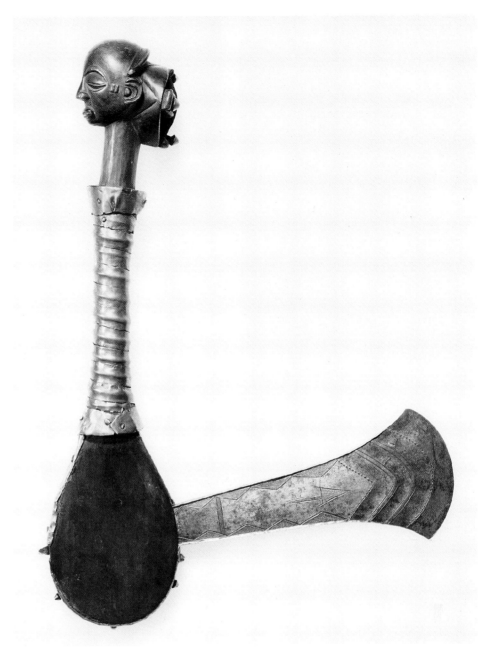

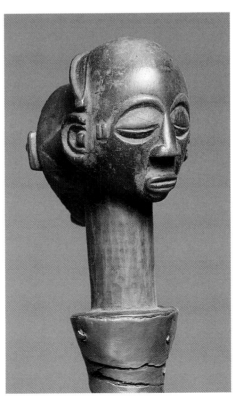

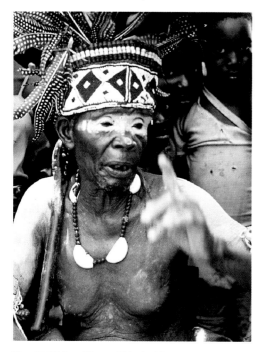

Fig. 67: Diviner (Bwana Vidye) with ax over right shoulder. *Photo: Mary Nooter Roberts and William J. Dewey, 1988.*

Fig. 68: Detail of diviner's ax showing engraved "scarification" patterns on the blade and metal tacks adorning the wooden shaft. *Photo: William J. Dewey, 1988.*

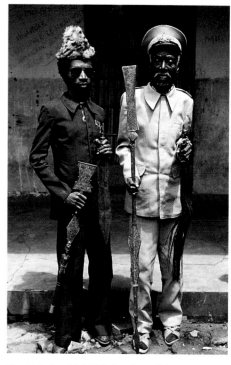

Fig. 69: Luba chief (right) and son (left) holding spear and staff. *Photo: Mary Nooter Roberts, 1989.*

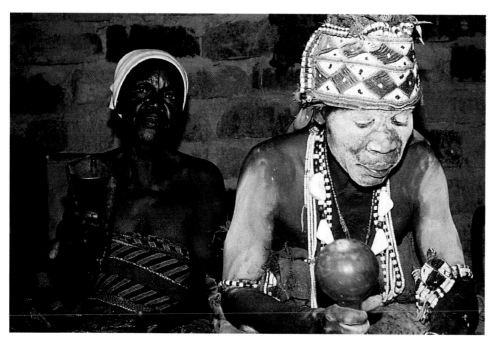

Fig. 71: Diviner and wife performing a consultation. The wife holds a large iron bell with which she calls the spirit, and inside which the diviner places medicines for the wife to transfer to the patient. *Photo: Mary Nooter Roberts, 1988.*

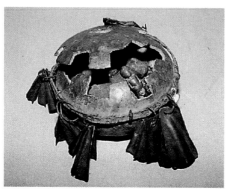

Fig. 72: Divination gourd decorated with metal bangles for calling spirits. *In the collection of the Royal Museum of Central Africa, Tervuren, Belgium (acc. no. 70.42.1).*

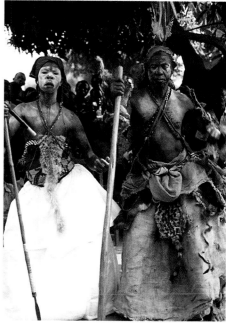

Fig. 70: Mbudye dancers performing with a copper-wrapped spear and a simple wooden staff. *Photo: Mary Nooter Roberts, 1987.*

smelting furnace and human procreation and birth. We suggest that the transformative actions of repeated hammering, annealing, folding, and welding at the forge are metaphorically linked to the growth and maturation of members of society and to the perpetuation of society itself.[18] Just as scarification beautifies a girl at the threshold of adulthood (Kitenge-Ya 1976), inscriptions on blades render axes anthropomorphic, and stand for the social transformations and resulting powers of those who wield them.

Spears are another object type that seems to have a long history: both iron and copper spear points have been found in archaeological contexts. Like axes, spears figure prominently in myth and ritual, and especially in the investitures of kings and chiefs (cat. no. 26). The new king dances with a spear in hand as he emerges from the kobo ka malwa, the "house of suffering" (Burton 1961:22, Nooter 1984:52–53). Thereafter, the spear and other weapons are used by his most heroic soldiers to carry him in the kutomboka dance previously described. Part of the dance is a reenactment of an incident from the Luba Epic, in which Kalala Ilunga escapes death in a trap set by his uncle Nkongolo, by thrusting his spear through a mat upon which he has been asked to dance, revealing the concealed pit prepared to destroy him.

The most elaborately decorated spears were apparently restricted in use to the most important chiefs and kings (fig. 69). Lesser chiefs, religious figures, and particular members of Mbudye use nonfigurative (or less elaborate) spears whose shafts are wrapped in copper ribbon (fig. 70). Among Mbudye members, for instance, the second in command, called Kamanje, carries an ax and such a spear as his emblems when he enforces society rules.

Staffs of office are of great political importance, and parts of them were fabricated by blacksmiths. Most blacksmiths only add the most basic of wooden handles to tools they make, but some are remembered as skilled woodcarvers who produced finely carved and forged items. Many staffs are embellished with ribbons of copper, iron, or both, through the work of blacksmiths. Furthermore, the base of most staffs of office is a simple iron spike to be thrust into the ground, allowing the staff to be planted upright (cat. no. 27). Occasionally, though, the iron points are shaped, and a few staffs, exemplified by two in the Coudron Collection, are made entirely of iron (Roberts 1994:27, 31). Petit also reports having seen among a chief's regalia an iron staff that had a conical anvil shape as its finial (1993:483). It was called a "*mulumbu*", a term usually used for ceremonial spears. The chief said his mulumbu was periodically covered with white chalk, as a symbol of purity and communication with ancestors, and that the loss of this object in war would be a sure sign of impending defeat.

Iron bells have had wide importance as emblems of leadership in Africa (Vansina 1969, Gansemans 1981). Numerous examples of side-welded, clapperless bells have been found in the archaeological excavations of the Upemba Depression (Hiernaux et al 1971; Maret 1985a, 1992; Nenquin 1963). In those ancient contexts, they are often attached to chains and then to belts. In more recent times a pregnant woman might wear such bells around her waist if her fetus was misaligned in the womb. The sound of the bell, it was explained, would cause the unborn child to right its position.

Kings, chiefs, and titled elders were called to their meals by the ringing of side-welded bells, which also announced their passage while traveling. In 1988, Mutombo Mukulu, a titled elder, explained that a modern, imported bell among his ritual paraphernalia was used for the same purposes. The culinary restrictions introduced by Mbidi Kiluwe are still important to Luba royalty, and it is imperative that they never be seen by anyone while they are consuming any food or beverage. The bell is used to announce that a meal is ready so others will know to let them eat in private. Etiquette also demands that proper respect and greetings be extended to royal persons, so that bells are used to warn others of their approach when they travel. Bells are used in music in Mbudye, and in other religious contexts as well. When a Bwana Vidye spirit medium goes into trance, his wife or another female relative rings a bell to call his spirits (fig. 71). Gourds containing objects used for divination often have small bells attached to the outside, to summon

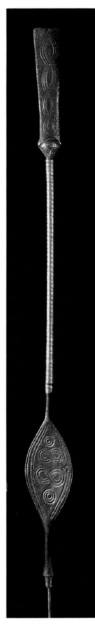
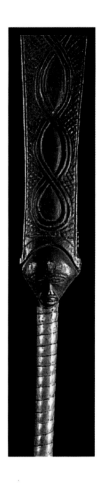

Cat. 27: Staff of office. Luba, Zaire.
African staffs of office have many roles and functions, as symbols of office and as metaphorical extensions of the hand. But for Luba peoples, staffs also function as visual records of the details of family history, migration, and genealogy. High-level office-holders carry staffs to public proceedings and perform historical recitations to honor ancestors and teach their descendants about family ties to Luba kingship. The top of this staff is adorned with iron pins that signify the importance of ironworking to Luba kings, and the copper wrappings on the shaft allude to the region's wealth of natural resources. *Wood. H. 61.75 in. American Museum of Natural History, Inv. no. 90.0/5059.*

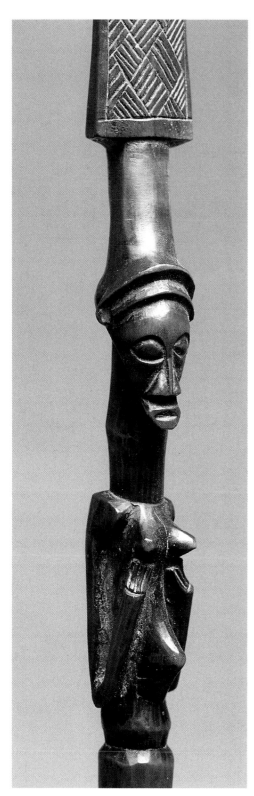

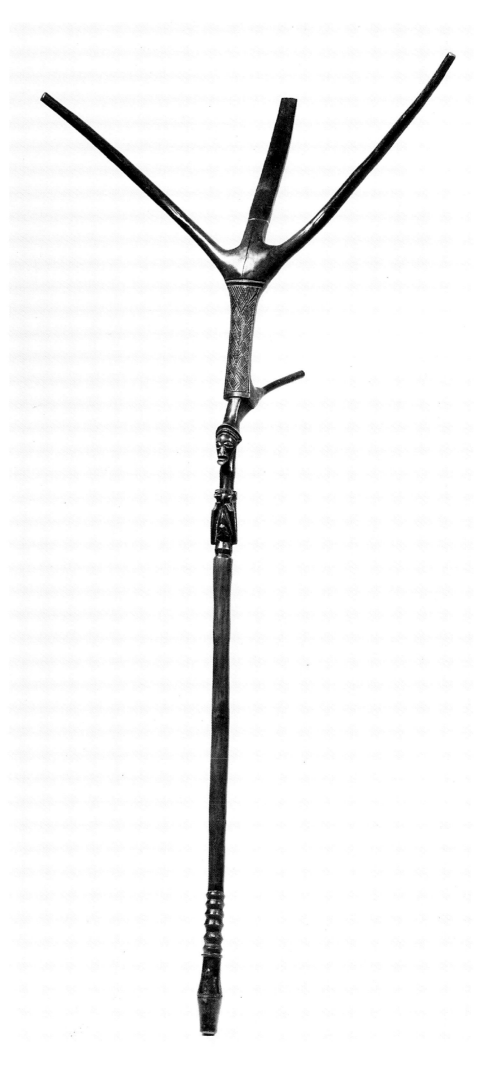

CAT. 28: BOW STAND (DETAIL ABOVE AND RIGHT). LUBA, ZAIRE. Bow stands made of iron and wood are unique to the regions of southeastern Zaire, northern Zambia, and Malawi. Only iron bow stands exist in Zambia, whereas both iron and wooden bow stands are known in Luba territories. This example, acquired in 1913, is unusual for its asymmetrical, angular forms and the elongated geometry of its human figure. Its branches project in a daringly unconventional way, echoing the shape of the tree from which it was carved. This bow stand probably comes from a region far to the southeast of the Luba Heartland. *Wood. H. 29.7 in. Staatliches Museum für Völkerkunde Munich, Inv. no. 13-57-122.*

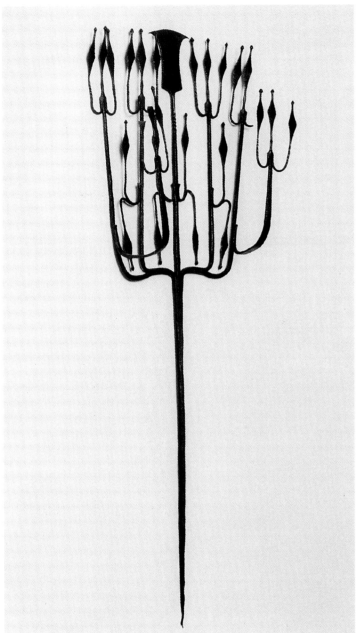
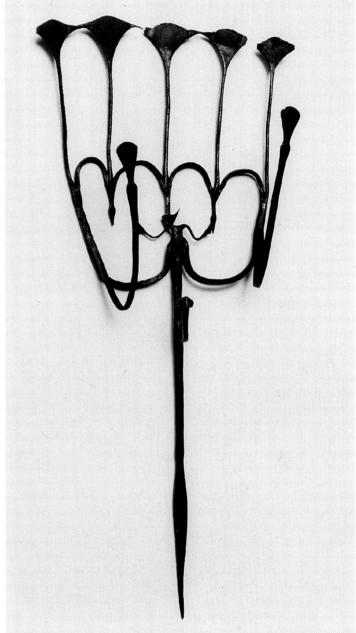

CATS. 29 AND 30: BOW STANDS. LUBA, ZAIRE.
Iron bow stands, tour de force works in
metal, are found over a wide demographic
area. Brilliant interpretations of the bow
stand form more commonly rendered in
wood, they also incorporate elements of
other ceremonial forms, such as axes, spears,
razors, anvil-shaped pins, and the hourglass
shape of lukasa memory boards. Iron bow
stands combine two contributions of the
culture hero Mbidi Kiluwe, hunting and
metalworking, in a single form. They also
make a powerful statement about iron and its
importance to Luba world view and political
authority. *Iron. 17: H. 22.8 in.; 18: H. 35.8 in.*
Staatliche Museen zu Berlin, Preussischer
Kulturbesitz, Museum für Völkerkunde, Inv.
no. III E 4883a and III E 110592 respectively.

Fig. 73: *Nsakakabemba* iron bow-stand, photographed by Audrey I. Richards in the Bemba area of Zambia before 1930. Man *30 (1935):31.*

the spirits (fig. 72).

Bow stands are a final symbol of chiefly power that was sometimes made of iron. The Luba culture hero Mbidi Kiluwe was a renowned hunter, whose most cherished possession was his bow; bow stands, then, remind people of their relationship to the origins of sacred kingship in Mbidi. These objects may serve literally to hold bows and arrows, but they are primarily symbols of chiefly authority subject to elaborate ritual and taboo (cat. no. 28). Never displayed in public, they were guarded in a special house by a female dignitary whose role was to provide prayers and sacrifice (Nooter 1990:65a, citing Albert Maesen). Iron bow-stands apparently had the same function as wooden ones, and have been found over a large geographic area, as discussed in the last chapter of this book. Audrey Richards (1935:31) has noted that owners of bow stands found in Zambia "declare emphatically that the arrowstands came from Lubaland" (fig. 73).

These tour-de-force iron sculptures combine elements of other ceremonial forms, such as axes, spears, razors, anvil-shaped pins, and the hourglass shape of lukasa memory boards (cat. nos. 29 and 30). Master blacksmiths seem to have been making a conscious run-through of their formal repertoire in these extraordinary objects. The special symbolic meanings of forged metal and their associations with political power coalesce in iron bow-stands to make a powerful statement about iron and its importance in the Luba world view. In this one object, many aspects of royal memory are visually summed up.

Endnotes

1. Funding for our field research was provided by the John Paul Getty Trust while we were postdoctoral fellows at the Center for Materials research in Archaeology and Ethnology, Massachusetts Institute of Technology. We most gratefully acknowledge Allen Roberts's editorial guidance and contributions to our text.

2. This paragraph is adapted from Dewey and Roberts, *Iron, Master of Them All* (1993), an overview of iron as a master metaphor in sub-Saharan Africa. The booklet was published for an exhibition of the same title and the Fifth Stanley Conference on African Art, held at the University of Iowa in April 1993, proceedings from which will be published in 1996.

3. Useful work on ironworking as performance and on symbolic aspects of the technology includes Dewey 1986 and 1990, Herbert 1993, McNaughton 1988, Roberts forthcoming 1996a, Van der Merwe and Avery 1987, the essays in Échard 1983, David and LeBléis 1988, Childs 1991c, and O'Neill, Mulhy, and Lambrecht 1989.

4. The following paragraphs synthesize accounts in Burton 1961; Colle 1913; Lucas 1966–67; Nooter 1984, 1990a; Theuws 1961; Van Avermaet and Mbuya 1954; and Womersley 1984.

5. Editor's note: Pierre Petit (personal communication 1995) has heard an account in which Kalala defeats Nkongolo in a game of tops, using a conical iron object. The symbolic importance of this shape is demonstrated below.

6. "King Mwine Munza [Kalala Ilunga's praise name, which commemorates his being the first king of the new dynasty, based at Munza], in his clever attempt to settle the country and organize the wild warring clans, . . . conceived a plan that proved to be eminently successful. He sent to surprisingly scattered parts of the country a son, a nephew or a daughter with her husband, or even a retired counselor, to take charge of these clans and, in order to ensure their acceptance by the people, he gave them, or sent them later, a blacksmith's forge or set of bellows that could be used for their forging or smelting, together with instructions as to how to smelt the iron should it be found. Many clans or sub-tribes of the Luba proudly point to the origin of their sub-chiefship" through the acquisition of these transformative gifts (Womersley 1984:21).

7. In the following overview, rituals are at times described in the ethnographic present. Interregnum and investiture continue, although they have changed in many aspects through the years since the observations of early missionaries and colonial administrators like W. F. P. Burton, Pierre Colle, E. d'Orjo de Marchovelette, F. Verbeke, and Harold Womersley. We have often chosen to return to the language tense of the early observers, and so acknowledge we are glossing over historical change.

8. A model for such turbulent times was the reign of tyranny and instability of Nkongolo, the "drunken king" (Heusch 1982) and lord of all excess.

9. *Mulebweulu* (or *mulabyeulu*, according to Petit 1993:433) may literally mean "Up there!" and it is possible that Harold Womersley transcribed an explanatory term, reifying it as the "name" of the "sky hook."

10. Another type of hairpin that has a razor on the end, and that doubles as a tattooing instrument, is known as a *kishimbo* (Van Avermaet and Mbuya 1954:661). The *kinyundo* is merely described as a hairpin by Van Avermaet and Mbuya. The dictionary also mentions the word "*kilundu*" as a nail with a rounded head, such as a tapestry nail, or as the type of hairpin worn in particular by chiefs and other notables (ibid.:385). Van Avermaet and Mbuya also take the word "*kinyundo*" to describe a hairpin, but theirs is the only dictionary to do so; it is

more commonly translated as "hammer/anvil." The Bemba hammer/anvil is known as *nondo*, and "brass tacks used in ornamenting the butt of a gun" are known as *nundu* (White Fathers 1954:494, 564).

11. "Hammer/anvils" proper consist of a small flattened platform on a post that could be thrust into the ground so that the smith could use the platform to beat his red-hot iron; sometimes, too, the post was used as a handle and the platform as the head of a hammer. This post design led to another name for them, "pillar anvils," and the easy analogy of the similarly shaped *binyundo* (*kinyundo*, singular) pins as miniature anvils. The hammer/anvils—*nyundo*—in public collections or seen in the field are simple in construction. Among nearby Kuba, a wonderfully elaborate anvil of copper and iron in the collections of the Institut des Musées Nationaux du Zaïre (Cornet 1982:82–83) is said to have been made by a celebrated eighteenth-century blacksmith prince named Myeel.

12. The manner in which the cruciform coiffure of northern Tabwa and Hemba, called "*bitungu*", may be related to elements of cosmology including crossroads, the meeting of the four cardinal winds, and the dry season and its brushfires is discussed in Roberts 1980:343–52.

13. In much of colonial Africa, iron-smelting is said to have been outlawed by the colonizers to reduce self-sufficiency, as colonial capitalism forced Africans to sell their labor to pay taxes and to buy goods they used to make for themselves (Roberts 1996a). In some parts of Africa there were in fact official policies to this end, in others the policy was unofficial practice; in others still, however, such stories are most likely ex-post-facto explanations without historical basis. Insufficient archival research on Belgian policies in the Luba area has been undertaken to indicate what was the case here.

14. Several Tabwa interviewed by Roberts (1996a) possessed heirloom *butale* iron, and as this was brought out to show the anthropologist, discussion ensued about precolonial political economy, how clever the ancestors were, and how bad things have gotten during the reign of Mobutu Sese Seko.

15. Muleka WaIlunga Kakese, Mwaba village, 2 September 1988, explained that if people broke the rule of sitting higher than the smith, they could become sterile. The same fate, he explained, would befall anyone who stole from a blacksmith.

16. These are in the collection of the Museum of Mankind (British Museum), with accession numbers 1904.6–11.8 and –.9. The only information regarding them is that each bracelet had a value of one fowl, suggesting that they may have been used as currency tokens.

17. Some knife blades also have *ntapo*-type decorations; as with axes, these ornate knives would seem to have been utilized by the royal elite. Luba scarification is discussed in chapter 3 of this book.

18. Annealing is a process that decreases the internal stress in metal caused by hammering, through heating and gradual cooling.

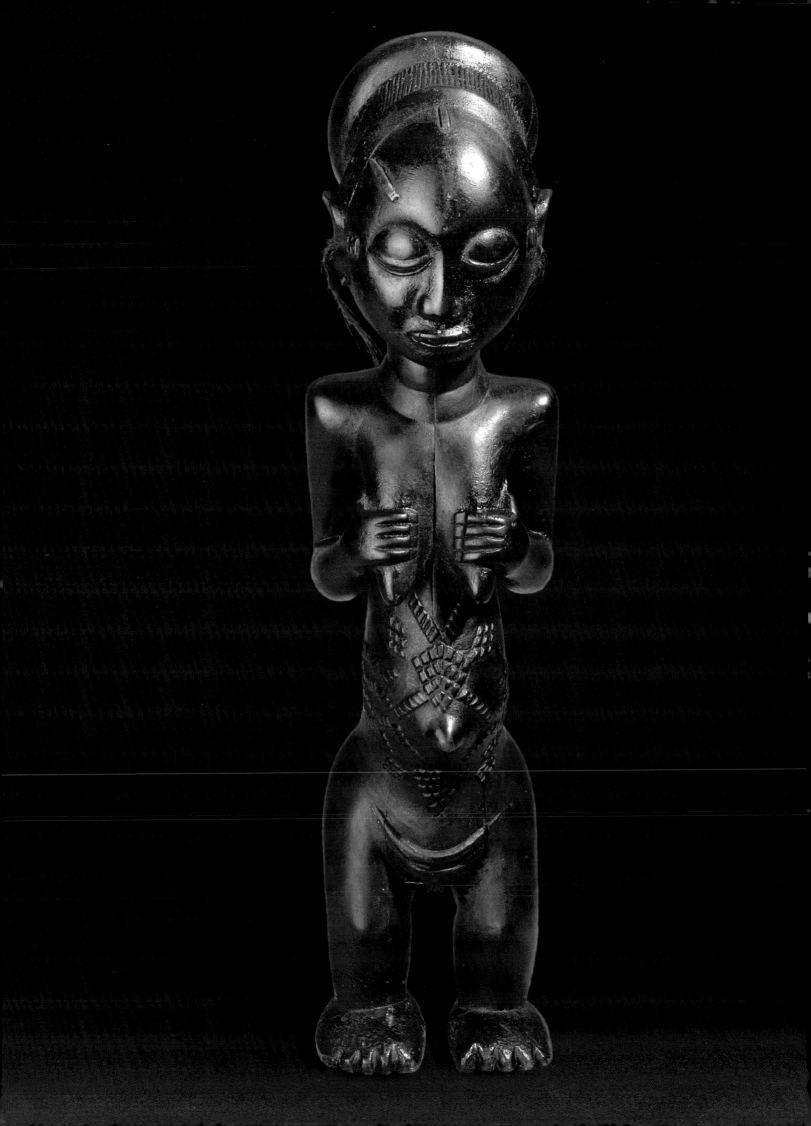

CHAPTER 3

Body Memory

Part I: Defining the Person

Mary Nooter Roberts and Allen F. Roberts

CAT. 31: STANDING FEMALE FIGURE. LUBA, ZAIRE. In Luba belief, beauty is not innate but is created over the course of a lifetime. Physical perfection reflects moral perfection. The body is a canvas on which to work: one makes oneself beautiful through cosmetic adornments and manipulations that Luba people consider aesthetically and spiritually pleasing. This quietly regal figure, showing scarifications, an elegant coiffure, gleaming black skin, elongated labia, and the gesture of hands to breasts, is a locus of memory and meaning and a home for the spirit. *Wood, copper, fiber. H. 17.3 in. Trustees of the British Museum, London, Inv. no. 1910-441.*

The human body provides a first threshold to and from others. As Anita Jacobson-Widding has written, "The fixed boundary of the body would thus symbolize the dividing line between opposed categories" (1983:371). These categories include the inside/outside of the person, or "ego," as Freud had it, and of the broader social group in which ego finds identity.

If the body is a threshold to others, ambiguity is inevitable.[1] "The body presents the paradox of contained and container at once"; one's attention continually shifts back and forth between an exterior view of the body as idealized object and an interior view of the body extending outward to others (Stewart 1993:104; see also M. Johnson 1987). A mirroring effect results. It was around this paradox that Jacques Lacan constructed his theories of the self. Toddlers attain the "'joyful assumption of their specular image'" at the critically important "mirror stage," which is marked by "the precipitation of the 'I' into that dialectic of identification between the object and the subject" (Fernandez 1986:166, citing Lacan).

One first knows one's own body in "pieces and parts . . . disassociated limbs and an absent center," all defined by sensations and needs (Stewart 1993:105). Indeed, one can never see one's own face, except in a mirror. During Lacan's mirror stage, an infant "acquires an imaginary identification of the real, corporeal image as a unified image" in its parents' persons. But remember the mirror's "essential perplexity" of reversal and its "see-through effect," for identification of the "I" simultaneously generates the other, "who can either satisfy or refuse to satisfy the needs of the subject" (Needham 1981:35, Fernandez 1986:162). The paradox is that across its threshold, the body becomes "both a mode and object of knowing," for the self is "constituted outside its physical being by its image" (Stewart 1993:131).

Thereafter, by a "process of projection and introjection," the body assumes the abstracted form by which one knows it. Yet such knowledge must always be mediated by the gaze of others. We can never see our own totality. Others may possess the images of our faces and whole bodies, but we cannot. "The face becomes a text, a space which must be 'read' and interpreted in order to exist," but one that is read with "trepidation, for this reading is never apparent from the surface alone; it is continually confronted by the correction of the other" for his or her own purposes (Stewart 1993:115–17, 125–27). For this reason, Jacques Derrida suggests that self-portraiture is executed as though one were blind (1993). Artists and blind people are visionaries, but—or, rather, because—they can express what they cannot see.

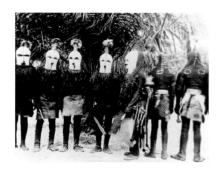

Fig. 74: Luba maskers wearing *kifwebe* masks and knitted garments. Masks make tangible the spirit identities that inhabit the universe, and the constructed nature of identity. *Photo: W. F. P. Burton, 1927–35. Courtesy of the University of the Witwatersrand Art Galleries, BPC 01.3.*

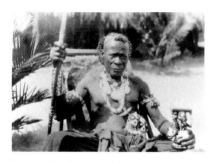

Fig. 75: Chief Twito-Kilulwe wearing mnemonically coded beaded necklaces, arm bands, bracelets, hair ornaments, and bandoliers. Both the man's body and the sculpted headrest he holds become hangers onto which memories are attached through the language of beads. *Photo: W. F. P. Burton, 1927–35. Courtesy of the University of the Witwatersrand Art Galleries, BPC 13.9.*

Cat. 32 (opposite): Striated mask. Luba, Zaire. This important kifwebe mask is of a type collected around the turn of the century by missionaries among eastern Luba and Luba-ized Tabwa living along the Luvua River in the lands around the present-day town of Kiambi. They were apparently danced at the death of a chief or other eminent person, or when a person assumed an important political title. The etymology of "kifwebe," the name of a spirit, is "to chase away, or put to flight, death." Such a sense would be appropriate to a further context for their use: in the rituals of the Kazanzi Society, through which sorcery is confronted and eliminated from the community. Complex costumes of animal skins and raffia were worn, and the masks were danced in couples, one representing a male spirit, the other a female. One surmises that the masks were performed to mark moments of important social transition and transformation. *Wood, raffia, bark, pigment, twine. H. 36.2 in. Seattle Art Museum, Gift of Katherine White and the Boeing Company, Inv. no. 81.17.869.*

Creation of the person is effected in this way. The word "person" is from the Latin *persona*, a "mask (especially one worn by an actor), hence the character played by an actor" (Morris 1969:978). Masks are preeminent threshold devices, always between. So, too, is the embellished skin (cat. nos. 32 and 33; fig. 74). Creation of the person is continuous, forever negotiated, never completed. As Susan Stewart suggests, the self behind the persona is "strangely disembodied, neither present nor absent, found in neither part nor whole, but, in fact, *created*" in the exchange of the other's glance or gaze (1993:127). In the process, memory is made.

Body Memory

The body as surface and interior, container and contained, is a "place of meeting and transfer" where memory is created, perpetuated, and sustained. Body memory is "intrinsic to the body" and to "how we remember in and by and through the body" (Casey 1987:147). Memory does not occur in the cocoon of the mind, isolated and detached from external forces; instead, it is always located on the borderline of the body, at the threshold of self and other(s). The body is a mirror that limns the observer's gaze and the object of that gaze, reflecting one back upon the other. Memory is the mask of one's person, always in the in-between, always becoming, always in the present, always enacted through the "now" of bodily experience (ibid.:178).

Luba memory spirals from microcosmic to macrocosmic levels and back again, encompassing deeper and broader expanses of history and geography with each concentric movement. As we shall see in the chapters to follow, mnemonic principles guide remembrance through imbricated models, from the body as an "inscribed surface of events" to the architectonic layout of the royal court, the landscape configured in sacred spirit sites, and, finally, a cosmology of seasons, heavens, and the underworld.

The present chapter investigates the complex ways in which the human body serves as a fundamental locus of and model for Luba memory (cat. no. 34). We shall concentrate on the nature of mnemonic devices themselves—the "cognitive cuing structures" of visual images or words that mediate between the subject of memory and the person who wishes to remember (Bellezza 1981:252). Memory may be "attached" to the body in the form of objects of personal adornment, such as beaded necklaces, arm bands, and headdresses (fig. 75); or it may be inscribed upon the surface of the body through the permanently transforming art of scarification (fig. 76). Configuring the exterior of the body in these ways maps anatomy and makes the body a surface to be "read." The person emerges from such readings, made of memory, and making memory.

It is not every body that offers itself as an appropriate vehicle for memory containment and transmission. Sculpture from the Luba Heartland, with its proliferation of female images and virtual absence of male imagery, reflects Luba concepts about the gendering of power and the ambiguities inherent in Luba royal ideology and practice. Women were historically important as the emissaries and advisors of kings, and Luba women often married surrounding chiefs to extend Luba influence to peripheral territories (Reefe 1981). The memory of deceased kings was and is further preserved through the persons of female spirit mediums. To express this complex and ambiguous gendering of power, Luba male officeholders have created their emblems of office in the form of women's bodies as spirit containers (cat. no. 35).

Mnemonic Devices

Mnemonic devices organize and encode information to make it more memorable—that is, more usefully available (Bellezza 1981:252). A prevailing characteristic of mnemonics is that they operate by "the use of cognitive structures that, somewhat disturbingly, have little or no formal relation to the conceptual content of the material being learned" (ibid.:247). In other words, an arbitrary association is proposed: *X* stands for *Y*, even though *X* and *Y* may have no other relationship to each other beyond our agreement that *X does* stand for *Y*. This "conscious use of artifice" is why such heuristic devices are often referred to as "artificial memory" (ibid.). Of interest to us here are "cognitive cuing structures," whether visual images or words, that mediate between the subject of memory and the person who wishes to remember (ibid.:252); and in particular, the ways that these

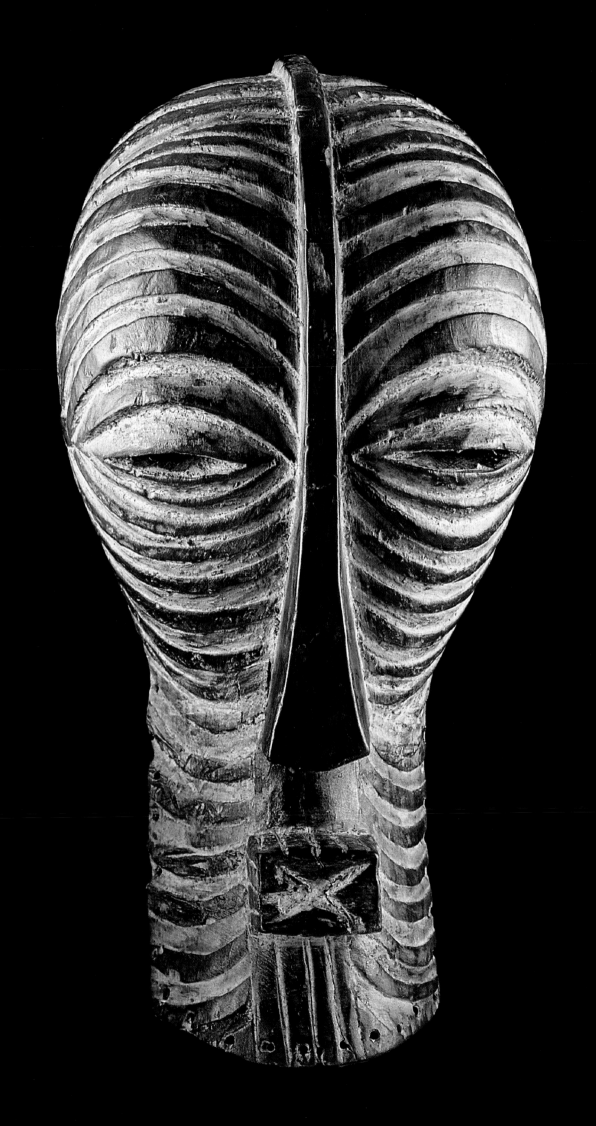

CAT 33 (OPPOSITE): STRIATED MASK. LUBA-SONGYE, ZAIRE. In addition to their use in certain royal ceremonies, Luba kifwebe masks are worn on the night of the new moon, when villagers dance to honor their ancestors. Masks are threshold devices, creating a "skin" between this world and the other. The English word "person" derives from the Latin word for "mask," suggesting that the individual's creation of his or her identity is continuous, forever negotiated, never completed. Luba construct their identities according to a language of body adornments that "make" the person, just as a mask evokes the memory of a spirit. *Wood, pigment. H. 12 in. Private collection, Belgium.*

CAT 34 (BELOW): STANDING FEMALE FIGURE. LUBA, ZAIRE. Memory may be attached to the body in the form of accouterments, clothing, and hair styles, or it may be inscribed on the body's surface in the form of scarification, a kind of writing that renders the human body a "text" to be read and remembered. Luba scarification patterns are named, and may have multilayered meanings and allusions. A woman decides which patterns she will wear and the messages she wishes to convey. Her body thus becomes a threshold between herself and others. *Wood. H. 11.25 in. Collection of Lawrence Gussman.*

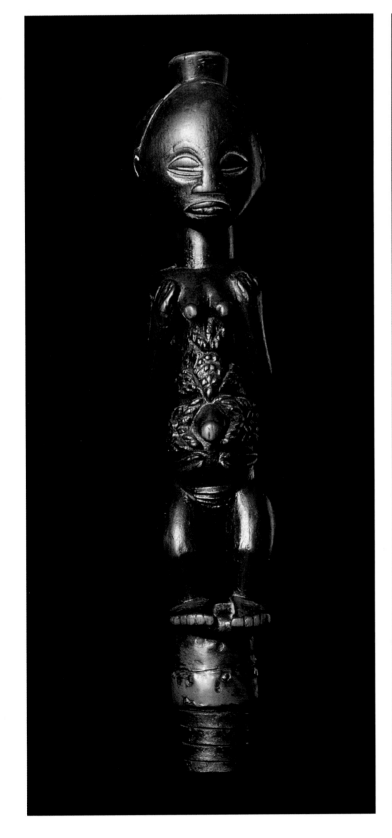

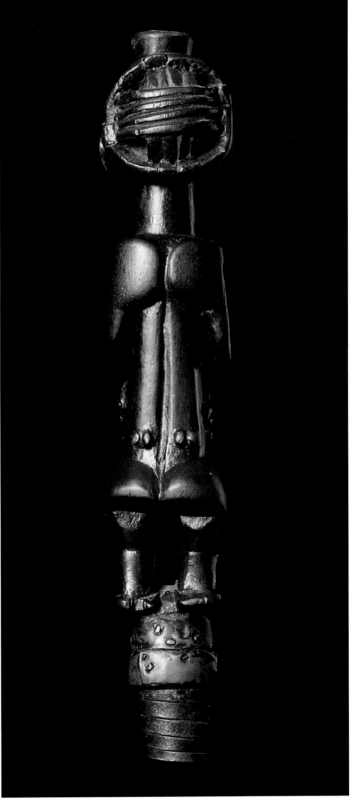

Fig. 76: Luba woman with ornate scarification patterns on chest and shoulders that serve as mnemonic inscriptions upon the body. The original caption accompanying this photograph stated that "Mwanza women have little beadwork, but lots of cicatrization."
Photo: W. F. P. Burton, 1927–35. Courtesy of the University of the Witwatersrand Art Galleries, BPC 21.8.

Fig. 77: Illustration of a female spirit medium possessed by the spirit of a long-deceased king shown wearing beaded bracelets, arm bands, necklaces, and bandoliers, as well as scarification patterns. Luba think women better suited to spirit possession than men are. *From E. Hodgson,* Fishing for Fisher Folk, *p. 181, based on a photograph by W. F. P. Burton in the archives of the University of the Witwatersrand Art Galleries.*

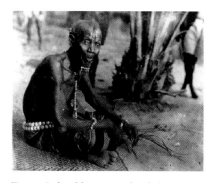

Fig. 78: Luba elder wearing beaded ornaments in coiffure, forelock, and beard, as well as bracelets, necklace, and waistband. *Photo: W. F. P. Burton, 1927–35. Courtesy of the University of the Witwatersrand Art Galleries, BPC 121.6.*

mediating elements can be moved about on or in relation to the body, to represent and stimulate different memories.

Some of the most basic building materials for Luba cognitive cuing structures are beads and shells worn as body adornments, and the tegumentary bumps of scarification. Memory is a semantic system, and for Luba these tiny items are among its morphemes—that is, its indivisible units of form and meaning. It is useful to recall the conjunction of form and meaning in the word "idea," which, although now obsolete in this sense, once connoted "a mental image of something remembered" (Soukhanov 1993:895, 2,131). For Luba, beads and scarification present a similar cognitive loop: morphemes of memory are assembled to produce images that trigger ideas that provoke actions that lead to the creation of more memory.

Luba memory practices conform to mnemotechnics, which Francis Bellezza calls "peg-type" and "chain-type" mnemonics (1981). In chain-type mnemonics, a visual image associates two things or words in a list or paradigm; then a different image links the second and the third; and so forth. The overlapping sequence interlocks like a chain, allowing one to reconstruct a complicated set of data (ibid.:254–55). If chain-type mnemonics are linear, peg-type mnemonics are created on a field or plane, according to location. What needs to be remembered is assigned, "pegged," and so "placed" in a corresponding image locus. The remembered "peg" prompts the image of its place, which in turn brings access to the contextual field of the memory. Both chain and peg mnemonics are effective for recalling complex information. Luba necklaces of beads are chain mnemonics, while scarification is a peg-type system. We shall consider the former first.

Chains of Memory

In the past, most shells and beads reached the Luba Heartland through networks of long-distance trade extending to the Atlantic and Indian Oceans. They were often given monetary and symbolic values as special-purpose currencies in such transactions.[2] Their variations in size, type, color, shape, and availability; their possibilities of assemblage and use-value; and the visibility resulting from all these attributes made shells and beads appropriate vehicles for generating and transmitting complex bodies of knowledge.

Despite their elementary significance as cognitive cuing structures, beads and shells have been overlooked by most art historians and others studying Luba expressive culture.[3] Some scholars disregard beadwork because most beads were of foreign manufacture and were obtained by trade, and are therefore not "authentically indigenous" goods; others have simply dismissed beadwork as nonsculptural and therefore somehow aesthetically lacking. The result is that an important field of semantic activity has been ignored. Indeed, one could take a broader view and argue that the semantic system of memory is the basis for Luba aesthetics itself.

As morphemes, beads and shells may be assembled in cognitive cuing structures as lieux de mémoire. For Luba, a bead or shell always signifies "place": of a personage, title, rank, or role, or, more directly, a feature of geography or architecture. As mnemonic devices, then, beads and shells themselves become the memory of what they have signified. Sometimes these bead-to-subject relationships are conveyed by linear contingencies, as when beads and shells are strung in a necklace. At issue is which bead lies next to which, like morphemes composing a word, or words a sentence. At other times, memory is made available when beads and shells are configured on a plane, such as the surface of a beaded armband or headdress. Such an art form only became possible late in the precolonial period, when tiny "seed" beads began to reach the Luba Heartland (Erikson 1969:59).

In both cases, the memory conveyed by beads and shells is negotiated by their positions and contiguities (figs. 77 and 78). The semantic character of beadwork is such that it provides both the structure and the fluidity necessary to promote the associations and transactions of memory. In particular, sequences of beads and shells defy any notion of static memory, for they are and imply an actively adjunctive cumulative process.[4]

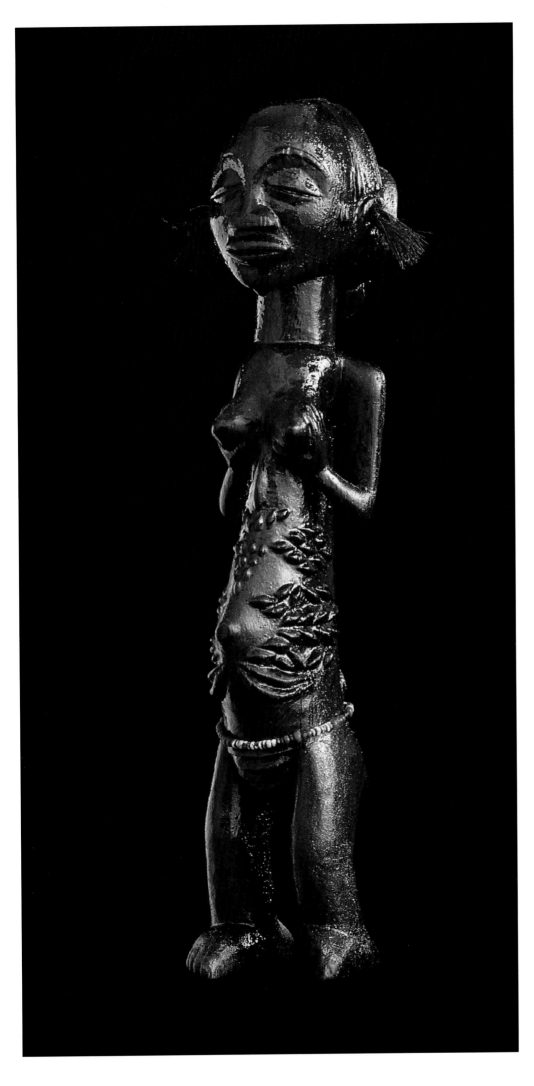

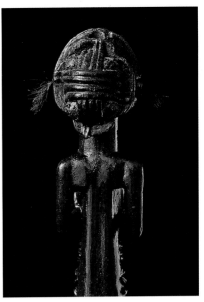

CAT. 35: STANDING FEMALE FIGURE. LUBA, ZAIRE. The female image predominates in Luba art. Women were important political actors historically, as emissaries and ambassadors, counselors and advisers. Women of the royal patriline were intermarried with outlying chiefs, thus extending the scope of Luba power into the surrounding areas. And women of the court had titles and functions critical to the exercise of power. In these roles, and in their abilities as spirit mediums, women were crucial to the balance of authority in the kingdom at home and in the Luba view of the cosmos at large. *Wood, fiber, beads, organic material. H. 12.5 in. Drs. Daniel and Marian Malcolm.*

Part II: Pearls of Wisdom

Jeanette Kawende Fina Nkindi and Guy De Plaen

Fig. 79: *Mpande* cone-shell necklace belonging to a royal titleholder. *Photo: Mary Nooter Roberts, Kinkondja, 1987.*

Fig. 80: Necklace composed primarily of precious beads called *"malungo a bukulu."* The beads indicate the status of the owners and confer power upon the wearer. Beads generate and transmit complex bodies of knowledge through variations in size, type, color, and availability. *Photo: Jeanette Kawende Fina Nkindi and Guy De Plaen.*

Fig. 81 (opposite): Chief Kajingu of Mwanza in full regalia, wearing beadwork cap and cone-shell necklace, and holding a fly whisk with a beaded handle. The beaded accouterments are rendered in a pattern composed of the *nkaka* scarification design. *Photo: W. F. P. Burton, 1927–35. Courtesy of the University of the Witwatersrand Art Galleries, BPC 13.11.*

Shells have long been an essential element of Luba expressive culture. Archaeology in the Upemba Depression has confirmed that both cowries and cone shells are present in ninth-century graves, in which they have been found placed around skulls and sometimes in the coiffure or over the mouth. Luba chiefs of the most ancient royal lineage, at Kabongo, still have necklaces made from *nsumba* or *mpande* cone-shell disks (fig. 79).[5] Such royal necklaces may include entire cone shells, combined with beads and leopard or lion teeth, or disks cut from the blunt end of a cone shell, sometimes divided into isosceles triangles.

For a chief's necklace, each of twelve triangular segments of cone shell may alternate with leopard canines and a precious bead called *"bihii bya bukulu."* Royal males including paternal uncles, brothers, sons, and nephews of the king may wear such necklaces, but with a smaller number of shells due to their lesser rank (figs. 81–83). Royal *Bilumbu* diviners may also wear such necklaces, but without leopard teeth. Chiefs heading collectives of villages subject to the king's court wear a single section of shell surrounded by beads of lesser value, and may only wear their necklaces in their own locales, as it is forbidden to wear them in the king's presence.[6]

The symbolic relationship between cone-shell disks and political authority is based on the shell's whiteness and interior spiral. "White" for Luba peoples is the color of bone, chalk, purity, and the spirits. The link with the other world is fundamental to sacred royalty. At his residence, a king must eat near and with the relics of his ancestors.[7] Luba associate the spiral inside the cone-shell disk with the rainbow. The rainbow stands for the primeval king Nkongolo Mwamba, who, after being killed by his nephew, Kalala Ilunga, was transformed into an enormous red serpent. The rainbow is the breath of this aquatic and subterranean creature, joining the living to the dead. The symbolism of the serpent is so powerful that some Luba chiefs are forbidden from viewing the striations of the shell, which they must wear in such a way that only the reverse side is exposed.[8]

Cone-shell disks play an important part in a number of royal rites, which contribute to their capacity to serve as a powerful mnemonic of kingship practices and precepts when they are used in other contexts. Among the most important rituals is that of *kusuma mpande* (also called *"musumo-a-disumba"*), which occurs just prior to enthronement among Luba of Kabongo, and after ten years of reign among Luba at Mulongo. During this ritual, the future king wears a cone-shell disk covering his lips, while he holds the heart of a dog or leopard in his mouth. He is forbidden to swallow, chew, or spit out the heart until the end of the rite. According to oral accounts, the king "consumes" the riches of royalty through kusuma mpande. At the same time, though, he becomes completely alone in the world, for he surpasses his human condition. The animal's heart marks a total rupture between the future king and his descendance. To become king, then, implies a kind of death.[9]

In the Luba chiefdoms of Malemba Nkulu and Kifwa, the term for "cone-shell disk" also designates large, spherical, opaque white glass beads from which necklaces were made for chiefs and other high-ranking dignitaries. Like the disks, the beads were imported into the central African interior, most having been manufactured in Venice or in Gablonz (a town in what is now the Czech Republic).[10] It is beads of this sort that are generically called "bihii bya bukulu." In the past, their important exchange value was limited to transactions such as bridewealth, ransom, and the like. Of these, *malungo* are spherical or oval beads of medium size, ranging from sky blue to dark blue. Luba compare them in size and color to the eggs of *luvila* weaverbirds (fig. 84). Possession of these beads used to be reserved for certain royal titleholders, who assiduously kept them for their inheritance.

One finds bihii bya bukulu beads in all the ancient spirit capitals where kings once resided. The abundance of beads in these sites signifies the memory of specific kings. Outside the royal

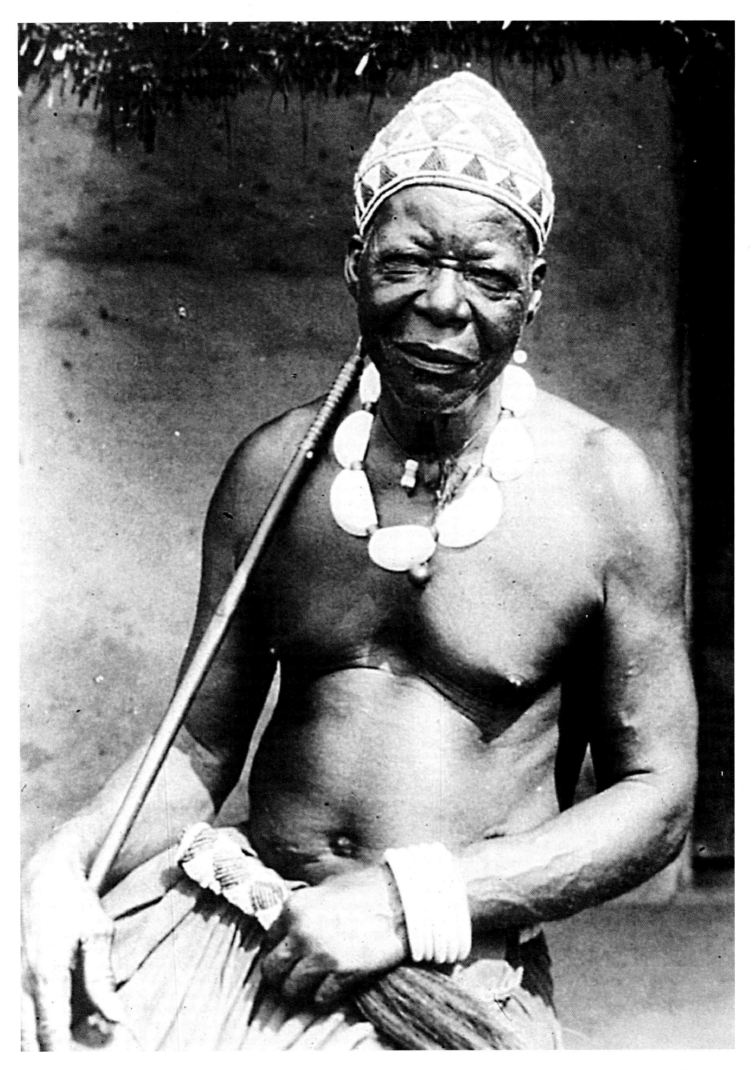

Fig. 82: Titleholder Kioni of Kinkondja seated on antelope skin and wearing an mpande cone-shell necklace with three sections of shell. The number and shape of the cone-shell segments is indicative of rank and title. *Photo: Mary Nooter Roberts, 1987.*

Fig. 83: Titleholder of Kinkondja displaying cone-shell necklace, beaded necklace, and *dilanga* staff of office. *Photo: Mary Nooter Roberts, 1987.*

court, chiefs who headed clusters of tributary villages could wear bihii bya bukulu beads, as could certain artists and professionals, including blacksmiths, big-game hunters, noted sculptors (fig. 85), Bilumbu diviners, and some healers.

Ensembles of Beads: Value and Transmission

Bihii bya bukulu beads were usually assembled by tens. With two or three such groups, one could create a necklace running from one's index finger to the middle of one's forearm. Such a necklace was worth one entire cone-shell disk, or ten triangular segments cut from one. In the past, the value of bihii bya bukulu beads was such that the loss of a single bead might require the forfeiture of a human being or two flintlock muskets to the royal court.[11]

Beads were also transmitted to the royal court as deferential gifts from *bilolo*, the chiefs of villages subjected to the authority of the king (fig. 86).[12] When the king imposed fines for crimes, he might demand payment in beads. Diviners and healers were recompensed with beads when they cured serious illness (fig. 90). Beads could also be confiscated by the king if their possession could not be justified according to sumptuary rules defining the kinds of beads that people of particular rank and title might possess and wear publically. In exchange for beads, kings sometimes offered the marriage of a royal female relative, a woman previously surrendered to the king in payment of a litigation, or even one of the king's own lesser wives. Beads were also used for paying funerary compensations or for bridewealth, and to finalize other alliances. From this inventory, it is clear that Luba rules, regulations, and customs were devised to direct beads toward the king so that he could redistribute them; and that their circulation integrated politics, rules of alliance, and justice. Bihii bya bukulu beads had a special semantic (and, thus, mnemonic) relationship with the king, then. Apart from their symbolic meanings, beaded objects of adornment made it possible for people to recognize the children and relatives of the king instantly, especially outside the royal court.

Bihii bya bukulu were not the only precious beads for Luba. Other kinds were used to complete the necklaces of kings, chiefs, and titleholders. These included ovoid *bikuya* beads, spherical *bibubu* beads, and tubular *bididi* beads.[13] Such beads might have been of lesser value, but they retained a significant economic role, for one could exchange them, as opposed to bihii bya bukulu, which were meant to be possessed and kept by royalty. Still, the value of these other beads was determined in reference to bihii bya bukulu beads and to mpande cone-shell disks, and their blue and white colors allowed further analogy to those other beads and disks. Neighbors of the Luba Heartland, such as Kalebwe, Kabinda, and Songye, preferred to represent authority with beads different from the ones chosen by Luba, thus facilitating trade between Luba and those groups.

Three sorts of beads found important places in Luba religious functions as well. Together, they are called "*malungo a bukulu.*" Respectively dark blue, white, and translucent, these beads are rare and ancient, and it is said that only Tembo and Twa hunter-gatherers knew how to obtain them, as well as diviners and other spirit mediums possessed by great spirits.[14] Varied needs justified the possession of these invaluable beads: illness, divination, protection, war, acquisition of power, and the like. Malungo a bukulu beads were often linked to therapeutic groups, either as a sign of cathartic initiation or as payment for health care received from practitioners. They often formed part of a medicinal compound to enhance or harness a particular power, such as when someone wished magically to render himself invisible. In such a preparation, the beads were mixed with the shavings from a blind person's walking stick and with different symbolic plants, and a list of prohibitions was observed.[15]

The doughnut-shaped blue beads of this group were used in a variety of contexts to indicate their connection to a particular person. They could be worn in the hair, placed in the mouth, or attached to a gun. To secure the most powerful association with a given individual, they were sometimes grilled or boiled in a concoction that included that person's hair and nails. The owner of these elements was thus integrated with the beads. A bead withdrawn and used in some other

context was therefore the visible résumé of the preceding preparation, and of all its mnemonic intentionality.

Positioning Power

Beads may have value and significance as individual objects, but it is in their stringing that their mnemonic potential begins to be realized. A necklace of beads is deceptively minimalist: as a chain-style cognitive cuing structure, a necklace can be an efficacious instrument for input and transmission of complex memory. The following narration of a chief's necklace will show how the type and positioning of its beads can stimulate memory of the distribution and hierarchy of authority within the royal court. Although the disposition of and terms for different titles and ranks remain specific to each region and period, one can still elucidate the general principle of chain-style mnemonics through a narration such as this one. The particular beads in the necklace connote a general association with authority, but only their position in the string determines which specific personage is represented by each bead. In other words, the necklace constitutes a linear model of the Luba power structure.

The beaded necklace of Chief Kifwa is composed of forty-one beads strung in a specific order (fig. 87).[16] The necklace should be read from a central point, indicated by a leopard canine, which divides the necklace in two. This tooth specifies the nature of the wearer's power and authority. Whenever a hunter encounters a leopard in the forest, he should report to the village, "I have seen the king!" Like a leopard, the king is said to see without being seen. A bracelet of leopard skin is worn by the king's children and other kin, so that others may recognize their royalty. One also says that the leopard is as solitary as the king himself should be. A single leopard tooth therefore summarizes many rites, customs, and proverbs relating to kingship.[17] Next to the leopard tooth is a triangular segment of mpande cone-shell disk, its whiteness a reference to pemba chalk as a symbol of purity, the spirit world, and beneficence.

The necklace has upper and lower sides. The mpande segment is meant to lie against the wearer's throat, its spiral "up" or "out." The large bihii bya bukulu beads on the left side of the necklace (that is, the wearer's left) stand for the eleven lineages descended from the founding ancestor—lineages that did not beget the present chief. These lineages are represented on the necklace because they were integrated into the politics of the royal court after payment of a symbolic indemnity giving them the privilege of being anointed with white chalk. This indemnity is called "*mpalo*," and secures the right to acquire titles and the benefits of deferential gifts from subjected peoples.

The beads on the right side of the necklace represent the twelfth lineage issuing from the founding ancestor of Kasongo ka Mwikalebwe—the lineage that does inherit the throne. This lineage, then, stands in opposition to the other eleven on the inauspicious left side.[18] Each bead represents a specific title and role, and is often paired with a second bead that refers to the sacred enclosure in which that titleholder takes his strictly solitary meals. The progression of personages proceeds from the most important, located nearest the leopard tooth, to the lowest ranking at the extremity of the strand, worn at the back of the wearer's neck.

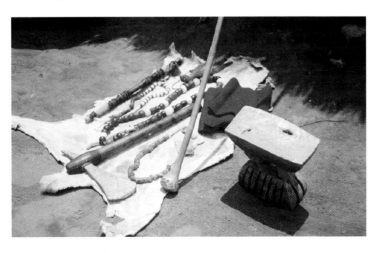

Fig. 84: Accouterments of office belonging to titleholder Mutombo Mukulu (a village official in the Collective of Kinkondja) include large malungo beaded apparel worn around the neck and the waist, in addition to a knife, an ax, and an imported bell. The word "malungo" comes from the same root as the Kiluba word for memory, underscoring the close connection between strings of beads and the morphemes of memory. *Photo: William J. Dewey, 1988.*

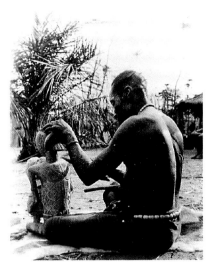

Fig. 85: Luba artist at work wearing beaded waistband that shows special rank and high standing in Luba society. *Photo: W. F. P. Burton, 1927–35. Courtesy of the University of the Witwatersrand Art Galleries, BPC 05.13.*

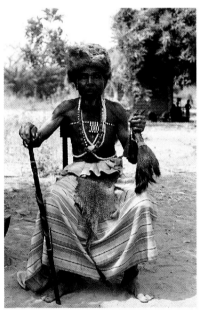

Fig. 86: Luba village chief wearing beaded emblems around his neck and on his chest, and symbolic animal pelts on his skirt and head. He holds a fly whisk and a staff. Beaded accouterments are at least as important to chiefly regalia as sculpted emblems of office, and were used in the past as payments and gifts to the royal court by the chiefs of villages subjected to the authority of the king. *Photo: Mary Nooter Roberts, 1987.*

Moving to the left from the central cone-shell segment, the first bead represents the classificatory father of the chief, often the paternal uncle, called "Sha Mfumu." This titleholder is the chief's guardian, who watches over his insignia, and also tends his sacred fire. All kings and chiefs of Luba sacred kingship are required to eat meals prepared on such a fire, kept alight in the private enclosures next to their residences. He who eats food prepared in this way is said "to eat the sacred fire of power."

Next are three *miheto* beads. Two blue ones represent enclosures where the sacred fire burns, the first for Chief Kifwa, the other for his father. The little white bead in between represents the sacred enclosure that shelters relics of the deceased rulers who preceded the reigning chief. These relics are always in close proximity to the chief, who takes his meals with the ancestors in this enclosure, separated from other humans by silence.

The next bead, a bibubu, represents Inabanza, another father of the sovereign.[19] He possesses an enclosure represented by another blue bead, a *musheto*, as well as relics of deceased Inabanzas represented by a white musheto bead.

A bibubu follows, and represents Kimekinda, a counselor to the sovereign. He is the messenger of order and calm. He also has an enclosure like the others, represented by a blue bead and then a white bead.

The next large bibubu bead stands for Muya Nvita, a military leader who fights for the chief and possesses an enclosure and sacred fire.

The round, medium-sized bead that follows is Kangelekezya, the spokesman who brings messages to the chief and makes announcements for him throughout the territory. An enclosure is reserved for him as well.

Lamine is represented by the next bead. He cares for the insignia as well as the physical integrity of the chief. At the death of a chief, Lamine's role is fundamental, for it is he who will separate the head, teeth, and nails, which are sacred relics, from the rest of the cadaver. This counselor possesses an enclosure, indicated by the *mutunda* bead that follows.

A large, sky-blue bead announces the role of Twite Mukulu, who must verify the correct observance of rites at the death of a chief, assist in the selection of an heir, and ensure a successful enthronement. It is Twite who brought the sacred fire from Kabongo to the present chiefdom, and as a foreigner, he is represented by a different-colored bead. Twite marks the continuity of sacred power from the Kabongo court.

The next smaller bead, a bibubu, is Mwine Kilolo, the administrative head of the village who takes charge of visitors. An enclosure is reserved for him.

The next bibubu bead is Kihanzula Nkasa, who serves as "the word": she says everything that needs to be said without reserve or shame. She does not have an enclosure, but is an important personage nevertheless.

Mwina Kilingo is represented by the bibubu bead that follows. He is the guardian of the houses of deceased chiefs, and of their relics. This bead completes the left-hand side of the necklace.

The right side of the necklace, which stands for the direct lineage of the reigning chief, begins with a blue musheto bead, depicting the second enclosure where the sovereign can receive the titleholder Tshikala. The bead bibubu follows, and symbolizes Tshikala in his absence. Tshikala also has his own enclosure, shown by the next bead. Tshikala organizes mourning rites for the chief's parents.

The white bibubu bead that follows is the father of the chief. He protects and defends the sovereign with the aid of Tshikala. He also possesses an enclosure.

The third large bibubu on the right is the titleholder Kalala. Being from the same descendance as the chief, he can replace and defend him. His enclosure follows.

The fourth white bibubu bead announces the presence of Mulunda, friend and confidant of the chief. He must prevent the sovereign from becoming too isolated and solitary. He also has an enclosure.

A fifth white bibubu bead is the Sha-Banza. He is of the same lineage as the chief, and is chosen among the paternal uncles. He looks for important information to transmit to Mulunda, the chief's confidant, for the chief is otherwise isolated from all contact with the population. An enclosure is reserved for Sha-Banza as well.

A sixth bibubu bead evokes the title Nsenga, whose role is close to that of Mulunda. His

enclosure is indicated by the musheto bead.

The seventh bibubu bead is a titleholder without an enclosure. His meals can be prepared on the fire of one of his dignitaries.

A blue bead follows, evoking Inabanza, and is the eighth very light-blue-bead. This is a female titleholder who prepares the chief's meals and oversees the other women of the court, especially during funerals.

The ninth bibubu bead is Tshikala wa Mukalo, the official in charge of gifts and justice in all villages that depend upon this chief. He also has a small enclosure, and could stand in for the chief if he suddenly dies.

A last bibubu bead is Kalala wa Muhalo. His work is identical to that of the Kalala of the chief's enclosure, and wherever he goes, he is welcomed like the chief.

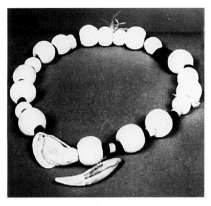

Fig. 87: The necklace of Chief Kifwa Kabula Kisangani wa Nyemba narrated on these pages. The necklace, now in the collection of the Zairian National Museum in Lubumbashi, represents the responsibilities and rites at the heart of the royal court for a given region during a given epoch, and thus serves as a microcosm of the society as a whole. The necklace is photographed upside-down; "left" in the narrative is our right in the photo. *Photo: Jeanette Kawende Fina Nkindi and Guy De Plaen.*

The pairing of most of these beads in a linear configuration, linking a titled personage to an enclosure or some other architectural feature (fig. 88), conforms to the structure of a chain-link mnemonic, in which *A* and *B* are read as a pair, then *C* and *D*. The paired associations facilitate memory, as does the linkage of a person to a place; the progression of linked features also creates a descending hierarchy of value and meaning. It is no coincidence that among Luba-ized peoples east of the Heartland, the word "malango," "memory," has the same verb root as "a string of beads" (Vandermeiren 1913:776, Van Acker 1907:43). A necklace literally and metaphorically strings meanings together and links otherwise unrelated ideas and precepts in an ensemble that produces knowledge and communicates power and order. In the case narrated above, the beaded necklace teaches the relationships between different political titles.

The reading of a necklace can be compared to the way a chief surrounds himself with his dignitaries, each with his or her place to stand and varying accouterments, pelts, necklaces, and staffs—in themselves mnemonic devices that denote, remember, and explain power (see chapter 5). Fig. 89 shows Chief Jacques Kabongo Kumwimba Makasa, Kayumba wa Meno, who came to power in 1963. In the photograph, Chief Kabongo is flanked by his titleholders, each of whom is carefully positioned according to his or her relationship to the chief and fellow titleholders, in the same way that the hierarchy of titles is encoded in Chief Kifwa's necklace. The photograph also illustrates the differentiation of each titleholder by his insignia and the animal pelts adorning his skirt. Luba animal taxonomy acts as a mnemonic, then, parallel to distinctions in bead types, colors, sizes, values, and rarity.

In short, beads recall personages and their attributes. By stringing them in a given order, one can narrate a structure of power. The visibility of such an armature for memory accentuates the importance of insignia and confirms the role of the person. Yet there is no such thing as complete or definitive mnemonic content, and even initiates cannot pretend to know everything represented by certain configurations of beads, or of the objects they adorn. A bihii bya bukulu bead or an mpande cone-shell disk will not have the same meaning to a profane novice as to an educated titleholder. The same kind of bead worn by a chief or an Mbudye Society member may be very different in what it represents to that person in those contexts. Indeed, the meanings of beads as cognitive cuing devices are inexhaustible.

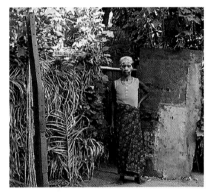

Fig. 88: The *mbala* sacred enclosure of a royal titleholder in Kinkondja. Within such an architectural structure, royal officials must eat alone, their meals being specially prepared according to numerous alimentary restrictions by their first wife, shown here with her face chalked white—a sign of being "in the taboos." This type of structure is represented on the chief's necklace by every other bead associated with a particular titleholder. *Photo: Mary Nooter Roberts, Kinkondja, 1987.*

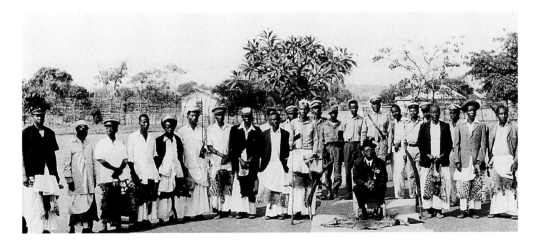

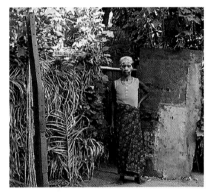

Fig. 89 (left): The royal entourage of Chief Jacques Kabongo Kumwimba Makasa. The photograph records and communicates the hierarchy of titles, their relationships, associations, and importance, in just the same way that the chief's necklace does. *Photo: Jeanette Kawende Fina Nkindi and Guy De Plaen.*

Part III: Inscription of Memory

Mary Nooter Roberts and Allen F. Roberts

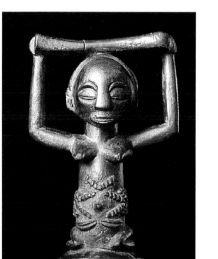

CAT. 36: HEADREST. LUBA, ZAIRE.
Throughout Africa, wooden headrests are used as pillows to preserve intricate and labor-intensive coiffures, and to keep the head and neck cool during sleep. Headrests were highly valued by Luba people, many of whom today recall their grandparents owning such objects. Headrests were occasionally buried with their owners, or even interred in place of the deceased when the body was irretrievable. During the Luba conflict with the Yeke at the end of the nineteenth century, the Yeke burned all Luba headrests while leaving other objects intact. *Wood. H. 8.5 in. Drs. Daniel and Marian Malcolm.*

CAT. 37 (OPPOSITE): STANDING FEMALE FIGURE. LUBA, ZAIRE. The bumps of scarification, and the patterns configured from them, can be combined and recombined in endless variations to create different messages and meanings according to one's status, identity, and political intentions. Luba sculptures such as this one accurately represent actual Luba scarification patterns, which were first applied to the skin during girls' initiation rites before marriage and were renewed and added to throughout a woman's lifetime, reflecting the cumulative nature of identity and memory. *Wood. H. 13.75 in. The University of Iowa Museum of Art, The Stanley Collection, Inv. no. CMS 298.*

In contrast to the ephemeral art of Luba beaded mnemonics, such as the necklace narrated by Jeanette Kawende Fina Nkindi and Guy De Plaen, scarification is a permanent mode of mnemonic inscription. Just as each bead in the necklace has a fan of references, values, and contexts to which it is linked, scarification patterns on the body—and especially the female body—are attributed specific meanings and mnemonic associations (cat. nos. 36 and 37). Yet unlike the linear arrangement of morphemes in a chain mnemonic, the morphemes of scarification are disposed over the area of a person's skin. In so doing, the boundary is fixed, the "I" is precipitated, and the social person is defined in a tegumentary text ready to be "read."

Scarification, shaping or obliteration of teeth, and genital modification change the body permanently, while related arts of adornment are ephemeral and performative. All such arts produce both protective closure and interaction with others. Body arts *perfect* the person. As the Latin root of the word implies, to perfect is to complete or fulfill in excellence (Morris 1969:974). The point is worth emphasizing, for some Africanist writers (e.g. Brain 1979:82–93) erroneously describe permanent transformations of the body as "mutilation," invariably a pejorative term that refers to rendering *im*perfect, damaging, maiming, excising, or depriving (Morris 1969:866).[20] While permanent body arts do "de-naturalize" (Mascia-Lees and Sharpe 1992), such distancing from nature is cultural *con*struction rather than *de*struction, and from an insider's viewpoint must be an altogether positive social process, albeit a purposefully painful one—a sacrifice, that is (Roberts 1988b).

In the West, ear piercing, tattooing, nose reduction, breast enlargement, and other plastic surgeries are not considered psychopathological; rather, these modifications beautify, conveying people's sense of how they *should* and *would* look, as opposed to how they were born. So it is with scarification and other body expression in Africa, through which pertinent social information is made available for others to "read" and appreciate. Dominique Zahan has urged anthropologists to study "the tegumentary language of non-Western peoples, for whom the verb is replaced by a beard, hairstyle, hair-plucking, scarification, tattooing, and body-painting" (1975:101). As he put it, the skin is the first "canvas" of humanity, a threshold between self and others that implies interaction and exchange (ibid.:101; see also Devisch 1983:5).

Focus upon the semantics of body arts becomes even more appropriate when one understands Africans' own senses of how body arts are significant. For Baule of the Côte d'Ivoire, scarification is a "mark of civilization" that serves to differentiate and distance people from "raw nature," and imposes meaning upon the chaos of the wilderness (Vogel 1988:97–100). Among matrilineal peoples of central Africa, it is very common to employ scarification as a means of both emphasizing and protecting the navel as the threshold point between one's self and one's mother and lineage (Faïk-Nzuji 1993:57). The first scarification motif a Hemba girl in Zaire receives is called "guardian of the navel" (*acunga musu*), for instance (Kazadi Ntole 1980:3–5). Nuba girls of the Sudan receive scarification when they mature physically, as a "beauty necessity" that signals "reproductive capacities" (Faris 1988:34–35). Beauty is not innate, then, but must be created. The skins of Ga'anda girls of northeastern Nigeria are virtually covered with scarification patterns signifying permanent transition to social identity and responsibility, an expression that further assures perpetuation of society itself (Berns 1988:58–63).

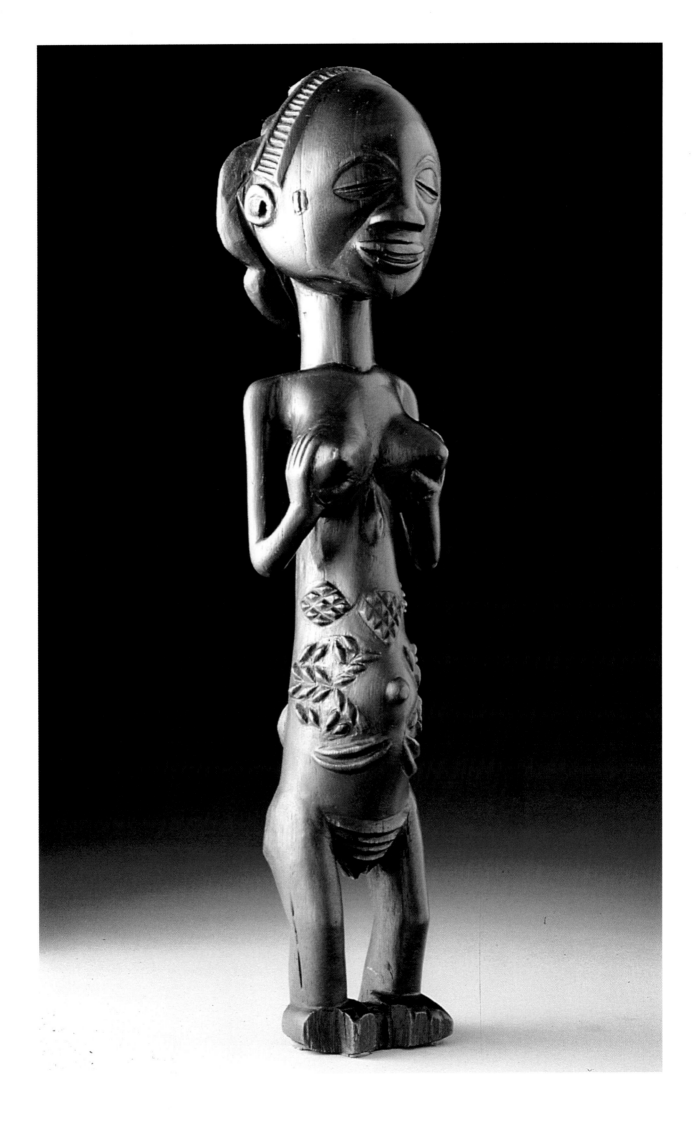

CAT. 38 (RIGHT): DRUM. LUBA, ZAIRE. Many
important Luba emblems have no figurative
elements but are embellished with elegantly
engraved geometric designs—another form
of scarification. Just as a woman's body is
considered unfit for marriage until scarified,
so a royal emblem is thought mundane until
it bears these marks of civilization. Luba
royal drums are used at the investiture and
funeral of rulers, or at the death of a ruler's
child. The type of drum shown here is also
used by Mbudye members on the occasion of
dance performances and initiations. In the
past, court drummers were always blind.
Nowadays, the use of drums is less exclusive
and more widespread. *Wood, leather,
upholstery tacks. H. 14.5 in. Marc and Denyse
Ginzberg.*

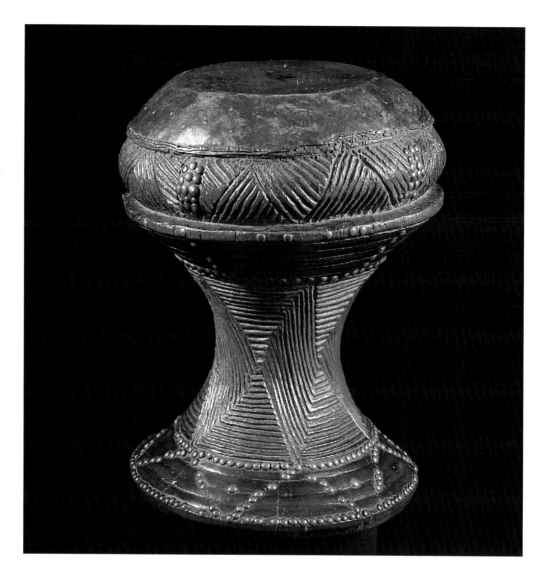

**CAT. 39 (RIGHT): TWIN FIGURES. LUBA,
ZAIRE.** There is hardly a Luba object that
does not have scarifications in the form of the
nkaka pattern. Even totally nonfigurative
objects are embellished with these marks of
civilization, thereby anthropomorphizing
them. These schematic Luba sculptures are
probably twin figures, made and used to
honor the "children of the moon." Although
they are simple in form, their patterns convey
their importance and their role as memory
transmitters. *Wood, beads. H. 4.3 in. Private
collection, Brussels.*

**CAT. 40 (OPPOSITE): HEADREST SUP-
PORTED BY PAIRED FEMALE FIGURES.
LUBA, ZAIRE.** Coiffures were and are
important to Luba; early Western
explorers in the region nicknamed them
"the headdress people." Hair styles too
are memory devices, indicating profes-
sion, title, status, and personal history.
A coiffure can identify a person as
single, engaged, married with children,
divorced, or widowed. Hair styles also
indicate the professions of fishermen,
herders, diviners, secret-association
members, and chiefs. But the primary
purpose of styling is aesthetic: as one
Luba person put it, "An elegant coiffure
makes a woman radiant." Like scarifica-
tion, a beautiful coiffure is a sign of
civilization, and a visible measure of a
person's social worth and self-esteem.
The female figures supporting this
headrest may allude to female spirit
mediums, who often lived in pairs to
represent the twinned guardian spirits
of Luba kingship. *Wood. H. 7 in.
National Museum of African Art,
Washington, Museum Purchase, Inv. no.
86.12.14.*

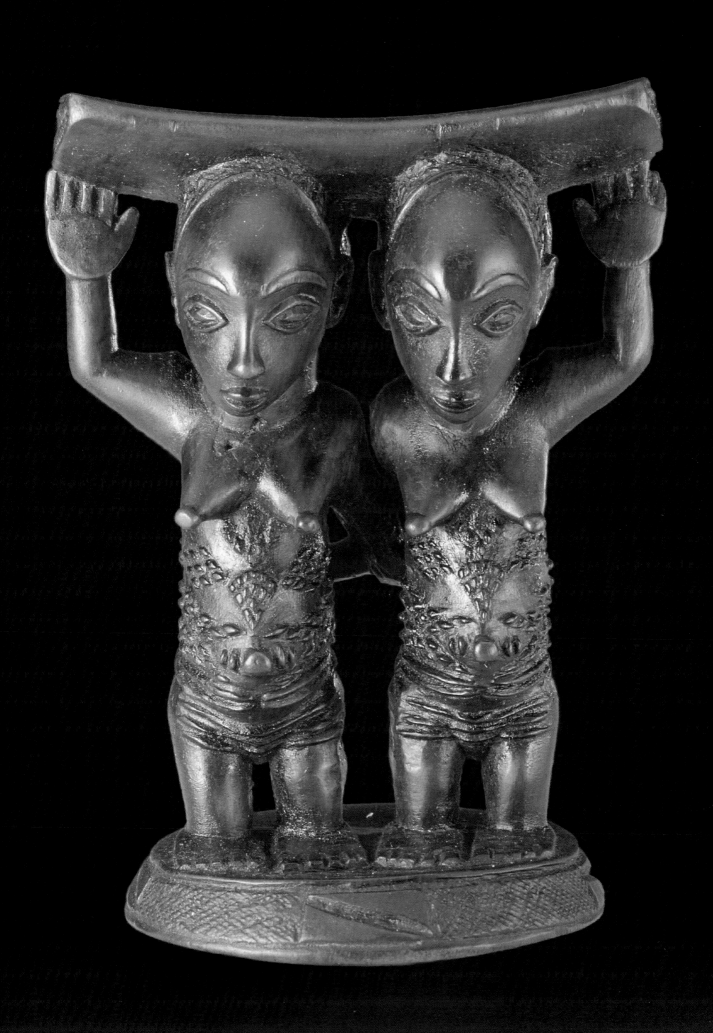

Luba Scarification as "Writing"

"Ntapo," the Luba word for scarification, comes from the verb "*kutapa*," meaning to pierce or incise (Van Avermaet and Mbuya 1954:678). Among Luba, ornate scarification is a women's art. The process involves using a *lusimbo* razor to make light incisions, into which soot mixed with the juice of a fruit that turns a glowing black is inserted, to create small welts on the skin.[21] The operation is performed by a specialist in the village following girls' *butanda* initiation and prior to marriage, for which it is virtually a prerequisite.[22]

Luba use the metaphor of women's scarification to describe any container decorated with geometric designs (cat. nos. 38 and 41). Objects displaying ntapo markings include gourds, pots (cat. no. 43), mats, baskets, walls of houses (figs. 91–95), and many Luba royal emblems such as lukasa memory boards, axes, and staffs of office. People often claim that the purpose of such markings is simply "to beautify or to embellish" (*kunenenya*), yet while "kunenenya" does mean this, it can also be "to render harmony, order, rank, and hierarchy" (Van Avermaet and Mbuya 1954:430). Furthermore, a synonym for "kunenenya" is "*kulenga*," which means "to decorate, adorn, arrange, order." This association also characterizes the language of neighboring groups: among As'ohendo, a western Luba group, the noun "scarification" (*tondongo*) is "decoration," but with the sense of thereby establishing *order* (Faïk-Nzuji 1993:56–58).

Establishment of order underlies mnemonic recall. It is order that anchors and fixes sequence, but something broader than sequence is also implied. As David Freedberg stresses, corporeal embellishment is never the result of an impulse "simply to decorate" (1989:82–98). The verb "to scarify" (*kutapa*) also means to cut away, clear, and make passable. The importance of the metaphor of blazing and clearing the path that leads to the royal capital is discussed in chapter 4. Pathways are the routes of memory, and roads to remembrance (cf. Casey 1987). Victor Turner equated the blazing of a path to the creation of symbolic sense among Ndembu people living southwest of the Luba Heartland (1970). In chapter 5, a chief explains that the scarification patterns on the torso of a wooden female figure are *dibulu*, or centers of political organization. In other words, fashioning the female body, like the definition and modeling of the royal capital, is an act of civilization, creating order, form, and meaning over the diffuse powers of the unmarked and unsettled wasteland (cat. nos. 39 and 40).[23]

Kulemba (or *kulèmba*), a verb meaning "to scarify" that is shared by Luba and Tabwa, also means "to draw, paint, or inscribe." Since the early colonial years, the same verb has been extended to include the sense of "to write" (Van Avermaet and Mbuya 1954:169, 349; Roberts 1988c:41). The messages so "written" can be very important ones. As Frances Yates suggests, "The art of Memory is like an inner writing. . . . For the places are very much like wax tablets or papyrus, the images like the letters, the arrangement and disposition of the images like the script, and the delivery is like the reading" (1966:7). Scarification, then, is an inscription of power upon the surface of the human body, a writing etched permanently and painfully into the skin to render otherwise barren, uncivilized expanses of territory a landscape of meaning and memory.

Semantics of Scarification

There are regional variations in scarification design, just as there are numerous dialects of the Luba language. Patterns have come and gone like fashions, and surrounding peoples have emulated the scarifications of royal Luba women. W. F. P. Burton recounts that people would travel a hundred miles or more to see the scarifications of the king's first wife, so that they might imitate them (1961).[24] Nevertheless, there is remarkable consistency in the names and forms of many designs. Those still worn by older Luba women in many regions today include:

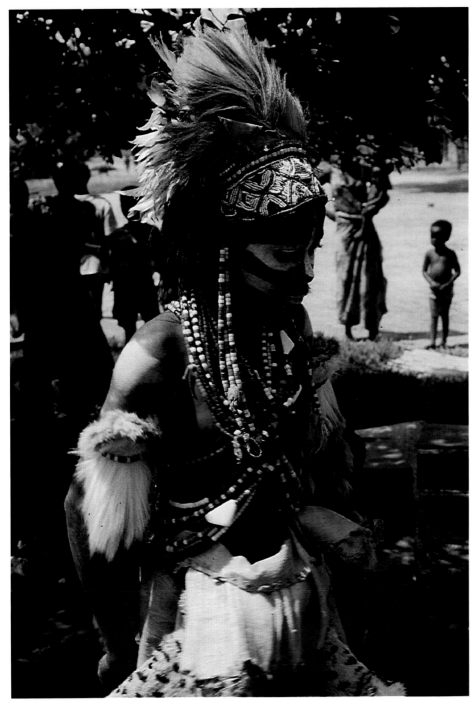

Fig. 90: Royal Bilumbu diviner bedecked in beaded necklaces, bandoliers, and nkaka headdress. The beadwork creates a kind of armature for the diviner's body and head, serving to strengthen and protect his person as his body is overtaken by that of his possessing spirit for the duration of each day's consultations. *Photo: Mary Nooter Roberts, 1989.*

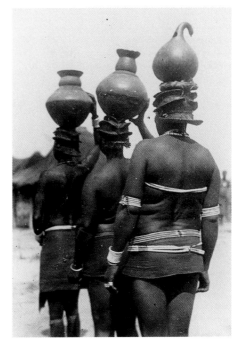

Fig. 91: Luba women wearing the "step"- or "cascade"-style coiffure typical of the Luba Shankadi region in the Heartland, and carrying pots and a gourd on their heads. *Photo: W. F. P. Burton, 1927–35. Courtesy of the University of the Witwatersrand Art Galleries, Album 27.*

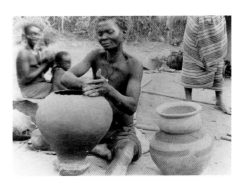

Fig. 92: Luba woman potter at work. When the pot is shaped, the woman will adorn the surface with geometric patterns referred to as "scarifications." The purpose of the markings is both to beautify the object and to render it an effective receptacle for spiritual energies. *Photo: W. F. P. Burton, 1927–35. Courtesy of the University of the Witwatersrand Art Galleries, BPC 071.6.*

Fig. 93: Group of pots adorned with "scarifications" in the form of incised, abstract geometric designs called "nkaka"—a pattern that adorns all objects intended to hold spiritual vitality or to be used for rites that invoke spiritual aid. *Photo: Mary Nooter Roberts, 1987.*

CAT. 41 (BELOW): SKIRT. LUBA, ZAIRE.
Indigenous Luba garments were rarely collected and little record of them survives in the West. This raffia skirt was probably wrapped around a woman's hips. It is significant that its only embellishment besides the fringe is a schematic line of beads disposed in the nkaka pattern—a scarification pattern that adorns almost all Luba objects associated with the containment of spiritual vitality. *Woven raffia fiber, beads. L. 59 in. Burton Collection, Social Anthropology Department, University of the Witwatersrand Art Galleries, Johannesburg, Inv. no. WME/221.*

CAT. 43 (OPPOSITE): ANTHROPOMORPHIC POT. LUBA, ZAIRE. Anthropomorphic Luba pots were used by royal diviners to identify and cure illness. The figure is an effigy of a spirit. Medicine is placed in the pot, which is then used as an oracle: through this vehicle the spirit pronounces information on a particular illness, crime, or other misfortune. The language that emanates from the object, however, must be translated and interpreted by the diviner, who serves as intermediary between the client and the spirit. Luba pots are always decorated with scarification patterns. In this example, the two pronounced lines below the navel represent *milalo*, among the most sensual of all Luba scarifications. *Ceramic, woven fiber. H. 6.9 in. Private collection.*

CAT. 42: HEADDRESS. LUBA, ZAIRE. The beaded headdress worn by royal Bilumbu diviners and Mbudye Association members when they enter a state of spirit possession is called "nkaka," also the name of the pangolin (a scaly anteater) and of a certain scarification pattern. Luba officials say that the nkaka headdress is mnemonically coded with references to proverbs and prohibitions, and with "lakes" symbolizing the spirit capitals of kings and the culture heroes of the Luba Epic. The headdress also protects and encloses the possessed wearer's head in the same way that the pangolin's scaly armature defends the animal from even the fiercest of predators. *Beads, cloth, fiber, leather. H. 20 in. Private collection.*

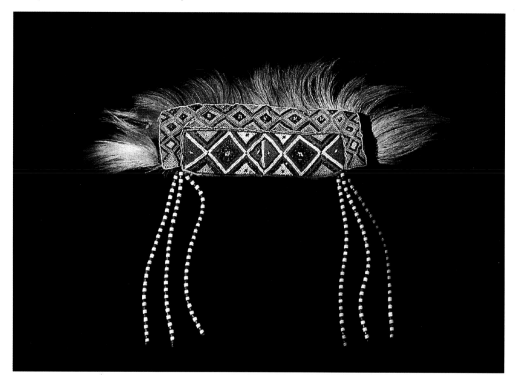

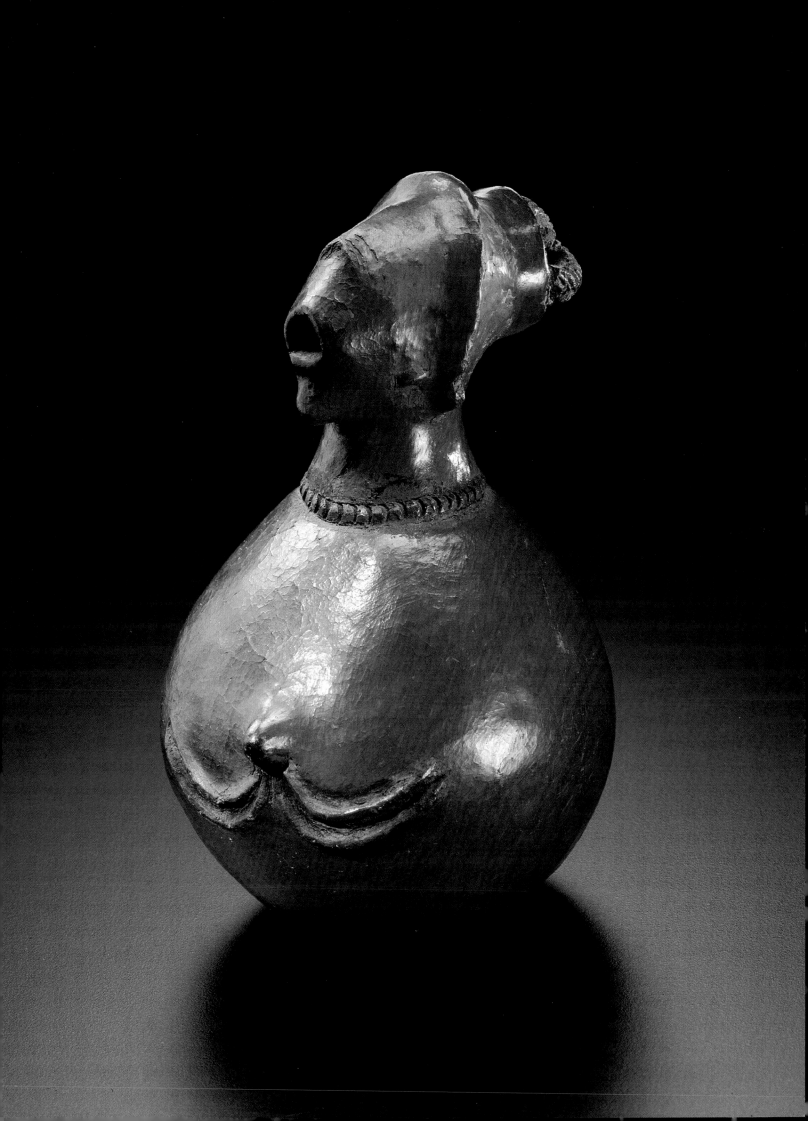

Fig. 94: Detail of a woven mat also displaying "scarification" patterns in its disposition of designs. Mats are used for sitting, and communicate a complex language of status and rights through their patterning and positioning. *Photo: Mary Nooter Roberts, 1987.*

Fig. 95: Exterior walls of a Luba house in red, yellow, brown, gray, black, and white, and rendered with the same triangular and diamond patterns that are associated with royalty and spirit containment. *Photo: W. F. P. Burton, 1927–35. Courtesy of the University of the Witwatersrand Art Galleries, BPC 22.23.*

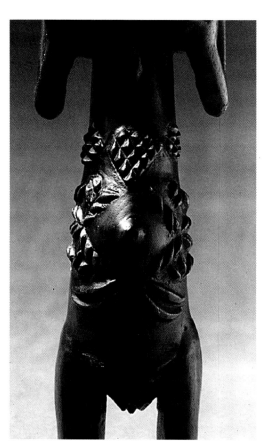

Fig. 96: Frontal detail of Cat. no. 37 standing female figure showing the vocabulary of scarification patterns commonly found on Luba sculpture. *Collection: University of Iowa Museum of Art. Photo: Steve Tatum.*

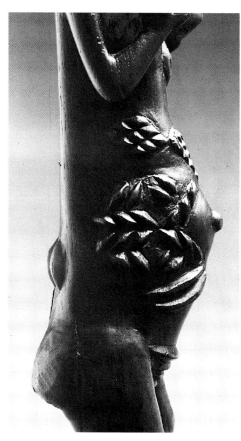

Fig. 97: Profile detail of same sculpture. *Photo: Steve Tatum.*

Fig. 98: Diagram of Luba scarification patterns from early archival photograph taken by De Witte in Nyonga, Shaba, in 1925. Photograph in the collection of the Royal Museum of Central Africa, Tervuren, Belgium. *Drawing made by Louise Van Geesbergen, 1988.*

milalo	horizontal parallel lines below the navel on lower belly and thighs.
nkonda	arched lines above each buttock.
meso a tete	"grasshopper eyes": round protuberances above each of the *nkonda* curved lines above the buttocks.
kibwasasa	"comb": four scarifications under the breasts in the form of a comb, just where the husband lays his head on his wife's chest.
musamo	"headrest": marks on the upper arm where the husband lays his head at night (also the name for headrests sculpted in wood).
lunenyenye	"star": a large welt between the breasts.
nkaka	"pangolin" or "diviner's beaded headdress": patterns of isosceles triangles across the chest.
bukanga	a line down the forehead and nose.
impolo	"tears": marks placed underneath the eyes to add gaiety to the smile.
kisanji	"thumb piano" or "music": clustered marks on either side of the navel.
lusanga lwa nso	"dorsal fin of an eel": a pattern descending along the vertebrae.
bisanga	small scars on the chest and between the breasts.
tunyungo	small scars grouped in the form of lozenges on the stomach.

Much like the beads and shells of chief's necklaces and other royal accouterments, the individual bumps of scarification, and the patterns configured from these "morphemes," constitute a vocabulary that can be combined and recombined in endless variations to create different messages and meanings according to the identity, status, and political intentions of the wearer (figs. 96 and 97). Patterns are often renewed during the course of a lifetime, and new patterns are added to complement old ones, reflecting the cumulative nature of identity and memory (fig. 98).

Mapping Anatomy

It is likely that in the past, when Luba women's scarification was more complex than it has become during the colonial and postcolonial periods, a schedule was followed as to when different parts of the body would be inscribed, following a girl's physical development. Kazadi Ntole reports that among Hemba, a male woodcarver would trace designs on a girl's skin with a staining sap, and then would scarify "less intimate parts of the body, leaving the rest to women" (1980:3–5). Patterns were first made around the navel, when a girl was between eight and eleven years old; then, at puberty, other designs were made on the chest and abdomen. Later in life, markings were made on the tenderest parts of the face. The degree of scarification was probably elective, and communicated a woman's ability to withstand intense pain (Roberts 1988b:44). The person was made in the process.

The conscious placement of particular patterns on designated zones of the body constitutes a mapping of the anatomy, in much the same way that landscape is given definition and meaning through the pinpointing of landmarks such as sacred forests, mineral-rich mountains, hot springs, caves, and lakes where spirits are said to reside. By endowing each zone of the body with an image and corresponding meaning, scarification transforms otherwise barren space into place, and the undifferentiated and anonymous body into a place of intimacy, meaning, and value (cf. Casey 1987:185–86). A topology of intentionality results (cf. Tilley 1994:14–20).[25]

As a peg-type mnemonic, the attachment or inscription of images and their names to loci on the body facilitates remembrance and transforms the body into a memorial landscape. As we shall see in the next section, such an assertion confirms Aristotle's contention that "the primary action of place is that of *containing*" (Casey 1987:186). Scarification creates "additional surface" for the body, and emphasizes difference between ego and other. In so doing, this art idealizes the body, even as it stresses the body's paradoxes as both container and contained, in an engagement with the interpretive gaze of others (Stewart 1993:127).

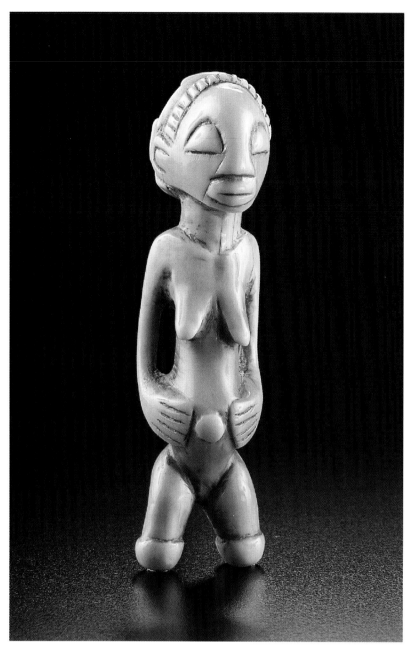

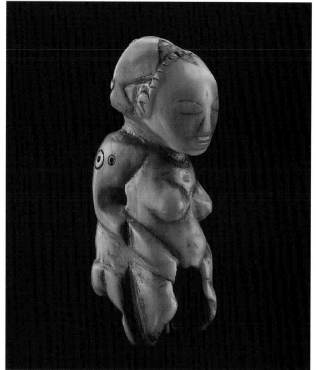

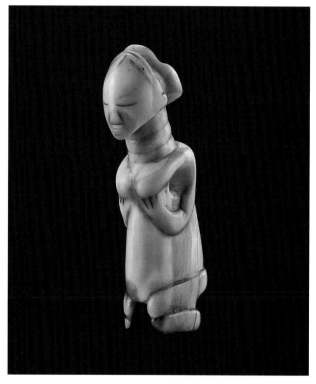

Cat. 44.a–g: Ivory pendants. Luba, Zaire.
Luba ivory pendants are portraits, or at
least likenesses, and are named and honored
in memory of certain revered ancestors.
Sculpted from bone and horn as well as from
ivory, these delicate diminutive figures were
suspended from cords together with other
objects, including amulets, beads, and horns.
The cords were worn diagonally across the
chest or were attached to the arm. Devotees
anointed the figures with oil in homage to the
ancestors. Such treatments, together with
regular handling and contact with the human
body, gave the figures a smooth, lustrous
surface and a rich caramel color ranging from
yellowish-brown to auburn. The figures were
also sometimes attached to the tops of
scepters carried by chiefs.

The facial features of many of these pendants
have worn away from handling and wear over
the years. The smooth caramel surface and
the worn armholes testify to extended use
and suspension. Luba ivory pendants are
among the most intimate and personal of all
Luba objects, and reflect a close association
with the human body. Tiny enough to be
easily held and caressed in the hand, ivory
pendants nevertheless uphold the same
aesthetic as larger, more imposing Luba
royal emblems.

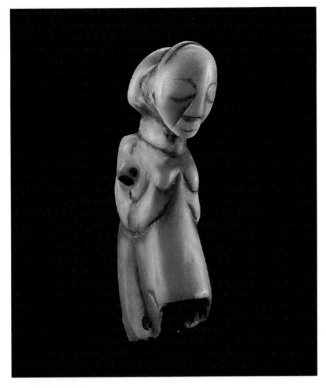

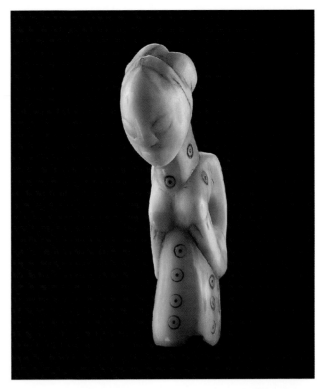

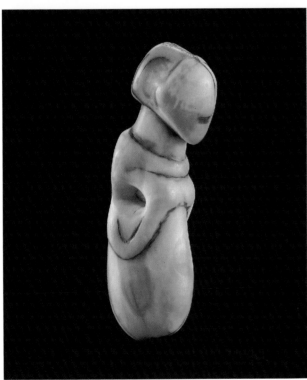

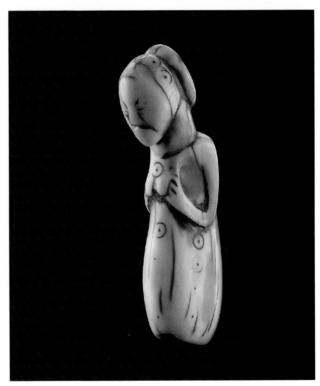

Luba ivories were widely collected during the late nineteenth and early twentieth centuries, but are no longer used today. Although each figure is slightly different in its detail, all share a minimalist conception of the human form, usually emphasizing head and torso to the total exclusion of the legs. The gesture of the hands on the breasts signifies devotion, respect, and, according to some Luba spokespersons, the containment of royal secrets. Large demure eyes dominate the heads, which often incline along the natural curve of the ivory. Scarifications are rendered generically as incised concentric circles; these embody fundamental principles of life and continuity. The coiffures are intricately detailed to imitate actual Luba women's coiffures of the nineteenth century. *Ivory. H. 3-4 in.. Private collection.*

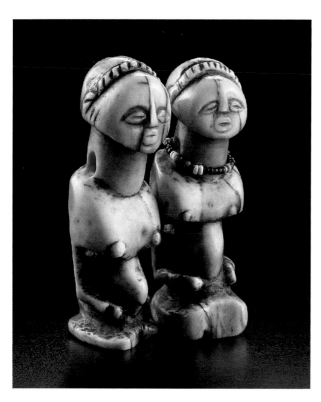

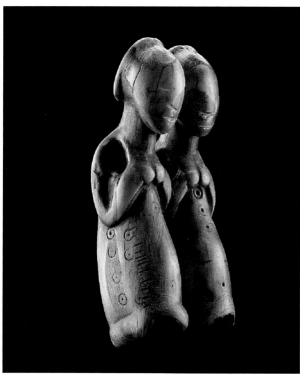

CAT. 44 H-I (LEFT TOP AND BOTTOM): IVORY PENDANTS. LUBA, ZAIRE. Like many Luba sculptures in wood, ivory pendants also were sometimes made in pairs. Worn against the body, suspended from a cord, the paired pendants served to evoke the memory of twinned ancestral spirits. *Ivory. H. 3–4 in. Private collection.*

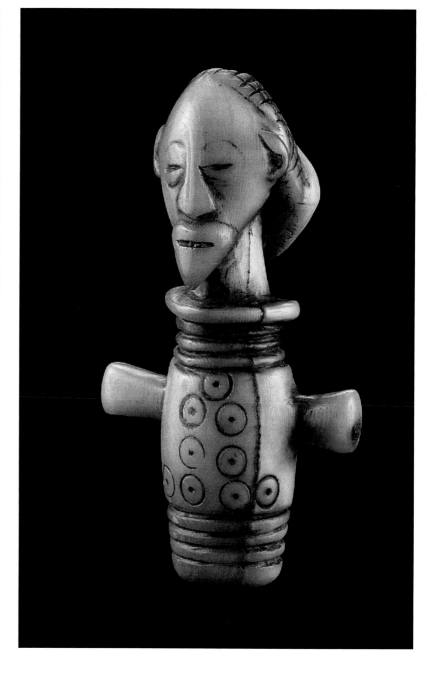

CAT. 44J (RIGHT): IVORY WHISTLE. LUBA, ZAIRE. Luba ritual specialists such as diviners use whistles to call the spirits. Whistles are usually made from wood, and are nonfigurative; this is a rare example of an anthropomorphic whistle made from ivory. The figure shows some of the attributes important to Luba aesthetics, including an elegant coiffure and scarification markings, represented schematically by the punched circles on the figure's torso. In addition to rattles and bells, whistles were and are an important instrument for invoking the spirits' attention and trust. *Ivory. H. 3.6 in. Private collection.*

Textured Textuality

The most frequently stated purpose of Luba scarification is to beautify and to eroticize. At night, a woman applies oil to her scarified skin so that it will gleam in the dim lamplight of her bedroom chamber. Sculptures were once oiled as well, and some nineteenth-century objects still possess glossy or sticky black surfaces as a result. To both the visual and the tactile senses, scarification is highly erotic. Luba men and women alike assert that a man has only to caress his lover's scarified body and they both will be instantly excited. For this reason, a finely scarified young woman becomes eminently marriageable.

Luba appreciate the tactile richness of textured skin (see Rubin 1974:7), and at least until recently, they thought an unscarified woman so unattractive that she would be considered unfit for sexual relations, let alone marriage.[26] Luba and neighboring Hemba girls whose skins have not yet been scarified, and are therefore still smooth, are teased and compared to men, gourds, slimy mushrooms, slippery catfish, eels, or other scaleless animals that slip through the hand (Kazadi Ntole 1980:10–11, Nooter 1991:245). Likewise, an unscarified woman may be compared to the slippery trunk of a banana tree, or to a snakelike bird called *muhulu-hulu* (probably an anhinga or cormorant). Proverbs further express men's distaste for a woman without scarifications: "The woman with fine scarifications is invited into the house where men are drinking beer, while the woman without them will stay outside"; or "You, who are slippery like a mushroom, do you not see the *kasimbo* razor with which to scarify yourself?"

Luba definitions of the erotic are not strictly physical, however. For Luba, eroticism in life and art is closely linked to spiritual domains. Bodily transformations such as scarification and the elongation of the labia render a woman an effective vessel with which to capture and hold potent energies, and thereby establish direct communication with the spirit world. Every detail of the sculpted female figure is inscribed, from swelling scarifications and extended labia to sumptuous coiffures (figs. 99 and 100) and gleaming black skin. Luba men consider these not only ideal features in a woman, but attractive and meaningful to the denizens of the spirit world (Nooter 1991:chapter 5; cat. no. 45). As one man said, "Spirits respond more favorably to women, which is why *mikisi* [sculptural containers for spirits] depict women with scarifications."

Among Luba-related peoples, complex interrelationships exist between corporeal tegumentary language, social identity, physical perfection, and cosmological principles. Analysis of the Luba pattern called "nkaka" shows how scarification functions as a peg-type cognitive cuing structure and triggers a barrage of associations, contexts, and meanings. Nkaka consists of a row of isosceles triangles (cat. no. 41), and is similar in form to the ubiquitous Tabwa *balamwezi* pattern, which refers to "the rising of the new moon" (see Roberts 1985). The pattern is often located across the chest above a woman's breasts (fig. 98). In nature, an nkaka is the scaly anteater or pangolin (Nooter 1990a and 1991:44–45; Roberts 1990a). Pangolins are sacrificed for ritual and magical use of their scales, which are considered resistant, durable, and strong (see Roberts 1995a:83–87).

The nkaka pattern appears on objects whose purpose is to contain power. For example, it adorns the rims of ceramic vessels that potters describe as "female bodies" and would not think of leaving "unscarified." Pots may house ancestral spirits in the family shrine, where they are worshiped every month at the rising of the new moon. The pattern also decorates virtually all Luba royal emblems in which the ruler's possessing spirit resides: the rims of stools, the backs of lukasa memory boards, the branches of bow stands, the handles of axes, and the like. "Nkaka" is also the name of the beaded headdress worn by Bilumbu diviners and Mbudye Society members when they enter a state of spirit possession, "to catch and hold the spirit within" (see chapters 4 and 6; cat. no. 42).

The basis of the nkaka design reveals the enigmatic signs of the most esoteric of all Luba mnemonics: the taboos and restrictions of sacred kingship called *bizila*. The paradox of Luba authority is that supernatural agency may be harnessed only through strict abstinence and observance of ritual procedures. Luba women are stewards of these interdictions, to assure that male officials adhere to them strictly. This is exemplified in sculpture by the hands-to-breasts gesture

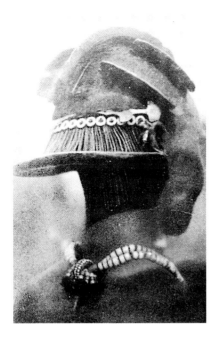

Fig. 100 (left): Watercolor painting of a Luba Shankadi woman wearing a coiffure in the "step" or "cascade" style that was popular in the late nineteenth and early twentieth centuries. The painting is from a book of over thirty paintings in the collection of the Royal Museum of Central Africa, Tervuren, each one showing a different headdress or hairstyle worn by Luba men and women to express a status, a profession, or a condition, such as widowhood or engagement. Coiffure, then, like scarification and beadwork, is another form of body memory, a corporeal mode of communicating information about a person's past, personal history, and identity.

Fig. 99 (above): Woman from near Sungu Monga wearing an elaborate hairstyle in the "step" or "cascade" motif. The coiffure is ornamented with iron hairpins that are symbolically related to the sacred anvil, secret of the Luba kingdom's success. *Photo: W. F. P. Burton, 1927-35.*

Cat. 45 (opposite): Headrest, made by the "Master of the Cascade Headdress." Luba-Shankadi, Zaire.
A dynamic pose, delicately chiseled features, and dramatically tumbling coiffure are the hallmarks of a series of headrests, one stool, and one *kashekesheke* divining instrument attributable to a single nineteenth-century artist or workshop. The type of hair style depicted in these sculptures is called "*mikanda*," "steps" or "cascade," inspiring Westerners to call this artist the "Master of the Cascade Coiffure." Such layered articulation of the hair, and, in sculpture, the use of angular, open forms, were especially popular up to 1928 around the villages of Kabondo Dianda and Busangu in the Luba-Shankadi area. Styled over a canework frame, the "cascade" hair style took almost fifty hours to complete. If a headrest was used at night, the hair style could last two to three months. *Wood, beads. H. 6.9 in. Horstmann Collection.*

that has been erroneously linked to fertility. Luba women explain that within their breasts, they guard the royal prohibitions upon which kingship depends (cat. no. 44a–j).[27] The localization of secrets within the breasts also explains why certain titled women—as well as the sculpture representing them—wear beaded cords or *lukuka* across the tops of their breasts. These are worn whenever women call spirits for their husbands, enter a state of spirit possession themselves, or perform tasks regulated by royal prohibitions, such as collecting water, cooking food, and guarding the compound during their husbands' absence. Such a cord securely encircles, encloses, and binds the secrets within the women's breasts. As one woman said, "To wear the lukuka carries great power: it is a powerful sign, indicating that she who wears it carries the goodness and the greatness of the spirit."

Luba aesthetics explicitly denote metaphysics, then. To be "in the taboos," Luba place great value on firm, textured surfaces that refer to containment, resistance, and the concentration of power. In contrast, the "lifting of taboos" is associated with smooth, untextured things like slippery eels or plants, silky mushrooms, and unscarified women—all connoting release, dispersion, and entropic forces.

Analysis of a single scarification pattern like nkaka demonstrates the complexity of association and meaning that may be attached to any given sign in this mnemonic system. Yet the attempt to attach precise meanings to specific patterns is ultimately a futile exercise. Meaning in Luba art is always contingent upon each reading, and is forever vanishing in its own secrecy, which, paradoxically enough, is the totality of its own signification. As noted above, Luba scarifications may be erotic, but what renders them powerful is the secrecy of their textured textuality. Secrecy as the paradoxical unity of revelation and concealment, presence and absence, and meaning and non-meaning transcends the arbitrary nature of the sign (Nooter 1993:240). As such, we may read as much as we wish into the designs, and our readings will not be false; but they are only tangential to the essence of the secret, which ultimately stands only for itself.[28]

As such, Luba beaded body adornments and scarification markings do not document, describe, represent, or symbolize as much as they *dispose*. They become meaningful through their elucidation, during the moment of their disclosure. Permanent body arts place a person in a social universe. A woman's body may reflect her own person, and at the same time become a template for society as a whole (Douglas 1973). Among Luba, royal women's bellies are decorated with scarified scriptures containing arcane messages about the sacred powers of kings. As such, the women are receptacles of spiritual energy and beholders of political secrets (Nooter 1990b:43–44). The body's inside/outside paradox is revealed in this last phrase, for in containing the supernatural, Luba royal women are able to participate in the most private workings of the state. Indeed, their very bodies present "a discourse on power" to those permitted to see them (ibid.).

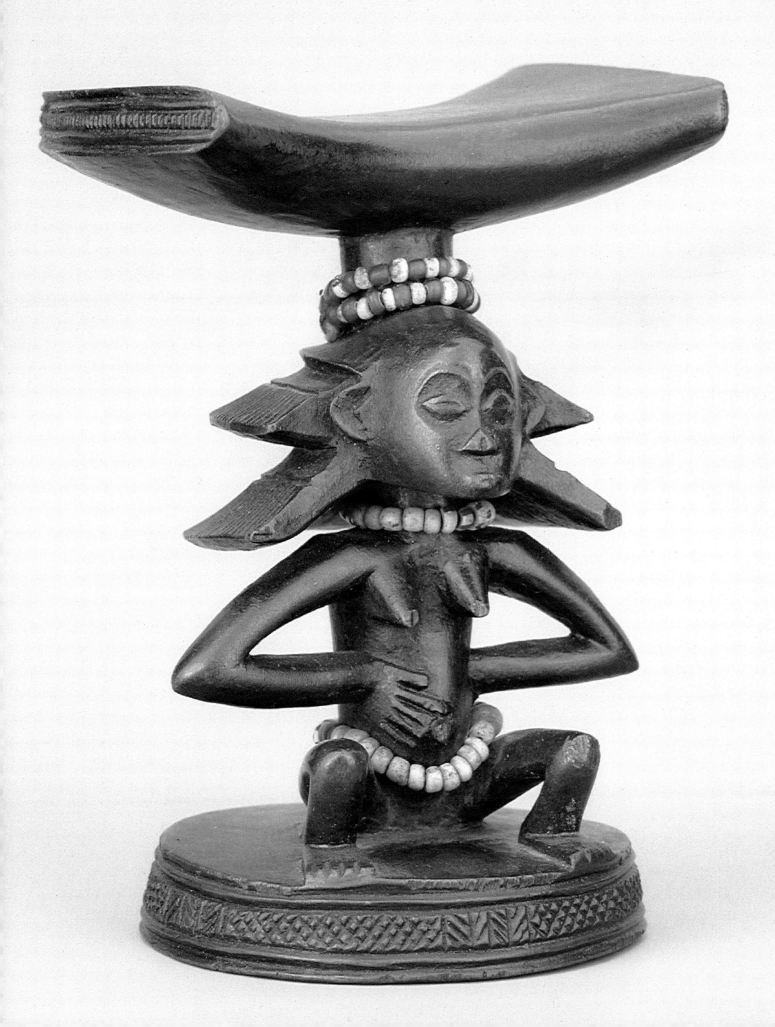

Endnotes

1. The ambiguities of thresholds are the subject of Allen Roberts's *THRESHOLD: African Art on the Verge*, forthcoming 1997. These first paragraphs are adapted from that text.

2. Special-purpose currencies are limited to specific spheres of exchange, such as bridewealth or the ransoming of war captives. In some places, use of cowries and some other tokens approached that of general-purpose currencies, through which a great variety of things and services can be exchanged against the common value of the tokens. Small copper crosses and cowries may have approached such general use for ancient people of the Luba Heartland (Maret 1981), but data is too sketchy to allow any detailed assertions in this regard.

3. The use of beads in African expressive culture has received surprisingly little focused study. Margret Carey's *Beads and Beadwork of West and Central Africa* (1991) and Christrand Geary and Andrea Nicolls's *Beaded Splendor* (1994) provide a useful but brief introduction, and Joan Erikson's *The Universal Bead* (1969) a more general grounding. Paul Einzig reports early ethnographic tidbits (1966:119–22), and Robert Liu provides a useful bibliography (1984). See also *Ornament*, formerly *The Bead Journal*.

4. The late Arnold Rubin (1974:13–14) was one of the few scholars to consider African cumulative sculpture to date (see also Blier 1995:75-79). Rubin found that accumulation is "a distinctly African artistic convention," and discerned four types: adjunctive (one or a small number of elements added to a core), integumented (a surface entirely covered), reticulated (small units added in configurations), and sheathed (a covering conforming to contours). According to this scheme, chain-type mnemonics are adjunctive, while peg-type are reticulated or integumented.

5. The disks are carefully cut perpendicular to the shell's length, to reveal a tight spiral of pure white material bored to permit stringing. The symbolism and literature of *mpande* cone-shell disks among Luba and related people of southeastern Zaire are discussed in Roberts 1990a:45–46.

6. The ethnographic present here is admittedly nebulous. Beadwork is still made and used by Luba chiefs and kings, but the memory so implied has changed radically during the colonial and postcolonial periods. Necklaces and other emblems have been buried with chiefs, and others have been sold or collected. Emblems such as medallions awarded by the colonial authorities to "authentic" chiefs, or insignia of the Zairian army or government, have replaced mpande-shell disks in some instances. Still, people often keep memory devices such as the shells and beads discussed here, albeit sometimes more as heirlooms than as active mnemonic devices.

7. The taking and keeping of relics is itself a chain-type body mnemonic, following the same logic as the stringing of beads explained here. Among Luba-ized people such as northern Tabwa, for example, Chief B's skull was kept and venerated by his successor, Chief C, while the rest of B's remains were buried under a watercourse with the skull of his predecessor, Chief A; see Roberts forthcoming(b) for historical accounts and contemporary exegeses.

8. These suggestions differ from explanations offered by Tabwa and Luba-ized peoples to the east of the Heartland, among whom the cone-shell disk is a lunar emblem associated with the culture hero Mbidi Kiluwe, fertility, the genealogical spiral of lineage, and the labyrinthine descent into the cavern of Kibawa, keeper of the dead (see chapter 7). As suggested elsewhere (Roberts 1990a, 1991), the solar serpent Nkongolo and the lunar hero Mbidi form a dialectic as tightly interlocked as yin and yang, so these two explanations of cone-shell disks are not so much contradictory as they are complementary. See Heusch 1982 for extensive discussion of Nkongolo, the "drunken king."

9. Related use of mpande shells among Bwile people of southeastern Zaire is reported by Pierre Petit in chapter 7; related Tabwa ethnography is presented in Roberts 1990a and forthcoming(b).

10. W. G. N. van der Sleen offers a survey and brief history of these and other beads imported into central and east Africa from Europe and, earlier, from India (n.d.).

11. The relationship between loss of these beads and the royal court is not well documented; nor do we know much about "forfeiture of human beings" and domestic slavery among Luba, except during the late nineteenth century, when domestic and export slavery became virtually indistinguishable. The reference to muskets suggests that such retribution for a lost bead dates to the latter half of the nineteenth century, when muskets were introduced to inner central Africa by Nyamwezi elephant hunters and Swahili slavers; see chapter 7.

12. The editors have substituted "deferential gift" for the authors' term "tribute," due to confusion resulting from the application of that word during the colonial period. While subjected people might be obliged to give the king gifts as tribute, many others gave irregular gifts of deference, as a junior occasionally will to his senior kinsman. Belgian colonial authorities considered any and all gifts to be "tribute" "paid" by "vassals" to their "suzerain," and seized upon this as "proof" of a Luba "empire." See chapter 7 for further discussion.

13. The prefix *bi-* denotes a plural noun, with *ki-* its singular. To facilitate reading for those unfamiliar with Bantu languages, we have chosen to use the plural as a collective noun for both singular and plural.

14. Tembo and Twa are so-called "Pygmoid" peoples living among Luba and related peoples; see chapter 6, footnote 10.

15. Magical preparations of this sort are discussed in chapter 6. A shamanistic healer among neighboring Tabwa told Allen Roberts that these beads had similar use in the old days, but could not explain why they were so magically potent. He denied that the color or shape contributed to their power, but Roberts suspects that the blue/"black" association is significant, and that the shape may echo other objects such as bored stones used in important rituals concerning earth spirits. See Roberts 1984, 1993.

16. The full name of the chief to whom the necklace belonged is Kifwa Kabula Kisangani wa Nyemba, from the collectivity of Kifwa. The necklace is now in the Zairian National Museum, Lubumbashi.

17. Leopards are associated with authority figures throughout central Africa. The animal's most salient attribute is its utter rapacity, and it is by no means a coincidence that President Mobutu Sese Seko has adopted a leopard-skin cap as a symbol of his "Authentic" authority (as the term in quotation marks is peculiarly defined in Zaire). See Roberts 1995a:96–102 for a discussion of leopard symbolism and relevant bibliography.

18. The right/left divide has symbolic correlatives: auspicious/inauspicious, east/west, men/women. See Roberts 1991 for relevant Luba ethnography and bibliography.

19. "*Ina*" means "mother," and there is confusion in the account, for the eighth bead on the right side of the necklace represents the same figure, as a "female titleholder." For illustrative accounts of how confusing it can be to reconstruct memory of forgotten mnemonics, see Barth 1987 and Berliner 1981.

20. One is especially apt to hear such harsh value judgments when art forms seem most exotic and "unhealthy" to people outside a culture, as in the case of certain African genital operations in the opinions of some in the West (e.g. Mascia-Lees and Sharpe 1992). Such assessments are as ideological as are Africans' stubborn attempts to

protect body arts from outside interference.

21. Some proportion of Luba and other people of African heritage have a genetic propensity to produce keloids—an overabundance of scar tissue. In the case of a woman lacking this trait, incisions might be made several times to achieve the degree of prominence desired.

22. *Butanda* is held just prior to or at the onset of puberty. The purpose is to instruct young girls in various aspects of womanhood: menstruation, sexuality, childbearing, and domestic life. Details of butanda are discussed in Burton 1961:151, Kitenge-Ya 1976:169, Nooter 1991:241–43, and Petit 1993:209–37.

23. There are other applications of this principle among Luba and neighboring peoples. One is astronomy, wherein clusters of stars are discerned and lent meaning by naming. As when hunters blaze trees to find their way through a forest, astronomy picks out significant stars from the millions visible. Ideas and events are stellified in this way (Roberts 1981). Scarification works in a similar but opposite manner, for rather than providing too much information, the skin is a tabula rasa.

24. Scarification designs were borrowed, copied, and traded like currency in the Luba area. As Kitenge-Ya states, the best way to integrate oneself with the conquerer is to copy his physical and moral traits (1976:163). Kitenge-Ya claims that this phenomenon occurred among many "Luba-ized" ethnic groups, who simultaneously experienced tribalization and detribalization as they were absorbed into the sphere of Luba power. See chapter 7 for discussion of such "peripheral visions."

25. Archival photographs of women's scarifications from the turn of the century show that certain of the patterns bear a striking resemblance to those painted on the early-twentieth-century initiation murals discussed in chapter 4, which represent geographical landmarks, spirit sites, and other important *lieux de mèmoire*.

26. Missionaries and colonial "agents of civilization" have long discouraged scarification (Roberts 1988b). Today, many young Luba women living in cities refuse to be scarified, for they consider it an obsolete tradition that has no place in today's world. Middle-aged women who possess scarifications are sometimes embarrassed by them, and are reluctant to show them in public; but they often find it extremely amusing to discuss the subject. Elderly women usually have no shame regarding scarifications. They display them with pride, discuss them seriously, and consider them a critical aspect of womanly identity and status. As one old woman put it, "Unfortunately, young women no longer have scarifications: [as a consequence,] they are nothing."

27. This may explain why several chiefs and titleholders in the Kinkondja region own stools whose supports are sculpted not as full female figures but simply as breasts protruding from the column of the base.

28. Studies of secret knowledge in non-Western societies have shown that content is usually insignificant compared with the form that a secret takes and the social boundaries it creates (Murphy 1980 and forthcoming). Jan Vansina demonstrates this in his firsthand account of initiation among Kuba, for whom "the secret of their initiation was that they had none" (1973:304). The result is the discovery that knowledge can never be anything but partial and that truth is forever fleeting. Ultimate truth is always unattainable; the only thing that *is* attainable is the knowledge of its unattainability. See Nooter 1993.

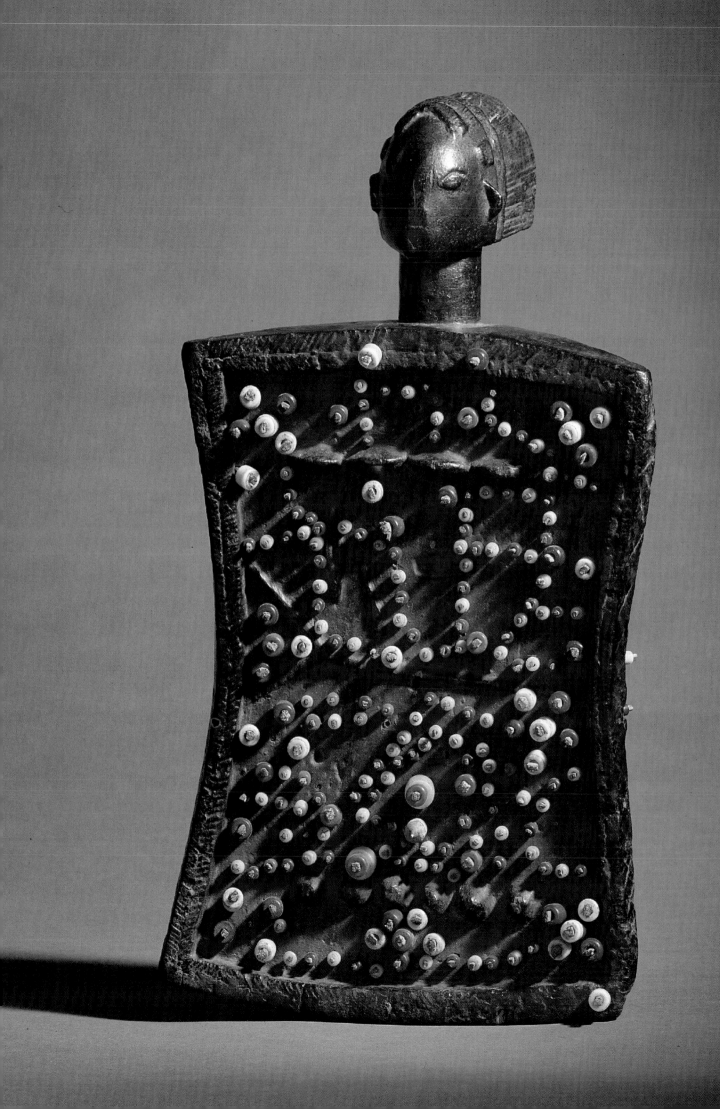

CHAPTER 4

Luba Memory Theater

Mary Nooter Roberts

When Guilio Camillo Delminio proposed his "memory theater" to the philosophical circles of Renaissance Italy, his idea was received with widespread enthusiasm. Yet, ironically, we have largely forgotten "the divine Camillo," as his admirers called him. Nonetheless, Camillo's memory theater and the "memory palace" of Matteo Ricci, his contemporary, provide instructive parallels with Luba models of memory. In particular, they demonstrate how a vast body of knowledge can be firmly fixed in "eternal places" by assigning images to loci easily grasped by memory.[1]

Camillo's memory theater, according to a contemporary, was conceived as

> a work of wood . . . marked with many images, and full of little boxes; there are various orders and grades in it. . . . All things that the human mind can conceive and which we cannot see with the corporeal eye . . . may be expressed by certain corporeal signs in such a way that the beholder may at once perceive with his eyes everything that is otherwise hidden in the depths of the human mind. And it is because of this corporeal looking that he calls it a theater (quoted in Yates 1966:131–32).

Similarly, Matteo Ricci created a memory palace through which hundreds of Chinese characters could be memorized. As he had it, "'To everything we wish to remember . . . we should give an image; and to every one of those images we should assign a position where it can repose peacefully until we are ready to reclaim it by an act of memory'" (quoted in Spence 1976:2).

The Renaissance memory theater shares a great deal with Luba mnemonic systems. Both represent "the order of eternal truth" through an architectural model capable of encompassing abundant knowledge in its spacious and varied layout. Both retain and engender knowledge that may be worldly or occult, elementary or sacred. Furthermore, both create memory places whose images have affective or emotional appeal, and are regarded as "inner talismans" with their own mystical efficacy (Yates 1966:154).[2] Increasingly widespread use of the printing press displaced humanist arts of memory in Renaissance Europe, and it was only in occult activities that they persisted or were taken up again. Similarly, the introduction of writing during the African colonial period lessened Luba dependence on oral narratives, except in contexts of arcane knowledge. But no writing system could or can reproduce the knowledge embedded and encoded—even imbued—within Luba memory arts and devices. The imageric and multireferential nature of that

CAT. 46: MEMORY BOARD OR LUKASA. LUBA, ZAIRE. Lukasa memory devices provide a framework for history while permitting multiple interpretations of it. Mbudye court historians associate memories with particular loci on a lukasa. Through a rectangular or hourglass shape that represents the Luba landscape, the royal court, human anatomy, and the emblematic royal tortoise all at once, the memory board embodies multiple levels of information simultaneously. Beads, coded by size and color, and incised or raised ideograms provide a means to evoke events, places, and names in the past. *Wood, beads, metal. H. 13.4 in. Susanne K. Bennet.*

Fig. 101: Early-twentieth-century members of the Mbudye Society. *Photo: Burton 1961: fig. 20.*

Fig. 102: The dress and adornments of late-twentieth-century Mbudye Society members show striking similarities to those in the early archival photographs. *Photo: Mary Nooter Roberts, 1989.*

knowledge requires such a mnemonic system, for its possibilities of combination and juxtaposition as well as for its hermetic potential.

Mbudye and Politics

What the Renaissance and Luba mnemonic systems do not share is political purpose: Camillo's memory theater was not explicitly political at all, while Luba mnemonics always have this dimension. Luba memory devices serve as a check and balance to political authority, and are actively used for political legitimation. The association called Mbudye was created to fulfill these needs, becoming "the memory of society" (figs. 101 and 102). Mbudye's primary role was to guard Luba political and historical precepts, and to disseminate this knowledge selectively and discreetly through ritual. Mbudye members were "men of memory" (Reefe 1981), serving as genealogists, court historians, and the "traditionalists" of Luba society (see Le Goff 1992:56).

If Mbudye institutionalized memory itself, and the processes through which history was made, maintained, and transmitted, it did so through visual memory devices (fig. 103) that encode the semantic principles underlying most other Luba mnemonic arts, such as staffs, stools, bow stands, and axes. The site-specific wall murals and earthen thrones of Mbudye lodges, and the complex memory boards called "lukasa," were compelling mnemonic devices for proverbial instruction, narrative recitation of history and ideology, and panegyrical performances to honor a king and his retinue. Association members also staged dances for public entertainment, some of which reenacted the origins of kingship (fig. 104). Certain dances further incorporated beaded headdresses and costumes that were decorated with some of the same mnemonic patterns of Mbudye wall murals, clay thrones, and memory boards.

In each of these expressive forms, memory was structured around spatial principles. Whether through the narration of two- and three-dimensional art forms, the recitation and performance of praise songs, or the kinetic arts of dance, Mbudye memory phenomena were devised and oriented around architectural models, place names, and other topoi that facilitated memorization. Data presented here will show how and why Luba historians selected lieux de mémoire for the facilitation of memory, and how the maps of memory as conveyed through initiations might be seen as a Luba model of the mind itself.

Mbudye as Performance

Mbudye memory rituals and visual mnemonic devices are devised to teach and encode an "official" history of the Luba state, while at the same time subverting historical absolutism by allowing for transmutation and refabulation with every narrative telling, from one political arena to the next. As discussed in the introduction to this book, Pierre Nora has taught us that history and memory are in eternal contention: history always seeks to suppress memory, memory forever undercuts the presumptuousness of history. In short, they are dialectically interdependent and in creative tension.

Mbudye memory devices assist memory, not through word-for-word mnemonic reproduction, but rather through a "generative reconstruction" of the past. And the generation is always the "now" of the narration. As Jack Goody further emphasizes, "the support of rememoration is not situated on the superficial level of word-for-word, nor on the level of 'deep' structures that many mythologists discern. . . . On the contrary, it seems that the important role is played by the narrative dimension and by other structures at the level of particular events" (1977:34). Particular events are performed; performance is theater; Mbudye members are actors on a stage of memory.

Don Camillo excluded the performative dimension from his "theater." But not only is the Luba mnemonic system oriented around the architectural features of a theater (in this case the court), it is also a field of intense performative activity. In this essay, the word "theater" is employed in full awareness of all the drama, artifice, and actor/audience dimensions that it commonly implies. As discussed in the introduction to this book, Luba notions of memory are built upon the dialogic qualities of orality and the dialectics of litigation and argument, and also suggest verbs of active chance—verbs of game-playing, hunting, and bricolage. Memory demands full-fledged perfor-

mance, and the narrative readings, songs, and dances of Mbudye demonstrate the extent to which its members act out the dramas of memory.

The Mbudye Association in Luba History

In his landmark work on central African history, *Kingdoms of the Savanna* (1966), Jan Vansina postulates that there was an institutional check-and-balance system in Luba politics. Mbudye fulfilled this role. It was so highly secretive, though, that its full significance eluded even the most observant amateur ethnographers among early missionaries and colonial administrators. Through the late nineteenth and early twentieth centuries, there was an Mbudye chapter in every region where there was a prominent Luba chieftaincy or kingship, for the two institutions were interdependent. In Pierre Colle's words, Mbudye was "the national society par excellence" among Luba (1913 2:568), and colonial statistics confirm that large numbers of people were Mbudye members in the early part of this century (Henroteaux 1945:98). Luba today state that Mbudye is as old as kingship itself, and that the association was imported from somewhere else, but both of these positions reflect current ideology. In the past and still, the origins of Mbudye have been intensely debated, for accounts of origin and patronage created during the last century are themselves vested with political interest. To whom the association is credited and when it was founded involve issues of legitimacy, authenticity, and proprietorship; and the variety of accounts demonstrates that different explanations were and still are invented to reinforce local claims to power. As one might expect, memory of the memory society is subject to constant negotiation. Memory is timeless and frameless, and when pinned down in particular histories, other particular histories will challenge.

Some early missionaries and colonial officers referred to Mbudye in their monographs or territorial reports, and several devoted entire articles or chapters to this and other Luba secret institutions. Most of these observers failed to grasp the real purpose and nature of Mbudye, however, and the extent to which it shaped Luba politics.[3] The historian Thomas Reefe (1978, 1981) was the first author to emphasize this aspect of the organization.

Through their initiation rites, Mbudye members acquire supernatural qualities and powers that allow them to arbitrate disputes and settle litigations (Reefe 1978:111). Although precolonial Luba rulers wielded far more overt political power than Mbudye, they nevertheless were subject to the society's reprisals. The association could expel a chief from office if he abused his authority, or acted against the will of its members. The counterpoint of these two institutions was critical to the internal balance of power, and may well have been influential in the formation and expansion of the Luba state (Reefe 1978:111, 1981:46–48).[4]

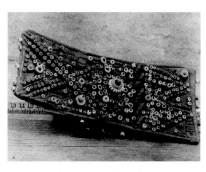

Fig. 103: Lukasa memory board from the early twentieth century. *Photo: W. F. P. Burton, 1927–35. Courtesy of the University of the Witwatersrand Art Galleries, BPC 04.48.*

Fig. 104: Mbudye dancers from the late nineteenth or early twentieth century. A line of men dressed in wide skirts, probably made from spotted genet or serval skins and fiber, dance to the accompaniment of two drums. In dress, composition of performers, orchestra, and even choreography, the scene is similar to Mbudye performances of the late twentieth century. *Drawing: Léon Dardenne, 1865–1912. Courtesy of the archives of the Royal Museum of Central Africa, Tervuren, Belgium, A.221 R.G. 264. Gift of the Ministry of the Colonies, 1911.*

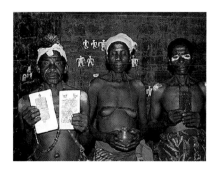

Fig. 105: High-ranking Mbudye titleholders during an initiation proceeding. Standing against the painted walls of the initiation house, they hold mnemonic gourds and a lukasa board, as well as an image, brought by the photographer, of a lukasa now in the West but originally from their region. *Photo: Mary Nooter Roberts, 1988.*

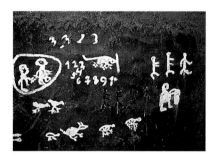

Fig. 106: Mural in an Mbudye initiation house. The blackened figures refer to the *ngulungu*, or uninitiated people, who are considered ignorant; the whiteness of the other figures refers to the clairvoyance that comes with initiation into the esoteric secrets of Luba royalty. *Photo: Mary Nooter Roberts, 1988.*

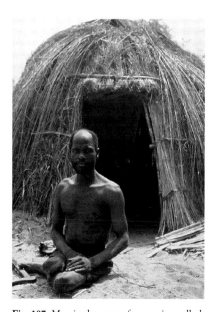

Fig. 107: Man in the state of mourning called "*kusubila*," during which, to express the sadness, loss, and darkness of this state, he is discouraged from washing and attending to normal hygienic practices. The first stage of initiation into the Mbudye Society is a metaphor for the symbolic death associated with kusubila. *Photo: Mary Nooter Roberts, 1987.*

To ensure the allegiance of Mbudye members, Luba rulers were themselves required to undergo Mbudye initiation during their investiture rites. A king or chief who did not submit to Mbudye was considered "illegitimate," and his authority was not recognized. In addition, initiation was a prerequisite for all men and women who might be seeking high office in the ranks of Luba royalty, including officeholders, subchiefs, spirit mediums, diviners, and healers. Every branch of royalty, no matter how specialized, participated in and was subject to rules and regulations that assured institutional efficacy and access to the spirit world. Mbudye was responsible for ensuring respect of these rules. As one person explained, "Yes, they came, those who know how to initiate people, because initiation is to show or teach the prohibitions of all sorts, some of which apply to diviners and others to chiefs. Should they disregard these restrictions, they will not sustain their authority for long."

Vestiges of Mbudye still exist, and the author was initiated into its ranks. The luster, scope, and power of Mbudye have been greatly diminished, though, as the chiefs Mbudye once served are now servants to the central government, and the practices of Mbudye have become largely irrelevant to the stress of coping with everyday life in Zaire. Still, Mbudye memory persists, as do some of its practices. Here is its role in the making of Luba histories, then and now. Unless otherwise indicated, the ethnographic present refers to the late 1980s, when I conducted research among Luba.

Initiation and the Transmission of Memory

Mbudye initiation usually involves four stages, the first three of which prepare the novice for the elaborate rites and rigors of the fourth stage, when use of the lukasa memory board is learned (fig. 105). The progression through each entails symbolic death and rebirth. Not coincidentally, the "death" of the initiate is cast in the "blackness" of forgetting. Through such "deaths," one abandons and forgets one's earlier identity as an *ngulungu* or "uninitiated person," to embark on the path to enlightened (and so "whitened") knowledge (fig. 106). "Ngulungu" literally refers to the bushbuck (*Tragelaphus scriptus*). This small antelope is "truculent" and "arrogant," for it will bark at and even charge a farmer while eating his own crops. Presumably, those not yet initiated to Mbudye are deemed as brutish as bushbucks (Roberts 1995a:54–56).

As the stages of initiation unfold, the lieux de mémoire of Luba royal history are taught and committed to memory through various symbols of initiation, and an initiate's body becomes a locus for memory through spirit possession. Spatial metaphors are constructed, becoming progressively more complex, spiritually charged, and arcane with each stage. At the same time, the visual didactics that are used during the course of the initiation become less representational and increasingly abstract.

The first requirement of the novice is "to drink into the association" (*kutoma mbudye*). The initiate is presented with a beverage that contains a precious stone bearing the same name as the Mbudye word for nonmember, "ngulungu." The consumption of all contents except the stone signifies the initiate's absorption of the society's secrets while leaving the uninitiated behind.[5] The novice may faint—a "death" in its own right—after which she or he is transported to a secret meeting house. Upon regaining consciousess, the initiate is covered with black ash or soot to indicate mourning. Among Luba, mourning (*kusubila*) is an extended period during which people do not bathe or attend to other ordinary hygienic and cosmetic practices. Such forgetful abstention is a way to frame and thereby emphasize their grief and affliction at a time of loss. Once blackened, the novice is called "*kafita*" or "*mudye wa mufitu*," a reference simultaneously to sadness, grief, obscurity, lack of status, and, most important to our discussion, to oblivion, oblivis-cence (forgetting), and the sense of loss associated with leaving the past behind (fig. 107).

During this first stage, a candidate assumes the identity of Nkongolo Mwamba, the "drunken king" of the Luba epic. In Makwidi village, Mbudye members describe the process of rendering the novice unconscious as *kuhehela Nkongolo*, "to breathe or blow the rainbow" onto the novice, because "Nkongolo" refers to both the king and an immense serpent that breathes forth the rainbow to "burn" the rains and desiccate one's crops (see chapter 7). This identification refers to

the cruel, incestuous king who represents death, loss, and infertility (Heusch 1982), in the same way that the novice has been reduced to a state of death, darkness, and mourning. Yet even as the novice is identified with Nkongolo, she or he is painted black, the color of secrecy, potency, and promise (Roberts 1993). "Black" is insight and invisibility, and if this first stage of Mbudye initiation is an effacement or erasure, it also sets the initiate on the path to new identity, intellect, and spiritual grounding, through models of behavior that—paradoxical as it may seem—include elements of philosophy and praxis embodied by both the "black" culture hero Mbidi Kiluwe and the "red" antihero Nkongolo.

A Path of Sculpted Spirits

The word "*kusubula*," the name of the second stage of Mbudye initiation, literally means "to put an end to mourning by lifting taboos," with a further sense of ritual purification (fig. 108). In Mbudye initiation, "kusubula" also refers to instruction of the novice into a new way of life, with its own set of rules and regulations and its own system of procedures relating to rank and title. It is in this second stage that space begins to shape memory and articulate precepts of power. The novice is led down a path by a man holding the title "Kamanji," who wields an ax to define the path with authority and whose role is to show the way while assuring the initiate's security and protection. The path may be a tracing in the sand or an actual route, and is called "*musebo*"—a road or passageway demarcated for the first time with a hoe or an ax. The path is a recurring motif in Luba royal symbolism, as well as a common feature shared by memory and place, where pathways cut "in and through their midst" (Casey 1987:204).

In the vicinity of Kabongo, the titleholder who performs the task of Kamanji is known as the Mukanda wa dishinda, "the letter [or panel, billboard, or indicator] of the road."[6] Whenever Mbudye members travel, he precedes them with his ax and makes blazes, tracks, and traces in the path to create and show the way. "*Kafùndanshi*" is the name for this ax, which is used to mark the path that leads to civilization.[7] A chief employs an instrument of the same name to define the boundaries of his lands, and the verb from which this noun is derived, *kufùnda*, "to inscribe," has been extended to mean "to translate, or to write" by contemporary Luba (Van Avermaet and Mbuya 1954:169). The Mukanda wa dishinda, then, is the "letter," his ax the tool of inscription, his message memory.

The path is enhanced on both sides with signs, some of them in the form of sculpted wooden figures representing the Mbudye hierarchy and its tutelary spirits (fig. 109). Combined with proverbs, these stations along the way express principles of Mbudye ethics and philosophy, such as cooperation among members, respect for authorities, and the solemn oath of secrecy. Sculptures are no longer used these days, but they are remembered by elderly Mbudye members and described by early missionaries to the area. Writing in 1930, W. F. P. Burton reported "a row of *bankishi* human figures round the base of a tree, and pieces of cloth tied in a circle, said to be 'the capital of the chief,'" or a *kitenta*, as discussed below. "Sometimes these *masubu* objects are beautifully carved, and there are a few sets of really rare ones, shiny with age and valuable works of art. . . . Other sets are rudely carved in light wood, for altogether there are about eighty of them. . . . Nowadays some are merely crudely fashioned in green banana stalk and grass" (1930:231–32).

The large number of sculptures used in Mbudye initiation testifies to the many leadership titles and roles within the association. Each Mbudye chapter is an autonomous unit, with its own hierarchy and administrative infrastructure. Mbudye's titles are critically important to an understanding of the society's political significance, for many of them are also found in the king's coterie of dignitaries and counselors.[8] Every Mbudye initiate is expected to learn and memorize this hierarchy, which is crucial to the regulation of power. As we shall see, these constellations of sculpture are represented and remembered through the beads and other ideograms of the lukasa memory board.

Each title is represented by a sculpture because it is never possible to assemble every member for each initiation, so the sculptures serve as surrogates, familiarizing the initiate with Mbudye's

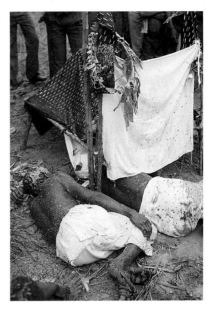

Fig. 108: Following the period of kusubila or mourning, Luba practice *kusubula*, the lifting of the mourning period. Here, a man's widows enact the ritual that takes them from kusubila to kusubula, which includes the breaking of pots and the spreading of beer all around the shrine where the clothing and relics of the deceased are worshiped. The second stage of Mbudye initiation metaphorically signifies the emergence from the darkness associated with kusubila, as the initiate leaves his previous identity behind and enters a new stage of enlightened understanding. *Photo: Mary Nooter Roberts, 1988.*

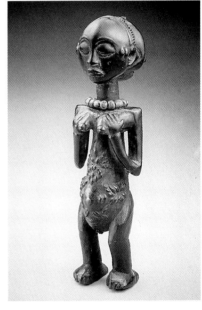

Fig. 109: Standing female figure of the type once used in Mbudye initiation rites to represent the myriad titles and officeholders in the Luba royal hierarchy. H.: 28.5 cm. Private collection. *Photo: courtesy of Louis de Strycker.*

CAT. 47 (OPPOSITE): HERMAPHRODITE FIGURE IN BULI STYLE. LUBA-IZED KUNDA, ZAIRE. Concepts of gender and power are inextricably linked in Luba thought. Male and female elements merge in the exercise of leadership, where men enact the visible, overt side of power and women its covert, secret side. Gender ambiguity pervades Luba royal prerogative, where kings are incarnated after death by women, are depicted on insignia as female figures, and wear women's coiffures on their enthrone-ment day. Women's ability effectively to contain spirit and to guard royal secrets accounts for their crucial roles in dynastic history as political and religious mediators, and in visual representation as embodiments of spirit and cosmological order. *Wood. H. 11.8 in. Private collection.*

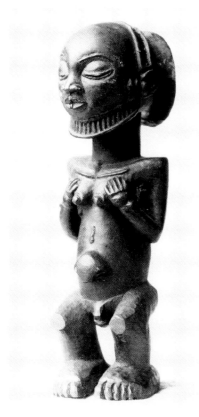

CAT. 48: HERMAPHRODITE FIGURE. LUBA, ZAIRE. Though most Luba sculpture is female, some figures are ambiguously gendered. This one is both male and female, with a penis, a beard, breasts, and gestures usually associated in Luba art with women, such as hands to breasts. In Luba sculpture, hermaphrodism expresses the dualistic nature of power. As one Luba person put it, "Luba men are chiefs in the daytime, but women are chiefs at night." This sculpture may have been used in Mbudye initiations to represent the members of royal hierarchy, with their titles, roles, and emblems. *Wood. H. 8.5 in. National Museum of Natural History, Smithsonian Institution, Washington, Gift of Mrs. Sarita S. Ward, Inv. no. 323.300.*

structure. As an elder explained, for every title there is both a spirit and a person—the spirit embodied by the sculpture, and the actual person who holds that title. Though the sculptures depict both male and female spirits, the gender of the figures is almost always female, for reasons explored in the previous chapter (cat. nos. 47 and 48).

The figures often have holes in the the base or between the legs to hold an iron rod, so that they can be planted upright in the ground next to the path of initiation. Having passed through a corridor of these figures, novices come to the lukuka—a cord or cloth that bars the path to the court where the highest-ranking titleholders are assembled in the secret meeting house. "Lukuka," as we saw in chapter 3, is also the name of the beaded emblem worn across the chests of female Mbudye members and spirit mediums. Kamanji crosses the barrier to inform another titleholder, the Twite, that the novices have arrived. The Twite instructs Kamanji to proceed with the explana-tion of all that lies along the path. When finished, he should bring the initiates back to the court.

Kamanji begins the exegesis of each of the signs, including the proverbs associated with them. In addition to figurative sculptures, the signs include natural objects like twigs, stones, leaves, and roots that are bent, strung, or positioned in significant ways. Some of the proverbs elicited by the signs reinforce the order of hierarchy and respect for superior rank. Others refer to the acquisition of the esoteric knowledge that distinguishes Mbudye members from uninitiated people. Finally, a number of proverbs concern Mbudye solidarity (Nooter 1991:103–5). The purpose of this second stage, then, is to establish the principles of social order, political hierarchy, and stratification that characterize Luba royalty. The placement of mnemonic signs along a conceptual or actual path helps the initiate to memorize the order and hierarchy that underlie the Luba royal court. As Frances Yates has suggested, such a method "ensures that the points are remembered in the right order, since the order is fixed by the sequence of places in the building" or, in this case, along the path (1966:3).

Breaking through the Sky

Only those possessing the financial means and aspiring to Mbudye leadership may "climb the platform" to the next stage of initiation, called "*lukala,*" from the word for a "threshold, earthen mound, ladder, [or] degree" (Van Avermaet and Mbuya 1954:220). "To climb the ladder" is to become an Mbudye dignitary. Lukala ritual is performed in a specially designated house with a raised step in the entrance. To cross this threshold signifies the novice's progress toward higher learning and leadership status (see Roberts forthcoming 1997).

The content of lukala's teachings is more sophisticated than previous stages of initiation: while the principles of secrecy, solidarity, and respect for rank continue to be reinforced, here the spiritual precepts of Luba political organization are also learned. In particular, initiates become familiarized with the guardian spirits of Luba sacred kingship. This precious information is encoded in wall murals of abstract and figurative signs depicted on all the interior walls of the house where lukala is performed (fig. 110). Burton wrote that "rough maps are chalked on the wall. The whole country from the Lualaba to the Sankuru is marked, with the chief lakes and rivers, the noted abodes of spirits, and the capitals of the various chiefs. The initiate is stood before the wall, and questioned as to where each river flows and the names of the tutelary spirits of each locality" (Burton 1930:236).

At this stage, Mbudye didactic symbols shift from the three-dimensional figurative sculpture and natural objects of the second initiation phase to two-dimensional pictorial representations that are more reductive in form, and far more enigmatic in their rendering. A turn-of-the-century Mbudye mural photographed by Burton consists entirely of geometric motifs, with an emphasis on cross shapes, spirals, radiating circles, and step forms (fig. 111). Nowadays there seems to be a shift to more obvious forms of representation: murals from two houses photographed by the author in the late 1980s include stick-figure depictions of humans and the recognizable forms of animals, musical instruments, geographical features (lakes, mountains, and caves), and elements of the cosmos (sun, moon, rainbow, and stars) (figs. 112–114).

The paintings in both cases are in white on black, except when the figures are meant to depict

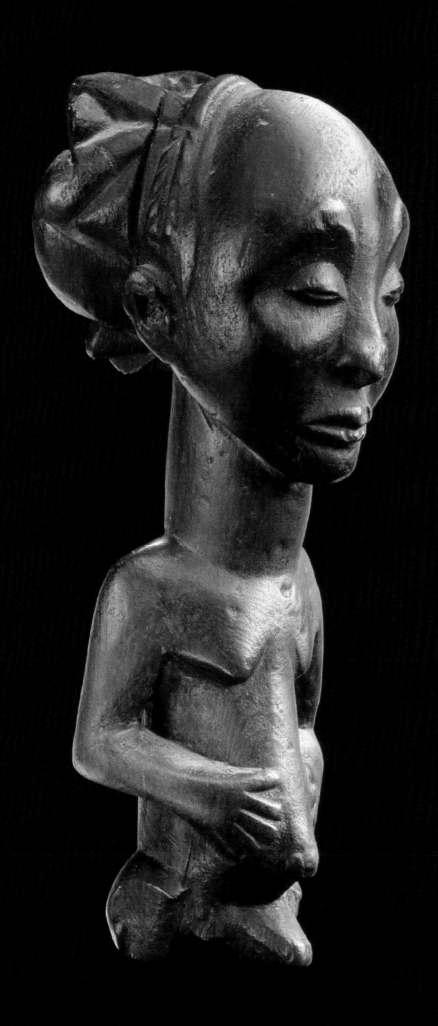

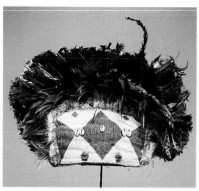

CAT. 49: HEADDRESS. LUBA, ZAIRE. An nkaka headdress is worn by all ritual specialists who undergo possession, and the purpose of this colorful rectangular headband, with its juxtaposed isosceles triangles and lozenges, is to take hold of the spirit as it mounts the diviner's head and to contain, control, and protect it. Luba sources say that an nkaka headdress encrypts esoteric signs within its beadwork, and all royal officeholders initiated into the highest levels of the Mbudye Association should be able to recite the proverbs linked with each of the coded patterns of color, which usually relate to principles of royalty also represented on the lukasa memory board. Some Mbudye members state that the beaded lozenges refer to "lakes" or spirit capitals, and that the ranks of Mbudye members can be determined by the number of lozenges on the headdresses. *Beads, leather, cloth. H. 21 in. Virginia Museum of Fine Arts.*

CAT. 50 (OPPOSITE): BEADED MASK. TABWA, ZAIRE. This mask, collected on the northern end of Lake Mweru, may have been associated with the Mbudye Association, for its iconography is an elaboration of the mnemonic beaded headdresses worn by Mbudye members and related Bilumbu royal diviners during states of spirit possession. The headdresses are called "nkaka" because their beaded triangles are related metaphorically to the similarly shaped scales of the nkaka, or pangolin, and to a scarification pattern of the same name. The spiral at the center of this mask's forehead represents the eye of Kibawa, an earth spirit whom eastern Luba associate with the culture hero and bearer of sacred royalty, Mbidi Kiluwe. *Glass beads, leather, rooster feathers, monkey pelts. H. 35 in. The University of Iowa Museum of Art, The Stanley Collection, Inv. no. CMS 656.*

the novices in the first initiation stage, when they are kafita, or blackened, to signify ritual death and oblivion (see fig. 106). The paintings cover every supporting wall, including those of the outer entrance, where Kibelo and Mashinda, guardians of the meeting house, are portrayed (figs. 112–114). Narrative exegesis of the murals during the initiation by senior officials traces the migration of Mbudye adepts from their place of origin, and documents their passage through initiation stages. Just as the sculpted figures in the kusubula stage were associated with proverbs, so the wall murals disclose their significance through spoken maxims. Some of these refer to the regulations and precepts of Mbudye membership, others to episodes in the Luba Epic. Still others familiarize the novice with the spirit pantheon, and, lastly, some reflect the thirst for power associated with the acquisition of knowledge.

During or just after the interpretation of the wall maps, each initiate adopts the name and supernatural qualities of a particular spirit. Twinned tutelary spirits (*vidye*) of Mbudye inhabit sacred lakes, and include Lubaba and Shimbi, Banze and Mpange, Kiala and Yumba, and Dolo and Kisula. Once the person's spirit pair is chosen, the initiate will be possessed by those spirits at every Mbudye assembly, including funerals, initiations, dance performances, the investitures of chiefs, and the monthly celebration of the rising of a new moon. It is only after achieving such ecstasy that an initiate acquires an Mbudye title. Then he or she dons a sacred beaded headdress called "nkaka" (cat. nos. 49 and 50). Chalk is applied halfway down the face and on the chest and arms, to reinforce the visual metaphor of enlightenment (*kutoka*) and to indicate that this Mbudye member has achieved a title and a spirit identity (fig. 115).

One can speculate about the relationship between the geometric form of older mural paintings and their use as both a memory device and a function of spirit possession. Recent neurological research on trance suggests that in the early stage of dissociation, one sees "entoptics"—luminous pinpoints, zigzags, and grids that increase in frequency and intensity until the mind loses direct control (Lewis-Williams and Dowson 1989). The mind seeks to construe what it is experiencing, and finally memory takes over and gives elaborated narrative form to this sensory experience (Roberts 1995a:76–77). The geometric patterns on the painted murals and clay thrones of Mbudye are strikingly similar to such entoptic visions, and may provide an explanation for the origins of the signs that have become Luba mnemonic forms.[9]

Memory Thrones

In addition to the progression from three-dimensional to graphic signs and the use of spatial relationships to suggest hierarchies, certain kinds of "furniture" become important at this third stage of Mbudye initiation, particularly associated with seating privileges. While initiates who have completed the first two stages have the right to sit on one kind of mat, those of lukala may sit on a different sort, made from a specific marsh plant. Kikungulu, the association leader, is entitled to sit on four mats at a time, while high-ranking titleholders may sit on two or more mats (Henroteaux 1945:99). Mats and their named woven patterns are key symbols in the language of Luba power, and recur in Luba art and ritual as indicators of rank and regulation (cat. no. 51).

Certain Mbudye meeting houses include one or more large earthen thrones called "kikalanyundo," constructed in the center of the main court where the most senior officers and wives take their places. These thrones conform to the definition of "lukala" itself: a mound of earth or a platform. Burton (1930:232) saw such a throne in the vicinity of Mwanza, reserved for Kikungulu. Burton's photograph shows schematic pictographs representing the Mbudye hierarchy divided into triangular and lozenge-shaped regions around the perimeter of the kikalanyundo (fig. 116). A colonial administrator saw a different throne consisting of two superimposed cones surrounded by four smaller thrones. "The most elevated throne is that of Musenge . . . to the left, there are the thrones of Bulunga and Kalemba, and to the right, those of Kaloba and Basokele. In seance, . . . these male titleholders sit on the same throne back to back with female counterparts of the same title and rank: men face towards the front, and women face to the back of the room" (Joset 1934:3).

These Mbudye thrones closely resemble the shape and design of a kitê magical mound pho-

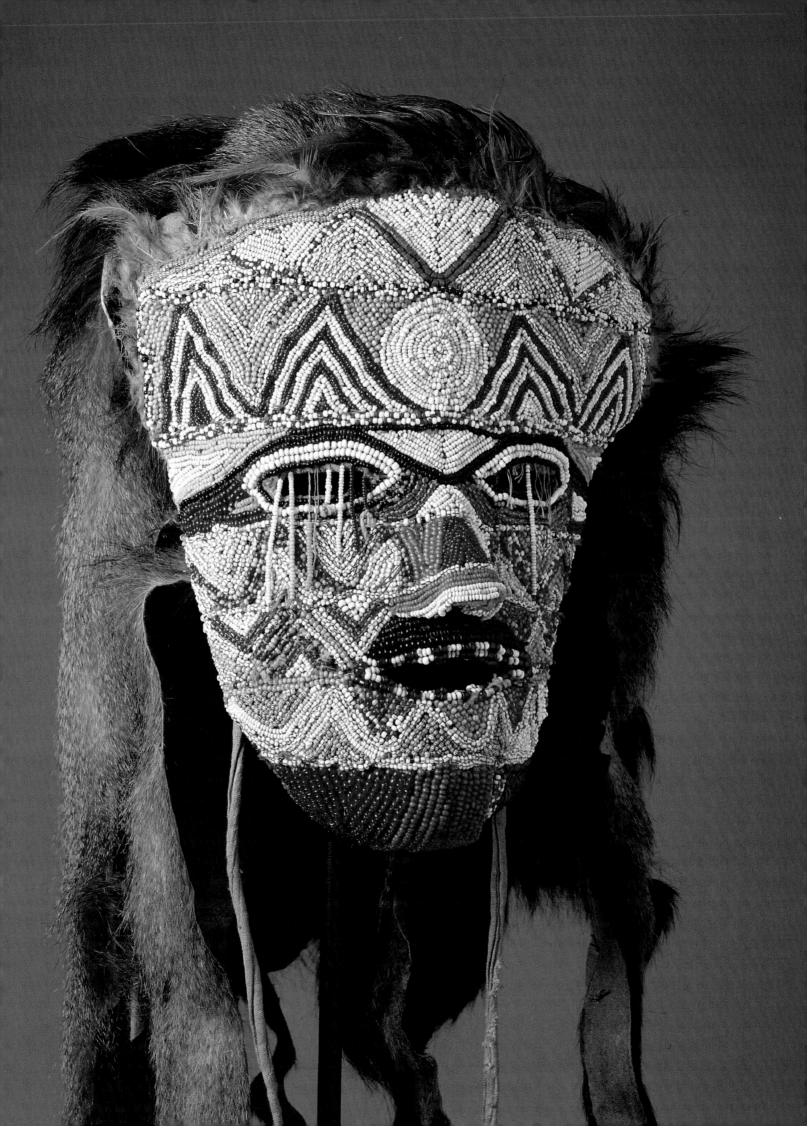

Fig. 110: Mural in an abandoned Mbudye initiation house, showing only geometric lines, dots, and other patterns similar to the entoptic signs seen during spirit possession states. *Photo: Mary Nooter Roberts, 1988.*

Fig. 111: Mural inside an Mbudye initiation lodge in the late nineteenth century. The profusion of geometric motifs and the lack of figurative elements suggests that murals from the period may have been entirely nonfigurative. *Photo: taken on the Charles Lemaire expedition to the Lofoi in 1898. Courtesy of the Section of Ethnography, Royal Museum of Central Africa, Tervuren, Belgium, E.PH. 5843, cl.933.*

tographed by Burton in the 1930s (see Introduction: figs. 17a,b). Kitê mounds contain potent medicines, and are painted with ideographs; when it rains and these are absorbed by the earth of the mound, and when they are repainted the next year, the potency of the magic inside the kitê is enhanced. It is important to recall here that the word "kitê" is derived from the same radical as "lutê," "memory" (see Introduction). In the case of the pictographic mounds, the knowledge encoded on the surface is absorbed again and again until the throne itself becomes a potent shrine of memory, embodied and contained. The ideographs painted around the surface of the kitê mound are strikingly similar to the motifs chalked on the kikalanyundo thrones and Mbudye wall murals, and probably function similarly, not just to encode memory, but to activate memory to purposeful efficacy.[10]

As William Dewey and Terry Childs have explained in chapter 2, the word "kikalanyundo" refers to an anvil. Memory itself is forged on this throne. "To climb the platform" or "to break the veil" in the lukala stage, then, has multiple levels of meaning. On one, "lukala" refers to the newly titled member's privileged access to the elevated status of the earthen thrones, indicating superiority over lower-ranking members who sit on leaves, mats, or animal skins. On a more profound level, lukala ritual provides a metaphor for the initiate's ascent into spirit possession and its state of grace, following rigorous memorization of the royal principles taught through the ideograms of the murals and thrones.

As a reference to this spirit possession, the initiate is presented with a last painted symbol, a red circle. The accompanying proverb refers to someone who has "broken through the sky" to see beyond the place where thunder and lightning strike. In other words, when an Mbudye initiate attains the level of lukala, she or he is no longer constrained by humanity's profane limitations, and can aspire to knowing all that can be known. Only in this transfigured state can the initiate begin to absorb and memorize the codified secrets of the lukasa memory board.

The Lukasa Memory Board

"Lukasa" refers to "rank, social position, or title of negotiability" (Van Avermaet and Mbuya 1954:235). Lukasa is the highest stage of royal initiation proceedings, and is attained only by a few members of the three principal branches of Luba royal culture: kings, diviners, and Mbudye members. Lukasa is the apex of esotericism, and involves full revelation of the precepts and principles believed to have been handed down by Mbidi Kiluwe.[11] Relationships between visual and verbal

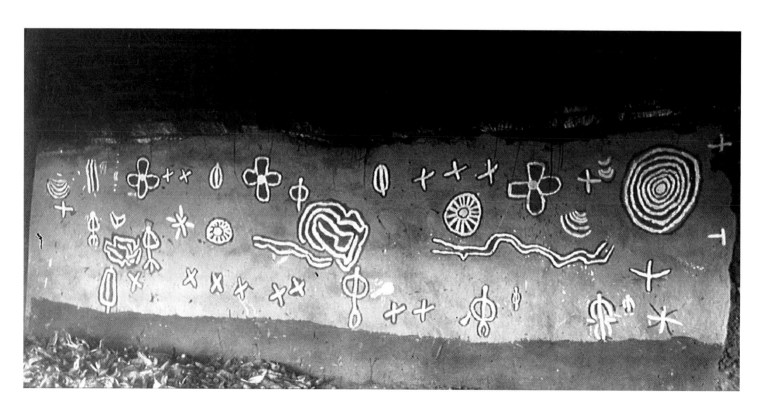

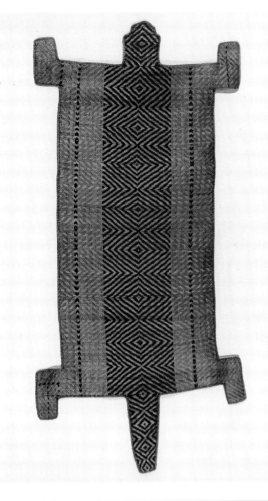

CAT. 51 (LEFT): MAT. LUBA, ZAIRE. Despite the central role of woven mats in everyday Luba life, and also in ritual and ceremonial contexts of the royal court, these nonfigurative Luba objects have rarely been exhibited or published. The simple, elegant designs seen on mats share the same semantic world with lukasa memory boards, and are also mnemonic. Indeed the design of this mat is nearly identical to that on the back of many lukasa memory boards and to the coded geometric regions of the nkaka beaded headdresses worn by royal officials when possessed by a spirit. This mat is exceptional for its zoomorphic form, and may have been used in the context of Mbudye initiation rites. *Woven fiber. L. 89.6 in. Burton Collection, Social Anthropology Department, University of the Witwatersrand Art Galleries, Johannesburg, Inv. no. WME/086.01.*

CAT. 52: MEMORY BOARD OR LUKASA. LUBA, ZAIRE. This unusual lukasa shows a full figure seated on the surface of a board inscribed with ideograms, in addition to a finely sculpted head emerging from the top. It is the most sculptural lukasa known. Why the figure is positioned in this way is not clear. The ideograms are also more explicit than those usually seen on lukasas; they resemble the sticklike figures, both human and animal, depicted on the walls of contemporary initiation houses, as well as the figures painted around the sides of the *kikalanyundo* earthen throne used during initiation rites and the kitê shrine used to contain medicinal substances. *Wood. H. 11 in. Linden-Museum, Stuttgart, Inv. no. F 52561 L.*

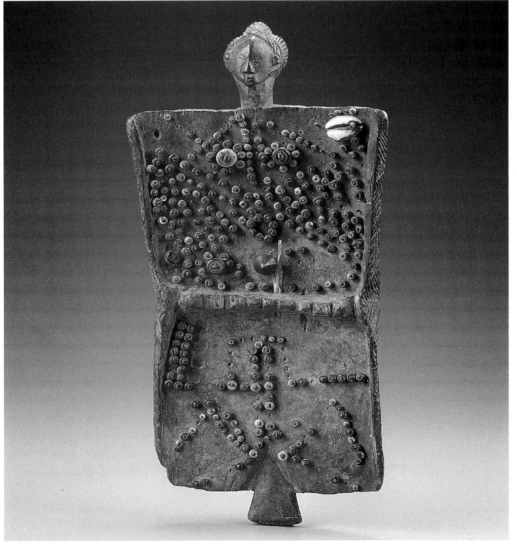

CAT 53: MEMORY BOARD OR LUKASA. LUBA, ZAIRE. Memory boards with both a head and a tail were described by some Mbudye members as representations of the crocodile, and signify the interdependence of Kikungulu (leader of the association, represented by the head) and Kaloba (owner of the land, represented by the tail). The dynamic between land chiefs and tenants (royal officials) was a crucial aspect of Luba political diplomacy. This board, which shows signs of extensive use, also possesses an iron pin to signify the kingdom for which the board was made, and a cowrie shell to designate another important spirit capital to which the kingdom was connected. *Wood, beads, metal. H. 12 in. Private collection, Brussels.*

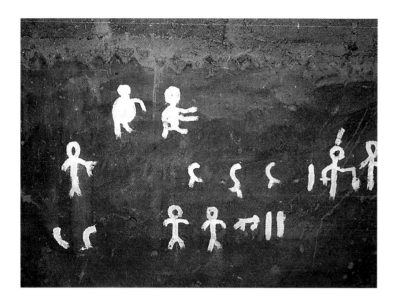

Figs. 112–114 (left): Series of murals covering every interior wall of a contemporary initiation house. The images combine human stick figures, figures of animals, elements of the cosmos (sun, moon, stars), and even numbers. Initiates stand before these walls and are made to memorize the multilayered messages inscribed in the pictorial scenes. The images refer to the origins of Luba sacred kingship, to the dwelling places of spirits throughout the landscape, and to the migrations taken by different groups to arrive at their present locales. *Photo: Mary Nooter Roberts, 1988.*

Fig. 115 (right): Mbudye initiate with chalk smeared on lower half of face and arms. The progressive chalking of the head and torso indicates how many levels an Mbudye initiate has passed through, the highest grade being marked by total covering of the face and chest. *Photo: W. F. P. Burton, 1927. Courtesy of the Section of Ethnography, Royal Museum of Central Africa, Tervuren, Belgium.*

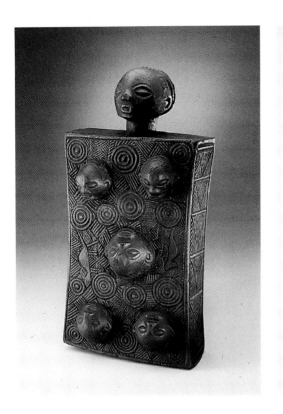

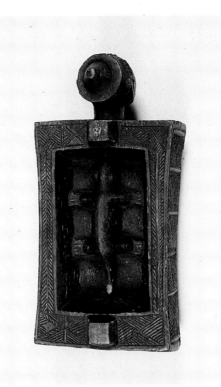

CAT. 54 (LEFT): MEMORY BOARD OR LUKASA.
Luba, Zaire. The dominant features on any lukasa memory board are the kitenta spirit capitals commemorating the reigns of particular kings. Sometimes shown by metal pins, cowrie shells, or dominant beads, here they are rendered as sculpted human heads, creating focal points of memory on the landscape of the board. A kitenta can refer specifically to the burial place of a king, but more generally it designates the elevated seat or resting place of a spirit. Certain heights, like the summits of mountains, are thought to be the spirits' heads. *Wood. H. 16 in. National Museum of Natural History, Smithsonian Institution, Washington, Gift of Mrs. Sarita S. Ward, Inv. no. 323.440.*

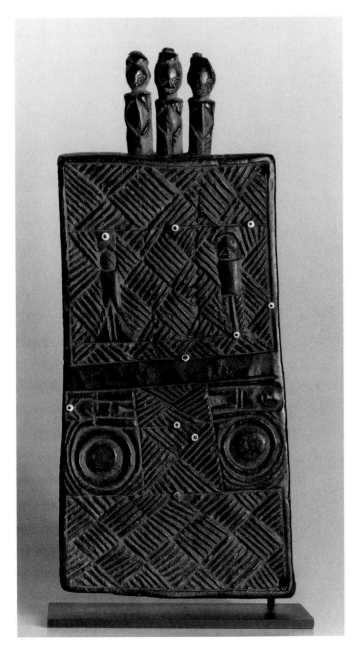

CAT. 55 (LEFT): LUKASA OR MEMORY BOARD.
Luba, Zaire. It is rare to see a lukasa with three figures protruding from the top, as here. Mbudye members explain that the figures allude to the head of the Mbudye Association, Kikungulu, flanked by his two senior officers, Tusulo and Kipanga. This lukasa is also larger than most, and has a smaller number of beads. The two circles carved into the wood may represent kitenta spirit capitals, and the incised human figures may refer to specific culture heroes of the Luba Epic. *Wood, beads, tacks. H. 16 in. The University of Iowa Museum of Art, The Stanley Collection, Inv. no. x1986.570.*

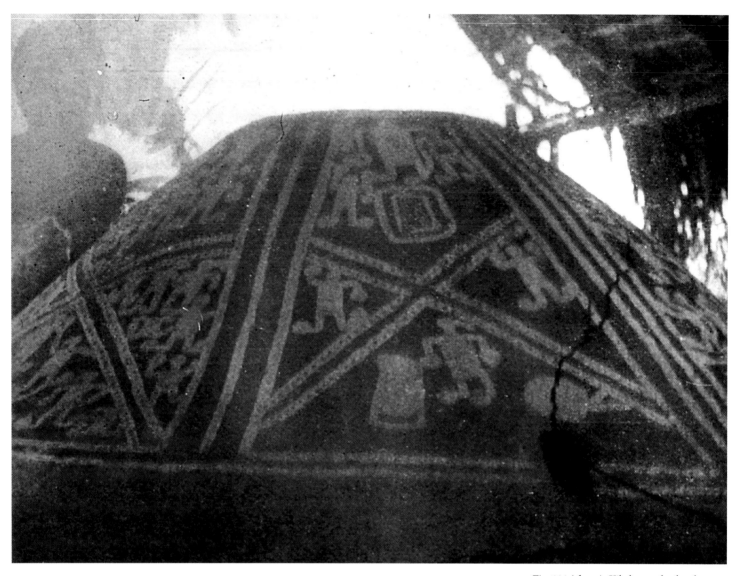

Fig. 116 (above): Kikalanyundo clay throne used in Mbudye initiation rites. The throne's entire surface is painted with pictorial mnemonic motifs used to instruct initiates into esoteric principles of Luba royal authority and history. *Photo: W. F. P. Burton, 1927. Courtesy of the Section of Ethnography, Royal Museum of Central Africa, Tervuren, Belgium.*

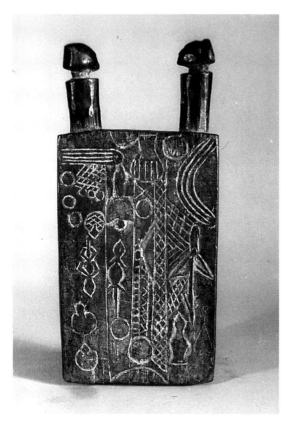

Fig. 117 (left): Lukasa with two heads and incised pictorial images, from the Malemba zone of the Luba Heartland. The two heads represent male and female Mbudye members respectively. *Collection: the Royal Museum of Central Africa, Tervuren, Belgium, acc. no. 78.57.3. Photo: courtesy of the Section of Ethnography, Royal Museum of Central Africa.*

Fig. 120 (right): Lukasa memory boards consist of a vocabulary of mnemonic signs. This key, provided by Jeanette Kawende Fina Nkindi and Guy De Plaen, shows the principal bead patterns found on most lukasas and their significance. The meaning varies with each reading, but the overall structure characterizes every board. *Diagram by Chris Di Maggio.*

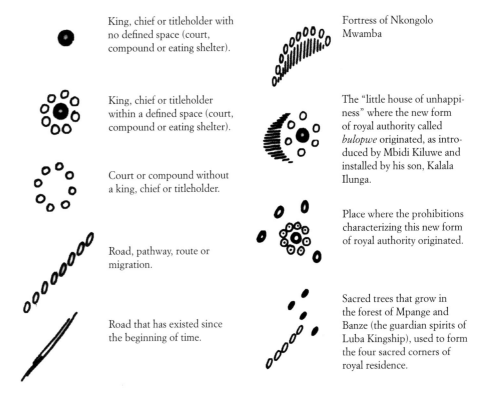

King, chief or titleholder with no defined space (court, compound or eating shelter).

King, chief or titleholder within a defined space (court, compound or eating shelter).

Court or compound without a king, chief or titleholder.

Road, pathway, route or migration.

Road that has existed since the beginning of time.

Fortress of Nkongolo Mwamba

The "little house of unhappiness" where the new form of royal authority called *bulopwe* originated, as introduced by Mbidi Kiluwe and installed by his son, Kalala Ilunga.

Place where the prohibitions characterizing this new form of royal authority originated.

Sacred trees that grow in the forest of Mpange and Banze (the guardian spirits of Luba Kingship), used to form the four sacred corners of royal residence.

Fig. 118 : The male gender of this lukasa is evident from the center of the board's bottom half, where the largest protruding object represents a phallus and was made to fit into the depression of the female board in fig. 119. *Collection: John Studstill. Photo: courtesy of Thomas. Q. Reefe.*

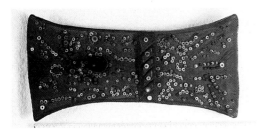

Fig. 119 : Lukasa memory boards have male and female qualities. Not only is each board divided longitudinally into female (left) and male (right) sides, but every board is one or the other gender. This board is said to be female, as evidenced by the small (vaginal) depression in the center of the bottom half of the board, and was intended to be mated with the male board in fig. 118. *Collection: Thomas Q. Reefe. Photo: courtesy of Thomas Q. Reefe.*

Fig. 121 (right): A lukasa is constructed on the model of a king's court or capital, with all the officials and their functions, the rites, and the sacred places of royalty indicated in a residential blueprint. The model shown in this diagram was the type of court constructed during the reign of Kasongo Kalombo (died 1886), son of Ilunga Kabale, and later during the reigns of Kasongo Niembo (died 1931) and Kabongo Kumwimba Tshimbu (died 1948). *Diagram provided by Jeanette Kawende Fina Nkindi and Guy De Plaen.*

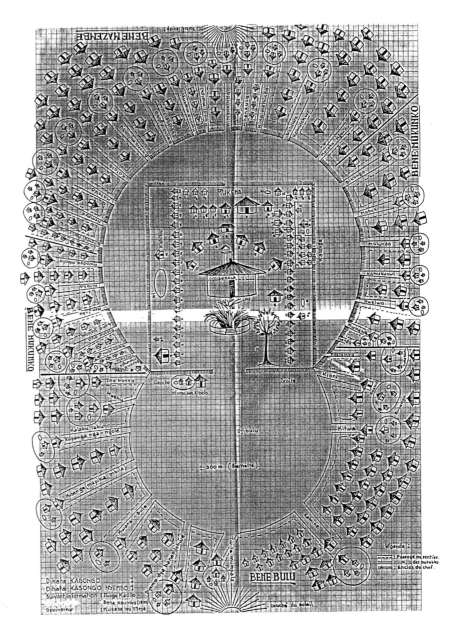

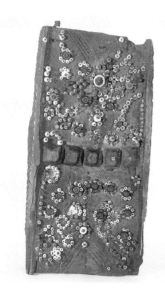

Fig. 122: Inside (or front) of a lukasa showing a division across the center created from five raised bumps. These refer to the "veil" or threshold that Mbudye initiates must cross to attain the level of *lukala*, a word that literally refers to a raised earthen threshold in a house. The five protrusions also represent the thrones found in the royal residence, signifying the highest principles of power and leadership. *Photo: courtesy of Marc L. Félix.*

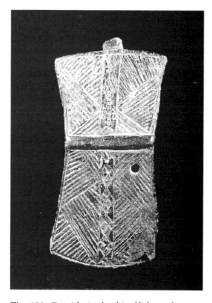

Fig. 123: Outside (or back) of lukasa showing a hole that represents an Mbudye "lake," and into which initiates must place their hands to receive the blessing of the founding ancestor of the association, Lolo Inangómbe. *Photo: anonymous.*

CAT. 56 (OPPOSITE): GAME BOARD. LUBA, ZAIRE. The design of the Luba game board is related to the architectural principles of the lukasa: the game board is structured according to the layout and planning of villages and houses, in much the same way that the lukasa's rectangular configuration mirrors that of the palace compound and its architectural features. *Wood. H. 26.4 in. Private collection.*

arts may be evident at every stage of Mbudye initiation in songs, proverbs, and praise phrases voiced to explain natural objects, figural sculpture, wall paintings, and ideographic earthen thrones; but this visual-verbal nexus reaches its climax in lukasa.

"Lukasa" is the name for both the topmost grade of Mbudye and the mnemonic device used to convey the teachings of this stage. This instrument is a hand-sized (or somewhat longer) rectangular wooden board embellished with clusters of beads and shells, and/or with figures incised or carved in relief (cat. no. 52). These enigmatic signs convey the principles upon which Luba politics are founded, and demonstrate the visual vocabulary from which all other Luba royal emblems are constructed.

Lukasas are collectively possessed by each regional chapter of Mbudye. Chiefs and kings are initiated with the lukasa of the chapter in their lands, and some may commission personal lukasas for their treasuries. Lukasas are sculpted by members of the association. Most chapters have at least one member who is a craftsman and sculptor sufficiently knowledged and skilled to effect this important work. Often the details of the lukasa's design and form are dictated by a spirit medium, and according to some accounts, specifically a Mwadi, the female incarnation of a king. The Mwadi perpetuates royal memory through her body and being. Through divine inspiration, she receives instructions for the lukasa's form, and conveys this precious information to the artist carving a lukasa.

The lukasa board often conforms to the shape of the human hand; indeed, Reefe calls it a "long hand" or "claw" (1977:49), following a literal definition of the word "lukasa" (Van Avermaet and Mbuya 1954:234–35). All lukasas are considered to have an "inside" and "outside," corresponding to what a Western observer would interpret as the board's front and back, respectively. The outside of the lukasa is covered with geometric designs, as are the narrow sides. The articulation of the usually concave "inside" of the lukasa varies by region. There are two principal styles: examples from around Kabongo are covered with beads of diverse colors and sizes, sometimes display a prominent metal hairpin and cowrie shells, and may or may not include a sculpted head emerging from the top (cat. no. 53). Lukasas from Luba fishing groups (called Bene Laba) living along the banks of the Lualaba River are usually made without beads and shells, are incised with pictorial and geometric ideograms, and may incorporate two or more heads or full figures, and sometimes a tail (cat. no. 54).

While there are other interpretations, most people around Kabongo interviewed for this research agreed that the head on the "top" of the board represents Lolo Inang'ombe, the founding ancestress of Mbudye, who is or is associated with a tortoise.[12] Along the Lualaba, the same single head is identified as Kikungulu, the most senior of Mbudye titleholders. These two interpretations may be levels of the same identity, of course. Two heads on the top of a board (fig. 117) represent paired Bene Nyembo (Mbudye women) and Bene Kapongo (Mbudye men), and three heads may be the senior officials Kikungulu, Tusulo, and Kipanga (cat. no 55).

Tusulo Yusi of Mulongo village explained that lukasas with both a head and a tail represent a crocodile, and also depict the interdependence of the Kikungulu and the Kaloba, the latter a title for someone identified with the land. Should Kikungulu wish to undertake an action that involves land use and Kaloba refuse to let him, Kikungulu must obey, for Kaloba is the earth itself, whereas Kikungulu is only an occupant of the land. The dynamic between keepers of the land and their "tenant" royal officials is a crucial aspect of Luba political diplomacy, as it reflects both conquest and peaceful establishment of dependency vis-à-vis the Luba court.[13]

In the zone of Kabongo, Mbudye members claim that lukasa boards may be male or female, although the gender does not dictate that of the initiate who uses it. The principles a lukasa embodies, however, will vary according to whether it is male or female. Reefe adds that at least in some cases, paired boards may fit together to form a unified sculpture, for the female board has a vaginal hole into which a phallic symbol on the male lukasa can be inserted (1977:49) (figs. 118 and 119). Furthermore, each board is divided into male and female halves, both vertically and laterally, with one half devoted to the Bene Kapongo (male members), the other to the Bene Nyembo (female members). On a vertical axis, the board is also divided according to lineage descent: title-

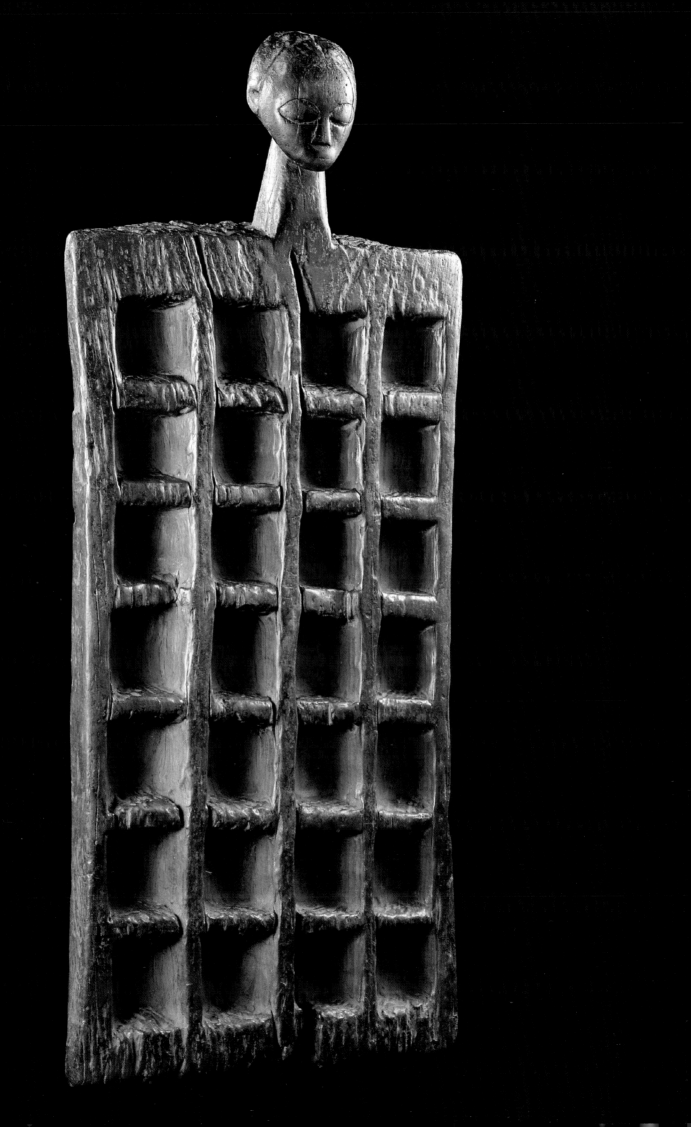

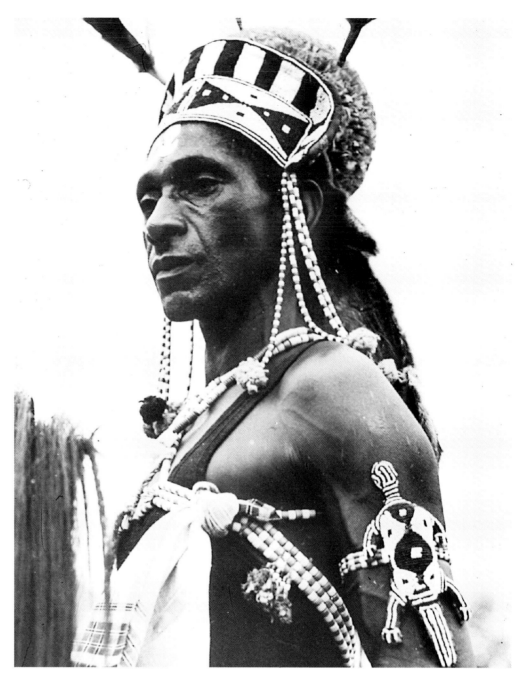

Fig. 124: High-ranking Mbudye member wearing an nkaka beaded headdress and an arm band beaded in the form of a turtle. *Photo: C. Lamote, 1945–50, Kabondo Dianda, Bukama Zone. Courtesy of the Section of Ethnography, Royal Museum of Central Africa, Tervuren, Belgium.*

holders are set to the left or the right according to whether they descend from the maternal or paternal sides of the royal family (reflecting similar organization of the chief's bead necklace discussed in chapter 3).

Reading a Lukasa

Paradoxically, lukasa memory devices provide a framework for history, while permitting multiple interpretations of the past. Once again, history and memory are in contest. The lukasa memory board illustrates how Luba organize memory according to a spatial grid. Space is used to remember multilayered bodies of knowledge pertaining to royalty, genealogy, medicine, and other complex and arcane subjects. Mbudye members associate memories with particular loci or lieux de mémoire on a lukasa. Through a rectangular or hourglass shape that represents the Luba landscape, the royal court, human anatomy, and the emblematic royal tortoise all at once, the memory board embodies multiple levels of information simultaneously. A lukasa is a visual rendering of Luba spatiotemporal thought, then, and a kind of memory theater of the Luba mind.

The gridlike form of a lukasa provides a mapping system to which bits of information can be attached in a certain order to facilitate remembrance. Beads, coded by size and color, and incised or raised ideograms provide further means of associating events, places, and names in the past. Reading a lukasa presupposes an extensive body of knowledge that includes royal history,

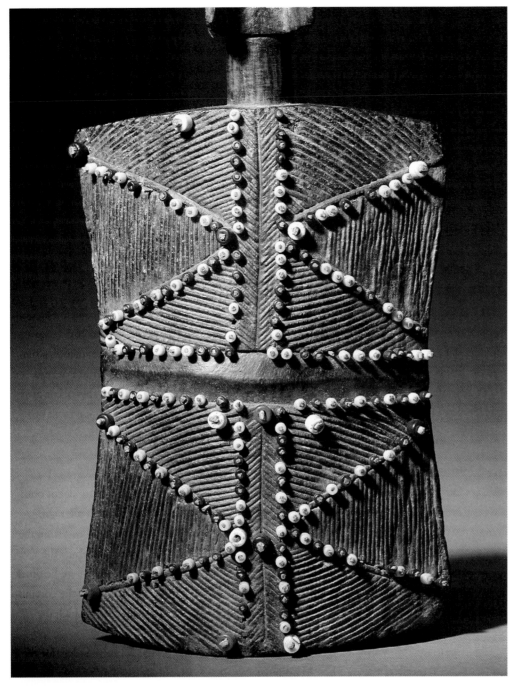

CAT. 46A (LEFT): BACK OF MEMORY BOARD OR LUKASA. LUBA, ZAIRE (DETAIL). Incised on the back, or "outside," of virtually every memory board is a stylized depiction of a tortoise shell, for the founding ancestress of the Mbudye Association was a woman in the guise of a tortoise. The triangular regions represent the tortoise's "scarifications"—the scutes of the carapace. Mbudye members explain that these scarified regions are called "lakes," and that each lake symbolizes the kitenta or spirit capital of an important king. Just as Luba believe that the patterns on a tortoise shell testify to the animal's longevity, so do the striations within the lukasa's lakes refer to the deeds and accomplishments of each king and to the prohibitions of sacred royalty. *Wood, beads, metal. H. 13.4 in. Susanne K. Bennet.*

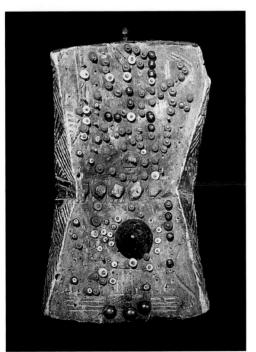 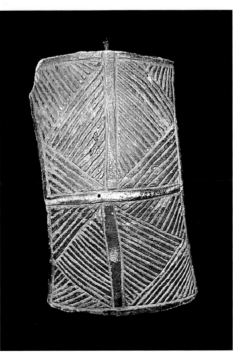

CAT. 57 (LEFT): MEMORY BOARD OR LUKASA (FRONT AND BACK). LUBA, ZAIRE. The most potent of kitenta or spirit capitals are represented on the lukasa memory board by a conical metal pin, which usually designates the king or culture hero in whose honor the board was made. The pointed end of the pin is inserted into a hole in the board containing medicinal ingredients. The prominent iron pin in this board is formally related to the anvil/hammer of Luba blacksmithing, and is a symbol for sacred royalty as a process of transformative power. *Wood. H. 6.5 in. National Museum of Natural History, Smithsonian Institution, Washington, Gift of Rev. and Mrs. Wesley A. Miller, Inv. no. 403.544.*

genealogies, and initiation procedures. All participants in Luba royal culture share a conception of social space and its political significance, although the center of that arena shifts according to where one happens to be standing at the time, and whose history is being created or recounted. Specific readings are contingent upon the region, chieftaincy, village, title, and clan of the reader and on his or her knowledge and oratory skill. The sign relationships of the beads, shells, and metal pins are a loose semantic system that allows for and, indeed, promotes and provokes modification and flexibility in deciphering.[14]

Colors are coded to elicit memory, as are the configurations of beads (fig. 120). Lines of beads often signify voyages, for example. A large bead surrounded by smaller ones is a king encircled by his dignitaries. A single medium-sized bead is the memory of a sacred lake. Red beads refer to Nkongolo, the cruelly hot-blooded ("red") despot of the Luba Epic. Small, white beads often stand for titleholders who wear chalk to honor the king and, more specifically, his ancestral spirits. Large, blue (glossed as "black") beads are Mbidi Kiluwe and Kalala Ilunga, the great culture heroes who introduced the arcane secrets of sacred kingship. Yet even these relationships between signifier and signified are in no way fixed or finite.

The lukasa is designed to be both flexible and authoritative in its interpretation. As the highest emblem of royal induction, it represents the apex of memory and erudition; yet memory is always situational, as are history and identity. As such, the lukasa's coded signs provide a semantic structure that provokes interpretation. A certain "selection of events" is thus remembered (Vansina 1978), reflecting transformations in memory and the needs for history that inexorably occur over time. Some of the major categories of specialized information to be found in the lukasa will be introduced before presenting a reading of such a memory board.

An Architecture of Memory

Mbudye members agree that the "inside" or front of the lukasa is an architectonic model of both the royal court and, simultaneously, the Mbudye meeting house. The lukasa's rectangular configuration mirrors the boundaries of the palace compound and its architectural features, from the high enclosure (*lupango*) around the king's residence to the houses of his principal wives, the shrine house where his sacred relics and regalia are guarded, and the sacred house where he dines (*mbala*)(fig. 121). The king's compound is surrounded by those of his dignitaries, and the community is further divided longitudinally, according to the "sides" of the royal line from which its residents are descended (cat. no 56).

The rendering of the court is also a representation of the *kinyengele* or Mbudye lodge, for the two constructions mirror one another. Almost all lukasas are horizontally divided on both front and back, bisected by a row of mounds in relief, or by a simple line. Many are also penetrated by a hole. These features refer to episodes in Mbudye initiation that are conducted in the kinyengele: the line of mounds is the veil that separates the first initiation stages from the last. Raised circles refer to the earthen mounds of lukala, which the initiate must mount in order to "break through the veil" (fig. 122). The hole may represent the lake from which the Mbudye members emerge in their origin story, or the tunnel into which initiates must crawl in the course of ritual "to meet Lolo Inang'ombe," the association's founding ancestress (fig. 123).

Descriptions of kinyengele meeting houses from the 1930s and 1940s echo the design of a lukasa (D'Orjo de Marchovelette 1940:279, Joset 1934:3). The lodge, a huge rectangular building measuring some twenty-five by ninety feet, was located on a path leading away from the village. It was divided in the middle, with a meeting area for the association in the back and a vestibule in the front. This latter room was fitted with bamboo and wooden partitions to form low and narrow passages, so that visitors were obliged to duck their heads and advance slowly. As we shall see in later chapters, this symbolic configuration suggests a "labyrinth of memory" (Teski and Climo 1995), and a thicket of overdetermined choice through which one must carefully wend one's way to arrive at and achieve the enlightened promise of the inner sanctums.

Separating the vestibule from the back meeting room was a large arcade, pierced with as many portals as there were passageways leading to it. Entrance to the meeting room was strictly forbid-

den to all but the highest-ranking members. Arriving there, one must have been impressed by the huge earthen kikalanyundo "memory throne" in the center of the room, composed of two truncated cones superimposed to create a seat at least a meter high. Surrounding it were four smaller but similar thrones, and behind these were large seats very low to the ground, arranged in a semicircle. Finally, a sculpted figure stood sentinel at the far end of the room. The building, enclosures, chambers, exits and entrances, vestibules, seats, and sculptures of an Mbudye meeting house, echoing those of a Luba king's court, supported a memory theater, as did the gangways, gates, and figures created by Don Camillo (Yates 1966:136–37).

Also indicated on the lukasa are trees and other flora planted in the royal compound. Some are probably herbal or magical medicines, but others serve as "dominant symbols" (Turner 1970) of Luba kingship. A tree called "*mumbu*" is used to construct the tall, dense lupango enclosure around the palace compound. Mumbu is said to live longer than other trees, and building the king's enclosure with it signifies and promotes both the longevity of a particular king and the eternal kingship perpetuated from generation to generation. A photograph from the late 1980s of the royal court of the Kalundwe king, Mutombo Mukulu, shows the king seated underneath a mumbu tree as a symbol of his power, according to the photographer, Veronique Goblet-Vanormelingen. For the smaller enclosure of the king's dining quarters (mbala), a *kaswa musenge* tree is used, for it is thought never to rot or dry out, and even when it is cut, it continues to grow. Near the entrance of the mbala, a single *mumo* tree is planted, for it mystically protects people from lightning. As these examples suggest, a lukasa maps the meaningful gardens of the court, reflecting yet another "geometry of ideas," in this case the ideal order and purpose of nature (Francis and Hester 1991).[15]

Capitals of Memory

The dominant feature on any lukasa is the kitenta, the most potent of the concepts relating to Luba royal authority. "Kitenta" is a synonym for "lukasa," but is an even more symbolically charged term, for while it refers to dignity, social status, and place in the court hierarchy, it also evokes the idea of a chair or elevated stool. The word "kitenta" is a synonym for "*kipona*," a seat of power (Van Avermaet and Mbuya 1954:696), and directly refers to the earthen mound or elevation upon which Kikungulu sits on the day of his investiture. A man in Kabongo explained that kitentas are the places of different kings, diviners, and Mbudye members associated with their highest accomplishments. As he said, "He who has been on 'four seats' is the one who has achieved the highest instruction." Burton elaborates on the definition, and notes that a kitenta represents the burial place of a king, or the *chef-lieu* of a guardian spirit, with specific reference to the former royal villages of deceased kings (1961:261). "*Kitenta kya vidye*" designates the elevated seat or resting place of a spirit. Certain heights, such as the summits of sacred mountains, are thought to be invested with spirit in this manner (Van Avermaet and Mbuya 1954:696).[16]

Each Mbudye chapter is linked to the kitenta or "spirit capital" of a particular king of the past. Those in the chieftaincies of Kabongo and Kasongo Niembo, for example, are associated with the kitenta of Ilunga Sungu (ca. 1780–1810); while those of Ankoro, Kiluba, Manono, and Kiambi honor that of Kumwimba Ngombe (ca. 1810–40); and Mbudye societies in the regions of Kinkondja, Mwanza, Malemba Nkulu, Bunda, and Mulongo worship the kitenta of Ilunga Kabale (ca. 1840–70). This loyalty suggests that the named kings may have been great patrons of each of those chapters.[17] Acknowledgment of a particular king may also refer to expansion of the Luba state, or to networks of kinship or trade established from the Heartland to the places where Mbudye chapters were then founded.

A single lukasa may represent several kitentas at once. The spirit capitals of lesser chiefs, Mbudye associations, and diviners are depicted on the board by prominent beads or cowrie shells. Members say that when there are a few isolated beads on the back or "outside" of the board, they correspond to beaded spirit capitals on the front. The most significant kitentas are represented on the lukasa by anvil-shaped iron kinyundo pins (see chapter 2), which indicate the burial places of the king or culture hero in whose honor the boards are made. The pin's pointed shaft is inserted

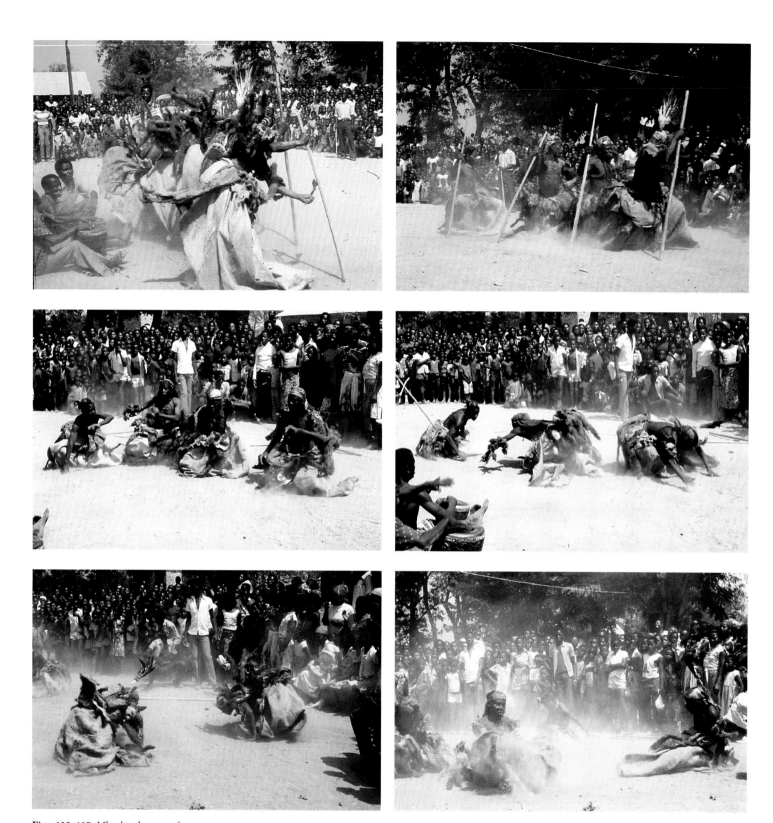

Figs. 132–137: Mbudye dance performance on the occasion of the ordination of several priests by the Catholic Church of Kinkondja, demonstrating the way certain Luba traditions are combined with Christianity in a perpetually changing cultural matrix. *Photos: Mary Nooter Roberts, 1987.*

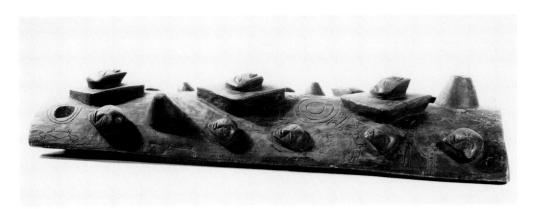

CAT. 58: LUKASA-RELATED DIVINATION BOARD. LUBA, ZAIRE. The documentation accompanying this object states that it was used for divination, yet it bears a closer resemblance to lukasa memory boards than to any known Luba divination instruments. Its planklike form, with heads and motifs carved in relief, might be a variation on the beads and ideograms found on most lukasas. On the other hand, it is also considerably larger than most lukasas, raising interesting questions about the development of the lukasa as an idea and a form. *Wood. H. 28 in. National Museum of Natural History, Smithsonian Institution, Washington, Gift of Mrs. Sarita S. Ward, Inv. no. 323.441.*

into a hole in the lukasa containing magical ingredients, which further charge this lieu de mémoire with instrumental efficacy (cat. no. 57). Narrating the story encoded on the board, in other words, can and does effect change.

Memory Landscapes

On the back of virtually every lukasa is the stylized depiction of a tortoise carapace, in reference to the founding ancestress of the Mbudye association, Lolo Inang'ombe. Incised triangles and other geometric regions represent the "scarifications" of the tortoise, or the scutes of its carapace (cat. no. 46a). An elder explained that the scutes are considered "beautiful to look at" because of the way they are disposed across the back of the shell. Another man added that the scutes give a lukasa "realism," and render the form of their mother, the tortoise: "On the back is marked all that relates to Mother Tortoise, to indicate that she accomplished so many deeds in so many days."

The same "scarifications" on the back of a lukasa are also called "lakes" (*dijiba*), and each is the kitenta spirit capital of an important king—because kings were buried under the water, people say. Luba note that the patterns on a tortoise shell testify to the animal's longevity (fig. 124); similarly, the striations within a lukasa's "lakes" are the deeds and accomplishments of each king. Lolo Inang'ombe, then, is the ultimate metaphor for kingship itself. She is the land that nurtured and sustained a kingship, upon whose plains and fields are etched the duration and deeds of each king, and from whose lakes emerged the various incarnations of power.[18]

The same incised patterns on the back and sides of a lukasa have yet a third interpretation, for they are bizila, the strict regulations and prohibitions concerning kingship and royalty. Bizila are numerous and vary by region, but they are critical to the balance of power between the court and Mbudye. Mbudye guards these prohibitions, ensures their respect, and punishes any who disobey them. Neglect of bizila brings disaster in droughts, epidemics, and the burgeoning of evil sorcery. Bizila refer to routine etiquette and protocol in both the royal court and the outside world, and to proper salutations, seating privileges and arrangements, entrance and exit procedures, and eating and drinking regulations. Some bizila are intended for Mbudye members themselves, others for nonmembers.

Many bizila are reinforced through proverbs and aphorisms. For example, the phrase "A person holding flies with clenched fists" (*wakupile luzi bipa*) signifies that the initiate who arrives at the lukasa level of Mbudye must hold onto the rules of Mbudye as tightly as if they were flies, never letting them escape. On one level, this proverb is a warning against divulging the secrets of the association, but on another, the image of holding flies must refer to seizing onto elusive memories and the ambiguities of doctrine.

A useful cross-cultural analogy can be drawn to the *dharani* of Buddhism, which are lists of words or statements summarizing complex doctrines. Dharani are formulas with magical powers, and form a mnemonic syllabary. More important than the content of the dharani, though, is the concept of "the holding, the complete holding, the not forgetting, the remembering and perfect holding, of the 84,000 Dharma teachings" (Gyatso 1992:175). When the striations on a lukasa are considered bizila (as opposed to something less abstract, like "lakes"), they may be likened to the "letter sameness" of the dharani. The striations and letters themselves have nothing to do with their ultimate meaning, and neither possess nor provoke emotion. Both are empty signifiers, repre-

senting only themselves, or, in this case, memory. Yet together they form a grid onto which memory can be mapped, and through which knowledge may be ordered and disposed in space.

Lukasa as Text

The narrated exegesis of a particular lukasa shows how initiates combine the elements previously discussed into a spatio-structural form that conveys both broad concepts of Luba royalty and the specific interests of local chieftaincies. The following "reading" of a lukasa was provided for the author in 1989 by Mbudye members and court historians at Makwidi, deemed the ancient residence of Kalala Ilunga, first Luba king and son of Mbidi Kiluwe. The lukasa in question is shown in figure 125; the author had brought a color photograph of it to the field, and Makwidi residents claimed that it was originally from their chieftainship. Reefe explains, however, that this lukasa was created for the missionary David Womersley, or for his father Harold, in the 1930s or 1940s.[19] Most likely, it was modeled on an earlier one that had been the property of this chiefdom. The notion of models upon models, based upon the memory of previous boards, is itself part of the memory process, as objects are relinquished, sold, or traded, and new ones take their place. The fact that this lukasa is a copy of an earlier one, or that the exegesis was formulated from a photograph rather than from the board directly, only underscores the perpetual refabulation of memory.

The narrative demonstrates how this board honors Kalala Ilunga, patron of Makwidi. The entire discourse is shaped around his leadership, his capital, and his relationships to other figures from the distant past. Houses, paths, roads, trees, lakes, clearings, shrines, and spirit capitals make up the lieux de mémoire of this lukasa, radiating from the central point of Kalala Ilunga's sacred Makwidi. The account explicitly reveals the way a mnemonic can manipulate the center/periphery dynamic that determines historical power relationships and realities (fig. 126).

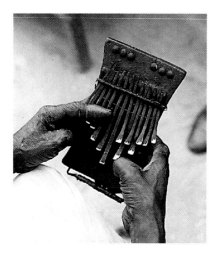

Fig. 127: A *kasanji* musical instrument bears a formal and a functional relationship to a lukasa. Used as a mnemonic for history, it is played by titleholders and court historians at special ceremonies connected with the royal court. *Photo: Mary Nooter Roberts, 1989.*

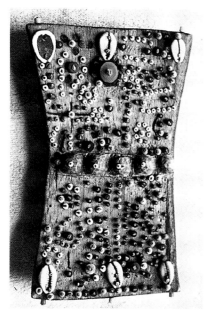

Fig. 125: Lukasa for which a "reading" was provided by Luba court officials in the sacred village of Makwidi, former royal capital of Kalala Ilunga. The entire interpretation is dedicated to Kalala Ilunga, who is represented by a large blue bead in the center of the board's upper half. *Photo: courtesy of Thomas Q. Reefe.*

Fig. 126 (opposite): Diagram of lukasa shown in fig. 125 illustrating the correspondence between the beads and shells and the accompanying oral narrative. *Diagram by Chris DiMaggio.*

The reading of this lukasa begins with the top-central cowrie shell, which represents the koba ka malwa, or "little house of unhappiness," where a chief is invested. This means we are at the royal capital. Below and to the left, the chief's personal residence is marked by a medium-sized blue bead encircled by twelve small white beads. These represent twelve of the chief's titleholders. The large light-blue bead just below the cowrie in the center represents the royal court of the first king, Kalala Ilunga Mwine Munza. Near this bead one can identify his children: Kazadi'a Milele (the first son), Kabamba, Ngombe, Malamba, and Makwidi.

The cowrie in the upper-left-hand corner is Mbidi Kiluwe, while that in the upper right is the kitenta spirit capital of three female spirit mediums, Mwadi Ilunga, Mwadi Bulunga, and Mwadi Mfyama. These mediums—indicated by three medium-sized white beads clustered to the left of the upper-right-hand cowrie—guard the sacred house that contains the dikumbo basket, which holds the relics of all the deceased chiefs of the dynasty's different branches. Also guarded there are the regalia of sacred kingship: the staff (kibango), the stool (kipona), the ax (kafùndanshi), the spear (mulumbu), and the lukasa. This shrine house is represented by a small yellowish bead.

On the left-hand side, the white bead piercing the center of an incised cross symbolizes Kalala Ilunga, whose praise name here is Kilunda-dya-lwala-mitabi—a reference not to the branches of a tree or to the tributaries of a river, but rather to the different ramifications of Kalala Ilunga's dynasty.

Lines of white beads throughout signify the road one takes to arrive at the various seats of power. On the upper-left-hand side, the path leads to Mbidi Kiluwe's spirit capital, whereas two semihorizontal lines on the upper-right side of the lukasa are the clearings through the bush that lead to the spirit capital of the three female spirit mediums.

Two beads, one white and one blue, directly below the large blue bead are the sacred trees in the king's compound; one is the mumbu and other an olive tree. An olive tree played a role in the founding myth.

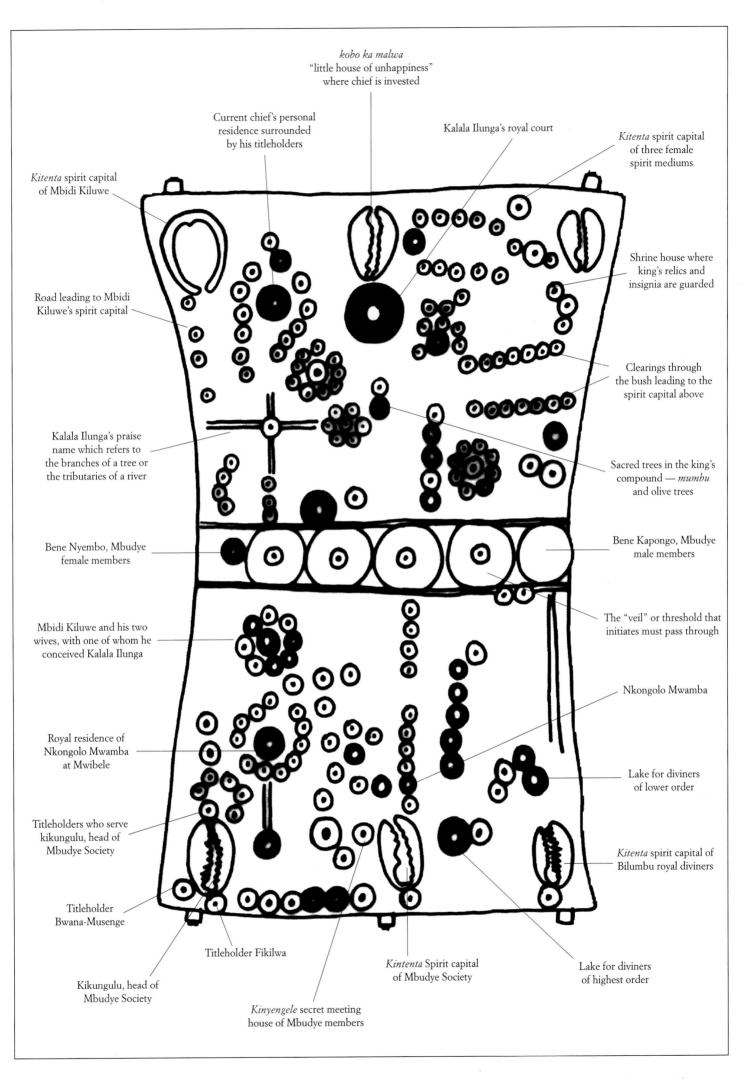

kobo ka malwa
"little house of unhappiness"
where chief is invested

Current chief's personal
residence surrounded
by his titleholders

Kalala Ilunga's royal court

Kitenta spirit capital
of three female
spirit mediums

Kitenta spirit capital
of Mbidi Kiluwe

Shrine house where
king's relics and
insignia are guarded

Road leading to Mbidi
Kiluwe's spirit capital

Clearings through
the bush leading to the
spirit capital above

Kalala Ilunga's praise
name which refers to
the branches of a tree or
the tributaries of a river

Sacred trees in the king's
compound — *mumbu*
and olive trees

Bene Nyembo, Mbudye
female members

Bene Kapongo, Mbudye
male members

Mbidi Kiluwe and his two
wives, with one of whom he
conceived Kalala Ilunga

The "veil" or threshold that
initiates must pass through

Nkongolo Mwamba

Royal residence of
Nkongolo Mwamba
at Mwibele

Lake for diviners
of lower order

Titleholders who serve
kikungulu, head of
Mbudye Society

Kitenta spirit capital of
Bilumbu royal diviners

Titleholder
Bwana-Musenge

Titleholder Fikilwa

Kikungulu, head of
Mbudye Society

Kintenta Spirit capital
of Mbudye Society

Lake for diviners
of highest order

Kinyengele secret meeting
house of Mbudye members

The row of raised bumps across the board's center constitutes the veil that initiates must penetrate in order to achieve the highest grade of Mbudye. Each represents a tree or plant, each of which, in turn, has its own proverb related to kingship. The first bump on the left is mulenga, a type of fern, which means, "The king is flexible like the fern, which bends in all directions in the wind." There is no problem a king refuses to solve. The second bump is kilon-golongo, a plant with tuberous roots, for "the rubbery tuber is not hard, but it can break the metal hoe"; the king is not "hard," but if you create problems for him, you will be broken. The third bump refers to a proverb stating that the king likes and is good to those who like him, but hates those who foster hatred for him. The fourth bump is musangala, a shrub that brings prosperity and benevolence; its corresponding proverb states that the king rejoices with all those who rejoice for him, and, likewise, rejects those who reject him.

The bead to the far left of this symbolic veil represents the place where the partridge dusts itself; the last mound at the extreme right, with no bead, stands for the place where the guinea fowl dusts itself. The partridge symbolizes the Bene Nyembo, or Mbudye women, and the guinea fowl the Bene Kapong, or Mbudye men. The reference is to male and female Mbudye members who wallow in the glory of the king. Related to this image is a proverb: "They ate the guinea fowl and forgot the partridge." In other words, men are taken into consideration, but to the neglect of women.

Moving to the lower half of the lukasa, the reading begins at the bottom. The first spirit capital is indicated by a cowrie at the bottom left, and represents the Kikungulu, head of the Mbudye Association. Located just below this shell are the officers Bwana-Musenge and Fikilwa. The circle of small white beads above the shell are the titleholders who serve the spirit capital of the Kikungulu, the largest of which represents the Kamanji, leader of the route.

The spirit capital of the Mbudye society is shown by the cowrie shell in the bottom center. This spiritual focal point is not coincidental with the secret meeting house, which is shown also, by a medium-sized white bead to the left of the central cowrie.

The last cowrie on the lower-right-hand side represents the spirit capital of the royal diviners. Some diviners and spirit mediums undergo a rite in which they plunge into a lake; these are the diviners of the highest order. They are shown on the board by a medium-sized blue bead between the central and the lower-right-hand cowries, which depicts the lake into which they throw themselves. Those who do not plunge have their own lake, which is indicated by a small blue bead placed directly above the lower-right-hand cowrie.

Situated around the central cowrie representing the Mbudye spirit capital are beads representing two types of members: those who have "broken the veil" and studied the lukasa, and who, therefore, have been granted passage to the royal court; and those lower-ranking members who have not yet graduated to the level of lukasa, and so are not permitted into the royal palace.

The small red bead above the lower central cowrie depicts Nkongolo Mwamba Seya, who was born in a village originally called Myamba ya Nkeba. The birth of this child produced an astonishing phenomenon: wherever the child went, the earth below his feet turned red. The villagers decided he must be the incarnation of the spirit of the rainbow, and the village therefore changed its name and the name of the child to Nkongolo, which means "rainbow."

The brown bead surrounded by small yellow beads in the lower left-hand quarter of the board depicts the royal residence of Nkongolo, which he established in the village of Mwibele, near the shores of Lake Boya and the present-day town of Kabongo. Right above the bead that stands for Nkongolo's court at Mwibele is a dark blue bead surrounded by blue and white beads; this circle alludes to Mbidi Kiluwe and his two wives, Kisula and Ilunga (Nkongolo's sisters at Mwibele), with one of whom Mbidi conceived Kalala Ilunga. Scattered blue beads to the right signify Mbidi Kiluwe's voyage to Lake Boya from his place of origin to the east.

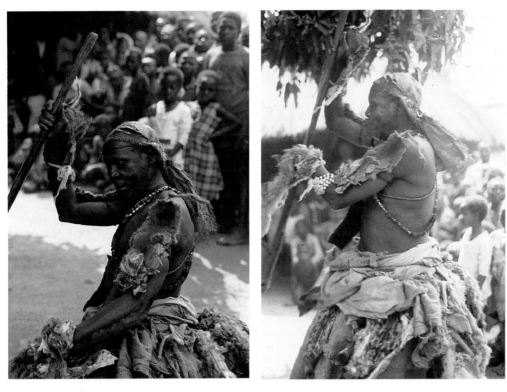

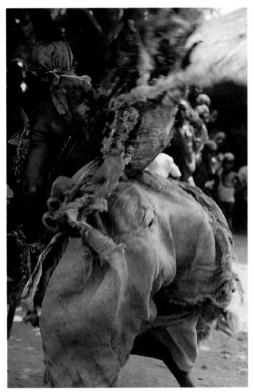

Figs. 138–141: Mbudye dance is mnemonic, for its choreography is designed to memorialize certain important events in Luba history. One of the most popular dance movements is an acrobatic feat that results in the hurling of the fur pieces worn on the dancers' skirts. *Photos: Mary Nooter Roberts, 1987.*

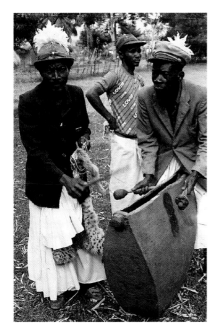

Fig. 128: Titleholders Twite and Kioni of Kabongo playing a slit drum in preparation for Chief Kabongo's arrival. Through the depth and variety of their tones, imitating the tones of spoken language, slit drums can convey messages over long distances. *Photo: Mary Nooter Roberts, 1989.*

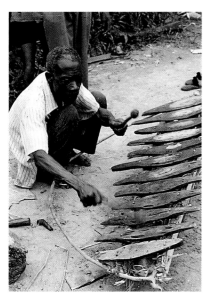

Fig. 129: Titleholder Kioni playing a balaphone, which serves as a mnemonic device through its transmission of historical songs and praises. *Photo: Mary Nooter Roberts, 1989.*

Had this lukasa hailed from a different village or chieftaincy, the reading would not have been the same. Rather than emphasizing Kalala Ilunga, the board would have honored another king or chief, and all of the dependent relationships of titleholders, Mbudye members, diviners, and spirit mediums would have been repositioned accordingly. Likewise, references to landmarks, roads, and voyages would have accommodated the histories, migrations, and deeds of that particular ruler. In this way, a lukasa is similar to the wax tablets of classical memory arts, "which remain when what has been written on them has been effaced and are ready to be written on again" (Yates 1966:7), and to Koranic healing boards, which are regularly inscribed and then washed of their sacred verses and numerological formulae, to serve the needs of particular clients and individual circumstances.

A lukasa stimulates several kinds of information, and the content of its reading depends upon who the reader is and what points she or he wishes to stress. When a number of Luba from around Kabongo, each an official of a different title or profession, provided readings of another lukasa (cat. no. 46), again from photographs, they rendered astonishingly different accounts of the same board. A chief used the lukasa to recount the origins of royalty (a version of the genesis myth), and his chieftaincy's descent from the dynastic line. A prominent titleholder stressed the configuration of the court, with its hierarchy of titles and codes of etiquette. Two Mbudye members articulated principles of the association, such as origins and the stages of initiation. And a famous diviner pointed out the prominent place of his profession within the structure of royalty, and the qualities of healing and power suggested by the placement of trees and herbs in the garden of the royal court.

The diversity of the interpretations stimulated by a single board does not indicate error, deceit, or misperception. Rather, it proves that lukasa readings are rhetorical moments for the persuasive argument and defense of a particular point of view (cat. no. 58). As Johannes Fabian writes of a different context, "Stressing visualization in terms of arbitrarily chosen 'reminders' makes memory an 'art' and removes the foundations of rhetoric from the philosophical problematic of an accurate account of reality. The main concern is with rhetorical effectiveness and success in convincing an audience, not with abstract demonstration of 'truth'" (1983:112).

Songs of Nostalgia

The lukasa not only stimulates recitation, it elicits music. There is a formal and functional relationship between a lukasa and a Luba musical instrument called "*kasanji*" (fig. 127). Although peoples throughout many parts of Africa possess plucked ideophones or "thumb pianos" of this type, Luba liken the kasanji to a lukasa memory board. Sometimes these instruments are embellished with heads and geometric design elements much like those of the lukasas, and their structure must bear symbolic as well as practical significance, as when the bridge supporting the keys is called a "*mwamba*" (Gansemans 1980:24), recalling the rainbow king Nkongolo Mwamba. Indeed, according to the titleholder Kioni of Kabongo, the kasanji, as a particular type of plucked ideophone among the several that Luba possess, was handed down from Nkongolo Mwamba for use at the courts of subsequent chiefs.

There may be (or may have once been) even more depth to playing a kasanji than this, for it is quite possible that the keys are named, and that the notes they produce can form tone poems, as Paul Berliner (1981:2–7, 56–58) has found among Shona people of Zimbabwe. In such a case, a kasanji's crisp notes might stand as musical lieux de mémoire, complementing the visual configurations of a lukasa. In other words, the named notes may serve as musical "pegs," evoking memory as do the pins and ideograms of a lukasa.

The Kioni of Kabongo stressed the explicit formal and functional connection between a kasanji and a lukasa. "Kasanji is made in the guise of a lukasa, for by playing it, one is reminded of the history of royalty. Songs provide a memorandum for recalling the past. A whole history can be recounted." The kasanji is played by trained specialists who are usually dignitaries at the royal court. Its songs exalt the king, just as a lukasa may be read or sung by a narrator to honor the founders of Luba kingship. Though kasanji songs are intended for public consumption, as

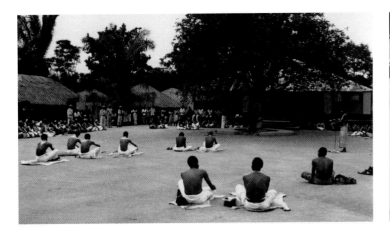
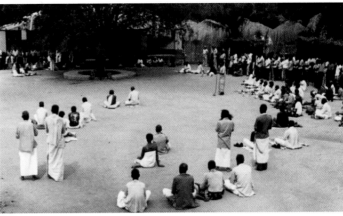

opposed to the highly esoteric information encoded on a lukasa, it may be that only the most erudite Mbudye recognize and understand the kasanji's tone poems.

Clan songs, panegyrics, and eulogies that laud the deeds and accomplishments of kings, chiefs, and lineage heads, often through reference to place names, are generically called "*numbi.*" There are three principal kinds of numbi: regional, village, and family songs (Van Avermaet and Mbuya 1954:380)(figs. 128 and 129). Among Luba to the west of the Heartland, such songs are called "*kasala,*" and are sung to encourage bravery, as on the battlefield; express joy, as when dignitaries are received by the king; and for mourning ceremonies honoring the dead. The singing of kasala provokes "nostalgia," and it is therefore not surprising that these songs' origins are always situated in the most ancient times, even at the beginnings of humanity itself (Mufuta 1968:48–49). The person performing these songs, the Mwena Kasala, "possesses" and is identified with them. While the songs are composed of well-known verses, there is also a good deal of improvising, and as Clémentine Faïk-Nzuji notes, such a person "feels . . . the sentiments of an entire social group" and is "the mirror of society" (1974:48–50).

Place names are critical elements of both numbi and kasala. The songs list different families and the lands belonging to them, sites of spirit habitation, watercourses, and other significant features of the landscape that enrich and particularize a region. It is as Yi-Fu Tuan states, "All people undertake to change amorphous space into articulated geography," for "when space feels thoroughly familiar to us, it has become place" (1990:73, 83).

Dignitaries visiting the royal court sing praises as they occupy their specified seating positions in the open yard, sitting on skins and mats that signify their rank in the royal hierarchy (figs. 130 and 131). Their songs are a performative accompaniment to the spatial ordering of their persons. The music serves to place them in the contexts of their clan histories and regional origins, and to place the whole landscape under the jurisdiction of the king. Music complements a lukasa, then, as an aural register to a visual model for the ceremonies of state during which the king holds office under a sacred tree, while his dignitaries and clients pay their respects to him and pronounce their places in the social universe.

The Dance of Memory

The culmination of Luba ceremonies of state are dances by Mbudye members. Like all other Mbudye expressive culture, dance, too, is mnemonic. Mbudye members are renowned for their spectacular dance displays on public occasions; indeed, many a colonial officer honored by a Mbudye performance assumed that the only purpose of Mbudye was entertainment. Mbudye members perform upon the king's or a chief's request for occasions of state, such as investitures and the welcoming of visitors. They also organize their own performances to celebrate the rising of a new moon, to initiate new members, or to honor funerals. Today, they may perform at Catholic services or political rallys (figs. 132–137).

Mbudye dancers perform in a state of spirit possession, which reveals itself in dazzling acrobatics enacted to the rhythms of a drum orchestra. Spectators are expected to lavish the dancers with gifts and applause. In addition to feathered and beaded headdresses (nkaka) and beaded

Figs. 130 (above left) and 131 (above right): Titleholders at the western Luba court of Mukombo Mukulu occupying their positions vis-à-vis the king within the royal compound, just as they are represented by the beads on a lukasa. The king is seated on a high-backed chair in the dark shade of the tree, and is therefore difficult to see. *Photos: Veronique Gobelet-Vanormelingen. Courtesy the National Museum of African Art, Eliot Elisofon Photographic Archives, Smithsonian Institution, Washington, D.C.*

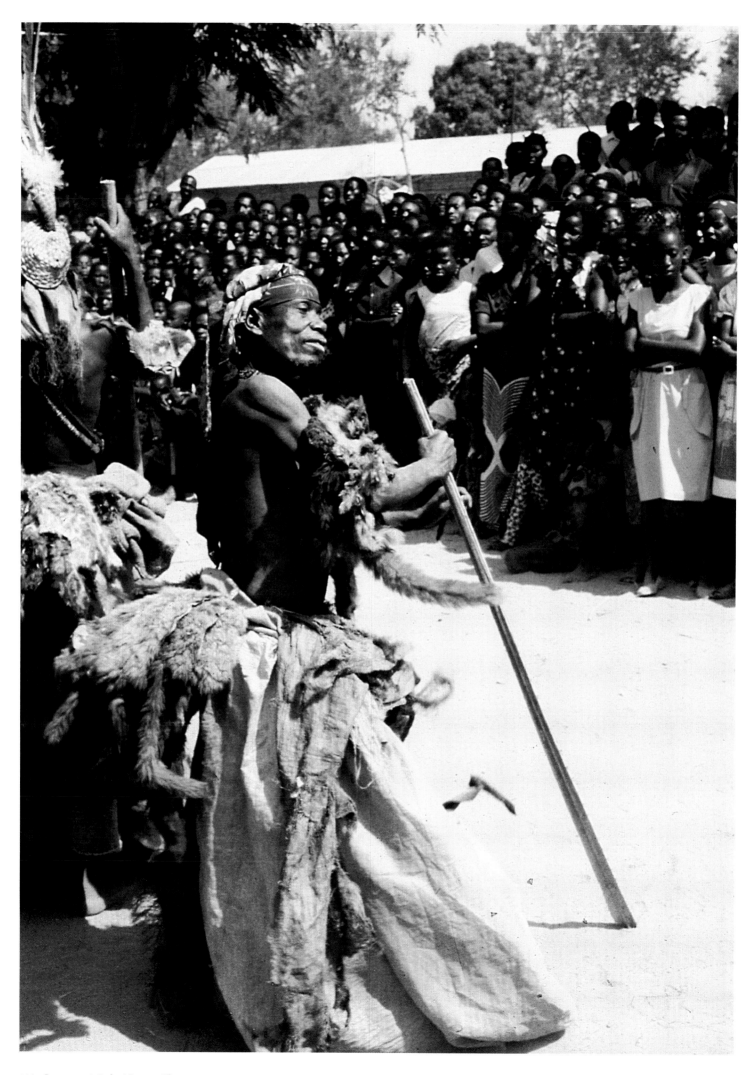

chest emblems, dancers don voluminous skirts layered with the skins and furs of symbolically significant animals, such as certain monkeys, squirrels, and spotted wildcats. When dancers hurl themselves forward in the quintessential Mbudye movement called "to throw the *mpongo*" (a small squirrel whose fur is so light that it flies up at the slightest movement), their costumes lift up in the back (figs. 138–141), revealing large magical bundles strapped to their waists. Although the constitution of these bundles is known only to those who make and use them, the sheer size of the packets sends a powerful message about their potency (figs. 142–144).

Mbudye dancers say that much of their choreography is inspired by episodes from the Luba genesis myth. In particular, the various "skits" that make up an Mbudye performance are generated from the memory of Kalala Ilunga's kutomboka dance, a dance he is said to have executed when Nkongolo Mwamba tried to kill him. As Adrienne Kaeppler writes, the motifs of choreography are not simply committed to memory. "Although a particular performance is transient, the structure is not, and even if a specific choreography is forgotten, knowledge of the structure of the system and the inventory of motifs will be remembered" (1991:109–20). Indeed, Luba say that the uniformity they perceive in Mbudye dances across space and time is due to the fact that the dances were originally taught by the first Mbudye members, who carried Kalala Ilunga's sacred memory basket, and, through initiation, they have been transmitted from generation to generation to all subsequent titleholders in the association.

Like other expressive forms, dance is certainly more adaptable than this Luba perception might suggest. Performances will vary according to their circumstances, just as the singing of numbi and kasala or the narrations of lukasa memory boards do. What Luba understand as the invariable nature of dance we might see as "the canons of taste, arising out of cultural conditioning"; yet these canons "have a recurrent . . . way of deliberately manipulating, composing, performing, and sometimes feeling the various elements" of dance (Hanna 1980:38). The "perpetually actual" uchronia of memory, then, brings to dance and other Luba mnemonic devices its "permanent evolution, [which is] open to the dialectic of remembering and forgetting, unconscious of its successive deformations, vulnerable to manipulation and appropriation, [and] susceptible to being long dormant and periodically revived" (Nora 1989:7–8). If Luba consider dance a feature of their history, memory struggles to unfetter each step and bound of an Mbudye performer's extraordinary acrobatics. Indeed, if memory (lutê) itself implies random movement (kutà) and a "wandering" (kunànga) of the mind, then narrative, music, song, and dance lend sense, poetry, and shape to the journey.

Conclusion

The mnemonics presented in this chapter, ranging from pictorial to sculptural, contemplative to kinetic, constitute the theater of Luba royal experience. Luba mnemonics are microcosmic and macrocosmic at the same time. These expressive forms are "keys to a code designed to present to the understanding a whole kind of doctrine in a single flash." Indeed "artworks . . . become vehicles for reaching some kind of fundamental truth" (Napier 1992:134), or at least for giving the *impression* of having reached such truth. "Truth," of course, is always in the eye of the beholder, in the words of the lukasa narrator, in the poetry of the numbi singer, in the fingers of the kasanzi plucker, and in the feet of the dancer. His or her ability to persuade others through a rendition of the past will determine how history is made. For as Richard Schechner rightly states, "to 'make history' is not to do something but to do something with what has been done. History is not what happened but what is encoded and transmitted. Performance is not merely a selection from data arranged and interpreted; it is behavior itself and carries in itself kernels of originality, making it the subject for further interpretation, the source of further study" (1985:51). The initiations, recitations, and spectacles of Mbudye lie somewhere between history and performance on the border between convention and creation, where past, present, and future conflate "to re-present a past for the future performance-to-be" (ibid.).

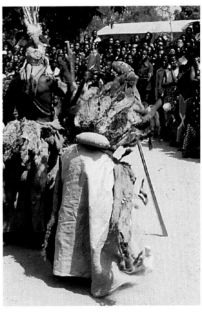

Figs. 142–144 (opposite and above): Dancer wearing a large medicinal bundle strapped to the back of his waist, visible only when he "throws his fur." The medicine empowers the dancer, who is thought to perform his dazzling acrobatic feats as a result of being in a state of spirit possession. *Photos: Mary Nooter Roberts, 1987.*

Endnotes

1. David Napier describes memory palaces as common in sixteenth-century Europe, especially among missionaries, who created and used them to memorize vast quantities of doctrine in order to impress and convert foreigners to Christianity (1992:55).

2. "Talisman" is taken here as "an object imprinted with an image which has been supposed to have been rendered magical, or to have magical efficacy, through having been made in accordance with certain magical rules" (Yates 1966:154).

3. See, for example, Burton 1961, Colle 1913, D'Orjo de Marchovelette 1940, Henroteaux 1945, and Joset 1934. These early accounts dwell on the allegedly lascivious nature of the association; the drunken, lewd, and otherwise excessive behavior of its members; and their supposed predilection for extortion, torture, blackmail, and other forms of corruption (Burton 1927:342, 335, Womersley 1984:26). Given the audiences for whom they wrote, these biases may be understandable, but clearly the authors made little or no attempt to understand the institution from Luba points of view.

4. Reefe sees Mbudye as "both the instrument and symbol of a Pax Luba" (1978:112). Yet the opposite could also be said: that the association, while in the guise of an agent of political consolidation, could be viewed as an agent of decentralization. Through initiation rites and the dissemination of esoteric information in mnemonic performances, Mbudye was responsible for the establishment of state power on a local level, the reproduction of the power structure far from its origins, and the involvement of individuals in the power game who were not biologically linked to the royal blood line. Furthermore, Mbudye was adapted to suit the needs of stateless peoples on the Luba peripheries, such as Hemba (Blakeley and Blakeley 1994:401–2) and some Tabwa (Roberts 1990a, 1990b).

5. In the Kabongo zone the stones are kept in a small gourd called "*lubanvu*," along with other objects like horns, beads, and a whistle. When a novice is ready to drink into the association, several small antelope horns are packed with recipes of herbal substances, the contents of which are then poured into a drinking gourd. To this is added water and the powder from the stones, and the initiate drinks the result to consume "the secrets of Mbudye." See our last chapter for a discussion of *ngulu* earth spirits and the role of quartz in the rituals of Luba-ized peoples.

6. "*Mukanda*" can refer to a letter or to the pieces of paper on which letters are written (Van Avermaet and Mbuya 1954:227), hence to communication of an inscribed message; but a homonym of the same tonality (probably a loan-word from peoples to the southwest of the Heartland) is the name for male initiation (ibid.). It is likely that the one informs the other, as both constitute communication.

7. The *kafundanshi* may also be a small hoe, and Harold Womersley uses the term to describe a double-headed spear (1984:71). Clearly, it is not the object but the function of making the path that is being named.

8. The highest titles in Mbudye are Kikungulu, the association's regional head, and Musenge (in the Kabongo region) or Tusulo (in the Kinkondja collective), the Kikungulu's second-in-command. Other, lesser titles designate functions ranging from the maintenance of the court to social control and distribution of goods.

9. Rock art in this part of central Africa has hardly been studied at all (Maret 1994:187); sites that have been investigated consist of geometrical patterns quite similar to those of Mbudye murals. Robin Derricourt illustrates some of these in the cover photograph of his monograph on northern Zambian archaeology, and associates them with Butwa (1980:13), a society quite like Mbudye that was practiced by peoples extending from Tabwa in southeastern Zaire southeastward into northern Malawi (Roberts 1988b).

10. The absorption of the pictographs into the kitê mound after the rains is reminiscent of how, in many African Islamic communities, a Koranic healing board may be washed of its ink and the resulting liquid drunk, as a kind of communion and as a "memorization" of the board's sacred but secret healing verses.

11. We would again stress that Mbudye has followed its own history of development, and while members believe that it has "always" existed as it now does, and that its precepts are inherited directly from Mbidi himself, there is likely to have been a great deal of invention of tradition along the way, as circumstances have changed and the society has been called upon to meet new conceptual and politico-economic needs. This is a continuing process.

12. In other accounts, the deity presiding over the association is described as a woman united with a buffalo, or as the offspring of a woman and a buffalo, thus the name Ina Ng'ombe (Mother Buffalo). Burton saw a rudimentary image of this spirit on the wall of an Mbudye house with the body of an animal and the head and chest of a woman (Burton 1961:159–60). As will be discussed in chapter 7, certain masks made by Luba-ized peoples peripheral to the Heartland, including the magnificent horned helmet mask now in the Royal Museum of Central Africa in Tervuren, Belgium, may represent the hero Mbidi Kiluwe as a buffalo. Certain Tabwa dance buffalo and human female masks in a structurally related drama (Roberts 1995a:22–25).

13. The phrase "owner of the land" is more common than "keeper" in central African literature, and refers to a chief deemed more autochthonous than a superior authority. "Owner" is a misnomer, however, for land was not "owned" as a commodity until the introduction of capitalism during the colonial period. Instead, the relationship of *mwine* is one of such intimate identification with the land that people say that such a chief "is" the land. "Keeper" is a better translation than "owner," then, for it suggests stewarding rather than capitalist property rights.

14. Thomas Reefe writes that "informants differed in their interpretations of certain bead patterns and carved markings but generally agreed as to the types of information the memory boards contained. This leads me to believe that there was a code for lukasa that was known to Mbudye members, but the exact manner in which this code was written with beads and carved marks depended upon the inclinations of the lukasa's creator" (1977:50). We would add that more political contingencies than those of the lukasa's creator are at play, with each narration a separate performance attuned to the needs of a particular audience.

15. A diviner and Mbudye member stated that the "real" mother of Mbudye is not Lolo Inang'ombe but a tree called "*munyenze*," which has healing properties, and that the abundant fruit of this tree are the association's members. Given the importance of herbal healing for Luba, it is not surprising that the founding ancestress should be personified as a tree of strength, growth, and abundant fruits; see Victor Turner's discussion of *mudyi*, the "milk tree" (*Diplorrhyncus condylocarpon*) of nearby Ndembu people of northwestern Zambia, as a "dominant symbol" referring to "values that are regarded as ends in themselves, that is, to axiomatic values" (1970:20).

16. Here the *kitenta kya vidye* corresponds to or overlaps with earth spirits known to Luba-ized and other peoples peripheral to the Heartland. *Vidye* are usually associated with the spirits of historically important persons, while

earth spirits called "*ngulu*" or "*miao*" by neighboring groups embody much more diffuse memory (Werner 1971). These matters are discussed in chapter 7.

17. Dates for the kings' reigns are from Reefe's chronology (1981).

18. References to tortoises are abundant in Mbudye art and ritual: numerous proverbs relate to tortoises, the tortoise plays a role in initiation rites, initiation emblems are linked to tortoises, tortoise shells are used as receptacles for medicines, and members obey numerous taboos in their treatment of tortoises. A tortoise's thirteen scutes are an apt symbol of the thirteen lunar months of a solar year (Roberts 1980). This suggests an important connection between the tortoise and Luba concepts of royalty as introduced by Mbidi Kiluwe, the lunar culture hero.

19. Reefe writes, "It was created from memory. My sense was that people were not going to relinquish (or admit to owning a lukasa) in those days, because of the anti-Mbudye attitude of missionaries (except the Womersleys) and the Belgian colonial administration. So, it was easier to simply commission a replica than to acquire a real lukasa. Because of its clear wood background it is more photogenic. It is more explicable, because it is almost a 'training tool.' It doesn't have everything the other ones have. It is not cluttered, dirty and used" (Reefe, personal communication, 1995).

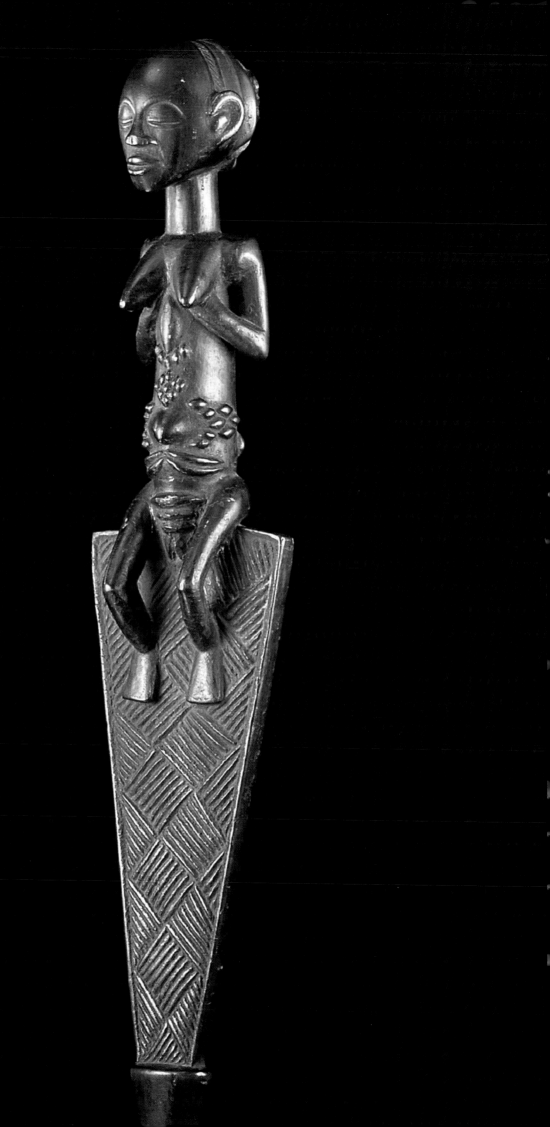

CHAPTER 5

Mapping Memory

Mary Nooter Roberts and Allen F. Roberts

Luba map memory through the iconography of stools, staffs, and other visual devices. Maps project an image of "truth," an aura of "fact," and an appearance of "objective reality." Maps "construct their own history" as they serve particular interests (Wood 1992:4, 28). The authority inscribed in maps causes those who use them to believe that they "are" the very landscape they reflect. As Jean Baudrillard states, in some ways a map is more real than the territory itself, for even after an empire falls, its map remains; a map

> is the generation by models of a real without origin or reality: a hyperreal. The territory no longer precedes the map, nor survives it. Henceforth, it is the map that precedes the territory—PRECESSION OF SIMULACRA—it is the map that engenders the territory. . . . It is the real, and not the map, whose vestiges subsist here and there, in the deserts which are no longer those of the Empire, but our own. The desert of the real itself (1983:2).

Maps both portray and lay claim to spatial experience. If space can only be experienced from one vantage point at a time—that of the person(s) perceiving it—then all cartographic representations reflect personal or factional visions. Maps created by states and nations seeking to colonize and govern foreign territories are clearly and purposefully subjective. Since the age of exploration, the cartography of the African continent has reflected the different interpretations that maps express regarding power, territorial conquest, and political legitimation (see Harley and Woodward 1987:506–9). Maps also secularize sacred geographies, and the transformation of three-dimensional reality into two-dimensional representation assists the domination of nonliterate peoples by those who control writing (Miller 1991:161). At the 1885 Conference of Berlin, representatives of the European powers (with Americans in the eaves, supporting claims to the Congo in particular) sat down and drew up a map, creating colonies with ruler and pencil (Cornevin 1970:113–16). Luba were making their own maps long before this.

A number of recent studies deconstruct the map and demonstrate the cultural nature of mapping and mapmaking. As Denis Wood tells us, there is a fine line between the two (1993b). Mapping is an informal activity, a kind of "getting around" in spaces and places so well known that they can be talked about and described without need of intervening devices. Mapmaking implies inscription of information in pursuit of sociopolitical goals, often by a "power elite"

CAT. 6A: STAFF OF OFFICE (DETAIL). LUBA, ZAIRE. Beyond their roles as prestige emblems, staffs serve as historical documents; their forms and designs encode information about their owners' lineage history. The simultaneous variety and similarity of the staffs shown on these pages evidence a kingdom that spread its influence in dynamic, far-reaching ways. Despite the large number of staffs, no two are identical. Each represents the history of a single king, chief, or titleholder, including details of migrations, genealogies, local tutelary spirits, and natural resources. Like chronicles and witnesses to the past, these emblems document the local-level political histories that constituted the larger Luba state. *Wood, copper. H. 53.4 in. Ethnografisch Museum, Antwerp, Inv. no. AE.61.62.2.*

Fig. 145: *Russuna and a Wife,* engraving published by the explorer Verney Lovett Cameron in 1887, showing a Luba chief seated on a sculpted royal stool supported by a female caryatid, and resting his feet on the lap of one of his wives. To indicate his semidivine atttributes, a Luba ruler's feet should never touch the ground.

CAT. 59 (OPPOSITE): CARYATID STOOL. LUBA, ZAIRE. Stools are associated with the complex hierarchy of seating privileges that distinguish members of the royal court. In Mbudye initiation rites, rank and title are indicated by the progressive accession to more prestigious forms of seating—from simple woven mats, to animal skins and furs, to modeled clay thrones adorned with geometric and figurative representations, and finally to the sculpted wooden stools and thrones that are the prerogative only of kings and spirit mediums. *Wood. H. 15 in. The University of Iowa Museum of Art, The Stanley Collection, Inv. no. CMS 457.*

(ibid.:52–53). Some societies need mapmaking, others do not—it depends on the nature of their social discourse. Mapmaking "is not a disinterested cartographic activity" but one "required for the stability and longevity of the state." A map "*requires and justifies* as it *records and demonstrates,*" and is a tool of societies that "subsume whatever they can—for example, the labor and culture of those they encounter." To put it still more bluntly, "Mapmaking societies . . . take and use" (Wood 1993a:6). Mapmaking, then, is a gauge of acquisitiveness, and suggests political ambition. Enter the Luba state, however loosely defined.

Maps begin with an environment that is not only inhabited and exploited but is conceptualized, interpreted, and rendered into "texts." As Karin Barber has written, comparing her work on Yoruba *oríkì* narratives to Ian Cunnison's earlier work (1969) among Luapula peoples on the Luba periphery, "the form of these texts [gained from the environment] does not derive from the place to which the memory or meaning adheres, but from principles governing the type of discourse it belongs to. To understand the significance of '*les lieux de mémoire,*' then, it is necessary to grasp the character of the texts: how they are constituted and how they interact" (Barber 1994:10).

As we have seen, Luba produce a wide variety of such texts in and through Mbudye and its expressive and material armatures. The lukasa memory board in particular, with its emphasis on spatial relationships and its references to architecture, geography, and the cosmos, makes explicit cartographic references. The board-as-map is both actual and conceptual, cosmological and anatomical. It links place, memory, and body on a plane that allows different readers to roam through its "landscape" along trajectories of their own choosing. Like memory, a lukasa has multiple exits and entrances, points of entry and egress, passageways and pathmarks that allow for movement in more than one direction (see Casey 1987:204).

If a memory board maps the Luba landscape, stools and staffs provide cartographic enlargements of details of this universe (cat. no. 59). Until now, art historians have viewed Luba staffs and stools primarily as prestige emblems, proclaiming the leadership and social positions of their owners (Fraser and Cole 1972). Or they have concentrated upon aesthetics and style (Neyt 1994). While stools and staffs do serve these important functions and manifest great artistic achievement, recent field research reveals Luba insignia as far more nuanced. For Luba, staffs and stools are historical documents whose hierarchical compositions of two- and three-dimensional forms are intended to be mnemonic texts.[1] Verbal exegeses are derived from them that not only reaffirm relationships between visual and verbal arts, but lend insight into the ways that individual holders of power view their roles and validate their social positions in Luba political hierarchies. In particular, staffs, stools, and the narratives that they elicit reveal how the model for Luba government conveyed through the Mbudye Society was appropriated, interpreted, and modified to validate local-level and individual claims to power by chiefdoms and lineages in outlying territories, both within what can be recognized as the Luba culture cluster and among related peoples who fell under or sought out Luba influence.

The colonial literature's emphasis on a Luba "empire" has caused outsiders to think of the term "Luba" as a homogeneous ethnic denomination and of their "empire" as a cohesive political entity. These definitions and attributions simplify what actually was and remains a complex ethnic mosaic, full of distinct groupings by lineage, clan, politics, and geography (including exploitation of local economic resources). The Luba Heartland is made up of diverse families and chieftaincies of varying size and influence. During the era of kingship, some of these chieftaincies were linked directly to the so-called "royal line," while others retained partial or complete independence. All shared aspects of Luba political ideology and praxis in terms of organization, investiture, and insignia. All shared, and continue to share, a common language, and the logic of that language as expressed through symbol and myth (see Heusch 1982). But the specific rituals practiced and the key metaphors developed by each chieftainship, as well as the hierarchy of political titles and the priority given to certain ancestral and earth spirits, reflect the distinctiveness of each polity and locale.

Differences of insignia among lineages and chieftaincies demonstrate how political actors draw

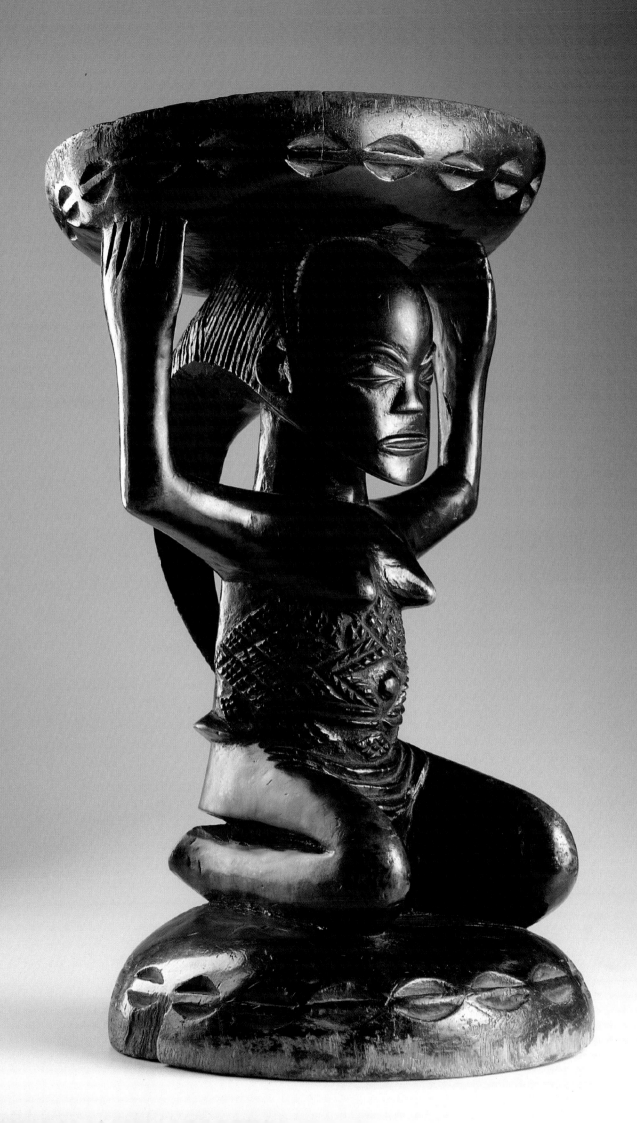

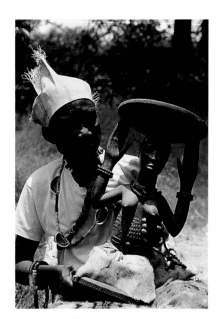

Fig. 146: A Luba village chief displays his caryatid stool, which was kept in a village separate from his own in order to protect it against theft, underscoring the immense value attributed to such insignia of office. *Photo: Mary Nooter Roberts, 1989.*

from the syntax of Luba precepts, as articulated through Mbudye, to construct local dialects of state and power. Chieftainship appropriates those elements crucial to kingship, such as royal prohibitions, court structure and protocol, hierarchies of officers, and spirit possession, and modifies them to meet local conditions and priorities. If the iconology of staffs and stools presents sculptural narratives, the reading of those narratives is defined by *local* historical consciousness and constitutes an act of power and resolution. Revelation of these texts, and discourse on their meaning, permits officeholders in peripheral positions of authority to assume (or generate?) power, and to place themselves in a position of local centrality while standing on the periphery of the Luba state.[2]

Unlike Luba oral traditions and charter myths, sculpted insignia stand as tangible documents of alliances, rebellions, and investitures. As "statement art," they confirm and glorify authority in a theater of ambition and intrigue.[3] They represent material evidence of transactions effected at specific times and places (as when a senior chief gives his junior a staff of office), and provide a necessary complement to the pristine uchronias and utopias of mythical time and space. These visual components of political discourse, then, are critical to an understanding of the heterogeneous and otherwise positional character of Luba polity.

Stools and staffs suggest two different kinds of place memory: one fixed and secured *in* space, the other subject to movements *through* space. A seat "sit-uates" power and memory in the past and the present, while a staff may be used for walking, voyages, battles, and processions (Roberts 1994). Stools elicit discourse relating to the underpinnings of authority in a given locale, while staffs are used to explain how power arrived at a certain place. In effect, stools are three-dimensional elaborations of the circles of beads configured on the lukasa memory board to represent kitenta spirit capitals and other centers of attention, while staffs are enlargements of the beaded lines and routings between such places, signifying voyages, migrations, and relationships.

Seats of Power

Stools are among the most important symbols of Luba kingship, as they are for many African peoples (fig. 145; cat. no. 60). Not only is the Luba king's palace referred to as a "seat of power," but seating is a metaphor for the many levels and layers of hierarchy that characterize Luba royal prerogatives. During initiation rites into Mbudye, the secret association responsible for indoctrination of all royal officeholders, rank and title are indicated by the progressive accession to more prestigious forms of seating, beginning with simple woven mats and proceeding to animal pelts, clay thrones adorned with geometric and figurative ideograms, and finally to sculpted wooden stools or thrones that are the prerogative of kings and royal spirit mediums (fig. 146).

There are two principal types of Luba stools. Almost all of those that have entered Western collections are caryatid stools, supported by single or occasionally double female figures (cat. no. 61). Nonfigurative Luba stools also exist, however, and consist of two round platforms mediated by four outwardly bowing supports embellished with deeply incised geometric patterns (fig. 147; cat. no. 62). It is thought that these latter stools may have been predecessors to the figurative ones.[4]

Stools are such potent emblems that they are often kept secretly in a different village from their possessor's home, to diminish the possibility of their theft or desecration. Swathed in white cloth and fastidiously preserved by an appointed official, a Luba stool is only brought out on rare occasions. As the receptacle for a king's spirit, it is not primarily a functional seat as such. The infrequency with which these stools are viewed reinforces the idea that they are intended not for human eyes (at least not primarily), but for those of the spirit world (Nooter 1993; see also Petit 1993:491–98).

As discussed in earlier chapters, Luba kings and chiefs once acceded to power and acquired the symbols of office through a rigorous investiture. Stools figured prominently in these rites, which set kings apart from the rest of society—indeed which removed them from humanity itself.[5] The king "is extraordinary in the literal sense of this word, he is a lion" (Theuws 1960:169). One way a ruler established his extrahuman nature was through transgression: a royal candidate

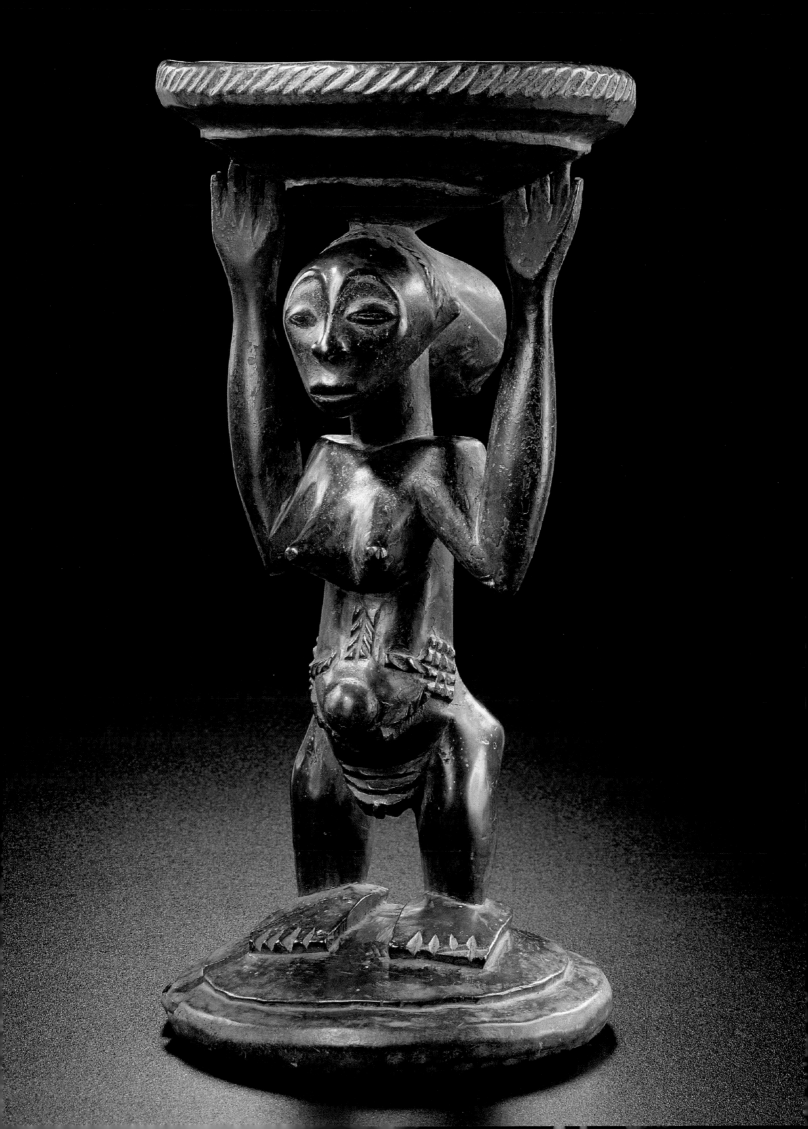

Fig. 147: Luba nonfigurative sculpted wooden stool with four supports and geometric patterning in the form of "scarifications." *Collection: the Royal Museum of Central Africa, Tervuren, Belgium. Photo: Mary Nooter Roberts.*

CAT. 61 (OPPOSITE): STOOL. LUBA, ZAIRE. The Luba stools that have entered Western collections are predominantly caryatid, supported by single or occasionally double female figures. Often the figures bear representations of cosmetic manipulations that are thought to enhance beauty and erotic pleasure, including scarifications and the elongation of the genital labia, a nonsurgical process required of all women prior to marriage. Yet, ironically, Luba stools were rarely intended for viewing. Swathed in white cloth and guarded fastidiously by an appointed official, stools were brought out only on rare occasions. Their purpose was to serve as receptacles for the king's spirit, rather than as functional objects as such. The rarity of their viewing accords with the idea that many insignia were not intended primarily for human eyes, but for the spirit world. *Wood, beads, glass, fiber. H. 16.75 in. Virginia Museum of Fine Arts, The Arthur and Margaret Glasgow Fund, Inv. no. 91.502.*

was confined in a ritual house where he engaged in incest with a close female relative, slept in the presence of the relics of previous kings, and ingested human blood from the dried cranium of his predecessor. After his transformation, he was subject to none of the usual prohibitions: "Being king is the charm that destroys all taboos" (*I pupu wa lwipaya bizila*), a proverb runs. The king had no need to avoid what would pollute others, even women's menstruation (ibid.). Indeed, blood was the agent that activated the king's reign, and that linked him to the awesome powers of the ancestors. It was this rite, called "kutomboka," that sanctified royal prerogatives (though a Luba king did not become "divine" until death, when he joined the pantheon of heroic spirits called Vidye). At the triumphal moment, the new king emerged from the enclosure fully bathed, freshly costumed in royal regalia, and flanked by his many dignitaries; a stool was placed upon a leopard skin, and the new ruler sat upon it as he swore an oath to office and addressed his people for the first time as king.

Stools are also associated with the kitenta, the spirit capitals of important rulers of the past. Indeed, the spirit of each king and the essence of each kingship are enshrined in a stool or throne. Furthermore, when a Luba king died; his royal residence was preserved for posterity as a "spirit capital" and important lieu de mémoire, where his spirit was incarnated by a medium called a Mwadi (Nooter 1991:271–76). This place became a kitenta, which may be translated literally as "seat" (fig. 148). In other words, the place became a symbolic seat of memory and power, in continuation of the reign of the deceased monarch. A sculpted stool is a concrete symbol of this larger, metaphysical "seat," and similarly expresses both fundamental and particular precepts of Luba power and dynastic succession (fig. 147 and 147a).

A stool was also used in Mbudye initiation rites called "kikalanyundo," after a conelike earthen throne with mnemonic images of royal hierarchy and power painted around its perimeter in white chalk (see fig. 116 in chapter 4). The novice mounted this throne upon reception of his or her spirit, following thorough memorization of the information inscribed upon wall murals and a lukasa memory board. The word "kikalanyundo" has the same root as the words for both an iron anvil (nyundo) and small iron hairpins called binyundo; it is through these dominant symbols that ideological connections are established between blacksmithing and the origins and sacred transformations of kingship. We have seen that the hairpin placed in the upper center of many lukasa memory boards represents the kitenta or spirit capital of the king in whose honor the board is made. The word "kitenta" is a synonym for "kipona," or throne, for it signifies the summit of power, the pinnacle of achievement, and the place where a holder of authority sits after he has experienced the catharsis of spirit possession and acquired a spirit identity.[6] But it also signifies the place where memories of preceding kings are glorified.

That the spirit capital might be represented as a stool with one or two caryatid figures may reflect the fact that in some areas, kings were buried in a seated position, posed on a female slave who had been executed or was buried alive.[7] The desire to be supported by a woman after death is related to the idea that the dynastic lineage was perpetuated through the birth-giving capacities of women, and refers to the king's reincarnation in the Mwadi, the woman who maintains his spirit capital. Luba nonfigurative stools also refer to the kitenta spirit capital, through etymology and symbolic texts.

Reading a Stool

The following narration of a kitenta stool illustrates the kind of mnemonic imagery found on both figurative and nonfigurative stools. The narrative represents a particular viewpoint on the Luba royal dynastic line, the view of members of a political faction who dispute that line's legitimacy. This reading exemplifies, then, the way visual devices and derivative exegeses may express power struggles, competition, and hierarchy. Accompanying the account is fig. 148, a drawing provided by Luba colleagues, showing the disposition of the important lieux de mémoire contained in and expressed by the stool. It also shows stools as members of a paradigmatic class with other mnemonic objects such as magical horns, anvil-shaped iron hairpins, and the clay thrones of Mbudye, each of which can be "read" and narrated as the stool is here.

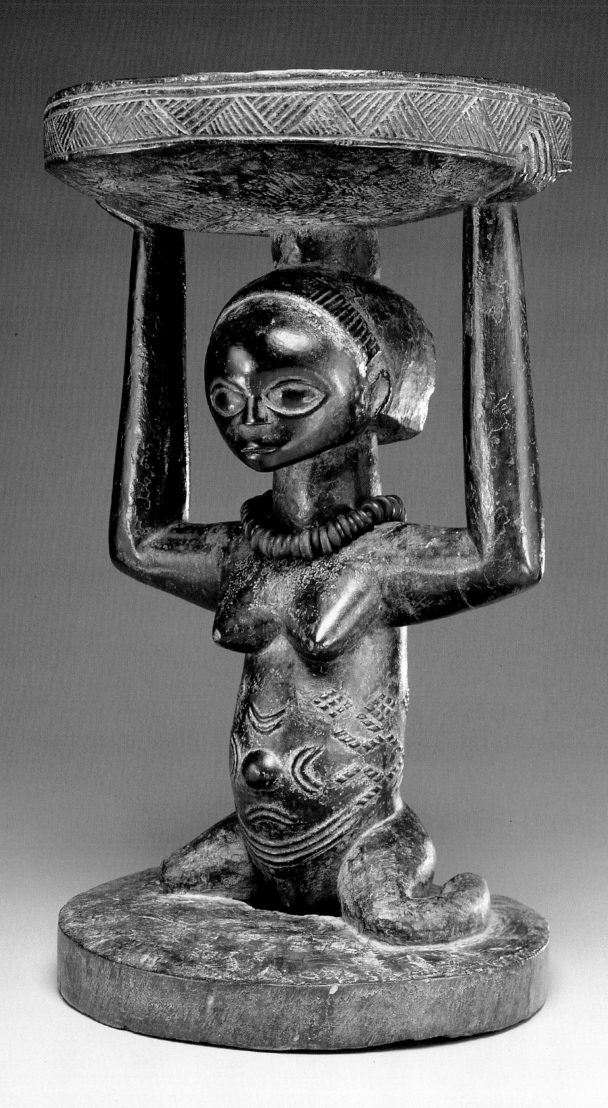

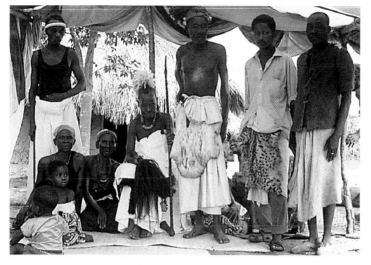

Fig. 147a: Kitenta spirit capital of King Kasongo Niembo, who died in 1931. A Mwadi, the female spirit incarnation of the king, is seated on a royal stool wearing the king's royal accouterments and surrounded by the king's former titleholders. The kitenta is the symbolic "seat" of power and spiritual vitality. *Photo: Thomas Q. Reefe, mid-1970s.*

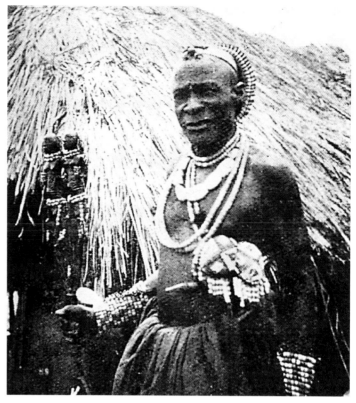

Fig. 149: Chief Kilulwe, photographed by in the early twentieth century. The chief displays a staff of office topped by two female figures sculpted arm-in-arm and laden with mnemonic beadwork. The double figures probably represent female spirit mediums, who often reside in pairs—a reflection of the fact that the tutelary spirits of Luba royalty are twin spirits who inhabit lakes dotting the Luba landscape. *Photo: J. van den Boogaerde, near Mwanza, in 1916-18.*

Fig. 148: Diagram of *kitenta* spirit capital based on an illustration provided by Kabulo Kiyaya and Nday Kintu. A *kitenta* represents not a stool in literal terms but, metaphorically, a seat of power.

1. The royal Court of Kalala Ilunga, first sacred king.
2. Kalala Ilunga surrounded by his titleholders.
3. The court of Kabamaka Mwine Munza, the female ruler who stayed on the throne of Kalala Ilunga to engender the lineage.
4. The court of Mwine Kibanza and his sub-chiefs.
5. The court of Kabongo.
6. The court of Kasongo Niembo and his sub-chiefs.
7. The sacred lakes of Munza, Buhemba, Nsamba, Mpanga and Banze.
8. The Bilumbu diviners and Mbudye members with their ranks and titles.
9. The central road is a large boulevard leading to the entrance of the *kitenta*.
10. The strings are for strength, while the two small black beads symbolize richness, to mean that every seat of royalty is a center of wealth and prosperity.

The sides of the stool have scarifications or geometric markings like those on the back of a lukasa and on staffs. The pointed end [or center of the stool's upper platform] is the summit or apex. Emerging from the point are two strings or thongs, to each of which is attached a small black bead. The whole body of the kitenta is covered with beads of different colors, creating roads from the summit to the base. There are five principal roads, of which the central one is the large boulevard that leads to the entrance of the kitenta. This road is barren, with no designs, beads, or scarifications. It leads from the pinnacle of the kitenta's summit to the center of the base, which signifies the palace of Kalala Ilunga, the founder of royalty.

Having arrived at the center, one puts down the little stick [used to indicate the various points] and pronounces a praise phrase in honor of Kalala Ilunga. After anointing oneself with white chalk, one picks up the stick again and continues the reading by passing the road that separates Kalala Ilunga from the Mbudye Society. From the court of Kalala Ilunga, one can either take the road to the left, toward the chieftaincy of Kibanza, or to the right, toward the quadrant of the Mbudye Association and the royal diviners. Within the region of Kalala Ilunga there is a large circle of twelve beads grouped around a prominent bead symbolizing Kalala Ilunga himself. Within the same region is a medium-sized circle of twelve beads representing the royalty of Kabambaka Mwine Munza, the female ruler who stayed on the throne of Kalala Ilunga to engender the lineage, which extends all the way to the present chief and his son.

In the second region, one finds Mwine Kibanza and the beads representing his subchiefs Madia, Nkombe, Kadilo, etc. There is also a medium-sized circle representing Kabongo. The powers of these rulers are nearly equivalent. Then in the third section is the royalty of Kasongo Niembo and his subchiefs. Finally, the last section represents the Bilumbu diviners and the Mbudye with their titles, beginning with Kikungulu all the way to Vidye Mulale Kijimba. The grooves near the summit of the kitenta symbolize the force of royal power, and serve to hold the kitenta upright. The strings are also for strength, while the two small black beads symbolize wealth, and mean that every seat of royalty is a center of prosperity.[8]

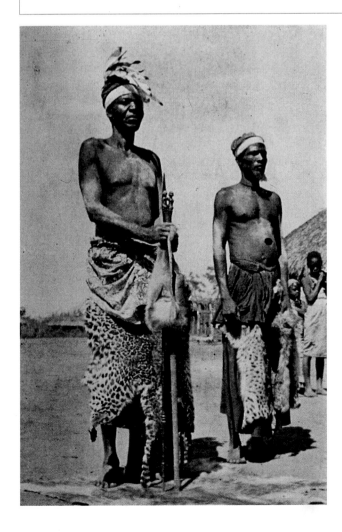

Fig. 150 (left): Titleholder Twite of Kabongo with sculpted staff of office surmounted by double female figures. *Photo by W. F. P. Burton, early twentieth century (1961:23, fig. 2).*

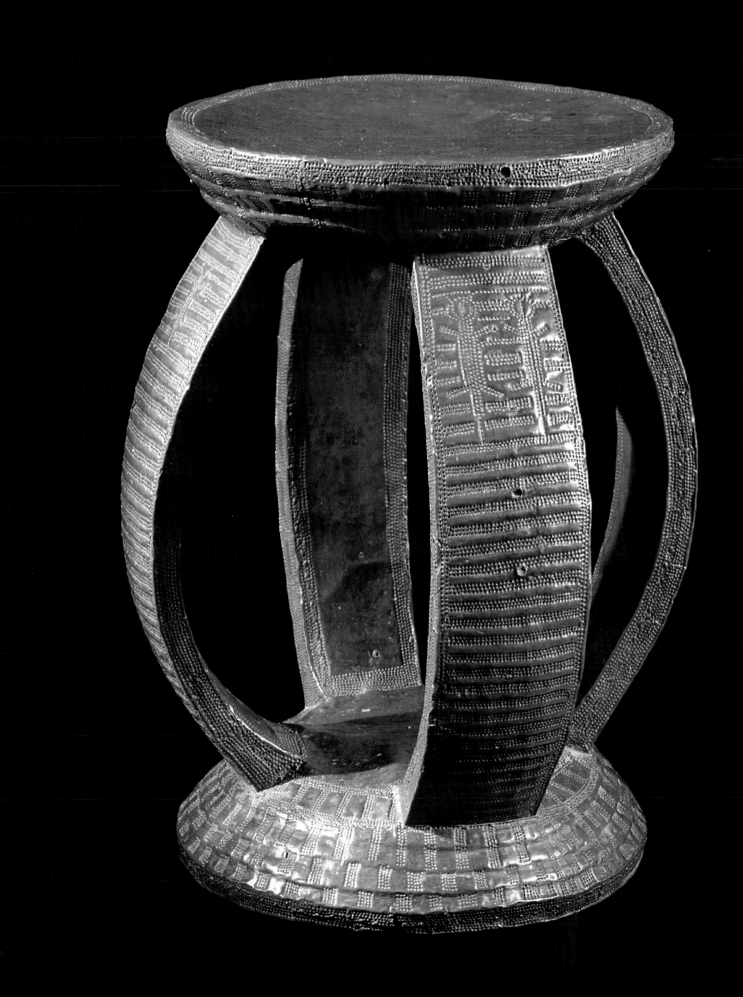

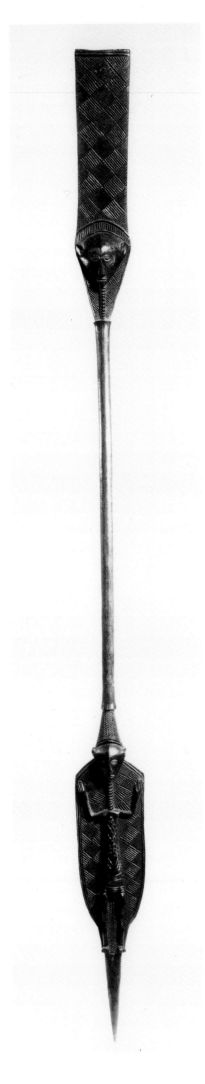

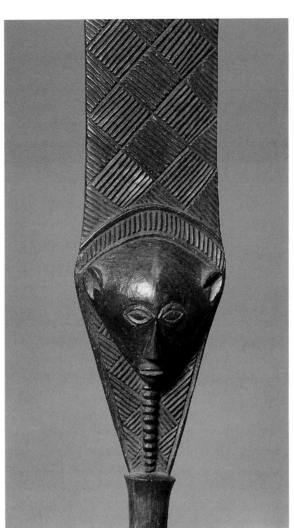

CAT. 62 (OPPOSITE): STOOL. LUBA, ZAIRE. In addition to the caryatid stools, Luba have produced nonfigurative stools consisting of two platforms mediated by four outwardly bowing supports embellished with deeply incised geometric patterns. These stools, it is thought, may have been predecessors to the figurative ones. This example has copper sheeting covering the wood, and the depiction of a lizardlike animal. In a reading of a Luba stool, the four supports constitute the "roads" leading to the king's capital, represented by the platform of the seat. A seat is therefore a center of political power and sacred authority. *Wood, copper. H. 17 in. Marc and Denyse Ginzberg.*

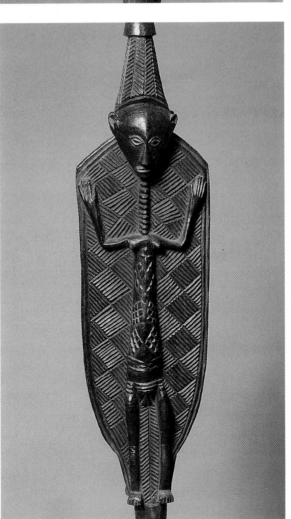

CAT. 63 (LEFT): STAFF OF OFFICE. LUBA, ZAIRE. A number of iconographic features allow staffs to be read like sculptural maps. The female figures shown seated or standing at the summit of staffs, or carved in relief on their broad sections, represent the female founders of specific royal lines, or the king himself. Many staffs, like this one, also include a pair of Janus heads—a reference to the twin tutelary spirits of Luba kingship, Mpanga and Mbanze, whose vigilant two-way gaze suggests clairvoyance and ambiguous dualities. *Wood. H. 66.5 in. Staatliches Museum für Völkerkunde, Munich, Inv. no. 11.1441.*

This reading of a kitenta, as it takes the form of a stool, reflects a political faction's attempts to disprove the authenticity of the royal line. The validity of the Kabongo dynasty is heatedly debated by Luba. Oral records in the region of Makwidi, where this narration was performed, challenge the authenticity of the royal genealogies that until now have been the basis of "official" Luba state history recognized by colonial and postcolonial authorities (Verhulpen 1936, Reefe 1981). The people of Makwidi claim to be direct descendants of Kalala Ilunga, and hold that the Kabongo line cannot be considered legitimately "royal" because its male ancestor was the rebellious son of an illegitimate child born through incest between Kalala Ilunga and his daughter. Rather, they hold that the real progenitor of the royal dynastic line is the daughter of Kalala Ilunga's legitimate son, who died in war, and whose lineage still occupies the throne of the Munza chieftaincy, located in Makwidi. The inhabitants of Makwidi proclaim themselves the rightful heirs to Kalala Ilunga's legacy, then, and can "prove" it by their possession of what they assert is the "original" stool narrated here, which is said to have been passed from Kalala Ilunga to his grandaughter.

The discord between the two royal lines is conveyed in the kitenta by the pronouncement of praise names related to each faction. Kibanza, for example, is one of the two royal lineages descended from the illegitimate son of Kalala Ilunga, whereas Kabambaka Mwine Munza, the woman mentioned as the daughter left upon the throne, is Kalala Ilunga's granddaughter, from whom the Makwidi line descends. These signs provide a memorandum for recalling and pronouncing interlineage anatagonisms and political struggles. Such debate reveals the continued importance of historical origins, authenticity, and political power for Luba, even a century after colonial conquest of the kingdom. Seats of memory may prove or disprove the political legitimation of particular histories, then, depending upon one's point of view.

Staffs as Sculpted Narratives

African staffs have many roles and functions (cat. no. 63). They support and comfort, bear one's weight, and protect one's interests; they can be used to prod and poke, thrash adversaries, or wave about in defiance. Ancestral presence can be as close at hand as the grip of one's staff, and, most important, staffs serve as metaphoric extensions of the hand (Roberts 1994:1–2). While they may thus be "adjuncts to the body" (Cartry 1992:28), Luba staffs also record details of family history, migration, and genealogy.[9] High-level officeholders carry staffs to public proceedings, and as the basis for historical recitations in which they honor their ancestors, brag about the accomplishments of their lineages, and teach their descendants about family ties to Luba kingship.

Like stools, staffs played a critical role in precolonial investiture ritual: the sister or first wife of the man to be enthroned preceded him with a staff of office, which she placed next to a royal stool. The ruler held this staff as he swore an oath of office (fig. 149). The custom of planting a staff in the ground appeared not only in all important public ceremonies but also in war, when staffs were carried into battle as rallying points, and were stuck in the ground among the slain enemy as signs of bloody victory (Burton 1961:31). When the staff was not in use, its care was assigned to one of the ruler's wives or titled dignitaries (fig. 150).

There are several kinds of Luba staff. Some echo the shape of the paddles used by boatmen on the lakes and rivers of Luba country. Called "*misupi*", these testify to ancestral migration along rivers and refer to an incident in the Luba Epic when Mbidi Kiluwe is ferried across a river to safety. Ferrymen are said to have been given sculptural paddles by kings, for the crossings they guarded were critical points of articulation for trade and political welfare (Reefe 1981:86–87). Another Luba staff, the staff of office called "kibango," functions more than any other chiefly insignia as a mnemonic text, its forms and designs constituting sculpted narratives.[10] Beyond their role as prestige items, staffs encode information about lineage history.

The simultaneous diversity and semantic equivalence of the staffs illustrated on these pages evidences a Luba kingdom that spread its influence in far-reaching, dynamic ways, and that was emulated and imitated far more widely than that. Of the several hundred kibango staffs known to us from field research and various collections, no two are identical. Each represents the history of a particular chief or titleholder, and the migrations of his ancestors, his genealogy, and the loca-

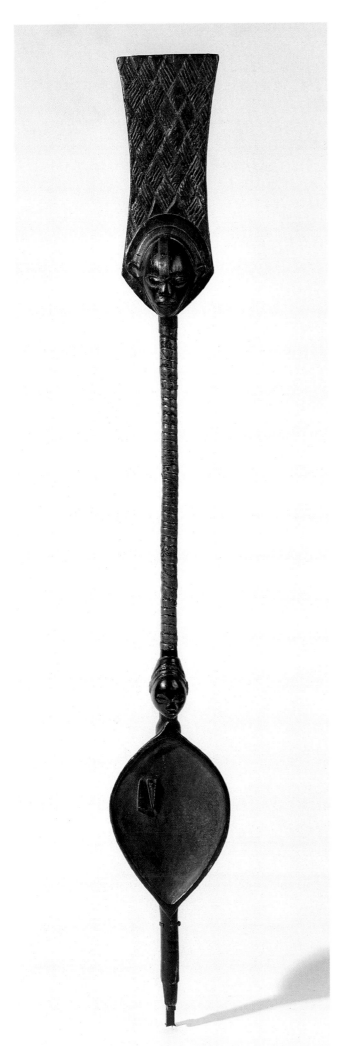

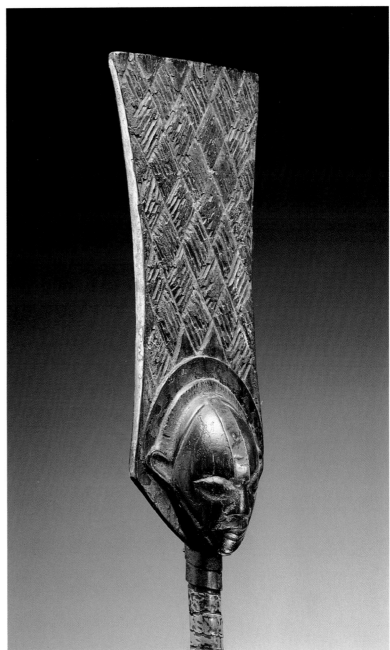

CAT. 64: STAFF OF OFFICE. LUBA, ZAIRE.
Royal staffs were both prestige items and
receptacles for sacral power. Sanctified by
ritual specialists, fortified with metal and
medicine, they took on supernatural qualities
and were said to have healing power. The
depiction of duiker horns on the lower
portion of this staff may refer to the staff's
curative capacities, since Luba doctors used
small antelope horns to hold medicine.
*Wood, copper. H. 51.9 in. Lucien Van de
Velde, Antwerp.*

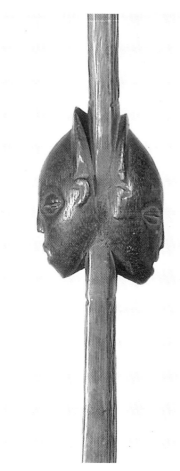

Fig. 151: Janus heads on a staff of office representing twin tutelary spirits of Luba kingship, Mpanga and Banze. *Photo: courtesy of the Section of Ethnography, Royal Museum of Central Africa, Tervuren, Belgium.*

tion of tutelary spirits and natural resources. Like witnesses to the past, these emblems chronicle the local political histories that constituted the web of relations within the Luba sphere of influence. They may be "read" as texts, though normally only by the owner and the spirit medium who consecrated them.

Staffs are also maps of power and shrines of healing. Memory, medicines, prayers, and prohibitions are implanted in a staff, rendering it a powerful device for curing and protection. The depiction of duiker horns on some staffs is a reference to the staff's curative capacities, since Luba healers use these small antelope horns to hold potent magical medicines (cat. no. 64). Staffs explicitly combine efficacy and curative powers with mnemonic qualities (Jordán 1994).

Despite their extreme sacredness and the secrecy in which they have been preserved, staffs are paradoxically one of the most widespread of Luba royal insignia. They are among the regalia said to have been introduced by Mbidi Kiluwe and his son Kalala Ilunga, the culture heroes who introduced sacred rule to Luba (Heusch 1982, Mudimbe 1991, Reefe 1981), and they have widespread distribution among chiefs and titleholders, territorial governors, village headmen, and female spirit mediums throughout both Luba territories and the lands of those affiliated with Luba, or emulating them (see chapter 7). At the royal court of Kabongo, the king's kibango staff is among the original articles in the royal treasury, said to have been given to Kalala Ilunga by Mbidi Kiluwe, and then handed down through the lineage to the present king. Comparison of that claim with the narrative of the stool from Makwidi, said to have been left there by Kalala as "proof" of the local lineage's legitimacy as against that of the Kabongo kingship, makes clear how contentious the readings of objects can become. As we have seen before, memory and history are often at variance.

Staffs are also owned by village chiefs. In the Kinkondja-Mulongo region, it is said that the possession of staffs is a special prerogative of three royal titleholders: Inabanza, Tshikala, and Ndalamba. As one man explained,

> In the beginning, Mbidi Kiluwe brought only one kibango royal staff for his son, Kalala Ilunga. It is only there where the royal staff was left that power was centered. The many staffs that one sees these days, scattered everywhere, are imitations copied from the first staff belonging to Kalala Ilunga. His children have tried to adapt their own histories and have adopted his insignia. In reality, the staffs owned by different titleholders are used to render themselves more prestigious and powerful and so give themselves more "weight," in memory of the original staff.

The statement makes clear how the charter of Luba sacred kingship was appropriated, interpreted, and modified to validate local claims to power, and the role of staffs in that process. A narrative "reading" of one staff might explain how the king came to the owner's locale and invested his grandfather in a royal title. Another staff might bear cartographic references, helping its possessor to remember how his great-grandfather's lineage maintained independence from the central kingdom in spite of Luba depredations. Staffs dating from the glory days of Luba kingship continue to shift in purpose and meaning as people adapt to changing circumstances. Staffs that once symbolized political relationships may now be updated to include tenets of Christianity and other contemporary realities, continuing to serve in everyday problem-solving as history is made (Nooter 1994, Roberts 1994).

A Case Study

An oral narrative presented to Mary Nooter by a subchief of Kinkondja illustrates how staffs of office sanction their owners' authority by affirming ties to the Luba dynasty.[11] Before colonial conquest, the chiefdom was ruled by the Kabongo kings, despite its proximity to the Kinkondja royal court. Subsequently, Belgian administrators put the chiefdom under the jurisdiction of Kinkondja; even so, however, the chief's allegiance remains with Kabongo, the Luba kingdom's legendary "dynastic center," which he considers more prestigious than Kinkondja, which was only defined as a substate relatively recently under colonial authority. He inherited his staff in 1956, when he suc-

Fig. 152: Staff of office belonging to a subchief in the Collective of Kinkondja. The king is represented by the female figure at the top of the staff, the twin tutelary spirits Mpanga and Banze are depicted by Janus heads, and each of the broad sections of the staff is a representation of a *dibulu*, or administrative center. The staff reads like a map, recording the king's journey from the royal center, at the top, to the staff owner's local village, at the bottom. The scarifications on the female figure's torso and the patterns on the diamond-shaped dibulu sections symbolize the transposition of royal secrets from the royal capital to outlying regions. *Drawing made by Nancy Ingram Nooter based upon a sketch by Mary Nooter Roberts, 1987.*

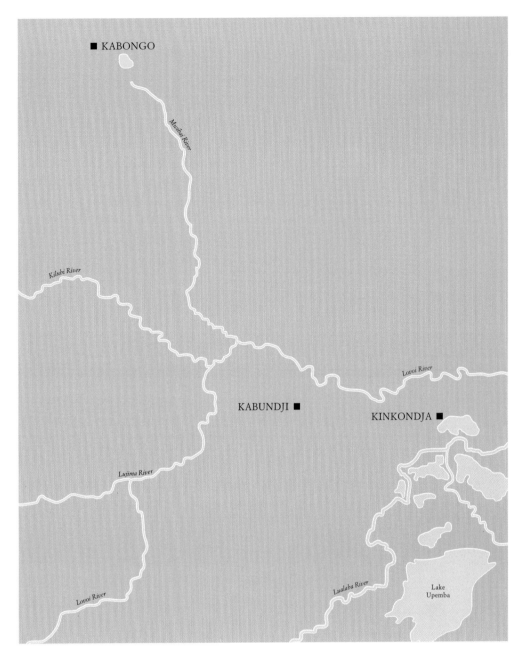

Fig. 153: Map of Luba Shankadi region showing the three political centers depicted on the chief's staff by the three dibulu diamond-shaped sections: Kabongo, Kabundji, and Kinkondja. *Map by Chris Di Maggio.*

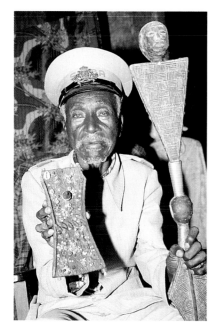

Fig. 154: Luba chief displays a lukasa memory board next to a staff of office, to illustrate the close relationship between the two object types in their modes of mnemonic recall. *Photo: Mary Nooter Roberts, 1989.*

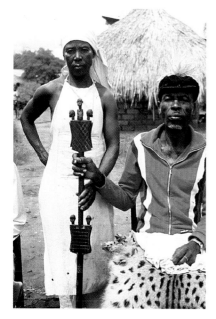

Fig. 155: Luba village chief and his first wife display a staff of office that derives its form from the same principles as that of a lukasa, with the broad dibulu sections of the staff echoing the hourglass form of some lukasas. *Photo: Mary Nooter Roberts, 1989.*

ceeded his father as chief; it had been sculpted in 1937 by a well-known artist of the region, who is now deceased (fig. 152).

The chief recounted that the female figure surmounting his staff represents both the spirit of all Luba kings and chiefs, and the physical extent of their power. In the region of Kabongo, this exalted spirit of kingship is called Mwanza Lulu, or Mwanza Mountain; in the vicinity of Kinkondja, it is known as or associated with Mutonkole, a spirit residing in Lake Kisale. Appearing on the staff in the form of a female figure, the king stands upon Janus heads portraying the female mediums of twin spirits named Mpanga and Banze (fig. 151), who preserve and protect the history and sacred prohibitions of Luba kingship. Mpanga and Banze inhabit a sacred forest near Kabongo, where all kings of the founding dynasty are invested.

After this investiture in the sacred forest, a king began his voyage. The chief explained that a king's staff can be read like a map (he used the French word "*carte*"): the unelaborated portions on its shaft represent uninhabited savanna, while a diamond-shaped section called "*dibulu dya bwadi bwa Mpanga*" is the "royal capital" near Kabongo, where the first legitimate king, Kalala Ilunga, organized his royal court and named his highest-ranking titleholders (fig. 153). Kings still hold political meetings and ceremonies of state here.

Having established his court and instituted a system of titles, that first king proceeded southeast to Kabundji (see fig. 153), which is represented on the staff by the second sculpted diamond-shape, called "*dibulu dya Kabundji*." Here he established a center for the investiture of all chiefs and Mbudye Society members residing outside the capital of Kabongo. This, then, became the administrative link between the capital and outlying provinces. The third and final dibulu represents the village of the chief who owned the staff. It bears the praise phrase, "The place where all the little streams come together and where all the chief's subjects and titleholders come to spread chalk on their skin in his honor." This last dibulu signifies the unity of the chiefdom, then, and stresses respect for the chief's authority. The four corners of the diamond also represent the territorial limits of the chief's power.

The staff helps the chief to recall and recount that his village became a political center when a royal official was sent to define the territories of the Kabongo king. The Kabongo rulers had long sought the chiefdom in question as a client group, because of its renowned iron-smelting and the skill of its blacksmiths, and because its location on the eastern limit of the Luba Heartland would allow it to play a role in protecting the state's frontier. When the official from Kabongo arrived, he found seven villages, of which the present chief's was the most industrious. Of the two clans residing there, the official selected one to rule, and named a chief, upon whom he bestowed a title and a staff. The responsibilities of this chief included surveying and protecting the area, increasing population by encouraging people to settle there, and investing dependent village chiefs. In realizing these duties, the present chief said, the chiefdom become a client region of the king of Kabongo.[12]

The final section of the staff is an iron spike, which can be driven into the ground to stand the staff upright. Iron, the chief explained, signifies his power—stable, durable, and resistant. It also stands for the indigenous nature of his power, for just as the men who smelted and forged this iron were not foreigners to his lands, the chief's power does not come from outside his chiefdom. And just as the staff's iron tip may be thrust into the earth, so the chief's power is rooted deep in the soil where his ancestors are buried.

A staff like this one—at first the original staff, and later its replacements—has passed through the hands of each successor to the chief's title. Whenever the staff has been depleted of power (an event that might be revealed through divination when, say, the chief was unable to avoid calamity befalling his community), it has been revitalized by a ritual specialist residing near Kabongo.[13] The staff is taken to the sacred Heartland, in other words, to renew the strength of association and resolve implicit in its history. Similarly, if the staff were lost, stolen, or damaged, and a new one had to be made or procured, it would be devoid of power and value until sanctified at the royal capital. These rituals reconfirm that the owner's authority is derived from the line of Luba kings. As the chief explained, the owner's power comes from the sacred forest of the twin spirits Mpanga

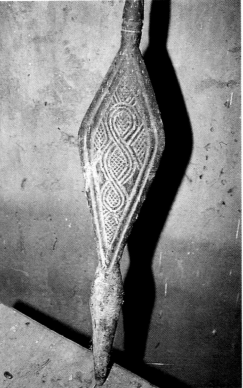

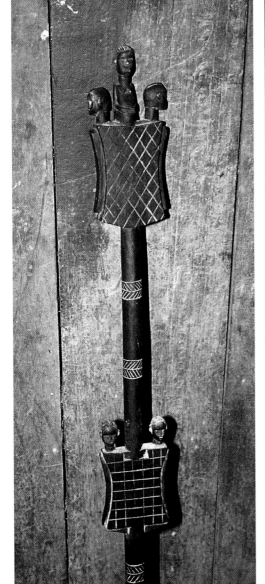

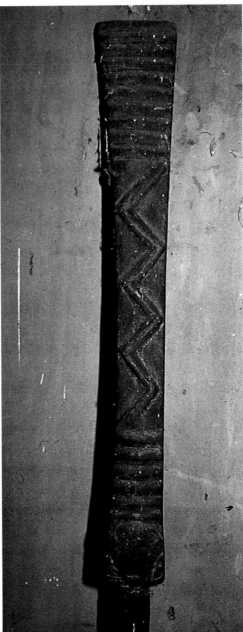

Fig. 156 (far left): A blacksmith displays a freshly carved staff of office possessing multiple dibulu sections along its shaft, a reference to a journey that spanned several administrative centers along the landscape. *Photo: Thomas Q. Reefe, mid-1970s.*

Fig. 157 (left): Detail of lower section of staff showing the dibulu administrative center of the chiefdom in question. Lines around the perimeter of the lozenge represent the roads taken by titled officers to approach the capital, differing according to their rank. The staff thus mnemonically records rights and prerogatives of royalty. *Photo: Mary Nooter Roberts, 1988.*

Fig. 158 (far left): This staff incorporates the lukasa form in a literal way, and depicts the twin spirits Mpange and Banze flanking the central figure, who is both the chief himself and Kikungulu, the head of the Mbudye Society. *Photo: Mary Nooter Roberts, 1989.*

Fig. 159 (left): Detail of the upper section of a staff mnemonically recording the accouterments of a titleholder, with a vertical zigzag line depicting a cone-shell necklace and horizontal lines representing multiple strands of beads worn by all high-status persons. *Photo: Mary Nooter Roberts, 1988.*

and Banze, for they are the force behind both the king's rule and his own. Though the chief looks to the center as a source of legitimacy, then, his relationship to the king is more mimetic than strictly dependent.

The chief ended his narrative where he began, with the female image surmounting his staff. Its gesture of hands to breasts is seen in many Luba works of art (cat. nos. 65,66). The chief explained that hidden within a woman's breasts are the bizila, or royal prohibitions, of which certain women are the ultimate guardians. The chief related the scarification patterns on the figure's abdomen to the engraved patterns on the dibulu sections of the staff (fig. 152); these inscriptions are given the same form in order to signify the secret of the state's success—namely, the transposition of Luba political organization from the royal capital of Kabongo to smaller chieftainships. The chief added that these scarifications were those of the chief's first wife, which were copied by ordinary women seeking to emulate royalty. When people worshiped in the past, he explained, they always removed their clothes. All women had scarifications, and spirits responded above all to women: they were more "favorable" to women, he said. In this sense, the scarifications represent the masses of women who have recognized Luba kings and chiefs like him—leaders who, on the staff, are portrayed as a female figure elevated on a pedestal between two spirit wives (fig. 158).

Horizontal bands incised across each diamond-shaped dibulu section are given another signifi-cance as well: they are said to represent specific local mountains deemed to contain precious resources and to be guarded by powerful earth spirits. The chief cited each mountain represented by a triangle on his staff, and the copper, iron, gold, and other minerals extracted from or hidden within it.[14] To obtain these metals in the old days, the chief sent an intermediary, called a "*kitobo*," to collect from villagers food and beer that were then offered to the earth spirits so that they would "liberate" the resources people needed. When a quantity of minerals was "freed" in this way, a portion of what was then mined was brought to Kabongo. A titleholder named Kanami kya Nindi, for instance, was responsible for carrying iron ore to the king. The remaining ore was smelted and forged into tools such as axes, hoes, machetes, and knives; or it might be hidden away and sold to Lele, Kuba, or traders from Angola. The iconography of the chief's staff, then, recapit-ulates these important local relationships of political economy, as well as the region's links to the royal center.

Staffs and Lieux de Mémoire

The chief's narration of his staff reveals a number of similarities to the reading of a lukasa memory board, especially in the way both objects define or delineate the cardinal points of a socially and ideologically significant space (cat. no. 67). Some chiefs explicitly make analogies between the staff and the lukasa: one showed the author a lukasa and a figurative staff side by side, and discussed their related meanings (fig. 154). Another also stressed relationships between the two kinds of insignia, and showed how his staff incorporated the hourglass form of a lukasa in its construction (figs. 155 and 158).

In the exegesis above, the word "dibulu" is used to designate a political center. "Dibulu" is a synonym for "*kwipata*," or royal court, although it also refers more specifically to the administra-tive precinct of a royal compound. Like the lukasa, a dibulu has four corners. On a staff, the long shaft connecting the dibulu administrative capitals represents the uncleared savanna as a wilder-ness rich with natural resources, as emphasized by copper coils. The interruption of the "road" or "path" of the staff's shaft by three dibulus recalls Mbudye initiation procedures and the clearing of the path that leads to the secret meeting house or to the king's court, signaling dichotomies between the unsettled wilderness and the sociopolitical order so important to Mbudye.

The staff also reflects social hierarchies. Just as with the lukasa, reading begins at the top, with the king and the principles of sacred rule that he personifies. And just as a lukasa may have a head at its top, signifying kingship, and a tail at the bottom, representing the "keeper of the land," so a staff has an iron spike at the bottom with which the staff is thrust into the soil.[15] The three diamond or lozenge shapes of the chief's staff represent a declining progression from the presti-

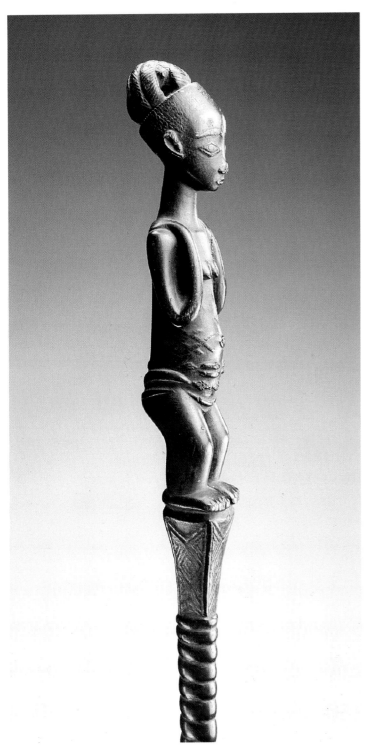

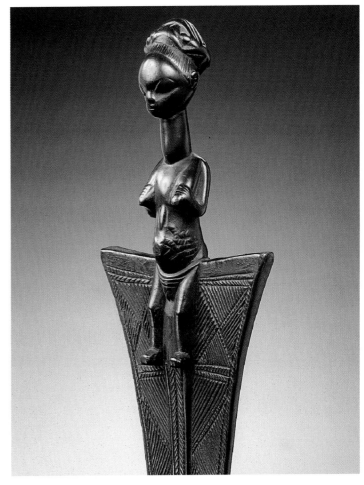

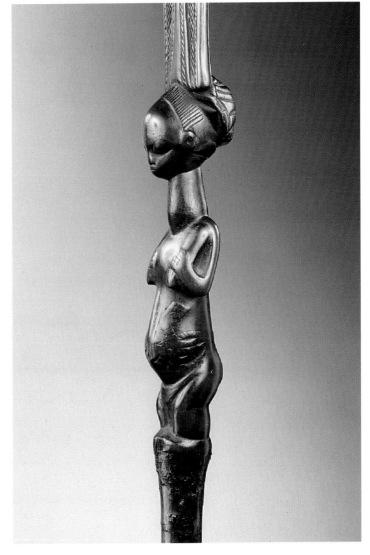

CAT. 65 (ABOVE): STAFF OF OFFICE. LUBA, ZAIRE. A Luba staff is like an enlarged detail of a map, for a staff tells the story of an individual family, lineage, or chiefdom, and how kingship came to their region. The map is read vertically, from top to bottom, beginning with the female figure at the summit of the staff. As one progresses down the staff, it is as if one were journeying across the Luba landscape, through the uninhabited savanna represented by the plain, unadorned shaft. Luba staff narrators often identify the surmounting female figure as the king, whose spirit is carried in the body of a woman, and whose powers are tucked secretly within her breasts. *Wood. H. 51 in. Private collection.*

CAT. 66 (ABOVE RIGHT AND BELOW RIGHT): STAFF OF OFFICE. LUBA, ZAIRE. The word "kingship" cannot accurately portray the true nature of Luba royalty, which was based on the duality of the sexes. The pervasive representation of women on male officeholders' emblems, and the important roles of women in Luba political and religious history as spirit mediums, reinforce the ambiguous gendering of power. This staff, with its portrayal of two women, each looking in a different direction, expresses the Luba belief in women's powers to bridge both worlds and to mediate between kings and the *vidye* spirits. *Wood. H. 44.6 in. Lucien Van de Velde, Antwerp.*

gious dynastic royal court of Kabongo down to the most "peripheral" and small-scale polity—that is, both literally and figuratively, the political economy of the people most "down to earth." One informant said that a complex staff like the one discussed above points to a significant remove from the Luba dynasty (fig. 156), for a king's staff would be simple in comparison, with no need to map dibulu stations of power.

The scarifications and female imagery of many Luba staffs are the same as the incised patterning found on the outside or back of lukasa memory boards, for they too represent the founding mother and the significant features of the land itself, such as the rich natural resources associated with places inhabited and personified by earth spirits. As one owner of a staff said, "Staffs are made for Luba royalty in general. But they differ in meaning according to whether they belong to people of the savanna or those living along rivers. Riverine peoples explain [the staff's symbolism] in terms of aquatic spirits, while those of the savanna know only the spirits of mountains."

Staffs and Local-Level Politics

Another staff shown to Mary Nooter, and interpreted by members of the inheritor's family and by a spirit medium, is equally rich in significance. In contrast to those discussed above, this staff belongs to a royal titleholder rather than a chief, and its interpretation is oriented toward the attributes, trappings, and political purposes of the title: "This staff is for Inabanza. You can know which titleholder it is for by the way it is sculpted. . . . The staff indicates the positions that titleholders must take in relation to the chief or king when they visit the ruler's court."

This staff has Janus heads carved at the finial instead of a full female figure; but the entire staff is considered to be anthropomorphic, even its nonfigurative parts. The grip is a rectangular section representing a head, which wears the sort of nkaka headdress possessed by Bilumbu spirit mediums, high-ranking chiefs, and Mbudye members (fig. 159). It also shows the multiple strands of beads that are worn by all high-status persons. Vertical zigzag imagery refers to the cone-shell necklace worn by certain titleholders, composed of three or more cone-shell disks that have been chipped and filed into isosceles triangles.[16]

Like the first staff, this one documents a historical episode, in which King Kasongo Niembo of the royal dynastic line sent one of his wives to her natal village in the Bukama area, to found or confirm a relationship between that region and the king. Her role was to collect gifts of deference from lesser chiefs and send them to Kasongo Niembo. Eventually, she bestowed the sacred powers and regalia of Luba royalty upon the son of one of her brothers, and this heritage was carried on through the patrilineage, although retaining her name as the founding ancestress. One of those interpreting this staff asserted that full female figures carved as the finials of staffs often depict the king's female emissaries, sent to forge political alliances in just this manner (cat. nos. 65 and 66).

Again, the staff has more than one reading, for it also records the importance of natural resources to the local political economy, with the section surmounted by a head representing a place of rich resources and the earth spirit who is its guardian. The narrator explained, "In the past, we didn't know that the minerals were so valuable, and only the spirits recognized their importance. Women also knew, because they have an intelligence that exceeds that of men."[17] The staff also makes numerous references to lukasa memory boards. For example, it is explained as having an "outside" and an "inside," and the curved inner side is described as "female." A carved lozenge form represents the royal court, referred to as "dibulu" by this narrator as a similar shape was by the last (fig. 157). Lines around the perimeter of the lozenge represent the roads taken by titled officers to approach the capital, differing according to their rank. "Every titleholder has his way of entering the court, approaching the chief, and sitting. It is an insult to walk directly in front of or up to a chief. The chief can tell who is approaching from a distance by the particular route he takes and where he sits."

Like the lukasa, then, this staff demonstrates the considerable emphasis on protocol and the prohibitions of the court, as well as the costuming, headdresses, and beads that are the trappings of royalty. As elements from the wilderness, these regalia endow their wearer with sacred properties and abilities. The narrator explained that some staffs are imbued with magical substances for

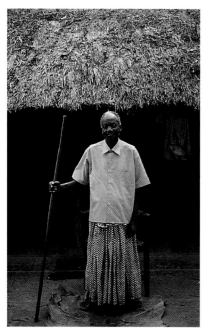

Fig. 160: Titleholder Inabanza of Kinkondja displays his dilanga staff before his house. The dilanga is a simple sticklike staff that in recent times has replaced the more rare and elaborated *kibango* staffs sculpted with anthropomorphic heads, full figures, and scarification patterns. *Photo: Mary Nooter Roberts, 1987.*

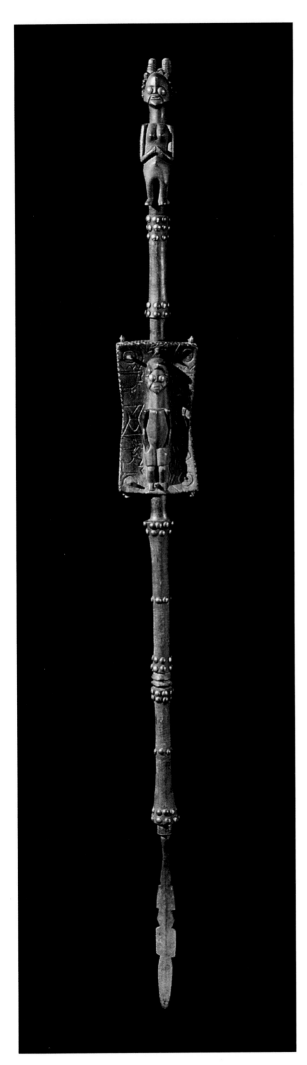

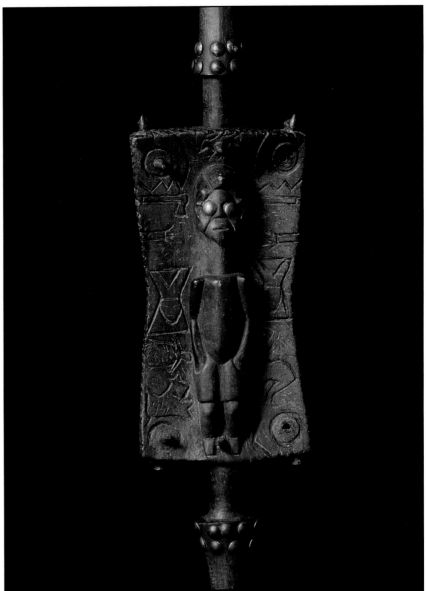

CAT. 67: STAFF OF OFFICE. LUBA-IZED TABWA, ZAIRE. Staffs reveal how the charter for Luba government, as conveyed more completely by the lukasa memory board, was appropriated, interpreted, and modified to validate local-level and individual claims to power. Here the broad sections of the staff imitate the form of a lukasa memory board, and include figures, patterns, and ideograms that are mnemonic in purpose. *Wood. H. 53 in. Al and Margaret Coudron.*

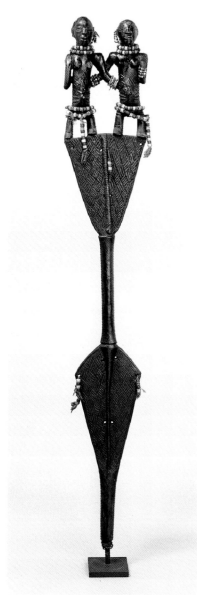

CAT. 68: STAFF OF OFFICE. LUBA, ZAIRE.
Many staffs of office are surmounted by two female figures, sometimes arm-in-arm, as here, or else in an embrace. These two women are probably the spirit mediums for one of the pairs of Luba tutelary spirits, such as Mpanga and Banze, or Lubaba and Shimbi. These powerful spirits reside in lakes, to which their spirit mediums often live in close proximity. The two women shown here are bedecked with beaded messages—on their necks, wrists, waists, and in their hair. Their scarifications differ from one another, just as every Luba woman's torso is as unique as her person. And their surfaces exude oil, from years of palm-oil applications. *Wood, beads, fibers, palm oil. H. 40.9 in. Seattle Art Museum, Gift of Katherine White and the Boeing Company, Inv. no. 81.17.874.*

the protection of the chief's court or the titleholder's compound. If the staff is made at the location of an earth spirit, however, it needs no such additions, for it has already received power directly from the spirits, along with the prohibitions concerning its use and the exegesis of its meaning.

As we have seen from these examples, then, there is considerable diversity in the form and iconography of Luba staffs of office (cat. nos. 68, 69, and 70). No two staffs are identical, and the depth of their reading varies from interpreter to interpreter and from one occasion to the next.[18] As one titleholder stated, "Some kibango staffs draw their form and meaning from a lukasa and have significant designs. Others do not, and their designs . . . serve only for decoration." "Decoration," however, always has the potential for elaboration and exegesis, depending on who is doing the talking and who the listening. One person's "decoration" may be another's secret source of information (cf. Barth 1987). The diversity of staffs is a reflection not only of different regional styles, then, but of variations in Luba notions of power and of different situations for narration. Staffs reflect multiple perceptions through the ambiguities and nuances of a language of power and a code of authority.

Whether staffs are derived from lukasa memory boards or whether the boards derive from them is of little consequence: the two share a syntax, and provide textual components from which a verbal discourse on power can be constructed and construed. In the rituals of the Mbudye Society, the power of this discourse is established through the enunciation of royal secrets (Nooter 1991). Luba staffs of office play on the same principle for individuals and lineages seeking to imprint their names in the chronicles of the prestigious Luba dynastic past, or finding their identity in opposition to and imitation of that center. Thus staffs, in their number and diversity, reflect both the homogeneity and the specificity of the many chiefdoms that constitute the Luba sphere of influence. As one man said, "To give away one's staff is to give away power. To lose it to another family is to give away the title of one's own family."

Staffs as Shrines of Memory

One staff owner elaborated on the healing, curative, and protective functions of staffs. As he explained, a staff guards its owner and protects his body. It may also guard his residence or compound and secure his safety on voyages. In order for the staff to perform such functions, it must have a magical bundle inserted into the head or some other part(s) of it (see Colle 1913:443).

The substances placed inside the staff are *bijimba* (see chapter 6), empowering and activating agents that may include relics of human experience (a vestige of someone who has died an unnatural death, for example), animal parts, unusual things found along one's path, and other snippets of life. These ingredients are placed in a clamshell, where they are mixed and ground into a paste; as each one is deposited in the shell, its name is cited. Then the owner of the staff cuts his fingernails and those of his wives and children and adds them to the shell, thereby protecting them in the haven of meaning that he is creating.[19] The concoction is then inserted into the staff, anointed with chalk, and covered with a little piece of cloth, as a stopper. This powerful magic ensures the protection of the court, the chief's family, and the greater community who look to the chief for leadership. The bundle as a whole is called "*bitê bijimba*"—"bitê," as the plural of the word "kitê," discussed in our introduction, being derived from the same root as "lutê," "memory."

One can assume that what is "remembered" through such magic is the narrative history that is embodied in the staff's iconography, and that must be protected at all costs if the chief and his community are to maintain their identity and prosper. That narrative, in other words, is not just a story, to be idly recounted. Instead, it is vitality itself: memory activated, animated, and protected by bitê magic. The chief and his family are in and of this memory, as they concretize and affirm when they place their fingernail clippings in the bitê bijimba.

Another kind of staff is called "*dilanga*," from the verb "*kulanga*," "to think, reflect upon, consider in spirit, meditate upon, offer an opinion about, suppose, claim, intend, or affirm" (Van Avermaet and Mbuya 1954:339). Through its name, such a staff is also associated with memory and, nowadays, with nostalgia. Several different titleholders interviewed by Mary Nooter possess dilanga, which are tall, thin sticks that are uncarved or otherwise elaborated except by a

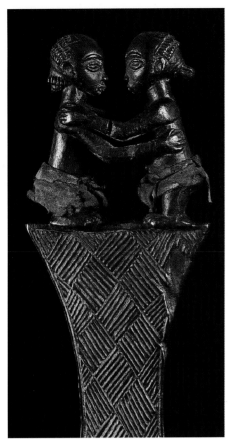

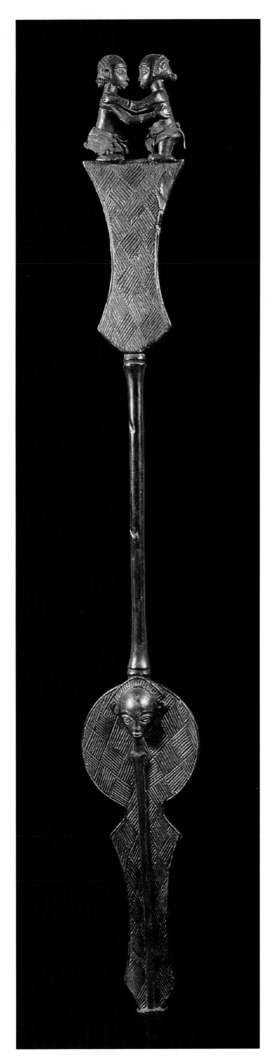

CAT. 69 (ABOVE AND RIGHT): STAFF OF OFFICE. LUBA, ZAIRE. Staffs elicit stories through their form and iconography. One staff might be accompanied by a narrative that records how the king came to the owner's town and invested his grandfather into a royal title, while another man uses his staff and its cartographic references to remember how his great-grandfather's clan maintained independence from the central kingdom despite Luba depredations. Staffs dating to the period of kingship continue to shift in purpose and meaning as people adapt to their changing circumstances. Staffs that once symbolized political relationships may now be interpreted as including tenets of Christianity and other contemporary realities; but they still serve in everyday problem-solving as history is made. *Wood, copper, cloth. H. 47.5 in. Buffalo Museum of Science, Inv. no. C12779.*

CAT. 70: STAFF OF OFFICE. LUBA, ZAIRE. Dibulu, the broad sections of Luba staffs, represent the administrative centers that are part of every royal capital. The dibulu often takes the form of a triangle, a diamond, or an hourglass shape, and is always engraved with the same geometric patterns found on the backs of lukasa memory boards. The long, unadorned, or copper-wrapped shafts represent uninhabited savannahs and signify the roads leading to the administrative centers of the kingdom. And the metal point at the bottom of most staffs signifies both the material wealth and the strength of the chiefdom that the staff honors. *Wood, copper, iron. H. 62 in. National Museum of Natural History, Smithsonian Institution, Washington, Gift of Mrs. Sarita S. Ward, Inv. no. 323.054.*

small bell attached to the finial, which tinkles as the bearer walks. One man explained that he used to possess a kibango figurative staff, but that it is now lost (probably to the international art market), and he only has a dilanga in its place (fig. 160). Memory does inhere in a dilanga, recording the possessor's relationship to the royal court; but in these troubled times, the Luba state has lost its luster and its memories are sadly diminished.

Staffs and the Making of History

It is important to recognize Luba staffs of office as an art form that continues to shift and evolve in purpose and meaning as people adapt to their changing circumstances (and this despite the Luba ideology according to which the meanings of such objects are "eternal"). A final case nicely illustrates such culture-building.

An elderly man said that he first saw the staff he now possesses at the home of a man holding the royal title of Twite. He did not learn the staff's meaning until he himself was "called by the Holy Spirit"—that is, as recognized in the Roman Catholicism introduced to Luba in the late nineteenth century. At the time of this revelation, the man's wife was very ill. She had been struck by a falling tree, and had fractured her spine. A local dispensary nurse informed her that she should go to the regional capital city of Lubumbashi for an operation. On the eve of their departure, as the man was praying for a safe trip, the Holy Spirit came to him to announce that God would heal his wife. During the same night, two angels came down to earth, and as one sat at the woman's head and the other at her foot, they performed the needed surgery on her back. As the man's wife regained her strength, he himself fell ill, and he went to a three-day revival meeting where he "officially" received the Holy Spirit. After this, he began to heal the mentally ill and the physically disabled. It was the Holy Spirit who gave him this ability to "see clearly" and communicate with spirits. He recognizes spirits by their clothing and regalia, including kibango staffs that they may possess. It was after these events that the man acquired and understood his own staff.

He continued his account, stressing that not only chiefs and titleholders have staffs, but spirits as well. In the old days, when a staff was carved, the elders took it to the place of the spirits, where they prayed and made offerings of a goat, sheep, or chickens. They placed the staff next to these sacrifices and summoned the spirit. A hole was made in the head of the figure carved on the staff, through which the spirit could bring its power to the staff. The elders sang twin songs and the spirit announced the bizila prohibitions associated with the staff and its prerogatives. Thereafter, their prayers were answered. These days, when a spirit comes and one says he approaches it in the name of Jesus, wishing to receive its power to continue good work, he gains the ability to chase away "demons," save "haunted persons" from evil spirits, and contend with sorcerers, all in the name of Jesus. If Jesus accepts that he care for someone who is deranged or harassed by sorcerers, he will begin to treat the person, for that is his work.

This moving account reveals an updating of imagery to include the tenets of Christianity, but in a matrix of Luba religion. As texts, Luba staffs of office may be read not only for philosophical edification, or to determine important political relationships: they also serve practical purposes in everyday problem-solving. These dynamic processes include looking to whatever sources of power one can summon when disaster strikes, such as a wife breaking her back, or when one must make critical decisions. Christianity has been "folded into" such circumstances, as history is made. Staffs, then, like other Luba art objects, remain active sources of inspiration, even in today's trials and tribulations.[20]

Endnotes

1. A related point, emphasized below, is that the details of staffs, stools, and other objects change over time. It is always possible that something created without an accompanying narrative may be given one at some later date, as culture-building proceeds.

2. Luba ethnicity, and center/periphery political and economic relations, are subjects of chapter 7.

3. The distinction Malcolm McLeod proposes between "statement art" and "process art," the one being confirmatory, the other transformational (1976), has been used to describe the sudden flowering of arts among Tabwa in the late nineteenth century, when certain chiefs began to consolidate their power through participation in the east African ivory and slave trades (Roberts 1985). In this context, art forms were invented or elaborated in ways similar to the appropriation of central insignia by outlying Luba chiefs that is described here.

4. Kawende Fina Nkindi, personal communication with Mary Nooter Roberts, 1987. The term "figurative" is somewhat problematic. Here it refers to literal representation of human anatomy, no matter how distant from the realist form of, say, a photograph; yet it is also clear that nonliteral representation of human anatomy may appear in the symbolism of apparently nonfigurative objects made and used by Luba. It is possible that the flourishing of more literal arts responds to increased consolidation of the Luba state, as well as to outside influences; see Schildkrout and Keim 1992, Roberts 1985.

5. Despite the signal importance of investiture rituals, accounts of them are fragmentary, perhaps because of the deep secrecy in which the king's transformation was conducted. See Burton 1961:22, Colle 1913:183, Sendwe 1954:84, Van Avermaet and Mbuya 1954:710, Theuws 1962:216, and Verbeke 1937:59, among others. Recent field research is reported in Nooter 1990a and 1991 and in Petit 1993.

6. As we shall see in chapter 7, the term "kitenta" is also related to the verb "kutentama," used to refer to possession when a spirit "mounts" a person, and to the rising of a new moon (kwezi kutentama), a key metaphor for enlightenment and courage. Bemba chiefs' stools (often, it seems, of Luba style and manufacture) are called "fitentamino," from the same verb and symbolism (White Fathers 1954:158).

7. This interpretation may be legitimate on an obvious level of meaning, but, as explored in chapter 3, the association between women and political power among Luba is vastly more nuanced than it might suggest. Luba royal burials are described in D'Orjo de Marchovelette 1950:350–53, Womersley 1984:83–86, and by other authors reviewed in Petit 1993:395–410. Related rituals among Tabwa and other neighboring peoples are discussed in Roberts forthcoming(b).

8. Reading and interpretation by Nday Kintu, Makwidi village; translated from KiLuba to French by Kabulo Kiyaya, and from French to English by the author, 1989.

9. Luba staffs are discussed in Nooter 1984, 1990b, 1991, and 1994, where relevant bibliography is also reviewed.

10. The etymology of "kibango" is unclear. The dictionary does not offer it as a term for "staff," listing the synonym "mukombo" instead (Van Avermaet and Mbuya 1954:279; see also Gillis 1981:48). Yet Nooter's informants commonly used "kibango," and it is also cited in Burton 1961:31. It is probably derived from the verb "kubanga," "to recount history or a story" (Van Avermaet and Mbuya 1954:51). François Neyt suggests that it may also refer to a woman's headwrap and to the coiffure of a Bwana Vidye diviner, and he reviews earlier literature (1994:122–23).

11. The chief did not want his staff photographed, and his name and that of his village have been kept confidential to protect the staff from theft for sale on the international market. He did, however, allow Mary Nooter to make a sketch of the staff, reproduced in fig. 151 as redrawn by Nancy Ingram Nooter.

12. Even so clearcut a statement of affiliation does not mean that the chiefdom in question was included in a Luba "empire." There is no particular history of central rule here, only one of influence and mutual dependence. The result was more a network of satellite chiefdoms than a state ruled from the center (see Arens and Karp 1989 for a discussion of circulating centers of power).

13. Rituals concerning the ownership of staffs are still practiced today, though they vary widely from region to region.

14. Rather than strictly describing early practice, the chief's narrative reflects modern knowledge of the mineral wealth of southern Zaire. The only metals known to have been extracted in this region in precolonial times were iron and perhaps copper. In this sense, earth spirits sometimes serve a "cargo cult" function, in that they are thought to harbor resources that were unknown until the colonial period. Tabwa, neighbors of Luba, for example, say that precious goods like cement and kerosene can be found in sacred mountains; see Roberts 1982, 1984. According to some accounts (especially on the periphery of the Luba Heartland), mineral wealth is the "excrement" of the rainbow-breathing serpent Nkongolo Mwamba.

15. See chapter 4, footnote 13, for an explanation of "keeper of the land."

16. Cone-shell disks, called "mpande," represent the moon, while their internal spiral may stand for the labyrinth of time and genealogical lineage; see Roberts 1990a.

17. See footnote 14 above.

18. That people can "read" the staffs despite such differences is a result of their "semantic equivalence"—that is, of the "grammatical" rules that, as metonyms, they share. These ideas are discussed in more detail in Roberts 1995a:18–19 and Layton 1992:33–34.

19. Bundles of this sort, sometimes called "mwanzambale" by Luba, Tabwa, and other peoples of the region, are associated with the Bugabo healing society; a brief description of such a confection is offered in Roberts 1995a:94–95, and Bugabo is discussed in Roberts forthcoming(c).

20. An interesting cross-cultural parallel to the updating of Luba staffs is the case of the mregho memory sticks made by Chagga people of Tanzania. In the past, these were used to recount the esoterica of initiation, but now they are being reinvented as a "Chagga Bible" in contemporary contexts of politics and the epidemiology of AIDS; see Kerner 1994, 1995.

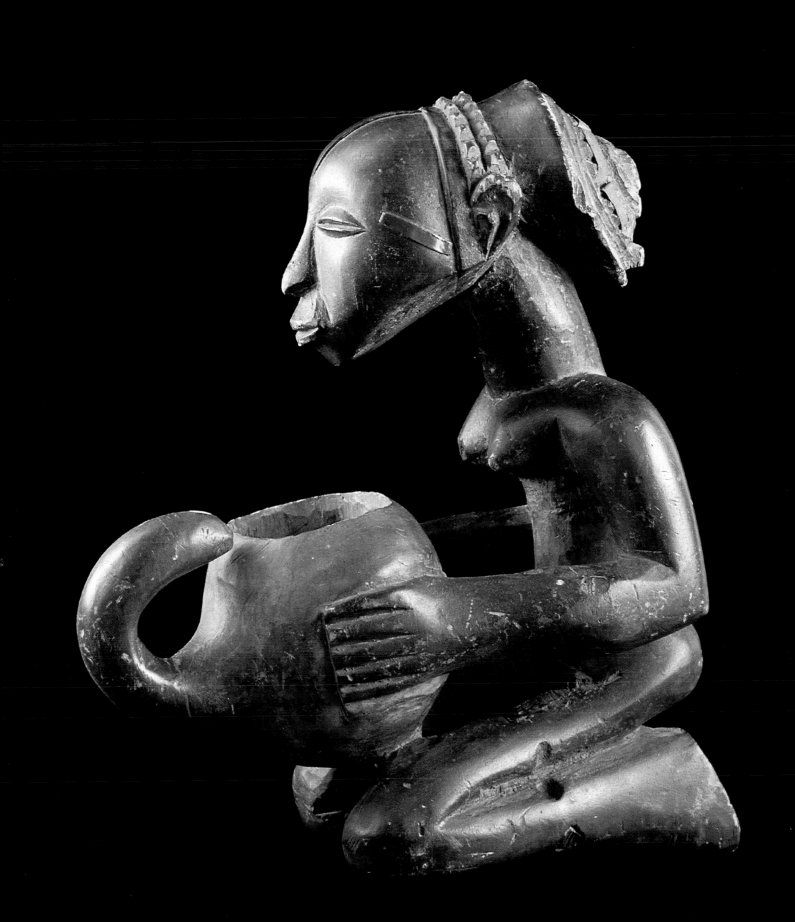

Memory in Motion

Mary Nooter Roberts and Allen F. Roberts

Some things are best forgotten, others are lost by simple slippage. To be created and remain accessible, memory must serve purposes. In both happy times and bad, it is called upon to offer its secure sense of continuity and to suggest solutions to dilemmas. Problem-solving through memory is our subject in this chapter, for Luba use a number of mnemonic devices, practices, and performances to address and redress misfortune (cat. no. 71).

Life *ought* to make sense, and often it does. In his classic treatise *The Elementary Forms of the Religious Life*, Émile Durkheim asserted that the object of religion—this "eminently collective thing"—is, "before everything else, to express and explain . . . that which is constant and regular." Religion, which is essentially "confirmatory" of the "monotonies" of existence, then, offers people an all-important sense of security (1966:43, 63, 80).

Even though misfortune is the obvious fate of humankind, it is nonetheless always surprising to those afflicted. Why me? It is the grotesque *unfairness* of it all that Luba whose children die of a petty illness like diarrhea, or who contract AIDS, or who suffer from the "diabolical immodesty" of the Zairian dictatorship (Mudimbe 1989:10), find so devilishly difficult to understand. As Clifford Geertz eloquently writes, "The strange opacity of certain empirical events, the dumb senselessness of intense or inexorable pain, and the enigmatic unaccountability of gross iniquity all raise the uncomfortable suspicion that perhaps the world . . . has no genuine order at all. . . . And the religious response to this suspicion is in each case the same: the formulation, by means of symbols, of an image of such a genuine order of the world which will account for, and even celebrate, the perceived ambiguities, puzzles, and paradoxes in human experience" (1979:85). Despite the philosophical explanation offered by every religion, misfortune still has to be figured out and fixed, and if in such circumstances people turn to memory as a refuge and a response, divination provides the conceptual tools and cathartic practices to put life back together and get on with it.

Every society has, does, and will engage in divination. As Philip Peek states, "no aspect of life is *not* touched by divination" (1991:1, 3). Those Americans who wholeheartedly believe in astrology, like those who don't but nonetheless furtively sneak a peek at newspaper horoscopes, are looking to one of the many forms of divination available to them. We all need to have things presented just a bit differently from what we already know and expect. We need another framework, a new view of old relationships, a glimpse of something that might happen, even though we know it probably won't.

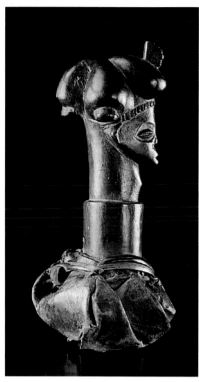

CAT. 72 AND 73 (ABOVE AND OPPOSITE): DIVINATION PESTLES. LUBA, ZAIRE.
Although the precise history of these pestles is unknown, they were once used for *lubùko*, any of several techniques used to consult the spirits and to learn the hidden causes of things. Divination is actually a process not of "fortune-telling" but of reconstructing memory and history to discern the reasons for present misfortune. The wear on these pestles' handles and the age of the leather-encased bundles testify to considerable use and handling over many years. *Wood, metal, leather, fiber. H. 8.2 in. Felix Collection. Wood, metal, leather, fiber. H. 7 in. Private collection, Brussels.*

Divination begins with recognition that there is a problem in need of elucidation.[1] Geertz's "perceived ambiguities, puzzles, and paradoxes in human experience" (1979:85) present life at its most unformed and incipient (see Roberts 1995a:19). In such circumstances, as James Fernandez tells us, one calls upon metaphor, "the essential figure of speech," to "recast the inchoate (and ineffable) . . . into various manageable perspectives" (1977:101, 103, 126).[2] Metaphors do this by taking experience plumbed from memory, or invented and presented as though this were the case. "We do learn something new in metaphor" (ibid.:103), which bridges from the unknown or hard to express in the here-and-now to something remembered from the past that is perceived as resonant and apposite. Through the analogy and hypothesis of metaphor, "organizing images" are generated that the ritual actions of divination put into effect. And ritual, as Victor Turner demonstrated so well, is *transformative* (1970:95) (cat. nos. 72 and 73; fig. nos. 161 and 162).

As often happens when trying to explain cultural practices in a different language, we have no terms to express this process in precisely the way that Luba do. The dictionary tells us that "divination" in English suggests discovering "hidden knowledge by occult . . . means." The Latin root is "divine," referring to that which is sacred or godlike; but the dictionary editors reflect jaded contemporary usage by stating that divination is "the practice of *attempting* to foretell future events" (Flexner 1987:575) by means of "an *alleged* supernatural agency" (Soukhanov 1993:544; emphases added). That is, we no longer readily believe it possible to know future "truth," especially from a "supernatural agency," no matter how we might yearn and "attempt" to do so. This has not always been the case, of course. A once common but now archaic synonym for divination is "soothsaying," from "sooth": "the truth." Centuries ago, "sooth" was used as a verb "akin to 'is'" (ibid.:1,820), leaving no doubt that prophesy revealed the real. But did such seers always see a future truth? Another ancient synonym for "soothsayer" is the Greek term "*mantis*," from which we get words for particular types of divination, such as "geomancy." The Indo-European root of "*mantis*" gives us a fan of words, from "mind" to "demonstrate," "memento" to "museum," "mentor" to "mnemonic" (Soukhanov 1993:2, 114). In other words, the mind demonstrates what might be meaningful and useful in the future by bridging to memory through divination.

For Luba and, it has been said, most African peoples (Devisch 1985:65), divination takes this last sense: it is a process not of "fortune-telling" but of reconstructing the past to discern the causes of present misfortune.[3] Many African people feel that physical illness, infertility, loss of a cherished object, lack of "luck" in hunting, surprisingly poor crops, or yet other forms of unhappiness occur because of human or spiritual interference in their lives, or because of some gross breach of etiquette or other blunder that they have committed without being aware of its eventual consequences. "Through divination, an individual ill becomes a social one" (ibid.:58). Through divination, history is negotiated and reconstructed until—from an insider's point of view—a particular incident in the past causing disharmony in the present can be found and agreed upon. Once this occurs, it is hoped, redress can be made and the future will be rosier (Roberts 1988a:125; see also V. Turner 1975:209). From an outsider's perspective, though, such a process does not necessarily imply a positivist search for "true" truth. Instead, present and past are connected through metaphor and analogy, so that misfortune *now* makes sense in terms of what has happened, been explained, and solved *then*. The "organizing images" (Fernandez 1986:126) resulting from divination assure "continuity of meaning between the current problem and the meaning of analogous events in the past" (Devisch 1985:65, 73–74).

The most common Luba verb for "to divine" is "*kubùka*," "to consult the spirits through consecrated formulae to learn hidden things from them" (Van Avermaet and Mbuya 1954:88) (fig. 163).[4] Another Luba verb used to refer to the desired effects of divination is "*kusokola*": "to discover, disclose, divulge, reveal, or betray" (ibid.:624). In all these translations, there is a sense that something hidden is being made to appear.[5] Many uses of "kusokola" are strictly literal, as when it refers to opening maize cobs and stripping them to their kernels; the word may further imply displacement after revelation, as when someone's malevolence is detected, resulting in his or her banishment from a village. In such cases, derivatives of "kusokola" may specifically refer to the discoveries and disclosures of divination, and imply the milandù history-making that results (see

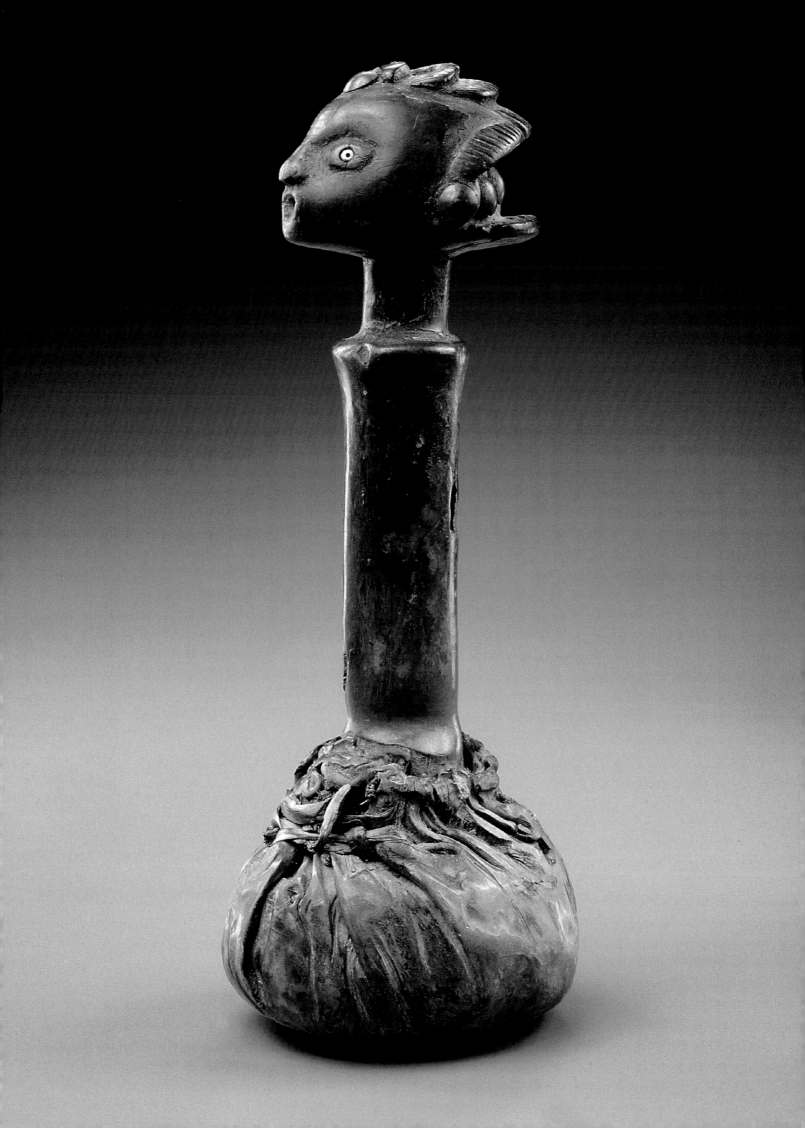

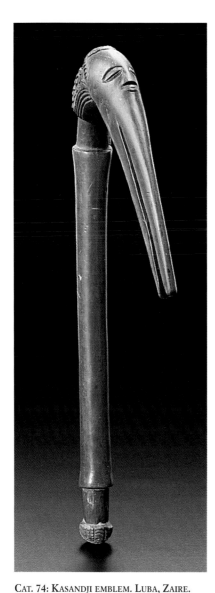

CAT. 74: KASANDJI EMBLEM. LUBA, ZAIRE.
Kasandji members seen in early-twentieth-century photographs are indistinguishable from Bilumbu diviners and Mbudye members, but each institution did have emblems specific to it. A wooden emblem combining a human head with an abstracted bird head extending into a long beak is the signature object of this little-known association. It was presumably worn over the shoulder, like a ceremonial ax, although it lacks metal completely, making it entirely nonfunctional. *Wood. H. 12 in. Formerly Paul Guillaume Collection, Paris. Private collection.*

CAT. 75 (OPPOSITE): MASK. LUBA, ZAIRE.
The similarity of this dramatically elongated mask to the emblem shown in cat. 74 suggests that the mask was used by and for the Kasandji Association (also called Buyembe), a healing society that worked in tandem with royal Bilumbu diviners. Kasandji specialists were known for the medicines they prepared, containing fragments of human bone, considered a powerful ingredient for transmitting life force. In the past, specialized institutions for healing were numerous, and they often shared emblems, symbols, and rituals. Once a Bilumbu diviner determined the cause of a client's misfortune, a Kasandji specialist might be summoned to prepare the cure. *Wood, pigment. H. 26.6 in. Trustees of the British Museum, London, Inv. no. 1904.6–11.29.*

Van Acker 1907:61, White Fathers 1954:709–11).[6]

Divination, then, is an altogether political phenomenon.[7] Decision-making of this sort often implicates individuals or factions as causes of or solutions to problems. Among Luba as among the people of every society, there is a "prevalence of deceit" (Bailey 1991), and greedy, jealous, or angry people sometimes resort to the evil magic of sorcery to gain advantage and destroy their adversaries. Some people in the community will agree with the hypotheses of a given divination, while others—and especially those accused—just as fervently will not. The transformative potential of divination ritual, then, can lead or contribute to competition, contention, and outright conflict, even as people seek to redress problems and get on with life.

Divination was and still is closely linked to political life among Luba. Diviners are the equivalents of doctors, therapists, lawyers, and priests for individuals, families, factions, chieftaincies, and entire kingdoms. Divination looms large in the Luba charter for sacred kingship, and even today, the archetype of each item belonging to a royal diviner is said to have been introduced by Mijibu wa Kalenga, the first diviner and the hero who helped Mbidi Kiluwe and his son Kalala Ilunga overthrow the tyrannical antihero Nkongolo Mwamba. Both the founding myth and historical accounts demonstrate the degree to which kingship has been and remains dependent upon the memory capacity of powerful diviners. This branch of royalty caters both to the most individual, personal needs and to conflicts that threaten the well-being of the community as a whole. But diviners' connections to the origins of the state, and their subsequent historical importance, are remembered only as they reinvent themselves in the performative present, through divination and related ritual (cat. nos. 74 and 75).

"Fire by Friction"

The Luba descriptive noun for divination, "*lubùko*," can refer to the hidden truths sought through divination, to the séance itself, and to the instruments with which one seeks revelation (Van Avermaet and Mbuya 1954:88–89). Specialists in any divination techniques that do not require spirit possession are called "*bambuki*" (singular: *mbuki*), a word derived from the same root as "*lubùko*." Peoples all over the region, including Ndembu of Zambia (V. Turner 1975), use derivatives from the same root. There are many kinds of lubùko divination, and, as Luba themselves do, we shall distinguish between what Dominique Zahan has called "intellectual" divination, conducted through the interpretation of mnemonic devices (1979:86), and the trance of spirit mediums who serve as direct messengers from the other world.[8]

Of the first sort of lubùko, we shall concentrate on a form called "*kashekesheke*" (or "*kashyeke-shyêke*"), in which either a small sculpture—a *kakishi*—or a *kabaya* gourd is usually employed as an oracle (fig. 164).[9] Kashekesheke is said to have existed prior to the introduction of Luba sacred kingship, while Bilumbu spirit possession, to be discussed below, emerged as a branch of royal authority. In both types of divination, the diviner's body joins the client to the spirit world. In kashekesheke this association may be assisted through magical medicines, while in Bilumbu it is assured through the psychodrama of trance. In both cases, divination unfolds through kinesis, reflecting the importance of movement and dislocation to history-making and other mnemonic processes. As we shall see, divination, perhaps more than any other form of Luba artistic expression, reveals the performative dimensions of memory.

Kashekesheke is said to have been practiced well before the arrival of Mbidi Kiluwe and the beginnings of sacred kingship, yet its precise origins are debated. Some claim that the technique was passed down from Luba ancestors so long ago that it is not possible to determine when it was introduced. Others attribute it to Tembo hunter-gatherers, now living in Kiambi Collectivity in the Zone of Manono.[10] Tembo often use kashekesheke to discover the reasons for poor hunting (see Roberts 1995a:66–68). Many of the names of kashekesheke spirits, such as Mpombo, Kakudji, and Mwilambwe, are said to be Tembo names recalling these unsurpassed hunters, who are believed to have used the divination technique for centuries.

Kashekesheke is a personal, noninstitutional form of therapeutic practice. It invokes ancestral spirits called "*bafu*" (literally "the dead"), as opposed to the Vidye spirits of royalty. While bafu

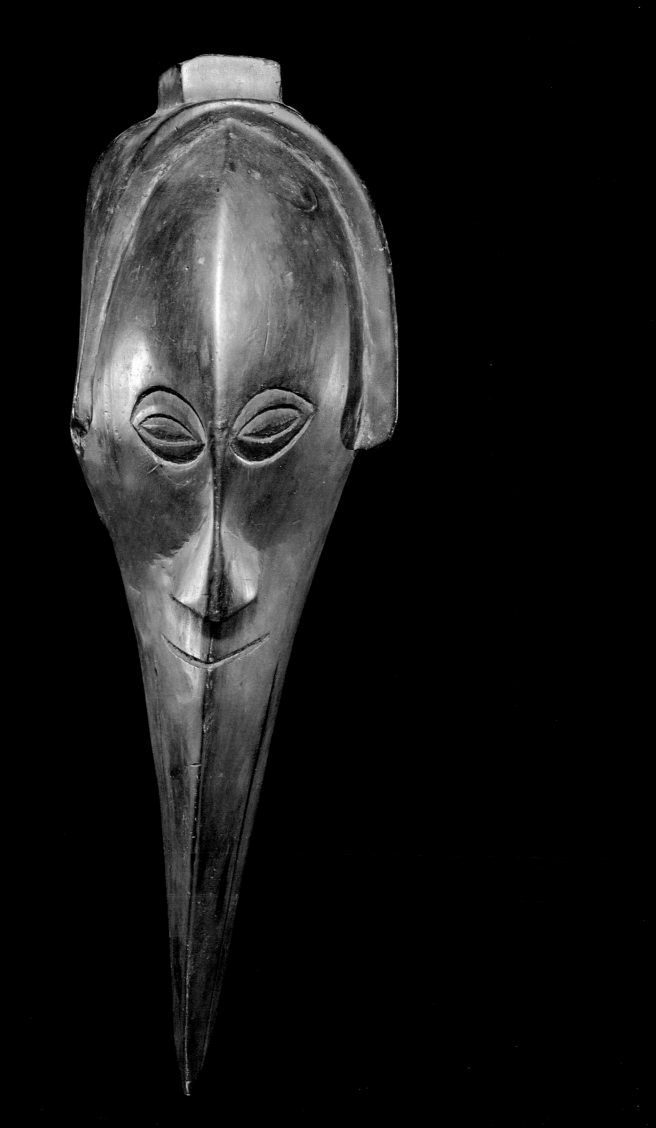

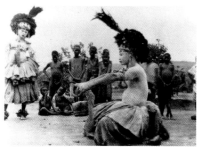

Figs. 161 (above) and 162 (below): Diviners of the royal Bilumbu Society were closely linked to other associations, including Bukasandji (also called Buyembe). Often a Luba specialist belonged to both associations, which shared the same accouterments and practices of spirit possession and ritual performance. *Photos: W. F. P. Burton, 1927–35. Courtesy of the University of the Witwatersrand Art Galleries, BPC 12G.9 and 12G.8.*

spirits may be angry about their demise, and therefore initially vindictive, they will offer succor to those survivors who honor them. Every step of a Luba person's life is guided by bafu, who act as agents of memory (Burton 1961:40–49). Oracles like kashekesheke are a window to their world.

The word "kashekesheke" refers most specifically to the instrument, the gourd or figure used in the divination session (cat. no. 76). As such, "kashekesheke" has at least two levels of meaning: first, it is onomatopoeic, reflecting the "sheke-sheke" sound the divination instrument makes when rubbed on the ground or on a mat (fig. 165). Second, the verb "*kusheka*" refers to sawing, whether the literal cutting of planks of wood or the back-and-forth movement of other objects. More generally, "kusheka" can refer to anything especially significant (Van Avermaet and Mbuya 1954:604). A derivative verb is "*kushekula,*" "to discover what is hidden," said to be synonymous with "*kujingulula,*" "to know or to recognize." As such, the practitioner of kashekesheke is seeking to discover and to know the cause of a given problem in order to find a solution.

"Kashekesheke" is the name given to this technique in the Luba Shankadi lands of Bukama, Kabongo, and Malemba. To the north, near Songye country, the same technique is called "*katotora*" or "*katotola,*" from the verb "*kutotola,*" "to hit something several times to obtain a result" or "to knock on a door repeatedly, to gain entrance" (D'Orjo de Marchovelette 1954:487). According to Théodore Theuws, a katotora instrument is fashioned from wood of the *kikwebaii* tree, the sap of which is used as an emetic. By analogy, the katotola is supposed to "vomit the truth" (see Maret et al. 1973:10). The katotora is sometimes used on a sculpted wooden headrest or stool (as opposed to a mat), producing the rapping noise its name suggests (Burton 1961:65, Van Avermaet and Mbuya 1954:89).

Kashekesheke practitioners may be male or female, although women specialists are more common. Women usually receive the power to conduct kashekesheke from an ancestral spirit appearing in a dream, while men require *lusalo*—the insertion of herbal and magical medicines under a person's skin. Unlike cosmetic scarification, which is considered aesthetic and erotic, lusalo augments personal power.[11] There are different kinds of lusalo, each localized in its own zone of the body (fig. 166). In the case of the diviner, a lusalo incision is made in the fleshy portion of the palm below the thumb of the right hand—the part of the hand, in other words, that will be in direct contact with the divining instrument.

Of the two sorts of objects used for kashekesheke divination, the diminutive wooden kakishi figure is the more expensive, since its manufacture requires the services of an artist (although male diviners sometimes carve their own) (cat. no. 77). Nowadays it is rare to see kashekesheke diviners using wooden instruments; they use the cup-shaped kabaya gourd instead, though they may also use an aluminum cup or a tin can (fig. 167).[12] All of these are thought just as efficacious as the older wooden instruments, since the power of kashekesheke resides not in the object itself but in spiritual guidance, and in the lusalo medicinal insertions which are activated through contact with the object (Burton 1961:67; see also Van Avermaet and Mbuya 1954:89).

Kakishi figures are three to six inches tall. The form a particular figure should take is communicated to the diviner by his or her spirit in a dream. Though the spirits may be male or female, the figures are always female, even when they are abstract or have a nongendered head: to Luba, women are strong vessels for spiritual presence. The figures often have intricate coiffures, and some display engraved or raised designs representing scarification. The sculpture's body, usually rectangular, is hollow; both client and diviner insert their first two fingers into this opening and clasp the sides with their thumbs. Thus the divining instrument creates a bridge between diviner and client, linking the diviner's insight to the client's experience. The two-headed Janus figures that surmount some kakishi carvings underscore this threshold effect, for one face is said to look to the world of the dead, the other to that of the living (D'Orjo de Marchovelette 1954:491). A smooth, worn base on a kashekesheke figure attests to considerable rubbing against a mat, stool, or the ground (cat. no. 78).

At the start of a consultation, the client exposes the problem for which she or he has come to consult the diviner's spirit.[13] Next, client and diviner negotiate an appropriate fee, which may take the form of money, beads, palm wine, or a chicken. The diviner prepares the kakishi sculpture, or

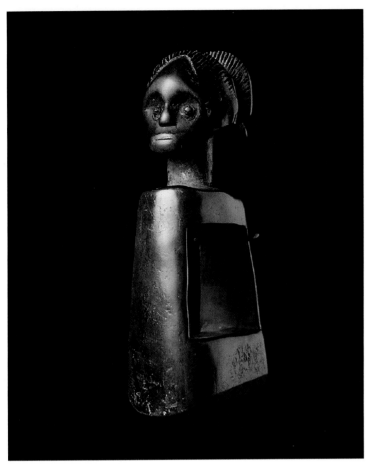

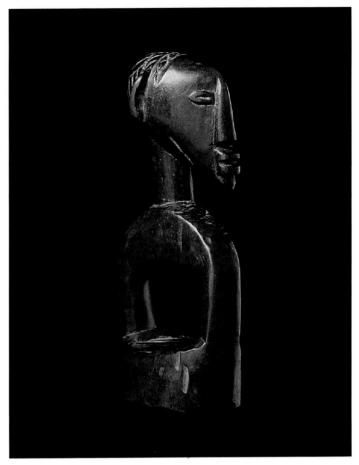

CAT. 76: KASHEKESHEKE DIVINING INSTRUMENT. LUBA, ZAIRE. Kashekesheke is one of the oldest Luba forms of divination, a technique to reconstruct memories and personal histories for purposes of problem-solving. The diminutive sculpted wooden figure used for kashekesheke divination is called by the name of the diviner's consulting spirit. The figure's form is dictated to the diviner in a dream by the spirit itself. But whether the ancestor is male or female, the sculpted figures are always considered female, even when abstracted or possessing only a head. *Wood. H. 5.25 in. From the personal collection of Armand P. Arman.*

CAT. 77: KASHEKESHEKE DIVINING INSTRUMENT. LUBA-SONGYE, ZAIRE. Kashekesheke is an oracle for contacting the ancestors, who act as agents of memory. The small carved instruments used for kashekesheke often have a rich, lustrous patina from extensive use. The objects' bottoms may be worn smooth by continuous rubbing against a mat or the ground, producing the "sheke-sheke" sound from which the name "kashekesheke" comes. Among groups to the north of Luba, most notably the Songye, a similar technique is called "kata-tora," a word that in part derives from the rapping noise made by tapping the instrument against a wooden headrest or stool. *Wood. H. 5 in. Drs. Nicole and John Dintenfass.*

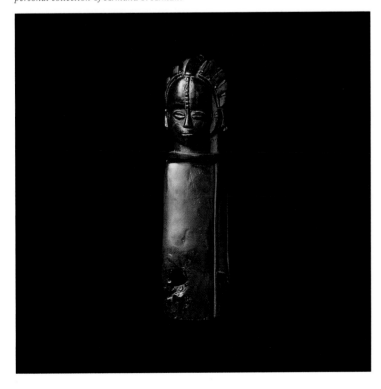

CAT. 78 : KASHEKESHEKE DIVINING INSTRU-MENT. LUBA, ZAIRE. During a consultation, client and diviner together hold the sculpture, which responds to their questions with coded movements. Usually the answers are either yes or no; still, through an extended dialogue with the figure, the diviner can unravel complex family histories and interpersonal conflicts that may shed light on the cause of misfortune. *Wood. H. 5.75 in. Drs. Nicole and John Dintenfass.*

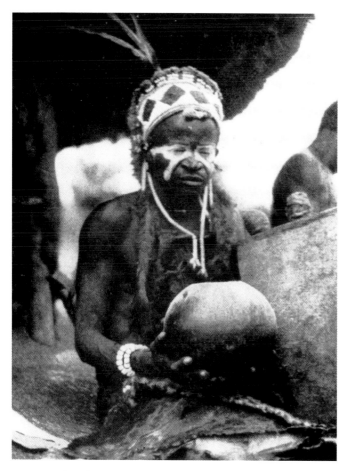

Fig. 164: An ancient nonroyal form of divination practiced by Luba and Luba-related peoples is called "kashekesheke" in the Luba Heartland and "*katatora*" in surrounding regions. Diviner and client together hold a small sculpted instrument that responds to the diviner's questions through coded movements to reconstruct personal histories. *Photo: W. F. P. Burton, 1927–35. Courtesy of the University of the Witwatersrand Art Galleries, BPC 05.2.*

Fig. 163: Luba Bilumbu diviner, photographed some time between 1927 and 1935, wearing nkaka beaded headdress and holding a gourd that provides visions into past events and recommendations for future action. *Photo: Burton 1961: fig. 9.*

Fig. 165 (below): Luba diviners continue to use kashekesheke as a form of problem-solving. Here, a man who has lost eight children consults a female diviner on the recommended course of action. *Photo: Mary Nooter Roberts, 1989.*

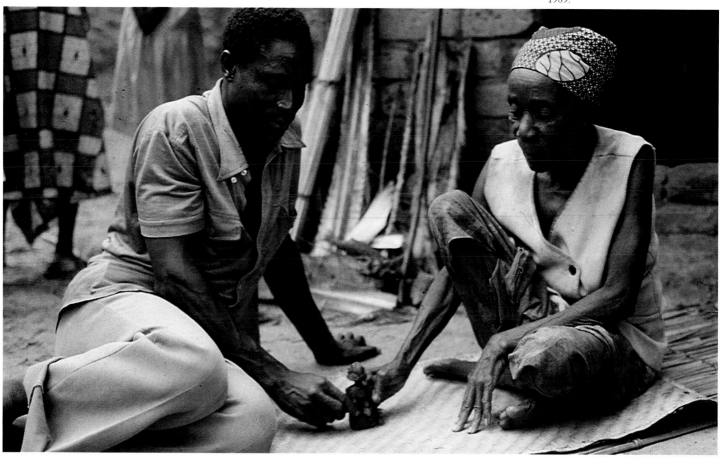

the gourd or cup, by rubbing its surface with leaves from certain aromatic plants to invoke the spirit's attention, then greets the spirit by pronouncing an honorary praise phrase.[14] Opening a dialogue with the spirit, the diviner poses questions to determine the cause of the client's misfortune. As long as the questions do not pertain directly to the problem, the statuette remains motionless. If the diviner touches upon the problem, however, the spirit moves the figure in coded patterns.[15]

The answers obtained through kashekesheke are usually simple—either affirmative or negative. In most areas, a positive response is signaled by a forceful counterclockwise, circular motion across the woven mat on which diviner and client are seated. The circling encloses and creates a space of representation, centering attention on the breakthrough point of spiritual insight (see Arnheim 1988). Negation is signified by a different motion: the figure inclines its head and brushes rapidly back and forth across the mat, as if to sweep its surface. Such motion vacillates and fails to enclose. The term kashekesheke, then, refers more directly to the negative "sweeping" away of nonsense than to the positive centering upon "truth."[16] In both cases, the action may be repeated many times to add emphasis. Through an extended dialogue articulated by the figure, the diviner unravels complex family histories and interpersonal conflicts, shedding light on the cause of the current difficulty.[17]

The kashekesheke instrument, be it a kabaya gourd or a kakishi figure, is not washed except on the day of the rising of a new moon. On the night of this monthly lunar celebration, the diviner rubs the object with chalk to express purity, loyalty, and gratitude to the spirit world. For people throughout southeastern Zaire, the rising of the new moon is a dominant symbol of courage and renewal; as in kashekesheke, it often refers specifically to the gaining of "enlightenment" after fearsomely "dark" perplexity (Roberts 1985).

An example of the problems brought before kashekesheke diviners, and of the solutions they offer clients, is found in a consultation in March 1989, to determine the cause of the overwhelmingly tragic, consecutive deaths of the client's eight children. The spirit indicated that the affliction was initiated after the loss of the first infant, when the child's paternal grandfather had paid mortuary fees but the grandmother had refused to do the same. As a converted Christian, she no longer felt obligated to honor such customs. The diviner concluded that the deaths would continue until she agreed to pay.

Such sad affairs illustrate how, in divination, "an individual ill becomes a social one" (Devisch 1985:58). Although this particular consultation was meant to provide understanding and redress for a truly horrific personal problem, the diagnosis included social criticism of the sort that could not be made more directly without open confrontation and conflict. The spirit commentary obtained through kashekesheke suggests the violence done to family dynamics when important practices and the social relationships they imply are ignored or abandoned: the offending Christian grandmother could only save her birthright if she showed herself sufficiently chastened. To do so, though, would require her to put her family before her church, the anchor of her culture before the promise of her adopted creed.

To summarize: kashekesheke is a personal form of divination that is not directly associated with Luba royalty. It combines the invocation of family spirits with medicinal mechanisms to find solutions to problems of both a personal and a collective nature. A Luba proverb states of this process, "There is no liar in kashekesheke divination, because you are holding [the instrument], and so am I." As the bridge is established between the dire difficulties of this world and the insight and promise of the other, both parties feel the overwhelming force of the spirit. The spirit's "organizing image" must still be negotiated in terms of local-level politics: the Christian grandmother is presented with a hard choice. That choice, however, is hers to make.

Visions of Royal Mediums

Another form of divination, Bilumbu, is said to have gained prominence among Luba with the introduction of sacred kingship.[18] As seen in previous chapters, the genesis myth recounts how Nkongolo's despotism is overthrown and replaced by a refined form of kingship personified in

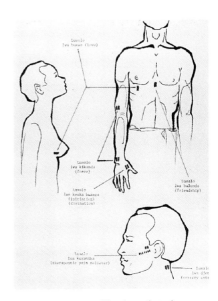

Fig. 166: Diagram of *lusalo* medicinal insertions used for a variety of purposes, including the fostering of love and friendship, as a pain reliever, and for strength. Practitioners of kashekesheke must receive a lusalo insertion in the space between their thumb and index finger to activate their powers of clairvoyance. *Drawing courtesy of Nancy I. Nooter.*

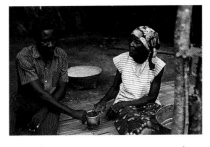

Fig. 167: Kashekesheke divination specialist Keuzi of Kinkondja performing a consultation with her grandson (Mary Nooter Roberts's research assistant), and using an aluminum cup in place of a sculpted wooden instrument. *Photo: Mary Nooter Roberts, 1987.*

Fig. 168: Engraving of late-nineteenth-century Luba royal Bilumbu diviners performing an outdoor group consultation. *From Cameron 1877.*

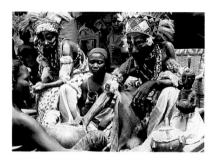

Fig. 169: Contemporary Luba Bilumbu diviners performing a series of morning consultations, using gourds, a sculpted bowl figure, and beaded accouterments very similar to those illustrated in fig. 168, from a century earlier. *Photo: Mary Nooter Roberts, 1989.*

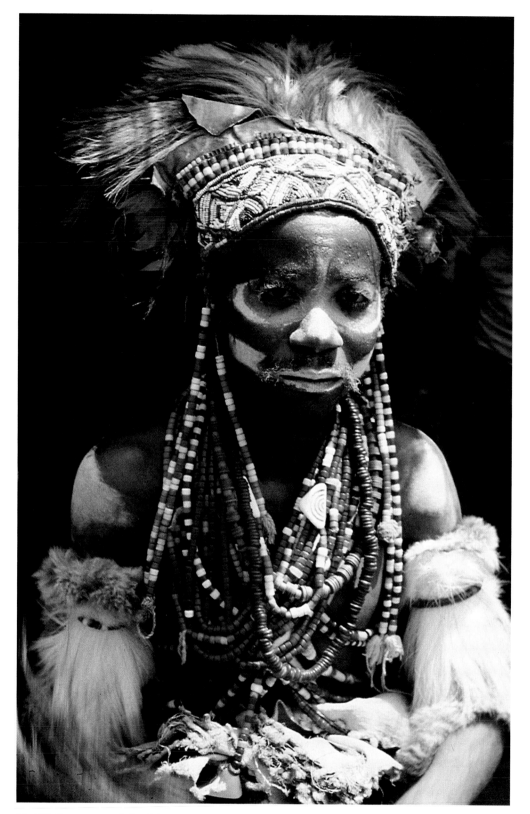

Fig. 170: Contemporary Luba diviner wearing accouterments of office that bear a striking resemblance to those depicted in Burton's watercolor from the early twentieth century (fig. 171), testifying to the longevity of the institution of Bilumbu, which nevertheless continues to adapt to sociopolitical change. *Photo: Mary Nooter Roberts, 1989.*

Mbidi Kiluwe. Yet the fact that the first Luba king to follow this model, Mbidi's son Kalala Ilunga, is a child of Nkongolo's sister defines sacred kingship as a synthesis of dialectically opposed principles: the shadowy underworld of Nkongolo *and* the enlightenment and cultivation of Mbidi (see Mudimbe 1991, Heusch 1982:102). A character in the genesis myth who mediates these conflicting impulses is Mijibu wa Kalenga (also called Banza Mijibu or Banza Bwanga), the first diviner.

According to the genesis myth, Luba kingship would not have been established without Mijibu's counsel and clairvoyance. Mijibu raises the future king, Kalala Ilunga, and bridges the gap from chaos to stability through the creation and manipulation of sacred objects. Throughout Kalala's childhood, Mijibu guides and supplies him with the necessary concepts and equipment to combat and finally defeat his uncle, Nkongolo Mwamba. Mijibu is sensitive, enlightened, and able to discern truth beyond the limited vision of ordinary humans. All Bilumbu, female and male, past and present, are regarded as personifications of Mijibu wa Kalenga. In his ability to mediate opposed realms, principles, and forces, he is a source of their physical and spiritual inspiration.

Western explorers and missionaries of the late nineteenth and early twentieth centuries made engravings and paintings of Bilumbu diviners and left descriptions of divination practice (figs. 168 and 171). The similarity between these records and present-day custom is remarkable, reflecting the resilience of Bilumbu through the colonial period (figs. 169 and 170). Bilumbu diviners maintain a strong presence in Luba village life today, and chiefs continue to consult them in times of turmoil and social upheaval.

As Thomas Reefe notes, "frequent consultation by kings and their representatives with mediums and diviners on matters of state, served to bind outlying ancestral spirits to the destiny of the Luba royal dynasty" (1981:204). Kings and chiefs called on diviners to assist with decisions relating to war, sorcery, and the sneaky behavior of suspected aspirants to the throne, and also to regulate access to natural resources, oversee annual renewal rites of kingship, and provide medical and judicial expertise. Chiefs still depend on diviners for their everyday wisdom.

Bilumbu diviners may be male or female. Male diviners are called "Bilumbu" when not in trance and the honorific "Bwana Vidye" when they are. Female diviners of the same sort are called "*Bifikwa*" in villages bordering the Lualaba River (fig. 172), and "*Bibinda*" in Kabongo Zone. In the recent past, some Bifikwa were "of great repute" and "immense influence," and being "indwelt by the renowned heroes of the past," they carried spears and axes and acted "generally in as masculine a fashion as possible" (Burton 1961:51, 53). It is said that in the past, female diviners were more common than their male counterparts, but today the ratio is more than reversed. Of the twenty-some contemporary Bilumbu diviners interviewed among Luba for this study, only two were women. Nevertheless, Luba consider women more apt for spirit mediumship than men, suggesting their continued sense of women's importance to the most profound religious moments. Women are often associated with spirit-possession cults elsewhere in Africa and, for that matter, in the rest of the world too, especially in circumstances where they are losing social prerogatives and politico-economic importance. Then such religious activities may be "thinly disguised protest movements" (Lewis 1991:12, 26; cf. Karp 1989:97–98), and W. F. P. Burton mentions that at least one Bifikwa "took a definitely anti-European attitude" (1961:53). Among more contemporary Luba the opposite seems the case, and one can speculate that this shift to male spirit-mediumship manifests a reaction to the frustrations and humiliations resulting from the collapse of the Zairian economy and the increasing absurdity of President Mobutu's oppressive dictatorship (Nzongola-Ntalaja 1994, Young 1994). Possession in such circumstances reflects men's political impotence and growing hopelessness, but also their brave defiance through "heroic flights of ecstacy" (Lewis 1991:28–30).

"Dilating Our Being in the World"

Like the Mulopwe, or sacred king, and the members of the Mbudye Society, Bilumbu diviners are incarnations of Luba culture heroes—not so much by strict identification as through more general ideological and symbolic analogy. By sharing costuming, insignia, education, and initiation into the principles of the lukasa, all these politico-religious figures reproduce Luba royal culture

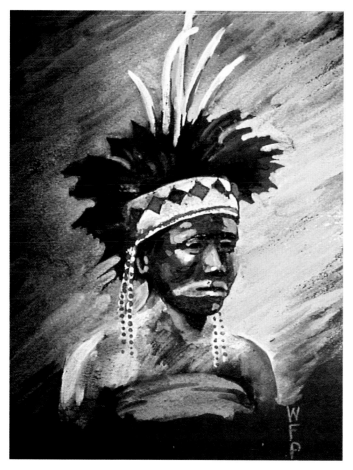

Fig. 171: A Luba royal diviner, seen in a watercolor painting made by Burton between 1928 and 1930. From a watercolor album in the Section of Ethnography of the Royal Museum of Central Africa, Tervuren, Belgium.

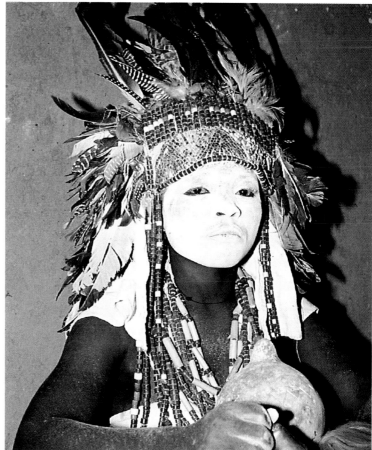

Fig. 172: A female Bilumbu diviner referred to as "Kifikwa." It is nearly impossible to discern a diviner's gender, since the accouterments and emblems of divination are distinguished not according to sex but by the particular attributes of the possessing spirit. *Photo: Mary Nooter Roberts, 1988.*

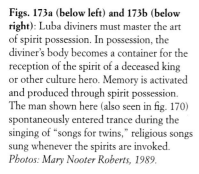

Figs. 173a (below left) and 173b (below right): Luba diviners must master the art of spirit possession. In possession, the diviner's body becomes a container for the reception of the spirit of a deceased king or other culture hero. Memory is activated and produced through spirit possession. The man shown here (also seen in fig. 170) spontaneously entered trance during the singing of "songs for twins," religious songs sung whenever the spirits are invoked. *Photos: Mary Nooter Roberts, 1989.*

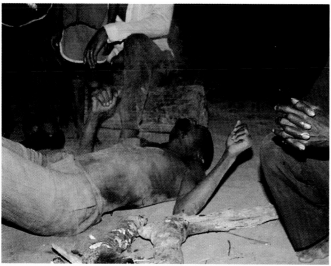

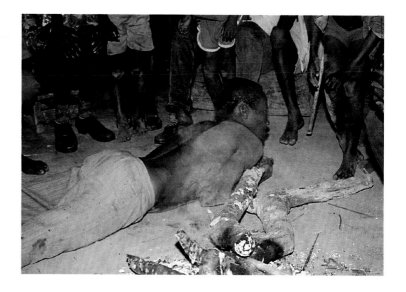

through a form of body memory in which they reflect and perhaps even re-create the major figures of the Luba charter myth.[19] In spirit mediumship, the diviner's body is "a 'place' of memories" that "furnishes an unmediated access to the remembered past. . . . Because it re-enacts the past, it need not represent it: its own kinesthesias link it from within to the felt movements which it is reinstating; as a way of 'dilating our being in the world,' body memory includes its own past" (Casey 1987:178, citing Maurice Merleau-Ponty).

The diviner in spirit mediumship is conceived as an intermediary between people and spirits. The accent is on communication: the medium's words and actions are translatable, which differentiates them from some forms of frenzied trance or madness.[20] In possession, the subject is "mounted" or taken over by the spirit, to become its very embodiment. The first few times someone is possessed are usually involuntary and spontaneous, and are characterized by uncontrollable trembling and shrieking (figs. 173a,b). These terrifying initial stages are rightly considered an illness, and involve a painful struggle as the possessing spirit forcibly occupies the body of the subject or "host" (cf. Karp 1989:94–96). Yet diviners who use possession professionally for daily consultations train themselves to enter trance voluntarily, in a controlled manner. Once this technique is mastered, they may be considered mediums.

Luba use two different verbs to describe the act and perhaps the sensations of entering into a possession state: "*kukwata*" and "*kutentama*." Both imply motion and kinesis. "Kukwata" means to capture, hold, or grasp; more specifically, though, it designates seizure by an outside force (Van Avermaet and Mbuya 1954:293–94). Contemporary Luba extend this verb to refer to photography: "*kukwata foto*" is "to seize" [that is, "take"] a photograph. In photographs, "'Speed is at the bottom of it all,' as Hart Crane said (writing about Stieglitz in 1923), [for] 'the hundredth of a second [is] caught so precisely that the motion is continued from the picture indefinitely: the moment [is] made eternal'" (Sontag 1990:65). Used in the context of Bilumbu possession, "kukwata" refers to being seized by a spirit, but with an added implication of stopping time, freezing the frame, and capturing the moment to "see" the problem amid the "noise" of lived reality.

"Kutentama," the other verb describing entrance to the possession state, refers to the action of rising and perching on top of something. A noun derived from this same verb, for instance, refers to an epiphytic plant, like an orchid or a fern, that takes root high in the branches of a tree. "Kutentama kwezi" specifically describes the rising of the new moon each month, after the interlunary two or three nights of frightening darkness. Luba see an analogy between the moon's ascent and a spirit mounting a diviner's head, for just as the new moon brings into visibility what has been hidden in obscurity, so the possession state affords a diviner an enlightened vision surpassing that of ordinary mortals (Van Avermaet and Mbuya 1954:696–97, Roberts 1985, 1990a:39).

It is "kutentama" that gives us the word "kitenta," the name for Luba spirit capitals where memory of previous kings is preserved through their incarnation in women called "Mwadi." This semantic relationship suggests that the activity of spirit possession is closely associated with memories of kingship, and that each time a diviner is seized by the possessing spirit, she or he embodies the royal past. To borrow a term coined by the dramatist Richard Schechner, Bilumbu spirit mediumship is a performative "rebehavior" of the past in ways that are appropriate to the present (1985:36). In this sense, the principal spirits of Luba kingship are continually reinvented in the context of present sociopolitical circumstances, suggesting that kingship is not an absolute or enduring reality so much as an ideological construct of the mind forever reshaped, reconfigured, and re-presented to accommodate the needs and demands of the moment.

Calling the Spirit

All Bilumbu spirit mediums must master the teachings of the lukasa and obey the royal office's requirements and prohibitions concerning secrecy, salutations, eating and drinking procedures, and court etiquette. Luba diviners explain that a medium must respect those royal prohibitions in order to achieve the resistance and asceticism necessary for the concentration of energies. In possession, a Bilumbu diviner assumes the identity of his or her consulting spirit. For a period that may last for several long hours, a diviner's identity is subsumed by that of the spirit: the diviner

Figs. 174 (left) and 175 (right): Diviners' wives assist in calling forth the spirit through the use of sound. One wife uses an iron bell while another gently sweeps in front of the house inside which her husband awaits the spirits' arrival. Percussive sound is often the stimulus for awakening the spirit to divination. *Photos: Mary Nooter Roberts, 1988.*

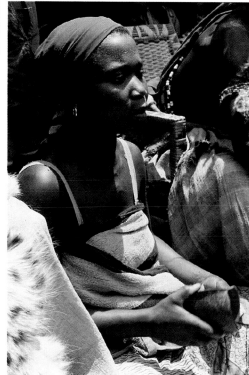

Figs. 176 (left) and 177 (right): Once the spirit has been summoned, its presence must be sustained through the singing of songs for twins to the percussive accompaniment of bells and rattles. *Photos: Mary Nooter Roberts, 1989.*

talks, acts, and thinks as the spirit itself. In figs. 173a and 173b, a diviner is shown in trance, through which he experiences convulsions and frenzied bursts of hysteria. Like Mbudye members, who also practice spirit possession, Bilumbu do not depend on any chemical substance to achieve this state. Rather, it is induced through a combination of voice, percussion, and willpower.

If the diviner is a man, his wife (or wives) often plays a key role in the invocation of his spirits. Called Kapamba, or "Mother of Twins" (Theuws 1960:132), she serves as the guardian of her husband's spirits, ensures that he respects the taboos, assists in "calling" the spirit, and may translate the possessed diviner's utterances for his client.[21] Normally, a Kapamba sits outside the door of the house within which the diviner is preparing for a consultation. While he shakes an object-filled gourd and pronounces a long series of chantlike praise phrases, the Kapamba either beats an iron bell called a "*ludibu*" or sweeps the sand in front of the house (figs. 174–175). Both motions are performed in even rhythms that provide a syncopated complement to the diviner's soliloquy and produce the aesthetic climate necessary to trigger his transformation to spirit-person.

A second assistant to many Bilumbu mediums is called a "Kitobo," a term with the general sense of "guide." Like a Kapamba, a Kitobo will direct a séance, sometimes leading the musical accompaniment. In particular, a Kitobo interprets the medium's speech, which is often in another language from that of the audience, or in glossalia (Nooter 1991:225–26, Roberts 1988a). A Kitobo is also found at certain important locations of spiritual activity, such as waterfalls, lakes, or grottoes associated with earth spirits. In such places the Kitobo is again a guide, mediating between the spirits and those who may come to consult them as oracles, or to make offerings through "ecological cults" meant to assure access to important natural resources (Roberts 1984).

Trance may also be induced through the singing of sacred songs for twins, whom Luba view as powerful and ambiguous, and who are called "children of the moon," in reference to lunar phases (Theuws 1960:132).[22] Since most Luba spirits manifest themselves as twins, the diviner and his wives invoke them with songs whose bawdy lyrics refer to the extraordinary fertility of mothers of twins, the power of women more generally, and the dastardly doings of witches. The mere singing of the songs, or the playing of wooden whistles, gourd rattles, and iron bells, may send the specialist into trance (fig. 176). As Gilbert Rouget writes, "music provides the entranced person with a mirror in which he can read the image of his borrowed identity . . . and reflect it back again upon the group" (1985:325). For this reason, songs for twins are sung throughout the course of a divination consultation to assure the continued presence and cherished involvement of spirits.

Diviners use an array of musical instruments to call and sustain the spirit. The ludibu bell (fig. 177), used by members of the Mbudye society as well as by Bilumbu, differs from the double gongs of chiefs called "*lubembo*" in that it has a single chamber and sometimes possesses a clapper. This sort of bell is associated with hunting, for small ones are tied to the necks of dogs sent into thickets to flush out game. The diviner uses a ludibu to "call" and make offerings to the spirit, the idea being that the bell communicates with the other world, just as a hunting dog is thought to have an exceptionally piercing vision that allows it to see what its master cannot. Large iron bells are sometimes packed with medicines that the diviner, through his Kapamba, gives to his client.

Whistles and rattles are also important instruments in the diviner's kit, to accompany the songs for twins. Whistles are carved from ivory or wood, and are similar to ones used by hunters to signal each other in dense forest. Powerful magic is sometimes kept in the hollow interiors of whistles. Rattles are produced from one or more tiny dried gourds that still possess their seeds (Gansemans 1980:8–16); the handles are sometimes decorated with fur or feathers, and may be carved to represent a human head. The sounds of bells, whistles, and rattles transcend mortal limitations and help initiate communication with spirits. They are said to be reproductions of the original instruments that Mbidi Kiluwe gave to Mijibu wa Kalenga when Luba kingship practices were introduced; in other versions of the story, they were made by Mijibu himself. Ludibu bells are found in archaeological excavations in the Upemba Depression, however, suggesting that their use predates the origins of kingship as described in the myth, and that they have been part of ritual practice in the area for many centuries. As S. Terry Childs and Pierre de Maret suggest in chapter 1 of this volume, contemporary Luba ideological explanations of technology, material

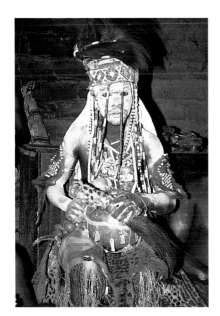

Fig. 178: This diviner has two possessing spirits, for each of whom he dresses differently. Here he dons the full apparel of a beaded nkaka headdress surmounted by blue monkey fur, layered beadwork on the chest, arm bands, and fur attached to his skirt. By wearing the accouterments that serve to remember the spirit, the diviner's body becomes a mnemonic. *Photo: Mary Nooter Roberts, 1988.*

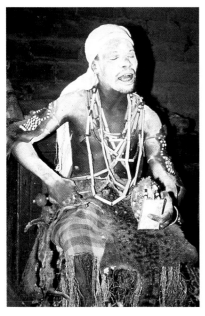

Fig. 179: The same diviner seen in fig. 178 is shown here possessed by his other spirit, for whom he dons only a simple head wrap, reed necklaces, and a white skirt. *Photo: Mary Nooter Roberts, 1988.*

culture, and social change are sometimes belied by the archaeological record.

Body Mnemonics

Once Bilumbu mediums have been "seized" (kukwata) by the spirit, or once the spirit has mounted (kutentama) to their heads, they chalk their faces with pemba chalk, called "the diviner's oil," and don a costume that reflects the spirit's attributes.[23] The complexity of Bilumbu costumes and paraphernalia distinguishes these royal diviners from nonroyal mediums like kashekesheke specialists, who wear no particular attire. Bilumbu costuming includes many of the same articles worn by high-ranking Mbudye members when they experience trance states, as discussed in chapters 3 and 4. These include bead and shell necklaces, turtle-shaped beaded arm-bands called "*batyita*," animal pelts, feathers, and the beaded headdresses called "nkaka" (figs. 180–182). The word "nkaka" also refers to the pangolin. Pangolin scales are considered strong, durable, and resistant, and pangolins themselves are curious animals, as shockingly "human" as they are comically bestial. They are so significant conceptually that neighboring Tabwa say "the king of beasts is not the lion but the pangolin" (Roberts 1995a:82–87). For these reasons, pangolin scales are often included in the medicinal compositions of Luba diviners and healers (Grévisse 1956:77, Van Avermaet and Mbuya 1954:216). An nkaka headdress is worn by all royal specialists who undergo possession (including Mbudye members), and the purpose of this colorful rectangular headband, with its juxtaposed isosceles triangles and lozenges, is to take hold of the spirit as it mounts the diviner's head and to contain, control, and protect it—a bit like the way a pangolin wraps itself up into a ball, its horny scales defending it from danger (fig. 183).

Luba sources also say that an nkaka headdress encrypts esoteric signs within its beadwork. An initiated Bwana Vidye (Bilumbu medium) should be able to recite the proverbs linked with each of the coded patterns of color, which usually refer to principles of royalty also represented on the lukasa memory board. These symbols are constantly updated both in form and meaning. Among Tabwa, for example, the central motif of most nkaka headdresses is a spiral, but in some examples the spiral is replaced by a pinwheel, a house, or a human skull flanked by a rooster. Tabwa also say that Bulumbu adepts can "read" and explain nkaka headdresses, for these designs are variations on a basic structure that follows semantic or representational rules. Use of the word "semantics" implies something else as well: "the study or science of meaning in language forms, particularly with regard to its historical change" (Morris 1969:1,177). The equivalence of the motifs found on nkaka headdresses derives from a "visual vocabulary" (MacGaffey 1988) providing a message that endures despite individual artistic interpretation, the need to convey particular messages, and radical social change (see Roberts 1990a:40).

Often a shock of guinea-fowl or rooster feathers surmounts an nkaka headdress, in reference to the "dawning" of wisdom (Roberts 1990a). These may be completed by a carmine-colored feather from a Lady Ross' turaco (*nduba*), denoting fearlessness, and by long streamers from a pennant-winged nightjar (Burton 1961:54), suggesting the Bwana Vidye's ability to see through the "gathered dusk" of ignorance and obfuscation. One or more fur pelts then hang down from the nkaka over the head, neck, and shoulders. These may be skins of the lemur (ibid.) or of the blue monkey (*Circopithecus mitis*), both arboreal creatures that rarely touch the ground. Tabwa see a blue monkey's high acrobatics as analogous to the way a possessing spirit will perch upon (kutentama) and take over (kukwata) a person's head and being (Roberts 1990a:45) (fig. 178). Sometimes an nkaka headdress may include the fur of a genet (*Genetta genetta*) or other spotted cat instead of a blue monkey pelt; these skins may also appear in the diviner's skirt. The genet's spots may refer to the alternation of day and night, or to the stars in the firmament; it is the prerogative of royalty to own and wear such skins, again reinforcing the link between diviners and kingship (ibid., and Roberts 1995b).

Bwana Vidye may also wear necklaces and waistbands of reed segments (fig. 179), the dried heads of ground hornbills (fig. 184) (considered "obdurate sentinels" of the other world— Roberts 1995a:67–70, quoting René Bravmann), small, constantly tinkling iron bells (Burton 1961:55), and batyita arm bands representing tortoises. These last are inspired by Lolo

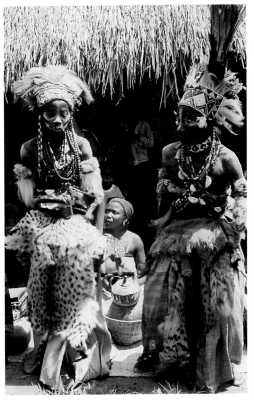

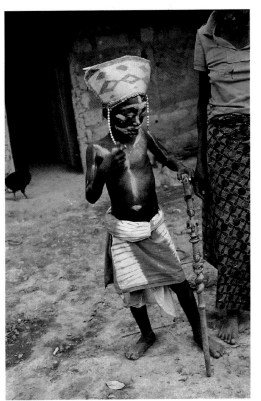

Figs. 181 (left) and 182 (above): The nine-year-old son and grandson of the diviners in fig. 180 knows that he will become a diviner too, and is shown here rehearsing for the part with his own "nkaka" headdress and a staff. His grandmother assists with the dance, after his friend has called the spirit with a rattle. *Photos: Mary Nooter Roberts, 1989.*

Fig. 180: Father-and-son diviners don the appropriate dress and adornments once the spirits have "mounted their heads." Their bodies become a mnemonic hanger for the attributes associated with their possessing spirits. *Photo: Mary Nooter Roberts, 1989.*

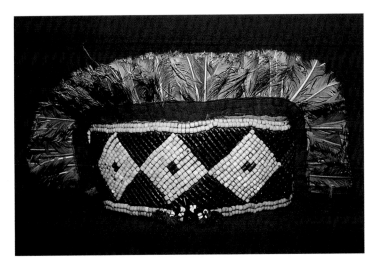

Fig. 183: Nkaka beaded headdress. Collection: the Section of Ethnography, Royal Museum of Central Africa, Tervuren, Belgium.

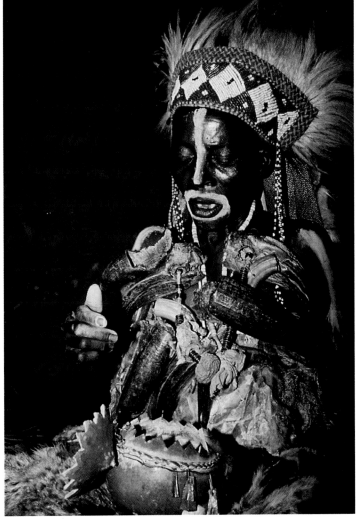

Fig. 184 (right): A female diviner named Banza Mutake possesses accouterments that emphasize the color red and include the skulls of hornbills and other animals. Banza Mutake was the third wife of a famous diviner in the Kabongo Zone who taught her the profession. When he died, she inherited his emblems, instruments, and reputation, and is now a widely respected diviner in the Luba area. *Photo: Mary Nooter Roberts, 1988.*

Fig. 185: A variety of gourds are used for Bilumbu divination, each with its own purpose, but all mnemonic in the sense that they are intended to provide information about the past, and to reconstruct historical events that may explain present misfortune. *Photo: Mary Nooter Roberts, 1988.*

Figs. 186 (top) and 187 (bottom): This divination basket was collected from a mission where a former diviner had left it when he converted to Christianity. The basket is like the diviner's "suitcase," containing his headdress, arm bands, necklaces, and the mnemonic gourds that were essential to his practice. Each of the two containers inside the basket remains full of a wide assortment of natural and manufactured items, including small figurative sculptures. Collection: the Royal Museum of Central Africa, Tervuren, Belgium, acc. no. 70.63.

Inang'ombe, "Mother Tortoise," the presiding deity of the Mbudye Society. One diviner explained that a tortoise carapace is an effective container for medicinal compounds, for the shell conceals its powerful contents from the uninitiated. Another suggested that his arm bands help him see clearly and respond lucidly. Reference is also made to the lukasa memory board, the outer form of which is that of a tortoise.[24]

Bilumbu own axes with iron blades and wooden, sometimes copper-wrapped handles, which they carry over their shoulders to display rank, just as Mbudye members, chiefs, and titleholders do. The axes of Bilumbu are called "*mutole*" or "kibiki." They do not always have an anthropomorphic head, as the axes of chiefs usually do, but they often do have engraved geometric patterns on their metal blades, said to refer to rank and title.

The costuming of a Bwana Vidye varies according to his or her rank. Bilumbu spirit possession transforms the medium into a living mnemonic, and his or her body into a memorial for the attributes of one or more spirits. Possessing spirits are often associated with conceptually important places, such as lakes, rivers, waterfalls, and caves.[25] In possession, though, Bwana Vidye diviners also incarnate Mijibu wa Kalenga. The medium's costuming, instruments, accouterments, chants, and songs constitute a multimedia, multireferential vocabulary that reifies the presence of spirits. The body becomes both a text and a container for the spirit, and as the diviner performs the transformations of Bilumbu ritual, spiritual force is refabulated for a present-day audience.

Memory in Motion

While Bilumbu diviners communicate with their possessing spirits by incantations, songs, and percussion, the spirits respond through visual codes, including the kinetic arrangement of items in a gourd or basket. For different purposes and occasions, Bwana Vidye among Luba, like some diviners among their Songye, Aruund (Lunda), Chokwe, Lovale, and Ovimbundu neighbors, use baskets and a variety of gourds that contain sundry natural and artificial objects (fig. 185). During consultation, a diviner shakes such a gourd and interprets the resulting configurations of items. Each object is mnemonically multireferential, or, as Turner would say, "polyvalent" (1970)—able to "hook up" conceptually to other objects, like atoms in molecules of meaning, or complex polymers of narrated memory. The juxtapositions of a basket's objects remind the diviners of certain general cultural rubrics and relationships through which they can classify the client's specific case. A metaphoric bridging occurs between general precepts and past precedents, on the one hand, and present-day woes on the other. In this way, sense and order can be perceived and created from the indecipherable simultaneity of lived experience (see V. Turner 1975:239). The contents of the gourd are a microcosm of memory, intention, and hope, then, and the product of the objects' reconfiguration is a pregnant hypothesis (Roberts 1995a:95).

The items in the gourd are like the ideograms or beads of a lukasa or a staff. Here, though, the "bits" of meaning and experience are broken loose from the interpretive restraint of narrative plot. Though lukasas and staffs provide flexible systems of signification, they nonetheless present a static, fixed mode of narrative representation that can be experienced through their consolidated physical forms. The kinetic mnemonic devices used by Luba diviners, on the other hand, constitute a system whose parts are meaningfully aligned only through "random" casting, movement, and motion. Such a memory system allows for greater latitude of interpretation than a lukasa or other "sculpted narrative," a flexibility obviously necessary to cope with the vicissitudes of everyday life. And from an insider's viewpoint, of course, there is nothing random about the process or its results, for the objects' movements and juxtapositions are directed by spirits to reveal otherwise hidden concepts, relationships, and purposes.[26] The prototypes for the objects and processes of this kind of divination are said to have been introduced by Mijibu wa Kalenga. A Bwana Vidye must be in trance to interpret a gourd's constellations of symbols; it is trance that allows the diviner to transcend this world so as to gain insight from the other.

Most consultations are held inside diviners' homes. Once a Bwana Vidye has donned his or her apparel and set up the consultation area, clients are asked to enter the house, but only after taking off their shirts, shoes, watches, hats, and belts.[27] In other words, as many worldly signs are

removed as is possible and polite. The client takes his or her place on a mat on the floor, while the diviner sits on a stool or bed, with the Kapamba (wife) and Kitobo (guide) to either side. The entire consultation is accompanied by songs for twins, sung by the diviner, his wife or wives, and his children, all of whom are usually present.

The equipment for divination—calabashes, figures, horns, small baskets—is kept in a covered basket called a "*kitumpo*" (figs. 186–187) or, nowadays, in a metal trunk. Ordinarily, only the diviner may look into the basket or trunk to view the paraphernalia, and during consultations the diviner removes one object at a time for use, without ever exposing all of the trunk's contents. Among the most important objects in a Bilumbu kit is a sacred gourd containing natural and manufactured objects (fig. 188). This gourd, called "*mboko*" in the villages of Kinkondja and Malemba and "*kileo*" in the Kabongo Zone, is considered a source of well-being, wealth, good health, and truth (see Van Avermaet and Mbuya 1954:76–77).

An mboko is filled with an array of objects, including tiny iron replicas of tools; composite magical bundles contained in antelope horns, cowrie shells, and the carapaces of dried beetles; one or more human teeth; caddis-fly cases; fruits, seeds, and twigs; bird beaks and claws; chalk; and a dozen or more miniature carved wooden human figures.[28] This is the raw material with which the diviner diagnoses a problem. Facing the seated client, the Bwana Vidye shakes the mboko, then opens the lid to peer inside. Whichever objects or figures are standing or have come to the surface of the jumble of chalk-covered pieces are taken as revelatory signs. From these, the diviner begins to form "organizing images" and a hypothesis concerning the client's difficulty. The process is repeated again and again until a relatively clear understanding of the problem has been formulated. As one diviner explained the process, "the Bwana Vidye looks at the wooden figures, which give him information that he surrenders to the client. Understanding the configuration of figures in the gourd is possible only when the spirit has taken possession of the diviner. At that moment he can interpret the different aspects of these statues. Ordinary people, or Bilumbu not in possession, cannot determine their meaning or function."

The symbols in the gourd are a multireferential, "open-ended analogical system" (Peek 1991:12), and only the diviner is capable of decoding and disclosing the secret meanings of their juxtapositions. The individual symbols are mnemonic, as are their larger configurations. But unlike lukasas, which uphold state and institutional ideology, and staffs, which validate personal claims to power, the mboko's messages are based on a set of moral premises intended to ensure health, justice, and social harmony. Turner, who has studied similar divination techniques among Zambian Ndembu to the southwest, suggests that "diviners are extraordinarily shrewd and practical. . . . The way they interpret their divinatory symbols reveals deep insight both into the structure of their own society and into human nature. . . . The symbols are mnemonics, shorthands, cyphers; . . . they serve as reminders to the diviner of certain general rubrics of culture within which he can classify the specific instance of behavior" (V. Turner 1975:209 and 239).

The items in an mboko include both sculpted human figures, in postures such as coitus, and a wide variety of natural objects (fig. 189). Like the items in Ndembu divination baskets, these objects represent many things and each has many meanings:

> Some represent structural features in human life, aspects of the cultural landscape, principles of social organization and social groups and categories, and dominant customs regulating economic, sexual and social life. Others represent forces or dynamic entities, such as motives, wishes, desires, and feelings. Not infrequently the same symbol expresses both an established custom and a set of stereotyped conflicts and forms of competition that have developed around it. It is roughly true that the human figurines represent universal psychological types while many of the other objects refer specifically to Ndembu structure and culture (ibid.:214).

The diviner's skill is determined, however, by "the way in which he adapts his general exegesis of the objects to the given circumstances" (ibid.:217).

Fig. 188: Diviners shake the *mboko* as they ask their possessing spirit a question, then "read" the arrangement of figures as they land and fall next to one another. Often the figure that stands straight up out of the jumble holds the key message, telling the diviner the reason for the client's present affliction. *Photo: Mary Nooter Roberts, 1988.*

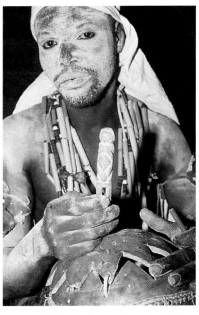

Fig. 189: A diviner shows a figure from his mboko to explain how it represents a state of being, a condition, or an affliction. Figures may represent mourning, theft, divorce, or sorcery, for example. *Photo: Mary Nooter Roberts, 1988.*

CAT. 79: FIGURE WITH CAVITY. LUBA, ZAIRE.
Among Luba, aesthetic beauty has social
value and healing powers. The coiffures of
some Luba sculptures still contain medicinal
substances. These are inserted into cavities
carved in the top of the head, or tucked into
the carved tresses of the hair, lodged between
the sculpted chignons. Throughout Africa,
the head is considered a seat of power, locus
of wisdom and clairvoyance. As the feature
of cosmetic beautification that most directly
affects the head, coiffure is given great
importance in Luba thought and practice.
Wood. H. 7.6 in. Private collection, Brussels.

CAT. 80 (OPPOSITE): BOWL FIGURE. LUBA,
ZAIRE. Bowl figures used for divination
represent the wife of the diviner's possessing
spirit. Her portrayal in sculptural form
underscores the role of the diviner's actual
wife as an intermediary in the process of
invocation and consultation, and reinforces
the Luba notion of women as spirit contain-
ers in both life and art. The diminutive
figures clinging to the bowl and to the female
figure in this object are an innovation, and it
is not known whether they depict children
or spirits. Another bowl figure by the same
hand can be seen in the American Museum
of Natural History, New York, although
the latter lacks the addition of the smaller
figures. *Wood, glass, beads. H. 13.3 in.*
Museu Carlos Machado, Ponta Delgada
(Açores), Inv. no. 256.

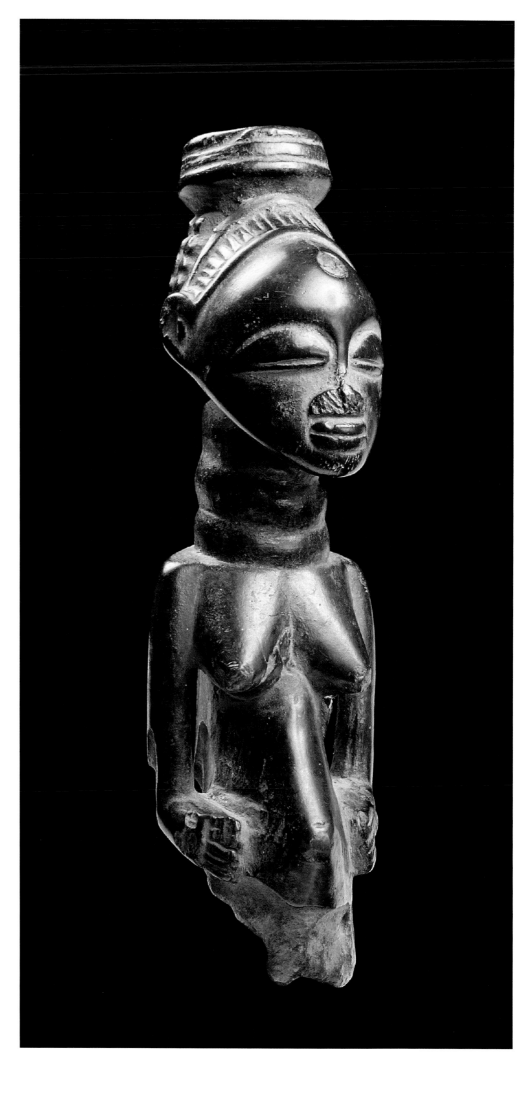

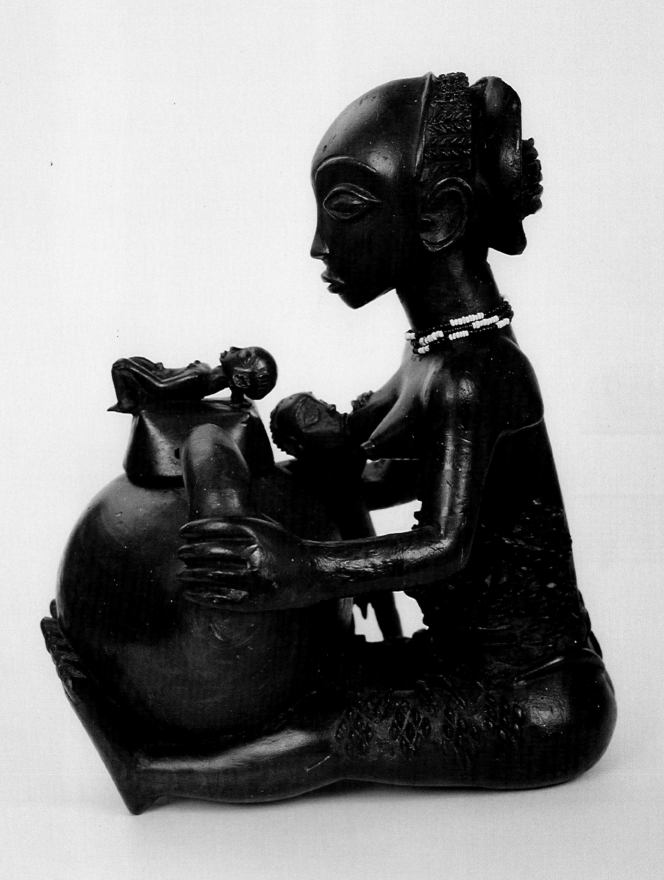

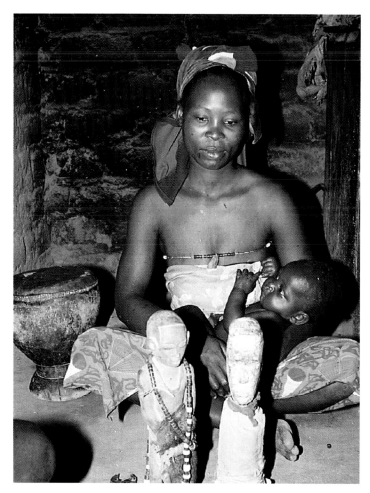

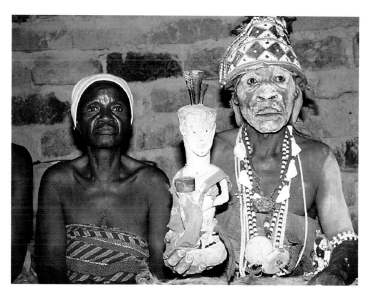

Fig. 190 (above): A diviner and his wife perform a consultation with an nkishi sculpture that is charged with activating agents implanted inside the horns protruding from the head. *Photo: Mary Nooter Roberts, 1988.*

Fig. 191 (left): Diviner's wife and child with two nkishi figures used for problems associated with sterility. Nkishi figures are usually charged with medicinal substances, and these two have the additions of beads, chalk, and fur attachments. *Photo: Mary Nooter Roberts, 1988.*

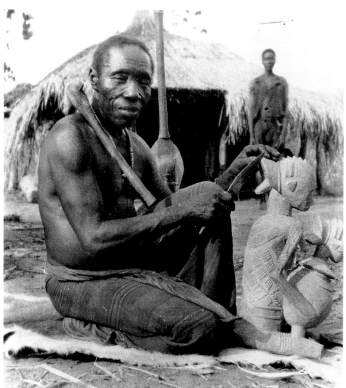

Fig. 192: A Kitwa, the personal woodcarver of a chief, using a knife and adze only to sculpt a bowl figure in the form of a woman holding a bowl. The Kitwa's kibango or carved staff is behind him. *Photo: W. F. P. Burton, 1927–35. Courtesy of the University of the Witwatersrand Art Galleries, BPC 05.15.*

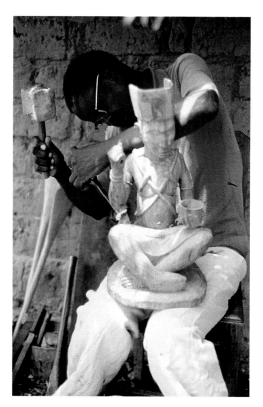

Fig. 193: Bowl figures are still in demand among Luba diviners, but they are now made in the form of male figures holding bowls, instead of the female figures of nineteenth- and early-twentieth-century examples. *Photo: Mary Nooter Roberts, 1988.*

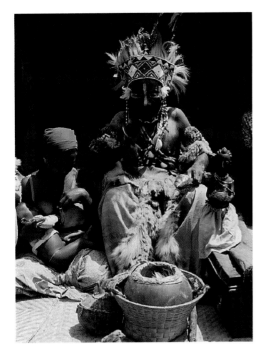

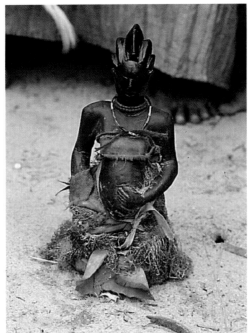

Figs. 194 (far left) and 195 (left):
Contemporary Luba diviners explain that the bowl figure (when female) represents the wife of the diviner's possessing spirit. Bowl figures also refer to the first Luba diviner, Mijibu wa Kalenga, who facilitated Kalala Ilunga's accession to the throne. *Photos: Mary Nooter Roberts, 1988–89.*

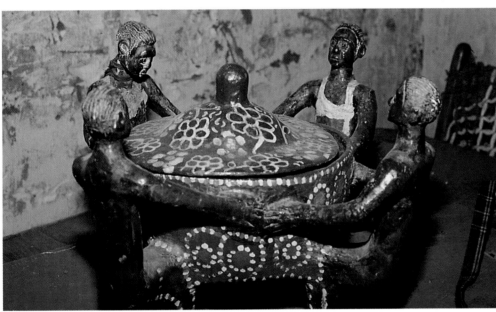

Fig. 196: Some contemporary chiefs own clay bowl figures with multiple human forms. *Photo: Mary Nooter Roberts, 1988.*

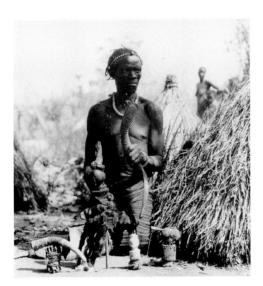

Fig. 197: A Luba diviner/healer is shown with several nkishi figures and a horn used for invoking the spirits to action. *Photo: W. F. P. Burton, 1927–35. Courtesy of the University of the Witwatersrand Art Galleries, BPC 04.9.*

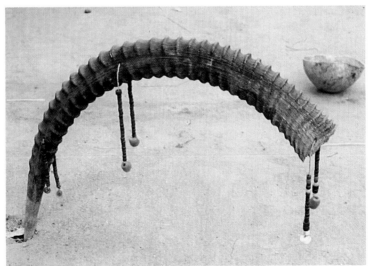

Fig. 198: A spiritually charged horn installed in a Luba diviner's compound. *Photo: Mary Nooter Roberts, 1988.*

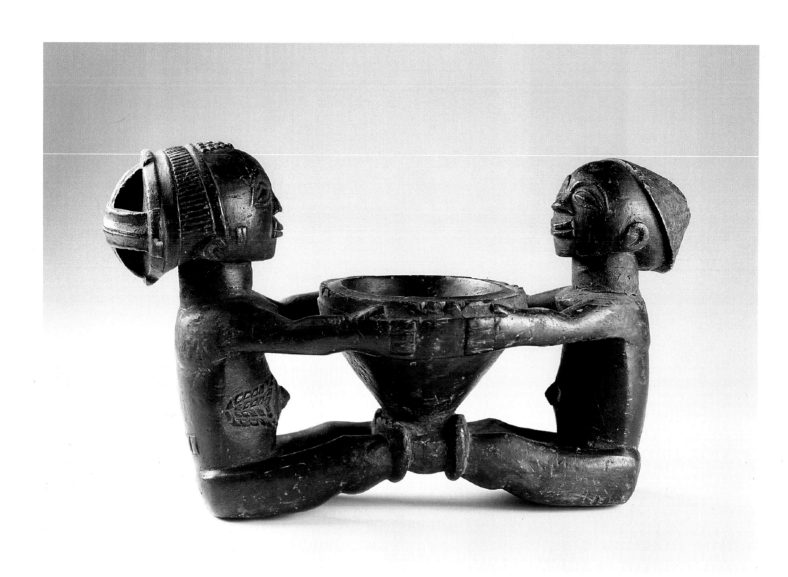

CAT. 81 (ABOVE): BOWL FIGURE. LUBA, ZAIRE. This bowl figure is important historically, for it was published in Pierre Colle's two-volume monograph of 1913 on Luba people located to the northeast of the Heartland, in Kyombo's chiefdom. Two figures grasp the bowl, which would have been filled with white chalk and other offerings. One of the two figures wears the *kaposhi* hair style of former days—the cross-shaped coiffure found on most Luba and eastern Luba sculptures. It was the coiffure of Luba chiefs and some of their wives. The other figure wears a different hair style, often seen on sculptures made much farther to the east, toward the Tabwa region. *Wood. H. 8 in. Felix Collection.*

CAT. 82 (RIGHT): PAIR OF BOWL FIGURES. LUBA, ZAIRE. The scale and style of these two bowl figures are intimate and personal. Bowl figures serve as oracles for royal Bilumbu diviners. The female figure depicted on a bowl figure can track down malevolent forces and act as a spy in the service of the diviner. Such figures are also reputed to have curative capacities. Whether these two bowl figures constitute a pair, or were the property of two different diviners is unknown. But they represent the sculptural vision of an innovative artist. *Wood. H. 7 in., 6.2 in., respectively. Private collection, Brussels.*

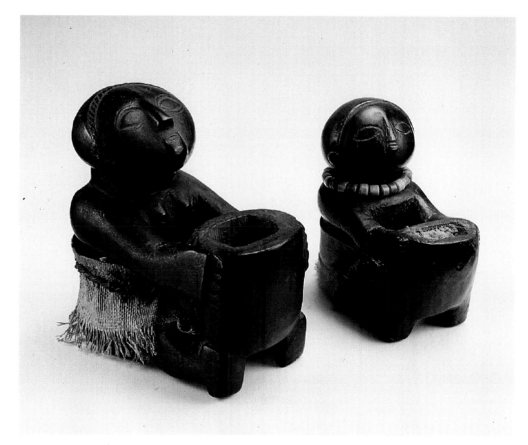

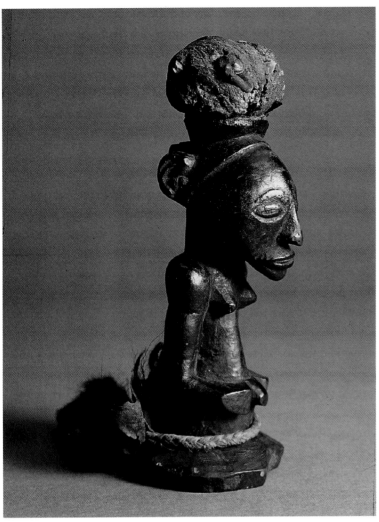

CAT. 83: FIGURE WITH MEDICINAL CHARGE. LUBA, ZAIRE. Many Luba sculpted figures are considered void until charged with substances. These compounds include items thought to have rare and enhanced life powers, such as pulverized fragments of human bone, or the hair of twins. These may be embedded into a hole in the figure's head or stomach. By enhancing the object in this way, the ritual specialist invites the spirit to inhabit the receptacle, which can then be used to assist with particular tasks. *Wood, skin, resin, fiber. H. 7.8 in. Staatliches Museum für Völkerkunde, Munich, Inv. no. 11.1483.*

CAT. 84: JANUS FIGURE. KUSU, ZAIRE. The precise context in which this figure was used is impossible to ascertain, since Janus figures are not restricted to any single domain. They may be used for divination, or as part of a chief's royal treasury, or for religious veneration and invocation. Yet the presence in this figure of horns and other substances implanted in the head suggests that it was probably a vehicle for healing and other apotropaic purposes. That the faces look in opposite directions signifies vision into the other, ordinarily invisible world. Luba say that horns give figures "the power of locomotion." The figure thus has the power not only to see into the beyond, but to go there as well. *Wood, horn, metal tacks, nails, organic material. H. 13.5 in. The University of Iowa Museum of Art, The Stanley Collection, Inv. no. CMS 583.*

A Luba diviner from the village of Masangu named many of the items contained in his kileo, and offered their meanings as isolated signs. One figure represents a cadaver; if it appears upright, it signals that the client is being followed by an aggressive spirit. Another, depicting a person with a rifle, identifies the afflicting spirit as that of a deceased hunter armed with a gun. Among the nonsculpted objects are a part of an owl, suggesting that the client or someone dear may have mental problems; the head of a *sapa-dya-sepya* bird, which indicates that the client has been ensorceled by a woman; and a caddis-fly case, suggesting that a council should be held to discuss a particular matter.

Another kind of large decorated gourd called "*kilemba*" is used to determine guilt or innocence in controversial cases ranging from theft and adultery to sorcery and murder.[29] Like the mboko or kileo, the kilemba contains an assortment of items that respond to questions posed by the diviner; but the objects are less varied, including only a few miniature human figures, besides chalk, money, and beads. Whenever there is a disagreement between the diviner and the client, the kilemba is placed on the client's lap. If the gourd is sensed to adhere to the client's legs, this implies guilt, or indicates that the client has been lying. If the client is shown to be innocent of the crime or dilemma in question, the diviner will take chalk from the gourd and spread it on the person's arms, face, and chest to signify acquittal (Burton 1961:70).

In both mboko or kileo and kilemba, as well as in nonroyal techniques like kashekesheke, the spirits communicate with a diviner through kinesis. While the beads on a lukasa fix meaning and attach memory to place, the objects of divinatory instruments are detached from static positions; they are unleashed, let loose, and relocated. In this way the diviner effects the transformation of "jumbled thought into sequential thought" (Parkin 1991:183). "The diviner makes sense out of the afflicted world brought to his attention by rescuing sequence out the muddle of simultaneity and synchronicity . . . [and by] the production of domesticated sequences of action out of the wild, existential simultaneity of experience" (Fernandez 1991:218). As David Parkin further suggests, the client is the "point of reference and guidance" for this process. "That is to say, by his nods, cues, and statements of agreement, the patient helps the diviner, encouraging him to proceed from one possibility to another, [thus] converting an unmanageably large number of interpretations into a more limited number." Diviner and client, then, are in some sense "mirror images of each other" (1991:184–85). Through their concerted concentration, they achieve the brilliant intellectual results needed to sustain life and give it purpose, even in the face of "the

CAT. 85: AMULET WITH TWO FIGURES. LUBA, ZAIRE. This amulet, identified in the museum records as a "house fetish," may have been hung on a wall to ward away intruders or other malevolent forces. Whatever its purpose, *bwanga* or medicinal substances have been included to give the amulet its potency. Stylistically, the figures on this amulet resemble art from the western areas of Luba-Kasai and Lulua, where Ludwig Wolf, who collected it in 1886, is known to have traveled. These half figures, called "*kakudji*," signal the importance of the head and torso as loci of personal strength and action. *Wood, basketry, fiber, seeds. H. 10.6 in. Staatliche Museen zu Berlin, Preussischer Kulturbesitz, Museum für Völkerkunde, Acquired from Ludwig Wolf, 1886, Inv. no. III C 3624.*

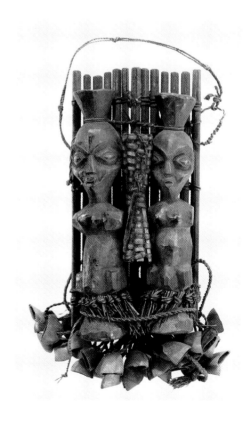

CAT. 86: AMULET WITH TWO FIGURES. LUBA, ZAIRE. The purpose of this delicate amulet with two figures joined by a string of beads is unknown. It is notable, however, that the figures' bodies have been reduced to a geometric shape reminiscent of the lukasa memory board, and with "scarification" patterns of the type carved on all royal emblems and memory devices. The linking of the two figures by beads may also be an allusion to memory, since one of the words for "memory" in the Luba language also means "a string of beads." The paired figures may refer to the twin spirits of Luba kingship, who embody the memory of the Luba past. *Wood, beads, fiber. H. 3.7 in. Staatliches Museum für Völkerkunde, Munich, Inv. no. 13-57-188.*

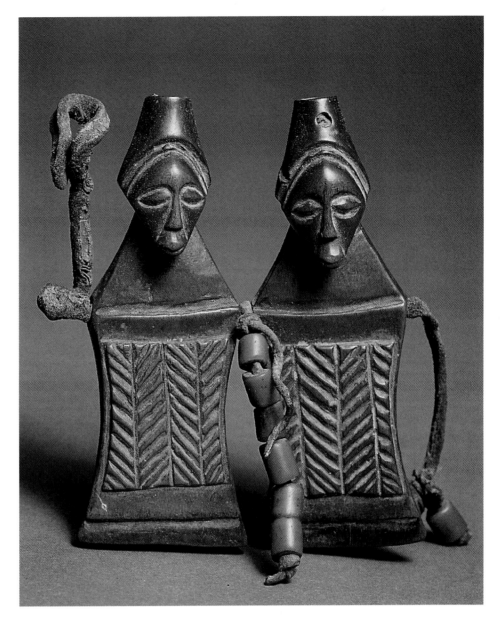

CAT. 87: AMULET WITH FOUR FIGURES. LUBA, ZAIRE. Luba and Luba-related peoples wear and display small sculpted amulets for strength, for luck in hunting, and to remedy illness. Sometimes they are hidden within the raffia of dance masks, and they frequently constitute part of a spirit medium's divining kit. This particular example may have been worn by a woman during childbirth. *Wood, leather, fiber. H. 4.3 in. Staatliche Museen zu Berlin, Preussischer Kulturbesitz, Museum für Völkerkunde, Gift of Hösemann, 1898, Inv. no. III C 8534.*

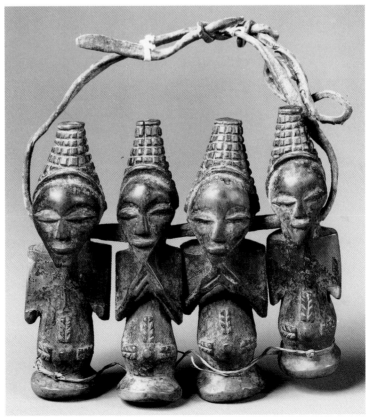

CAT. 88 (OPPOSITE): KABWELULU GOURD
FIGURE. LUBA, ZAIRE. A *kabwelulu* is a figure
surmounting a gourd used during initiation
rites of the Bugabo Society, an association
dedicated to hunting, healing, and fighting
crime. The sculpture is an example of a "little
world" created out of the bits and pieces of a
person's or group's memory and experience:
during initiations, novices would place in
the gourd certain secret items that would
accumulate over time until the sculpture
acquired a power far greater than any of its
parts. The gourd thus produced the memory
of the event of activating the sculpture.
*Wood, calabash, seeds, metal. H. 16.25 in. The
Walt Disney-Tishman African Art Collection,
Inv. No. 1984.AF.051.132.*

dumb senselessness of intense or inexorable pain, and the enigmatic unaccountability of gross iniquity" (Geertz 1979:85) so distressingly common in contemporary Zaire.

Memory Figures

In addition to the meaningful contents of gourds, a Bwana Vidye uses an array of sculpted human figures as receptacles for magical medicines (figs. 190–93). Generically called "nkishi," some are specifically for men, some for women, others for the community as a whole; some have particular purposes, others provide general protection; some nurture, some destroy; some manifest grand intentions, others petty desires; some catch thieves, or help retrieve lost articles, others reverse sterility or seek revenge from sorcery (Weydert 1938:28) (cat. no. 79).

The most important nkishi figures belonging to a royal diviner represent women holding bowls or gourds (cat. nos. 80–82). Luba "bowl figures" characteristically depict a woman kneeling, or seated with her legs straight out in front of her, and in either case holding a bowl on her lap. These figures often have a horn filled with bijimba activating agents implanted in their heads, and some bear anvil-shaped iron hairpins in their coiffures. The bowl, or gourd, that the figure holds is similar to the mboko gourd of the Bilumbu diviner, and contains chalk and beads. This sort of figure has been adopted by certain Luba kings and chiefs for use in court rituals that reflect the ways it is used by spirit mediums. Political decisions, the king hopes, are "enlightened" by the chalk held in the bowl. For a Luba king, the female figure is said to represent Mpanga and the bowl Banze, the twin tutelary spirits of sacred royalty (figs. 195–96) (Petit 1993:428–29; 1995:126–28).

Some identify the bowl-bearing woman as the wife of a possessing spirit, and during consultations such a sculpture is placed to the left of a Bwana Vidye while his own wife, or Kapamba, takes her place at his right (fig. 194). Around Kabongo, the name for such a figure is "*kalenga*"; some claim that the figure depicts Mijibu wa Kalenga himself. That Mijibu is portrayed as a woman reflects the sense that all spirits take abode in the strong bodies of women. Such gender reversal further emphasizes the capacity of a diviner to mediate and so transcend ordinary dialectics, including that of life and the hereafter.

Bowl-bearing figures have curative powers. A Bwana Vidye may mix a pinch of pemba chalk from the bowl with medicinal substances to be dispensed to patients. Aside from its whiteness, chalk both instigates and stands for all that is auspicious, especially communication with the other world.[30] Chalk is "surrogate moonlight" (Roberts 1985), and refers to the enlightenment of a new moon rising—kutentama kwezi, the same verb describing trance. The bowl figure also has oracular powers: it serves as a mouthpiece for the spirit, and is thought capable of traveling from one locale to another to gather evidence concerning suspected sorcerers or other ne'er-do-wells. On studying a photograph of one such nkishi, one Bilumbu diviner explained that the figure is called Kajama, the name of a spirit in the vicinity of Kabondo Dianda. A horn in the figure's head gives it the power of locomotion, while its iron hairpins serve to "close" or "lock" it, both protecting its spirit and preventing that spirit from either speaking openly or leaving the figure against the diviner's wishes. When the hairpins are removed, the figure begins to recount what it has seen in its peregrinations, he added, thereby *making* memory as it *relays* memory.[31]

Shards of Memory

An nkishi is considered an inanimate piece of wood until charged with magical substances and invocations. As Tabwa diviners say, the figure is like a gun that needs ammunition to fire. These activating agents, called "bijimba," are sometimes artifacts of human circumstance, intended both to symbolize and to produce similar experience: a charred bit of bone from someone who has died lost and alone in the forest, for example, is used to bring abject solitude to any who attack the bearer (see Roberts 1992a).[32] Relics of this sort are keen-cutting shards of memory, used to shape the course of present circumstances and future events (fig. 197). We are speaking here of "an analogical mode of thought" (Tambiah 1973:199), an active metaphoric bridging that depends on what Walter Benjamin termed the genius of "man's mimetic faculty" (1986:333–34). In short, use of bijimba entails what is called (and often dismissed as) "magic" in the West (fig. 198).[33]

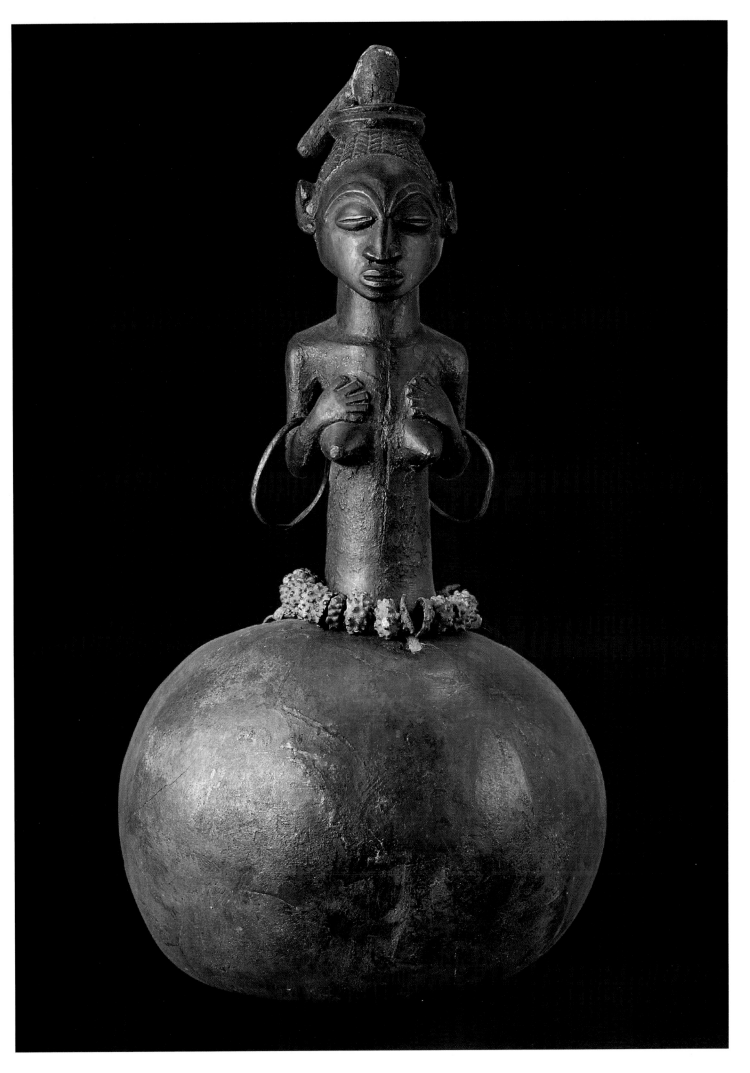

Magic is a dynamic process, a disassembly of the fixity of meaning followed by manipulation and reconfiguration to help people achieve stated or implicit goals. Conceptualizing, creating, and using magic are essentially synecdochic practices. The totality of the experience of, say, blindness—the loneliness and alienation such an affliction must bring, the blind man's years of struggle to find his way, his uncanny ability to get about with minimal difficulty, and everything else blindness is, has been, and might be for this particular soul and anyone else so affected—all this is reduced to a tiny piece of a blind man's stick. The cane is chosen because, as Jacques Derrida writes, it is the man's "saving eye, his emergency eye, one might even say his optical prosthesis, more precious than his own pupils" (1993:9). Luba fishermen and hunters use a blind man's stick as a bijimba, "for just as the cane replaced the eyes of the poor man, they believe that this bijimba will allow them to see fish and game; others use it to make themselves invisible, and it is sold dearly" (Van Avermaet and Mbuya 1954:279). In other words, a tiny piece of this wood placed in a magical bundle is thought to extend vision beyond what ordinary people can see.

This same bijimba can also "blind" those who would thwart one. Used as a magic of invisibility, it serves nowadays to allow people to pass by roadblocks and similar harassments at the hands of Zairian police, soldiers, and other authorities prowling about in search of extortion victims. The power of activating agents like a blind man's stick derives not only from the metaphors they represent, but from the conceptual resolve to reduce a whole dimension of perspicacity, imagery, and experience into one small, meaningful object.[34]

Combined in a bundle, bijimba magical elements create what Tabwa call a "little world" (*kadunia*) of their own confection (cat. nos. 83–84). A crumb of this, a shaving of that, and the merest hint of something else are used to construct such a "little world." Because the pieces are so small, some charred, and all eventually ground together and mixed in a paste, no one can identify the particular elements after they are assembled. What the healer and his clients know, others can only guess. This, of course, is the point: *anything* can be in the bundle. It is what *might* be there that is most frightening to those who would challenge the possessor of magic.

Making this bundle is an *event*. If the essence of such a "magma of ingredients . . . without any figurative pretense" (Surgy 1993:114) is to be captured at all, poetic metaphor is required. As a magical bundle is confected, a storm of meaning is created that threatens to explode in all directions at once. Each element may have its explanation, but such particularities are lost in the bundle's localization of energy (cat. nos. 85–87). The bundle's awesome overall power is far greater than any of its parts. Instead, a magical bundle "traps forces . . . [and] is the place where the visible articulates with the invisible" (Heusch 1988:15). As a client plays the two worlds against each other, in a far-reaching dialectic of the then and the now, and the expectation of what one "deserves" in life and what one usually gets, memory is made.

When a Bilumbu diviner makes or commissions an nkishi figure, the "storm of meaning" is animated.[35] Bijimba may be enclosed in a horn inserted into an nkishi's head; embedded in tiny holes carved at the figure's ears, temples, or other points of anatomical articulation to augment perceptive and tactile senses; or wrapped in cloth or lizard skin to wrap around the figure's neck or waist. By charging an nkishi in this way, a diviner invites a spirit to inhabit the figure and endows it with extraordinary powers, so that it can assist the diviner in his or her attempts to change the world for the better (cat. no. 88).

Endnotes

1. Divination is an active quest. Luba also possess many less-dramatic forms of "passive" information-gathering and hypothesis-testing that, like divination, imply spiritual intervention; these include omens, oracles, and dreams that a person may interpret or take to a diviner for explanation. See Burton 1961 for a broad range of examples from northern Luba, and Fourche and Morlighem 1939:6–13 and McLean and Solomon 1971 for related, Luba-Kasai examples.

2. The importance of metaphor, metonymy, synecdoche, and irony in African art and expressive culture is discussed in Roberts 1995a:18–22, where a "conceptual toolkit" is presented to assist readers—in that case to understand the significance of animals in African art.

3. Some forms of African divination may look to the future, as Ifa is said to do for Yoruba and related peoples. But if other forms now do the same, they have probably been adapted to do so relatively recently, in a change consistent with acceptance of capitalism and its goal-driven philosophy of profit. Indeed, one might speculate that the aspect of Ifa that looks to the future is related to the capitalism of the markets that have flourished in Yoruba society for centuries.

4. Several authors (e.g. D'Orjo de Marchovelette 1954:487) have misassociated this verb with *kubuka*, "to awaken," which has a different tonality from *kubùka* (Van Avermaet and Mbuya 1954:89). D'Orjo de Marchovelette correctly states that there is no Luba verb or usage that corresponds to a Western sense of "to divine" (ibid.).

5. Victor Turner contrasts Ndembu equivalents of these two verbs, noting that "*kusolola*" ("*kusokola*" for Luba) is "the manifestation of what resists conceptualization in the linguistic terms available to Ndembu.... Divination seeks to uncover the private malignity that is infecting the public body, while revelation asserts the fundamental power and health of society and nature grasped integrally" through "authoritative images and root metaphors" (1975:15–16). While Luba might not draw the distinction as clearly as Turner does for Ndembu, it is likely that of the two forms of divination to be discussed below, *kashekesheke* is an example of Turner's "divination," while Bilumbu spirit possession answers best to his sense of "revelation" (kusokola).

6. As discussed in the introduction to this book, "*milandù*" for Luba is "a dispute to which one returns" (Van Avermaet and Mbuya 1954:338) as well as a word referring to memory. Other usage makes it clear that the word implies negotiation and related discursive activity, as history is created from memory.

7. "Politics" is by no means limited to the activities of formal government, especially in societies such as many of those in southeastern Zaire, which have leaders rather than rulers. See Swartz 1968 for a useful discussion of local-level politics in small-scale societies.

8. Other types of Luba divination include a host of friction or rubbing oracles, and devices depending upon mirrors and other reflective surfaces. For a list of Luba-Kasai devices current early this century, see Fourche and Morlighem 1939:18–26.

9. Field data on kashekesheke were provided to Mary Nooter Roberts by the following Luba colleagues: Maman Keuzi of Kipamba, Kasongo ka Kadilwa and Malonda of Kabwila, Maman Ngoi Mukemwendo of Kabumbulu, Tshikala and brother Kabeya of Mwanza Seya, Tata Kumbi-Kumbi of Lwakidi-Mando, Mutonkole Milumbu of Kipamba, and Bwana Kudie and other Bilumbu possession diviners listed in the next section. Written sources for kashekesheke include Burton 1961, D'Orjo de Marchovelette 1954, and Faider-Thomas n.d. Kashekesheke among Tabwa is described in Davis-Roberts 1980:67–68 and passim.

10. Tembo, Twa, and Mbote are among the names of the hunter-gatherer peoples who live in small bands among Luba, Tabwa, and related groups of southeastern Zaire. The literature calls them "Pygmoid" peoples (Schebesta 1952), for they are culturally related to Mbuti and other "Pygmies" of the Ituri rainforest, but they have long since adapted to the open woods and savannas south of Ituri, and are not small in stature, as Mbuti are. Most often, they live in a kind of symbiosis with sedentary farmers, trading forest goods for agricultural produce; but the relationship is often one of mutual mockery and distrust. Although all of these peoples are virtually ignored in the literature, see Terashima 1980 and Roberts 1995a:66–68. "Zones" and "Collectivities" are Zairian administrative terms, the one more inclusive than the other: a "Region" is a state containing "Subregions" containing "Zones" containing "Collectivities," these last often corresponding to colonial paramouncies or precolonial kingdoms.

11. Depending on the ingredients of the magical medicines employed, *lusalo* may also ensure victory in war and luck in hunting, protect from and actively combat sorcery, prevent or correct sterility, and renew conjugal attraction. Lusalo is also performed for a variety of physical disorders, from minor discomforts like headaches and rheumatism to more serious diseases. Finally, lusalo may be an exchange to create blood brothers (Verhulpen 1936:171).

12. The reason for this, one can speculate, is partly that so many *kakishi* figures have been collected for the international art market, and partly that missionaries and colonial authorities discouraged Luba and other people in southeastern Zaire from using objects they considered "pagan." Gourds and tin cans could be "hidden in plain sight" from opponents of Luba religion (see Roberts 1990a). It may also be that tin cans reflect a symbolism derived from modern product-consumption.

13. Kashekesheke divination does not always require two people; sometimes it is performed by the medium alone. The diviner Keuzi explained that whenever she has a nightmare, she consults her spirit about the dream's meaning when she wakes.

14. The plant most commonly used is *lwenye*, which grows freely around most Luba homes. Lwenye is known to have healing properties, and is used in a wide variety of ritual and medicinal contexts. As one Luba diviner exclaimed, "It is lwenye that gives us strength.... If you should touch it you will provoke it." Odor and olfactory perception are important though usually overlooked aspects of spiritual contact through divination and other processes. Tabwa, Luba-Kasai (Fourche and Morlighem 1939:17), and other Luba-related peoples use wild basil (*Ocimum basilicum*) and other aromatics both to attract helpful spirits and to dispel and repel malicious ones that would disrupt a séance.

15. An obvious but potentially misleading analogy to kashekesheke is the Ouija™ board, advertised by its maker, Parker Brothers, as a "mystifying oracle."™ Trademark designs on the Ouija show ethereal faces guiding the hands of the players, who lightly touch either side of a plastic "message indicator" as it skates over the board, pointing to letters purportedly spelling out a communication from the other world. We are also reminded of American water-witching, in which a diviner uses a divining rod to locate subterranean springs that might be tapped by a well. One of the authors of this article, Allen Roberts, once held one side of such a stick (the other was held by his father), and felt the irresistible downward plunge indicating that water had been found. The difference between both these devices and kashekesheke is that while some people take them seriously, more do not. Contact with ancestral spirits through kashekesheke, on the other hand, is a religious truth for those who practice it.

16. These opposed motions quite likely have deep cosmo-
logical underpinnings. In the European and North
American imagination, north is "up" and south is
"down"; for Luba and related people, however, it is
south that is "up." And if one is facing south, east will
be to the left, west to the right. Counterclockwise move-
ment, then, seems to proceed from east to west, hence
symbolically from beginning to end and dawn to dark-
ness, bringing enlightenment to ignorance. Bantu
languages generally have explicit directional names for
east and west but not for south and north, which are
unbounded "up" and "down." The sweeping motion of
a kashekesheke's negative response may replicate this
open-ended lack of closure.

17. The statue may answer in other ways: to give the re-
sponse "a man," it may rub the client's chin, indicating a
beard; if the response is "a woman," the figure makes a
similar motion across the chest. When the answer refers
to the spirits of the dead, the figure will burrow itself
headfirst into the ground (Burton 1961:65–66). If the
problem relates to illness, the statue may indicate the
location of the affliction by touching the body. If the ill-
ness is caused by an ancestor, the statue will "dance." If
an illness or death is caused by someone's hurtful words,
the figure will touch the client's mouth. Should the case
concern adultery, then the statue may point to the sexual
organs.

18. The term "Bilumbu," a plural noun, suggests the
"essence" of the practice, as does "*tshilumbu*" among
Luba-Kasai (Fourche and Morlighem 1939) and
"*bulumbu*" among Tabwa and other Luba-influenced
peoples. The singular form is "*Kilumbu*," but for sim-
plicity we shall use "Bilumbu" to refer to both singular
and plural practitioners; similarly, "*bwana*" (an honorific
greeting rather like "sir") will be used here as both
singular and plural. The assertion that Bilumbu dates
from the development of a consolidated Luba state
comes from current ideology rather than historical
research. Among neighboring peoples to the east, who
never or hardly ever knew state political organization,
Bilumbu exists as a spirit possession cult; see Roberts
1984, 1988a, 1990a. The history of religion in central
Africa is in its infancy as a scholarly field, but see the rel-
evant writings of Wim van Binsbergen (e.g. 1981) and
those of the authors in Ranger and Kimambo 1972.

19. Some deem it offensive to use the term "costume" to
refer to African dress; in the present volume the word is
used to refer to the "fashion of dress appropriate to a
particular occasion," following one of its several dictio-
nary definitions (Flexner 1987:458).

20. Writers have drawn many heuristic distinctions among
different types of possession. I. M. Lewis differentiates
between "trance"—altered consciousness that is unex-
pected, or without particular significance—and "posses-
sion," which includes cultural contextualization (1991:9).
He notes that both can appear in the same society, as
in the case of Luba. One may also note a difference
between spirit mediums, through whom the spirit comes
to communicate with the world of the living, and
shamans, who leave this world through possession or
dream (sometimes drug induced) to interact with spirits
and bring back their advice (ibid.:44, discussing the
work of Luc de Heusch). By this definition, Bilumbu are
clearly spirit mediums, though there are other forms of
healing among Luba and neighboring peoples that are
shamanistic (e.g. Tulunga among Tabwa and possibly
Buyembe among Luba).

21. Possession can shift genders, a woman Bilumbu becom-
ing a male spirit, a male becoming a female spirit. In a
Tabwa case, a female Bulumbu adept was possessed by a
male spirit and took her daughter as Kapamba (Roberts
1988a). Tabwa also use the term "Kapamba" to refer to
the mistress of ceremonies at a funeral. Then, the

Kapamba sees to logistical details and leads the aggres-
sive interclan joking that is so important to ritual trans-
formation in such circumstances.

22. Detailed discussion of the significance of twins in Luba
life and cosmology is presented in Gansemans 1981 and
Petit 1993:132–59.

23. The literature often misrepresents *pemba* (or, more
correctly, *mpemba*) chalk as "kaolin." Chalk is a soft,
compact calcium carbonate ($CaCO_3$) readily found in
southeastern Zaire, where the ancient sea-bottoms that
contain such deposits often come to the surface. Kaolin,
on the other hand, is a fine white aluminum-silicate clay
($Al_2O_3 \cdot 2SiO_2 \cdot 2H_2O$) such as that used to make porce-
lain in China. For Tabwa and eastern Luba, chalk is
"surrogate moonlight," used to "enlighten" the faces of
those realizing spiritual grace; see Roberts 1985.

24. As suggested elsewhere in this book, there is a great deal
more symbolism involved here, for turtles and tortoises
are conceptually important animals to peoples through-
out the area. Among other messages, the thirteen scutes
of a turtle's carapace may refer to the thirteen lunar
months in a solar year. Mbidi Kiluwe is a lunar hero, and
his association with arcane knowledge is probably at
play in chelonian symbolism. See Roberts 1991, 1993,
and especially 1980:353–83.

25. The Luba belief in such spirits is an extension of the
belief in "territorial" or "earth spirits" found more
explicitly, it seems, in less politically centralized societies
such as Tabwa and peoples southeast of the Heartland.
The growing literature on these spirits and the "ecologi-
cal cults" (once) associated with them is reviewed in
Roberts 1984 and 1990a.

26. After watching basket divination, a skeptic might con-
clude that the diviner skillfully manipulates the basket so
that particular objects rise to the surface of the pile, to
suggest the relationships and outcomes the diviner
intends to convey to the client. Still, a hypothesis is pro-
posed that allows the client to reformulate memory and
intention, as solutions to nagging problems are sought.

27. Clothing of this sort was introduced just before the colo-
nial period, but the modesty it now implies was enforced
by missionaries and by "civilizing" colonial policy. See
Roberts forthcoming(a).

28. This list is drawn from one of two such gourds
(#70.63.23) in the collection of the Royal Museum of
Central Africa, Tervuren, Belgium.

29. "Sorcery" is a gloss derived from three different Luba
verbs: *kulowa*, *kufinga*, and *kwifyàkula*, all of which
suggest malevolence and a desire to harm others, often
through the use of aggressive magic (*bwanga*). A host
of other terms (e.g., *bufwitshi*) refer to activities deemed
heinously antisocial and life-threatening if not prose-
cuted and punished (Van Avermaet and Mbuya 1954:159,
370–71). There is an enormous literature on this and
related topics for Luba and other central African peo-
ples; see, among others, Delfosse 1948, Mudimbe 1991,
and Mulago 1973.

30. The symbolism of the red-white-black triad of colors
recognized by Luba and other Bantu-speaking peoples is
discussed in V. Turner 1970, Jacobson-Widding 1979,
and Roberts 1993; Zahan 1977 offers cross-cultural data
from elsewhere in Africa. Petit 1993:425–32 reviews the
literature on the use of chalk and related white symbol-
ism in the investiture of a Luba king, including the man-
ner in which the king's own mboko-bowl-bearing figure
receives its chalk, and the symbolic opposition between
chalk and the blood of menstruation.

31. In this, the figure may reenact an aspect of investiture
ritual, when, according to one account, the twin tutelary
spirits Mpanga and Banze are said to release an mboko
gourd containing chalk from the depths of their lake;
this gourd is animated, and makes its own way to the
royal court (Petit 1993:428). The figure, then, is an inno-

cent inversion of an *nzùnzi*, an animated figure empowered by a magical bundle to do a sorcerer's nefarious bidding (Lambo 1947:143, Theuws 1961).

32. "Bijimba" is a plural form; for clarity, we shall use it as a collective noun. Among groups east of the Heartland, the same word is pronounced and written as "vizimba"/"kizimba."

33. Luba and other Zairians often use the French word "*magie*" these days, as a gloss for local terms such as "*bwanga.*" Again, there is a vast literature on the nature of magic in Africa and the rest of the world, including discussion of whether or not the term "magic" is appropriate to African experience. Claude Lévi-Strauss's discussion of "the science of the concrete" remains an excellent point of departure for such matters. "Magic postulates a complete and all-embracing determinism," he says, and "it is therefore better, instead of contrasting magic and science, to compare them as two parallel modes of acquiring knowledge" that "differ not so much in kind as in the different types of phenomena to which they are applied" (1966:11, 13).

34. These topics are discussed in greater detail in Roberts 1995a:66–67, 91–95; the synecdoche of magic is also the subject of a chapter in Roberts forthcoming 1997. Tabwa vizimba (what Luba call bijimba) are discussed extensively in Davis-Roberts 1980, and Roberts forthcoming(c).

35. Figures, magical bundles, and herbal remedies are often "prescribed" by Bilumbu and then executed by other healers, often generically called "*bang'anga*" (singular: "*mung'anga*" or "*ng'anga*"). The constitution and practice of magic follow fads; many of those that were current among Luba in the 1930s are outlined in Weydert 1938.

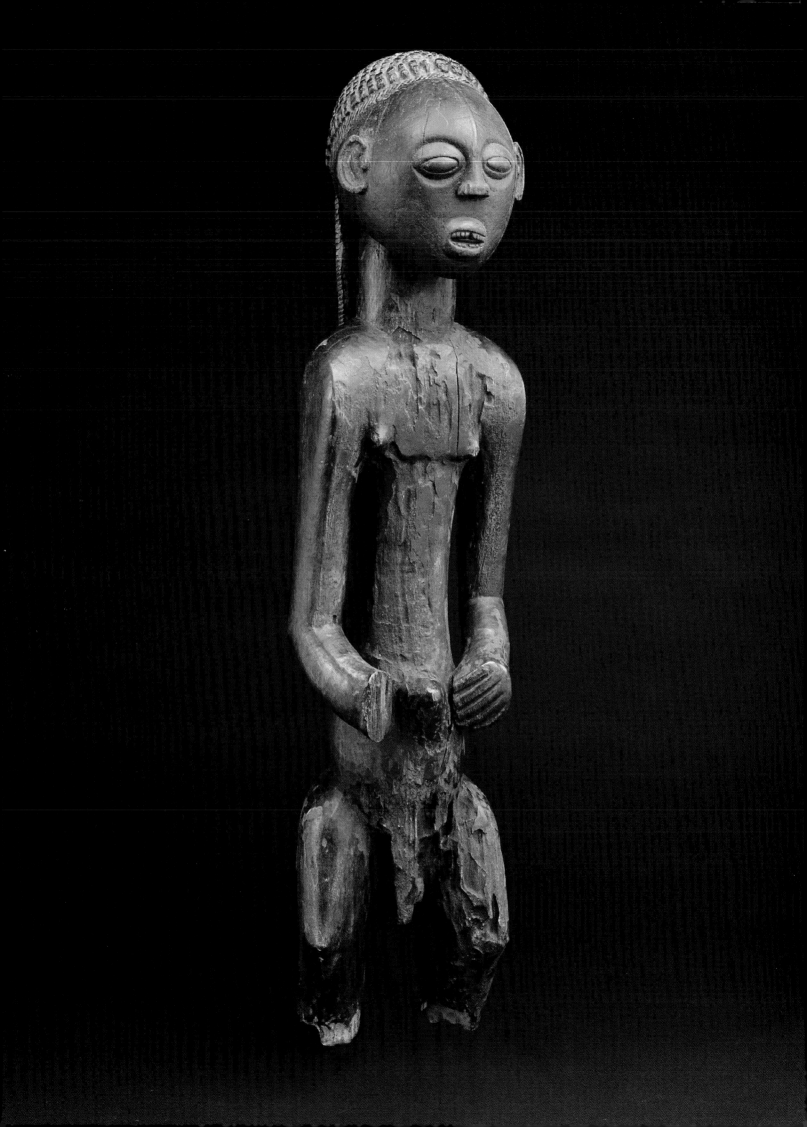

CHAPTER 7

Peripheral Visions

Allen F. Roberts,
with a contribution from Pierre Petit

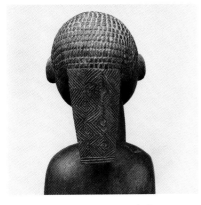

CAT. 89 (OPPOSITE AND ABOVE): STANDING MALE FIGURE. TUMBWE, ZAIRE. The largest Tumbwe sculpture known, this imposing male figure with hands resting on abdomen is a masterwork of Tumbwe artistry. Tumbwe are northern Luba-ized Tabwa peoples who are kin or subjects of Chief Tumbwe. Although they were a matrilineal people, their artistic repertoire emphasizes the male form; the patrilineal Luba, meanwhile, depicted women in their art. The rendering of this regal figure shares more with Hemba, Kusu, and certain other Luba-ized groups who honored ancestral spirits through sculptural portraiture in the form of standing male figures. One can sense affinities to Luba, however, through the facial features and the patterns on the back of the coiffure, which reproduce the incised geometric patterns found on the back of lukasa memory boards and other Luba royal emblems. An ancestral figure, then, might be seen as a complex document about history, migration, generational continuity, and political legitimacy. *Wood. H. 33.9 in. Seattle Art Museum, Gift of Katherine White and the Boeing Company, Inv. no. 81.17.790.*

Art in the Luba Heartland has served memory and the making of history in a variety of ways, as demonstrated in previous chapters . "Luba," however, is a social identity available to a much wider complex of cultures than that of the Heartland. As Pierre Petit notes, "Luba" is a most ambiguous category, one that is situationally defined (1993:30). It may refer to people of the Luba Heartland, also sometimes called Luba Shankadi, after their association with the court of sacred kings, or it can refer to people living in a much vaster land, sometimes called Urua; it can include both Luba-Shaba (Katanga) and Luba-Kasai; or it can refer to those who speak the Luba language, regardless of their cultural origins. The etymology of the name "Luba" is disputed, some holding that it means ones who are "mistaken," "lost," or "wandering," others arguing that it is a sobriquet dating to the 1880s and the East African slave trade, like many other "tribal" and "ethnic" names in Zaire (Van Avermaet and Mbuya 1954:374–75, Van Malderen 1940:205). What is most certain is that as a collective term, "Luba" has many different applications to many different realities.

In this last chapter, we shall consider the art and expressive culture of groups peripheral to the Heartland, with an emphasis on those living to the east, such as Hemba, "Luba-Hemba," "Tumbwe," "Holoholo," Tabwa, Bwile, and eastern Lunda, with a few Swahili added for good measure (fig. 199).[1] As will be explained more fully below, the quotation marks around several of these ethnic terms imply that certain "tribes," "ethnic groups," or "ethnicities" are not what they might seem as they appear on maps, as attributions for art objects, or as they are discussed in the literature. But first we must take one more look at what it may mean to be "Luba."

Luba Ethnicity

With tragic irony, ethnicities arise as "partitive ideologies" in situations of inequality (especially among social classes in capitalist political economies) and "out of conflicts engendered in competition for favored positions among . . . tribal constructs" (Wilmsen 1995:310). That is, paradoxically enough, ethnicity can be both divisive and a source of solidarity. All too often, ethnicity can also be name-calling or worse, as we know from the history of ethnic and "race" relations in the United States and Europe. In the Congo Free State (1885–1908) and Belgian Congo (1908–60), "Luba" took on all of these characteristics, and the ambiguities such ethnicity implies: in some circumstances it was very rewarding to be "Luba," in others it was anything but.

CAT. 90 (OPPOSITE): STANDING MALE FIGURE. KUSU, ZAIRE. Patrilineal Luba sculpt primarily female figures and their matrilineal neighbors sculpt male images throughout southeastern Zaire. Kusu, who were linked to Luba royalty through marriage and gift exchange, perfected a tradition of male ancestral representations, of which this monumental work is an example. Kusu figures are not literal portraits, but they do allude to the status and identity of an individual who played an important leadership role in the community. *Wood. H. 26.3 in. Private collection.*

During the colonial period, "Luba" became what Crawford Young calls a "supertribe," borrowing the term from Jean Rouche's descriptions of west African societies (1965:240–41).[2] Supertribalism took root in the booming urban centers of Congolese mining, where subtleties of social identity based on lineage, clan, natal village, and chiefdom lost much of their pertinence. An "uprooted class" of African labor migrants became established around these centers (see Mitchell 1956), for whom loose glosses such as "Luba" were sufficient to identify generalities of geographical origin, maternal language, food preferences, and the like.

Of the several Congolese supertribes that emerged, "Luba" became synonymous, for many Western expatriates in Africa, with superior intellect, hard work, and economic success. Being "Luba" brought advantages in hiring, and in the colony, and especially in its fabulously rich southern province, there was "a frequently heard allegation that 'all the top jobs are held by Luba'" (Young 1965:264). Africans living far from the Copper Belt who heard of or interacted with Luba sometimes called them the "Europeans" of Africa, or suggested that Europeans and Luba had a common cosmogonic origin, thus explaining the phenomenal achievements that Luba realized in the colonial system (Colle 1913:46). Some even suggested that Luba "look" European, and have "evolved" further than other Zairians (T. Turner 1993:594). Many people seeking work have willingly called themselves "Luba," whether or not they had any affiliation with the Heartland.

The trade and political networks of the old Luba kingdom and the developing myth of a precolonial Luba "empire" certainly contributed to the advantages associated with Luba ethnicity, as did early missionary seminaries, schools, and job-training programs in the Luba Heartland; early colonial efforts to restructure indigenous society so as to maximize the availability of labor for Copper Belt mines near the Heartland; and development of a "Bantu philosophy" based on a Luba model (Jewsiewicki 1989, T. Turner 1993). The effect was circular, too, for ideas of a glorious precolonial empire were reinforced by Luba economic and political success in the colonial context. It must be emphasized, then, that in the cases of many who claim Luba identity, or have it ascribed to them, reference is being made to a reality with a short history that continues to change through postcolonial times—witness the "ethnic cleansing" of Kasaian peoples from Luba-dominated cities in the early 1990s (T. Turner 1993). These factors influence the contemporary understanding of who is or is not Luba, and of how to understand the extension of Luba art and expressive culture outward toward the peripheries of Luba influence. For the most part, the arts we seek to understand predate the creation of colonial and postcolonial social identities, yet present-day field research into the arts must take the identities into consideration as the century-long reality of contemporary Luba—and "Luba."

Lineage and Clan

Despite the sweeping generalizations of Luba ethnicity, there is every indication that in precolonial times (and in many contexts still), lineage and clan were the first and most significant social identities in this part of central Africa. In anthropology, a "lineage" is defined as the extended family of those to whom one can directly trace kinship. A "clan" is generally identified as a much larger group of people who claim to be related through kinship, but do not necessarily know how this might be so, except through distant, apical ancestors and ancestresses from whom they and their fellows are descended. Clans are more open-ended and inclusive than lineages, and devices such as "classificatory kinship" (used to heighten relationships to kinsmen who "ought" to be more closely related than they are, because of trade or other alliances) and "fictive kinship" (to incorporate otherwise unrelated domestic slaves, war captives, or other dependants) allow clanship to be broadened when this is politically or economically expedient.

"The goodwill that comes from kinship can be brilliantly adapted to political and economic ends" (Bohannan and Curtin 1995:72), and it is the solidarities of kinship and clanship that provide the necessary cohesion for small-scale societies. Heartland Luba observe patrilineal descent, while groups around them, especially to the south and east, are generally matrilineal, with a few described as observing double unilineal descent—that is, with a little of both (Blakeley and Blakeley 1994:400). From a materialist viewpoint, patrilineal descent assures that inheritance

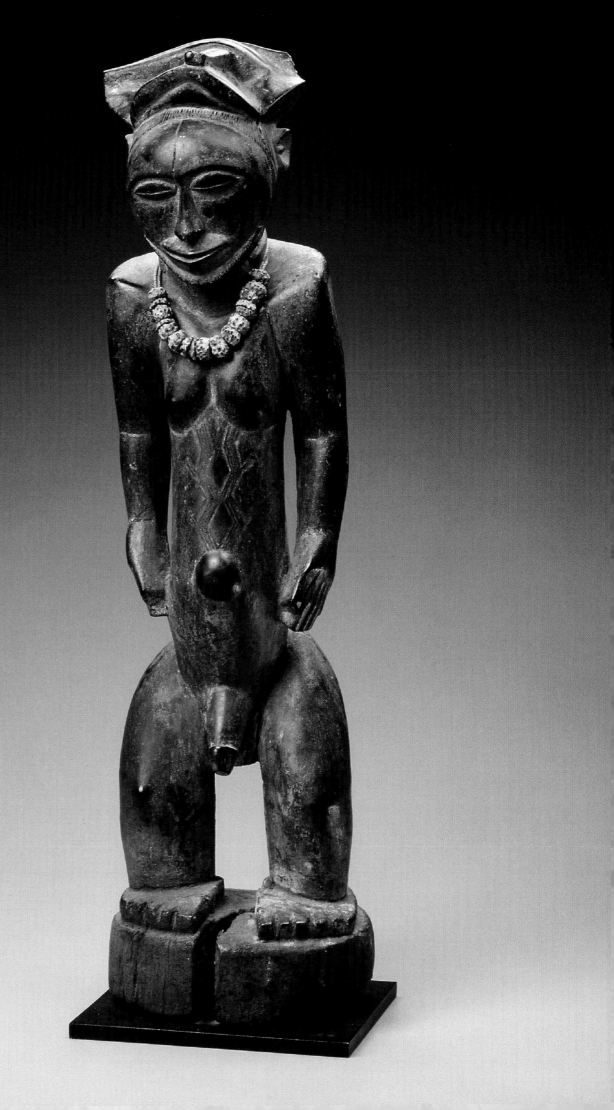

Fig. 199: Map of lands east of the Luba Heartland. *Map by Chris Di Maggio.*

Fig. 200: The King of Kazembe being carried in procession on the shoulders of an attendant, and followed by his entourage. Kings are often carried this way, as a sign of honor, for a king's feet should never touch the ground. *Photo: from Crawford 1924:182.*

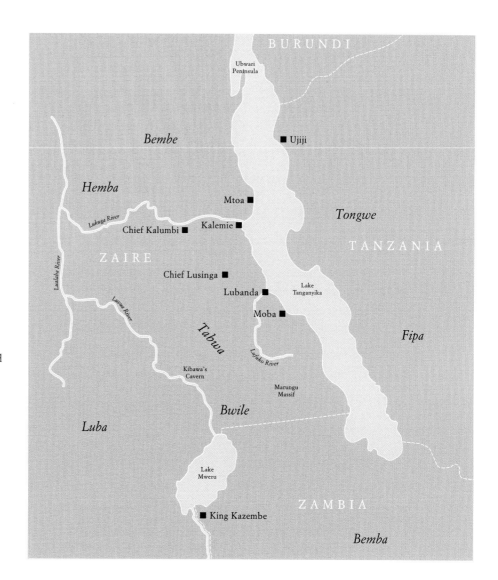

remains in a closely defined male line. Property in goods and inherited offices can be controlled by corporate groups, and one most often finds patrilineal descent where there are significant natural resources, relatively dense population, and consolidated political organization. Alliances among patrilineages are often created through marriage, for women from one lineage provide children (and especially sons) to another.

In areas where population is sparse and resources relatively few, as is true east and south of the Heartland, matrilineal descent offers its own advantages. Men marry out of their mothers' lineages, and in what anthropologists have called the "matrilineal puzzle" (because of its perplexities to those unfamiliar with it), men's biological children will be of a different lineage from their own, while men's heirs are their sisters' sons. The loose network of potential relations that results can be very useful in regions of low population-density like much of southeastern Zaire. Matrilineal descent and its extension in clanship allow people to find fellowship when traveling for trade, in search of healing, or for other benign pursuits.

Differences between patrilineal and matrilineal descent systems were exploited by Luba seeking to broaden their influence outward from the Heartland. If a non-Luba (matrilineal) chief married a Luba (patrilineal) woman, her children would follow her line of descent, according to the matrilineal custom of her husband, while simultaneously being of the same clan as patrilineal Luba, and thus providing a natural platform for ongoing alliance with the Heartland (Reefe 1981:135). Influence and collaboration—but *not* empire—were thereby extended.

These differences in social organization have direct relevance to an understanding of a paradoxical aspect of art in southeastern Zaire. As we have seen, many figures from the patrilineal people of the Luba Heartland portray women, whereas in outlying, matrilineal groups, male ancestral figures are far more prominent (cat. nos. 89-92). One would think the opposite would be the case: that patrilineal groups would revere their male ancestors and matrilineal people their

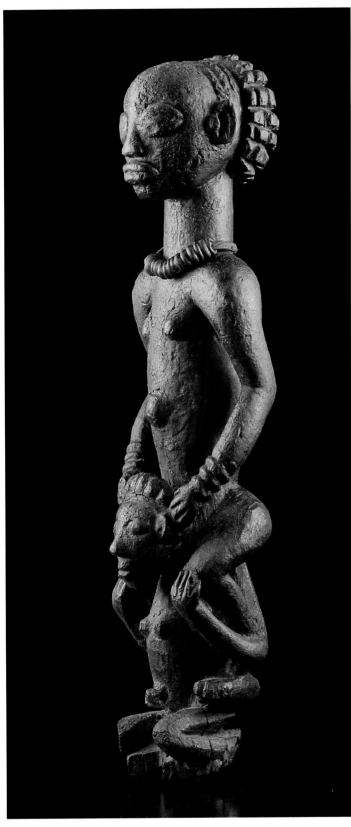

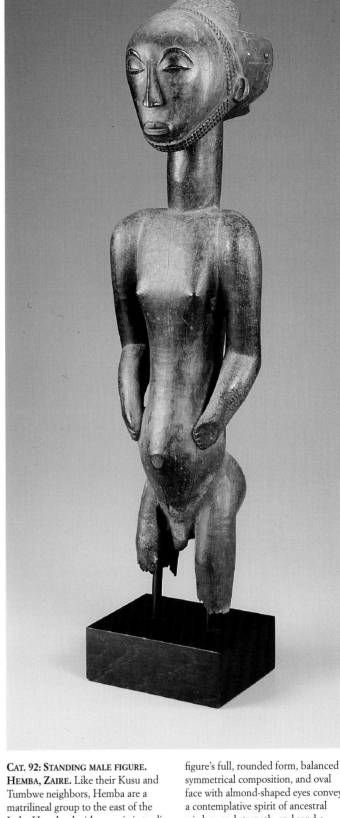

CAT. 91: DOUBLE FIGURE. LUBA, ZAIRE. This eastern Luba sculpture depicts one figure being carried on the shoulders of another. The motif has many possible interpretations: kings and chiefs were sometimes carried on the shoulders of dignitaries during investiture rites and other ceremonies of state. Girls undergoing initiation were also carried on the shoulders of a titleholder at one point during these transformative rites. The act was linked to the idea that a person in a state of liminality should never touch the ground, and also reinforced the ideas of support and elevation expressed by the proliferation of Luba caryatid stools. The gender of the figure being carried is again ambiguous, since the breasts are minimal enough to be those of either men or women; the coiffure too is worn by both sexes. Since the female figures on most Luba staffs refer to the king himself, the actual depiction of gender is in any case less important than the indirect references and metaphorical allusions the figure carries. *Wood. H. 20.8 in. Joseph Christiaens.*

CAT. 92: STANDING MALE FIGURE. HEMBA, ZAIRE. Like their Kusu and Tumbwe neighbors, Hemba are a matrilineal group to the east of the Luba Heartland with an artistic tradition of sculpture devoted primarily to male sculptural representations of ancestors. While Hemba ancestral figures are intended as portraits, they do not reproduce individual traits of the deceased in a literal way. This figure's full, rounded form, balanced symmetrical composition, and oval face with almond-shaped eyes convey a contemplative spirit of ancestral wisdom and strength, and send a powerful ideological message about family continuity and the perpetuation of the clan. *Wood. H. 30 in. Private collection.*

Fig. 201: Male figure riding a buffalo. Whereas Luba did not represent their culture heroes in literal, sculptural terms, some of the peoples surrounding the Heartland created masks and figures to evoke the qualities of Mbidi Kiluwe. Mbidi is sometimes represented as a figure riding on the back of an antelope or an elephant—a reference to his prowess as a hunter who rode the lead herd animal in the chase. *H.: 193 mm. L.: 232 mm. The Royal Museum of Central Africa, Tervuren, Belgium, G.5752; acc. no. 77.17.8. Photo: courtesy of the Section of Ethnography, Royal Museum of Central Africa.*

CAT. 93 (OPPOSITE): FIGURE RIDING AN ANTELOPE. LUBA-IZED PEOPLE, ZAIRE. The manner by which different peoples of southeastern Zaire have represented the heroes of Luba kingship lends insight into the nature of those peoples' affiliation with the Luba state. While residents of the Luba Heartland did not represent Luba culture heroes in figurative arts but only performatively, through possession rites, Luba-ized peoples to the east produced figures of Mbidi Kiluwe as a hunting spirit named "Luwe." This sculpture of a male figure riding an antelope is probably an allusion to Mbidi Kiluwe as the spirit riding the lead animal of a herd toward the pit traps of hunters, as Luwe spirits are known to do. *Wood. H. 9.37 in. Dallas Museum of Art, The Clark and Frances Stillman Collection of Congo Sculpture, Gift of Eugene and Margaret McDermott, Inv. no. 1969.S.99.*

ancestresses. We have seen that among Luba, male spirits are often portrayed and embodied by female figures, because women are thought spiritually stronger, and their bodies more susceptible to spiritual intervention; they are also thought to keep the most sacred secrets of power hidden in their breasts. Peripheral peoples whose ancestral figures are mostly male (or in clusters of a male with one or more female figures denoting relatives in the nuclear family) are in some ways the reverse: their male figures stand for lines of descent traced through mothers (cat. nos. 90 and 91; fig. 200). Both cases of gender reversal emphasize the dialectical interdependence of men and women in this region; in agriculture and other pursuits, they work in close ways that are remarkably egalitarian for Africa.

Matrilineal peoples, some of whom can be described as "Luba-ized" (as explained shortly), stress the puzzlements of male positions in a social organization that perpetuates and glorifies inheritance through women. If Luba female figures often hold their breasts, referring to the potent secrets held there, male figures of peripheral peoples often point to or touch their navels with one or both hands, to emphasize descent through the matriline (cat. no. 92). If the female figure's gesture refers to a mother's milk, which nourishes the male children of her husband's line of succession, the other bespeaks the blood uniting mother to son through the matrilineage.

Cosmology and Logic

Social identity is situational. That is, people can often identify themselves in several different ways, such as lineage, clan, chiefdom, tribe, or ethnicity (again, these last two being emphasized, exaggerated, or invented in the colonial period); they can also refer to region, membership in societies like Mbudye, guild professions like hunting or iron-smelting, and nowadays to religious sects such as Catholicism or Seventh-Day Adventism. Underlying all these categories are commonalities of language and cosmology.

Dialects vary throughout southeastern Zaire, but Luba have a "basic language correspondence" of 60 percent or more with neighboring peoples (Bastin et al. 1983:189, Werner 1971:10). This means that not only are these tongues more or less mutually intelligible, they are based on similar grammar and produce a unified logic. Cosmology is shared too, as Luc de Heusch has demonstrated so brilliantly (1982). What differs from one group to the next is local history and the way that language and cosmology have been used to articulate the universe.

In this regard, an important contrast may be posited between the Heartland and its peripheries. The peculiar concentration of natural resources, higher population-density, convergence of caravan trails, and other factors that led to the formation of a Luba state in the Upemba Depression is not to be found elsewhere. People in the Heartland, then, have needed to explain to themselves aspects of life unknown or irrelevant to people on the peripheries. In particular, they developed the Luba Epic we have invoked so often in this book, to explain, legitimize, and glorify sacred royalty. Peripheral peoples have not experienced the same necessity, and so do not possess similar charters. But they still understand life and take action through the same basic logic and cosmology.

These complicated issues are most easily understood through an illustration. Throughout southeastern Zaire and adjacent lands inhabited by Bantu-speaking peoples, essential philosophical oppositions are expressed through the red-white-black triad of primary colors. "Red" stands for violent and bloody transformation. These are ambiguous qualities, for "red" may suggest both destruction, as through sorcery and other malevolence, and raw but creative change leading to a "white" state of harmony and grace. Similarly "black," which lies at the opposite cusp of the triangle, can imply both dark secrecy, which can gnaw away at people through suspicion of malicious intentions, and the kind of insight that, like "red" qualities, can be a source of inspirational power leading to "white" communion with spiritual forces (Roberts 1993).

Both red and black involve abstruse concepts, then, and to make them more readily grasped and easily *used*, people have both reified and personified them in myth and ritual (see Mudimbe 1991:74). All the qualities of "red" are subsumed in an immense (some say endless) chthonic serpent, which breathes forth the rainbow (also deemed red) from its underground lair, to

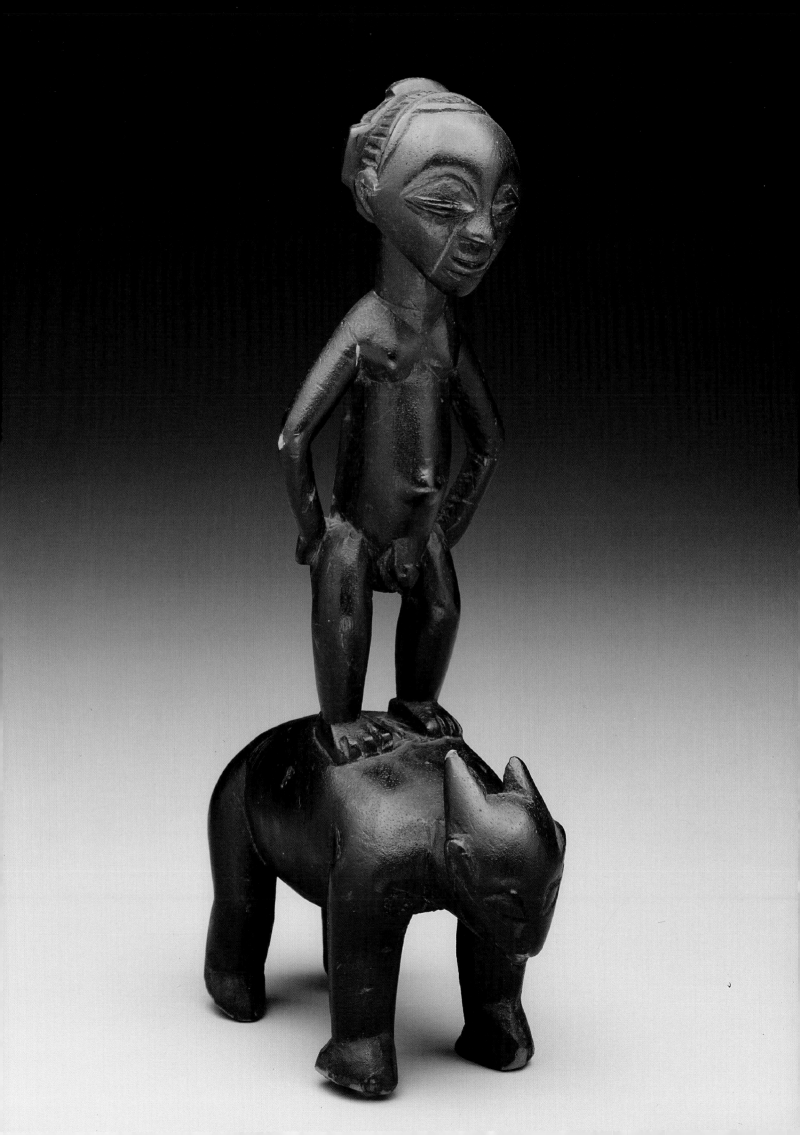

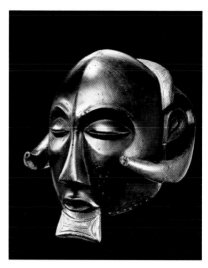

Fig. 202: Not only has this mask become a logo of "the Congo" for many westerners around the world, it is also a memory device for Luba peoples themselves: they see it as evoking the remembrance of their greatest culture hero, Mbidi Kiluwe, who is often referred to metaphorically as a majestic black buffalo. H.: 15.35 in. Collection: the Royal Museum of Central Africa, Tervuren, Belgium, Inv. no. 234.70. *Photo: courtesy of the Section of Ethnography, Royal Museum of Central Africa.*

CAT. 94 (OPPOSITE): STOOL WITH WOMAN RIDING AN ELEPHANT. LUBA-IZED PEOPLE, ZAIRE. Outside the Heartland, away from the consolidated politics of the Luba kingdom, Mbidi Kiluwe has another life as a spirit associated with hunting, and here sculptural representations of him have been made. Luba once had a hunting guild called "Buluwe," which practiced magic for protection and success in the hunt. Portraying a woman sitting on an elephant's back, this stool may represent Mbidi Kiluwe as a hunting spirit riding the lead animal of a herd. *Wood, beads. H. 20.5 in. Dr. Vaughana Feary.*

desiccate, burn, and bring an end to rains. "Black" is a celestial ram, whose head-butting produces thunder and lightning. The two color/forces are in eternal competition and keep each other in check, in a fugue of the seasons (Roberts 1980, Heusch 1982).

Luba call the rainbow-breathing serpent Nkongolo Mwamba, and in developing an epic to explain the origins of sacred royalty, they personify the snake as the "red"-skinned tyrant of the same name, whose incest, alcoholism, brutal bloodletting, and other heatedly excessive behavior characterize all that is primordial and primitive. Similarly, "black" becomes Mbidi Kiluwe, the "cool" hero from the east who introduces the secrets of refined behavior and sacred kingship with which Luba narrators identify the civilization of their state. Mbidi and his son Kalala overthrow Nkongolo, setting the world on the course with which contemporary Luba choose to identify themselves. History begins as Nkongolo is beheaded (Mudimbe 1991:83).

People peripheral to the Heartland retain the "red"/"black" dialectic without this second-level personification. Tabwa people living along the shores of Lake Tanganyika call their immense serpent, analogous to Nkongolo, Nfwimina. They may use a piece or artifact of Nfwimina in a potent magic to assure the success of transformative processes such as the iron-smelting of yesteryear (Roberts forthcoming 1996a). They also understand the potential of "black" secrecy, and seek its power in magic (Roberts 1993); and like Luba, they consider life a dialectical struggle of "red" and "black" forces, each needing its other for "white" balance and grace.

Peoples living between Tabwa communities and the Luba Heartland combine elements of both variations of this common system of thought, and their visual arts reflect this synthesis. In the Heartland, the great heroes of sacred kingship, Mbidi Kiluwe and Kalala Ilunga, were not represented in figural sculpture until very recently, when several semipublic figures of them are known to have been created, works that are more like popular than sacred art. Instead, the two heroes are considered among the Vidye spirits that may possess Bilumbu diviners and Mbudye-society members. Outside the Heartland, though, away from the consolidated politics of the Luba state, Mbidi has another life as a spirit associated with hunting, and here figures of him do exist.

Luba have (or had when big game was still plentiful) a hunting guild called Buluwe, which practiced magic for protection and success (Bouillon 1954). Zela, Lomotwa, Ushi, Sanga, and other Luba-related peoples of southeastern Zaire and northeastern Zambia similarly refer to a spirit called Luwe. Further, they identify this spirit as Mbidi Kiluwe (Marchal 1937, Grévisse 1956:100–105), but also at play here is a far older and more basic concept, which appears in the cosmologies of peoples as far afield as Zimbabwe.[3] For Ila-speaking peoples of southeastern Zambia, for instance, Luwe is "a one-legged goblin that rides about the forest mounted on an eland . . . [and] is himself a great hunter." Subia of the middle Zambezi speak of Chi-luve, a wood spirit half of whose body is wax; he has power over the herds, and is a trickster. For Lamba of eastern Zambia, Kaluwe is also a "protector of wild herds." Like these spirits, Mbidi Kiluwe is a dichotomous hero for Luba, for as the essence of "black" symbolism, he personifies the ambiguities of secret knowledge (Roberts 1991, 1993). For peripheral peoples, these ambiguities play out in what we would call the "luck" of hunting.

Luwe spirits ride the lead animal of a herd toward the blinds or pit traps of hunters. Sculptures in what is generally called an "eastern Luba" or "Luba-Hemba" style depict this relationship (fig. 201). A figure in the Stillman Collection of the Dallas Museum of Art shows a male figure standing on an antelope's shoulders (cat. no. 93), for instance, and a stool in the collection of Dr. Vaughana Macy Feary portrays a woman sitting on an elephant's back (cat. no. 94). It is our hypothesis that both portray Mbidi Kiluwe as a hunting spirit.[4] Jos Gansemans reports that hunters may occasionally report seeing the spirits of their deceased fathers riding a lead game animal in the same way; perhaps some of these sculpted figures reflect such potent visions, and were placed in the Kaluwe shrines that were sometimes maintained by hunters using *buyanga* magic (1981:226–27). Furthermore, "black" animals (that is, animals not only of this color but also demonstrating the qualities of "black" symbolism) are associated with the culture hero. "*Mbidi*," as the first of his names, refers to a melanistic serval—that is, a black or dark brown individual of what is most frequently a species of spotted cat. Mbidi Kiluwe is associated with

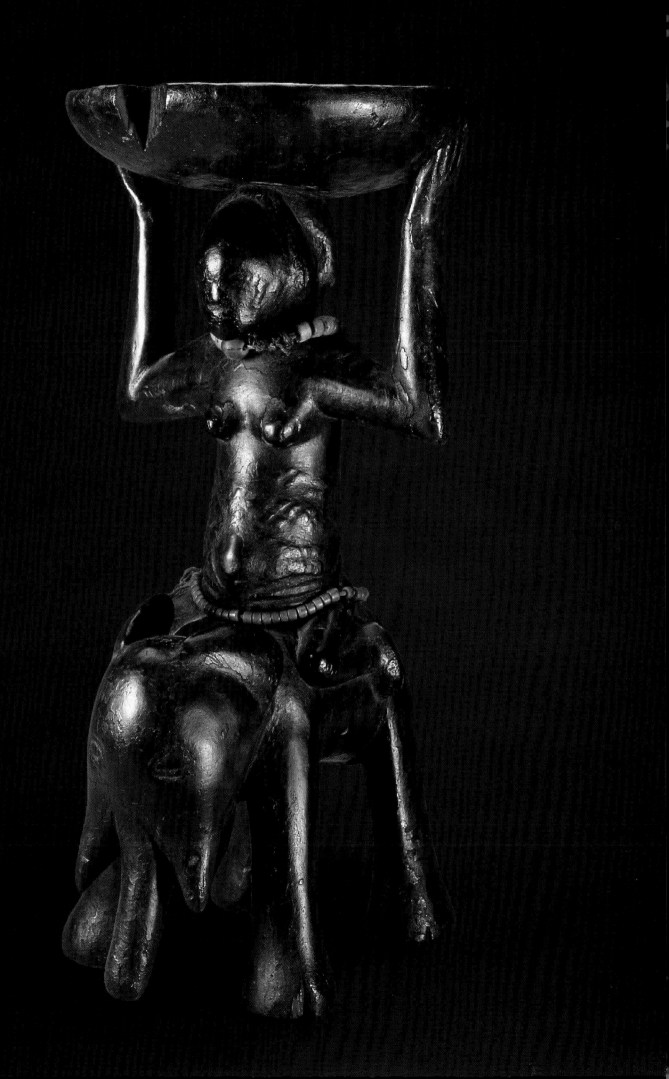

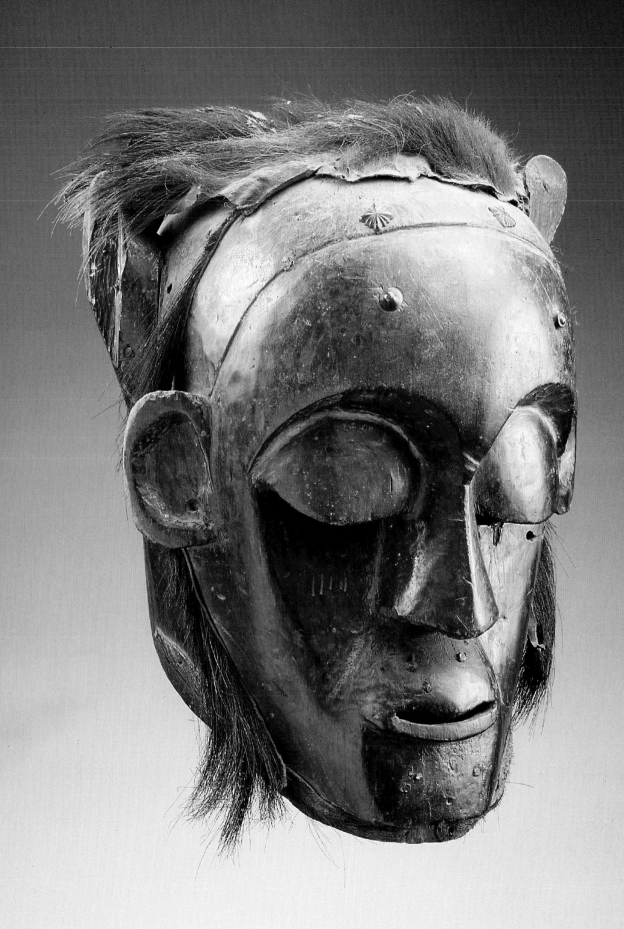

CAT. 95 (OPPOSITE): MASK. LUBA, ZAIRE. Luba masks are rare, and little is known of the contexts of their use and the symbolism of their iconography. One can speculate that some zoomorphic masks are intended to represent the great Luba culture heroes, or at least to evoke their memory, through their metaphoric associations with particular animals like the buffalo. This unusual mask combines anthropomorphic features with hair and fibers from such animals as leopard, buffalo, and hyena, and may once have been worn by an Mbudye adept in mnemonic reenactments of Luba myth. *Wood, hair, leather, metal. H. 16 in. Private collection, Brussels.*

CAT. 96: STOOL. LUBA, ZAIRE. This stool was made by an artist or small workshop renowned for a corpus of exceptional works of art, including stools, bow stands, and figures. The artist has been referred to in the literature as "Frobenius's 'Warua' Master," because the earliest known works by this hand were collected in 1904 by the German ethnographer Leo Frobenius, who labeled the works by the regional name "Warua" but supplied no further information. The fact that this artist's oeuvre is restricted to stools, bow stands, and nkishi figures indicates that he was a specialist, and suggests that kings and chiefs may have commissioned different kinds of regalia from different sculptors according to their strengths in particular object types. *Wood, beads. H. 16.5 in. The University Museum of Archaeology and Anthropology, University of Pennsylvania, Inv. no. AF 5121.*

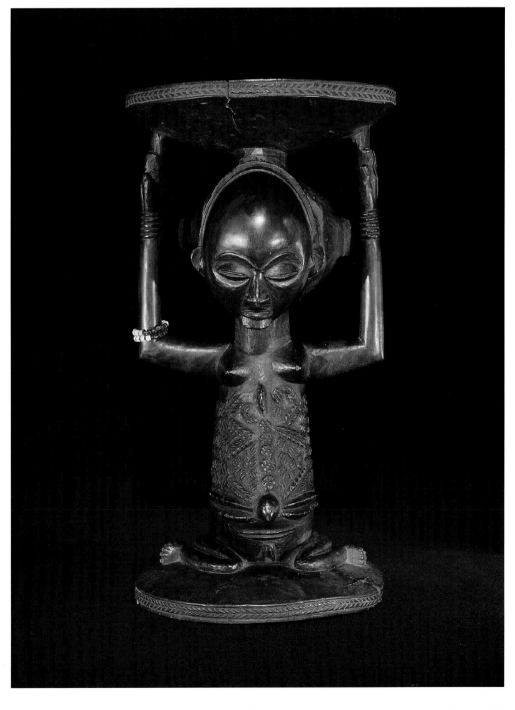

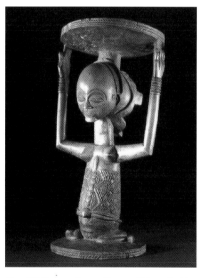

more imposing animals as well, and, significantly, is praised as "shiningly black like the buffalo" (Womersley 1984:7).

This association explains the most magnificent Luba mask from the Musée Royal de l'Afrique Centrale in Tervuren, Belgium (fig. 202). As justly celebrated as this object is, it is also altogether enigmatic: nothing is known of its provenance, iconography, or use; nor is it clear how it got to Tabora, in what is now central Tanzania, where it was collected in 1899 by Commandant Michaux. Luba masks have been and remain rare (although significant numbers of new zoomorphic and beaded forms seem to be emerging—see Félix 1992, Roberts 1990a). That we are left to speculate about this mask is tragic proof of the ironies of a great collection such as that of the Musée Royal: we often know nothing whatsoever about the most significant objects, which may be so well-known, as this mask surely is, that for many they stand for "Luba" art, or even for "African" art more generally. Hypotheses can be proposed concerning the meanings of this mask, however, and the hope must be that they will lead to further field and archival research.

Two key features of the mask are its horns and the bird on the back of its head. This latter was broken off and separated from the mask so long ago now that most viewers of the mask are not aware of it as a significant feature. Because the head is missing from the bird figure and it is difficult to track down a photograph of the bird still attached to the mask (see J. Maes 1924, plates 44–45), positive identification of what one can guess is an important emblematic animal is nearly impossible. Still, because the bird is portrayed in conjunction with the mask's horns, an educated guess is that the bird is a drongo (*Dicrurus adsimilis*), striking for its jet-black plumage. Tabwa associate this bird with the clan of the Luba culture hero Mbidi Kiluwe.[5]

Many have assumed the horns of this mask to be those of a ram. Alternatively, though, the primary reference may be to buffalo horns, which the artist has represented in a manner reflecting a style of coiffure (J. Maes 1924:39). This interpretation is strengthened when the mask is viewed from the side, instead of from the front or in three-quarters view, as in most published photographs (e.g. Neyt 1994:209). A third—and the most probable—possibility is that the horns represent both animals. Both rams and buffalo are associated with Mbidi Kiluwe, especially as he is understood by peoples on the peripheries of Luba influence. It is our hypothesis that this mask, like several other Luba helmet masks, was created and performed to portray the culture hero (cat. no. 95).[6] Luba and neighboring peoples consider a giant black winged ram (sometimes a goat) named Nkuba (or something similar) to be the origin of thunder and lightning (Colle 1913:719, Weghsteen 1953:22). Fat-tailed Barbary sheep were raised in this part of Africa well before Europeans arrived (Thomson 1968, 2:35), and rams' butting of heads when they are in rut gives rise to the analogy with thunder (Roberts 1995a:35–38). In one myth, thunder is personified as a hunter and lightning as his son (Claerhout 1949), a structural equivalence with Mbidi and Kalala (see Heusch 1982). The buffalo is also an emblem of Mbidi. Often, bull buffalo are "almost coal black," and they are "mostly nocturnal" or crepuscular (that is, active at dusk and dawn). Furthermore, although they are large animals, they can virtually disappear during the daytime, seeking refuge in thickets around sources of water. People fear buffalo because of their apparent "invisibility": they are there but not seen, and so doubly dangerous. Buffalo, then, possess opposed traits, either alternately or seemingly at the same time: they are docile and aggressive, visible and invisible, in water or mud and out, active at night's beginning and at its end. Such paradoxes of buffalo behavior are the bases for suggesting a metaphoric bridge between buffalo and human beings (Roberts 1995a:22–25).

Among turn-of-the-century Luba-ized people in the village of Chief Kyombo, a boy leaving initiation camp was greeted with the cry, "Here is the buffalo, here is the buffalo!" (Colle 1913:275). Furthermore, as mentioned above, Mbidi Kiluwe is praised as being "shiningly black like the buffalo" (Womersley 1984:7). In the Mbudye Society, the purposes of which include extolling Mbidi Kiluwe, the central figure is the spirit Lolo Inang'ombe; though Lolo is principally associated with tortoises, she is also said to be a woman married to a buffalo, the child of a woman and a buffalo, or, as in an Mbudye wall painting W. F. P. Burton once saw, a dichotomous being with the body of an animal (a buffalo?) and the torso and head of a woman (Burton 1961:159–60,

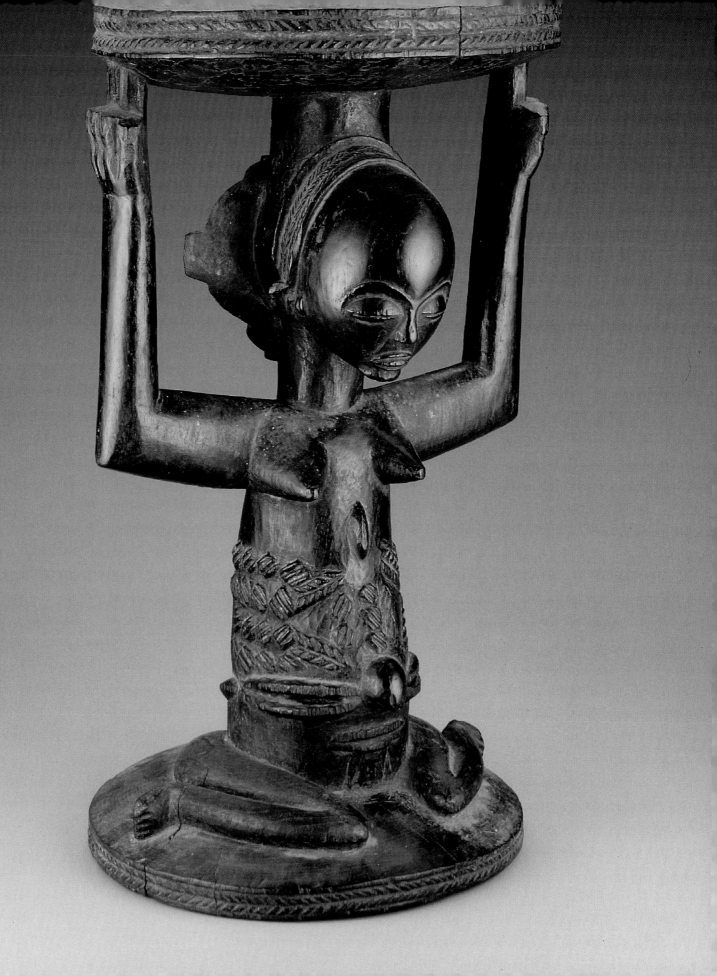

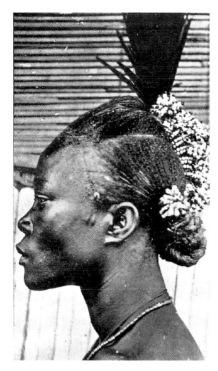

Fig. 203: An eastern Luba woman with an elegant beaded coiffure and facial scarifications. The diversity of peoples in this region who borrowed Luba ideas in varying degrees is evident not only in sculpture and oral tradition but in the expressive art of body adornment. *Photo: from Crawford 1924:208.*

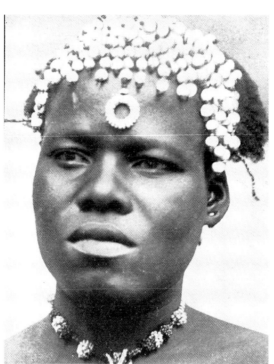

Fig. 204: An eastern Luba woman of an unidentified ethnic group with an elaborately beaded hair-style. Lake Mweru region, c. 1900. *Photo: from Crawford 1924:294.*

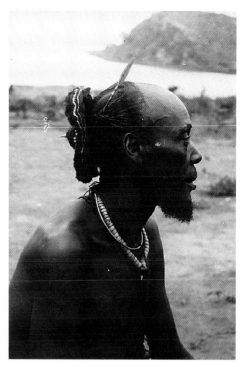

Fig. 205: A "Luba-ized" chief of an unidentified ethnic group (possibly Zela, Lomotwa, or Bwile) wearing a variaton of a Luba hair-style. *Photo: Charles Lemaire, Pweto, 1898. Courtesy of the Section of Ethnography, Royal Museum of Central Africa, Tervuren, Belgium, cl.966.*

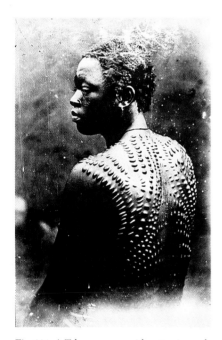

Fig. 206: A Tabwa woman with extensive and complex scarification patterns on her back and face, showing the degree of elaboration and perfection of the body that was common among Luba and Luba-related groups around the turn of the century. *Photo: unknown photographer, Kirungu, c. 1900. Courtesy of the White Fathers Archives, Rome.*

Nooter 1991:65–71). Among neighboring Tabwa, buffalo masks dancing with masks portraying women may represent this couple, or at least refer to the same play of metaphors (Roberts 1985). Marc Félix suggests that the Musée Royal helmet mask may have been danced with a female mask, like that collected in 1890 by Emin Pasha and now in the Museum für Völkerkunde in Berlin (1992:10).

Perhaps buffalo masks were danced to dramatize the bestial excess of the earliest humans, who, like Lolo Inang'ombe, coupled with buffalo. Why, though, should an animal that exhibits such paradoxical behavior be associated with heroes and chiefs? De Heusch suggests that the Bantu king is a "an ambivalent creature, at once beneficent and dangerous: a sacred monster" (1991:113). This, clearly, is what Luba may have sought to contemplate through masks like the magnificent one now in Tervuren, reflecting as they do a chief's incarnation of the contradictions, paradoxes, and ambiguities of daily social life.

Luba and "Luba-ized"

As we have seen, the Luba Heartland grew around the remarkable resources of the Upemba Depression. Outward from this center, a watercolor wash of peoples extend in every direction, their differences of language, culture, and history blending in such a way as to be discernible only by degree, rather than by clear-cut distinction (see Vansina 1966:19). Small chiefdoms were and still are to be found sprinkled over the land. A few have approached the consolidation characteristic of what may be called kingdoms, especially during the latter half of the nineteenth century, when participation in the east African ivory and slave trade brought incentives and means (Roberts 1985). But for the most part, such organization either did not occur at all or it blossomed and then quickly waned with colonial conquest. Instead, people lived as they still do, in small towns along important roads, waterways, and railroad lines; in villages led rather than ruled by a hereditary chief; and in tiny hamlets, often consisting of just a family or two.

In this social field characterized by "pastels" of cultural difference, people have long looked to Luba as the source of all that is prestigious, glamorous, and clever. If men wished and were able to

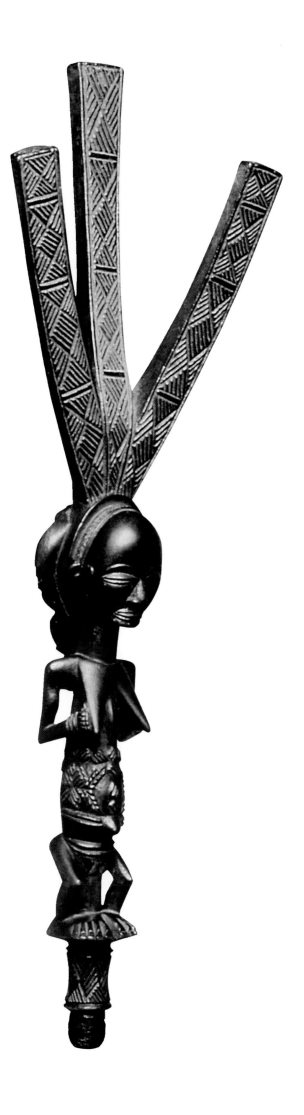

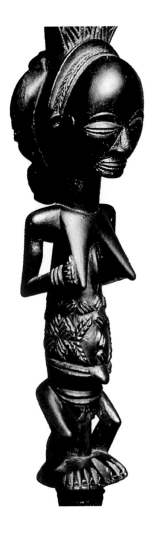

CAT. 99 (LEFT AND BELOW): BOW STAND. LUBA, ZAIRE. "Frobenius's Warua Master" sculpted bow stands for kings and chiefs throughout the Luba region, and several examples of his work are shown on these pages. This artist had a genius for combining an organic rendering of the human form with the symmetry and geometry of patterned branches. While each bow stand is unique, many examples have features in common. The gesture of hands to breasts, for example, refers to the Luba belief that certain women guard the secrets of royalty within their breasts. The metal shaft is a metaphor for the ironlike strength of a king's power. The patterns or "scarifications" on the bow stands' branches relate to royal prohibitions. *Wood, metal. H. 25.4 in. Monzino Collection.*

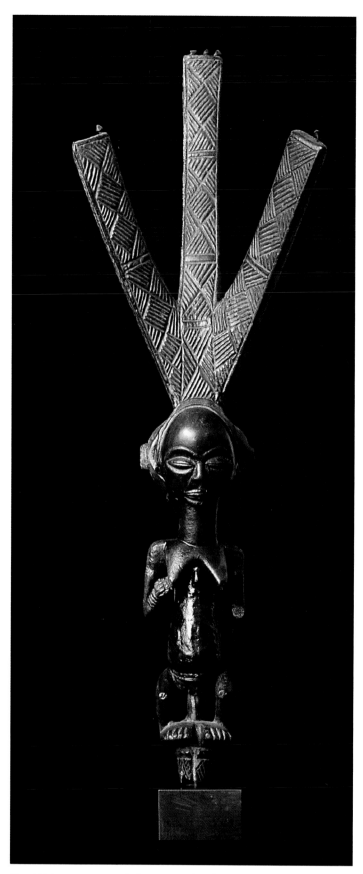

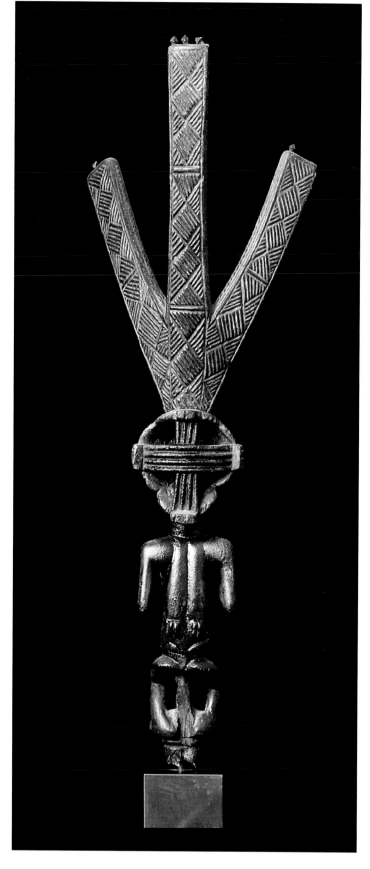

CAT. 100 (FRONT AND BACK): BOW STAND. LUBA, ZAIRE. The artist who made this bow stand appears to have been a specialist, for in addition to the three bow stands shown here, there are several others by the same hand in private and museum collections. They are virtually identical except for differences in wear, and also in their degrees of refinement. One can only surmise that they were commissioned by different chiefs at different times from this highly reputed sculptor, or that he made multiple copies for a single king or chief to be used for gift-giving. Whether chiefs came to him for his services or whether he was an itinerant artist also remains unknown. *Wood, metal. H. 24 in. Drs. Daniel and Marian Malcolm.*

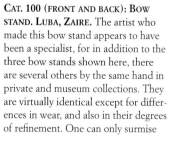

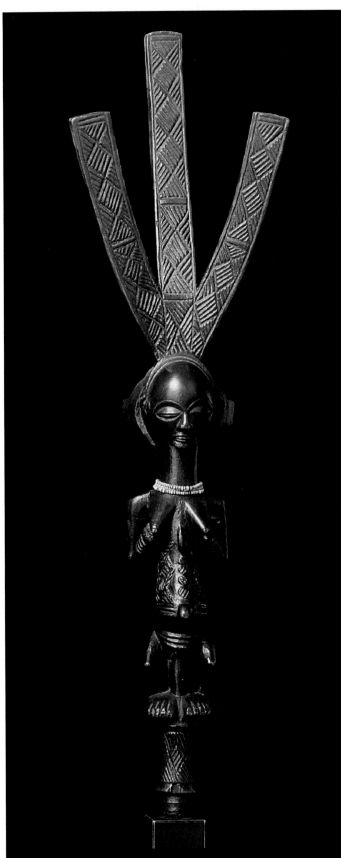

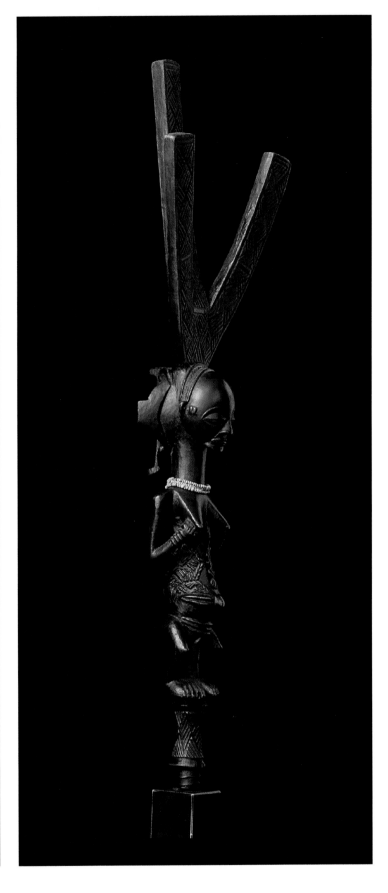

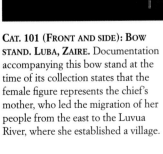

CAT. 101 (FRONT AND SIDE): BOW STAND. LUBA, ZAIRE. Documentation accompanying this bow stand at the time of its collection states that the female figure represents the chief's mother, who led the migration of her people from the east to the Luvua River, where she established a village. It is possible that the female figures on all bow stands refer to particular female founders of specific royal clans, making bow stands commemorative emblems for the remembrance of political origins and legitimacy. *Wood. H. 24 in. Private collection.*

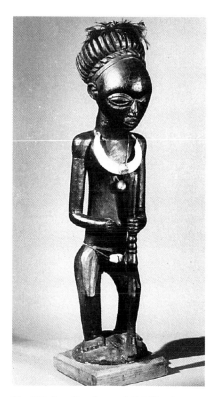

Fig. 207: Standing figure of Chief Lusinga, in Luba style. The figure was collected by Émile Storms in 1884, during a raid on Lusinga's village. It was commissioned and owned by Lusinga as a form of "statement art" to glorify his newfound "royalty." H.: 68.6 cm. Collection: the Royal Museum of Central Africa, Tervuren, Belgium, acc. no. 31660. *Photo: courtesy of the Section of Ethnography, Royal Museum of Central Africa.*

CAT. 102 (OPPOSITE): MALE FIGURE. LUBA, ZAIRE. The fact that the artists of the Warua Master workshop produced male figures in addition to female, and a female figure (cat. no. 104) with hands to the abdomen rather than to the breasts, indicates that they were working on the periphery of the Luba Heartland, where male ancestral figures are more common. This delicate sculpture of a male figure bears the same rendering of the human form as other works by the Warua Master, but its use is unknown. *Wood. H. 16.9 in. Private collection.*

assume more political power than the consensual dynamics of a stateless society allowed, they turned to Luba for their model for authority. Indeed, they sometimes went to the Luba court to acquire the trappings and potent magic of sacred royalty, also bringing home the latest fashions in clothing, coiffures, scarification, and other body arts (figs. 203–206). The most celebrated case of such a trip is that of Chief Kyombo, a man who shared a lineage of the Sanga (or "Bushpig") clan with Chief Tumbwe and others who are nowadays most readily considered of "Tabwa" ethnicity. Kyombo became "Luba-ized" (Verhulpen 1936), a term suggesting the dynamic nature of acquiring social identity.

Kyombo lived where the chiefdom of his name still lies, not far from the present-day town of Kiambi, along the eastern side of the Luvua River. In this area, called Uruwa (that is, "Land of the Luba") on older maps, a host of loosely defined peoples meet and intermingle; they are sometimes known as "Luba-Hemba," a spurious name invented during the colonial period (Colle 1913:45).[7] Sometime around 1800, Luba warriors were raiding this land, and Chief Tumbwe, seeking a negotiated alliance, sent his sister's son to visit the Luba king, Ilunga Nsungu (c. 1780–1810). In the presence of the king, the young man pulled up grass to sit on, and the king was so amused by this rustic behavior that he gave him the name Kyombo, "Grass," which was to become the title for a hereditary chieftainship thereafter (ibid.:58, Reefe 1981:125). Kyombo and his people brought home the fire of sacred royalty, the accouterments of court demeanor, and became so "Luba-ized" that Father Pierre Colle, who founded a Catholic mission in Kyombo's village and spent a great many years there, entitled his encyclopedic monograph *Les Baluba* (1913). Despite Kyombo's affectations, there is no evidence that he was politically linked to the Heartland, as the term "empire" would imply. Many an exhibition caption for a Luba object, as well as longer descriptions of the Luba kingdom of the Upemba Depression, have come from the detailed ethnography Colle wrote about Kyombo's people. The irony is that Kyombo's people were both Luba and not Luba at all.

Peripheral Visions

Three clusters of objects collected among Luba-ized people, and now in Western museums, find their contexts in such histories. The first comprises a number of stools, bow stands, and figures either carved by a single hand or coming from the same small workshop that Susan Vogel has called "Frobenius's Warua Master" (1986:172–75) (cat. nos. 96–104). The adventurer Leo Frobenius field-collected several of these objects in 1904, labeling them "Warua" and offering no further explanation of their provenance or use.[8] The late Albert Maesen guessed that the man was Kunda, a name (and perhaps an epithet meaning "slave") designating a clan, more generally known as Kamanya, that has been folded into other ethnicities throughout the region, such as Tabwa and the so-called "Holoholo" and "Sikasingo."[9] By some accounts, Mbidi Kiluwe himself was Kunda.[10] As Vogel notes, the "Warua" artist (or artists) was certainly a master, and his works are "beautiful and tough, crisp but not cold." What is most interesting here is the range of objects he made, and their duplication. Perhaps they were commissioned by a chief who then gave them to his dependants, as François Neyt suggests to explain the distribution of stools and other objects of the so-called "Buli workshop," another Kunda enterprise (1994:216–17; see also Olbrechts 1946:71–74, Boone 1961:85–87). Art objects were also given to settle debts or end hostilities, and occasionally celebrated stools or other regalia might be stolen from one chief to enhance the treasury of another (Nooter 1990b:38–39). It is also possible that the "Warua Master" was an itinerant artist traveling from chiefdom to chiefdom, or otherwise carving objects to meet the demand of clients in different areas desiring prestigious works in a "Luba" style.

The second cluster comprises several figures now in the Musée Royal de l'Afrique Centrale in Tervuren. One represents the male ancestors of Lusinga (fig. 207), a Tabwa chief of the Sanga or "Bushpig" clan. Lusinga and his people are sometimes called "Tumbwe," after the name of an important chief of the same clan; but as an ethnic term, "Tumbwe" is a colonial invention and bears no relevance to precolonial objects such as this one.[11]

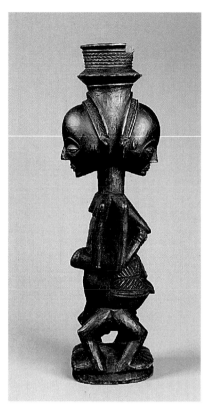

CAT. 103: JANUS FIGURE. LUBA, ZAIRE.
Another category of art perfected by the
Warua Master was a Janus-formed figure.
This example, also collected by Frobenius in
1904, has two figures, male and female,
joined back-to-back, and sharing a single
cavity in the top of their heads. The term
"Warua" is the Arabic pronunciation of
"BaLuba," and offers no particular detail as
to the geographical or ethnic origins of these
works. Like all of the artist's works, this one
emphasizes a large rounded head with ele-
gant coiffure and a scarification-laden torso,
while the legs are reduced to diminutive,
snakelike forms. *Wood. H. 13.5 in. Staatliche
Museen zu Berlin, Preussischer Kulturbesitz,
Museum für Völkerkunde, Inv. no. III C
19996.*

Until the mid nineteenth century (and in many places still today), Tabwa lands were "bestrewn with . . . countless small villages, each nearly independent from the others, and without political cohesion" (Storms ca. 1884). In the 1860s and 1870s, however, as Lusinga and several other Tabwa chiefs participated in the trade of ivory and slaves to the east African coast, they began to consolidate their power, following elements of a Luba model. The figure in the Musée Royal is a fine example of "statement art"—an invention of tradition to glorify Lusinga's matrilineage as he sought to legitimize his growing authority (Roberts 1985). Standing for the newly "dynastic" line of chiefs named Lusinga, this figure was commissioned from an artist who was either himself of a Luba-ized people or knew how to produce sculpture after an eastern-Luba aesthetic. In this, it is distinctly different from ancestral sculpture made for Lusinga's classificatory mother's brother Tumbwe, for nearby Hemba chiefs, or for southern Tabwa chiefs of the Zimba or "leopard" clan such as Manda. There is no evidence that Lusinga sought or was granted Luba regalia or other esoterica of the royal court, nor is there any hint that he was politically allied to the Luba kingdom. Rather, he engaged in mimesis, imitating things he considered glamorously and expediently "Luba."[12]

Still, whatever Lusinga adopted was also immediately adapted to his own cultural realities. The figure's "female" left hand, for example, lies next to the navel, signifying Lusinga's attachment to his matrilineage, while the "male" right hand grasps a staff (or perhaps the abstracted form of a musket?) as an object of authority. The figure's cruciform coiffure was popular among late-nineteenth-century men of northern Tabwa, Hemba, and other Luba-influenced peoples (Neyt 1977:402–11). A crescent-shaped necklace made from bushpig teeth refers to Lusinga's clan, and suggests the animal's proficient "farming" as it roots about with its tusks, as well as the way it lays waste to cultivated fields, in a metaphor for Lusinga's military might (Roberts 1995a: 57–59). The necklace also invokes the rich symbolism of the rising of a new crescent moon, as a source of both hope and arcane knowledge. Lusinga probably kept the figure and others related to it in a special house where he made offerings and occasionally slept, to communicate with his ancestral spirits. At the new moon, one may surmise that the figure was displayed publicly and anointed with the palm oil that still exudes from its surface, as a focus for community ritual exalting Lusinga's newfound "royalty."

To expand his wealth and authority, Lusinga became an active participant in the slave trade. Sometime in the 1870s, he and his people moved eastward from lands adjacent to his Luba-ized kinsman Kyombo, where one can guess that this figure was commissioned, to settle in the mountains along the western shores of Lake Tanganyika. Lusinga was among the first warlords to introduce guns to the area from East Africa, and he soon became quite the "sanguinary potentate" (Thomson 1968, 2:51), taking control of one of the few safe harbors whence slaves could be taken across the lake to the caravan trails through what is now Tanzania.

In 1883, Lieutenant Émile Storms of the International African Association (IAI) established an outpost at Mpala, not far from Lusinga's village. Moving west, Storms hoped to meet Henry Stanley's expedition slowly coming eastward, and thus realize the IAI's plan to create a "White line across the Dark Continent," as a contemporary tract had it (anonymous 1883).[13] Lusinga immediately proved a thorn in Storms's side, confronting Storms soon after the Belgian lieutenant created a fort at Mpala. Infuriated by Lusinga's effrontery, Storms vented his anger in his diary, stating his intention to overthrow the chief at the first opportunity. Lusinga and his maternal uncle Kansabala had chosen defensible positions in the mountains, however, and Storms was obliged to wait until his men could be seconded by those of the visiting German East African Expedition, led by Paul Reichard. In 1884, these combined forces easily vanquished Lusinga and Kansabala. Elderly people at Mpala still remember the victory song of Storms's men as they returned to the outpost and presented the lieutenant with Lusinga's head. Storms sent the skull to Europe as an anthropological specimen, and threatened recalcitrant Tabwa with a similar fate, as is also still recalled. He considered his conquest of Lusinga instrumental to his establishment of his "empire" at Mpala, which he ceded to Catholic missionaries in 1885 as the seat of the "Christian Kingdom" they would found there. The men of Storms's punitive expedition also pillaged the stockades of

CAT. 104: FEMALE FIGURE. LUBA, ZAIRE. Although this female figure is not necessarily by the Warua Master, it shares much in common with his style, and was collected at the same time as the earliest Warua Master acquisitions. Elegant and still, the figure departs from most Luba female representations in the lack of scarification and the gesture of hands to abdomen, as opposed to breasts. These anomalies are not easily explained, but the result is sculpturally strong and produces a balanced, harmonious composition. The figure also differs from other Warua Master works in the softness of the features and the accentuated collar bone. It is otherwise highly resonant with his oeuvres, especially in the profile view of the face. *Wood. H. 24.4 in. Staatliches Museum für Völkerkunde, Munich, Inv. no. 05.65.*

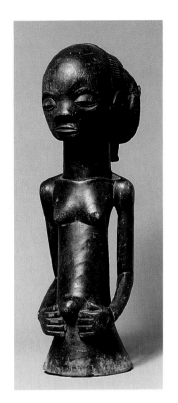

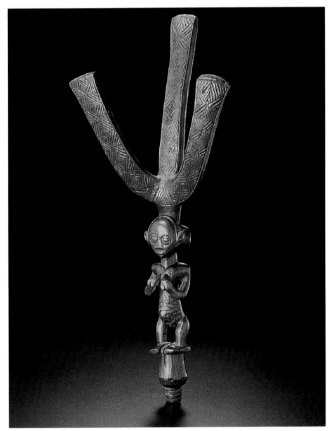

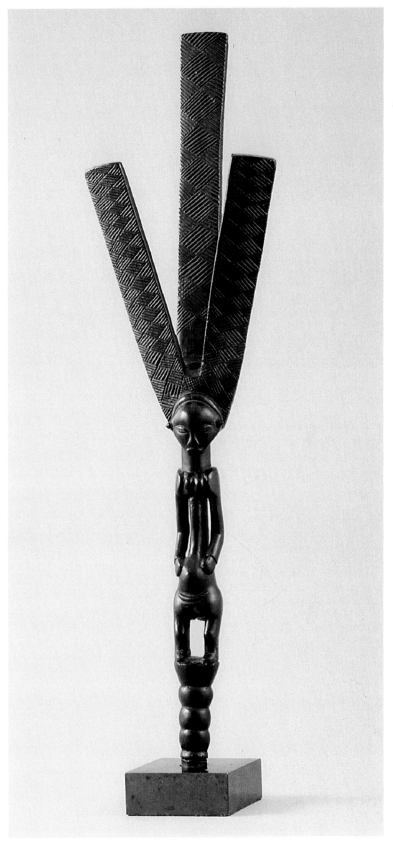

CAT. 105: BOW STAND FROM THE MIOT TREASURY. LUBA, ZAIRE. An entire treasury of ten objects was collected by Fernand Miot, who arrived on the shores of Lake Tanganyika in 1893 as a member of a mission to put an end to slavery. Following Miot's intervention in a dispute between Chief Kalumbi and another chief, in which Kalumbi was found to be at fault, a conflict ensued leading to Miot's ransacking of the chief's village, thus obtaining the ten objects in question. The eclecticism of Kalumbi's treasury reflects that of Luba chiefs, whose regalia could be wide-ranging. *Wood. H. 24.4 in. Dede and Oscar Feldman.*

CAT. 106: BOW STAND FROM THE MIOT TREASURY. LUBA, ZAIRE. Due to the widespread dispersal of African art to museum and private collections all over the world, one rarely sees the components of a single historical treasury united. Shown here are five of ten objects documented as having belonged to a single Luba-ized chief in 1895. Although Chief Kalumbi was of the Sanga clan and perhaps a kinsman of the Tabwa chief Tumbwe, his treasury consists mostly of Luba regalia, as well as a Buli bowl figure and a Kuba drinking cup. There is some redundancy, such as three bow stands and three staffs, and surprising omissions, such as no stool. In addition to finely incised patterning and an elegant female figure, this fine Luba-style bow stand possesses two anvil-shaped pins inserted into the wood at the location of the temples. *Wood, metal. H. 21.6 in. Horstmann Collection.*

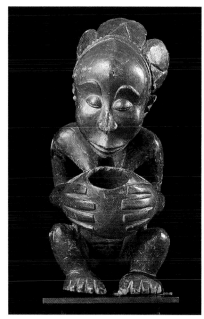

CAT. 107 (ABOVE AND OPPOSITE): BOWL FIG-
URE IN BULI STYLE FROM THE MIOT TREASURY.
LUBA-IZED KUNDA, ZAIRE. The term "Luba"
is a loose attribution for congeries of peoples
partaking of a single concept of sacred royalty,
and the treasuries of kings and chiefs reflect
the fluidity of Luba identity. Among the items
in Chief Kalumbi's treasury was this remark-
able Buli-style bowl figure. The presence of a
work in this anomalous style in the royal trea-
sury not only reflects the heterogeneity of
Luba-influenced treasuries, but demonstrates
the mobility of artworks during the period of
kingship. It indicates a wide distribution of the
Buli style, extending as far as the upper course
of the Lukuga, and suggests that the atelier
was part of the dynamic history of exchange
and interaction among Luba-ized peoples in
the latter part of the nineteenth century. This
particular figure is one of the earliest known
Buli works, and represents the innovation of
an extraordinary artist who went beyond the
boundaries of convention and expectation to
create a corpus of daringly moving sculptures.
Wood. H. 14.6 in. Private collection.

both Lusinga and Kansabala, and in the booty they brought back to Storms and Reichard were ancestral figures such as Lusinga's and others now in the Musée Royale de l'Afrique Centrale and the Berlin Museum für Völkerkunde.

A last case is the so-called "Miot Treasury."[14] Fernand Miot was a member of the fourth expedition of the Belgian Anti-Slavery Society, which arrived on the shores of Lake Tanganyika in late 1893. He and his fellows had dragged two 57-mm. Nordenfeld cannons all the way from the east African coast. There was great population movement during this turbulent time, as battles raged between diehard slavers like Mwina and Rumaliza and representatives of the Congo Free State (Roberts 1989). Miot guarded the CFS outpost at Albertville (Kalemie) while the Nordenfelds were used in an assault on the fortress of Mwine, located three days west on the Lukuga River (Verhoeven 1929:131–42). Thereafter, Miot and his men patrolled the Lukuga valley, where he obtained the treasury of Chief Kalumbi.

Kalumbi was of the Sanga clan and perhaps a kinsman of the Tabwa chief Tumbwe. He occu-pied a strategic position near the confluence of the Niembo and Lukuga rivers, at the crossroads of important east-west and north-south trails. In 1895, Kalumbi became embroiled in a dispute with Mwine, who by then had been forced to cease slave-raiding. In order to maintain the fragile peace, Miot intervened, found Kalumbi at fault, and, when the chief proved recalcitrant, marched on and briefly occupied Kalumbi's village. The chiefs people fled, heckling Miot from the safety of the woods surrounding the abandoned village. Miot and his men appear to have ransacked the place in response, and it is probably then that Kalumbi's treasury was seized.[15]

Kalumbi could be expected to possess objects of statement art. Visiting the area in 1879, Joseph Thomson had found that "a prominent feature in all the Warua villages are the numerous carved idols" (1968:153), but such passing commentary fails to suggest the stylistic diversity of such art. The Miot treasury consists of three bow stands (two Luba in style, the other more char-acteristic of northern Hemba), a Buli-style bowl figure, three Luba staffs including a *masupi* paddle staff, a Kuba (?) cup, an ivory pestle, and an unusual headrest that may have come from southwest of the Luba Heartland (cat. nos. 105–109). Clearly, the chief must have participated in the frenetic trade of goods, slaves, and ivory through the Lukuga corridor, collecting this wide variety of prestige objects to reflect his growing status. His eclecticism echoes that of Luba chiefs, whose treasuries could be equally wide-ranging (Weydert 1938:5), and demonstrates the ability to *have* that is synonymous with authority.

Distant Visions

If the "Warua Master" works, Lusinga's figure, and the Miot Treasury reflect the peripheral visions of Luba-ized peoples (however minimal the mimesis might be), other peoples altogether unrelated to Luba nonetheless looked to the Heartland for symbols of authority. One such was King Kazembe of the eastern Lunda (Aruund) (fig. 208).

The Kazembe kingdom is located in the valley of the Luapula River, south of Lake Mweru in northeastern Zambia. The area is exceptionally rich in fishing, and is located on important east-west trails across the continent. The kingdom has a glorious history that can be traced back to the central Lunda court of Mwata Yamvo, in southwestern Zaire (Chinyanta and Chiwale 1989). Indeed, Kazembe's people "continually look to the past to explain, to justify, and to act" (Cunnison 1959:149), using some of the same memory processes as Luba.

Sometime around the turn of the eighteenth century, so the story goes, an errant Luba "prince" named Chibinda Ilunga visited the Lunda kingdom. When he fell in love with the Lunda queen, Lueji, a new dynasty was begun, thus recapitulating the origin myth of Luba sacred royalty. This blending of Luba and Lunda politics alienated some Lunda, who hived off to begin new chief-doms. Among these was the future kingdom of Kazembe (Cunnison 1959:151–78).

Early in the nineteenth century, there were pitched battles between Luba and Kazembe's men, and a canal Luba built from the Luapula River to Kayo lagoon, to lead their assault on Kazembe's capital, is still serviceable (Mwata Kazembe XIV 1969:70, 133). Still, Kazembe's kingdom expanded, mainly through its participation in the east African ivory and slave trade (though it was

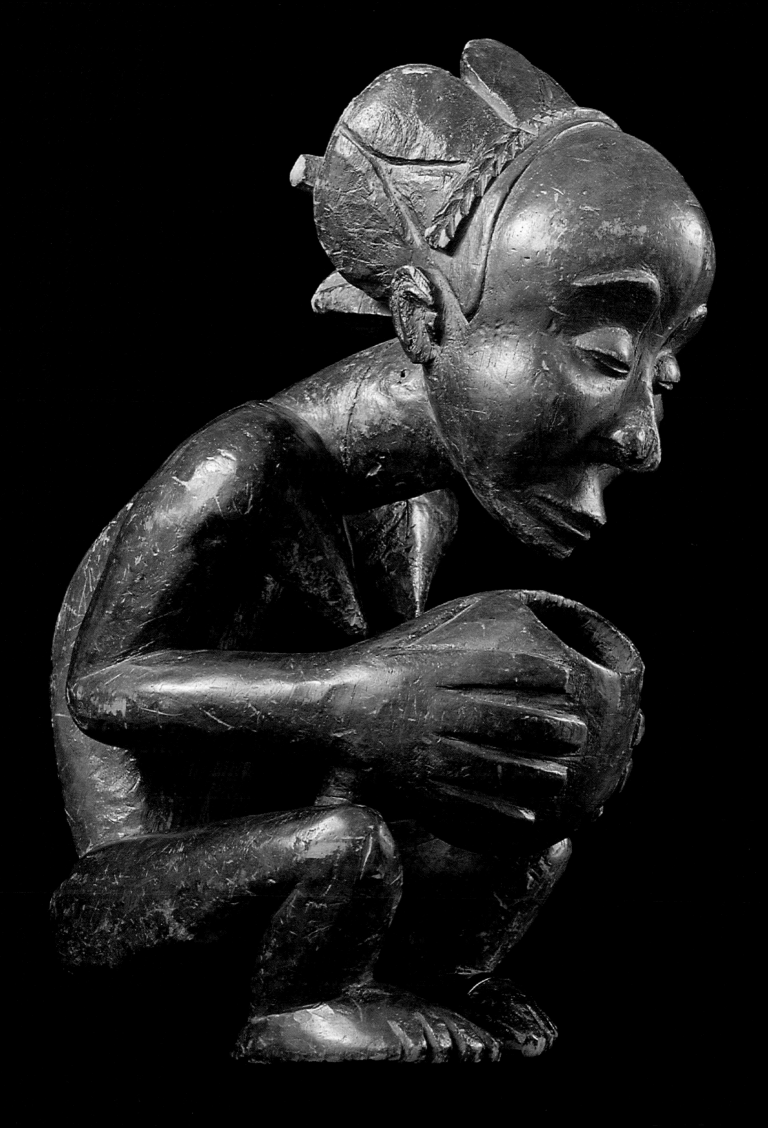

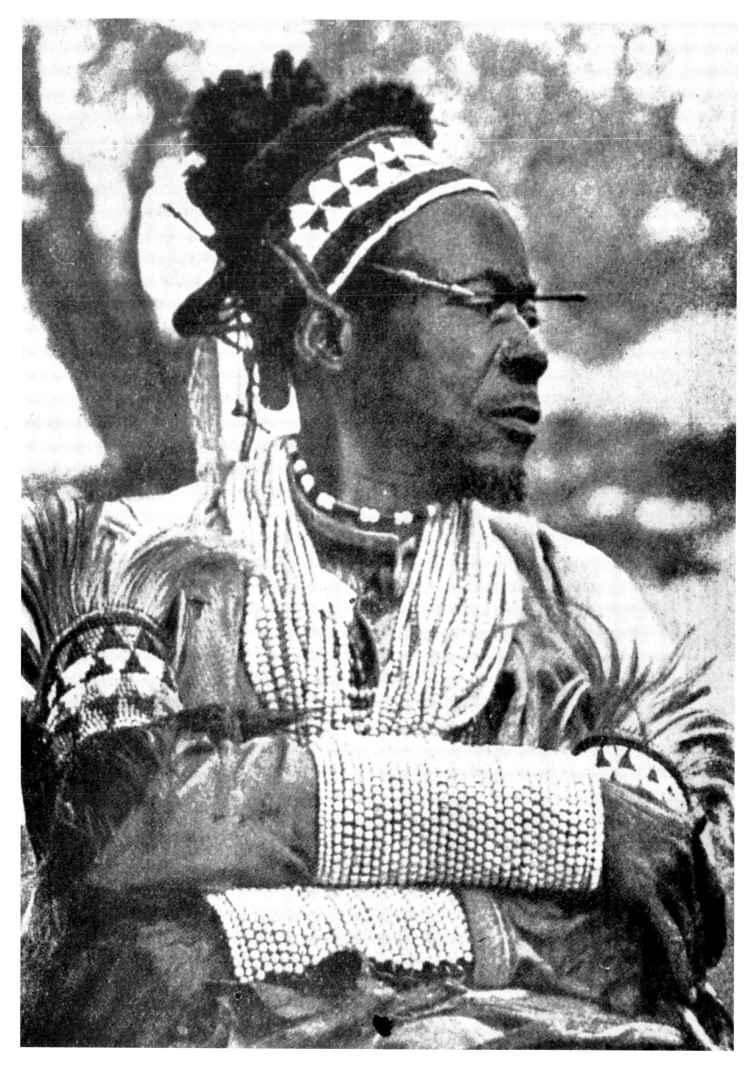

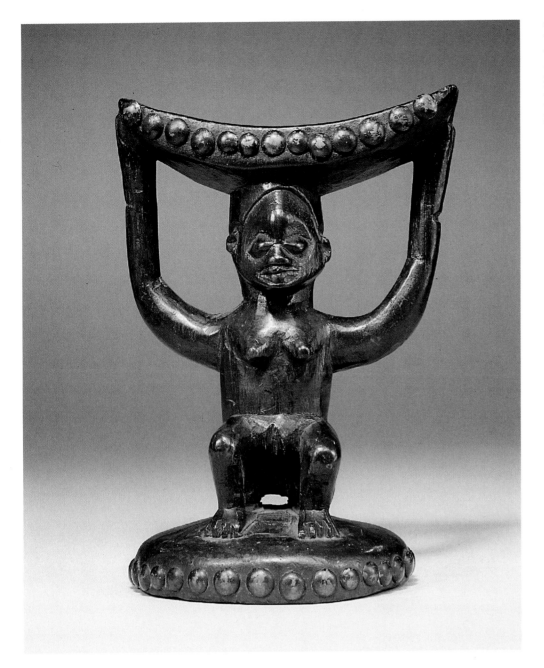

CAT. 108 (LEFT): HEADREST FROM THE MIOT TREASURY. LUBA, ZAIRE. Kalumbi's village was in a strategic position near the confluence of the Niembo and Lukuga rivers, on important east-west and north-south trails. It was due to the chief's participation in the trade of goods, slaves, and ivory through the Lukuga corridor that he was able to collect such a wide variety of prestige objects to reflect his growing status. This headrest appears to be from a region to the southwest of the Luba Heartland, and could only have traveled so far east through the mobility of trade traffic. The diversity of emblems demonstrates how outlying chiefs remember their links to Luba royalty through the acquisition of emblems with particular histories. *Wood, metal. H. 6.25 in. Olivier Cohen.*

also visited by a number of trade expeditions coming all the way from Portuguese Angola). And as the pomp and circumstance grew at his court, Kazembe acquired Luba-style objects for regalia. A photograph published by the missionary Dan Crawford (1924:182) shows King Kazembe with a Luba caryatid stool on the ground to his right; he is seated in a fancy European armchair.[16] In his right hand he holds a fly whisk, in his left a staff of office that looks to be from Lele or some other west-central Zairian group (fig. 209). Several Luba staffs were seized from Kazembe in 1899 by a British South Africa Company expedition; they are now in the national museum in Bulawayo, Zimbabwe (A. D. Roberts 1973:344–45). Perhaps this one was acquired to take their place.

Nearby, in northeastern Zambia, the Bemba paramount Chitimukulu also traces his ancestry back to Luba and/or Lunda origins (A. D. Roberts 1973:49–51), and like Kazembe, he and his subchiefs have long used Luba emblems of authority. Chief Mwamba possesses a kibango-type Luba staff surmounted by two figures now given Bemba names, after a man and woman important to their migration myth. The scarification of the female figure accords well with that attributed to the Bemba heroine, thus facilitating the analogy. The staff used to be taken into battle, and more recently was carried by the chief when he traveled. Historian Andrew Roberts saw the staff carefully placed among the chief's relics in 1969 (ibid.:41, 344, plate 4). Several senior Bemba chiefs are also known to have possessed iron bow-stands brought from Luba country, and Luba-style double iron bells are reported in the treasuries of several chiefs in the area (ibid.:345). Indeed, eighteenth-century Luba iron bow-stands are known to have been possessed, considered sacred,

Fig. 208 (opposite): Portrait of eastern Lunda King Kazembe (1904–19) showing the elaboration of accouterments, prevalent throughout the greater Luba region in the late nineteenth and early twentieth centuries. *Photo: B. R. Turner, from Crawford 1924:96.*

and used in investiture rituals by chiefs among Bisa, Unga, and other southern Zambian peoples (Richards 1935).

Bwile Myopia: A Note from Recent Research by Pierre Petit

We complete our consideration of peripheral visions with a note drawn from recent field research among Bwile by Dr. Pierre Petit. Bwile live astride the border between Zaire and Zambia, in the area of Lake Mweru. As the following brief study demonstrates, ethnic identity is always a matter of debate, dispute, and negotiation; and over the years, Bwile have been willingly and unwillingly drawn into several different ethnicities, including Tabwa (Kaoze ca. 1930). Indeed "Bwile," or "Bwilile," seems to be a tribal name for what is essentially a clan known as the Anza, and in the 1950s, Ian Cunnison found that "Bwilile are uninterested in the name Bwilile given to them. They are primarily interested in their clan affiliations" (1959:50). Social identity continues to shift in modern Zambia, however, and here is Dr. Petit's account of this dynamic process of memory and the making of history.[17]

"Don't be angry if people call you Bwile. Be proud, it is your tribe." It was with these words that Tarcitius Koti, a retired national parliamentarian, ended his speech, in November 1993, to the several thousand people assembled to celebrate the fifty-sixth year of Chief Puta's reign. He had begun his talk by evoking the origins of Bwile chiefs Puta and Mpweto as being "Luba from Kola."[18] His statement about Bwile identity comes in response to the unfortunate connotations sometimes given the term in urban centers to the south, where it is a synonym for all that is unsophisticated and backward.

Zambian Bwile chiefs all claim that their ancestors came from far away, and were Luba. From the viewpoint of Lambwe Chomba, a female Bwile chief, the ancestor left Kola with two objects of regalia that are still revered: a *kyambaso* stool and an mpande conus-shell disk. Mpweto, another Bwile chief, claims to be descended from one of Kalala Ilunga's sisters, and says that the mpande shell he owns was obtained from the Luba royal court. Yet another account, recorded in the 1930s at Chief Nganye's village in Zaire, also suggests that the latter's ancestry can be traced to a sister of Kalala, and that mpande shells and *makosa* sinew bracelets were royal Luba regalia used by Nganye and other Bwile chiefs.

Once again, we see the radiance of Luba identity—of this veritable "label of quality," which for these peoples of central Africa is rather similar to what Rome represented for early European nations. It is with regard to the Luba that Bwile define themselves, even though they might have traced their origins to much closer kingdoms like those of the Bemba, of the Lunda king Kazembe, or of the Tabwa paramount Nsama, especially since these last two submitted several Bwile chiefdoms to their authority in the nineteenth century (Labrecque 1951:27–30, Whiteley 1974:23).

Political power is not all that Bwile attribute to Luba, however, for their spiritual power has the same roots. An account by Mankunga Kalungwe (1990:121) illustrates the relationship between the two: "to renew and consolidate their bonds with Luba chiefs, after their investiture Bwile chiefs go to seek their 'spiritual wives' . . . at the spirit Kibawa's cave in the Kamanya chiefdom." For these Bwile, Kibawa is both a powerful spirit and a place, a mountain with a deep cavern where ngulu possession spirits and the *ifikolwe* ancestors reside. In reality, this cave is near the village of Mpenge, in the northern part of Bwile country (Van Acker 1924:88, Colle 1913:419). This is a frontier where the population, according to a visitor in 1901, is "a mix of Bwile and Luba" (Van Acker 1924:81). Whatever the case, Kalungwe's account situates Kibawa in the Mwenge Kamanya chiefdom, which is "Luba" from a southern Bwile point of view. The location of Kibawa's cave on the west side of the Luvua River (which they also give the Luba name Lualaba) is a geographical mistake that is repeated by possession spirits that are deemed to cross the Luvua from west to east, to reach Bwile mediums. Such spirits from the other side of the river must come from Luba.

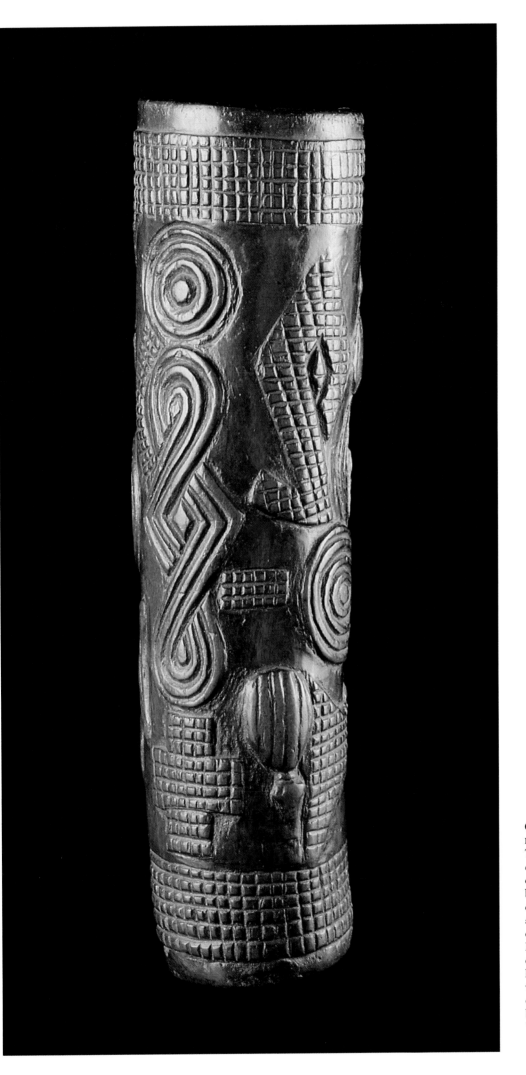

**CAT. 109: DRINKING CUP IN KUBA STYLE
FROM MIOT TREASURY. KUBA, ZAIRE.**
The composition of the Miot Treasury
demonstrates the "open frontiers" quality
of Luba royal diplomacy—the sharing,
borrowing, and emulating of Luba regalia by
outlying peoples seeking to participate in the
aura of Luba kingship, and the acquisition of
other, entirely foreign items as well. How a
Kuba drinking cup found its way into this
eastern Luba treasury is unclear, but it must
have made a statement about the chief's
worldliness and prestige to possess objects
emanating from such great distances and
belonging to non-Luba royal treasuries.
Wood. H. 9.5 in. Rolin Collection.

Certain spirits speak Luba through their mediums, many songs sung during séances are in the same language, and some mediums go to be initiated into their craft by Luba practitioners. One diviner interviewed went to "Luba" people in Zaire to be initiated into Tufunga, a cult for which a principal spirit is Kasongo Muyembe, a typically Luba name (Colle 1913:552–3).[19] The same man regularly returns to increase his esoteric knowledge, and such voyages allow him to introduce elements of Luba culture to Bwile. For example, the diviner commissioned a figure for one of his spirits, named "Madame Jeanne," from a carver in Mpweto. The object is like a Luba bowl-bearing figure, but to accommodate Bwile culture, she holds a basket.[20]

In summary, then, Bwile chiefs say their origins are Luba and offer their regalia as proof. Crossing the "Lualaba" (Luvua), which marks the conceptual border with Luba country, is important to two moments of their history. Luba country is also the land of spirits, and Kibawa is explicitly located on the western side of the river, even if, in reality, the cave is on the east side. This geographical fiction answers to an intellectual need: the frontiers of spirit and political worlds must coincide. Luba do the same, for Mbidi Kiluwe is said to come from *east* of the river, whence hail the greatest Vidye possessing spirits as well (Petit 1995). If one overlooks the east/west inversion, then, Luba and Bwile create the same imaginary geography to structure their reflections concerning the beginnings of the world and the world of beginnings.

The Periphery Becomes Central

To round out Dr. Petit's story and bring our discussion to a close, let us return to Kibawa's cavern, an archetypal lieu de mémoire. Kibawa is an especially important ngulu earth spirit, of a sort recognized by peoples throughout east-central Africa (Werner 1971). In earlier days, earth spirits were offered "ecological" or "territorial cults" to assure continued abundance of hunting, fishing, and other natural resources, and perhaps play a role in maintaining social and political order beyond the village level (Binsbergen 1981, 1978:65; Roberts 1984; Schoffeleers 1978). Kibawa was first recognized in the early 1890s, through *kasesema* prophesy (Roberts 1988a, 1990b).[21] This was a time of extreme duress, when turmoil from the violent end of the slave trade was matched by natural disasters including drought, famine, plagues of locusts, and epidemics of smallpox and sleeping sickness. Just when people were in danger of mass starvation, Kibawa announced his desire to help them through an outbreak of rinderpest from which vast numbers of game animals perished, producing a windfall of meat. Throughout central and southern Africa, people posited relationships between this epizootic and the radically destructive social changes suffered at the time (Van Onselen 1972; see also Roberts 1982, Rossiter 1984). Kibawa required that people abandon Swahili and other colonial affectations, and in important ways, recognition of the spirit was a nativistic device through which people might restore their sense of dignity and purpose.

Recognition of Kibawa occurred at the same time that the first long narratives of the Luba Epic were recorded among Luba and Luba-ized peoples. In several of these accounts, Mbidi Kiluwe is said to hail from a Kunda or other chiefdom far to the east of the Heartland, somewhere around the present-day town of Moba, on the shore of Lake Tanganyika (Roberts 1991). He is also praised as "chief of Kibawa" (Colle 1913:357, Verbeke 1937:55–58). As we have seen, Mbidi is the "black" hero who embodies dark secrecy; when he is called "chief of Kibawa," the enigmas of his being and bearing, and the innovation for which he is so famous, are given—indeed are made into—a place. Perhaps Kibawa's cavern might be dubbed "Secret of the country," as a Kongo spirit cave is (Maret 1994:187). What is clear is that for many people at the turn of the century, the center of Luba thought was shifting back to the periphery.

Kibawa's cavern is a real place, in lands of Mpenge, a subchief of the Bwile chief Nganye, east of the Luvua River. From the 1890s till the 1930s or a bit later, the cave was visited as an oracle by people from a radius extending a hundred miles or more. A kitobo or guide would lead supplicants through the bamboo thicket surrounding the mouth of the cavern, in a process metaphorically alluding to their desire to wend their ways back through memory, to discover the

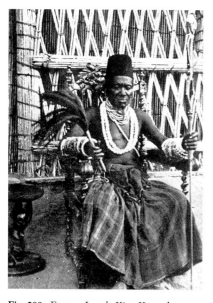

Fig. 209 : Eastern Lunda King Kazembe "adjudicating." The emblems of his office include a beautiful Luba-style stool, a European chair, a tall staff of unknown origin, a fly whisk, and a beaded necklace. It was common for Eastern Lunda and Luba-ized chiefs to commission regalia from Luba artists or to obtain Luba and other insignia through mutual gift-exchange. *Photo: from Crawford 1924:182.*

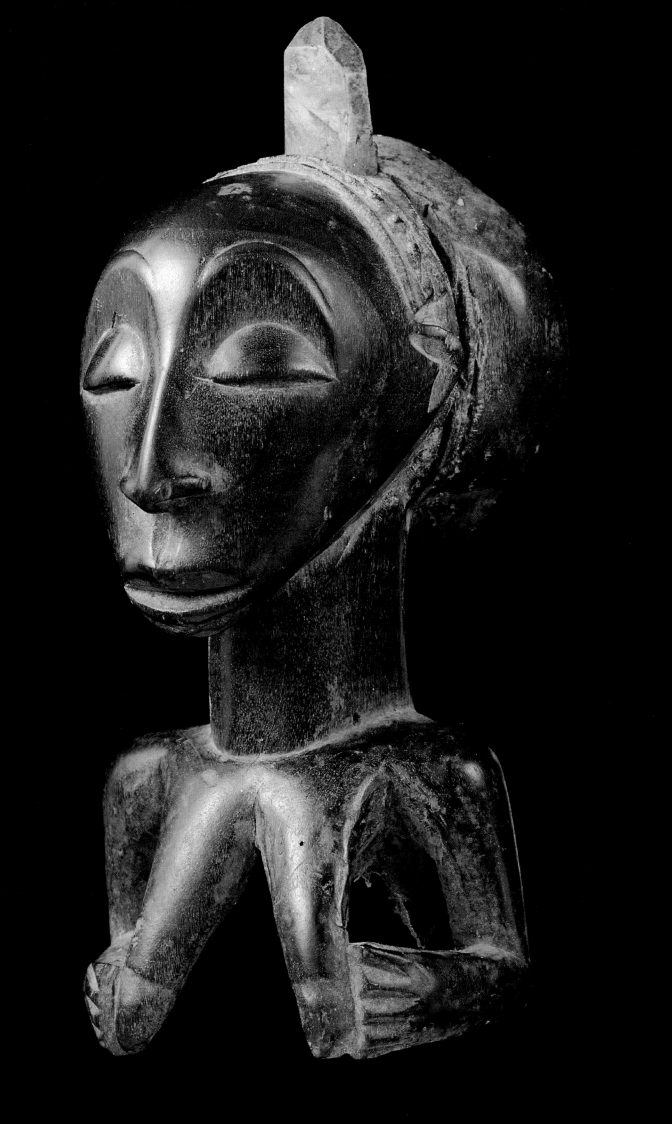

source of some affliction or to solve particularly thorny litigation (Roberts 1988a). The kitobo would lead people deep into the recesses of the cave, where they would hear the gurgling of Kibawa's great water-pipe, the voices of dearly departed kin, and other domestic sounds.[22] As Kevin Maxwell has said of another oracular cave in northern Zambia, "these places are sacred . . . because their engulfing sounds create a panharmonic center, which can integrate and motivate the rest of their fragmented experience. The wholeness [of the place] makes them whole again" (1983:88). Once inside Kibawa's cavern, people did not want to leave.

During this same period, Kibawa served a political function. Chiefs from throughout the area went to the cavern to obtain quartz crystals, or *kisimba*, the name also given to the second-born of twins. Quartz crystals are common in the region. When people are traveling at night, as they often do to avoid hot weather and storms, if someone should notice that a facet of a crystal "reflects the dubious light of the moon," as an early missionary had it (Guillemé 1887), he or she will take the stone back to the shrine at home, for this is a clear communication from divinity (Roberts 1985:28). Only chiefs or those they designated could touch the crystals obtained from Kibawa, and a chief would sleep in a special hut with his spirit wife Kisimba to receive prophetic dreams. The missionary Dan Crawford recognized the centrality of this icon, and, as a proselytizing strategy, told Chief Mpweto to surrender his to him. The chief refused, but that night he heard a wind from the hut where Kisimba slept, and when he looked, the object had fled back to Kibawa, as is said to have happened when chiefs died (cited in Tytgat 1918). It is likely that several figures from Luba-ized peoples that have quartz crystals set into the tops of their heads represent Kisimba (cat. no. 110), as may a scepter embedded with crystals now in the collections of the Musée Royal in Tervuren (#35490). Or perhaps they are Kibawa himself.

One can speculate that from the 1890s to the 1930s, Kibawa's cavern was the center of a milieu de mémoire, as Pierre Nora (1989) would define this term. That is, people throughout the area lived the reality of the place, and sought uchronious harmony with the spirit world deep in the recesses of the cavern. What distinguish the activities at Kibawa's cavern are the geographical and cultural distances covered by those seeking assistance there. Previously, earth spirits had ordinarily been offered "territorial cults" by people of a single social identity (a lineage, clan, or chiefdom), who identified themselves with the lands where the spirit resided. In Kibawa, participation was significantly broadened to become what J. M. Schoffeleers calls a "federative cult" cutting across different ethnic and politico-economic groups (1978:10). Recognition of Kibawa was a political event attuned to people's resistance to early colonial occupation, and the adaptations they were making to it. This was not one chiefdom's or clan's problem—it was everyone's. The cavern was a very sacred place of collective memory and local culture, which found its definition and purpose in a nativistic resentment of colonial encroachment. When a Greek man, perhaps a merchant, passed by the cavern in 1913 and arrogantly fired his gun into its darkness, he died a few days later (Tytgat 1918).

A significant shift occurred in the use of the cave in the 1930s, from a community focus for religious and politico-economic activities to a new individualism needed to cope with the introduction of colonial capitalism. It was at this time that many Luba-ized peoples and their neighbors adopted and adapted Bilumbu spirit possession from the Heartland. The ecological cults and other collective religious activities of earlier times were both prohibited by missionaries and irrelevant in capitalist contexts in which the talent, achievement, and wealth of individuals was increasingly stressed. Some now say that ngulu earth spirits have fled their sites to congregate in Kibawa's cavern (Roberts 1984). The same is said of ancestral spirits, now deemed to reside in an underworld ruled by Kibawa. Through possession, ancestral spirits and earth spirits act in congress (in ways not clearly defined), so that an afflicted person may realize the ecstacy of trance and an earth spirit can speak and otherwise express itself through the medium (Roberts 1988a, 1990a).

As of the 1930s, then, Kibawa's cavern has become a true lieu de mémoire where "memory crystallizes and secretes itself." Furthermore, there is a need for such lieux de mémoire in contemporary Zaire, where milieux de mémoire are being abandoned and forgotten as history

"accelerates" (Nora 1989:7–8). Not only have Luba and Luba-ized peoples of southeastern Zaire been obliged to accept and accommodate linear time, they have learned to live with the adage "Time is money," repeated ad nauseam as the single phrase of English that many Zairians know. Kibawa is "'an oblivion from which, at random moments, present resemblances enable us to resuscitate dead recollections'" and achieve transcendence (Terdiman 1993:1, 167, citing Marcel Proust). As such, it is a retreat where, in dream and ecstacy, one can find release from the everyday humiliation, persecution, and want of Mobutu's Zaire.

If Kibawa's cavern is a lieu de mémoire, then Mbidi Kiluwe, as "chief of Kibawa," personifies memory itself. As we have seen, Mbidi is always hard to pin down. Even on a lukasa memory board, he is usually indicated by lines of beads indicating where he has been or where he is going, rather than where he is. He's "black," with all the insinuations of arcane knowledge that this color connotes for Luba; and he is "invisible," like anything "black" that hides in the night. Like other spirits of the Luwe paradigm, he is dichotomous and vertically divided, embodying all the paradoxes of right/left symmetry and asymmetry. He comes from a vaguely defined place in the east, and is always errant; and he is the moon, whose phases create a celestial symphony of "enlightenment" and dark arts (see Theuws 1968:11). Luba say that history begins with Mbidi's son Kalala Ilunga, rather than with Mbidi himself, for it is Kalala who defeats Nkongolo Mwamba to become the first king of the royal dynasty. If Kalala is the blinding flash of lightning, and the punctual event that begins historical time, Mbidi is the thunder, black and diffuse. Having confronted Nkongolo, Mbidi disappears back toward the east, and is not heard from again except as a hero of hunting, as he rides the savanna forests astride a bellwether beast, or as chief of Kibawa. Indeed, from a structuralist point of view, Mbidi *is* Kibawa. As such, Mbidi is memory, hemmed in by the histories begun by his son.

Endnotes

1. The eastern bias of this essay reflects the principal author's fieldwork among Tabwa and related peoples. Equally pertinent study could obviously be made of relations between the Luba Heartland and peoples in other directions, especially toward the west (e.g. the kingdom of Mutombo Mukulu and beyond).

2. The word "tribe" has fallen out of favor as politically incorrect, and rightly so, when it is only applied to non-industrial peoples as yet another hegemonic device. The usual alternative for describing social identity among African peoples is "ethnic group," yet, as discussed below, using this to the exclusion of "tribe" prevents one from understanding the dynamics of identity formation over time, and especially with the imposition of colonial capitalism. It is useful to retain "tribe" and "ethnicity" as separate terms, as well as "clan," "lineage," and other kin-based identities discussed here. A useful review of Luba ethnicity is presented in Goehring 1970, while Luba ethnogenesis as debated by current scholars is presented in T. Turner 1993, with cross-cultural examples in Vail 1989. The attributes of urban Luba mentioned here may apply more directly to Luba-Kasai than to Luba-Shaba people.

3. Von Sicard 1966 lists twenty-five variants of the Luwe spirit, including several in Zimbabwe, and further associates the term with the Milky Way and with the bush pig, a symbolically important animal, in Swahili called "*nguruwe*" (another derivative of *-luwe*). The citations here are from von Sicard; see also Roberts 1991 for more detailed discussion and relevant bibliography.

4. It must be understood that away from the Heartland, where Mbidi's place in the charter myth of sacred royalty is irrelevant (or at least matters less), the same character and the principles he personifies can take different form, as in these examples. Such shifts mean that Mbidi Kiluwe or the spirit Luwe is not "Mbidi Kiluwe," founder of Heartland royalty, but something else; yet because of the Luba kingdom's pervasive influence in the region, people are generally aware of the prestige associated with the "historical" figure, and of his place in local cosmology. Mbidi, then, is several things at once, as befits a culture hero.

5. The mask's bird might also, more prosaically, be identified as an oxpecker (*Buphagus erythorhynchus*), which might explain its odd position on the back of the mask, head down, as though searching for ticks and other vermin on a buffalo's neck.

6. A Luba mask collected by Emil Torday in 1909 at Banagasu (Mack 1991:20) is probably of the same genre, and illustrates the diversity within the idiom, as does another mask now in the collections of the Minneapolis Institute of Art.

7. "Hemba" means "east," so "Luba-Hemba," like its synonym "eastern Luba," is a name suggesting geographical placement in relation to the Heartland. The term can refer to virtually anyone east of a certain line, then, and during the colonial period it became an inclusive ethnicity subsuming a number of clans and other small groupings. Hemba themselves accepted and used this nomenclature to their political advantage, as they sought to build a "tribal" identity. (We gratefully remember the late Albert Maesen's discussion of this and related points with us in 1988.) Pamela and Thomas Blakeley present Hemba as they apparently choose to see themselves now: "400,000" ethnically undifferentiated people (1994). Still, judging from Luba, Tabwa, Shila, and other latterday ethnicities in the region, cultural differences exist just below the surface of such generalities. François Neyt visually presents a sense of Hemba diversity in his grand exposition of ancestral figures from the area (1977:24 and passim).

8. Warua is "Baluba" as pronounced by nineteenth-century Swahili slavers and, in imitation, by early European visitors (Roland 1963:9). The term refers to a vast area inhabited by Luba-ized peoples, rather than to the Luba Heartland. Rival collector Emil Torday's withering view of the adventures of Leo Frobenius is presented in Mack 1991:27–28.

9. Albert Maesen, personal communication with the authors, 1988.

10. The meager literature on Kunda is reviewed in Boone 1961:82–91; on the Kamanya clan and the origins of Mbidi Kiluwe, see Biebuyck 1981:17, R. Maes 1963, Roberts 1991, and Roland 1963:10.

11. Detailed discussions of this and related figures, the history of Chief Lusinga, and relevant bibliography are presented in Roberts 1985, 1986a, and 1995c.

12. Mimesis in African ritual and other circumstances is discussed in Jackson 1989.

13. My thanks to Louis de Strycker for making this rare document available to me.

14. The following discussion of the Miot Treasury is enhanced by discussion and archival data provided by Louis de Strycker, who has also tracked down the pieces, dispersed after their sale by Miot's family in the late 1960s.

15. This is my hypothesis, for as Louis de Strycker notes, the circumstances in which Miot obtained his collection are anything but clear (private communication to the authors, 1995). A punitive act such as that described here would be consistent with other, better-documented cases, such as that of Émile Storms and Chief Lusinga, also described here, in which the seizing of objects was meant to bring ignominy to a chiefdom. Strycker suggests that the ivory pestle may not be from Kalumbi's.

16. The photograph's caption reads "The king adjudicating," without further identification. A photograph of a different man from Chinyanta and Chiwale 1989:37 is labeled "Kazembe, 1904–1919," and therefore must show Kazembe XI Muonga Kapakata; the Crawford photograph then might show Kazembe XI's predecessor, Kanyembo Ntemena Kazembe X, but a photograph of that king published by Chinyanta and Chiwale (ibid.:37) also seems to show a different man; and a photograph of Chinyata Kasasa Kazembe XII, who ruled from 1919 to 1935, published by Chinyanta and Chiwale (ibid.) also seems of a different person. One is left to wonder whether someone sat in for Kazembe when Crawford took his picture as "the king adjudicating."

17. Dr. Petit's account, here translated from the French, has been abridged to meet the needs of this chapter. We have not cited the names of his informants, though he does in the text submitted to us. Our sincere thanks to Dr. Petit for sharing the results of research he undertook in 1993 and 1994.

18. Editors' note: Kola is the mythical point of origin claimed by many peoples peripheral to Luba; some have associated it with Angola, others with a place much closer, and symbolically significant: Ankoro, at the confluence of the Lualaba and Luvua rivers. See Roberts 1980.

19. Editors' note: *Buyembe* is the magic of the Kazanzi Association, an antiwitchcraft and mutual-aid society important to Luba politics and closely associated with Mbudye; see Colle 1913:528, Verhulpen 1936:173, and Reefe 1981. Kazanzi is virtually defunct nowadays, but people still practice Buyembe, as discussed through an extended case study in Roberts 1992a. A magical figure called Kasongo-Muyembe seen by Colle (1905:79) at Chief Kyombo's was set atop an iron spike and empowered by horns and bells around its head.

20. Editors' note: This example of ongoing change is reminiscent of another among Luba and Luba-ized people around the towns of Ankoro and Kiambi (Chief Kyombo's chef-lieu). Marc Félix reports and illustrates a

new subject of *kifwebe* masks called "*la belle Madeleine*," which "depicts a beautiful Belgian nun . . . who was said to have been the mistress of Chief Ngoy. . . . The Madeleine mask is now also used by a syncretic voluntary association called Baba na Mama of which the central figure of devotion is the Virgin Mary, and it also performs, in conjunction with a series of zoomorphic masks, a danced duet combining the beauty and the beast" (1992:11, 13). Félix also notes that these "duets" are similar to the pairing of buffalo and human masks among Tabwa and Luba-ized peoples around Lake Mweru (ibid.:11), perhaps including Bwile.

21. People told me in the 1970s that this was the case, and I have found early archival sources mentioning it also; still, it is possible that Kibawa preexisted the epizootic and took on new meanings and tasks when various epidemics and other disasters struck during this period.

22. Luba also believe in an underground afterworld called Kalunga Nyembo, which may have two levels, the lower for evildoers. Some Janus-faced figures are said to look into our world and that other (Theuws 1964:29–31, 33).

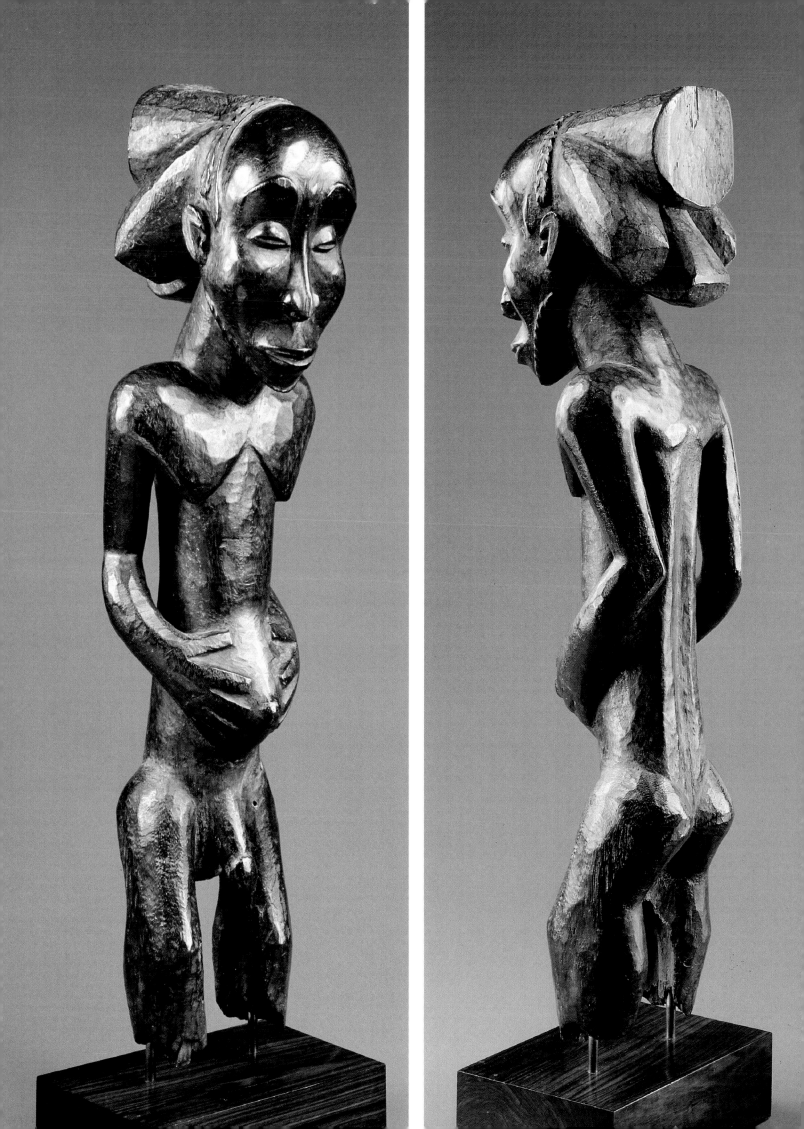

AFTERWORD

The Idea of "Luba"

V. Y. Mudimbe

CAT. 111: STANDING MALE FIGURE IN BULI STYLE. LUBA, ZAIRE. Works in the so-called "Buli" style represent an alternative vision, a distinctive interpretation of Luba art, and visually reinforce the way history is remembered and remade through the embodiments of an idea. Not only is this a male figure, but it appears aged. This is certainly a departure from the timeless quality of most Luba art, and would seem to comment on the decline of the state at the end of the nineteenth century, when these works were created. It seems probable that there was an original artist (or two) who sculpted the majority of the Buli works in the mid-nineteenth century, playing on a variety of themes, and that he was succeeded several decades later by one or two disciples who perpetuated the style with works that were finely sculpted but more academic in their execution, and lighter in color. This sculpture, with its dark patina and its affecting presence, can be attributed to the earlier, original artist of the style. *Wood. H. 28.3 in. Private collection.*

The preceding chapters comment on a being, in the ordinary meaning of the concept: in effect, the term "Luba" signifies and indicates an existence (as opposed to nonexistence), something that has actuality, both materially and as an idea. As witnessed here, that being's history, language, and organizational functions can be described from both real evidence and theoretical grids. They constitute systems that submit to specific norms, thus qualifying the being as this or that particular kind of coherence worthy of a book and an exhibition detailing some of its features.

Despite its pitfalls, an organicist metaphor of "Luba" as a concrete historical existence situates the term as referring to a living culture; that is, to a totality of ways of existing and *Weltanschauungen*, a totality constructed by groups of human beings and transmitted from one generation to the next. In sum, the metaphor suggests a *home*, in a bodily guise that would incarnate the ambiguous complexity of any individual or subject. The organizers of this exhibition have chosen to consider this home as the object of commentaries, thus indicating it as that which makes discourses metaphoric. What is metaphoric is by definition incapable of rendering any elucidation about the being of the object itself in a transparent way. On the other hand, on anthropological, historical, or aesthetic grounds, this home is imbued with thoughts, which it expresses in discourses about its past, organization, and achievements.

Such is the paradox of any discourse on a particular culture. Indeed a number of contemporary theorists have suggested, quite validly, that all discourses—even philosophical and scientific—fail in their objective of bringing metaphor under the conceptual rule of an inclusive and comprehensive classification, because the very language in which they postulate such an ambition, and try to actualize it, is already part of a larger, more obscure, and inescapable metaphoric web.

There are reasons for believing, however, that the options that characterize this book and exhibition will not lead to rancorous debate. In focusing on a cultural body as an existing entity, the writers and curators do not reject the demands of the scientific discipline, specifically the impulse to express rules of activities and arrangement beyond those concerned only with the signification of an order. This focus equips the reader with useful critical understandings. In the production of knowledge about anything, we should not confuse the order of conceptual apprehensions with the order of *things*; and we should keep in mind, as Michel Foucault would put it, that when it comes to historical and cultural bodies or events we might decide to study, "there is nothing absolutely primary to be interpreted, since fundamentally, everything is already interpreta-

tion; every sign is, in itself, not the thing susceptible to interpretation but the interpretation of other signs."

Speaking more figuratively, I could invoke here Clifford Geertz's fascinating illustration in *The Interpretation of Cultures*: "There is an Indian story—at least I heard it as an Indian story—about an Englishman who, having been told that the world rested on a platform which rested on the back of an elephant which rested in turn on the back of a turtle, asked (perhaps he was an ethnographer; it is the way they behave), what did the turtle rest on? Another turtle. And that turtle? 'Ah, Sahib, after that it is turtles all the way down.'" The story points to a nerve center of any successful practice of a discipline: knowledge is worthwhile in itself, and all is worthy of study.

Apropos the being of Luba posited as a living body, and thus as a locus of meanings, the exhibition and the studies accompanying it chronicle features, elements, and stories that can become objects of delight, both in themselves and in sociopolitical negotiations. This is because—to refer to Kantian distinctions—they are gratifying, pleasing, or can be esteemed, and as such would respectively be qualified as agreeable, beautiful, or good, qualities corresponding to inclination, favor, and respect. Indeed these virtues signify a reflective judgment that can really only validate itself when proceeding from a good grasp of the relationship between, on the one hand, the features, elements, and stories chosen, and on the other, three major sets of paradigms: a specific space-time dimension, a particular social formation, and that formation's collective consciousness and unconsciousness.

The reader of this book will have been struck by the variety of recourses to space and time, and particularly by the ways in which mythical references to genesis can be duplicated in historical events, and how the latter, or, more simply, any contemporary element, may found its authority on its reflection of these founding myths. In this sense, for example, the contemporary institutions of Bulopwe (imported sacred royalty) and Bufumu (indigenous social order) reenact in their architecture the complementary yet conflictual inheritance of founding fathers Mbidi Kiluwe and Nkongolo Mwamba, an inheritance symbolized in Kalala Ilunga and actualized in the body of a Luba king. This temporal circularity can be compared to both the map of the Luba "empire" and its etiological narratives. Here is an empire dominated by a symbolic body that transcends all dynastic lines, thus rendering any chronology of successions problematic. On the other hand, despite the centrality of the royal icon, the empire has no center, and its etiology superimposes a mythical narrative as a collective memory onto a complex history of concrete political negotiations and geographical expansions.

"We come from the East. . . . " A spatial reference fuses with a sense of a primordial time, simultaneously indicating the possible origin of an endless cultural project. In effect, from the events represented by Nkongolo we can move in time and in space to other symbolic origins (such as the foundations of Lunda and Bemba cultures), which, in what they narrate, comment also on the histories of matrilinearity and patrilinearity in relation to exogamy, and on unbearable human nightmares (incest, patricide, regicide) and the images of them that have been articulated in historical negotiations for power. Here we understand concretely how the myth, in its dynamics of memory, is in dialogue with the contradictory trends of a history, and how history must transform itself from etiology into a different discourse in order to become a valid interpretation of complex sagas.

The Luba case inexorably brings to mind the ancient meaning of the term "*historia*" as a historical and geographical catalogue. We think of the Luba culture and its history in terms of tensions, efforts, and projects that have sustained a totality of social formations through time and space. In this perspective, it would be naive to bring back such controversial and controverted notions as the "genius" or "psychology" of a people. We have already noted the possibility of using the king's body as a principle of questioning. That body contains two conflictual inheritances; and from generation to generation, it has been rearticulated and recomposed, realizing and assuming itself in the opposing expectations of each social formation. It is not an accident that the mythological narratives of genesis inscribe themselves on the earth itself, for the earth reflects the king's body. Place and body memory converge in the king's person.

Thus a map provides the infinite signs of a finite culture. Each Luba village exists in the rhythmic face-to-face of a *mutu* or upper area versus a *tshibanda* or lower region; the first covering the east and the south, the second the west and the north. This dichotomy is faithfully reproduced in both the fecund households and the body politics of the community itself, and in this sense seems to witness a dualistic cosmology. On the other side of genesis, it can be seen incarnated in the basic structure of the social formation: the *diku* or nuclear family, sanctioned by both biological and religious logics, contributes to the *tshota* or ensemble of families claiming the "same blood." And whenever all the members of *diku* cannot share the *nzolo wa kakishi*—the gift, generally a chicken, offered to spirits—this limited structure divides itself into two. From infinite divisions by two, a culture (*tshisamba*) produces itself gradually as a *ditunga*, that is, as a territory and society. Its members are the *Bena-Ditunga*, "the people of the territory" as opposed to foreigners.

Indeed every Luba person is conscious of what, at first sight, may seem to be a generalized binarism. Written on the body of the king, this binarism testifies about a way of detailing a tradition, that tradition's exegeses, and some of its most significant characteristics. Even the mythological events of absolute beginnings can be reduced to binary oppositions. The Supreme Being brings life in two creations, each conceived in two seasons and comprising two types of beings, the celestial and the terrestrial. The elements of each of these classes are in turn divided into elder and junior, male and female. Yet looked at carefully, the beautiful classification in two is transformed into other more complex patterns. We need only recall the third party that must mediate and transcend the opposition of two, as is well represented in the junction of the Bufumu of Nkongolo and the Bulopwe of Mbidi in the body of the Luba king, symbolized by Kalala. A more telling illustration is the third category that fuses masculine and feminine, elder and junior beings and elements, and transmutes these primary ordering into absolutely new concepts. Thus the moon, for example, which in its primary classification is qualified as masculine and senior to other celestial bodies, becomes feminine and junior vis-à-vis the sun.

Each culture is its own symbolic system, anchored in a number of basic a prioris. Through education and socialization, these a prioris contribute directly to the constitution of contingent laws that inscribe them in human behavior as necessities. Codifications and their interpretations as collective rules or strategies indicate how the individual should determine his or her own relation to a past and its arbitrary purposes. The feel of the game that any subject develops—in being, acting, and creating—witnesses a habitus, an unconscious way of belonging to the community, its history, and its creativity. Such is the idea of "Luba."

This book and its exhibition sketch an exemplary outline for an approach to Luba culture. Finite histories are in suspense, and, beyond the facile periodizations that have fractured them, such histories gain a unique sense as original ideas.

Bibliography

Abiodun, Rowland
1990 "The Future of African Art Studies: An African Perspective." In *African Art Studies: The State of the Discipline*. Washington, D.C.: National Museum of African Art.

ACB (Archives du Congo Belge, Section Documentation)
1958 "*Documents pour servir à la connaissance des populations du Congo Belge: aperçu historique (1886–1933).*" Léopoldville. Copy consulted at the archives of the Bureau des Affaires Culturelles, Division Régionale des Affaires Politiques, Lubumbashi, Zaire.

Anciaux de Faveaux, E., and P. de Maret
1984 "*Premières datations pour la fonte du cuivre au Shaba (Zaire).*" *Bulletin de la Société Royale Belge d'Archéologie et de la Préhistoire* 95:5–21.

Anonymous
1883 *The Congo: The White Line across the Dark Continent. The Operations of the Association Internationale Africaine and of the Comité d'Étude du Haut Congo from December 1877 to October 1882, by a Participant in the Enterprise*. London: E. & F. N. Spon.

Arnheim, Rudolph
1988 *The Power of the Center: A Study of Composition in the Visual Arts*. Berkeley: University of California Press.

Bachelard, Gaston
1969 *The Poetics of Space*. Boston: Beacon Press.
1971 *The Poetics of Reverie*. Boston: Beacon Press.

Bailey, F. G.
1991 *The Prevalence of Deceit*. Ithaca: Cornell University Press.

Barber, Karin
1994 "The Secretion of *Oríkì* in the Material World." *Passages* (newsletter of the Program of African Studies, Northwestern University) 7:10–12.

Barth, Fredrik
1987 *Cosmologies in the Making*. New York: Cambridge University Press.

Bastin, Y., A. Coupez, and B. de Halleux
1983 "*Classification lexostatistique des langues bantoues (214 relevés).*" *Bulletin des Séances de l'Academie Royal des Sciences de l'Outre-Mer* 27(2):173–99.

Bateson, Gregory
1958 *Naven*. Stanford: at the University Press.

Baudrillard, Jean
1983 *Simulations*. New York: Semiotext(e).

Becker, Rayda
1992 "The Photographs of W. F. P. Burton." In *The Collection of W. F. P. Burton*. Ed. University Art Galleries staff. Johannesburg: University of the Witwatersrand Art Galleries.

Bellezza, Francis
1981 "Mnemonic Devices: Classication, Characteristics, and Criteria." *Review of Educational Research* 51(2):247–75.

Benjamin, Walter
1986 "On the Mimetic Faculty." In *Reflections by Walter Benjamin*. Ed. P. Demetz. New York: Schocken.
1988 "The Task of the Translator." In *Illuminations: Essays and Reflections by Walter Benjamin*. Ed. Hannah Arendt. New York: Schocken.

Berliner, Paul
1981 *The Soul of Mbira: Music and Traditions of the Shona People of Zimbabwe*. Berkeley: University of California Press.

Berns, Marla
1988 "Ga'anda Scarification: A Model for Art and Identity." In *Marks of Civilization: Artistic Transformations of the Human Body*. Ed. A. Rubin. Los Angeles: UCLA Fowler Museum of Cultural History.

Biebuyck, Daniel
1981 *Statuary from the Pre-Bembe Hunters*. Tervuren: Royal Museum of Central Africa.

Binsbergen, Wim van
1978 "Explorations in the History and Sociology of Territorial Cults in Zambia." In *Guardians of the Land: Essays on Central African Territorial Cults*. Ed. J. Schoffeleers. Gwelo (Zimbabwe): Mambo Press.
1981 *Religious Change in Zambia*. London: Kegan Paul.

Bisson, Michael
1975 "Copper Currency in Central Africa: The Archaeological Evidence." *World Archaeology* 6(3):276–92.
1976 "The Prehistoric Coppermines of Zambia." Unpublished Ph.D. dissertation, University of California, Santa Barbara.

Blakeley, Pamela, and Thomas Blakeley
1994 "Ancestors, 'Witchcraft,' and Foregrounding the Poetic: Men's Oratory and Women's Song-Dance in Hêmbá Funerary Performance." In *Religion in Africa*. Ed. T. Blakeley, W. van Beek, and D. Thomson. Portsmouth, N.H.: Heinemann and James Currey.

Blier, Suzanne
1995a *African Vodun: Art, Psychology and Power*. Chicago: at the University Press.
1995b "Vodun: West African Roots of Vodou." In *Sacred Arts of Haitian Vodou*. Ed. D. Cosentino. Los Angeles: UCLA Fowler Museum of Cultural History.

Blok, Anton
1991 "Reflections on 'Making History.'" In *Other Histories*. Ed. K. Hastrup. London: Routledge, for the European Assocation of Social Anthropologists.

Bohannan, Paul, and Philip Curtin
1995 *Africa and Africans*. 4th ed. Madison: University of Wisconsin Press.

Boone, Olga
1961 "*Carte ethnique du Congo, quart sud-est.*" *Annales* 37. Tervuren: Royal Museum of Central Africa.

Boterdal, M.
1909 "*Rapport d'Enquête, Chefferie de Mulongo.*" Manuscript in the Royal Museum of Central Africa, Tervuren, Belgium.

Bouillon, A.
1954 "*La corporation des chasseurs Baluba.*" *Zaïre* 8(6):563–94.

Boyer, Pascal
1990 *Tradition as Truth and Communication: A Cognitive Description of Traditional Discourse*. Cambridge: at the University Press.

Brain, Robert
1979 *The Decorated Body*. New York: Harper & Row.

Burton, W. F. P.
1927 "The Country of the Baluba in Central Katanga." *Geographical Journal* 70:321–42.
1930 "The Secret Societies of Lubaland, Congo Belge." *Bantu Studies* 4(4):217–50.
1960 "Notes and Watercolors of Luba Coiffures." Archives of the Ethnographic Section, Royal Museum of Central Africa, Tervuren.
1961 "Luba Religion and Magic in Custom and Belief." In *Annales* 35. Tervuren: Royal Museum of Central Africa.

Cameron, Verney Lovett
1877 *Across Africa*. New York: Harper & Brothers, 2 vols.

Carey, Margret
1991 *Beads and Beadwork of West and Central Africa*. Buckinghamshire: Shire Ethnography.

Cartry, Michel
1992 "From One Rite to Another: The Memory in Ritual and the Ethnologist's Recollection." In *Understanding Rituals*. Ed. D. de Coppet. London: Routledge, for the European Association of Social Anthropologists.

Casey, Edward
1987 *Remembering: A Phenomenological Study*. Bloomington: Indiana University Press.

Centner, T.
1963 "*L'Enfant africain et ses jeux dans le cadre de la vie traditionnelle au Katanga.*" *Mémoires du CEPSI* no. 17, Elizabethville (now Lubumbashi, Zaire).

Childs, S. Terry
1991a "Transformations: Iron and Copper Production in Central Africa." In *Recent Trends in Archaeo-Metallurgical Research*. Ed. P. Glumac. *MASCA Research Papers in Science and Archaeology* 8(I).
1991b "Iron as Utility or Expression: Reforging Function in Africa." In *Metals in Society: Theory beyond Methods*. Ed. R. Ehrenreich. *MASCA Research Papers in Science and Archaeology* 8(2).
1991c "Style, Technology and Iron-Smelting Furnaces in Bantu-Speaking Africa." *Journal of Anthropological Archaeology* 10:332–59.

Childs, S. Terry, and William Dewey
1995 "Forging Symbolic Meaning in Zaire and Zimbabwe." In *Culture and Technology of African Iron Production*. Ed. P. Schmidt. Gainesville: University of Florida Press.
forthcoming 1996 "Anvils and Hairpins for Blacksmiths and Kings." *Iowa Studies in African Art* 5.

Childs, S. Terry, William Dewey, Muya Kamwanga, and Pierre de Maret
1990 "Iron Age and Stone Age Research in the Shaba Region, Zaire: An Interdisciplinary and International Effort." *Nyame Akuma* 32:54–59.

Childs, S. Terry, and David Killick
1993 "Indigenous African Metallurgy: Nature and Culture." In *Annual Review of Anthropology* 22:317–37.

Chinyanta, Munona, and Chileya Chiwale
1989 *Mutomboko Ceremony and the Lunda-Kazembe Dynasty*. Lusaka: Kenneth Kaunda Foundation.

Churchland, Paul
1995 *The Engine of Reason, the Seat of the Soul: A Philosophical Journey into the Brain*. Boston: MIT Press.

Claerhout, P.
1949 "*Un mangeur de foudre!*" *Grands Lacs* 61(4–6/New Series 82–84):78.

Clifford, James
1988 *The Predicament of Culture*. Cambridge: Harvard University Press.

Clifford, James, Virginia Dominguez, and Trinh Minh-ha
1987 "Of Other Peoples: Beyond the 'Salvage' Paradigm." In *Discussions in Contemporary Culture*. Ed. Hal Foster. Seattle: Bay Press, for the Dia Art Foundation.

Colby, Benjamin, and Michael Cole
1973 "Culture, Memory and Narrative." In *Modes of Thought: Essays on Thinking in Western and Non-Western Societies*. Ed. R. Horton and R. Finnegan. London: Faber and Faber.

Colle, Pierre
1905 "*Croyances religieuses des Baluba.*" *Bulletin des missions des Pères Blancs d'Afrique* 78–81.
1913 *Les Baluba*. 2 vols. Antwerp: Albert Dewit.

Connerton, Paul
1991 *How Societies Remember*. New York: Cambridge University Press.

Cornet, Joseph
1982 "*Art royal kuba.*" In *Sura Dji: Visages et racines du Zaïre*. Paris: Musée des Arts Décoratifs.

Cornevin, Robert
1970 *Histoire du Congo, des origines préhistoriques à la République Démocratique du Congo*. Paris: Éditions Berger Levrault.

Cosentino, Donald
1991 "Afrokitsch." In *Africa Explores: 20th Century African Art*. Ed. Susan Vogel. New York: Center for African Art, and Munich: Prestel.

Crawford, Dan
1924 *Back to the Long Grass*. London: Hodder and Stoughton.

Cunnison, Ian
1959 *The Luapula Peoples of Northern Rhodesia*. Manchester: at the University Press, for the Rhodes-Livingstone Institute.
1969 "History on the Luapula." *Rhodes-Livingstone Papers* 21, 1st ed. 1951.

David, Nicholas, and Yves LeBléis
1988 *Dokwaza, the Last of the African Iron Maskers* (film). Calgary: University of Calgary Department of Communications Media.

Davis, John
1991 "History and the People without Europe." In *Other Histories*. Ed. K. Hastrup. London: Routledge, for the European Association of Social Anthropologists.

Davis, Natalie, and Randolph Starn
1989 "Introduction." In "Memory and Countermemory." Ed. N. Davis and R. Starn. *Representations* 26:1–6.

Davis-Roberts, Christopher
1980 "*Mungu na Mitishamba*: Illness and Medicine among the Tabwa of Zaire." Unpublished Ph.D. dissertation, the University of Chicago, Department of Anthropology.

De Boeck, Filip
forthcoming "Bodies of Rememberance: Knowledge, Experience and the Growing of Memory in Luunda Ritual Performance." In *Knowledge and Experience in African Ritual*, a special issue of *Africa* magazine edited by Richard F. Werbner.

Delfosse, C.
1948 "*Sorciers, devins, féticheurs, dans les milieux Baluba.*" *Bulletin de l'association des anciens étudiants de l'Université coloniale de Belgique* 2:10–27, 3:14–18.

Derricourt, Robin
1980 "People of the Lakes: Archaeological Studies in Northern Zambia." *Zambian Papers* 13. (Lusaka: Institute for African Studies, University of Zambia.)

Derrida, Jacques
1993 *Memoirs of the Blind: The Self-Portrait and Other Ruins*. Chicago: at the University Press.

Devisch, René (Renaat)
1983 "*Le corps sexué et social ou les modalités d'échange sensoriel chez les Yaka du Zaire.*" *Psychopathologie africaine* 19(1):5–31.
1985 "Perspectives on Divination in Contemporary Sub-Saharan Africa." In *Theoretical Explorations in African Religion*. Ed. W. van Binsbergen and M. Schoffeleers. Boston: Routledge Kegan Paul.
1988 "From Equal to Better: Investing the Chief among the Northern Yaka of Zaire." *Africa* 58(3):261–90.

Dewey, William J.
1986 "Shona Male and Female Artistry." *African Arts* 19(3):64–67.
1990 *Weapons for the Ancestors* (video). Iowa City: University of Iowa Video Production Unit.

Dewey, William, and Allen Roberts
1993 *Iron, Master of Them All*. Iowa City: The University of Iowa Museum of Art and the Project for Advanced Study of Art and Life in Africa.

Diouf, Mamadou
1992a "Islam: Peinture sous verre et idéologie populaire." In *Art pictoral zaïrois*. Ed. B. Jewsiewicki. Sillery, Quebec: Eds. du Septentrion.

1992b "Fresques murales et écriture de l'histoire: Le Set/Setal àDakar." *Politique africaine* 46:41–54.

Doke, Clement
1933 *English-Lamba Vocabulary*. Johannesburg: University of Witwatersrand Press.

Donohugh, Agnes, and Priscilla Berry
1932 "A Luba Tribe in Katanga: Customs and Folklore." *Africa* 5(2):176–83.

D'Orjo de Marchovelette, E.
1940 "Quelques considérations sur les 'Bambudie' du territoire de Kabongo." *Bulletin des juridictions indigènes du droit coutumier congolais* 10:275–89.

1950–51 "Notes sur les funérailles des chefs Ilunga Kabale et Kabongo Kumwimba: Historique de la chefferie Kongolo." *Bulletin des juridictions indigènes et du droit coutumier congolais* 18(12):350–68, 19(1):1–13.

1954 "La divination chez les Baluba au moyen du 'lubuko' ou 'katotola.'" *Zaïre* 8(5):487–505.

Douglas, Mary
1973 *Natural Symbols*. Baltimore: Penguin.

Dragoo, Don
1975 "The Trimmed-Core Tradition in Asiatic-American Contacts." In *Lithic Technology: Making and Using Stone Tools*. Ed. E. Swanson. The Hague: Colin Mouton.

Durkheim, Émile
1966 *The Elementary Forms of the Religious Life*. 1st ed. 1915. New York: Free Press.

Échard, Nicole, ed.
1983 "Métallurgies africaines." *Mémoires de la Société des Africanistes* 9.

Einzig, Paul
1966 *Primitive Money in Its Ethnological, Historical and Economic Aspects*. New York: Pergamon Press.

Erikson, Joan
1969 *The Universal Bead*. New York: Norton.

Esbenshade, Richard
1995 "Remembering to Forget: Memory, History, National Identity in Postwar East-Central Europe." *Representations* 49:72–96.

Fabian, Johannes
1983 *Time and the Other*. New York: Columbia University Press.

1986 *Language and Colonial Power*. Berkeley: University of California Press.

forthcoming *Remembering the Present*

Faider-Thomas, Thomas
n.d. "Katatora, objet divinatoire sculpté chez les Luba." *Congo-Tervuren* 18–20.

Faïk-Nzuji, Clémentine
1974 *Kasala: Chant héroïque luba*. Lubumbashi: Presses Universitaires du Zaïre.

1992 *Symboles graphiques en Afrique noire*. Paris: Karthala/CILTADE.

1993 *La Puissance du sacré: L'Homme, la nature et l'art en Afrique noire*. Brussels: La Renaissance du Livre.

Faris, James
1988 "Significance and Differences in the Male and Female Personal Art of the Southeast Nuba." In *Marks of Civilization: Artistic Transformations of the Human Body*. Ed. A. Rubin. Los Angeles: Museum of Cultural History, University of California, Los Angeles.

Félix, Marc
1992 "Luba Zoo: Kifwebe and Other Striped Masks." *Occasional Paper*. Brussels: Zaire Basin Art History Research Center.

Fernandez, James
1977 "The Performance of Ritual Metaphors." In *The Social Use of Metaphor*. Ed. J. D. Sapir and C. Crocker. Philadelphia: University of Pennsylvania Press.

1986 *Persuasions and Performances*. Bloomington: Indiana University Press.

1991 "Afterword." In *African Divination Systems: Ways of Knowing*. Ed. P. Peek. Bloomington: Indiana University Press.

Fischer, Werner, and Manfred Zirngibl
1978 *African Weapons*. Passau: Prinz-Verlag.

Flexner, Stuart
1987 *The Random House Dictionary of the English Language*. 2nd ed. New York: Random House.

Forché, Carolyn
1993 *Against Forgetting*. New York: Norton.

Foucault, Michel
1977 *Language, Counter-Memory, Practice*. Ed. D. Bouchard. Ithaca: Cornell University Press.

Fourche, J.-A. Tiarko, and H. Morlighem
1939 *Les communications des indigènes du Kasai avec les âmes des morts*. Brussels: Librairie Falk fils, for the Institut Royal Colonial Belge.

Francis, Mark, and Randolph Hester
1991 "The Garden as Idea, Place, and Action." In *The Meaning of Gardens*. Ed. M. Francis and R. Hester. Boston: MIT Press.

Fraser, Douglas, and Herbert Cole, eds.
1972 *African Art and Leadership*. Madison: University of Wisconsin Press.

Freedberg, David
1989 *The Power of Images: Studies in the History and Theory of Response*. Chicago: at the University Press.

Gansemans, Jos
1978 "La musique et son rôle dans la vie sociale et rituelle luba." *Annales du Musée Royal de l'Afrique Centrale* 95:47–121.

1980 "Les instruments de musique luba (Shaba, Zaïre)." *Annales du Musée Royal de l'Afrique Centrale* 103.

1981 "La musique et son rôle dans la vie sociale et rituelle luba." *Cahiers des Religions Africaines* 16(31–32):181–234.

Geary, Christrand, and Andrea Nicolls
1994 *Beaded Splendor*. Washington, D.C.: National Museum of African Art.

Geertz, Clifford
1979 "Religion as a Cultural System." In *Reader in Comparative Religion*. Ed. W. Lessa and E. Vogt. New York: Harper & Row.

1973 *The Interpretation of Cultures*. New York: Basic Books.

Gellner, Ernest
1973 "The Savage and the Modern Mind." In *Modes of Thought: Essays on Thinking in Western and Non-Western Societies*. Ed. R. Horton and R. Finnegan. London: Faber and Faber.

Gillis, A.
1981 *Dictionnaire Français-Kiluba*. Gent: Henri Dunantlaan 1.

Goehring, Heinz
1970 *Baluba: Studien xur Selbstordnung und Herrschaftsstruktur der Baluba*. Meiseheim am Glan (Anton Hain). *Studia Ethnologica* vol. 1.

Goody, Jack
1977 "Mémoire et apprentissage dans les sociétés avec et sans écriture: La Transmission du Bagre." *L'Homme* 17:29–52.

1987 *The Interface between the Written and the Oral*. Cambridge: at the University Press.

Gran, Guy, ed.
1979 *Zaire: The Political Economy of Underdevelopment*. New York: Praeger.

Grévisse, F.
1956–58 "Notes ethnographiques relatives à quelques populations autochtones du Haut-Katanga industriel." *Bulletin du Centre d'Étude des problèmes sociaux indigènes* 32:65–207, 33:68–150, 34:53–136.

Guillemé, Mathurin
1887 Letter, from Kibanga, to a Monsignor Morel, August. Unpublished document, C.19.438, General Archives of the Missionaries of Our Lady of Africa (the White Fathers), Rome.

Gyatso, Janet
1992 "Introduction." In *In the Mirror of Memory: Reflections on Mindfulness and Remembrance in Indian and Tibetan Buddhism*. Ed. Gyatso. Albany: State University of New York Press.

Hall, Martin
1984 "The Burden of Tribalism: The Social Context of Southern African Iron Age Studies." *American Antiquity* 49:455–67.

1990 "'Hidden history': Iron Age Archaeology in Southern Africa." In *A History of African Archaeology*. Ed. P. Robertshaw. London: James Currey.

Hallen, Barry, and J. O. Sodipo
1986 *Knowledge, Belief, and Witchcraft: Analytic Experiments in African Philosophy*. London: Ethnographica.

Hanna, Judith
1980 *To Dance Is Human: A Theory of Nonverbal Communication*. Austin: University of Texas Press.

Harley, Brian, and David Woodward
1987 "Concluding Remarks." In *History of Cartography* vol. 1, *Cartography in Prehistoric, Ancient, and Medieval Europe and the Mediterranean*. Ed. Harley and Woodward. Chicago: at the University Press.

Hastrup, Kirsten, ed.
1991 *Other Histories*. London: Routledge, for the European Association of Social Anthropologists.

Henige, David
1974 *The Chronology of Oral Tradition: Quest for a Chimera*. New York: Oxford University Press.

Henroteaux, M.
1945 "Notes sur la secte des bambudye." *Bulletin des juridictions indigènes et du droit coutumier congolais* 13(4):98–107.

Herbert, Eugenia
1984 *Red Gold of Africa*. Madison: University of Wisconsin Press.

1993 *Iron, Gender and Power*. Bloomington: Indiana University Press.

Heusch, Luc de
1982 *The Drunken King, or, the Origin of the State*. Bloomington: Indiana University Press.

1988 "Arts d'Afrique: une approche esthétique." In *Utotombo: L'Art d'Afrique dans les collections privées belges*. Brussels: Palais des Beaux-Arts.

1991 "The King Comes from Elsewhere." In *Body and Space: Symbolic Models of Unity and Division in African Cosmology and Experience*. Ed. A. Jacobson-Widding. *Uppsala Studies in Cultural Anthropology* 16. Stockholm: Almqvist and Wiksell.

Hiernaux, J., E. Longree, and J. De Buyst
1971 "Fouilles Archéologiques dans la Vallée du Haut-Lualaba, Zaire. I. Sanga, 1958." *Annales* 73. Tervuren: Royal Museum of Central Africa.

Hiernaux, J., E. Maquet, and J. de Buyst
1972 "Le cimetière protohistorique de Katoto (vallée du Lualaba, Congo-Kinshasa)." In *Sixième Congrés Panafricain de Préhistoire,*

Dakar, 1967. Chambéry: Les Imprimeries Réunies.

Jackson, Michael
1989 *Paths Toward a Clearing: Radical Empiricism and Ethnographic Inquiry*. Bloomington: Indiana University Press.

Jacobson-Widding, Anita
1979 "Red-White-Black as a Mode of Thought." In *Uppsala Studies in Cultural Anthropology* 1. Stockholm: Almqvist and Wiksell.

1983 "Body and Power: Symbolic Demarcations of Separate Identity." In *Identity: Personal and Socio-Cultural*. Ed. A. Jacobson-Widding. *Uppsala Studies in Cultural Anthropology* 5. Stockholm: Almqvist and Wiksell and Humanities Press.

Jewsiewicki, Bogumil
1989 "The Formation of the Political Culture in Ethnicity in the Belgian Congo." In *The Creation of Tribalism in Southern Africa*. Ed. L. Vail. Berkeley: University of California Press.

Jewsiewicki, Bogumil, and V. Y. Mudimbe
1993 "Africans' Memories and Contemporary History of Africa." In *History Making in Africa*, ed. V. Mudimbe and B. Jewsiewicki, an issue of *History and Theory: Studies in the Philosophy of History* 32(4).

Johnson, F.
1988 *A Standard Swahili-English Dictionary*. 1939. London: Oxford University Press.

Johnson, Mark
1987 *The Body in the Mind: The Bodily Basis of Meaning, Imagination, and Reason*. Chicago: at the University Press.

Jordàn, Manuel
1994 "Heavy Stuff and Heavy Staffs from Chokwe and Related Peoples of Angola, Zaire, and Zambia." In *Staffs of Life: Rods, Staffs, Scepters, and Wands from the Coudron Collection of African Art*. Ed. Allen Roberts. Iowa City: Project for Advanced Study of Art and Life in Africa and the University of Iowa Museum of Art.

Joset, Georges
1934 "Étude sur les sectes secrètes de la circonscription de Kinda, district du Lomami, territoire des Baluba." *Bulletin de la Société Royal Belge de Géographie* 58(1):28–44.

Kaeppler, Adrienne
1991 "Memory and Knowledge in the Production of Dance." In *Images of Memory*. Ed. S. Küchler and W. Melion. Washington, D.C.: Smithsonian Institution Press.

Kalungwe, Mankunga
1990 "Histoire des populations riveraines du lac Moero et de la vallée du Bas-Luapula." *Mbegu, Revue scientifique et pédagogique de l'Institut Supérieur Pédagogique de Lubumbashi* 21:104–24.

Kaoze, Stefano
n.d. "Croyances et pratiques religieuses de nos populations indigènes." Unsigned, undated manuscript in a folder labeled "Abbé Kaoze," Archives of the Kalemie-Moba Diocese, Kalemie, Zaire.

ca. 1930 "Les mikoa ou clans." Unpublished manuscript, Archives of the Kalemie-Moba Diocese, Kalemie, Zaire.

Karp, Ivan
1989 "Power and Capacity in Rituals of Possession." In *Creativity of Power: Cosmology and Action in African Societies*. Ed. W. Arens and I. Karp. Washington, D.C.: Smithsonian Institution Press.

Kazadi Ntole
1980 "Scarification et langage dans la culture des Bahemba." Unpublished conference paper.

Kerner, Donna
1994 "Mregbo Sticks and the Exegesis of the Body Politic." *Passages* (newsletter of the

Program of African Studies, Northwestern University) 7:3–5, 7.

1995 "Chaptering the Narrative: The Material of Memory in Kilimanjaro, Tanzania." In *The Labyrinth of Memory*. Ed. M. Teski and J. Climo. Westport, Conn: Bergin and Garvey.

Kirshenblatt-Gimblett, Barbara
1991 "Objects of Ethnography." In *Exhibiting Cultures*. Ed. I. Karp and S. Lavine. Washington, D.C.: Smithsonian Institution Press.

Kitenge-Ya
1976 "*Les Ntapo: Essai d'intérpretation générale des tatouages dans la monde afro-bantou.*" *Problèmes sociaux zaïrois* 114–15:159–69.

Küchler, Susanne and Walter Melion
1991 *Images of Memory: On Remembering and Representation*. Washington: Smithsonian Institution Press.

Labrecque, E.
1951 "*Histoire des Mwata Kazembe, chefs lunda du Luapula.*" *Lovania* 18:9–33.

Lambo, L.
1947 "*Étude sur les devins et sorciers.*" *Bulletin des juridictions indigènes et du droit coutumier congolais* 15(5):133–43.

Layton, Robert
1989 "Introduction: Who Needs the Past?" In *Who Needs the Past? Indigenous Values and Archaeology*. Ed. Layton. London: Unwin Hyman.

1992 *The Anthropology of Art*. 2nd ed. New York: Cambridge University Press.

Le Goff, Jacques
1992 *History and Memory*. New York: Columbia University Press.

Leakey, Louis B., Ruth Simpson, et al.
1972 *Pleistocene Men at Calico*. San Bernardino: San Bernardino County Museum.

Lechtman, Heather
1977 "Style in Technology—Some Early Thoughts." In *Material Culture—Styles, Organization and Dynamics of Technology*. Ed. R. Merrill and H. Lechtman. St. Paul: West.

Lévi-Strauss, Claude
1966 *The Savage Mind*. Chicago: at the University Press.

Lewis, I. M.
1991 *Ecstatic Religion: A Study of Shamanism and Spirit Possession*. 2nd ed. New York: Routledge.

Lewis-Williams, David, and Thomas Dowson
1989 *Images of Power: Understanding Bushman Rock Art*. Johannesburg: Southern Book Publishers.

Liu, Robert
1984 "The Bead in African Assembled Jewelry: Its Multiple Manifestations." In *Beauty by Design: The Aesthetics of African Adornment*. Ed. M.-T. Brincard. New York: African-American Institute.

Lopez, Donald S.
1992 "Memories of the Buddha." In *In the Mirror of Memory: Reflections on Mindfulness and Remembrance in Indian and Tibetan Buddhism*. Ed. J. Gyatso. Albany: State University of New York Press.

Lucas, Stephen A.
1966–67 "*L'Etat traditionnel Luba.*" *Problèmes Sociaux Congolais* 74:83–97, 79:93–116.

MacGaffey, Janet
1983 "How to Survive and Get Rich Amidst Devastation: The Second Economy in Zaire." *African Affairs* 82:351–66.

1986 "Fending for Yourself: The Organization of the Second Econommy in Zaire." In *The Crisis in Zaire: Myths and Realities*. Ed. Nzongola-Ntalaja. Trenton: Africa World Press.

MacGaffey, Wyatt
1983 *Modern Kongo Prophets*. Bloomington: Indiana University Press.

1988 "Complexity, Astonishment and Power: The Visual Vocabulary of Kongo Minkisi." *Journal of Southern African Studies* 14(2):188–203.

Mack, John
1991 *Emil Torday and the Art of the Congo, 1900–1909*. London: British Museum Publications.

Maes, Joseph
1924 *Aniota Kifwebe: Les masques des populations du Congo Belge*. Antwerp: Editions de Stikken.

Maes, R.
1963 "*Rapport sur le releve des coutumes des Bakunda de la Chefferie Tondo et de la Chefferie Mwenge.*" *Bulletin des tribunaux coutumiers* 31(4):117–41.

Mair, Lucy
1977 *African Kingdoms*. Oxford: at the University Press.

Makonga, Bonaventure
1948 "*Samba-a-kya-Buta.*" *Bulletin des juridictions indigènes et du droit coutumier congolais* 10:304–16, 11:321–45.

Marchal, R.
1937 "*Le droit foncier coutumier des Bazela, des Balomotwa et des Baweushi.*" *Bulletin des juridictions indigènes et du droit coutumier du Katanga* 5(1):17–21, 41–51.

Maret, Pierre de
1977 "Sanga: New Excavations, More Data, and Some Related Problems." *Journal of African History* 18(3):321–37.

1978 "*Chronologie de l'âgo du fer dans la dépression de l'Upemba en république du Zaïre.*" 3 vols. Ph.D. dissertation, Université Libre de Bruxelles.

1979 "Luba Roots: The First Complete Iron Age Sequence in Zaire." *Current Anthropology* 20(1):233–35.

1980 "Bribes, débris, et bricolage." In "*L'expansion bantoue,*" *Actes du Colloque International du CNRS* 3:713–30.

1981 "*L'Évolution monétaire du Shaba central entre le 7e et le 18e siécle.*" *African Economic History* 10:117–49.

1985a "*Fouilles Archéologiques dans la Vallée du Haut-Lualaba, Zaire. II. Sanga et Katongo, 1974.*" 2 vols. *Annales*, Musée Royal de l'Afrique Centrale, Sciences humaines, #120, Tervuren.

1985b "The Smith's Myth and the Origin of Leadership in Central Africa." In *African Iron Working*. Ed. R. Haaland and P. Shinnie. Oslo: Norwegian University Press.

1990 "Phases and Facies in the Archaeology of Central Africa." In *A History of African Archaeology*. Ed. P. Robertshaw. London: James Currey.

1992 "*Fouilles Archéologiques dans la Vallée du Haut-Lualaba, Zaire. III. Kamilamba, Kikulu, et Malemba-Nkulu, 1974–75.*" 2 vols. *Annales*, Musée Royal de l'Afrique Centrale, Sciences humaines, #131, Tervuren.

1994 "Archaeological and Other Prehistoric Evidence of Traditional African Religious Experience." In *Religion in Africa*. Ed. T. Blakeley, W. van Beek, and D. Thomson. Portsmouth, N.H.: Heinemann and James Currey.

1995 "Croisette memories." In *Objets-Signes d'Afrique*. Ed. L. de Heusch. Tervuren: Musée Royal de l'Afrique Centrale.

Maret, Pierre de, Nicole Dery and Cathy Murdoch
1973 "The Luba-Shankadi Style" *African Arts* 7(1):8–15, 88.

Mascia-Lees, Frances, and Patricia Sharpe
1992 "Introduction: Soft-Tissue Modification and the Horror Within." In *Tattoo, Torture, Mutilation, and Adornment: The Denaturalization of the Body in Culture and Text*. Ed. F. Mascia-Lees and P. Sharpe. Albany: State University of New York Press.

Maxwell, Kevin
1983 *Bemba Myth and Ritual*. New York: Peter Lang.

McLean, David, and Ted Solomon
1971 "Divination among the Bena Lulua." *Journal of Religion in Africa* 4(1):25–44.

McLeod, Malcolm
1976 "Verbal Elements in West African Arts." *Quaderni Poro* 1:85–102.

McNaughton, Patrick
1988 *The Mande Blacksmiths: Knowledge, Power, and Art in West Africa*. Bloomington: Indiana University Press.

Miller, Arthur
1991 "Transformation of Time and Space: Oaxaca, Mexico, circa 1500–1700." In *Images of Memory*. Ed. S. Küchler and W. Melion. Washington, D.C.: Smithsonian Institution Press.

Mitchell, J. Clyde
1956 *The Kalela Dance*. Manchester: at the University Press.

Molyneaux, Brian
1994 "Introduction: The Represented Past." In *The Presented Past: Heritage, Museums and Education*. Ed. P. Stone and B. Molyneaux. London: Routledge.

Morris, William, ed.
1969 *The American Heritage Dictionary of the English Language*. Boston: Houghton Mifflin.

Mudimbe, V. Y.
1988 *The Invention of Africa*. Bloomington: Indiana University Press.

1989 *Shaba Deux: Les carnets de Mère Marie Gertrude*. Dakar: Présence Africaine.

1991 *Parables and Fables: Exegesis, Textuality, and Politics in Central Africa*. Madison: University of Wisconsin Press.

1994 *The Idea of Africa*. Bloomington: Indiana University Press and James Currey.

Mufuta, Pierre
1969 *Le Chant kasàlà des Luba*. Paris: Juillard, Collection classiques africaines.

Mulago, Vincent
1973 *La religion traditionnelle des Bantu et leur vision du monde*. Kinshasa: Bibliothèque du Centre d'Études des Religions africaines.

Muriuki, Godfrey
1990 "The Reconstruction of African History through Historical, Ethnographic, and Oral Sources." In *The Excluded Past*. Ed. P. Stone and R. Mackenzie. London: Unwin Hyman.

Murphy, William
1980 "Secret Knowledge as Property and Power in Kpelle Society." *Africa* 50:193–207.

forthcoming "Mende Aesthetics of Politics: Public Wonder and Secret Tricks."

Mwata Kazembe XIV
1969 "My Ancestors and My People." *Rhodes-Livingstone Communications* 23, "Central Bantu Historical Texts 2: Historical Traditions of the Eastern Lunda." Trans. from the CiBemba by Ian Cunnison. Lusaka: Rhodes-Livingstone Institute.

Napier, A. David
1992 *Foreign Bodies: Performance, Art, and Symbolic Anthropology*. Berkeley: University of California Press.

Needham, Rodney
1981 *Circumstantial Deliveries*. Berkeley: University of Calfornia Press.

Nenquin, Jacques
1963 "Excavations at Sanga, 1957. The Protohistoric Necropolis." In *Annales* 45. Tervuren: Royal Museum of Central Africa.

Neyt, François
1977 *La Grand Statuaire hemba du Zaire*. Louvain-la-Neuve: Institut Supérieur d'Archéologie et d'Histoire de l'Art.

1994 *Luba: To the Sources of the Zaire*. Paris: Musée Dapper.

Nooter, Mary
1984 "Luba Leadership Arts and the Politics of Prestige." Unpublished M.A. paper, Columbia University.

1990a Catalogue entries in *Art of Central Africa: Masterpieces from the Berlin Museum für Völkerkunde*. Ed. H-J Koloss. New York: The Metropolitan Museum of Art.

1990b "Secret Signs in Luba Sculptural Narrative: A Discourse on Power." *Iowa Studies in African Art* 3:35–60.

1991 "Luba Art and Polity: Creating Power in a Central African Kingdom." Unpublished Ph.D. dissertation, Columbia University.

1992 "Fragments of Forsaken Glory: Luba Royal Culture Invented and Represented (1883–1992)." In *Kings of Africa: Art and Authority in Central Africa*. Maastricht: Foundation Kings of Africa.

1993 *Secrecy: African Art That Conceals and Reveals*. Ed. M. Nooter. Munich: Prestel, for the Museum for African Art, New York.

1994 "The Sculpted Narratives of Luba Staffs of Office." In *Staffs of Life: Rods, Staffs, Sceptres, and Wands from the Coudron Collection of African Art*. Ed. A. Roberts. Iowa City: Project for Advanced Study of Art and Life in Africa and the University of Iowa Museum of Art.

Nora, Pierre
1984 *Les lieux de mémoire* vol. 1, *La République*. Paris: Gallimard.

1986 *Les lieux de mémoire* vol. 2, *La Nation*. Paris: Gallimard.

1989 "Between Memory and History." In "Memory and Countermemory," ed. N. Davis and R. Starn, *Representations* 26:7–25.

1993 *Les lieux de mémoire* vol. 3, *Les France*. Paris: Gallimard.

Nzongola-Ntalaja, Georges
1994 "Violation of Democratic Rights in Zaire." *Issue* (African Studies Association) 22(2):9–11.

Olbrechts, Frans
1947 *Plastiek van Kongo*. Antwerp: Standaard-Boekhandel.

O'Neill, Peter, S. Mulhy, and Winifred Lambrecht
1989 *Tree of Iron* (film). Gainesville: Foundation for African Prehistory and Archaeology.

Parkin, David
1991 "Simultaneity and Sequencing in the Oracular Speech of Kenyan Diviners." In *African Divination Systems: Ways of Knowing*. Ed. P. Peek. Bloomington: Indiana University Press.

Peek, Philip
1991 "Introduction: The Study of Divination, Past and Present." In *African Divination Systems: Ways of Knowing*. Ed. Peek. Bloomington: Indiana University Press.

Petit, Pierre
1989 "*Eléments d'Anthropologie sociale de la Chefferie Luba de Kinkondja, Shaba/Zaire.*" *Mémoire*, Université Libre de Bruxelles.

1993 "*Rites familiaux, rites royaux. Étude du système cérémoniel des Luba du Shaba (Zaire).*" Unpublished dissertation, Université Libre de Bruxelles.

1995 "*Le kaolin sacré et les porteuses de coupe (Luba du Shaba).*" In *Objects: Signs of Africa*. Ed. L. de Heusch. Tervuren: Musée Royal de l'Afrique Centrale.

Raharijaona, Victor
1989 "Archaeology and Oral Traditions in the Mitongoa-Andrainjato Area (Betsileo Region of Madagascar)." In *Who Needs the*

Past? Indigenous Values and Archaeology. Ed. R. Layton. London: Unwin Hyman.

Ranger, Terence, and Isario Kimambo, eds.
1972 *The Historical Study of African Religion.* London: Heinemann.

Reefe, Thomas
1977 "Lukasa: A Luba Memory Device." *African Arts* 10(4):48–50, 88.
1978 "The Luba Political Culture, c. 1500–c. 1800." *Enquêtes et documents d'histoire africaine* 3:105–16.
1981 *The Rainbow and the Kings: A History of the Luba Empire to 1891.* Berkeley: University of California Press.

Richards, Audrey
1935 "Bow Stand or Trident?" *Man* 35:390–92.

Roberts, Allen F.
1979 "'The Ransom of Ill-Starred Zaire': Plunder, Politics and Poverty in the OTRAG Concession." In *Zaire: The Political Economy of Underdevelopment.* Ed. G. Gran. New York: Praeger Scientific.
1980 "Heroic Beasts, Beastly Heroes: Principles of Cosmology and Chiefship Among the Lakeside BaTabwa of Zaire." Unpublished Ph.D. dissertation, the University of Chicago, Department of Anthropology.
1981 "Passage Stellified: Speculation upon Archaeoastronomy in Southeastern Zaire." *Archaeoastronomy* 4(4):27–37.
1982 "'Comets Importing Change of Time and State': Ephemerae and Process Among Tabwa of Zaire." *American Ethnologist* 9(4):712–29.
1984 "'Fishers of Men': Religion and Political Economy among Colonized 'Tabwa." *Africa* 54(2):49–70.
1985 "Social and Historical Contexts of Tabwa Art." In *The Rising of a New Moon: A Century of Tabwa Art.* Ed. A. Roberts and E. Maurer, Seattle: University of Washington Press for The University of Michigan Museum of Art.
1986a "'Like a Roaring Lion': Late 19th Century Tabwa Terrorism." In *Banditry, Rebellion and Social Protest in Africa.* Ed. D. Crummey. Portsmouth, N.H.: Heinemann Educational Books.
1986b "*Les arts du corps chez les Tabwa.*" *Arts d'Afrique Noire* 59, 15–20.
1987 "'Insidious Conquests': War-Time Politics along the Southwestern Shore of Lake Tanganyika." In *Africa and the First World War.* Ed. M. Page. London: MacMillan.
1988a "Through the Bamboo Thicket: The Social Process of Tabwa Ritual Performance." *TDR, The Drama Review* 32(2):123–38.
1988b "Tabwa Tegumentary Inscription." In *Marks of Civilization: Artistic Transformations of the Human Body.* Ed. A. Rubin. Los Angeles: Museum of Cultural History, University of California, Los Angeles.
1989 "History, Ethnicity and Change in the 'Christian Kingdom' of Southeastern Zaire." In *The Creation of Tribalism in Southern Africa: Studies in the Political Economy of Ideology.* Ed. L. Vail. Berkeley: University of California Press.
1990a "Tabwa Masks, 'An Old Trick of the Human Race.'" *African Arts* 23(2):cover, 36–47, 101–3.
1990b "Initiation, Art and Ideology in Southeastern Zaire." *Iowa Studies in African Art* 3:7–32.
1991 "Where the King Is Coming From." In *Body and Space: Symbolic Models of Unity and Division in African Cosmology and Experience.* Ed. A. Jacobson-Widding. Uppsala Studies in Cultural Anthropology 16:249–69. Stockholm: Almqvist and Wiksell.
1992 "Anarchy, Abjection and Absurdity: A Case of Metaphoric Medicine Among the Tabwa of Zaire." In *The Anthropology of*

Medicine: From Theory to Method. Ed. L. Romanucci-Ross, D. Moerman, and L. Tancredi. 2nd ed. New York and Amherst: Bergin for Praeger Scientific.
1993 "Insight, or, NOT Seeing Is Believing." In *Secrecy: African Art That Conceals and Reveals.* Ed. M. Nooter. New York: Museum for African Art.
1994 "Introduction." In *Staffs of Life: Rods, Staffs, Scepters, and Wands from the Coudron Collection of African Art.* Ed. A. Roberts. Iowa City: Project for Advanced Study of Art and Life in Africa and the University of Iowa Museum of Art.
1995a *Animals in African Art: From the Familiar to the Marvelous.* Munich: Prestel, for the Museum for African Art, New York.
1995b "Arts of Terror and Resistance in Eastern Zaire." *Elveghem Museum Studies* (University of Wisconsin). Special issue commemorating "African Reflections" exhibition, ed. H. Drewal.
1995c Entries, pp. 350–53, 360–61, 369–73, in *Trésors d'Afrique, Musée de Tervuren.* Ed. G. Verswijver et al. Tervuren: Musée royal de l'Afrique centrale.
forthcoming 1996a "Smelting Ironies: The Performance of a Tabwa Technology." In *Iron and Clay: Proceedings from the Fifth and Sixth Stanley Conferences on African Art.* Ed. W. Dewey, A. Roberts, and C. Roy. Iowa City: PASALA.
forthcoming 1996b *Reseen: Folk Art from the Global Scrap Heap.* Ed. C. Cerny and S. Seriff. New York: Harry N. Abrams, for the Museum of International Folk Art, Santa Fe.
forthcoming 1996c "The Aura of Amadu Bamba: Photography and Fabulation in Urban Senegal." Manuscript submitted for publication.
forthcoming 1997 *Threshold: African Art on the Verge.* New York: The Museum for African Art.
forthcoming(a) "Precolonial Tabwa Textiles." Submitted for publication.
forthcoming(b) "A Tabwa Chief's Last Crossroads." Submitted for publication.
forthcoming(c) "Bugabo: Arts, Ambiguity, and Transformation in Southeastern Zaire." Paper delivered at "Power Figures in Central Africa" conference, organized by Dr. Dunja Hersak, Brussels, 1992; being revised for publication.

Roberts, Andrew D.
1973 *A History of the Bemba: Political Growth and Change in North-Eastern Zambia before 1900.* London: Longman.

Robertshaw, Peter (ed.)
1990 *A History of African Archaeology.* London: James Currey.

Roland, Dom Hadelin
1963 "*Résumé de l'histoire ancienne du Katanga.*" *Bulletin du Centre d'Étude des problèmes sociaux indigènes* 61.

Rosen, Lawrence
1984 *Bargaining for Reality.* Chicago: at the University Press.

Rossiter, Paul
1984 "Cattle Plague." *Swara (East African Wild Life Society)* 7(2):14–16.

Rouget, Gilbert
1985 *Music and Trance.* Chicago: at the University Press.

Rubin, Arnold
1974 *African Accumulative Sculpture: Power and Display.* New York: Pace Gallery.

Rubin, Arnold, ed.
1988 *Marks of Civilization: Artistic Transformations of the Human Body.* Los Angeles: Museum of Cultural History, University of California, Los Angeles.

Schatzberg, Michael
1988 *The Dialectics of Oppression in Zaire.* Bloomington: Indiana University Press.

Schebesta, Paul
1952 "*Les Pygmées du Congo belge.*" *Annales de l'Institut de recherches du Congo belge* 26(2).

Schechner, Richard
1985 *Between Theatre and Anthropology.* Philadelphia: University of Pennsylvania Press.

Schildkrout, Enid, and Curtis Keim, eds.
1990 *African Reflections: Art from Northeastern Zaire.* Seattle: University of Washington Press, and New York: The American Museum of Natural History.

Schneider, Jane, and Rayna Rapp, eds.
1995 *Articulating Hidden Histories: Exploring the Influence of Eric Wolf.* Berkeley: University of California Press.

Schoffeleers, J. M.
1978 "Introduction." In *Guardians of the Land: Essays on Central African Territorial Cults.* Ed. Schoffeleers. Gwelo (Zimbabwe): Mambo Press.

Sendwe, Jason
1954 "*Traditions et coutumes ancestrales des Baluba Shankadji.*" *Bulletin du Centre d'étude des problèmes sociaux indigènes* 24:87–120.

Sicard, Harald von
1966 "Karanga Stars." *Southern Rhodesia Native Affairs Department Annual* 9(3):42–65.

Sleen, W. G. N. van der
n.d. *A Handbook on Beads.* York, Pa.: George Shumway.

Sontag, Susan
1990 *On Photography.* New York: Doubleday Anchor Books.

Soukhanov, Anne, ed.
1993 *The American Heritage Dictionary of the English Language.* 3rd ed. Boston: Houghton Mifflin.

Spence, Jonathan
1976 *The Memory Palace of Matteo Ricci.* New York: Penguin.

Stappers, L.
1964 *Les contes luba.* Tervuren: Musée Royal de l'Afrique Centrale.

Stewart, Susan
1993 *On Longing: Narratives of the Miniature, the Gigantic, the Souvenir, the Collection.* Durham: Duke University Press.

Storms, Émile
ca. 1884 "*Voyage à Oudjidji.*" Unpublished ms, Fonds Storms, Musée Royal de l'Afrique Centrale, Tervuren, Belgium.

Surgy, Albert de
1993 "*Les ingrédients des fétiches.*" In *Fétiches II: Puissance des objets, charme des mot.* Ed. de Surgy. *Systèmes de pensée en Afrique noire* 12.

Swartz, Marc
1968 "Introduction." In *Local-Level Politics.* Ed. Swartz. Chicago: Aldine.

Tambiah, Stanley
1973 "Form and Meaning of Magical Acts: A Point of View." In *Modes of Thought: Essays on Thinking in Western and Non-Western Societies.* Ed. R. Horton and R. Finnegan. London: Faber and Faber.

Terashima, Hideaki
1980 "Hunting Life of the Bambote: An Anthropological Study of Hunter-Gatherers in a Wooded Savanna." In *Africa 2, SENRI Ethnological Studies* 6. Ed. S. Wada and P. Eguchi. Osaka: National Museum of Ethnology.

Terdiman, Richard
1993 *Present Past: Modernity and the Memory Crisis.* Ithaca: Cornell University Press.

Teski, Marea, and Jacob Climo
1995 "Introduction." In *The Labyrinth of Memory: Ethnographic Journeys.* Ed. Teski and Climo. Westport, Conn.: Bergin and Garvey.

Theuws, Théodore
1954 "*Textes luba (Katanga).*" *Bulletin trimestriel du Centre d'étude des problèmes sociaux indigènes* 27.
1960 "*Naître et mourir dans le rituel luba.*" *Zaïre* 14(2–3):115–73.
1961 "*Le Réel dans la conception luba.*" *Zaïre* 15(1):3–44.
1962 "*De Luba-Mens.*" *Annales,* Musée Royal de l'Afrique Centrale, Sciences humaines, 38, Tervuren.
1964 "Outline of Luba Culture." *Cahiers économiques et sociaux (Kinshasa)* 2(1):3–39.
1968 "*Le Styx ambigu.*" *Bulletin du Centre d'Étude des problèmes sociaux indigènes* 81:5–33.

Thomson, Joseph
1968 *To the Central African Lakes and Back,* 1881. Reprint ed. 2 vols. London: Frank Cass.

Tilley, Christopher
1994 *A Phenomenology of Landscape: Places, Paths and Monuments.* Providence, R.I.: Berg.

Tuan, Yi-Fu
1977 *Space and Place.* Minneapolis: University of Minnesota Press.
1990 *Topophilia: A Study of Environmental Perception, Attitudes, and Values.* New York: Columbia University Press.

Turner, Thomas
1993 "'Batetela,' 'Baluba,' 'Basonge': Ethnogenesis in Zaire." *Cahiers d'Études africaines* 132(33–34):587–612.

Turner, Victor
1970 *The Forest of Symbols: Aspects of Ndembu Ritual.* Ithaca: Cornell University Press.
1975 *Revelation and Divination in Ndembu Ritual.* Ithaca: Cornell University Press.

Tytgat, L.
1918 "*Sectes secrètes et coutumes: le chisimba.*" Annexe au rapport mod. B, 2e trim., Mpweto, 29 June. Unpublished report, Archives of the Sous-Région du Tanganika, Kalemie, cl. 343.

Vail, Leroy, ed.
1989 *The Creation of Tribalism in South and Central Africa: Studies in the Political Economy of Ideology.* Berkeley: University of California Press.

Van Acker, G.
1907 "*Dictionnaire kitabwa-français, français-kitabwa.*" *Annales* 5. Tervuren: Musée Royal du Congo.
1924 *Bij de Baloeba's in Congo.* Antwerp: Procure der Missionarissen van Africa.

Van Avermaet, E. and J. Mbuya
1954 "*Dictionnaire Kiluba-Français.*" *Annales* 7. Tervuren: Royal Museum of Central Africa.

Van der Merwe, Nikolaas, and Donald Avery
1987 "Science and Magic in African Technology: Traditional Iron Smelting in Malawi." *Africa* 57(2):143–72.

Van der Noot, A.
1936 "*Quelques éléments historiques sur l'empire luba, son organisation et sa direction.*" *Bulletin des juridictions indigènes et du droit coutumier congolais* 4(7):141–49.

Van Malderen, A.
1940 "*Contribution à l'histoire et à l'ethnologie des indigènes du Katanga.*" *Bulletin des juridictions indigènes et du Droit coutumier congolais* 8(7):199–206, 8(8):227–39.

Van Noten, F.
1972 "*Les Tombes du Roi Cyirima Rujugira et de la Reine-Mère Nyirayuhi Kanjogera.*"

Annales, Musée Royal de l'Afrique Centrale, Sciences humaines, #77, Tervuren.

Van Onselen, C.
1972 "Reactions to Rinderpest in Southern Africa, 1896–97." *Journal of African History* 13(3):473–88.

Vandermeiren, Joseph
1913 *Vocabulaire Kiluba Hemba-Français, Français-Kiluba Hemba*. Brussels: Ministère des Colonies.

Vansina, Jan
1966 *Kingdoms of the Savanna*. Madison: University of Wisconsin Press.

1969 "The Bells of Kings." *Journal of African History* 10(2):187–97.

1973 "Initiation Rituals of the Bushong." In *Peoples and Cultures of Africa*. Ed. E. Skinner. New York: Columbia University Press.

1978 *The Children of Woot*. Madison: The University of Wisconsin Press.

1985 *Oral Tradition as History*. Madison: University of Wisconsin Press.

Verbeke, F.
1937 "*Le Bulopwe et le kutomboka par le sang humain chez les Baluba-Shankaji.*" *Bulletin des juridictions indigènes et du droit coutumier congolais* 5(2):52–61.

Verhoeven, Joseph
1929 *Jacques de Dixmude, l'Africain: Contribution à l'histoire de la société anti-esclavagiste belge, 1888–1894*. Brussels: Librairie Coloniale.

Verhulpen, E.
1936 *Baluba et Balubaïsés du Katanga*. Antwerp: Eds. de l'Avenir Belge.

Vogel, Susan
1986 *African Aesthetics*. New York: Center for African Art.

1988 "Baule Scarification: The Mark of Civilization." In *Marks of Civilization: Artistic Transformations of the Human Body*. Ed. A. Rubin. Los Angeles: Museum of Cultural History, University of California, Los Angeles.

Weghsteen, Joseph
1953 "*Haut-Congo: foudre et faiseurs de pluie.*" *Grands Lacs* 3(167):22.

Werner, Douglas
1971 "Some Developments in Bemba Religious History." *Journal of Religion in Africa* 4(1):1–24.

Weydert, Jean
1938 *Les Balubas chez eux*. Heffingen: published by the author.

White Fathers
1954 *The White Fathers' Bemba-English Dictionary*. London: Longmans.

Whiteley, W., ed.
1974 *Maisha ya Hamed bin Muhammed el Murjebi yaani Tippu Tip*. Nairobi: East African Literature Bureau.

Widstrand, Carl Gusta
1958 *African Axes*. Stockholm: Almquist and Wiksell.

Williams, Nancy, and Daymbalipu Manunggurr
1989 "Understanding Yolngu Signs of the Past." In *Who Needs the Past? Indigenous Values and Archaeology*. Ed. R. Layton. London: Unwin Hyman.

Wilmsen, Edwin
1995 ""Who Were the Bushmen? Historical Process in the Creation of an Ethnic Construct." In *Articulating Hidden Histories*. Ed. Jane Schneider and Rayna Rapp. Berkeley: University of California Press.

Wilson, Anne
1972 "Long Distance Trade and the Luba Lomami Empire." *Journal of African History* 13(4):575–89.

Wolf, Eric
1982 *Europe and the People without History*. Berkeley: University of Calfornia Press.

Womersley, Harold
1975 *In the Glow of the Fire*. London: Peniel Press.

1984 *Legends and History of the Luba*. Los Angeles: Crossroads Press.

Wood, Denis
1992 *The Power of Maps*. New York: Guilford Press.

1993a "Maps and Mapmaking." *Cartographica* 30(1):1–9.

1993b "The Fine Line between Mapping and Mapmaking." *Cartographica* 30(4):50–60.

Yates, Frances
1966 *The Art of Memory*. Chicago: at the University Press.

Yoder, John
1977 "A People on the Edge of Empires: A History of the Kanyok of Central Zaire." Ph.D. dissertation, Northwestern University. Published with revisions in 1992 as *The Kanyok of Zaire: An Institutional and Ideological History to 1895*. "African Studies Series" 74. New York: Cambridge University Press.

Young, Crawford
1965 *Politics in the Congo*. Princeton: at the University Press.

1994 "Zaire: The Shattered Illusion of the Integral State." *Journal of Modern African Studies* 32(2):247–63.

Young, James
1993 *The Texture of Memory: Holocaust Memorials and Meaning*. New Haven: Yale University Press.

Zahan, Dominique
1975 "*Couleurs et peintures corporelles en Afrique noire: le problème du* half-man." *Diogène* 90:115–35.

1977 "White, Red and Black: Colour Symbolism in Black Africa." In *Color Symbolism: Eranos Excerpts*. Zurich: Spring Publications.

1979 *The Religion, Spirituality, and Thought of Traditional Africa*. Chicago: at the University Press.

Glossary

Balubaïsé
"Luba-ized" groups peripheral to the Luba Heartland, who assumed and adapted elements of Luba royal behavior and art in imitation of esteemed neighbors.

bana balutê
"Men of Memory," who speak on behalf of a king or chief when history is evoked or challenged.

bihii bya bukulu
Precious beads worn by royalty as memory devices of relative status and position.

bijimba (vizimba)
Activating agents of magic, drawn from nature and human circumstance.

binyundo
Anvil-shaped pins, used to decorate a wide variety of objects and coiffures, that refer to the transformative power of the blacksmith's anvil.

bitê
A magical bundle inserted in wooden figures or other art works to invest them with active power.

bizila
Prohibitions or "taboos" that structure the responsibilities and prerogatives of royalty.

bufumu
Secular political authority, complementary to bulopwe sacred royalty.

bulopwe
Luba sacred royalty, complementary to bufumu secular authority.

Bwana Vidye
A medium possessed by spirits associated with royalty, who engages in divination for healing and litigation.

dibulu
Capitals or seats of political power, represented by diamond and rectangular shapes in the iconography of staffs and other "sculpted narratives."

dilanga
A long simple staff, unadorned but sometimes surmounted by bells, of a sort owned by many contemporary titleholders.

Heartland
The Luba Heartland is based on the center of sacred kingship in the Upemba Depression, in an economically rich area of small lakes and marshes.

Kalala Ilunga
Son of Mbidi Kiluwe, the Luba culture hero who, in the Luba Epic, introduces sacred royalty to the Luba Heartland. Kalala defeats his tyrannical uncle, Nkongolo Mwamba, and, as he founds the first sacred kingdom, introduces the making of history.

kashekesheke
Divination using a small wooden sculpture held by the practitioner and patient, through which spirits assist in determining the history of misfortune; called "katatora" by northern Luba and their neighbors

kibango
A carved wooden staff whose "sculpted narrative" can be read while the history of a particular kingdom or chiefdom is recounted.

kikalanyundo
The anvil-shaped earthen throne on which kings and Mbudye Society members are seated during their initiations, as the point of transformation and threshold to new realms of knowledge and power.

kipona
A wooden stool or throne that is more a symbolic seat of power than a piece of furniture; also a "sculpted narrative" with encrypted information referring to a particular history of sacred authority.

kitenta (bitenta)
A "spirit capital" or lieu de mémoire, associated with the reign of a particular deceased king; also a "seat of power" synonymous with "kipona," a wooden stool.

kitobo
A "guide" who interprets the glossolalia of spirit mediums and who leads in other encounters with the spirit world.

kiyengele
Mbudye Society lodge, where initiations and other important activities are held.

koba ka malwa
The "house of unhappiness," without door or windows, where a king is enclosed during investiture rituals during which he commits incest with a close female relative, thus removing himself from ordinary human society.

Lolo Inang'ombe
Founding ancestress of the Mbudye Society, often represented by a tortoise but sometimes associated with a buffalo.

lubùko
The most common Luba term for "divination."

lukasa
A Luba "memory board" read by Mbudye Society adepts as they narrate court histories, maps of the royal court, and locations of natural resources.

lutê
"Memory" in the Luba language.

kitê
An earthen mound invested with magic and painted with cosmographic signs.

Mbidi Kiluwe
The Luba culture hero who, in the Luba Epic, comes from the east to initiate the introduction of sacred roy–alty to the Heartland; also a hunter and hunting spirit, and the personification of "black" symbolism.

mboko
A sacred gourd containing mpemba chalk used in divination and other rituals to facilitate and signify contact with and blessing from the spirit world; also a gourd used in divination through which tiny objects are cast into "organizing images."

Mbudye Society
A secret association, closely related to Luba royalty, whose members use memory for problem-solving through divination and other performances.

Mijibu wa Kalenga
The first spirit medium and an important figure in the Luba Epic who saves Kalala Ilunga's life and facilitates contact with the spirit world.

milandu
A term for "memory" in the Luba language that also refers to the active negotiation of history in contexts of conflict or litigation.

misupi
A paddle-shaped staff that recalls ancestral migration along watercourses and refers to the crossing of rivers by the culture heroes Mbidi Kiluwe and Kalala Ilunga, as recounted in the Luba Epic.

mpande
A disk cut from a cone shell imported to the Luba Heartland from the Indian Ocean; an important lunar symbol worn by royalty.

mulopwe
A Luba sacred king.

Mwadi
A female medium possessed by the spirit of a deceased king, in whose former residence she resides and whose kitenta spirit capital she personifies.

nkaka
Literally "pangolin" (a scaly anteater), but figuratively both a scarification pattern of raised isosceles triangles and the beaded headband of members of Mbudye and several related secret associations. The beading is a mnemonic device, and can be "read" by society members.

nkishi (nkisi)
Wooden memory figures representing spirits, often enhanced with bizimba activating agents in magical bundles.

Nkongolo Mwamba
The tyrant antihero of the Luba Epic, who personifies excess and lack of "civilization" as contemporary Luba recognize it; also the immense underground serpent that breathes forth the rainbow and is the personifica-tion of "red" symbolism.

nyundo
A "pillar anvil" used by earlier Luba blacksmiths as both an anvil and a hammer.

pemba (mpemba)
White chalk used in many circumstances to signify benevolence, contact with the spirit world, and enlightenment.

Shankadi
Those Luba clans who share a dialect in which the word "shankadi" is used in salutations as a statement of respect. "Shankadi" as an ethnic denomination is a Western invention and is not used by Luba themselves.

Upemba Depression
A low-lying area of marshes and small lakes along the Lualaba River, one of the important tributaries of the Zaire/Congo River; the site of many ancient settlements, and of the Luba Heartland today.

Vidye
Possessing spirits of or associated with sacred kings and other royal persons.

Index

CURRENT DONORS

Richard Abrons
Mr. & Mrs. Charles Benenson
Dr. & Mrs. Sidney Clyman
Mr. & Mrs. Richard Faletti
Denyse & Marc Ginzberg
Daniel Shapiro & Agnes Gund
Mr. Lawrence Gussman
Jane & Gerald Katcher
Marian & Daniel Malcolm
Ms. Kathryn McAuliffe
Mr. Don Nelson
Robert & Lynne Rubin
Ceci & Irwin Smiley
Mr. Jason H. Wright

Mr. S. Thomas Alexander, III
Ms. Joan Barist
Mr. & Mrs. Jonathan Bell
Dr. Michael Berger
Mr. & Mrs. Jerry Blickman
Mr. & Mrs. Carroll Cline
Dr. & Mrs. Oliver Cobb
Mr. & Mrs. Charles Davis
Drs. Nicole & John Dintenfass
Drs. Jean & Noble Endicott
Ms. Diane Feldman &
 Frederick Cohen
Ms. Nancy D. Field
Dr. & Mrs. Joel Fyvolent
Mr. Danny Glover
Mr. Ronald Gold
Richard Kahan &
 Katherine Lobell
Mr. & Mrs. Jerome Kenney
Mr. Lincoln Kirstein
Mr. & Mrs. Jay Last
Mr. & Mrs. Philippe Leloup
Mr. & Mrs. Sol Levitt
Mr. & Mrs. Lee Lorenz
Mr. & Mrs. Samuel Lurie
Ms. Miki Marcu
Mrs. Tomme Matotan
Mr. & Mrs. Robert Menschel
Mr. & Mrs. Donald Morris
Mr. & Mrs. David
 Rockefeller, Sr.
Arthur G. Rosen &
 Deborah Sonzogni
Mr. Clifford Ross
Mrs. Harry Rubin
Mr. & Mrs. Robert E. Rubin
Mr. & Mrs. Edwin Silver
Mr. Marty Silverman
Mr. & Mrs. Saul Stanoff
Dr. Martin Trepel
Mr. Henry van Ameringen
Mr. Nils von der Heyde
Dr. & Mrs. Bernard Wagner
Mr. & Mrs. Frederic Wallace
Dr. & Mrs. Leon Wallace
Mr. & Mrs. George Wein
Mr. & Mrs. William Ziff, Jr.

Mr. & Mrs. Arnold Alderman
Mr. Ernst Anspach
Ms. Corice Arman
Mr. Dick Aurelio
Mr. Tony Bechara
Mr. Bill Berkman
Mr. Alan Brandt
Mr. & Mrs. Gustavo Cisneros
Mr. & Mrs. Marshall Cogan
Ms. Mary Cronson

Mr. & Mrs. Lewis Cullman
Mr. Hans D'Orville
Mr. & Mrs. Francois de Menil
Mr. Alain de Monbrison
Mr. & Mrs. Kurt Delbanco
Ms. Susan Engel
Mr. Lance Entwistle
Mr. & Mrs. George Feher
Nancy & Lincoln Field
Ms. Vianna Finch
Ms. Jean Fritts
Mr. Larry Gagosian
Mr. & Mrs. Arthur Goldberg
Mr. Hubert Goldet
Linda & Bill Goldstein
Dr. & Mrs. Gilbert Graham
Mr. Francis Greenburger
Rita & John Grunwald
Mr. & Mrs. Graham Gund
Ms. Esther J. Gushner
Mr. & Mrs. Evan Heller
Ms. Marilyn Holifield
Mr. Daniel Hourde
Mr. & Mrs. Carroll Janis
Mr. Leonard Kahan
Mr. Oumar Keinde
Mr. & Mrs. Roderick Kennedy
Dr. & Mrs. Samuel Klagsbrun
Mrs. Estelle M. Konheim
Mr. & Mrs. Arthur Kramer
Mr. Andrew Kreps
Mr. & Mrs. Leonard Lauder
Mr. & Mrs. Joe Lebworth
Mrs. Nancy Lensen-Tomasson
Mr. & Mrs. Brian Leyden
Mr. & Mrs. Robert Lifton
Mr. Barry Lites
Mr. Arthur Littwin
Mr. Eugene McCabe
Mrs. Kendall Mix
Dr. Werner Muensterberger
Mr. Peter Norton
Mr. David Owsley
Dr. & Mrs. Emanuel Papper
Mrs. Marion Parry
Ms. Kathy van der Pas
Mr. & Mrs. Guy Peyrelongue
Ms. Linda C. Phillips
Mr. & Mrs. Robert Pittman
Dr. Kenneth Prewitt
Mr. & Mrs. Norman Redlich
Mr. & Mrs. Fred Richman
Mr. Eric Robertson
Mr. & Mrs. Marvin
 Ross-Greifinger
Mr. Bruce Rozet
Mrs. Stephen Rubin
Mr. & Mrs. Ira Sahlman
Mr. & Mrs. Andrew S. Sardanis
Mr. & Mrs. Arthur Sarnoff
Ms. Ronnie Segal
Mr. Sydney L. Shaper
Mr. Merton Simpson
Mr. & Mrs. Morton Sosland
Mr. & Mrs. Paul Sperry
Mr. Jerry I. Speyer
Ellen & Bill Taubman
Mr. Lucien Van de Velde
Mr. & Mrs. Abraham Weiss
Mr. Thomas G.B. Wheelock
Mr. Eric White
Ms. Jody Wolfe
Mr. William Wright
Ms. Maureen Zarember
Ms. Ruth Ziegler

Ms. Marcelle S. Akwei
Ms. Susan Allen
Mr. Pierre Amrouche
Ms. Gillian Attfield
Ms. Elizabeth Calhoun Baker
Ms. Sandy Baker &
 Mr. Siliki Fofana
Mr. Neal Ball
Ms. Georgette F. Ballance
Ms. Cristal Baron
Ms. Blanche Barr
Mr. & Mrs. Robert Benton
Dr. & Mrs. Samuel Berkowitz
Mr. Mario Bick &
 Ms. Diana Brown
Mr. & Mrs. Frank Biondi
Mr. & Mrs. Joseph Blank
Dr. & Mrs. Claude Bloch
Jean Borgatti &
 Donald Morrison
Ms. Louis Bourgeois
Dr. & Mrs. James Bowman
Mr. Ed Bradley
Ms. Mimi Braun &
 Mr. Andrew Frackman
The Reverend &
 Mrs. Raymond Britt
Ms. Areta Buk
Ms. Catherine Cahill & Mr.
William Bernhard
Mr. Louis Capozzi
Mr. James Caradine
Mr. & Mrs. Robert Carey
Dr. Harcourt Carrington
Nancy & Russell Cecil
Ms. Debra Chatman
Mr. & Mrs. Arnold Cohen
Mr. Jeffrey Cohen &
 Ms. Nancy Seiser
Ms. Anita Contini & Mr.
 Stephen Van Anden
Johanna & Marvin Cooper
Mr. Herman Copen
Ms. Janet Cox
Ms. Catherine Craft &
 Mr. Alfred Kren
Mr. & Mrs. DuVal Cravens
Mr. & Mrs. Lewis Cullman
Mrs. Catherine Curran
Mr. & Mrs. Gerald Dannenberg
Deborah & Earl Davis
Ms. Gail Yvette Davis
Ms. Inmaculada de Habsburgo
Dr. D. David Dershaw
Frances & Thomas Dittmer
Mr. & Mrs. Allan Dworsky
Mr. & Mrs. Daniel Ehrlich
Ms. Barbara Eisold
Dr. & Mrs. Aaron Esman
Ms. Sharon Ettinger
Mr. Jack Faxon
Stella & Harry Fischbach
Mr. & Mrs. Thomas Flynn
Mr. & Mrs. Charles Frankel
Mr. & Mrs. Marc Franklin
Mr. & Mrs. Richard Furman
Mr. Alfred Geduldig
Mr. John Giltsoff
Mr. & Mrs. Paul Gottlieb
Ms. Gail Gregg &
 Mr. Arthur Sulzberger
Mr. & Mrs. Geoffrey Gund
Mr. Frances Haidt
Mr. & Mrs. Edward P. Harding
Riva & William Harper
Mr. Allen M. Harvey, Jr.
Dr. Eve Hazel

Ms. Lenore Hecht
Mrs. Nancy Herstand
Dr. & Mrs. Michael Heymann
Ms. J. Michelle Hill
Mr. & Mrs. Donald C.
 Hofstadter
Mr. David Holbrook
Mr. & Mrs. Bernard Jaffe
Mr. & Mrs. Christo Javacheff
Ms. Carolyn Johnson &
 Mr. Keith Spears
Mr. & Mrs. Harmer Johnson
Ms. Lucy Johnson
Mr. Chester W. Jones
Mr. Jerome L. Joss
Ms. Linda J. King
Mr. & Mrs. Barry Kitnick
Mr. & Mrs. Hugh Kohlmeyer
Ms. Ann Kowalsky & Mr.
 Jerrold Salzman
Mr. Werner Kramarsky
Mrs. Andrea Kramer
Mr. John Kunstadter
Mr. & Mrs. Bernard Kushner
Dr. John Lamberti
Terese & Alvin Lane
Mr. & Mrs. Guy Lanquetot
Mr. & Mrs. Elliot Lawrence
Mr. Michael Lax
Mr. & Mrs. Gerson Leiber
Ms. Lydia Lenaghan
Mr. & Mrs. Robert Levinson
Mr. & Mrs. Sol Levitt
Mr. Edgar Lewis
Ms. Maya Lin
Ms. Justine I. Linforth
Joanne & Lester Mantell
Ms. Miki Marcu
Mr. & Mrs. Edwin Margolis
Mr. & Mrs. Thomas Marill
Ms. Vivione Marshall
Mr. & Mrs. Lloyd McAulay
Dr. Margaret McEvoy &
 Mr. Arthur Storch
The Honorable John A.
 McKesson
Ms. Genevieve McMillan
Meryl & Robert Messineo
Mr. & Mrs. Robert E. Meyerhoff
Ms. Marguerite Michaels
Ms. Emily Michalopoulos
Mr. & Mrs. Peter Mickelsen
John & Elysabeth Miller
Mr. Sam Scott Miller
Mr. Leonard Morris
Mr. Peter Mullett
Mr. & Mrs. Daniel Murnick
Ms. Elizabeth Murray
Mr. Thomas Murray
Mr. Alain Noum
Ms. Judith Neisser
Mr. & Mrs. Milford Nemer
Mr. & Mrs. Roy Neuberger
Mr. & Mrs. Herbert Neuwalder
Ms. Carolyn Newhouse
Ms. Patricia Nitzberg
Mr. Michael Oliver
Mr. & Mrs. John Parkinson, III
Ms. Patricia Patton
Mr. Paul Peralta-Ramos
Mr. Klaus Perls
Ms. E. Anne Pidgeon
Mr. & Mrs. Max Pine
Mr. & Mrs. Leon Polsky
Mrs. Joseph Pulitzer
Mr. & Mrs. Fred Richman
Mr. & Mrs. George Rickey

Ms. Beatrice Riese
Jane & James Roche
Dr. Bennett Roth
Mr. & Mrs. William Roth
Ms. Barbara Rubin
Mr. & Mrs. Robert Schaffer
Dr. & Mrs. William Schlansky
Mr. & Mrs. Herbert Schorr
Mr. & Mrs. Martin Segal
Mr. Jeffrey Cohen &
 Ms. Nancy Seiser
Mr. & Mrs. Ralph Shapiro
Mr. Henry Shawah
Ms. Mary Jo Shepard
Mr. & Mrs. Sidamon Eristoff
Dr. & Mrs. Jerome Siegel
Ms. Beverly Sills &
 Mr. Peter Greenough
Mr. Paul Simon
Mr. & Mrs. Henricus Simonis
Ms. Ingrid Sischy
Mr. & Mrs. Kenneth Snelson
Ms. Joan Snyder &
 Ms. Maggie Camner
Ann & Paul Sperry
Ms. Joanne Stern
Ms. Isabel C. Stewart
Mr. David Stiffler
Mr. & Mrs. John Stremlau
Ms. Barbara Stratyner
Mr. George L. Sturman
Ms. Clara Diament Sujo
Mr. Jay Swanson
Mr. & Mrs. Arnold Syrop
Mr. Howard Tanenbaum
Mr. & Mrs. Mark Tansey
Mr. Farid Tawa
Mr. & Mrs. William Teel
Mrs. Gita Treimanis
Ms. Helen Tucker
Ms. Gloria P. Turner
Claudia & Christof Vonderau
Ms. Kathryn Walker
Mr. & Mrs. William Walsh
Mr. Stewart Warkow
Mr. Robert Weatherford
Mr. & Mrs. Michael Welch
Mr. & Mrs. Gregory Wells
Dr. Fredrick B. Williams
Mr. & Mrs. Oswald Williams
Mr. James Willis
Ms. Paula Wolff &
 Mr. Wayne Whalen
Professor &
 Mrs. William Williams
Mr. George Woodman
Mr. Thomas Zapf
Mr. & Mrs. Aristide Zolberg

257